Paintings of
The Prado

Paintings of
The Prado

Text by

José Rogelio Buendía

José Manuel Cruz Valdovinos

Ismael Gutiérrez Pastor

José Miguel Morales Folguera

José Luis Morales y Marín

Wifredo Rincón García

A Bulfinch Press Book
Little, Brown and Company
Boston • New York • Toronto • London

For Lunwerg Editores

General Director	Juan Carlos Luna
Art Director	Andrés Gamboa
Technical Director	Santiago Carregal
Designer	Bettina Benet
Editorial Coordinator	María José Moyano

Translated into English by

Caroline Clancy and Dominic Currin

Indexes by

Belén Fernández Fuentes

Copyright © 1994 by Lunwerg Editores, S.L., Barcelona

First North American Edition
ISBN 0-8212-2235-X
Library of Congress Catalog Card Number 95-76363
Bulfinch Press is an imprint and trademark of Little, Brown and Company (Inc.)
Published simultaneously in Canada by Little, Brown & Company (Canada) Limited
Printed in Spain

Paintings of
The Prado

CONTENTS

A t the dawn of this century, in *Los fantasmas del Museo del Prado* (The Ghosts of the Prado Museum), José María Salaverría wrote: "At the end of that promenade [of the Prado], set slightly low in the clearing, rises a large pink and grey building. One might venture to say that therein resides the loftiest, most glorious force in all Spain. Once the battle victories have died down, Spain will have a place in the minds of civilized people on account of its history and of the Prado Museum. The history of Spain weighs like some crushing burden on the memory of the world; but history is a dead matter. If Spain possessed nothing more than history, it would be forgotten by all. Spain has its Museum and thanks to it remains alive in the minds of men."

Today these words have lost none of their currency, as the crisis that began in 1898 lives on in the current history of Spain. However, the Prado, despite the neglect, negligence, and uncouthness of many of its rulers, has retained its pristine dignity virtually unscathed and intact. Its art collections have remained practically unaltered ever since the death of Ferdinand VII. Based primarily on the legacy of the Habsburgs and Bourbons, gaps in the collections have gradually been filled by means of bequests and acquisitions.

THE ROYAL COLLECTIONS

The art heritage built up by the early Castilian monarchs — Henry IV, John II, and his daughter, Isabella the Catholic — have unfortunately not been handed down to the Museum, owing to the custom of auctioning off a deceased monarch's assets. With Mendizábal's Disentailment, however, some such works from royal estates have been acquired by the Museum, including *The Fountain of Grace,* painted in the van Eyck workshop and donated to the Monastery of El Parral in Segovia by Henry IV. The collection of Isabella the Catholic was dispersed and the only surviving vestiges in Madrid are some panels from her portable tabernacle. Most of her estate was bequeathed to the Royal Chapel in Granada and subsequently destroyed. For their part, the works donated to the Miraflores Charterhouse by John II and his daughter were plundered by Napoleon's troops.

The first Spanish sovereign to collect works of art as part of crown heritage was Charles V, who bequeathed his collections, along with contributions from the estate of his aunt, Mary of Hungary, to his heir. Philip II thus inherited a splendid series of

Titians and added to his own collection with exquisite taste and skill, although it subsequently diminished through time, war, and fire. Jan van Eyck's *Arnolfini Marriage Portrait,* pillaged from the Oriente Palace by one of Napoleon's officers, later to be recovered by Spain's "allies," the English, is now conserved in the National Gallery in London. The fire in El Pardo Palace in 1604 ravaged the portrait gallery and with it a large portion of early Flemish works. Moreover, the Napoleonic invasion of Spain carried off a large number of the paintings that had survived in that royal residence, among them *The Sleeping Venus,* now one of the jewels of the Louvre.

The palace of El Pardo contained a painting gallery, expertly built up by Philip II, prompted by one of his father's gentlemen-in-waiting, Felipe de Guevara, who urged that the artworks be put on display, because "hidden from sight, they lose their value [...], which may only be done when exhibited in places where they are seen by many." The 1564 inventory of that palace mentions works that, happily, are on display in the Prado today, such as Titian's *Danäe.* Philip's gallery, with its profusion of portraits and profane works, was open only to noblemen and intellectuals. In contrast, the great collection of religious works held at El Escorial, on the sovereign's orders, was open to a larger viewing public. The paintings listed in the inventory entitled *Inventario de alhajas, pinturas [...] 1571–1598* numbered 1,150, making it one of the leading art galleries of the period. Philip II considered it necessary to offer his subjects works that would inspire them to practice piety and good behavior, while he and those closest to him jealously guarded delicately erotic paintings that evoked poetic and human feelings.

After the somewhat gray, melancholic doldrums of the reign of Philip III (who gave his cousin, Fernando, Correggio's poems, now in the Vienna museum), only the arrival of Rubens in Spain broke the spell of artistic barrenness in the country. The *Apostles* already among the Prado's exhibits, with the acquisition a few years ago of Rubens's splendid portrait of his patron, the duke of Lerma, the Museum completed its register of this artist's early period; the Royal San Fernando Fine Arts Academy has recently acquired his *Susanna and the Elders.*

Philip III's heir, Philip IV, was to become one of the most sensitive and ambitious collectors of the contemporary monarchy. He gave precise, categorical orders to his ambassador-agents to purchase the most beautiful works that came onto the art market. Thus, Velázquez, the finest Spanish painter of all time, many of whose works are housed in the Prado, was assigned the task of procuring paintings and sculptures for the royal residences during his second visit to Italy. His best acquisition was Veronese's *Venus and Adonis,* which was enlarged on Velázquez's return, possibly under his direction.

EL GRECO (1540–1614)
The Adoration of the Shepherds, c. 1605
(Detail)

The sovereign's passion for collecting led some aristocrats to part with their most prized treasures. Around 1650, the duke of Medina de las Torres, viceroy of Naples, offered the king his *Virgin and Child with SS. Anthony and Roch.* The fact that the disputed attribution sometimes gives it to Giorgione, sometimes to Titian, does not detract from its being one of the most exquisite early sixteenth-century Venetian works. For his part, the marquis of Leganés relinquished his portrait of *Federico Gonzaga,* also by Titian, while the marquis of Monterrey followed suit with Correggio's *Noli me tangere.* On the death of Rubens, Philip IV inherited a vast collection of the artist's works, including *The Three Graces* and *The Garden of Love,* in addition to paintings by van Dyck and other masterpieces such as Titian's *Self-Portrait.*

Unfortunately, the works painted by Rubens and his disciples for the Torre de la Parada are inconsistent in their quality and are poorly displayed in the Prado. It is to be hoped that with the remnant of works from the Buen Retiro Palace (Military Museum) about to be incorporated into the Prado, they will be rearranged and exhibited the way they were originally. The Kingdoms Room in the aforementioned palace would then recover its artistic, decorative, and symbolic value with paintings by Velázquez, Maino, Pereda, Zurbarán, and Rizi, among others.

The largest number of pictorial works was acquired by Ambassador Cárdenas at the auction of Charles I's estate in London. Through his purchase, Madrid received such masterpieces as *The Death of the Virgin,* by Mantegna, Dürer's *Self-Portrait,* Raphael's *Holy Family,* and the *Madonna of the Stair* by Andrea del Sarto. However, the pièce de résistance was undoubtedly Raphael's *Christ Falls on the Road to Calvary,* known as "El Pasmo," purchased in Sicily through the intervention of Viceroy Ayala.

The royal collections were further enlarged during the reign of Charles II, particularly with the commissions painted by Luca Giordano, nicknamed "Luca fa presto," who decorated residences such as El Escorial and the Casón del Buen Retiro. That was, moreover, the period when the fine Madrilenian school of painting began to flourish. The Prado houses works by Carreño, Coello, Cerezo, Escalante, Antolínez, and Cabezalero, although they still await suitable exhibition sites alongside works by the painters who preceded their generation.

The rise to power of the Bourbon dynasty in Spain was accompanied by changes in artistic taste. When fire gutted the Madrid Alcázar in 1734, ravaging irreplaceable works by Titian, Velázquez, and the early Flemish masters, Philip V gained the needed pretext to replace them with works more suited to his taste. The refurbished chambers became studded with portraits and allegorical paintings by such artists as Ranc and Van Loo. Subsequently, Giaquinto Corrado and Tiepolo adorned the ceilings of the new Royal Palace with prodigious decoration, and Michel-Ange

Houasse came to be among the first few artists to introduce innovations. Thanks to her dowry, Isabella Farnese helped to enlarge the royal collections and, to some extent, to mitigate the loss of the 537 paintings in the aforementioned fire. In 1724, the king purchased the collection of Carlo Maratta, which included works by several Italian artists as well as those by his own hand. Philip also acquired 60 works by David Teniers.

Although Charles III's paramount concern was the renovation or building of palaces, for which purpose he used myriad Italian and French artists and craftsmen, he did not relinquish the existing policy of art acquisition, which brought in works such as Velázquez's *Equestrian Portrait of Olivares,* Rembrandt's *Artemisia,* one of the masterpieces still awaiting restoration in the Museum, and Tintoretto's *Judith and Holofernes.* His patronage of the Bohemian artist Anton Raphael Mengs was partly instrumental in there now being so many of that artist's paintings housed in the Prado. However, it was the king's son, Charles IV, who shook off the classicist yoke and commissioned the genius Goya to paint the works that glorify the museum. The conservative taste of Charles's son, Ferdinand VIII, was manifest in his acquisition of Juan de Juanes's paramount achievement, the altarpiece adorning the church of San Esteban in Valencia.

THE EARLY DAYS OF THE MUSEUM

The building that was to house a large part of the royal collections had originally been intended as a "palace of the sciences," as Floridablanca termed it. That was in 1785, when the architect Juan de Villanueva was commissioned by Charles III to design for the Salón del Prado promenade a science academy, which would house natural science display rooms, laboratories, herbaria, and an adjoining botanical garden. The site chosen for the institution was the lushest, most picturesque spot in Madrid. Indeed, the Salón del Prado was a rendezvous point and place of leisure for all social classes from the court and the city, and along its walks strolled a veritable cross section of society, from innocent children to the most dandified boulevardiers, a place where *chulos,* society girls, and courtesans mixed with aristocrats. Many a rendezvous ended in one of the brothels in the surrounding area, where the church of Cristo de Medinaceli currently stands. The area had a patina of grandeur, with the Buen Retiro Palace looming up on the opposite side of the promenade.

The site was chosen not merely for its popularity, as Pedro de Medina pointed out in 1560, but for its beauty. From 1767 to 1779, José de Hermosilla directed public works to remodel the area. Plots of land were levelled and the dividing gully was filled in, which was subsequently to cause a problem of rising damp that afflicted the

Prado Museum for over a century. Ventura Rodríguez completed Hermosilla's project ten years later when he unveiled the monumental fountains of Cybele, Apollo, and Neptune, all designed by leading sculptors. Finally, the architect attempted to implement an ambitious scheme of building shops, an inn, and a tavern under a huge portico intended both to shelter three thousand people from sun and rain and to embellish architecturally the "City of the Bear and the Madrona."

Despite his being a prestigious architect, when Villanueva submitted his first design of the museum it was turned down by the sovereign who, as Floridablanca recalled, dismissed it as "just ideas," that is, mere preparatory sketches. Villanueva took up the challenge again and, with perseverance, produced a number of large, meticulous designs from which the king and his heir apparent, the future Charles IV, would choose.

In addition to the plans, including elevations and even a scale model of the building, Villanueva presented the king with a report detailing both the technical structure of the projected science museum and an assessment of its educational potential. The report and the estimate of expenditure were subsequently lost to posterity. They would have been extremely useful to Spanish museography, since the proposed museum was to operate both as a museum for exhibits that would attract the general public and as a center of learning and research. For instance, the early collection housed the so-called Dauphin's Treasure, which today is the sole surviving ensemble preserved from the original exhibits in the Prado. That precinct of culture also included a delightful botanical garden and the now half-hidden astronomical observatory.

Work got under way on the proposed science building and lasted until 1808. When the Napoleonic troops arrived in Madrid, construction had virtually come to a standstill. Murat's armies, however, used both the Prado and the Buen Retiro Palace as barracks. Until then, as Rumeu de Armas points out, the Crown had spent almost fifty million reales on the work. When the French troops finally withdrew, the fabric of the building had sustained damage, but the supporting structures had withstood the acts of barbarism.

Mariano Luis de Urquijo, the secretary of state from 1798 to 1800, was, since the time of Guevara, the first Spanish politician to have a clear idea in his mind about setting up a fine-arts museum in Madrid for research and public use. His friend Antonio Ponz was aware of this and, in 1774, received a letter from Mengs in which the artist wrote: "I should wish for all the priceless paintings divided between the royal residences to be assembled and placed together in a gallery in this royal palace (the Oriente)."

With the support of Spanish intellectuals, the illustrious politician intended to build a national gallery, as Dresden, Rome, Paris, and other cities had done. He set about bringing together masterpieces scattered about Spain's provinces, starting with Seville, where he ordered the removal of the paintings by Murillo that were housed in the marvelous church of the Hospital de la Caridad. This angered the city authorities, who were spurred into action by the powerful Brothers of Charity and by Sevillian intellectuals. The defeat led Urquijo to withdraw his idea of setting up a gallery of Spanish painting in the science museum. When he was succeeded as secretary of state by Pedro Ceballos, under the powerful auspices of Manuel Godoy, the two politicians decided to enlarge the modest collection in the San Fernando Academy by seizing works from the Society of Jesus, the Jesuits, after expelling its members and closing its convents. The institution had rooms, closed to the public, that housed nudes collected by Charles V, Philip II, and Philip IV that were on the verge of being destroyed at the urging of Charles III's confessor, the dreadful Fray Joaquín de Eleta. However, the intervention of the marquis of Santa Cruz, an advisor to the academy, led to those masterpieces being rescued in time. They were brought together with Goya's *Majas,* which Godoy had expropriated and kept in that building until 1827, when they were sent to the Prado.

What Urquijo was unable to achieve as Charles IV's minister he achieved by swearing allegiance to the intruder-king, Joseph Bonaparte, who appointed him chief adviser on cultural affairs. In 1809, he managed to secure a royal decree sanctioning the construction of a museum, to which end he had to draw up an inventory of all the paintings and sculptures assembled from the convents that had been closed in Madrid and Castile. He delegated this task to the antiquarian Frédéric Quilliet, a mercenary fellow who repudiated the royalist Bourbon camp and obsequiously served the intruding king. He was then granted special powers to plunder Spain's art heritage, which placed El Escorial, a large part of Andalusian heritage, and the royal collections themselves at his disposition. Van Eyck's *Arnolfini Marriage Portrait* was probably lost to Spain due to the painting's having been handed over to a Napoleonic official. A selection of the confiscated works was sent to the Musée Napoléon in Paris; other works were earmarked for the museum, while a large part was either kept by the antiquarian for personal benefit or handed over to his French patrons. One thousand five hundred canvases were deposited in the former convents of San Francisco, El Rosario, La Encarnación, and Doña María de Aragón, while some works were added to the collection in the Buen Retiro Palace, for which purpose the assistance of Spanish scholars was requested.

The project was never completed, however, owing to the treasury becoming

bankrupt. Instead, many of the artworks were included in Joseph Bonaparte's luggage when the French forces withdrew from Spain, a pillage partially thwarted by the outcome of the battle waged at Vitoria. Some important works were recovered, others were spirited off by the Napoleonic troops, and still others were taken by the commander-in-chief of the allied forces, Lord Wellington. (Some of these priceless works are currently housed in Aspley House, London.) Although Ferdinand VII later requested the return of those paintings, Lord Wellington replied that he had only taken a few trivia as souvenirs. They included the *Waterseller of Seville* and *Two Young Men Drinking,* both magnificent works by the young Velázquez that would have completed the collection in the Prado of paintings by Spain's foremost artist. Fortunately, most of the works that turned up in the Louvre were subsequently returned to Spain, although some were subject to alterations. Most of Raphael's panels, for instance, were transferred to canvas to better withstand the journey from Paris to Madrid.

Nevertheless, many of the paintings seized from politicians and the nobility and taken to France in 1809 by Baron Denon were rejected by the Musée Napoléon and fell into private hands. Thus, in addition to the many artworks stolen by French generals, such as those taken by Marshal Soult in Andalusia, the aforementioned pictures never returned to Spain and may now be found in private French, English, and American collections. To Spain's shame, as has so often happened, the Napoleonic selection committee included two illustrious Spanish painters and one restorer — Francisco de Goya, Mariano Maella, and Manuel Napoli. The fifty paintings of their choice were housed in the convent of San Francisco for three years. Neglect or patriotism led to the disappearance of some works, while others sustained considerable damage. Goya, who was apparently deemed "wanting in enthusiasm," was later removed from the committee and replaced by two mediocre artists. Finally, in 1813, the previously noted paintings, together with the Dauphin's Treasure, were dispatched to the Louvre. When they arrived in Paris, however, Denon was bitterly disappointed at the selection and, although it included the likes of Velázquez's *Joseph's Coat,* currently in El Escorial, he naturally regretted not finding works such as *Las Meninas,* which he had seen during his visit to the Royal Palace in Madrid.

Ferdinand VII was restored to the throne in 1814 and, being familiar with the Napoleon Museum and wishing to please his subjects, the monarch convened his counsellors to expound the idea of setting up a public museum that would appease his "enlightened" or "modern" subjects. The task was assigned to Pedro Franco, the cultivated duke of San Carlos and president of the academy, who had previously asked the king for permission to move the seat of the academy and its picture gallery to the

monastery of San Felipe el Real. The shrewd king decided to make over to him the Buenavista Palace, which on the surface appeared to be more suitable as a building and location. By ceding these premises, once owned by the dukes of Alba and subsequently by Manuel Godoy, Ferdinand was able to enhance his reputation and overturn possible claims to the building by the heirs of his parents' protégé.

The donation was accompanied by a promise to enlarge the meager academy collection of paintings with works from the royal collections. On July 14, accompanied by his family and entourage, Ferdinand publicly announced the assignment in the academy assembly hall. The secretary, Munárriz, a friend of Goya's, read out the constituent act for the institution, which was to include a gallery of paintings, engravings, statues, and architectural plans to provide a place of teaching and study for lecturers and pupils, "to satisfy the noble curiosity of locals and foreigners, and to grant Spain the glory it deserves."

However, the real state of affairs was quite different. When the academy architects surveyed the palace interior, they found that the roofing was in a similar state of repair to that of the Prado Museum nowadays — about to spring leaks and in need of immediate replacement, at a cost far beyond the budget allotted to the institution. The academic authorities then urged the king to change his mind and provide alternative premises, albeit less pretentious ones, more suited to the project. They suggested that the original building earmarked for the science museum in the Paseo del Prado might fit the purpose at a lower expense. But, with the national economy in a sorry state at the time, the royal council had other priorities. Under the pretext of the proposed change of premises, the museum scheme was postponed. Two years later, the council once again proposed refurbishing the existing building to house the paintings, this time at a lower cost, since the ceiling repair work needed in the Royal Palace had to be postponed.

Having ruled out the idea of creating a "Museo Fernandino," that of founding a "museum of science and art" was revived in 1818, this time with a definite name — El Prado. Probably owing to the enthusiasm of his wife, Isabella of Portugal, Ferdinand VII decided to set up one of the largest art galleries in Europe. After the death of his wife, however, the insistence of his new wife, Josefa Amalia of Saxony, was possibly more instrumental. She urged him to recreate the Zwinger Museum founded by her father, the king of Saxony and Poland, in the marvelous Rococo building in Dresden. The royal sanction drew some satisfaction from the fact that the paintings would thereby cease to cause any problems of space in the royal residences and that exhibiting the masterpieces from the early royal collections would be to the greater glory of the Crown.

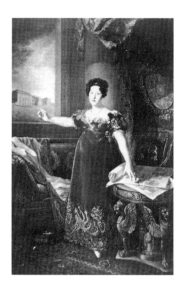

BERNARDO LÓPEZ
Queen María Isabel de Braganza, 1829
Casón del Buen Retiro
(Detail opposite)

The royal grant was used to restore the building and remodel parts of it to house exhibits, while the idea of a science academy was abandoned. The finest paintings in the Oriente Palace and other royal residences were transferred to the new museum. By the end of the summer of 1819, nearly one million copper reales had been committed to the building work and, on November 19, the Prado was inaugurated, formally but simply, at a ceremony presided over by Ferdinand VII and his German wife. The queen actually had the artist Bernardo López perpetuate her predecessor in a painting depicting her as the founder of the national art gallery. The legend of Bárbara de Braganza as an enthusiastic patroness of the arts was disseminated by the liberals after the death of Ferdinand VII with the aim of tarnishing the latter's reputation. Nevertheless, the fact that he was a dreadful ruler does not detract from the fact that he created the leading art institution on the Iberian Peninsula.

The museum's first director, the marquis of Santa Cruz, resigned after being dismissed as the ambassador to Paris in 1820. He was succeeded by the prince of Anglona (1820–1823), the marquis of Ariza (1823–1826), and the duke of Híjar (1826–1838). Throughout that long period of office, the museum was effectively run by its art consultant, Vicente López, whose portrait was painted in his office by Goya as an homage to "a Spanish art-lover." Possibly acting on advice from the Aragonese artist, who had visited Madrid from his residence in Bordeaux, López subsequently proposed that the museum should be refurbished to modernize the antiquated facilities. The project was shelved by Ariza but, when the duke of Híjar was appointed director, the proposed reform was sanctioned by the king on December 27, 1827. The renovations were completed a year and a half later and the museum's patient secretary, curator, and cataloguer, Luis Eusebi, brought out his last and definitive catalogue. A year later, the Flemish gallery was opened to the public. It included the modest number of Dutch paintings in the Prado collection, of which the prize was Rembrandt's *Artemisia.* By 1828, the Prado ceased to be merely a storehouse for artworks, with its collection being classified and exhibited by schools. Of the 1,628 paintings in the museum, 745 were put on display, a ratio similar to that which pertains at present.

The duke of Híjar's sound judgment led him to set up a commission headed by Eusebi, the chamber painter Juan Antonio Ribera, and the classical-romanticist sculptor José Alvarez Cubero, whose task it was to comb the royal residences for other works with which to enlarge the collection. Meanwhile, the paintings in the storerooms were dusted and protected against damage from insects and rats. On the death of the king, the indefatigable duke of Híjar decided to open new exhibition rooms to display paintings and sculptures that had recently come to light. He also

PETER PAUL RUBENS (1577–1640)
The Garden of Love, c. 1630
(Detail)

requested the Academy of Fine Arts to part with its nudes, a request that, as mentioned earlier, was fulfilled some years later. The Madrilenian public was then able to view Venetian *Venuses* and Goya's *Majas,* a privilege initially granted only to select visitors but subsequently extended to a cultivated public.

In 1837, the new director, José de Madrazo, published artworks from the Prado's finest exhibits. These books, produced in the Museum's workshops, became highly popular and, as so often happens when cultural works are popularized, the venture generated handsome profits. There were also instances of patriotic and artistic exemplarity at the time. Through the duke of Híjar, Godoy's widow, the countess of Chinchón, had started negotiating the sale of Velázquez's *Christ Crucified* to the Museum, a transaction she left unfinished. On her death in Paris, however, her heir, the duke of San Fernando, inherited the painting and gave it to Ferdinand VII, who immediately deposited it in the Museum. The paramount art gallery in Spain is still waiting for the countess's portrait to complete its peerless collection of Goyas. Some works that were controversial at the time but are now considered masterpieces found their way into the Museum. Such is the case for El Greco's *Holy Trinity,* which arrived in the Prado from Santo Domingo el Antiguo, Toledo, after being threatened with exportation, and his *Assumption of the Virgin,* currently in the Art Institute of Chicago.

On the death of Ferdinand VII, the museum was rescued by another politically and socially mediocre sovereign, Isabella II. Legally, the collections had to be divided between herself and her sister, Luisa Fernanda. The duke of Híjar immediately set up another commission, this time to lobby for the collection's indivisibility. The criteria for valuing artworks were rather different from those now in vogue and, while Raphael's *Christ Falls on the Road to Calvary* was valued at four million reales, the value of Velázquez's *Las Hilanderas* was set at only one hundred and twenty thousand reales. In 1845, Luisa Fernanda waived her right to the paintings, but they continued to be the queen's private property until 1865, when they were permanently transferred to the Crown Heritage, marking a return to the status instituted by Philip IV.

José de Madrazo was responsible for starting the practice, continued until Franco's time, by which the office of chamber painter was linked to that of director of the Prado Museum. The last such painter was Alvarez de Sotomayor, appointed by Alfonso XIII and reinstated by Franco. Madrazo's most successful venture was to set up a workshop where artworks were restored — rather hastily, arousing a certain amount of criticism. It was while he was in office that, under the pretext of protecting paintings from Carlist patrols, a number of masterpieces, such as Raphael's *Virgin of the Fish,* were transferred from El Escorial to the Prado. In 1853, Queen Isabella

opened an exhibition room that bore her name, where recent acquisitions and newly restored works were poorly displayed, lacking any chronological or stylistic criteria in their arrangement. Instead, they were crammed into what in effect acted as a storeroom, a state of affairs that lasted until the time of the refurbishment undertaken by Aureliano Beruete in 1922. He was instrumental in arranging the El Greco Room into a display worthy of the best contemporary museography. However, five years later, Pedro Muguruza rearranged the exhibits into lines, based on displays in American museums. This turned the Prado into a dull museum, and in some rooms the system has lasted until the present, pending urgently needed remodeling projects.

THE PRADO'S FORTUNES AND MISFORTUNES

After the transfer of works from El Escorial to the Prado mentioned earlier, only a few subsequent acquisitions have been worthy of note. One was Fra Angelico's *Annunciation Altarpiece* from the monastery of the Descalzas Reales. There were more blunders than successes. As Pérez Sánchez pointed out, "Federico, José de Madrazo's son and the favorite painter of the court and the upper classes, turned the Prado under his direction into his private home." There, he set up his workshop as well as a shop that sold antiques and decorative objects and that occasionally snapped up works that were intended for the Prado, a practice that lasted until the dawn of this century. The museum thus lost its regal character and became a mundane precinct, which brings to mind the recent affair in which chairs provided by an upmarket, glossy magazine were installed. Isabella II's deposition in 1868 and the appointment of Gisbert, the artist favored by the revolutionaries, did nothing to change the situation, which was criticized by two great art scholars — Gregorio Cruzada Villaamil and Ceferino Araujo. But they only managed to carry out Madrazo's old idea of transferring to the Prado the Goya tapestries housed in the palace vaults.

The Prado was renovated thanks to the perseverance of Vicente Poleró, who secured for the museum the artworks that had been banished to the Museo de la Trinidad in 1836 following Mendizábal's Disentailment. With the assistance of the cataloguer of that museum, Cruzada Villaamil, the huge cache of religious paintings was finally brought to the Prado. The move was tainted by the fact that the paintings were not properly stored, leaving them at risk of damage. Many were sent to provincial museums and official organizations, as well as episcopal palaces and remote village churches where certain politicians wielded influence. Most of the works that ended up in Urracal and Cantoria, in the province of Almería, were destroyed during the Spanish Civil War. A consignment dispatched to the would-be Foundation of

Santa María de Socuéllamos actually adorned the walls of an estate owned by the then minister of public works. After the Civil War they were absorbed by the antique market and it was only by a stroke of luck that some were recovered. Worse still, others were taken up by unofficial entities such as the Manufacturers Association of Sabadell. The acquisition of these works, once the property of the Church in Spain, filled the gaps in the Prado's collection of Spanish artists, whose oeuvres had been overlooked in the royal collections.

The Civil War led to the closure of the Prado Museum on August 30, 1936, and, in November, the artworks were hurriedly evacuated, first to Valencia and, at the end of the war, to Switzerland. Fortunately, the only painting to sustain damage was Goya's *May 2, 1808, in Madrid: The Charge of the Mamelukes,* which fell off the truck that was transporting it. The wounds it suffered have happily been left as a historical reminder of the times. The Prado opened its doors to the public again on July 7, 1939, although without the paintings that were being exhibited with enormous success in Geneva at the time. The outbreak of the Second World War forced a hasty repatriation of the works, however, which were brought back on a train bound for Spain with its lights blacked out. Once again, luck was with the Prado, which was opened in virtually the same condition as it had been left in 1936, after some minor damage caused by aerial flares and a few small, unexploded bombs had been repaired.

The last director during the monarchy, the painter Fernando Alvarez de Sotomayor, was reinstated, as was the deputy director, Francisco J. Sánchez Cantón, who had been dismissed in 1938 for refusing to allow the evacuation of some paintings, fearing that they might be sent to Russia in accordance with the wishes of certain members of the commission. In 1941, an exchange with France led to the arrival of the Soult *Our Lady of the Immaculate Conception,* by Murillo, and the stone sculpture known as the *Lady of Elche,* although the latter was transferred to the National Archaeological Museum in recent years. At about that time, the South American diplomat Mariano de Zayas donated some important ancient sculptures. The following year saw the construction of the flight of steps leading simultaneously to the upper and lower floors, an architectural arrangement used by Haan, a follower of Villanueva's, at Toledo University. Moreover, stone floors were laid in place of the old wooden ones, reportedly to prevent fire. Regrettably, this did away with the beautiful wooden flooring in the central gallery, which was similar to that proudly preserved in the Louvre.

The last time the Prado was enlarged was in 1956. At the end of the Civil War, the museum received the bequest of Francisco Cambó, which included Botticelli's *Story of*

Nastagio degli Onesti, enhancing the existing quattrocento collection. An *Angel* by Melozzo da Forli, on the other hand, turned out to be a forgery, as did a Fra Angelico that had been selected thirty years earlier by a committee of experts from among a set of fine Spanish and Flemish works belonging to a Madrilenian collector who wished to donate the best pieces from his collection. Alvarez de Sotomayor and Sánchez-Cantón, his deputy director at the time, foolishly turned down the offer of the Carlos Bestegui bequest, which included Goya's outstanding *Marchesa de La Solana* and excellent works from the French classical Romantic period. On condition that the portrait of the Basque patron by Zuloaga should preside over the ensemble, and given his enmity toward the director and the pretext that there was no space to exhibit the collection, Bestegui decided to make it over to the Louvre, where it is now lavishly displayed. In contrast, the exhibition of works from the collection of the duke of Alba, which university students had heroically salvaged from a fire in the Liria Palace during an aerial bombardment in 1937, met with unprecedented success.

The death of Alvarez de Sotomayor marked the last time a painter was to hold office as director of the museum (1939–1960). He was succeeded by J. Sánchez-Cantón (1960–1968). The most important acquisitions from the preceding period of office had been the works from El Escorial, notably Rogier van der Weyden's *Descent from the Cross,* three masterpieces by Bosch (*The Garden of Earthly Delights, The Hay Wain,* and *The Seven Deadly Sins*), and *The Washing of the Feet,* by Tintoretto. After the war, the three hundred thousand pesetas bequeathed by the count of Cartagena in 1930 continued to be carefully administered, being used, among other things, to fill the gaps in the Prado's collection of medieval works, with the acquisition of Fernando Gallego's *Pietà* and the splendid Renaissance painting by Pedro Machuca, *Epimetheus and Pandora.*

Sánchez-Cantón's endeavors were successfully furthered by Diego Angulo Iñíguez, who negotiated the acquisition of the *Duke of Lerma* by Rubens. He was succeeded by his deputy director, Francisco Xavier de Salas, a specialist in museology, a great connoisseur, and a diplomat who, with his team of assistants (which included the future director, Pérez Sánchez), set about revaluing the collections. Thanks to Salas, the Prado possesses one of the most beautiful examples of Italian Renaissance painting, Antonello da Messina's *The Dead Christ Supported by an Angel,* as well as an excellent canvas by Magnasco. The Spanish collection was enlarged with the addition of such works as Mateo Cerezo's *Still Life* and, above all, his *Head of a Stag,* which was donated by the marquis of Casa-Torres.

After the death of Franco in 1975, the ensuing process of democratization affected not only the political sphere but the museum itself. Thus, early the following year,

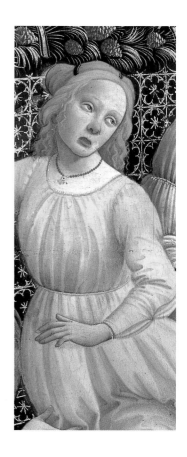

SANDRO BOTTICELLI (1445–1510)
The Story of Nastagio degli Onesti, 1483
(Detail)

Alfonso E. Pérez Sánchez delivered three lectures entitled "The Past, Present, and Future of the Prado Museum," in which he embarked on a critical analysis of the state of the collections and advocated a complete overhaul of the way in which the Museum's artworks were stored and exhibited. He also stressed that the Prado had to be exemplary as a center of culture, learning, and research. In order to revitalize its structure, he considered it essential to inventory all collections in the country. He likewise suggested that all expenses should be met by the state and that admission should be free of charge for all Spanish citizens. An Association of Friends of the Museum could be set up to help in drawing up cultural curricula and acquiring new works. Renovation work on the building and its enlargement — to include a library, restoration workshop, storage facilities, and offices — had to be undertaken at once by the new state administration. What seemed a utopian undertaking at the time has largely been achieved since then, by Pérez Sánchez and by the director, José María Pita Andrade, who held office from 1978 to 1981.

The Casón del Buen Retiro, part of the Buen Retiro Palace, was annexed to the Prado in 1980 and used to house part of the nineteenth-century collection, which had been started by Isabella II. Unfortunately, the works by Luca Giordano were rather hastily restored. Some years later, Picasso's *Guernica* was exhibited there on a temporary basis, in accordance with the artist's wishes. One of the successes of that period was the publication of the Prado *Bulletin,* which featured Pérez Sánchez's "El Prado disperso" (The Prado Dispersed). The fact that the Prado management had not been allowed to play a major role in the unveiling of *Guernica* prompted Pita Andrade to resign. He was replaced by the musicologist Federico Sopeña (1981–1983), whose removal from managerial duties was skillfully countered by the new deputy director, Manuela Mena, who supervised some magnificent restoration work. The period also saw the acquisition of minor eighteenth-century French and seventeenth-century Dutch works, while the curator, Matías Díaz-Padrón, published his excellent catalogue of seventeenth-century Flemish painting.

Pérez Sánchez, a connoisseur of the Prado and of Spanish and Italian Baroque painting, was finally appointed director in 1983. He immediately placed the great "sick man of our culture" under treatment. In his opening speech, he talked of the need to turn the Prado into a "living museum." In 1973 I had said as much in the first edition of my *El Prado Básico* (The Basic Prado). Work soon got under way to rearrange the exhibition halls and restore some of the flagship works, such as *Las Meninas* and *Las Hilanderas* by Velázquez, and Goya's *Jovellanos.* Restoration was conducted along scientific lines thanks to the contribution of the research team headed by María del Carmen Garrido. Prior to restoring works, preliminary studies

were performed, including the use of X-ray analysis, reflectography, and stratigraphy, which enabled the projects to be implemented successfully.

Progress was cut short, however, by the outbreak of the Gulf War and the emergence of the so-called new world order. A manifesto drawn up against Spanish participation in the conflict led to the instant dismissal of a number of high-ranking officials in the ministry of culture and the director of the Prado. The incoming director, Felipe María Garín Llompart, started out with resounding success, unequalled in the twentieth century, by securing the Manuel Villaescusa bequest. The latter, a Madrilenian lawyer who died in February 1991, appointed the Prado to be his sole heir and endowed the Museum with an enormous amount of money. This was used to purchase masterpieces such as the *Blindman Playing the Hurdy-Gurdy* by Georges de La Tour, which is an essential addition to the French collection. The Spanish collection was enhanced by the acquisition of an El Greco on an unprecedented theme derived from the adage *"El hombre es fuego, la mujer estopa, viene el diablo y sopla"* (Man is fire, woman is tow; the devil appears and begins to blow), and a *Still Life* by Sánchez Cotán, the purchase of which was paid for in part from the proceeds of the sale of the catalogue for the Velázquez exhibition. Other additions included a set of panels from Palencia ascribed to painters in the circle of Starnina, a fine Italian painter who worked in Valencia and Castile. Less successful was the acquisition of a *Pentecost* attributed to Yáñez de la Almedina, which should instead be ascribed to one of his more modest followers, and the insipid portrait, *Isabella the Catholic,* from the circle of Juan de Flandes. As at other times in the Museum's history, instances of indecision have cost its collections dearly, as attested recently with works — including the odd painting by Friedrich or Rembrandt — which have been put up for sale instead of being used to enrich the Prado's heritage. I believe that, in the present situation, works should only be purchased if they are to be put on display and not hidden away in the storerooms.

Due to their short terms of office, the Prado's last two directors, Garín and Calvo Serraller, have not been able to implement any far-reaching renovations. As has happened so often in the past, planned enlargements have ended up as refurbishments. The overall surface area of the Museum is the same as it was in 1956, while the portion available for exhibition has actually decreased in size, owing to the insertion of offices, a library, and a lecture hall, so that many of our valuable paintings are stored away and hidden from view. Hence, visitors have been deprived of seeing Mannerist masterpieces such as Cornelisz van Haarlem's *The Assembly of the Gods* or Elsheimer's captivating *Ceres,* while too many works by Correa del Vivar are on display, making his room boring.

GEORGES DE LA TOUR (1593–1652)
Blindman Playing the Hurdy-Gurdy
(Detail)

Soon after taking up his post, the present director, José María Luzón, commissioned a report itemizing the Museum's needs. The report deals first with the subject of a new and functional access to the Villanueva building, a suitable system for checking coats and other objects at the entrance, the arrangement of ticket offices and information booths, and assembly points for groups. It then tackles the issue of overall access to the Museum and suitable parking areas. Apart from focusing on facilities affecting visitors and students in the interior, the most significant part of the project deals with a future enlargement of the Museum, which will probably be accomplished in the vicinity of the Villanueva building or the Casón del Buen Retiro. The works stored in the Prado's vaults or scattered elsewhere would be exhibited after remodeling work is completed on the Military Museum (part of the former Buen Retiro Palace) and the cloister of the church of Los Jerónimos. A painting by Ribera, which had been stored away for two years, has now been put on display — a promising beginning that also includes an effectively arranged gallery room for seventeenth-century Flemish paintings. A commission made up of important connoisseurs and organizers now has the charge of ordering the collections. We trust that they, along with the members of the technical staff and the indefatigable new director, will turn the Prado Museum into what Ruben Darío would describe as "very old and very modern."

JUAN DE FLANDES (active 1480–1519)
The Ascension, c. 1510
(Detail)

THE SPANISH SCHOOL

Spanish art has traditionally enjoyed the benefit of patronage from only the Crown, the Church, and one or two other exceptional sources. In this it was different from France and Italy, where the aristocracy were both patrons and regular clientele. A middle class demand such as that which arose in the Low Countries, especially Holland, was nonexistent, as there was no real middle class in Spain until well into the nineteenth century. Charles III, however, ennobled dignitaries from the bourgeoisie, and from this "newly fledged" nobility emerged those who emulated the monarchy in their enthusiasm for Spanish painting. Some of their collections ultimately passed to the Crown through acquisition by the sovereigns.

On the other hand, we have the complex phenomenon of the Church's patronage. Apart from the reasons that led the religious orders and the secular clergy to look upon art as one of their great allies — that is, in attracting the faithful and in the promulgation of the lives and works of the new founders — Spain was a country that, at one particular moment, set itself up to be the first champion of the Counter-Reformation, so that the action of patronage in this sense became fundamental to the promotion of art in general and Spanish painters in particular.

The Prado collections divide into three broad sections according to the circumstances and provenance. The first section is made up of the royal collections. The second comes from Church patronage and comprises the whole series of canvases that were confiscated by the state as part of the measures taken to sequestrate church property. These at first formed an independent museum, the Museo de la Trinidad, and later the major part became the first Spanish national picture gallery. Finally, we have the third block — new acquisitions, bequests, and purchases. We find in consequence that more than two thirds of the total number of works making up the Prado Museum collections are derived from the patronage of Spanish painting by its two most important benefactors, the Crown and the Church.

Spanish painters of significance, from the second half of the sixteenth century and until well into the nineteenth century, seem, of necessity, to have been tied to the Crown, working in the royal service as salaried employees. Under the Habsburgs, every distinguished artist worked under these conditions, except for isolated examples such as Zurbarán, Murillo, or Valdés Leal.

During the Golden Age of Spanish painting, there was not a single artist of renown who was not associated with the royal household, or the greater part of whose works

resulted from circumstances other than commissions from the king. This occurred in the cases of Luis Paret y Alcázar and Luis Menéndez, who, although never enjoying the title of court painter, found their principal clients in the monarchy.

All these circumstances meant that the royal collections contained the largest number and highest quality of paintings of the so-called Spanish school, competing in this respect only with the Church. In the Prado catalogues prior to 1868, when the Museum housed only the royal collections, the number of Spanish works is much greater than that for any other artistic school. The 1819 catalogue lists 317 Spanish paintings; later, due to successive additions of works from the royal residences during the reigns of Ferdinand VII and Isabella II, as well as to acquisitions for the Museum by these sovereigns, we find that the number of paintings by Spanish artists was considerably increased.

Under the House of Habsburg, the sovereigns, as well as drawing together around them the various Spanish painters, tried to assemble in the old Madrid Alcázar and in other royal residences — particularly the Buen Retiro Palace — a series of works that proclaimed their zeal as collectors. In this respect the actions of Philip III and, even more, of Philip IV were outstanding. The latter had no hesitation in sending his painter, Diego Velázquez, to Italy to acquire those artworks he considered most important for his aristocratic and refined taste.

The House of Bourbon, however, initiated a more systematic policy that was effective in the protection of Spanish painting in all respects, and under Charles III promulgated the first legal measures to prevent the export of works of art from Spain.

On acceding to the throne at the end of the War of the Spanish Succession, the first sovereign of the new dynasty, Philip V, who was accustomed to the comforts of the French court, began to adapt the royal residences to the needs of the new European society. This was the start of a fruitful activity that would continue throughout the reigns of his successors. One very special circumstance, in the field of interest to us, was his second marriage, to Isabella Farnese, an event that proved to be a benchmark in the development of the plastic arts in Spain, for her organizing capacity and education was passed on to her descendants.

A woman of exquisite accomplishment, Isabella had been well versed in literature, music, and painting from her youth, the result of her mother's strict tuition. For years she was kept almost isolated from the Parma palace court and, in her retreat, she benefited immensely from the teaching her tutors and selected masters proffered for her education. Among the strict disciplines of her instruction, she was introduced to the world of the arts by Molinaretto and Pietro Antonio Avanzini.

Bottineau published information of great interest on the splendid collection that

Philip V and Isabella Farnese came to possess, and this has been amplified by Teresa Lavalle. Through Procaccini, the queen from Parma acquired the magnificent sculpture collection that had belonged to Queen Christina of Sweden, and also collections of paintings from Carlo Maratta and Scotti; but above all she was the true discoverer of Murillo, several of whose paintings she bought during the court's sojourn at Seville. For the most part these canvases can be found in the Prado Museum today.

Isabella Farnese's enthusiasm for collection in general and her predilection for Spanish painting in particular was inherited by her son, Charles III. Madrazo, in his *Viaje Artístico,* states that "the mere enumeration of the collections brought together by Charles III gives rise to true astonishment." This patronage of the Spanish school of painting was due not only to a desire to bring together the works of Spanish artists or to keep a considerable nucleus of painters in the royal household, but also to protect the Spanish artistic heritage. In October 1779, the first protective measures were dictated to prevent the pillaging that some foreigners had begun to perpetrate in Spain — as had occurred in Seville, particularly with Murillo's paintings.

Works by Velázquez, Zurbarán, Carreño, Murillo, Valdés Leal, Alonso Cano, Claudio Coello, Cerezo, etc., became part of the king's collection after a series of acquisitions of some important private collections, among which stand out those acquired from the duchess of Arco in 1762, from Kelly in 1764, the marquis of La Ensenada in 1769, and the marquis of Los Llanos, among others, all of which were devoted especially to paintings of the Spanish school.

It is appropriate to mention here that the achievements in the field of fine arts in general and painting in particular under Charles III were the harvest of a field duly sown in the previous reign by his half-brother Ferdinand VI.

This second son of Philip V married the Portuguese princess Bárbara de Braganza, daughter of John V, a cultivated woman with musical and artistic knowledge, who had a profound influence on his life and helped him greatly in this area. She personally took charge of the works for the Madrid Monastery of the Visitation, known as Las Salesas Reales. Ferdinand VI was able to carry forward definitively the works begun by his father for the new royal palace, without questioning the financial support needed, and enjoining his own most enthusiastic support for its prompt conclusion. In addition, he created the Royal San Fernando Fine Arts Academy, sending Spanish artists to study in Rome with its financial support. At the same time he attached to the royal household such prestigious painters as Jacopo Amigoni and Corrado Giaquinto, thereby providing a vital stimulus for the younger Spanish painters.

All this, as we have said, made it possible for the reign of his brother Charles III to

flourish. Besides the measures already mentioned with reference to the world of art, and beginning with the Financial Societies of Friends of the Country, he established lecture halls for the plastic arts throughout the country, from which an intense teaching effort was launched. Broadening this idea to advanced art tuition at the academy, he founded new art workshops in which painters were of special importance. Among them were the royal porcelain factory at Buen Retiro and the royal hard-stone laboratory; while others already in existence were encouraged, such as the royal glass factory at La Granja or, above all, the Royal Tapestry Manufactory of Santa Bárbara. This was a key factor in the rehabilitation of Spanish painting and provided work for many artists in the royal service.

The eighteenth century closed with the reign of Charles IV, undoubtedly the most gifted sovereign in the world of fine arts, whose activities in this field had begun before his accession, when he was prince of Asturias.

A lifelong collector and true patron — during his exile in Rome and right up to his death he always had artists in his service — Charles was an able draughtsman, who produced several compositions in pastels and in oils. He was also an accomplished clockmaker and had a broad knowledge of cabinetry. As a consequence, while still very young, he personally took direct charge of his apartments in the royal residences, continuing with the so-called lodges, and leaving his mark on the royal palace in Madrid, all in consonance with a classical purpose that definitively ended the old argument for academicism. Thus, as Juan José Junquera rightly observed, "if we consider all this and his active role as patron and connoisseur, the art of his time can be described as classicist, above all in the decorative and court aspects; however, it involves very different implications. In spite of his diversity and the highy varying currents of his training, the sense of unity in the decorative ensembles stands out, always presided over by a single creative intellect, generally an architect, and, in this case, the king and Juan de Villanueva together. A politically wavering Charles IV who was indecisive and inept, but whose artistic ideas were fully defined."

His exquisite taste led him to acquire the interesting collection of Menéndez still lifes, in the Prado today, and the splendid landscapes of Bilbao and Portugal, which he commissioned from Luis Paret y Alcázar.

The love of painting and the generosity of the Spanish royal house led, finally, to the founding of a museum for the public exhibition of the collections assembled by the sovereigns, predominantly of works from the Spanish school. It seems that it was Charles IV who was the first to contemplate this idea. We recently published an interesting document signed by the painter Manuel Nápoli, dated 1814, which contradicts the traditional idea of the origin of the Prado Museum, making clear that

the project was directly Ferdinand VII's own, and that he had not, as had been thought, imitated a project of Joseph Bonaparte but instead had the Buenavista Palace in mind as a location.

We now know that "in 1808, when the central council ordered the sale of Don Manuel de Godoy's possessions, [Ferdinand VII] demonstrated to the council through H.E. Don Pedro Ceballos how little support the sales of works of fine art would receive, and the great harm that the nation would suffer if the sale were confirmed, and he achieved its suspension. The following year, 1809, surrounded by enemy bayonets, seeing the severe harm that would be done if the fine arts works possessed by the religious orders were sold on their dissolution, he convinced the government of the need to create at court a gallery or collection of paintings and of the opportunity there now was of verifying what fine arts works the orders possessed. He secured their storage for this purpose and created a deposit of all of them in the Convent of the Rosary." Nápoli continues his account of Ferdinand VII's thoughts on the institution of a museum, saying, "and if it pleased His Majesty the King Don Ferdinand VI to enrich the pageantry of his history through creating and establishing in this court the study of the basic rudiments of the three noble arts, then it must fall to our beloved monarch to create an establishment to preserve the works of those who have distinguished themselves in these professions."

The legacy of the great traditional patron of art in Spain, the Church, was thus brought into the Prado Museum, for reasons which we will now try to summarize. It involved assembling a considerable number of Spanish paintings of high quality — a total of several hundred religious works — of subjects from both the Old and New Testaments.

A series of measures agreed by Mendizábal and confirmed in the decrees of July, 25, September 3, and March 8, 1836, and the Act of July 29, 1837, declared the extinction of the monasteries, convents, colleges, congregations, and other religious houses of both sexes. Their assets were awarded to the state, and ordered to be sold; the proceeds were to go toward the reduction of the national debt. Similar provisions were made for the assets of the secular clergy.

The Act of 1837 thus determined the confiscation by the government on the grounds that the artworks were national property, of all the property and rights over estates possessed by the secular clergy, whatever their origin, name, or the manner by which they had been acquired, ordering that they be disposed of in six parts in the first six years after 1840. These measures were remodeled in the Act of September 2, 1841, which exempted from confiscation the assets of prebendaries, chaplaincies, family livings and foundations, brotherhoods, charitable and educational

establishments, and the houses, smallholdings, and gardens of the prelates and parish priests. The Royal Order of December 31, 1837, provided for the foundation of a national museum to house the works of art confiscated from the provinces of Madrid, Toledo, Avila, and Segovia, and appointed a council to select the artistic pieces.

There then arose the problem of housing the works. In view of the substantial space required, the church of San Francisco el Grande was first proposed. This soon had to be changed, as the court decided to convert the church into the National Pantheon; finally the convent and church of La Trinidad was chosen. The building works to adapt the old convent and church to their new use were set in motion with great dispatch, and the new National Museum was opened in 1838. This establishment enjoyed scarcely thirty years of life before its treasures were combined with the royal collections in the Prado Museum, thus uniting the products of the two great historical sources of patronage, the Crown and the Church. In the first catalogue to appear after the amalgamation of these important groups of paintings, compiled by Pedro de Madrazo (*Catálogo descriptivo e histórico del Museo del Prado,* known as the *Catálogo extenso,* published in 1872), we find that of the 1,145 pictures included, 570 are Spanish.

The importance of the Museo Nacional de la Trinidad, which enabled so many key works of Spanish painting to be salvaged — in contrast to the large number that have disappeared owing to the neglect of individuals who took advantage of the forced sale measures — is described for us by José de Madrazo in a letter written a few days after the opening of the state museum: "I already told you that on the 24th of last month, being in the time of the queen regent, this National Museum would be opened, and so it has. When you return you will have the pleasure of seeing the boldness of our old Spanish painters, which consists of laying on the color without fear, and beside these excellent things you will find such neglect and crudeness that it is shameful. It is a school of great colorists with an easy manner with the brush. The paintings of Vicente Carducho, which were in the Carthusian monastery of El Paular, all of them very large and fifty-four in number, you will like very much, because they bring together composition, drawing, coloring, effect, and facility, although in none of these properties are they the equal of those painters who have been most distinguished in these qualities, but collectively in the field of art they merit a very high rank. The draperies are admirable and without the painter having gone to great trouble over them, I am sure that he simply painted them from the monks just as they appeared to him (direct interpretation, we would say nowadays). All these pictures represent the various stages of the life of St. Bruno, and were produced over four years, and it is not surprising that he could do so much work and so well in so short a time, because the

models for all of them were found quite normally in the convent. His major task must have been in the comparison of each one, which probably he did in the evenings, and the following day he would correct the groups from the models at his disposal. At the same time he would find the chiaroscuro masses, being portraits of all the Carthusians who then were in the convent; those who are not are friars from among the people or their servants.

"You will see several pictures by Brother Maino in various places, executed with a truly prodigious flair for reproduction and in a manner so detailed and so finished that they seem to be by the greatest Flemish masters.

"You will also see other lesser or unknown Spanish painters, but there are uncommon paintings well worth seeing. Of the rest I will not speak, because, as you already know, the artistic abilities show in some with a better facility than in others, like those of Carreño, Ricci, Coello, Escalante, Solís, Muñoz, Antolínez, etc., etc., but by Velázquez there are only the Prince Don Sebastián, and the little princesses, which you know well, and by Murillo, more than he himself ever had."

José de Madrazo's love and enthusiasm for Spanish painting now had the opportunity of being brought forth by his appointment as director of the Prado Museum, where he was in charge for several years, being succeeded by his son, Federico, who devoted the same care to the work of the Spanish artists.

The revolution of 1868 and the consequent dethronement of Isabella II brought to an end the long direction of Federico de Madrazo; he was replaced by another painter, Antonio Gisbert, from Alicante, who remained there until 1873.

It was during this short period that a series of events took place that were to be fundamental for the future of the institution and also, in certain respects, to the increase in the number of works from the Spanish school. The first measure taken by the revolutionary government was to nationalize the museum, and then, by decrees on November 25, 1870, and March 22, 1872, the Museo Nacional de la Trinidad was closed, and the greater part of its pictorial stock transferred to the Prado. A substantial number of works were sent to other less formal institutions due to problems of space, however. For a variety of reasons many of them disappeared, causing irreparable harm to Spain's artistic heritage. Gaya Nuño, in his *Historia del Museo del Prado,* after regretting the disappearance of the "Romantic Museum" founded by Espartero after Mendizábal's Disentailment, wrote with fair judgment, "so, not to return to the distressing subject, I simply weep for it here, lamenting that a people's regime should have begun its record with the crime — for it was no less — of destroying the wealth of the Museo de la Trinidad....It has to be believed that the authors of this disaster had neither heard of nor read Palomino, Ponz, nor Ceán Bermúdez, and it never

dawned upon them that distinguished sixteenth-century Madrid painting was being destroyed. So began a reckless distribution of paintings, not only to provincial museums, which could have been excusable, not only to more or less suitable state centers, which would not have been completely stupid, but the crime worsened in the time of the Restoration, when the recipients were episcopal palaces, urban and rural churches, remote and obscure town halls, and even private centers, such as the Sanatorio del Rosario, in Madrid. It was an abuse of authority so reprehensible — perhaps it would be better termed imprisonable — that it invited loss and dissipation, and the irreparably bad and abominable preservation of hundreds and hundreds of pictures, many of which have gone forever."

During this period, an old project of Federico de Madrazo's was put into effect: the transfer to the Prado of the series of cartoons for tapestries produced for the Royal Tapestry Manufactory of Santa Bárbara by various painters of the royal household in the last third of the eighteenth century, with Francisco de Goya at the head of the list and with the largest number of canvases. These had been stored in the cellars of the royal palace in Madrid, where they were kept in the worst possible conditions. Besides the Aragonese painter's works, the Prado also received — by orders of January 18 and February 9, 1870 — various pieces by Francisco and Ramón Bayeu, José del Castillo, and Ginés Andrés de Aguirre, and others. Other works produced for the same purpose came later.

Federico de Madrazo's role in rescuing this most important group of works must be highlighted, as must that of Gregorio Cruzada Villaamil in adding to the Spanish works in the Prado such a significant collection as these Goyas, which represent a section of the greatest interest in his catalogue. After the September revolution, on October 15, 1868, and a month before his removal, Madrazo presented a series of recommendations to the National (formerly the Crown) Heritage Council, among which the following is important: "It is essential to save the original cartoons by the famous Goya, which were the designs used for weaving the well-known tapestries in the Pardo, El Escorial, etc.; cartoons that are now in the palace cellars and very likely to be ruined. These could be placed in the upper gallery of the principal front of the Museum and glassed over, following the project of the architect Villanueva, who built the Museum; unless you prefer to hang in that gallery some sets of the magnificent and numerous collection of Flemish tapestries that also belonged to the Crown, and are in the palace, in which case the cartoons could decorate some ceilings, or any other place deemed suitable."

Another fundamental group in the history of art in general, the *Black Paintings* by Goya, which had decorated the walls of the house known as the Quinta del Sordo

(House of the Deaf Man), came to the Prado Museum transferred onto canvas by Salvador Martínez Cubells. This time, the works arrived for very different reasons from those that applied to the collections referred to above. After showing them with little success in the Paris Universal Exhibition in 1878, their owner, a banker of German origin, F. Emile d'Erlanger, donated them to the Prado three years later, in 1881.

In this century the Spanish school collection has been increased by successive bequests, among which the most notable have been those of Pablo Bosch and Fernández Durán, and also certain acquisitions, the criteria of selection for which have traditionally arisen more from the aesthetic preferences of the different directors than from criteria that reflect high standards and common sense.

Finally, and to close this brief historical résumé of the origins and vicissitudes of the works of the Spanish school in our first national picture gallery, it should be said that in 1894, with the creation of the Museum of Modern Art, a large number of nineteenth-century works, nearly all Spanish, was transferred, and of these a part was separated again in 1951, after the creation of the National Museum of Contemporary Art. Again, in 1971, and by ministerial order, the nineteenth-century works were returned to the Prado as a new section and, for this reason, although Spanish works, they will be dealt with later, in a separate section.

Having reviewed the provenance of most of the works constituting the Spanish school in the Prado Museum it is appropriate to make some observations as to its content and importance. If we follow a chronological sequence, we see that the representation of medieval painting is markedly lower than that of other artistic periods. In the framework of Mannerist painting, the unique figure of El Greco and the inclusion of his works, both in number and quality, makes this the most complete collection on exhibition in any museum.

However, there is no doubt that the great painters of the Spanish Baroque period are not only the most representative of this school but form one of the great attractions of the Prado Museum. The names of Zurbarán, Ribera, Murillo, and Velázquez appear before the astonished eyes of the visitor to this museum with the most complete collections of their respective oeuvres. In the particular case of Velázquez, it can be said that with the exception of a dozen paintings of interest (albeit this is the feeling of those at the Prado), the whole of the best production of this outstanding figure in the world of art is housed in the old building designed by Juan de Villanueva. Works such as *Las Meninas, The Surrender of Breda,* or *The Spinners,* are seminal pages in the history of art.

With reference to the eighteenth century, particularly its second half, in the section

of court painting, the collection is very representative. It shows a brilliant moment, still not very well appreciated, of Spain's artistic history, with names like Paret y Alcázar, the still life artist Menéndez, Francisco Bayeu, Mariano Salvador Maella, and many others, culminating at the close of this era with another exceptional figure, Francisco de Goya y Lucientes.

In the section devoted to this genius from Aragon, the number of works preserved in the Prado Museum forms the largest collection of works by this artist anywhere — more than one hundred pictures that, taken together, illustrate fully all the styles he used, from portraiture to religious paintings, from studio paintings to practically all the cartoons for tapestries produced for the Royal Tapestry Manufactory of Santa Bárbara. Outstanding are those pieces selected here, which are reproduced and briefly discussed, not forgetting the series that has been called "the Sistine Chapel of modern art," the *Black Paintings* that decorated the *Quinta del Sordo,* near the river Manzanares in Madrid, where the artist lived for several years.

PANTOCRATOR SUPPORTED BY ANGELS

Part of the set of murals that decorated the chapel of Santa Cruz de Maderuelo (Segovia), this piece occupied the dome. The series was completed by the *Evangelists* (a tetramorph) on the side walls, an apostolate with seraphim, a rendering of *Original Sin,* and a female figure that can be identified as the Virgin, as part of the redemption that would pardon humanity for the sins of its forefathers. On the façade is Mary Magdalen washing the feet of Christ, an Epiphany, and a Cross with the mystical lamb. Buendía thought that the artist of this early work was inspired by the Apocalypse of St. John, an opinion we do not share.

For his part, Cook related these works with the Master of the Church of Santa María de Tahull, from whose technique, however, they differ considerably.

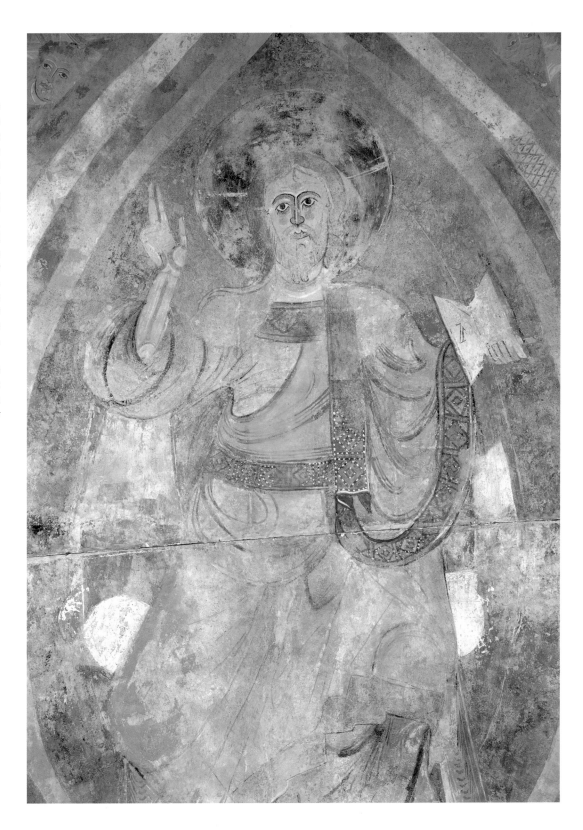

MASTER OF MADERUELO
(Anonymous master active c. 1123)
Pantocrator Supported by Angels, c.1130
Mural in fresco and tempera, transferred to canvas

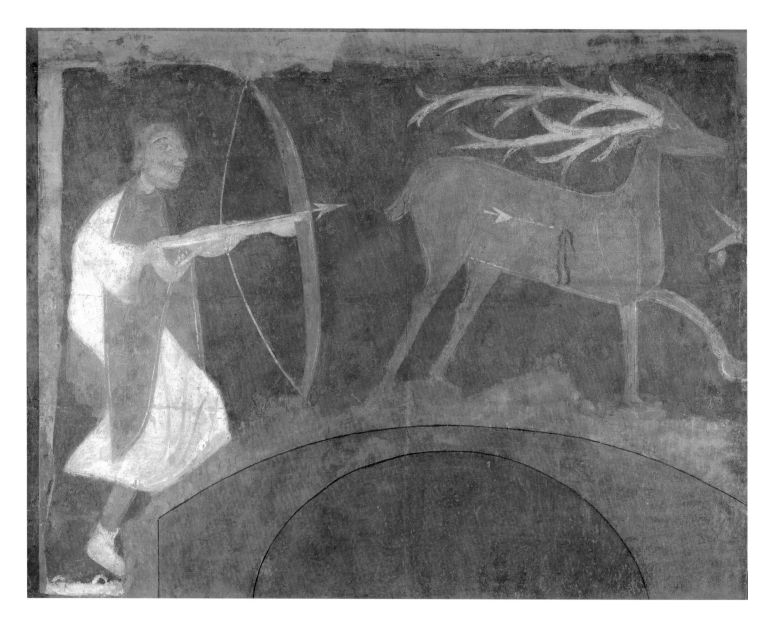

FIRST MASTER OF SAN BAUDELIO DE BERLANGA (twelfth century)
Head of a Stag, c. 1150
Mural in fresco transferred to canvas

HEAD OF A STAG

This is the first known example of Romanesque painting in Castile. It belongs to the set of murals from the Mozarabic church of Casillas de Berlanga, in the province of Soria, built in the twelfth century after the conquest of this area by Alfonso VI and during the repopulation carried out by Alfonso I, the Battler.

Unknown until 1907, after their discovery these murals were transferred onto canvas, then left the country and were distributed among institutions and private collections in the United States.

In 1957, through an agreement between Spain and the Metropolitan Museum of Art, in New York, some returned to Spain, on permanent loan, in exchange for the Romanesque apse from the church of Fuentidueña in Segovia, which was lent to the New York museum under the same conditions. The set consists of a series of hunting and rural scenes that occupied the upper part of the church walls. The second Master of Berlanga later decorated the lower part. As Camón has pointed out, there is an oriental air to these murals that does not occur in any other European art of the time.

HEAD OF A PROPHET

This comes from the bequest of Pablo Bosch, who left this panel to the Museum together with other works in his collection. Charles R. Post tentatively attributed it to Martín de Soria, but J. Gudiol and J. Ainaud de Lasarte later identified it, definitively, as by Jaume Huguet.

It must have formed part of a subpredella, a common element in the medieval altarpieces of the kingdom of Aragon. This work is from Huguet's first stage as master, Ainaud associated its technique and execution and the particular facial features — almond-shaped eyes and the sideways glance — with the figures in the San Jorge altarpiece.

The picture was painted in Zaragoza, where the artist worked until 1445, when he went to Tarragona. Although it belongs to his early work, there are typical details that are always present in his painting, as Gudiol pointed out: "We see in him a long and continuous struggle against original archaisms, the expression of a sensitivity so intense that it almost becomes a fever, able to capture the ineffable and imprison it in a net of the finest brushwork and vigorous but not overwhelmingly corporeal modeling."

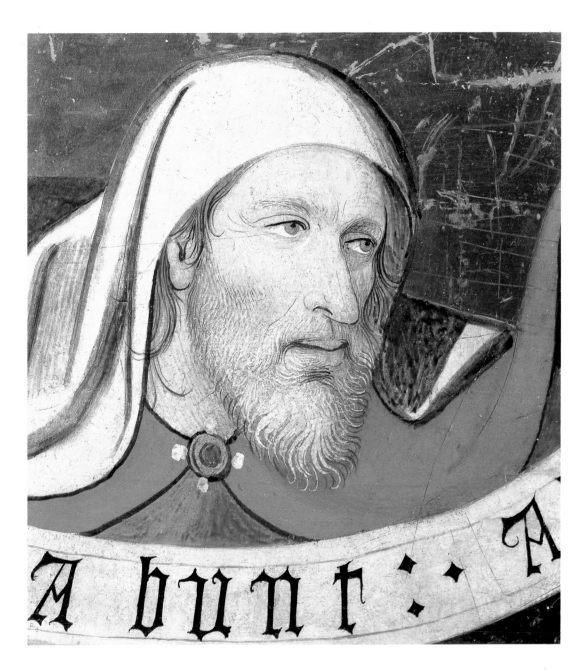

JAUME HUGUET (1414/15– ?)
Head of a Prophet, c. 1435
Tempera on panel, 30 × 26 cm

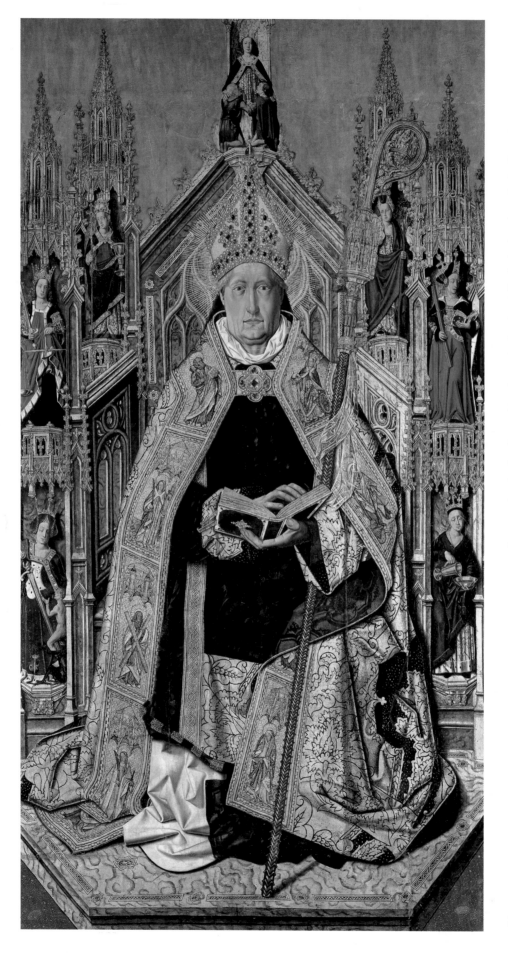

This painting was part of the altarpiece of Santo Domingo de Silos at Daroca (Zaragoza), being commissioned on September 5, 1477. Documents record that on November 17, 1477, this panel had already been completed. After Mendizábal's pernicious sequestration measures, it was appropriated by the San Luis scholar, Paulino Saviron, in 1869–1871, for the National Archeological Museum, from where it passed to the Prado Museum in 1920.

Seated upon a spectacular carved and gilded throne on which there are polychromed allegorical statues of the Virtues — Fortitude, Justice, Faith, Charity, Hope, Prudence, and Temperance — St. Dominic is enthroned as an abbot, with miter, crozier, book, and cape. The picture precisely fulfills what was stipulated in the contract of commission, which records that the pontifical vestments should be embroidered in gold.

BARTOLOMÉ BERMEJO
(active 1474–1495)
St. Dominic of Silos, c. 1474–1476
Tempera and oil on panel, 242 × 131 cm

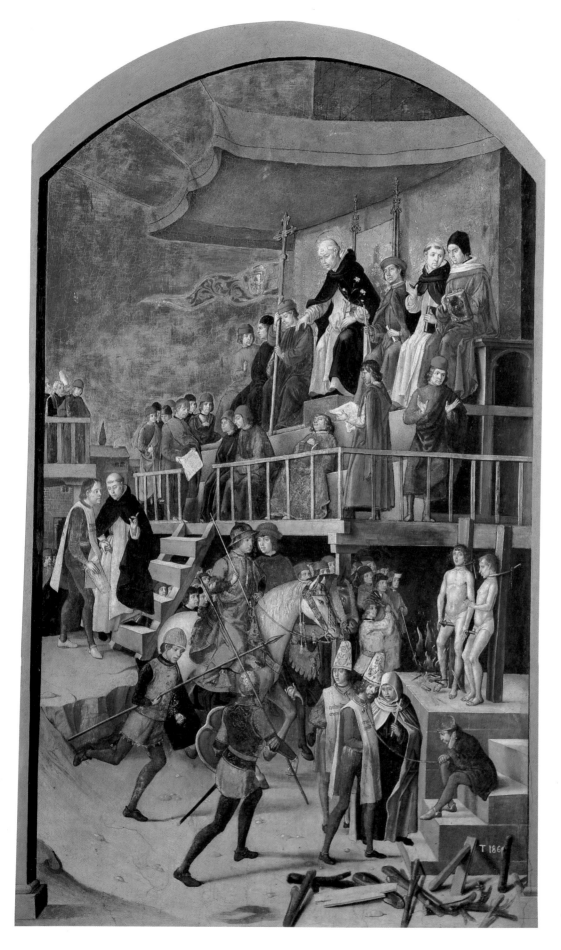

This painting comes from the Santo Domingo convent at Avila. The panel formed part of a small altarpiece in the upper Kings' Cloister, from where it was moved to the church and located next to the main altarpiece. It was acquired by the state by royal order, April 10, 1867, for a sum of 3,000 escudos. Buendía mistakenly notes that it came from the Museo de la Trinidad.

The scene represents an auto-da-fé in Albi, presided over by St. Dominic during his struggle against the Albigensians. In a startling composition, the court appears on a dais with a gilded canopy; next to the Holy Founder, one of the theologians who surround him holds the Inquisition standard, on which waves the fleur-de-lys cross. On a platform in the right foreground are two naked condemned men who are to be tried by fire. In front of them, others, wearing the *sambenito* and dunce's hat, are being exhorted by a monk to repentance. On the *sambenito* one can read the words, "condemned heretic."

A breath of gothicism is combined with the Renaissance elements that Berruguete had learned in Italy; it shows the influence of Piero della Francesca and Luca Signorelli, whose works he had studied in Urbino around 1475.

PEDRO BERRUGUETE
(active 1477–1504)
Auto-da-Fé, c. 1495
Tempera and oil on panel, 154 × 92 cm

THE ADORATION OF THE MAGI

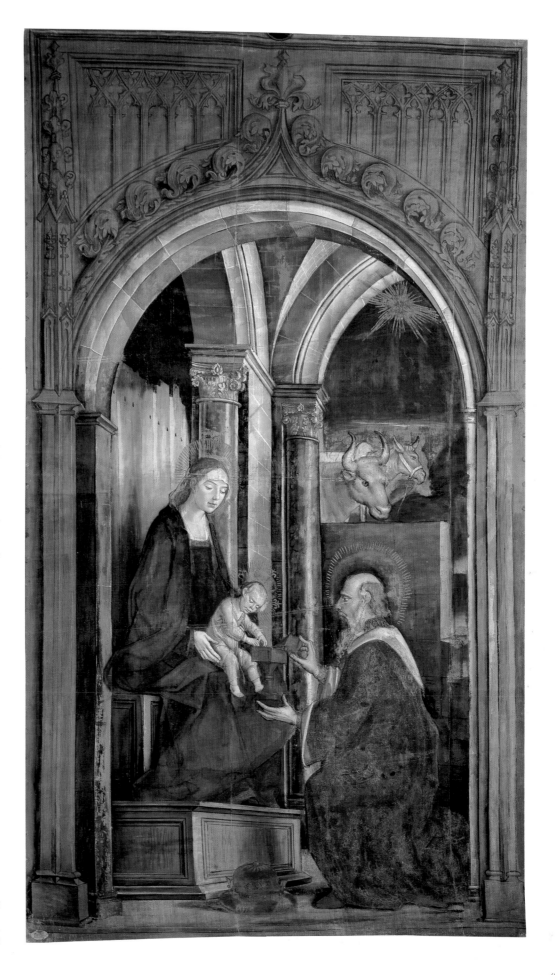

From a convent in Avila where, with *SS. Peter and Paul* (today deposited by the Prado in the Valladolid Museum), it was used as the organ or altarpiece doors, it came to the Prado from the Museo de la Trinidad in 1870.

In a small Renaissance templet, set in a rural landscape, the Virgin appears seated on a high throne with Jesus in her arms, while one of the Magi offers Him a golden casket from which the Child takes some coins. In the background are the ox and ass.

This work demonstrates a fluency of composition far from traditional convention, Berruguete's purpose being, above all, to create a feeling of realism. There is, without doubt, a new sense of space in relation to Spanish art of the time, which is accentuated by the innovative use of light that he so ably introduced. The Italian influence is tempered by his own inestimable resources.

PEDRO BERRUGUETE
The Adoration of the Magi
Gouache on twilled canvas,
350 × 206 cm

CHRIST GIVING HIS BLESSING

This is the center panel from the altarpiece donated to San Lorenzo del Toro by Don Pedro de Castilla (†1492). At the beginning of this century it belonged to F. Kleinberger, in whose collection it figured in the catalogue of the Golden Fleece Exhibition, which took place in Bruges in 1907. Pablo Bosch acquired it in 1913 and it came to the Prado as part of his bequest.

The seated Christ appears surrounded by tetramorphs and allegories of the Church and the Synagogue.

This work belongs to the period that ran from 1480 to 1490, in which Gallego produced his finest work. His style, developed through Flemish influence and teaching and the ambient tonal qualities in Castile where his painting developed, had now become his own. A range of cold tones dominates the chromatic criteria of these panels, which combine these elegant effects with others more vibrant and warm, such as those used in the robes of the subjects and in the flesh tints. At this time, too, Gallego had the ability to express the sense of allegory as we see it here, and which reached its culmination in his decoration of the dome of the library at Salamanca University.

FERNANDO GALLEGO
(active 1466–1507)
Christ Giving His Blessing, c. 1485
Oil on panel, 169 × 132 cm

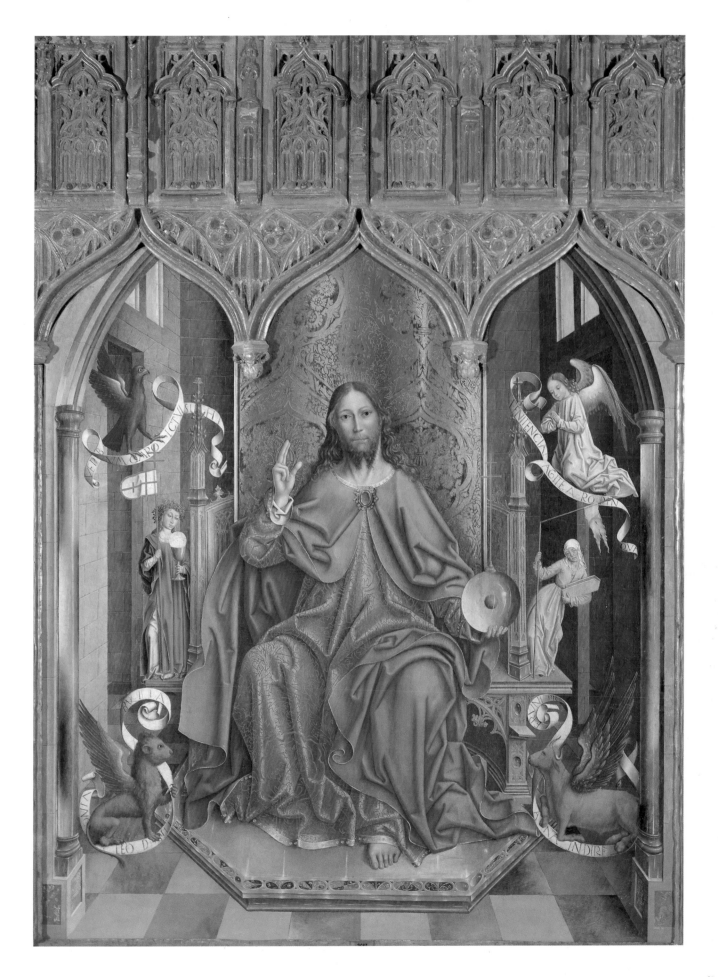

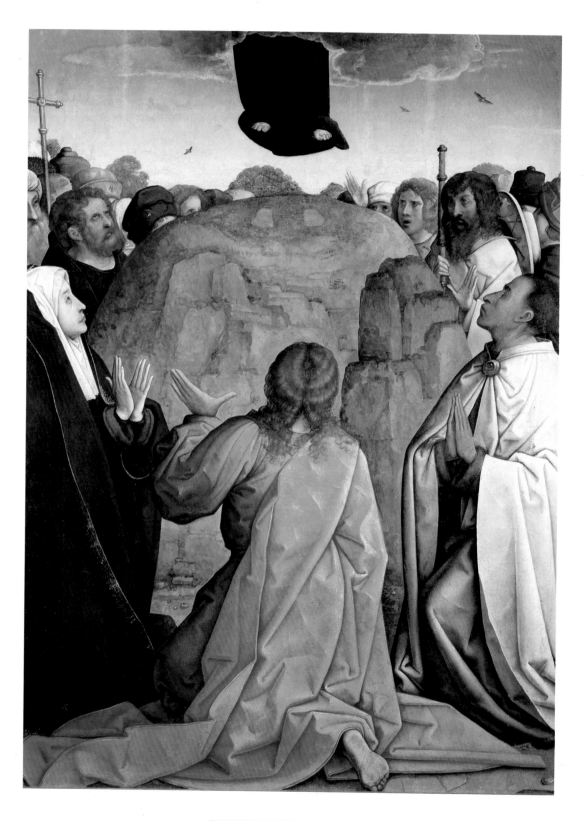

THE ASCENSION

This panel, with three others also in the Prado — *The Raising of Lazarus, The Prayer in the Garden,* and *The Coming of the Holy Spirit* — came from an altarpiece in the church of San Lázaro in Palencia. They later formed part of the Kress collection in the United States, and the set was acquired by the state for the Prado in May 1952.

A work of consummate skill and meticulous execution, with an exquisite and detailed portrayal of the different qualities of the characters, it resembles an enlarged miniature.

The combination of Flemish elements and Italian echoes, with the assimilation of a Spanish spirit imbues the work with qualities of solemnity and a strong chromaticism of vibrant expressiveness.

JUAN DE FLANDES (active 1480–1519)
The Ascension, c. 1510
Oil on panel, 110 × 84 cm

THE PRESENTATION OF JESUS IN THE TEMPLE

This work is one wing of a triptych that was in the Monastery of Guisando until 1836 when, following the Mendizábal sequestration measures, it was seized by the selection commission appointed at the headquarters of the Royal San Fernando Academy. On the closure of the Museo de la Trinidad, where it was then housed, it passed to the Prado Museum.

Also in the gallery are the other two panels from this triptych: *The Visitation* and *The Nativity*.

This panel portrays the moment in which the priest Simeon receives the Child from Mary's hands. In the middle ground, we see St. Joseph, with the basket of turtledoves, and St. Anne. As Diego Angulo said, Correa seems to have become converted to a Raphaelesque style in this work, "and with a mimicry more active and complicated than that of Borgoña, as though produced by a much more advanced epoch, the Renaissance."

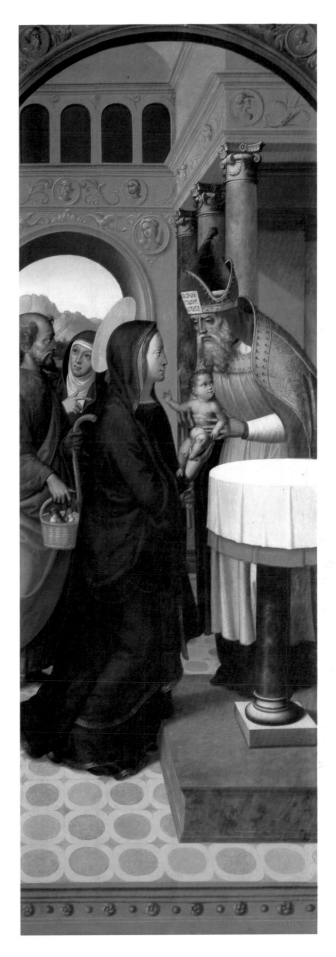

JUAN CORREA DE VIVAR (c. 1510–1566)
The Presentation of Jesus in the Temple
Oil on panel, 219 × 78 cm

JUAN VICENTE MASIP
The Martyrdom of St. Agnes (detail)

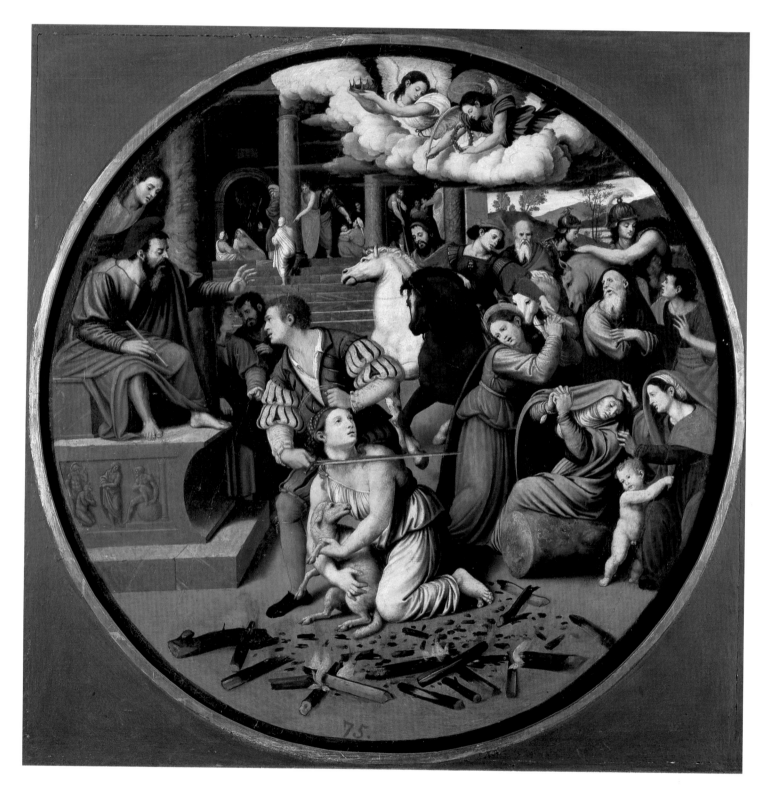

JUAN VICENTE MASIP (c. 1475–c. 1550)
The Martyrdom of St. Agnes
Oil on panel, diam. 58 cm

THE MARTYRDOM OF ST. AGNES

A companion work to *The Visitation* (cat. no. 851), this comes, according to Orellana — who claims that it is a work by Juan de Juanes — from the chapel of Santo Tomás de Villanueva, in the Augustine convent of San Julián, outside Valencia. However, this same expert says "do not seek them there, the curious thing is that...in order to pay for...the existing great reredos they were disposed of...by the convent to Don Manuel Xaramillo...a great connoisseur of painting and an inquisitor." After the death of the latter in Madrid in 1781, both panels were acquired by Don Francisco Castillo, Marquis of Jura Real. In 1826 both were purchased from his heirs by Ferdinand VII for 9,000 reals, and came to the Prado Museum.

The scene shows the moment in which the saint is decapitated while embracing the lamb. On the left is the judge, seated, and on the right a group of Christians, weeping. In the middle ground are four horsemen and the steps of a temple, which are peopled with beggars; within the temple is a nude goddess and an altar with fire. Two angels carrying crowns and palms complete the composition.

ST. CATHERINE OF ALEXANDRIA

Elías Tormo, who discovered this panel in 1915, is responsible for its classification as a work by Yáñez. Tormo describes it justly as one of the most beautiful Spanish paintings of the whole of the sixteenth century. It came to the Prado Museum in 1946 after its acquisition by the ministry of education from the heirs of the marquis of Casa Argudín.

The saint, shown in full length, appears with her characteristic attributes at her feet, the sword and the broken wheel of her martyrdom. A work of exquisite conception, the figure of the saint is, without doubt, one of the most spiritual creations of Spanish painting of the sixteenth century. The Italian influence is seen in the architectural background and the sweetness of the face — undoubtedly modeled after Leonardo — in contrast to the naturalistic treatment of the drapery and the adept handling of the melting color tones.

ST. ANNE, THE VIRGIN, ST. ELIZABETH, ST. JOHN, AND THE CHRIST CHILD

This probably comes from the altarpiece of La Almedina. It was acquired by the state in 1941 from the parish church of Infantes, with funds from the count of Cartagena's bequest.

On the left of the group of figures that gives the picture its title appears a reduced representation of the "Embrace at the Golden Gate."

The influence of Leonardo, whose ideas were introduced to Spain by this artist, is evident. A delicate chiaroscuro, full of nuance, enlivens the composition and the faces of the figures. As Camón pointed out, for the first time the substance of the painting is not the play of shadows coming from darkness and the clarity that emanates from light, but the disappearance of this dualism, leaving all the shadings as nuances of light. Nevertheless, this affection for Leonardo's forms was adapted to Yáñez's individual personality, as shown by the gentle handling of the masses — for example the face of the Virgin — inspired by his own original solutions.

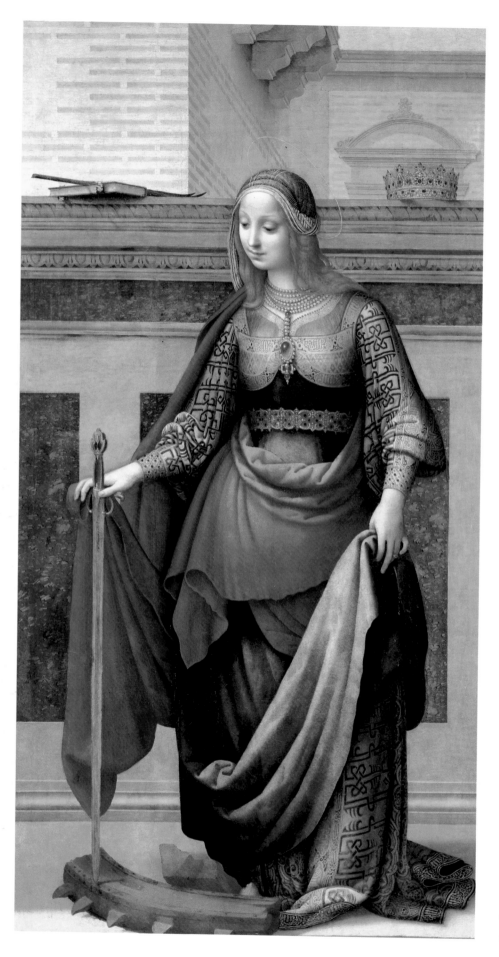

FERNANDO YÁÑEZ DE LA
ALMEDINA (active 1505–1536)
St. Catherine of Alexandria
Oil on panel, 212 × 112 cm

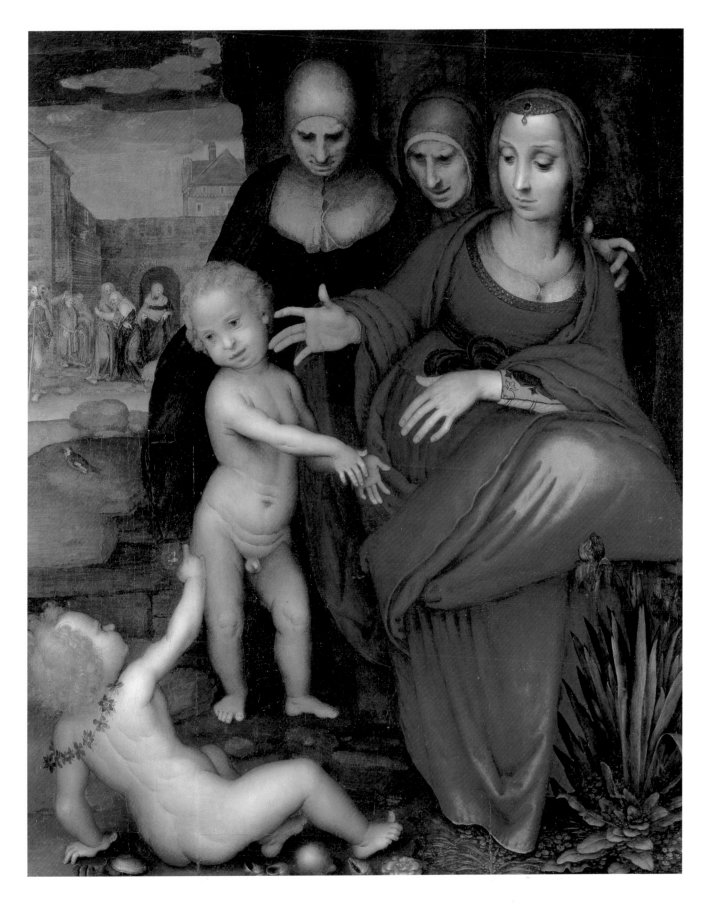

FERNANDO YÁÑEZ DE LA ALMEDINA
St. Anne, the Virgin, St. Elizabeth, St. John, and the Christ Child
Oil on panel, 140 × 119 cm

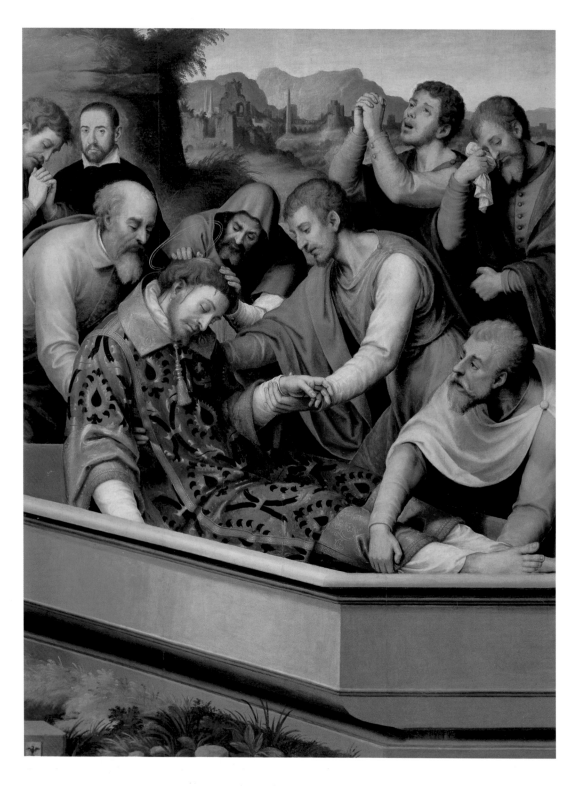

JUAN DE JUANES (1523?–1579)
The Burial of St. Stephen
Oil on panel, 160 × 123 cm

THE BURIAL OF ST. STEPHEN

This work was painted for the main altarpiece of San Esteban de Valencia, which comprises a series that is housed in the Museum. According to Orellana, they are "among the most beautiful" by this painter. The set was acquired in 1801 by Charles IV, during a sojourn in the city of Turia, through the good offices of the archbishop, Don Juan del Río.

The literary source used by Juanes is the passage from Acts 7:5, 2. In the lower left corner is a shield with a spread-eagle on a gold ground.

Four male figures are placing the body of the saint in the sepulcher, other figures being present; the figure on the left in the middle ground, dressed in black with a white collar, may possibly be a self-portrait of the painter. The background landscape, with its obelisks and ruins, has an especially Renaissance air.

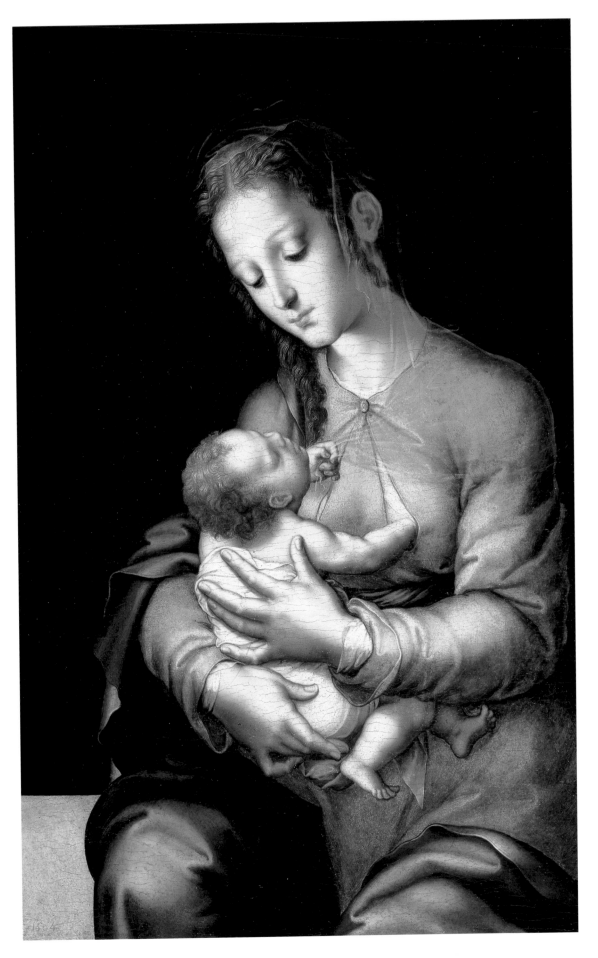

LUIS DE MORALES
(c. 1500–1586)
Virgin and Child, c. 1568
Oil on panel, 84 × 64 cm

VIRGIN AND CHILD

Morales, known as "El Divino," repeated this iconographic composition on several occasions; noteworthy among them is another version in the Museum (cat. no. 944). This one is without doubt of greater quality, and comes from the Pablo Bosch collection, which he bequeathed to the Prado.

The seated figure of Mary, almost full length, with the Child in her arms, has been compared by E. Gué de Trapier to a similar figure in the *Holy Family* by Luini, a painting that came to Spain in the sixteenth century and is now in the Prado. The influence of Leonardo is unquestionable in the oval face of Mary, an influence that came to Morales through engravings by van Scorel.

The mysticism that always enlivens the work of this artist is here heightened and more devout. An obscure gothicism gives body to some Mannerist accents of Flemish inspiration.

ECCE HOMO

This picture comes from the Fernández-Durán collection, which was bequeathed to the Museum in 1930.

The Christ figure in this half-length representation, holds a cane as a scepter in His left hand.

Morales showed a special predilection for this iconography throughout his career, creating a model that he repeats with renewed feeling in each version painted. It is thought, not without reason, that the source of inspiration for this composition could have been the study of Castilian carving. However, the painter was able to imbue it with a poignancy of intimate spiritual longing, with a tragic expressiveness in the face.

Perhaps we should remember the Nordic-style Portuguese Mannerism, which can be associated with Morales's work; this has made some art historians believe that the painter received his early training in Portugal. To these stylistic notes we must add that the expressive modeling of the figure shows a clear Italian lineage.

LUIS DE MORALES
Ecce Homo
Oil on canvas, 40 × 28 cm

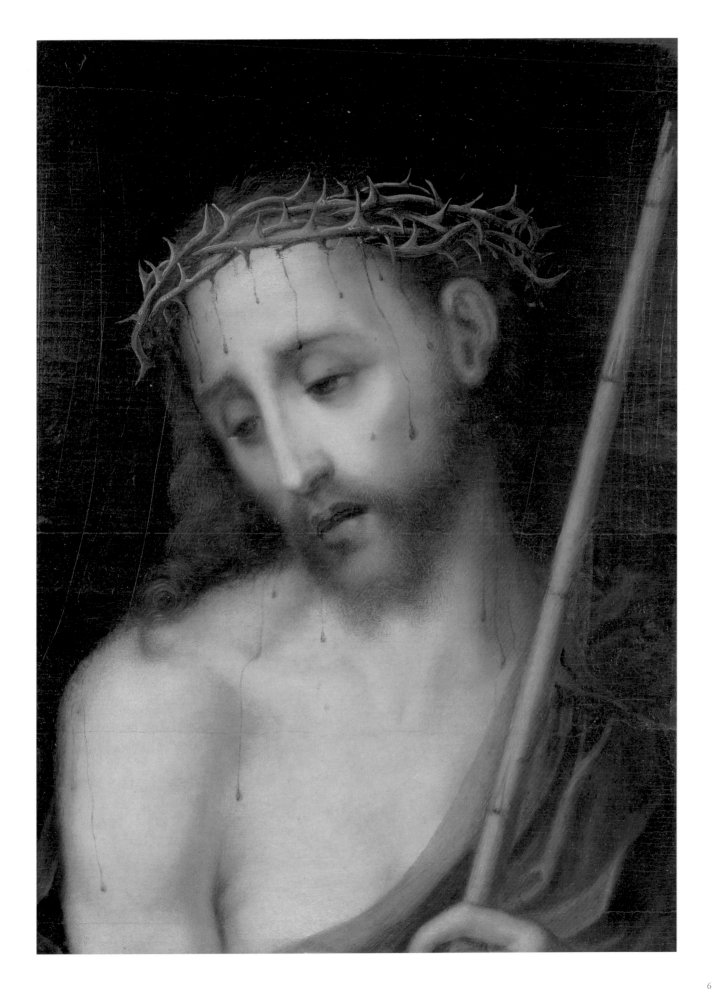

From the Bourgeois Frères collection in Paris, where it was in 1870, this was subsequently owned by Baron M. de Herzog of Budapest and Dimitri Angelopoulos. It was acquired by the Prado Museum in 1961 at P. and D. Colnaghi in London.

This is a small altarpiece, as can be seen from the carving that frames the painting, of a style associated with the art of Siloé. In a cartouche on the lower edge can be read: "This altarpiece was commissioned by Doña Inés del Castillo / wife of García Rodríguez of Montalvo, alderman of this town. Completed in the year 1547." The town alluded to in the inscription has not been identified. For Gómez Moreno, the painting is more closely related to the later career of this artist, and to his stay in Italy.

Sánchez Cantón pointed out the naturalistic quality of this work, portrayed in the figures of the soldier and the two children.

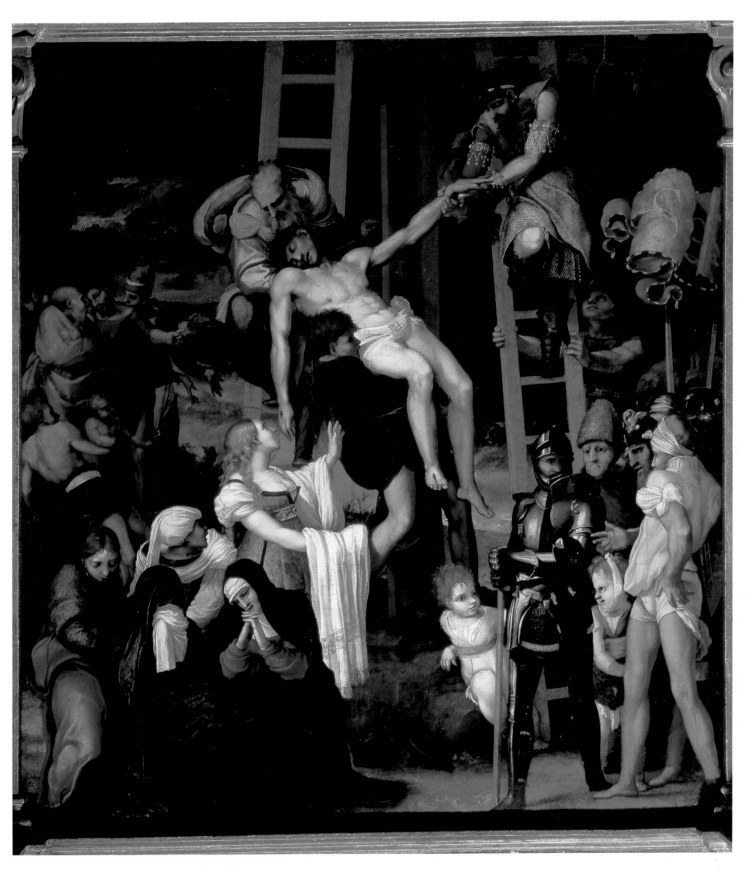

PEDRO MACHUCA (end of fifteenth century–1550)
The Descent from the Cross, 1547
Oil on panel, 141 × 128 cm

ALONSO SÁNCHEZ COELLO (1531/32–1588)
The Mystic Marriage of St. Catherine, 1578
Oil on cork, 164 × 80 cm

THE MYSTIC MARRIAGE OF ST. CATHERINE

This signed and dated picture comes from the monastery of San Lorenzo at El Escorial, where it was delivered by the artist on August 18, 1584, and for which Sánchez Coello was paid 150 ducats. It came to the Prado Museum in 1839.

It shows the Virgin, seated with the Christ Child, in the act of embracing St. Catherine, with two other female figures.

A combination of influences from Correggio and Parmigianino is present in this work, certainly the finest among the religious works that Sánchez Coello produced from time to time throughout his career, although his major work was as a portrait painter. He became the Spanish king's favorite painter in this genre, together with his master from Holland, Antonio Moro.

PORTRAIT OF ISABELLA CLARA EUGENIA

Isabella Clara Eugenia, born in Valsaín on August 12, 1566, was the daughter of Philip II by his third wife, Elizabeth of Valois. She married the Archduke Albert on April 18, 1599, and died in Brussels in 1633. The favorite daughter of the prudent king, she was an able vicereine in Flanders and acted as a great protectress of the arts.

In this three-quarter-length portrait, she appears standing with her right hand resting on the back of a crimson chair, while in her left she holds a kerchief. She wears a gown of white and gold, with lace collar and cuffs, adorned with feathers and pearls, a necklace, belt, and buttons of gold, and precious stones and pearls.

This picture was in the old Alcázar in Madrid until 1734, when the dreadful fire that destroyed the building took place. It was then placed in the Buen Retiro Palace.

ALONSO SÁNCHEZ COELLO
Portrait of Isabella Clara Eugenia, 1579
Oil on canvas, 116 × 102 cm

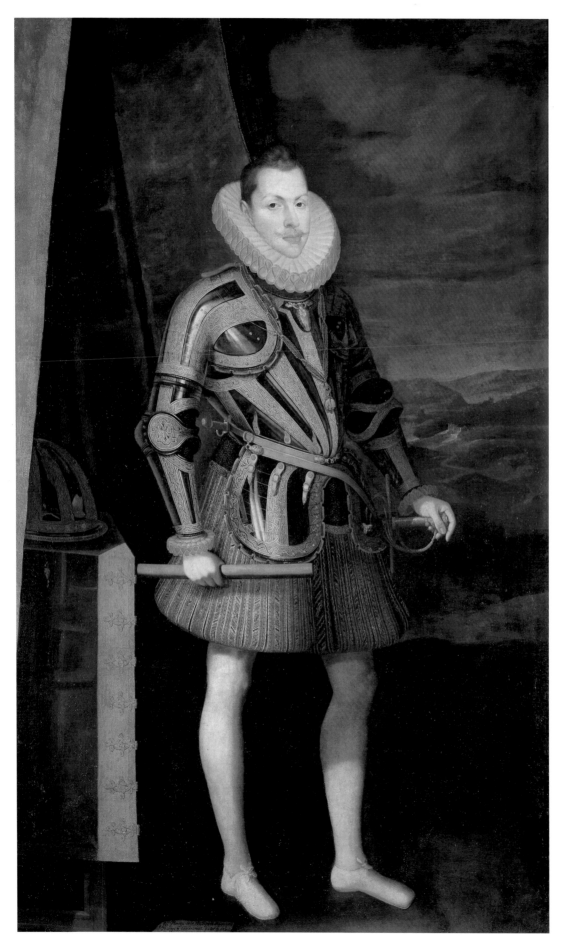

Paired with the portrait of Doña Margarita, the queen, also in the Museum, this portrait came to the Prado in 1934 as a bequest from the duke of Tarifa.

Pantoja de la Cruz, portrait painter to the household of Philip II and Philip III, together with Sánchez Coello, catches here the silhouette of the monarch in an elegant pose, capturing with depth the dignity of royalty.

Strong and contrasting coloring and a pure technique, a faithful reflection of his master Antonio Moro, are seen in the ambient tone in which the sovereign appears immersed. These important plastic techniques would be interpreted and taken to their ultimate conclusion a few years later by the genius and sensitivity of Velázquez. There is also a reminder of Titian in this portrait.

The meticulous execution tells us what an excellent miniaturist the artist was, taking care, to the very last detail, with each part of the composition.

JUAN PANTOJA DE LA CRUZ
(1553–1608)
Philip III
Oil on canvas, 204 × 122 cm

THE ADORATION OF THE SHEPHERDS

This comes from the altar of the artist's burial chapel in Santo Domingo el Antiguo in Toledo, the crypt of which was acquired on August 2, 1612, by Jorge Manuel, the painter's son, as a burial chamber for his father and himself. After the mortal remains were transferred elsewhere, the picture remained in its original position. It is known that it was valued on September 26, 1618, by his pupil, Luis Tristán, who said that he had seen it painted and that El Greco "was there," and that the face of the shepherd in the foreground could be considered as a self-portrait.

When the religious community that lived in the Dominican convent sold a canvas of The Trinity from the upper part of the great reredos to the sculptor Salvatierra, it was replaced in the same position by this painting. It came to the Prado on December 31, 1954, after being acquired by the state from the religious community for 1,600,000 pesetas.

As Wethey pointed out, in this work, "each brush stroke is full of form and meaning."

EL GRECO (1540–1614)
The Adoration of the Shepherds, c.1605
Oil on canvas, 319 × 180 cm
(Detail on overleaf)

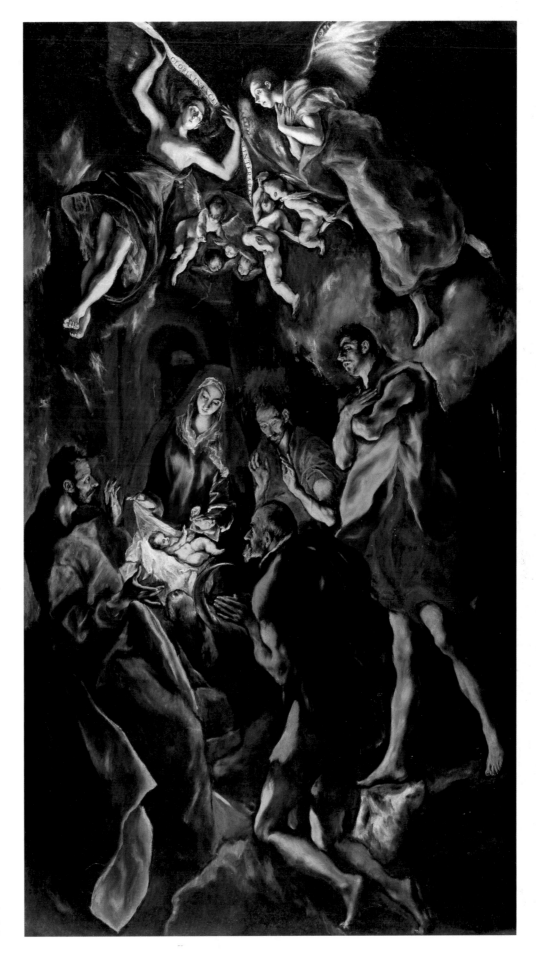

PORTRAIT OF A NOBLEMAN WITH HIS HAND ON HIS CHEST

This comes from the collection of the duke of Arco, in whose country house it was in 1794.

The various art historians and critics who have studied El Greco's work have tried to identify this enigmatic personality. The marquis of Hermosilla and Moreno Guerra thought that it was the Gentleman of the Order of Santiago, Juan de Silva, Marquis of Montemayor, Principal Notary of Toledo. On the other hand, Diego Angulo, in view of the attitude of the subject, suggested that the left arm was missing, that "there was no sign of it under the cloth," which made him think that this was a portrait of the writer Miguel de Cervantes himself, whom it seems the artist knew.

A key work within the genre of portraiture in Spanish sixteenth-century painting, the half-length figure, is soberly dressed in the attire of gentlemen of the era — black, with collar and cuffs of white lace. He wears a fine chain from which hangs a scallop shell. The hilt of the sword, of chased gold, is of great beauty.

THE ANNUNCIATION

This panel came to the Prado in 1868, having been acquired by the state from Doña Concepción Parody for 150 escudos by royal order of June 25 of that year. Cossío dates it between 1577 and 1580, and Wethey places it between 1570 and 1575.

A common subject in El Greco's work, and following his normal compositional scheme for this iconography, Mary is shown kneeling on a prie-dieu while, to the right, the beautiful figure of the Archangel Gabriel is shown on a cloud. In the background is an archway through which there seems to be a street. The composition is crowned by an outbreak of glory with angels and the Holy Spirit.

This iconography of Venetian inspiration is developed by El Greco in various paintings. It is typified by the position of the archangel on a cloud and is also used by Titian, Veronese, and Tintoretto in some of their paintings.

Truly this is a design meticulously finished in all its details. The vibrant coloring contrasts with the pink of the Virgin's robe and the blue of her cloak with the archangel's yellow tunic lined with red.

THE CORONATION OF THE VIRGIN

Signed with Greek characters on the right, this work came to the national picture gallery as part of the Pablo Bosch bequest. Four other El Greco paintings of the same subject are known, the most important being those in the hospital at Illescas and at San José in Toledo.

This painting's principal distinction from the painter's other versions of the subject is that the founders of the religious orders are shown around the principal theme of the composition.

A passionate spiritual exaltation is found in this work in which the figures seem dematerialized and inspired by chromatic elements of the most imaginative nuances.

EL GRECO
Portrait of a Nobleman with His Hand on His Chest, c. 1580
Oil on canvas, 81 × 66 cm

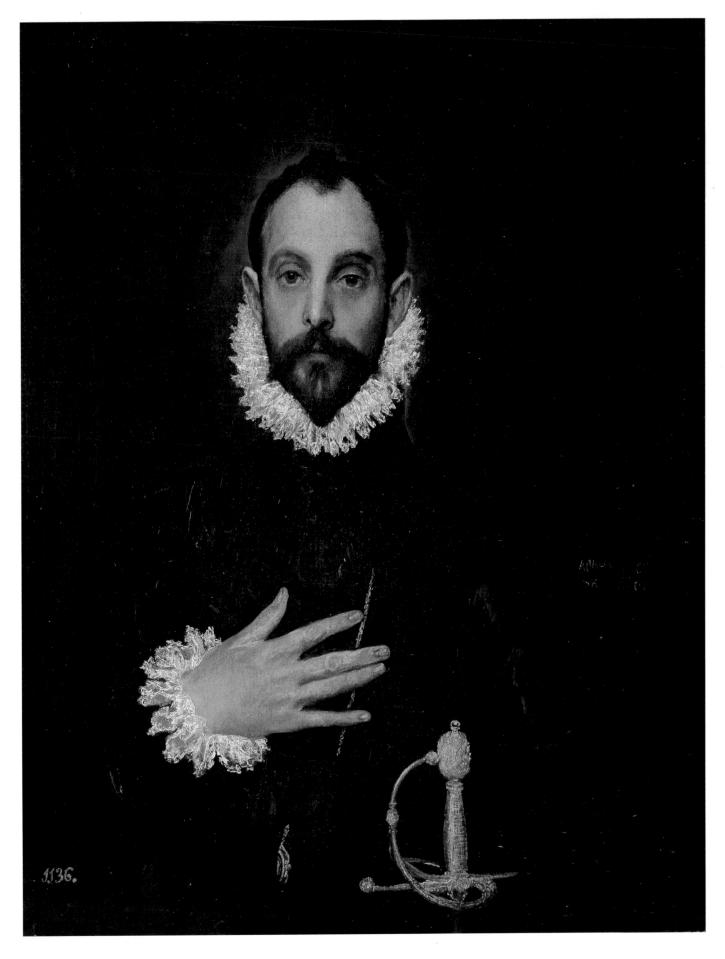

1136.

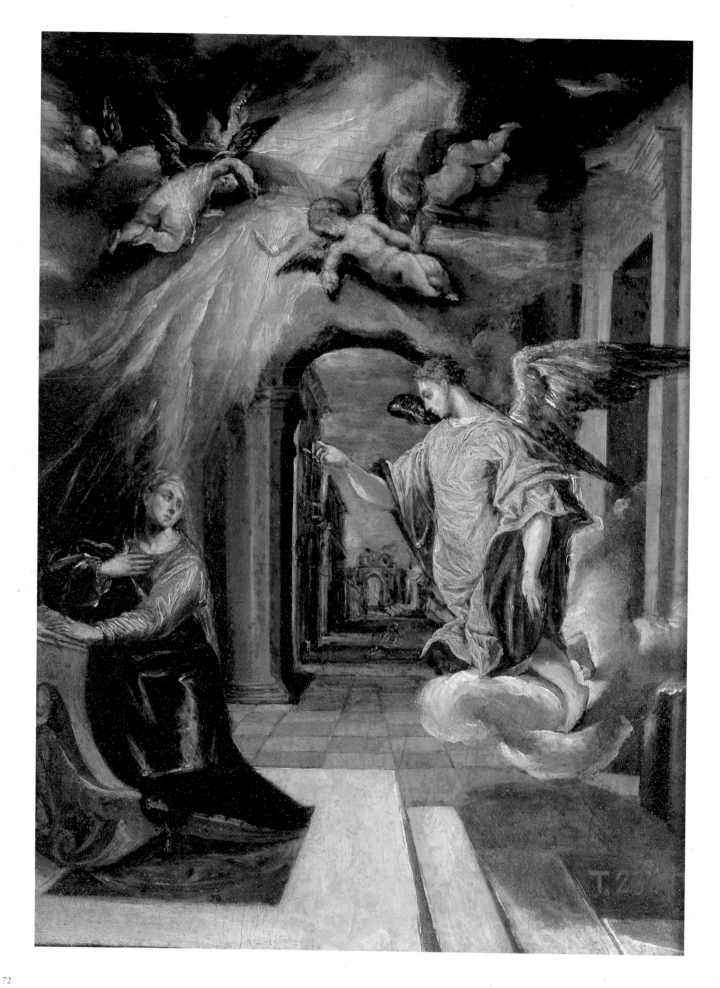

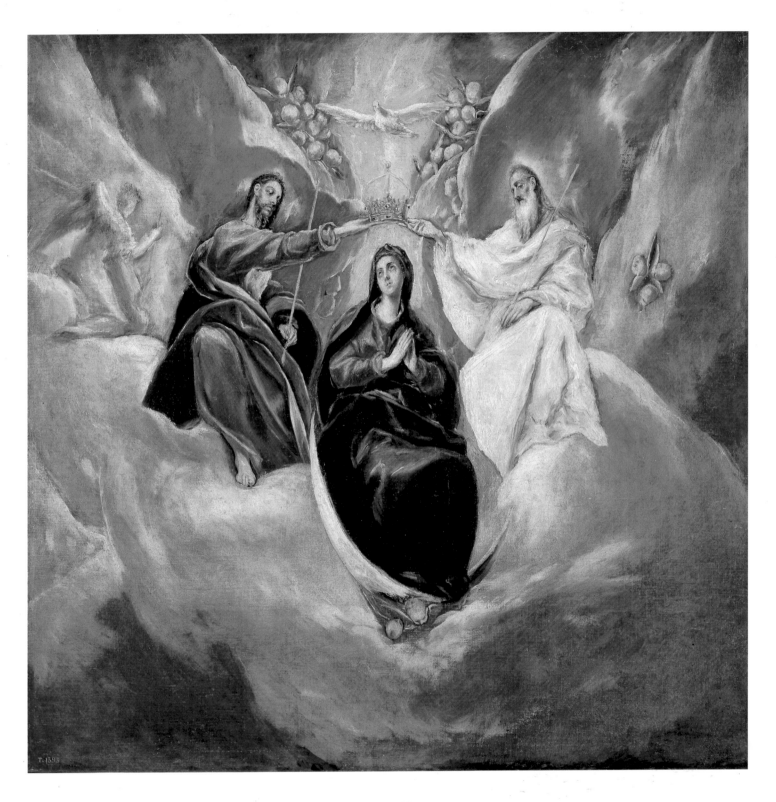

EL GRECO
The Coronation of the Virgin, c. 1590
Oil on canvas, 90 × 100 cm

EL GRECO
The Annunciation, c. 1575
Tempera and oil on panel, 26 × 19 cm

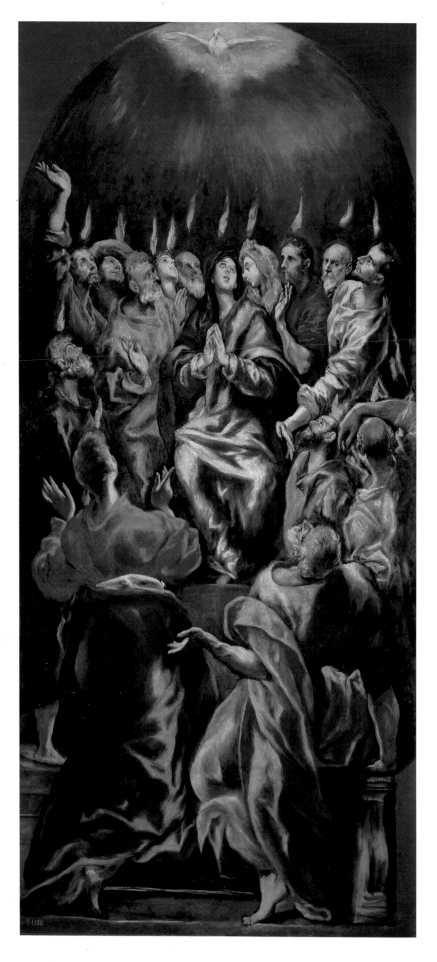

PENTECOST

Signed in Greek characters, this painting was sent to the Museo de la Trinidad from a dissolved convent in Toledo. It is a pendant to the Resurrection, which was also kept in the same museum.

Cossio thought that it was painted between 1604 and 1615, while Busuioceanu and Soehner gave a date after 1600. Wethey dated it toward 1610. Some writers take the third apostle on Mary's right as a portrait of the architect Covarrubias.

In a traditional iconography, the Virgin Mary is shown surrounded by thirteen apostles and a young female figure. Above the heads of each one appears the symbol of the tongue of fire; in the upper part is seen the Holy Spirit. The painter seems to have had some cooperation with his son, Jorge Manuel, as this is the only version known of this subject by the artist, who usually repeated his themes in different versions. Wethey does not think that it belonged to the same altarpiece as the *Resurrection,* with which it has associations of execution and identical dimensions, including the original form with a semicircular upper part.

EL GRECO
Pentecost, c. 1600
Oil on cloth, 275 × 127 cm

Signed on the ashlar stone on which the Virgin is seated, the picture comes from the Dominican convent of San Pedro Mártir in Toledo, where the artist was a monk. It was part of the principal altarpiece with three other canvases, two deposited by the Prado in Villanueva y Geltrú, and the other displayed in this Museum.

The Virgin is shown on the right with the Child in her arms and St. Joseph behind her. On the left is the group of magi; Balthazar is predominant, holding a little mother-of-pearl vessel.

A luminous chiaroscuro characterizes the work of the artist in general, and particularly this painting. However, the stepped composition is unusual, while not excluding a graceful movement in the different figures. The execution of the draperies is impeccable, as is the sumptuous coloring with tones of great purity. The influence of Italian artists, above all those of the Brescia school, is clear, and there are hints of Guido Reni and artists of the style of Gentileschi.

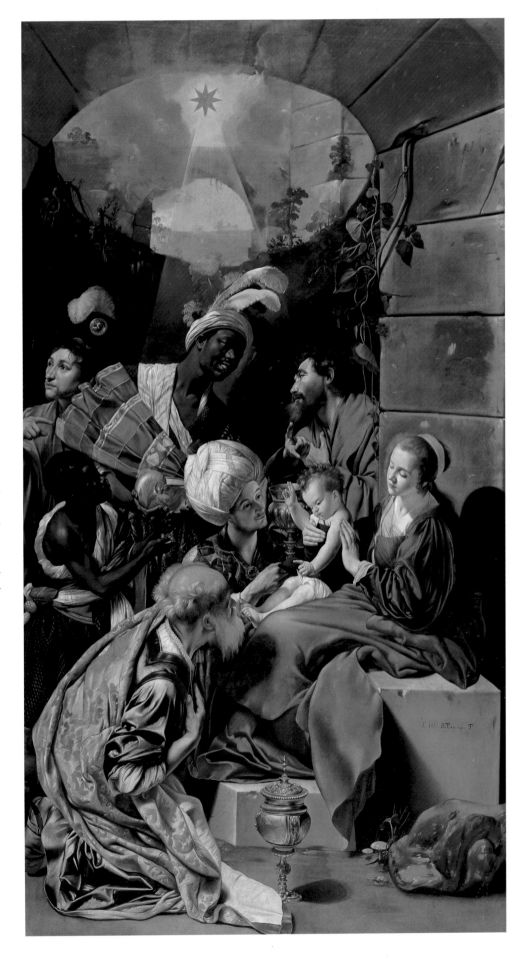

JUAN BAUTISTA MAINO (1578–1649)
The Adoration of the Magi
Oil on canvas, 315 × 174 cm.

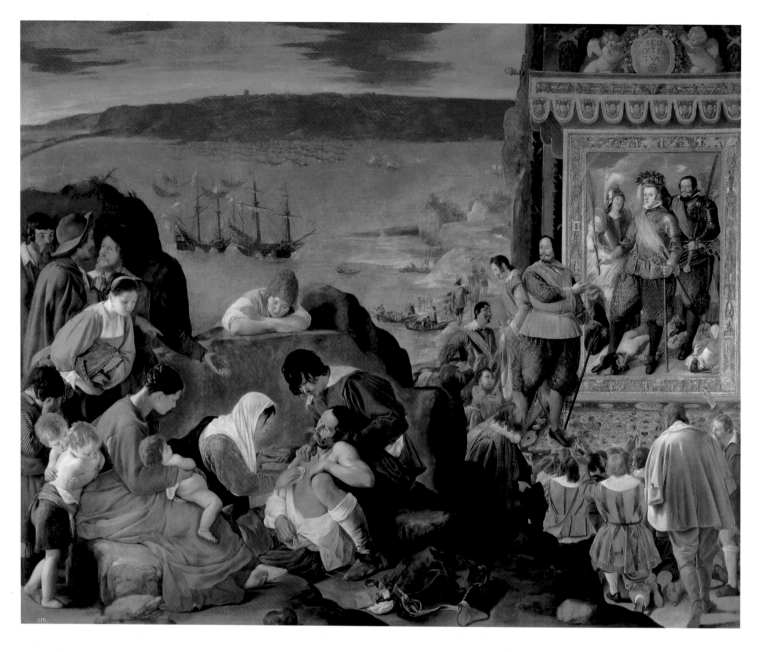

JUAN BAUTISTA MAINO
The Recovery of Bahía in Brazil
Oil on canvas, 309 × 381 cm

THE RECOVERY OF BAHÍA IN BRAZIL

Once part of a series of paintings of battles commissioned by the count-duke of Olivares, this work was painted for the Hall of Kingdoms in the Buen Retiro Palace. During the War of Independence it was taken to Paris and housed in the Musée Napoléon, then returned to Spain in October 1815, at which time it was sent to the academy, remaining there until 1827, when it came to the Prado Museum.

The canvas narrates the action in the Brazilian port of Bahía de Todos los Santos and the city of El Salvador, which, after being under Dutch rule, was recovered for Spain and Portugal — then under the same crown — on May 1, 1625. Some art historians think that Maino was inspired by a scene from the drama by Lope de Vega, *El Brazil restitudo* (Brazil Restored), particularly that point in the play where Don Fadrique exclaims in front of a portrait of Philip IV, "Great Philip, this people begs your pardon for their sins...." In this picture, we see Don Fadrique standing in front of a tapestry bearing the portrait of Philip accompanied by the count-duke of Olivares and an allegory of Victory, and with the corpses of Heresy, Anger, and War. All is set against a marine background with ships. The picture is among the most interesting of the series.

THE DEATH OF THE VENERABLE ODON OF NOVARA

This belongs to a series of 54 paintings, on different subjects of the order and its founder, St. Bruno, that Vincenzo Carducci was commissioned to produce for the Carthusian monastery of El Paular, in 1626, for a price of 6,000 ducats.

In remained in the place for which it was painted until 1836 when it was sent to the Museo de la Trinidad; from there it came to the Prado Museum in 1771.

The venerable Carthusian is shown with a cross on which Jesus Christ appears. To his left are several priests. The first of these is a self-portrait of Carducci himself. Some writers have identified the priest appearing behind as a portrait of Lope de Vega.

Carducci's dual intellectual and artistic training as both painter and writer shows in some of his works, as in this one, in which an intellectually perfect order has produced a compositional scheme of balanced elements. The Venetian influence is evident in this painting in the scale and robust modeling of the figures.

VICENZIO CARDUCCI or CARDUCHO (1576–1638)
The Death of the Venerable Odon of Novara, 1632
Oil on canvas, 342 × 302 cm

THE LAST SUPPER

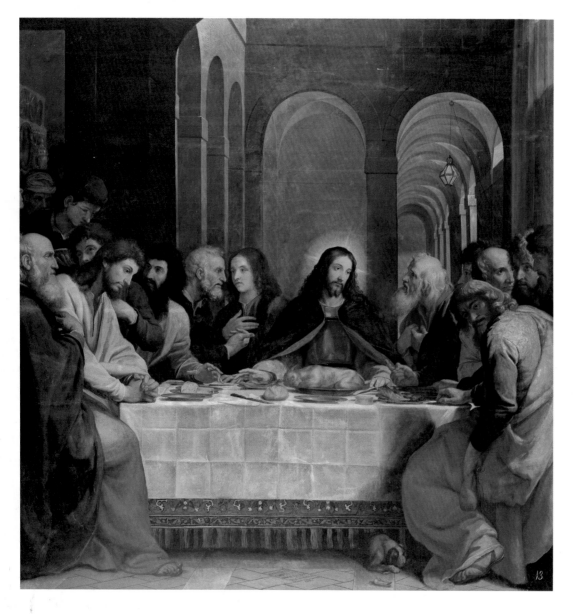

It would seem, according to Palomino, that this was painted for the Queen's Oratory in the old Alcázar in Madrid, where it remained until the disastrous fire of December 24, 1734, which destroyed the building. Saved from the fire, the canvas went to the Buen Retiro Palace.

The architectural background that frames the composition is outstanding. In this work typical Mannerist elements from the Escorial are combined with naturalistic factors from the early Baroque. Angulo remarked on the individuality of the faces, comparing them to those of Ribalta. The search for chiaroscuro effects does, in fact, give a definite character to these heads. It must be remembered that Bartolomeo Carducci was one of the original pillars of Baroque painting in Spain, through stylistic formulas that his brother Vincenzo would carry forward to their final form.

BARTOLOMÉ CARDUCCI or CARDUCHO (1560–1608)
The Last Supper, 1605
Oil on canvas, 256 × 244 cm

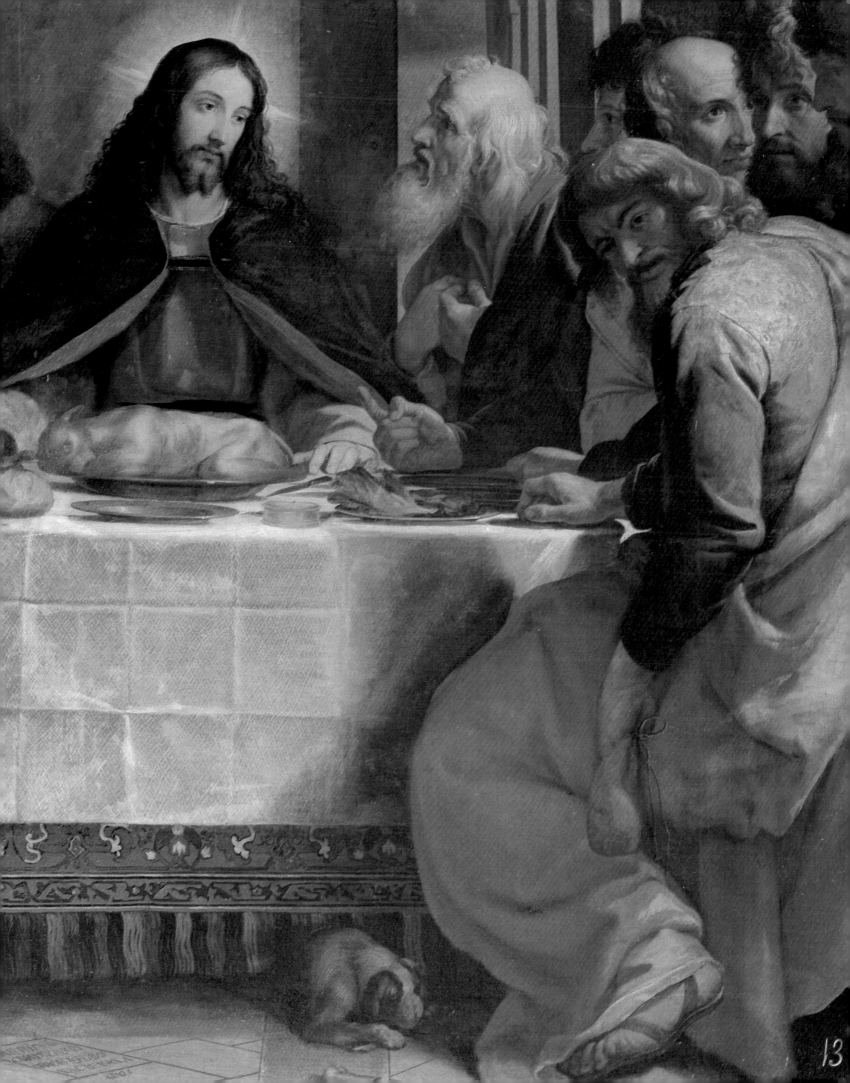

ST. BONAVENTURE RECEIVING THE
HABIT OF ST. FRANCIS

Given to the Prado Museum in
1925 by Dr. Joaquín Carvallo, a
collector from Extremadura, it had
hung in his castle at Villandry in
Turena. It was created for the church
of the San Buenaventura College in
Seville, where it was part of a series,
of which Herrera painted three more
canvases and Zurbarán painted four,
according to a contract of December
30, 1627.

This work shows the interior of a
church, with a dais in the
background on the left and the altar
on the right. St. Bonaventure, in a
ragged black garment, is kneeling
before St. Francis. On the floor are
the Franciscan habit and cord that
are to be put on him in the presence
of the community, which surrounds
the founder. To his right, an ancient
monk presents the postulant.

Herrera's modernity, as opposed
to the other Sevillian artists of his
generation, is clear, with more
advanced naturalism and a luminous
reflection that sets him apart from
the conventions used by his various
colleagues who followed Italian
forms. His own personal
development evidenced by this work
carries the Baroque style further
forward.

FRANCISCO DE HERRERA THE ELDER (1590–1656?)
St. Bonaventure Receiving the Habit of St. Francis
Oil on canvas, 231 × 215 cm

ESTEBAN MARCH (c. 1600–c. 1660)
The Crossing of the Red Sea
Oil on canvas, 129 × 176 cm

THE CROSSING OF THE RED SEA

This signed work recalls the moment when the Israelites, with their belongings and flocks, had miraculously crossed the Red Sea after the waters divided to let them pass. On the left, the pursuing Egyptian forces struggle in the waves.

According to the inventories, this work was in the Buen Retiro Palace in Madrid in 1772.

The predilection of this artist for compositions with many figures, as opposed to the more intimate style of Espinosa, his contemporary and fellow countryman, is clearly shown here. Palomino points to March's training with Orrente, from whom he absorbed a taste for the pastoral, for biblical painting, and for battles. Adding that he only worked when "driven by fervor or the force of necessity," and that, above all, moments during which he was in the grip of this fervor provided the optimum time for painting battle scenes.

FELIPE RAMÍREZ (documented between 1628 and 1631)
Still Life, 1628
Oil on canvas, 71 × 92 cm

Still Life

This canvas, signed and dated, was in a private collection before the Civil War of 1936–39. In 1940 it was bought for the Prado Museum with funds from the count of Cartagena's bequest.

The elements in the composition — a cardoon, irises in a gilded vase on a windowsill, with a partridge and two bunches of grapes hanging from above — are typical of the sober nature of the Spanish still life in the seventeenth century. The cardoon is a faithful copy of the one in the Sánchez Cotán painting from the Hernani collection, recently acquired by the Prado Museum (see page opposite). Bergströn remarked that the irises were a point of reference to give us an idea of how the flower paintings by this artist, now lost, must have been. Without doubt this is the painting referred to by Ceán Bermúdez in his *Diccionario* in the entry for Felipe Ramírez.

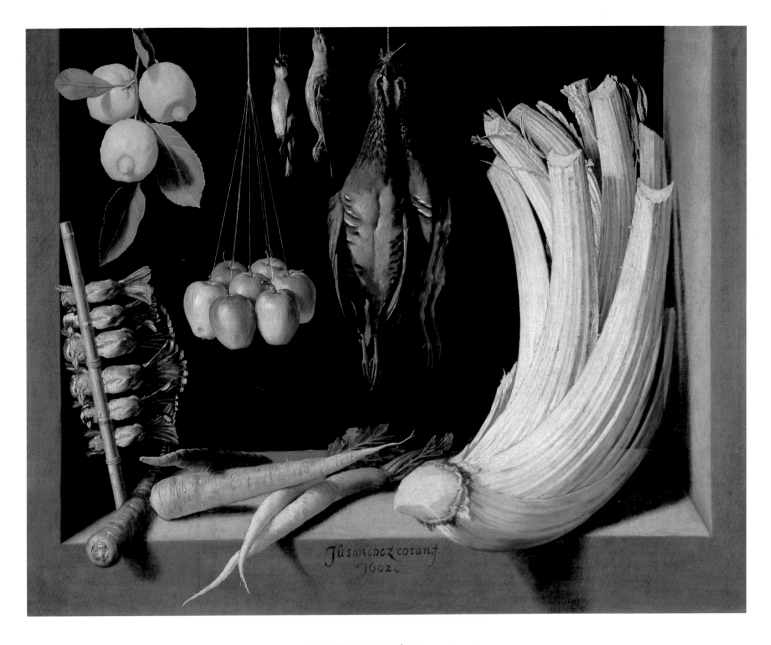

JUAN SÁNCHEZ COTÁN (dates unknown)
Still Life with Game, Vegetables, and Fruit, 1602
Oil on canvas, 68 × 89 cm

STILL LIFE WITH GAME, VEGETABLES, AND FRUIT

A painting that was in the collection of Prince Sebastián Gabriel de Borbón, this work was acquired from the duke of Hernani's widow in 1993 with funds from the Villaescusa bequest.

It is unquestionably the finest and best-known work by this Carthusian painter. In the artist's inventory of 1603 it figures as "another canvas of cardoons, with partridges, which is the original of the others." Several early copies are known and the still life by Felipe Ramírez in this Museum was inspired by it. (See page 82.)

Painted in Toledo before he entered the monastery, as Pérez Sánchez says, "the disposition of the elements creates a completely harmonious composition, avoiding the monotony imposed by the parallel forms of hanging game that affects other painters." With strong light contrasts within a clearly somber line, the precision of the depiction and the chromatic fusion give this work a unique beauty in its genre and in the panorama of Spanish art during the first part of the seventeenth century.

THE HOLY FAMILY, WITH SS.
ILDEFONSUS AND JOHN THE
EVANGELIST, AND THE MASTER
ALONSO DE VILLEGAS

In 1816, according to the relevant inventory, this painting was in the royal palace in Madrid.

The personage represented was doubtless the donor, Alonso de Villegas Selvago, born in Toledo in 1534, who died about 1615. An ecclesiastic, at the age of twenty he wrote *Comedia Selvagia,* although his best known and most scholarly work was the *Flos sanctorum* (1578–1594).

Mayer related the figure of the Virgin to another in a work by Jerónimo Murciano, engraved by Villamena.

In this work, which is considered a pioneering piece of the Toledo Baroque style, the painter combines his technique of Mannerist training with a naturalism that still shows the influence of tenebrism. He translates this into original chiaroscuro forms. These techniques were followed by other artists of his generation and perfected by those of the next.

BLAS DEL PRADO (c. 1545–1599)
The Holy Family, with SS. Ildefonsus and John the Evangelist, and the Master Alonso de Villegas, 1589
Oil on canvas, 209 × 165 cm

FRANCISCO DE ZURBARÁN (1598–1664)
Our Lady of the Immaculate Conception, c. 1628-1630
Oil on canvas, 139 × 104 cm

OUR LADY OF THE IMMACULATE CONCEPTION

This painting came from the collection of the marchioness of Puebla de Ovando, Seville, before it passed to the convent of the Esclavas Concepcionistas of the Sacred Heart in the same city, coming to the Prado Museum in 1956.

Zurbarán, with Pacheco and Murillo, was one of the great interpreters of this Marian dedication, shaping a Sevillian model as opposed to the manner of portraying this iconography in Madrid. This particular work is one of the most beautiful examples, with those of Jadraque — now the Sigüenza Museum — the National Gallery in London, and Langón.

As the source of the composition, Soria pointed to a 1605 engraving by Sadeler in which the figure of Mary appears among the symbols of the Laurentian litany. A definite sculptural feeling is detected in the pose of the figure, with its somewhat static quality, and in the treatment of the draperies.

THE DEFENSE OF CÁDIZ AGAINST THE ENGLISH

For the series of recent historical scenes that were hung on the walls of the Hall of Kingdoms in the Buen Retiro Palace, in accordance with a project of the count-duke of Olivares, Zurbarán executed two canvases of the successive battles against the English, which took place in Cádiz in 1625. This one represents the events of November 1, 1625, when Lord Wimbledon disembarked in the outskirts of Cádiz with eight thousand men. The governor of the city, Don Fernando Girón y Ponce de León, directed the defense from an armchair, to which he was confined because of his gout; nevertheless, he put the enemy to flight with only six hundred men.

According to María Luisa Caturla, the second painting, its whereabouts presently unknown, must have shown the entry into Cádiz of the fleet returning from the Indies, whose capture was the ultimate objective of Wimbledon's expedition. The canvases were hung at the ends of the north and south walls of the Hall of Kingdoms. As literary sources, Zurbarán used the narrative by Luis Gamboa y Eraso, which appeared in Cádiz in 1626, and that of Juan de Vega, published in Barcelona in 1625.

STILL LIFE WITH POTTERY

This comes from the collection of the Catalan politician and collector Francisco Cambó who donated it to the Prado Museum in 1940. An almost identical composition from the same source is in the Catalan Museum of Art. This duality has given rise to several hypotheses from art historians and critics. The most commonly held theories are that the Barcelona painting is a replica of that in Madrid — which is most probable — or that one of them is by Juan de Zurbarán or another artist of the master's workshop or circle.

Pérez Sánchez says that the red earthenware vessel is identical to that in a still life by Francisco de Palacios, painted in 1648 and preserved in the Harrach collection. W. Jordan points out that the vessel on the right is the same as that found in the painting of the *Annunciation* in the March collection in Palma, Mallorca. Camón Aznar refers to the beauty of these still life compositions "without drama or opulence. With symmetry as a basis of balance. With serenity, we could say, symbolic of Castilian tranquillity. They radiate only peacefulness, a concept of spiritual calm."

ST. ELIZABETH OF PORTUGAL

This has traditionally been identified in the Prado Museum catalogues as St. Casilda, because this saint is also portrayed with the miracle of converting into roses the food she had brought to share among the poor. This miracle was also attributed to St. Elizabeth of Hungary, the queen of Portugal's great aunt, for whom she was named.

A daughter of Pedro III of Aragón, she was born in the Aljafería Palace in Zaragoza in 1271. At the age of twenty-two she married King Dionís of Portugal, and spent her life in charitable works. Once widowed, she took the habit of the Poor Clares, founding this order in Coimbra, where she died. She was canonized by Pope Urban VIII in 1626.

She appears in seventeenth-century court dress, a form used by Zurbarán to present various saints, thus lending them a contemporary air and a naturalism accessible to the viewer. The provenance of this work is unknown. It appears for the first time in the catalogues of the Royal Palace in Madrid in 1814, in the Chimney Room. Although some writers think that it was acquired by Isabella Farnese, it is more likely that Charles IV bought it in Seville during his sojourn in that city in 1796.

FRANCISCO DE ZURBARÁN
The Defense of Cádiz Against the English, 1634
Oil on canvas, 302 × 323 cm

FRANCISCO DE ZURBARÁN
Still Life with Pottery
Oil on canvas, 46 × 84 cm

FRANCISCO DE ZURBARÁN
St. Elizabeth of Portugal
Oil on canvas, 184 × 90 cm

89

Attributed to Zurbarán at the beginning of this century, Ponz identified this canvas with certainty as a work by Ribalta. It was in the prior's cell of the Carthusian convent of Portacoeli (Valencia), where it remained until 1836, the date on which the convent was dissolved. It was acquired in 1940 with funds from the bequest of the count of Cartagena.

As a source of inspiration, the artist took the scene from Father Rivadeneyra's *Vida de San Bernardo.* As Interián de Ayala points out, this is the first biography of the saint in which this subject appears. The painting depicts the moment in which St. Bernard falls before a crucifix in a trance and Christ descends from the cross to embrace him. The influence of Caravaggio, whose work Ribalta had studied in Italy, is manifest.

The robust forms of the body of Christ contrast with the strong chiaroscuro in which, as Camón Aznar points out, the light has a meaning not merely plastic, but mystic.

FRANCISCO RIBALTA (1565–1628)
Christ Embracing St. Bernard
Oil on canvas, 158 × 113 cm

THE PRESENTATION OF THE VIRGIN IN THE TEMPLE

This work was traditionally attributed to Valdés Leal in the Prado Museum catalogues until after 1920, when doubts were expressed as to whose aesthetic ideology and technique it fully corresponds.

The priest welcomes the Virgin on the temple steps. In the foreground are SS. Joachim and Anne and three other figures, one of whom carries a ewer and is identified by various art historians as a self-portrait of the artist.

The solidity and ability in the modeling of the figures, a legacy from Cano, is shown in this work. Also evident is the influence of Pedro de Moya. The artist's knowledge of Rubens through prints is decisive, and can be detected in its reflection of the Flemish compositional style and the Venetian influence. With a meticulous and effective technique, Juan de Sevilla's mastery makes him the primary representative of the Granada school after the death of Cano. His work offers an absolutely valid and original chromatic interplay, one that is very far from the palette of his great master.

JUAN DE SEVILLA ROMERO (1643–1695)
The Presentation of the Virgin in the Temple
Oil on canvas, 153 × 130 cm

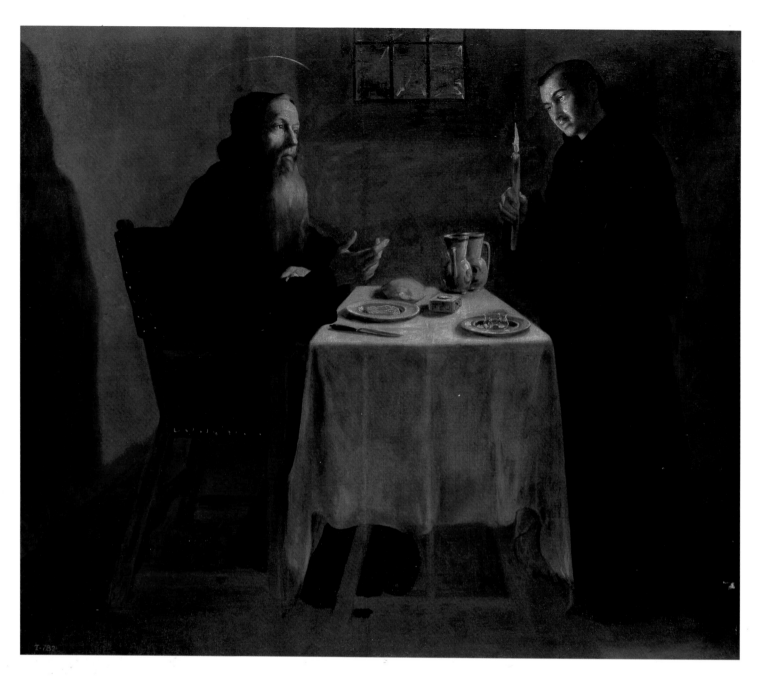

FRAY JUAN ANDRES RICCI or RIZI DE GUEVARA (dates unknown)
St. Benedict's Supper
Oil on canvas, 185 × 216 cm

St. Benedict's Supper

Together with its fellow, *St. Benedict Blessing the Bread*, also in the Prado, this picture came from the Monastery of San Millán de Yuso (La Cogolla), from where it passed to the Museo de la Trinidad. Some art historians have associated this canvas with one of the attempts to poison the holy founder. St. Benedict is shown seated at table, while a young monk in front of him holds a candle that lights the composition.

His early training in tenebrism gave this artist of Italian origin a predilection for difficult lighting, which here is clearly demonstrated. His technical thoroughness and restrained modeling have led certain art historians to consider him as the Castilian Zurbarán, through his manner of expressing the daily scenes of monastic life. Thus we have the splendid cloth that covers the table, against which appear the two monks in black contrasting with the luminous whiteness of the linen, and the light from the candle held by the young monk. Ricci was a contemporary of Velázquez, although he outlived him by twenty years. Nevertheless, the tremendous personality of the Sevillian never influenced the work of this artist, who was more concerned with the general ideas of the international Baroque movement.

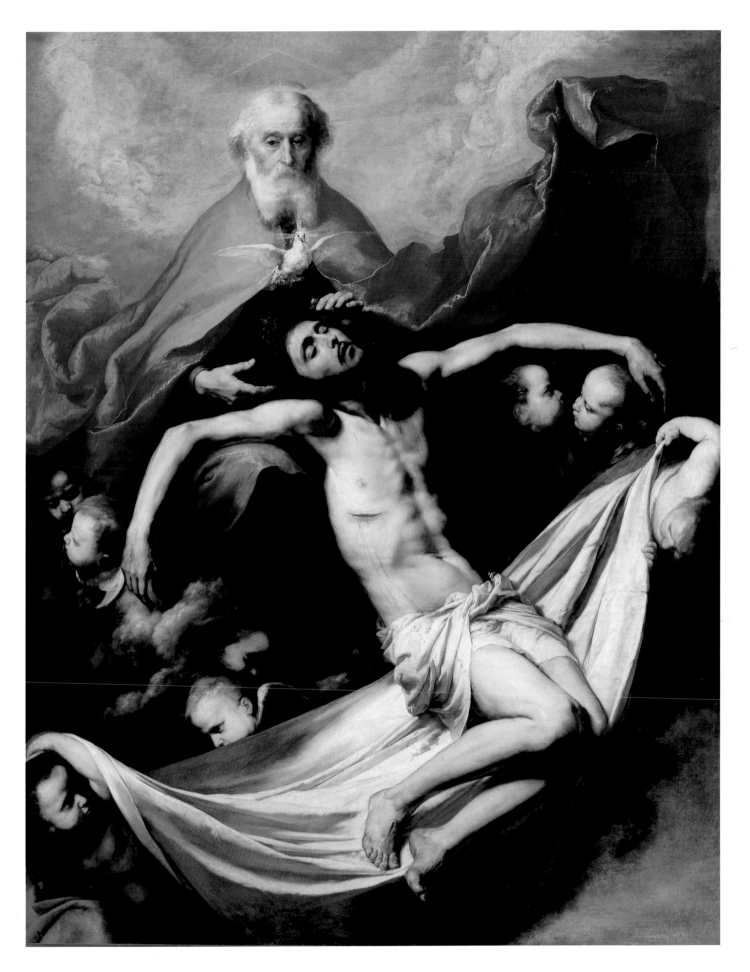

THE HOLY TRINITY

This picture was acquired by Ferdinand VII from the artist Agustí Esteve for the Prado Museum in 1820, through the intermediation of another painter, Vicente López.

Another version of the same date is in the Monastery of El Escorial, although it is much damaged and heavily restored. For the iconography of this painting, Ribera shows his adherence to a tradition originated by Albrecht Dürer and also found in the painting by El Greco for Santo Domingo el Antiguo (today in the Prado Museum). This was continued by El Greco's disciple Tristán, who knew Ribera in Italy and accompanied him during his sojourn in that country, thus producing the link with the El Greco iconography.

The recent cleaning of this composition has brought out a palette of brilliant tones and white shadings that admirably light up the shroud borne by the cherubs. The head of the Eternal Father is impeccably modeled and of rotund execution, as are the flesh tones of the body of Christ, executed with smooth and expert shadings, making this work a key piece in this stage of the artist's career.

THE MARTYRDOM OF ST. PHILIP

This comes from the royal collections and was saved from the fire at the Old Alcázar in 1734, when it went to the Buen Retiro Palace. At the end of the eighteenth century it was in the Royal Palace in Madrid, and came to the Prado in 1819.

The work was traditionally known as the *Martyrdom of St. Bartholomew,* a subject portrayed several times by Ribera. After iconographic research, it was identified as the *Martyrdom of St. Philip,* the patron saint of Philip IV, for whom it was painted.

In the eighteenth century, the painting was praised by several art critics, among them Antonio Ponz, who described it as "a painting of great force and powerful expression, particularly with regard to the executioners," an opinion that Ceán Bermúdez repeats in his *Diccionario.* Even in this century, in view of the modernity of the technique, which has sometimes been compared to Goya's, Eugenio D'Ors wrote that this work "offers our eyes the gift of a real festival, even including a theatrical air and sumptuous scenery," constituting "almost, almost...a Russian dance." Pérez Sánchez extols the superb skill in the lighting, saying that "the action is developed in the open air, on a background of luminous clouds, and the figures are displayed as being struck violently by a blinding sunlight."

Preceding page:
JOSÉ DE RIBERA (1591–1652)
The Holy Trinity, c. 1635
Oil on canvas, 226 × 118 cm

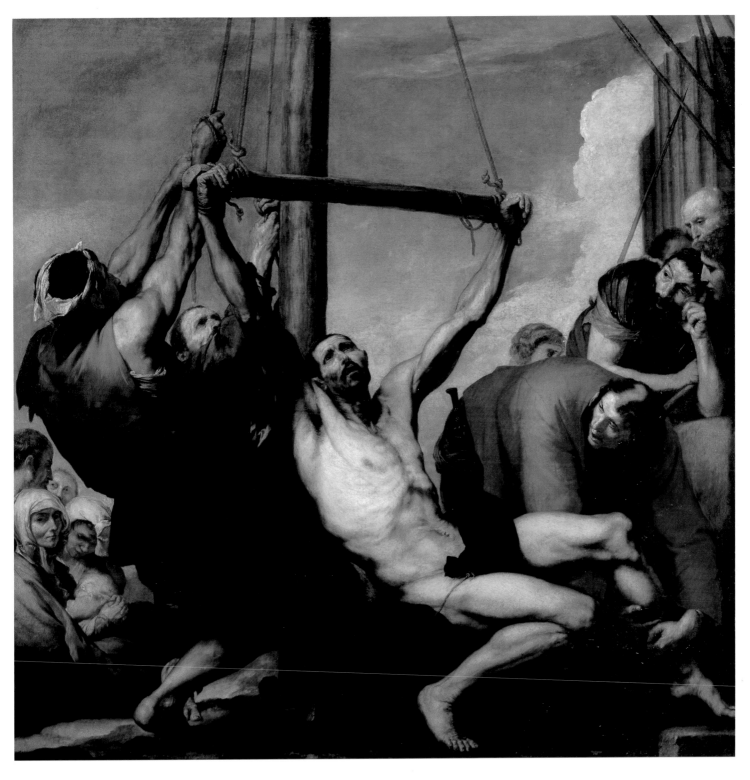

JOSÉ DE RIBERA
The Martyrdom of St. Philip, 1639
Oil on canvas, 234 × 234 cm

JACOB'S DREAM

The painting comes from the collection of Jerónimo de la Torre, where it was in 1658. It was acquired from his descendants by Isabella Farnese in 1718, at which time it passed to the Granja Palace. It was thought to be by Murillo. It appears in the Aranjuez inventories of 1794, later passed to the Royal San Fernando Academy of Fine Arts, and from there to the Prado in 1827.

The picture portrays the episode in Genesis 28:11–22, which tells of the dream in which Jacob saw a celestial stair ascended and descended by angels. Ribera captures the holy ladder with clarity but avoids the figures of the angels, concentrating on the biblical patriarch.

This painting is a companion piece to *The Deliverance of St. Peter,* with which it appears in the 1794 Aranjuez inventory. Markus Burke thought that these canvases had belonged to the duke of Medina de las Torres in 1669, and that actually are now in the Escorial, both of *The Adoration of the Shepherds.* The luminosity and pleasing colors of this painting explain its attribution to Murillo at the beginning of the eighteenth century.

THE DELIVERANCE OF ST. PETER

This painting and its companion piece, *Jacob's Dream,* belonged to Jerónimo de la Torre, from whose descendants Isabella Farnese acquired them for the Granja Palace. They were thought to be by Murillo, a painter for whom she had great admiration. In 1794 they were in the Aranjuez. This painting came to the Prado Museum in 1818.

In the luminous effect that starts from the high barred window, Pérez Sánchez has seen an echo of Caravaggio's style in his *Calling of St. Matthew* in S. Luigi de' Francesi, and a definite reminder of van Dyck's coloring in the figure of the angel. Felton finds clear influences of Tintoretto and Veronese.

Regarding the origin of the two paintings (which today we believe completely proven), Burke recently tried to identify them as two works described in the inventory of the duke of Medina de las Torres, dated 1668–1669, but these must be a different *St. Peter Delivered by the Angel* and *Jacob with Laban's Flock,* also by José de Ribera.

THE PENITENT MAGDALEN

This picture comes from the royal collections and was in the New Palace in Madrid in 1772, with *St. John the Baptist, St. Bartholomew,* and *St. Mary the Egyptian.* They were in the Princess's Conversation Room and, it seems, came from the descendants of Jerónimo de la Torre, who had owned a great collection including no less than ten paintings by Ribera. Elías Tormo considered the group of four paintings with which this *Penitent Magdalen* belongs to be a study in contrast between youth and age in men and women. It appears in the old inventories as *Santa Tade;* the signature and date only became visible during the most recent cleaning of the picture. In Bilbao Museum is another version, signed and dated 1637, which could be the head of this series. The figure of the Magdalen is one Ribera's most beautiful representations of his feminine ideal. The smooth flesh tones of the bust, face, and hands make an outstanding contrast to skillfully shaded red of the mantle. There is deep feeling in the spatial clarity of the luminous landscape on the left side of the painting.

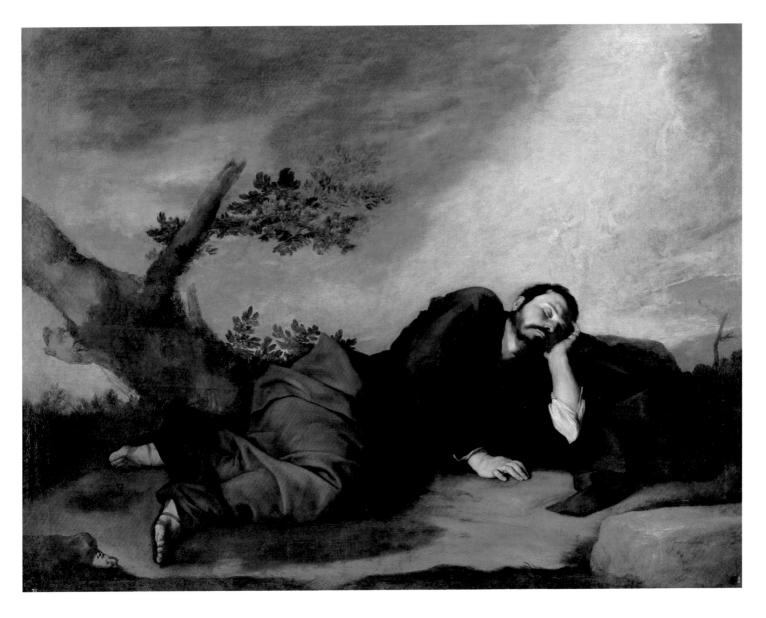

JOSÉ DE RIBERA
Jacob's Dream, 1639
Oil on canvas, 179 × 233 cm

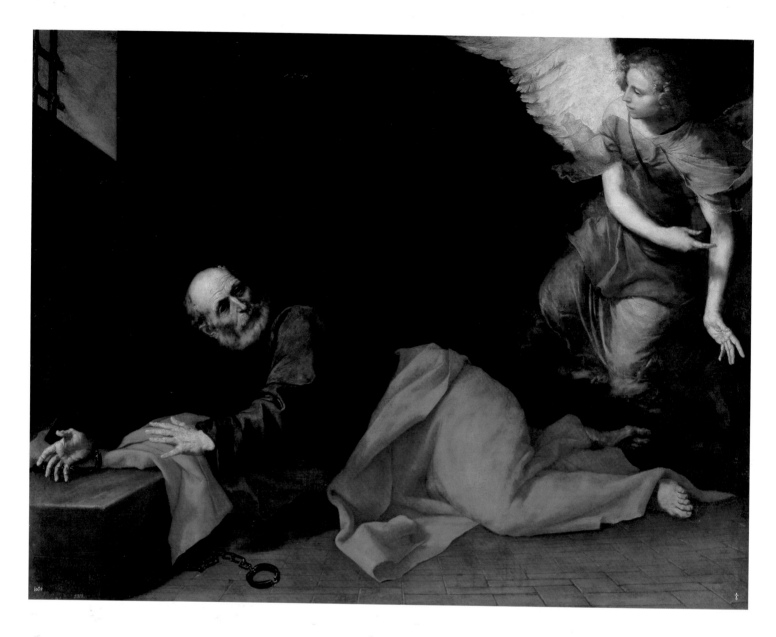

JOSÉ DE RIBERA
The Deliverance of St. Peter, 1639
Oil on canvas, 177 × 232 cm

JOSÉ DE RIBERA
The Penitent Magdalen, 1641
Oil on canvas, 182 × 149 cm

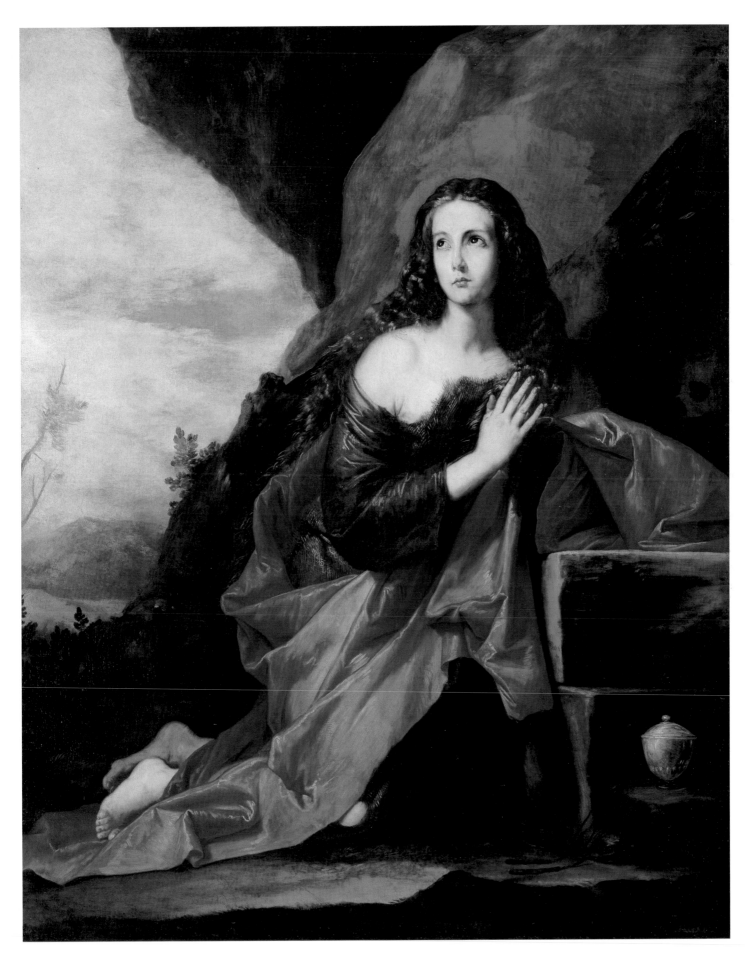

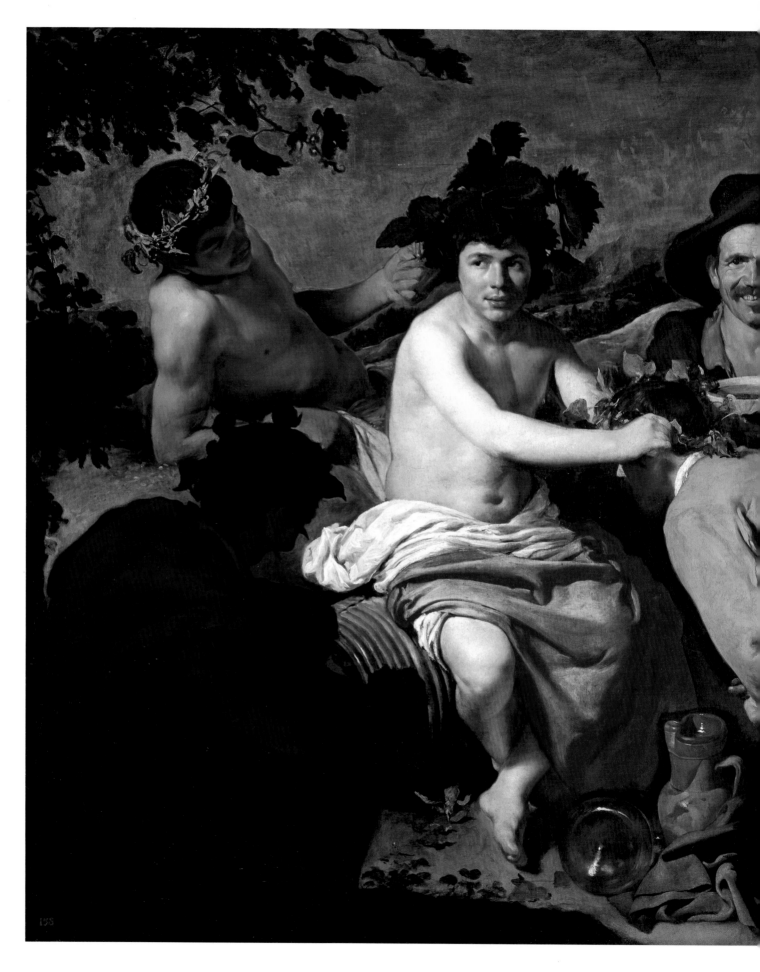

THE TOPERS, OR THE TRIUMPH OF BACCHUS

Velázquez was paid 100 ducats for this work, according to a document dated July 22, 1626. The painting stayed in the Alcázar at Madrid until the fire of 1734, when it was taken to the Buen Retiro Palace. It came to the Prado Museum in 1919.

Velázquez actually converted this mythological theme into a scene of great naturalism, one with a burlesque character — as Ortega y Gasset saw it, a kind of "divine still life...mythological."

It seems that it was Rubens who inspired the work when he told Velázquez of a masquerade that had taken place a few years earlier in Brussels, in honor of Archduke Albert and Duchess Isabella Clara Eugenia. The artist could also have had in mind an event mentioned by Estebanillo González about a wagon in a cavalcade with an entourage similar to that in the painting, which took place in Madrid.

As Julián Gallego points out, the picture can be divided into two halves; the left, almost Italian, with a reminder of Caravaggio in the figure of Bacchus; with the six townsfolk in the right half in the Spanish tradition. A replica has been in the Capodimonte Museum in Naples since the end of the seventeenth century.

DIEGO VELÁZQUEZ (1599–1660)
The Topers, or *The Triumph of Bacchus*, c.1627-28
Oil on canvas, 165 × 188 cm

DIEGO VELÁZQUEZ
Vulcan's Forge, c. 1631
Oil on canvas, 223 × 290 cm

Vulcan's Forge

Painted in Rome during his first visit to Italy, according to Pantorba, this canvas was produced at the same time as its pendant, *Joseph's Coat,* in the house of the Spanish ambassador to the Papal States, Manuel de Fonseca, Count of Monterrey. Servant boys from the embassy served as models for some of the figures. Both paintings were acquired from the artist in Madrid by the chief notary of Aragon, Jerónimo de Villanueva, who in his turn sold them to the king. They appear in the inventories of the Royal Palace in Madrid in 1772 and 1794. The scene displays the moment in which Apollo tells Vulcan of the infidelity of his wife, Venus, with Mars, for whom he is forging a suit of armor.

In the composition, Velázquez had in mind an engraving by Antonio Tempesta on the same subject (Amberes, 1606). The influence of Guido Reni is clear in the compositional scheme in the form of a frieze and there is an echo of classical sculpture in the manner of treating the anatomies of the various characters. In his analysis of this work, Camón Aznar records that, according to Homer, it was not Apollo who recounted the infidelity of the Goddess of Love to her husband, but the Sun. However, in this work the figure's head is crowned by a laurel wreath — an attribute of Apollo — which gives us his identity as represented by the painter. A presumed sketch for the head of Apollo is in a private American collection, but it is without question of a later date.

This is the largest painting produced by the artist. It was done for the Hall of Kingdoms — now the Military Museum and, with the Casón, all that remains of the old Buen Retiro Palace. The work was carried out at the same time as others being done — by Pereda, Maino, Zurbarán, Jusepe Leonardo, Vicente Carducho, Castelo, and Cajés — in order to furnish a gallery in which victories won by the Spanish army would be represented. It was the count-duke of Olivares who inspired these commissions.

The composition portrays the event of June 2, 1625, when the Dutch governor, Justin de Nassau, delivered the keys of the city, symbolically, to Ambrosio de Spinola, the commander of the Flemish Brigades. This happened, in fact, three days after the city was taken. In 1639, shortly after the canvas was painted, the city was lost forever, being reconquered by Frederick Henry of Orange. Three pictures were commissioned of this Spanish achievement, two from the Dutch painter Peeter Snayers and one from Velázquez. The Spanish painter seems to have been inspired by the drama of the same title by Calderón de la Barca, in which Spinola, on receiving the keys, says to the governor:

"Justin, I receive them
and I know how valiant you are,
that the valor of the vanquished
brings fame to the victor."

Velázquez found inspiration for the background landscapes in Flemish engravings, and for the composition, it is thought, in *Abraham and Melchisedech,* a print by Bernard Salomón published in *Quadrins Historiques de la Bible* (Lyon, 1553). Years later, the Velázquez scene was recreated by José Casado del Alisal in his *Surrender of Bailén,* in the Prado Museum–Casón de Buen Retiro.

DIEGO VELÁZQUEZ
The Lances, or *The Surrender of Breda,* c. 1634–35
Oil on canvas, 307 × 367 cm
(Detail on following page)

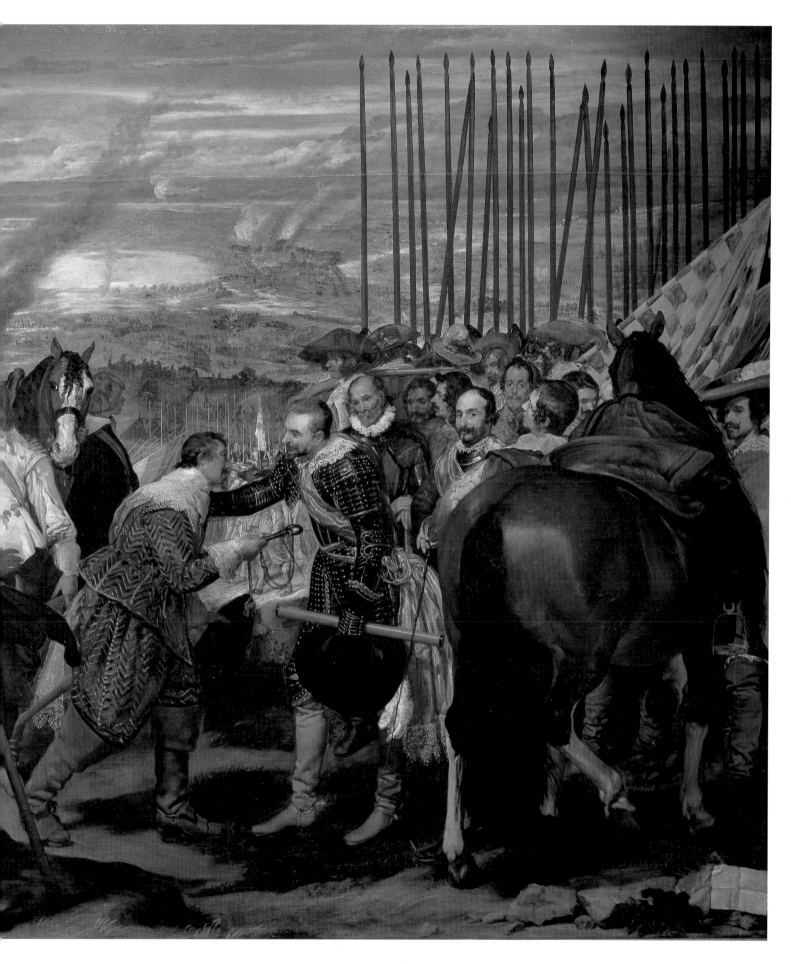

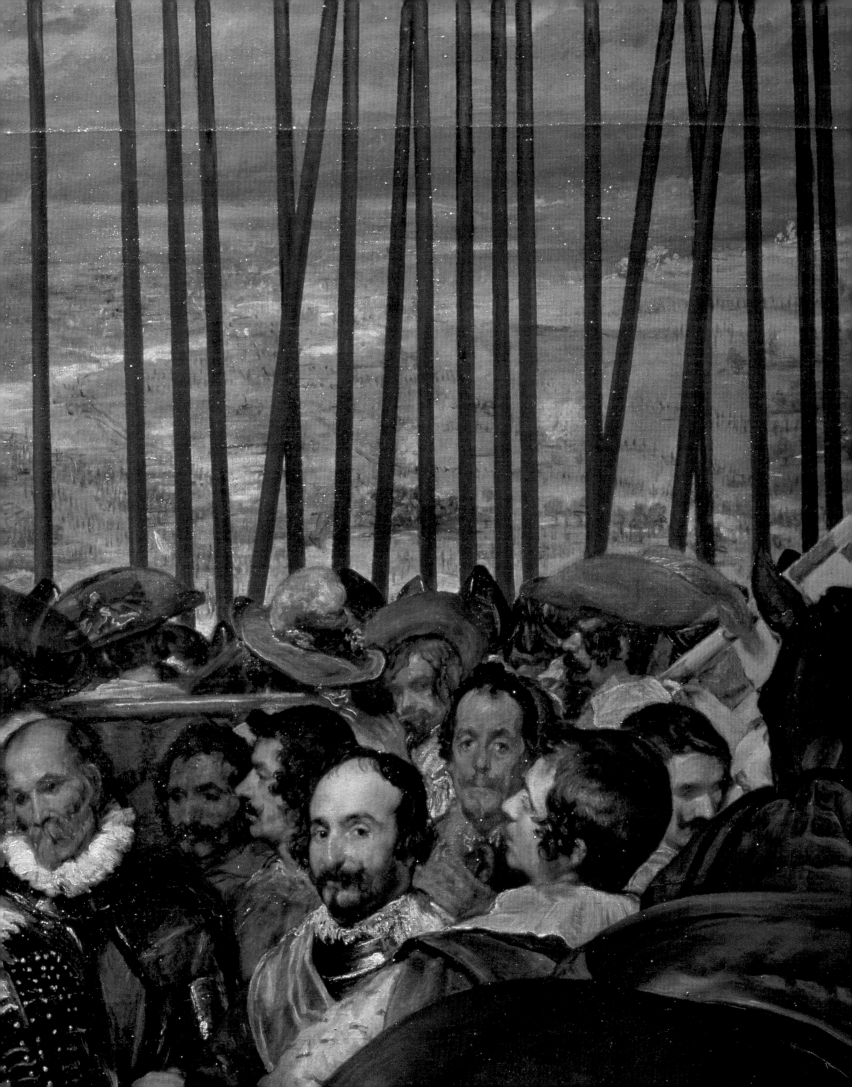

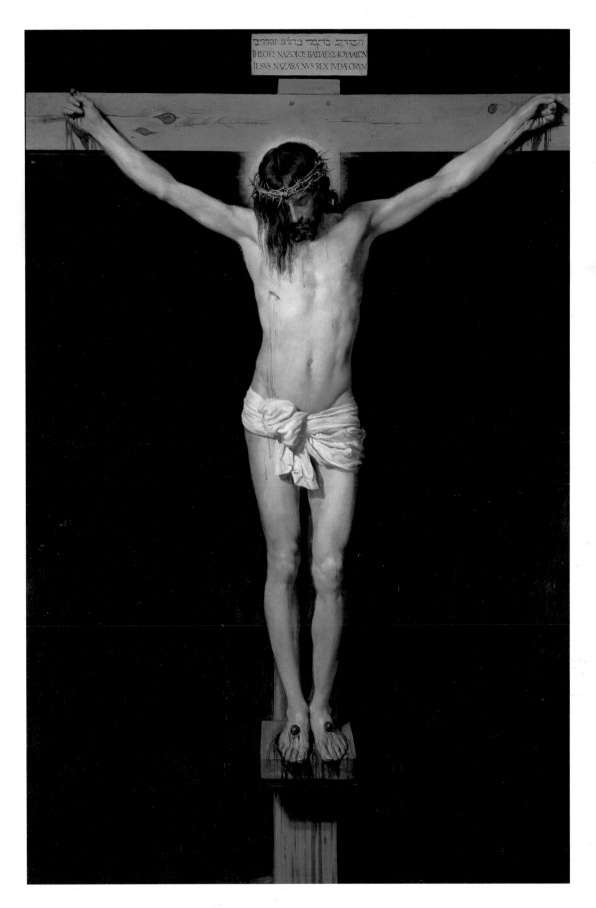

DIEGO VELÁZQUEZ
Christ Crucified, c. 1632
Oil on canvas, 248 × 169 cm

CHRIST CRUCIFIED

VIEW OF THE GARDEN OF THE
VILLA MEDICI IN ROME

VIEW OF THE GARDEN OF THE
VILLA MEDICI IN ROME II

This picture was painted by Velázquez for the Benedictine convent of nuns of San Plácido, where it remained in the sacristy until 1808, passing then into the collection of the minister Godoy, the favorite of Charles IV. After being sold in Paris, it was acquired by the duke of San Fernando de Quiroga, who left it in his will to Ferdinand VII. In 1829 it came to the Prado Museum. It seems that this canvas was commissioned by Philip IV, in expiation of a sentimental relationship the king had maintained with a novice. The chief notary of Aragon, Jerónimo de Villanueva, acted as go-between, which would account for his precipitate fall, being incarcerated by the Inquisition in the Toledo prison. Some writers assert that the painting was offered to the convent by Villanueva after completion of the five-year penalty imposed upon him.

It seems that this work used to have a landscape background, which has disappeared with the passage of time, due to the darkening of the pigments. It has even been suggested that there were two figures, the Virgin and St. John, flanking the Crucifixion. The serene beauty and the realistic tone that is maintained in Christ's body have inspired numerous literary creations, among which the celebrated poem by Miguel de Unamuno is outstanding.

Art historians have never agreed about the date of this work and its companion. Some believe they were executed during Velázquez's first visit to Italy (1629–1630), the support for this theory being that the painter lived in the Villa Medici during the summer of 1630. However, for others, because of the sketchlike, almost impressionist, atmosphere, it belongs to the second visit. As Trapier indicated, in this work Velázquez "was not influenced by his contemporaries but was far ahead of his time, and the painting has frequently been compared with Corot's Roman landscapes."

On the other hand, and in spite of the lack of landscape tradition in Spanish art, it is right to point out that Velázquez, with these two works, is the first artist to take an impression in oils directly from nature. This is the reason, says Pantorba, that the Sevillian did not set out to paint two "landscapes" but instead tried to capture two fleeting "impressions," in the style of Monet two centuries later.

Saved from the fire at the old Alcázar in 1734, they went to Buen Retiro and were later in the Royal Palace in Madrid, coming to the Prado Museum in 1819.

See the preceding entry.

The work seen here has also been called *Midday* to distinguish it from the companion piece, which is known as *Evening*. Standing in front of Serlio's architecture are two persons — on the right a gentleman with a cape, and what seems to be a gardener on the left — portrayed with an impressionist air from a basis of short, independent brush strokes. A strong romantic impulse is transmitted in the landscape, with the hill in the distance where nowadays the Villa Borghese stands, while the foliage in the upper part of the composition has a subtly poetic accent. Seen through the lower part of the central arch is a plinth with a statue of Ariadne, which is similar to that acquired by Velázquez for Philip IV and today is in the Prado Museum. The sculpture from the Villa Medici was subsequently taken to the Pitti Palace in Florence. Thanks to the statue, this landscape has also been known as *Ariadne's Loggia* or *Ariadne's Pavilion*. Two hundred years later the same view was painted by Corot.

DIEGO VELÁZQUEZ
View of the Garden of the Villa Medici in Rome,
c. 1649–1651
Oil on canvas, 48 × 42 cm

DIEGO VELÁZQUEZ
View of the Garden of the Villa Medici in Rome II,
c. 1649–1651
Oil on canvas, 44 × 38 cm

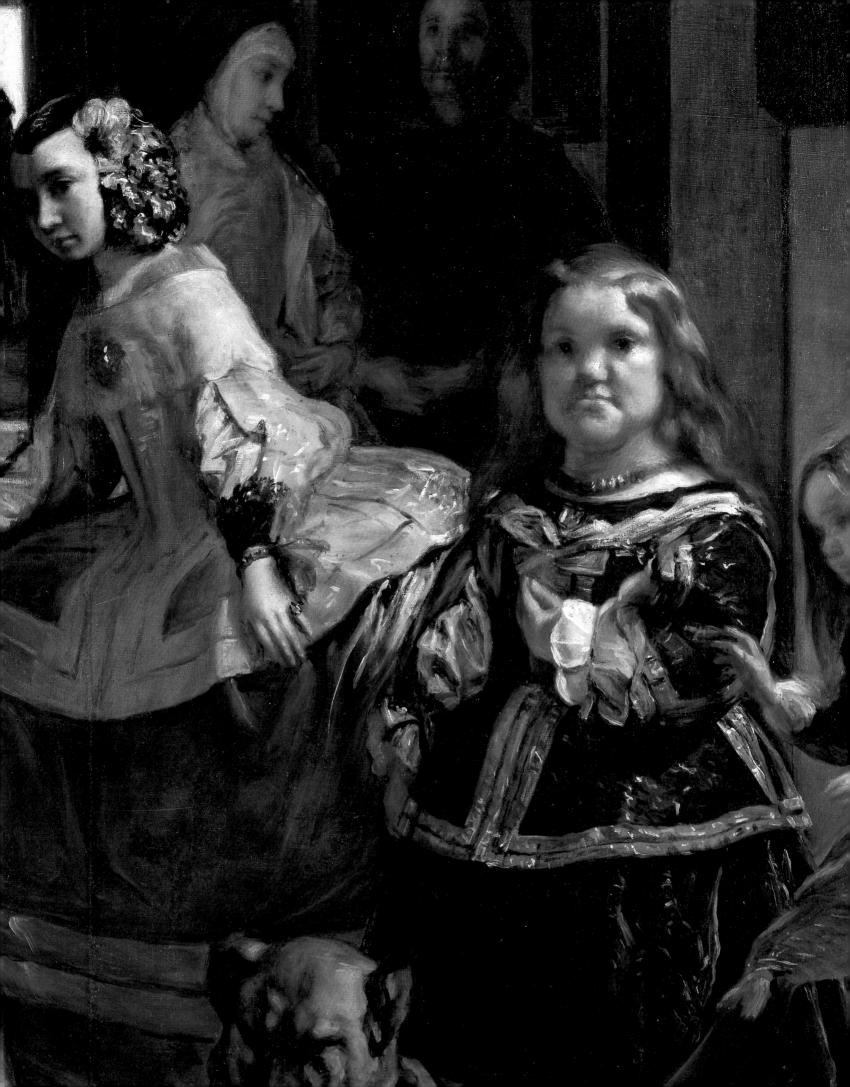

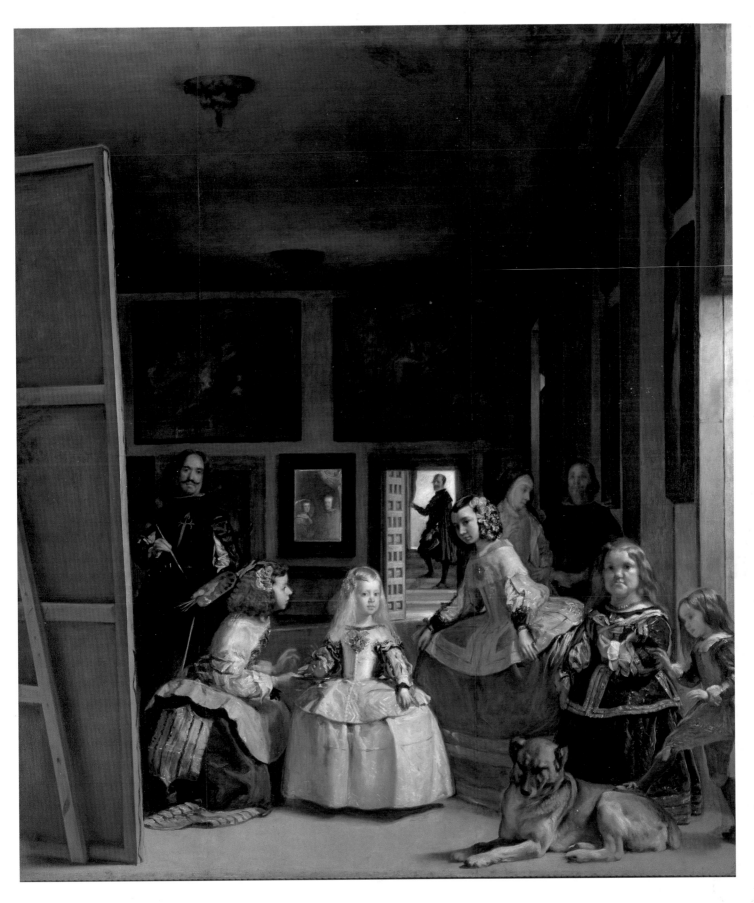

DIEGO VELÁZQUEZ
Las meninas, or *The Family of Philip IV*, c. 1656
Oil on canvas, 310 × 276 cm

LAS MENINAS OR THE FAMILY OF
PHILIP IV

A key work in all of art history, this painting is difficult to classify in terms of the nature of its thematic content; however, it represents one of the great achievements of the Baroque.

The scene is a chamber in the old Alcázar in Madrid, where Velázquez had his workshop. The group is centered upon the Infanta Margarita, who is seen between her ladies, María Augustina Sarmiento and Isabella de Velasco. On the right, behind a recumbent dog, are the two dwarfs, Mary Bárbola and Nicolás de Bertusato. In the middle ground are Doña Marcela de Ulloa and a groom of the chamber. In the background, in front of a small doorway, José Nieto, the chamberlain, and to the left the artist in front of his easel. Finally, reflected in a mirror, are glimpsed the effigies of the sovereigns. In the upper part of the central wall hang two pictures identified as copies painted by Juan Bautista del Mazo of the *Minerva and Arachne* by Rubens and the *Pan and Apollo* by Jordaens.

In reality the scene represents a sitting in which Velázquez was painting the faces of the sovereigns on his canvas before it was interrupted by the entry of the infanta with her companions. As Palomino tells us, "the infanta and her ladies often came to see Velázquez paint, finding it a delight and very entertaining." For Charles de Tolnay, Velázquez placed himself outside the composition as if he saw it in his thoughts, imagining it rather than painting it, in that creative moment that exalts the artist. When Lucas Jordan saw this picture for the first time he said, "This is the Theology of Painting," and, as Carl Justi said, there is no other painting that makes us forget this one.

A sketch, supposedly for this work, was in the old collection of Jovellanos; it has been attempted to identify it with a work in the Bankes collection in Kingston-Lacy (England), which is undoubtedly a reduced copy.

THE SPINNERS, OR THE FABLE OF
ARACHNE

Painted for Pedro de Arce, the king's huntsman, this canvas subsequently went to the collection of the dukes of Medinaceli. It was acquired by Philip V at the beginning of the eighteenth century and came to the Prado Museum in 1819.

In the Museum catalogues it is traditionally described thus: "the spinning, winding, and piecing-for-sales workshop in the Santa Isabella tapestry factory in Madrid. Five women are working. In the room beyond, three ladies are looking at a tapestry with a mythological theme, in which Minerva and Juno appear." Ortega y Gasset later stated that it was on a mythological subject, pointing out that it could be the Wedding of Thetis and Peleus, or The Fates. Finally, it was Angulo Iñiguez who discovered that it portrayed the fable of Arachne according to Ovid's *Metamorphoses*. This theory was confirmed by María Luisa Caturla who found in Pedro de Arce's inventory this reference to the painting: "The Fable of Arachne, by Velázquez."

The story goes that it angered Minerva that a tiresome young woman, Arachne, should be considered the better tapestry weaver, and so she complained to her father, Jupiter, who punished the maid by turning her into a spider.

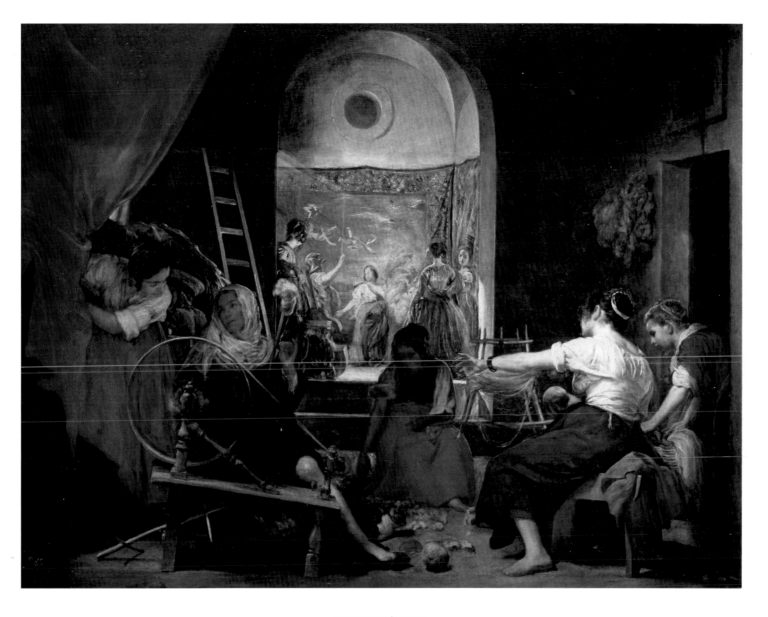

DIEGO VELÁZQUEZ
The Spinners, or *The Fable of Arachne,* c. 1657
Oil on canvas, 167 × 252 cm, with additions 220 × 289 cm
(Detail on following page)

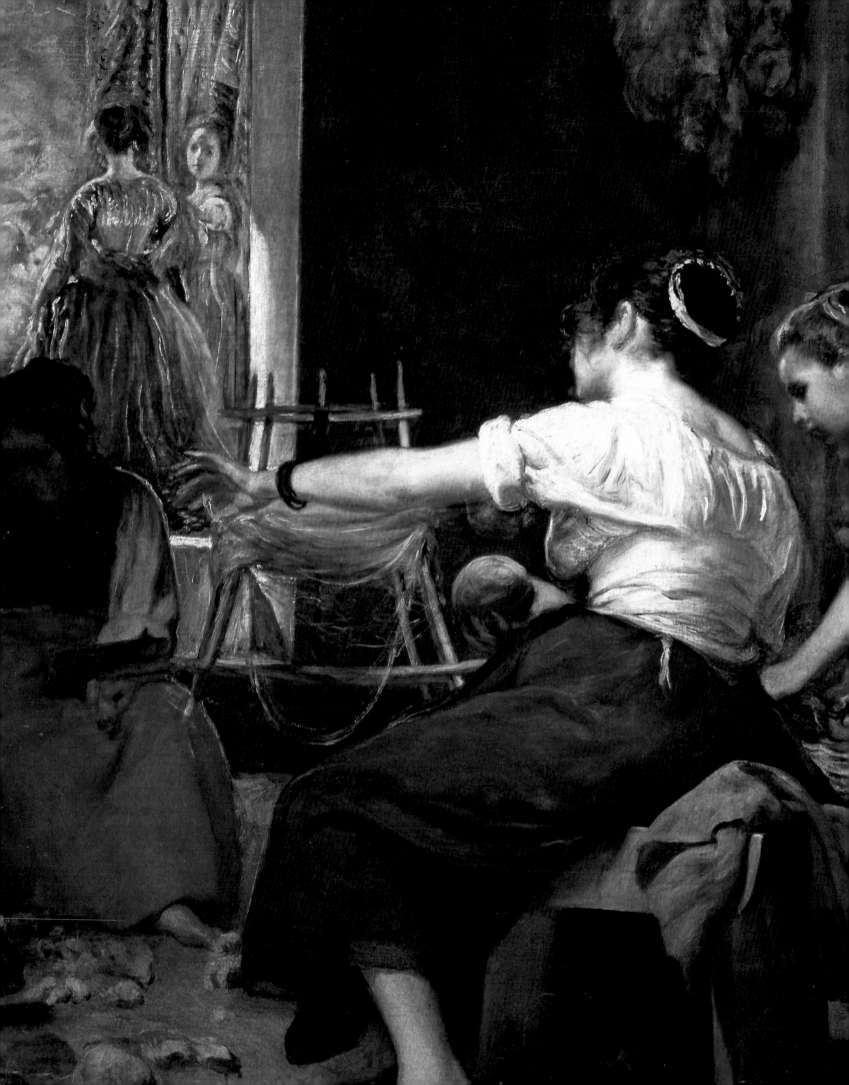

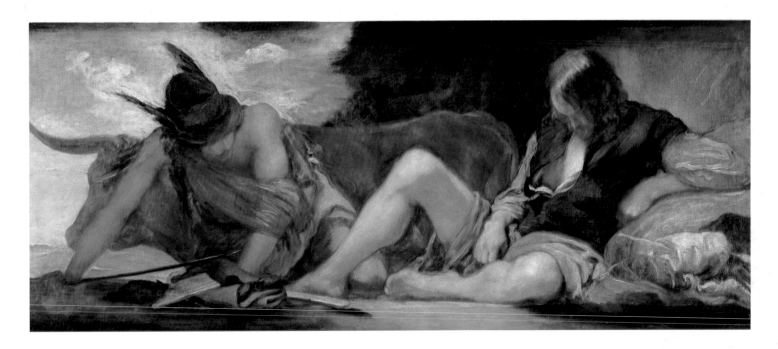

DIEGO VELÁZQUEZ
Mercury and Argos, c. 1659
Oil on canvas, 83 × 248 cm, with added strips above and below

MERCURY AND ARGOS

This present canvas was in the Hall of Mirrors of the Alcázar in Madrid, from where it was taken to the Royal Armory after the fire in 1734, and from there to the Royal Palace in Madrid. In 1818 it came to the Prado Museum.

Most commentators on the work of Velázquez are in agreement about the date of the painting, except for Camón Aznar who dates it between the arrival of the painter in Madrid and 1635. He points out the difference in tonality between this work and the paintings of the later years, since its range is close to his Roman period and even catches the tradition of his gray Madrid period with a tonality of grayish ochre, corresponding to a palette not later than 1634.

Velázquez painted four mythological compositions for the Alcázar Hall of Mirrors, of which only this one survives. The other three — *Venus and Adonis, Cupid and Psyche,* and *Apollo and Marsyas* — were destroyed in the 1734 fire. In this one, as Ortega y Gasset points out, Velázquez once more puts all the emphasis on "turning the myth inside out," bringing the subject closer to reality and making the characters more accessible to us.

JUAN BAUTISTA DEL MAZO (first third–end of seventeenth century)
The Hunting Party at Aranjuez
Oil on canvas, 187 × 246 cm.

THE HUNTING PARTY AT ARANJUEZ

This work was acquired from A. S. Drey of Munich in 1934, with funds from the count of Cartagena's bequest.

It was inventoried as a work by Mazo in the room in the tower next to the old Alcázar Park in Madrid in 1666. Later it passed to the Torre de la Parada and, after being in the Pardo for some time, returned to the Alcázar.

Joseph Bonaparte took it to France and later sold it to an ancestor of Lord Ashburton. At the beginning of this century it belonged to the Sedelmayer and Marcel Nemes collections.

A court scene is portrayed, in which Queen Isabella, her maids of honor, and three ladies are seated on a stand, while Philip IV, Don Ferdinand, and the huntsmen are in front with two deer; outside the fence are groups of servants, among them a

negro dwarf. The dog has been identified as the one accompanying Antonio "el ingrés" in his portrait in the Prado.

The influence of Velázquez is evident in this picture, which offers us one of the most delicious exteriors in seventeenth-century Spanish painting.

JUAN BAUTISTA DEL MAZO
View of the City of Zaragoza
Oil on canvas, 181 × 331 cm

VIEW OF THE CITY OF ZARAGOZA

This was attributed traditionally to the work of Velázquez and Mazo together; however, modern art critics seem to feel that the latter was the sole artist. It used to be thought that Velázquez painted the figures and Mazo the background. The picture appears in the 1686 inventories of the old Alcázar in Madrid.

The work was painted in Zaragoza, at the request of Prince Balthazar Charles, son of Philip IV, from a room in the ruined convent of San Lázaro, where the prince died on October 9, 1646. The convent was on the bank of the Ebro opposite the city, and was distinguished by the royal retinue that visited it. On the right, a sign written by the chronicler from Aragon, Juan Francisco Andrés de Ustarroz reads: IVSSV PHILIPPI, MAX. HIP. REGIS IOANNES BAVTISTA MAZO URBI CAESAR AVG. ULTIMVM PENICILLVM...ANNO MDXLVII. In the upper part, originally, Our Lady of the Pillar appeared sustained by angels, but this area was covered over due to its poor state of restoration in 1857, according to an order made by the director of the museum, the artist Juan Antonio de Ribera.

Various copies from the end of the seventeenth to the middle of the eighteenth centuries are known in private collections.

THE MIRACLE OF THE WELL

This has been in the Prado Museum since 1941. In the eighteenth century, Palomino wrote that "the painting is so perfectly drawn and colored, it is truly a miracle."

This canvas tells the story of the miracle of St. Isidor the Farmer, who saved a child from drowning in a well. Next to the saint are the child's mother, two women, and two children.

The Miracle of the Well is a key work in the oeuvre of this artist. Cano's sculptural vocation is clear in the firm modeling with which he treats the figures, their rounded volumes replete with solemnity. A monumental quality exists in the modeling of the faces and in the dress of the different characters. In the coloring and general atmosphere the influence of Velázquez is plain.

The religious feeling, which few artists of his generation could capture as well as Alonso, is combined here with a popular naturalism that makes some of his pictures, such as this, offer almost an impression of daily life, with echoes of popular customs: a characteristic that is at variance with its true purpose as an altarpiece picture. This tendency was common among Andalusian artists of the period, however, and was taken to its ultimate expression by Murillo.

ALONSO CANO (1601–1667)
The Miracle of the Well
Oil on canvas, 216 × 149 cm

THE DEAD CHRIST SUPPORTED BY AN ANGEL

This belonged to the marquis de la Ensenada's collection, it having been acquired by Charles III in 1769. According to the inventory, it was in the "passage to the royal bedchamber" in the Royal Palace in Madrid in 1772, and in the "private oratory" in 1794.

A sixteenth-century drawing with the same composition is known; it was probably made into an engraving and is likely to have served as a model for Cano. A reproduction appears in *Ausgewahlte Handzeichnungen aus vier Jahrhunderten* (G.G. Boerner, Dusseldorf, 1962, no. 73).

The work has a delicate classicism of measured impetus and profound content. A beautiful serenity pervades this mystical composition, which is interpreted with a chromatic skill that makes clear the artist's concern for the attitudes and suggested gestures of the characters represented.

There are reminiscences of Velázquez, above all in the flesh tones, the treatment of the heads, and the manner employed to apply the graduated coloring.

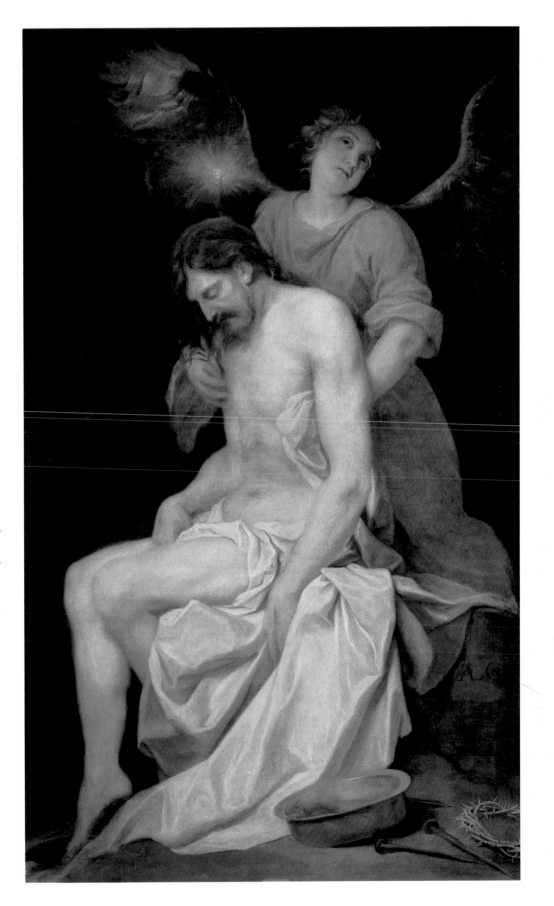

ALONSO CANO
The Dead Christ Supported by an Angel
Oil on canvas, 178 × 121 cm

MATEO CEREZO (c. 1626–1666)
Still Life, c. 1666
Oil on canvas, 100 × 127 cm

STILL LIFE

This painting was acquired from a private collection by the Prado Museum in 1970.

It has always been known, as Palomino pointed out, that Mateo Cerezo worked frequently in the genre of still life, although through the years very few paintings have been identified as belonging to this section of his work. The still lifes of flesh and fish in the Museum of the San Carlos de Méjico Academy have been taken as obligatory reference points. Recent studies, above all by Professors Buendía, Pérez Sánchez, and Gutiérrez Pastor, have brought to light new examples of his good work in this field, so that today it can be said that his quality as a still life painter equaled his ability in religious painting, and from time to time even surpassed it.

Cerezo's still lifes appear absolutely integrated into the great Spanish tradition of this genre, which was based upon elements of greater restraint than on the exuberance found in Flemish or Italian paintings of this nature. However, he seems less rigorous than his Spanish contemporaries, as echoes of Snyders or Fyt may be noted from time to time in Cerezo's canvases. With regard to this particular painting, a definite parallel is found in the composition with some canvases by van der Hamen.

The Mystic Marriage of St. Catherine

Acquired by Ferdinand VII in 1829 for the Prado Museum for 12,000 reales, this picture comes from the heirs of the Valencia merchant José Antonio Ruíz. At the time, the signature was hidden and the picture was attributed to Escalante. It must have been a success in its time since, in the following year, it was repeated by Cerezo in the large painting in the Palencia cathedral. A presumed sketch was noted that belonged to Félix Boix in 1927, but its whereabouts today are unknown.

The elegance and canon of the figures and their arrangement speaks of the imprint of van Dyck, and we find a clear reference to Carreño in the figure of St. Joseph and in the treatment of the background landscape. The still life in the foreground is of special interest. As Camón has pointed out, in this work Cerezo obtains a miraculous brushwork — smooth, resilient, full of gracious impressions, capturing the richest play of light and contrasts of the Spanish Baroque. The scenic arrangement used in the composition is, without question, a clear reflection of the work of Francisco Rizi.

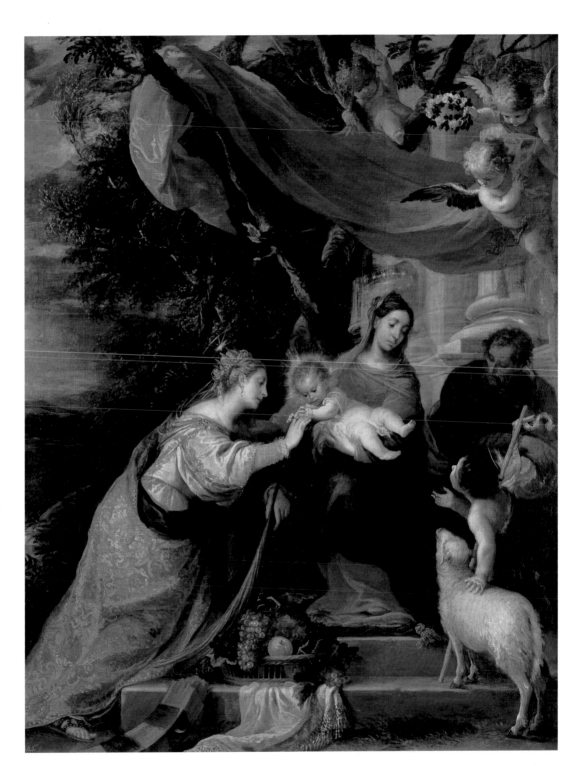

MATEO CEREZO
The Mystic Marriage of St. Catherine, 1660
Oil on canvas, 207 × 163 cm

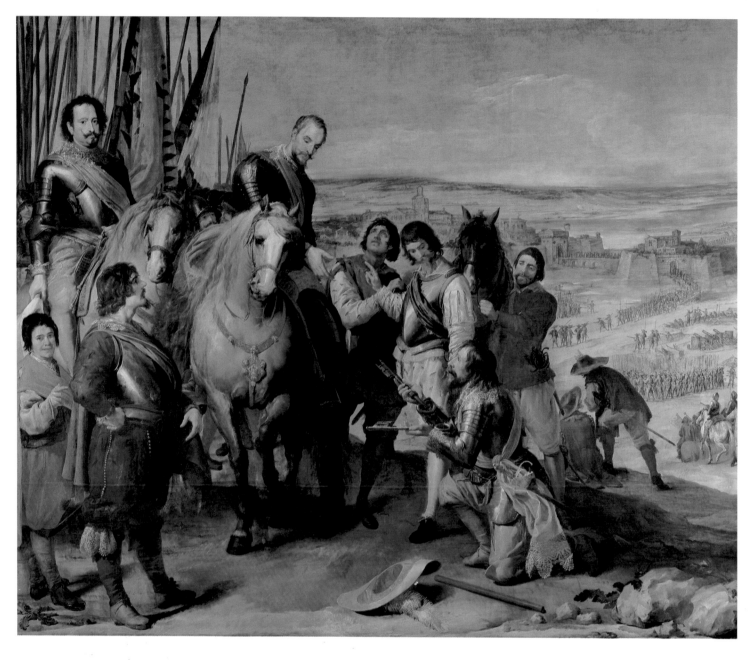

JUSEPE LEONARDO (1601–c. 1652)
The Surrender of Juliers, c. 1634
Oil on canvas, 307 × 381 cm

THE SURRENDER OF JULIERS

Painted for the Hall of Kingdoms of the Buen Retiro Palace, *The Surrender of Juliers* formed part of the battle series commissioned from diverse painters by the count-duke of Olivares. Also in the Prado Museum is a preparatory sketch from the Pedro Fernández Durán collection, through whose bequest the canvas came to the Museum.

The scene represents the moment in which Ambrosio de Spinola, later Marquis of Leganés, brought the siege of the Dutch city of Juliers to an end, after a long struggle, on February 3, 1622.

Accompanied by his retinue, the governor of the city, kneeling and unhatted, delivers the keys of the city to the conqueror. The defeated troops depart over the drawbridge while the Spanish army accords Spinola the honors of battle.

This is the painting referred to by Palomino, Ponz, Ceán, etc., as having been on the side altar of La Epístola in the Church of the Savior in Madrid, where it remained until the French invasion, when it went to a private collection. In the last century it belonged to Antonio Lora, in Loja (Granada). It was sold at Sotheby's on June 20, 1985, and was bought by the state for the Prado Museum.

The holy apostle appears standing, full length, leaning on his cross, and crowned with roses by two cherubs, one of whom carries the palm of martyrdom, that event being portrayed in the middle ground.

Both in the model, robustly drawn on a basis of solid volumes, and in the manner of presentation, we have the mark of Vincenzo Carducci, although in the execution Rizi shows a greater agility with the brush, a more vibrant chromaticism, and better luminosity, as befits a work made after detailed study of those by Rubens and the great Venetian painters of the second half of the sixteenth century.

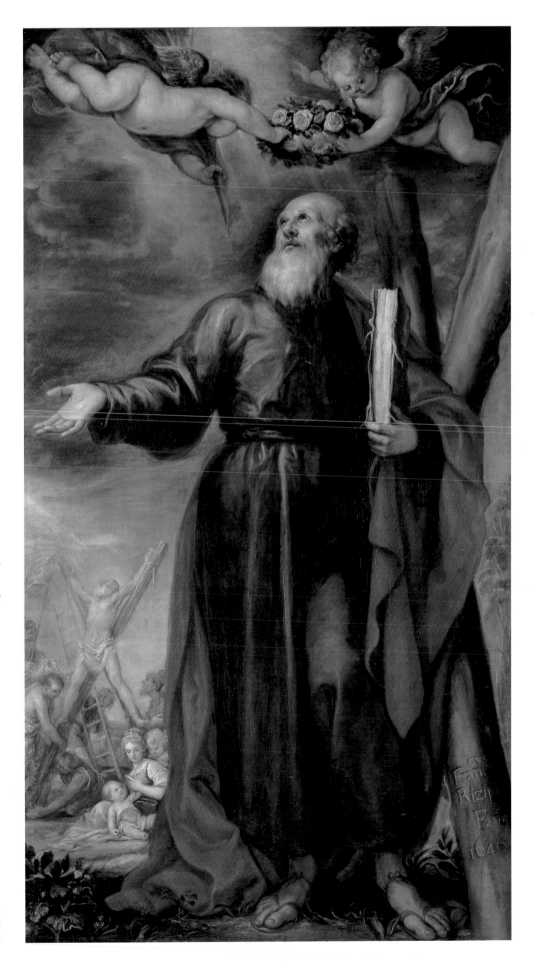

FRANCISCO RIZI (1614–1685)
St. Andrew, 1646
Oil on canvas, 247 × 139 cm

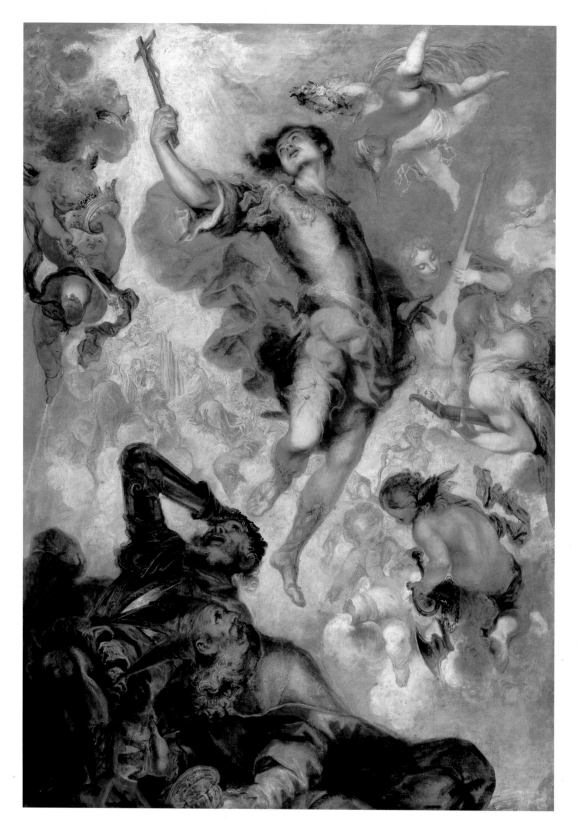

THE TRIUMPH OF ST. HERMENEGILD

As María Luisa Caturla has shown, this work was painted between July and October 1653, after the painter's return from Italy, as the central picture of the altarpiece for the convent of the Carmelitas Descalzos in Madrid, which is now the church of San José.

The artist was conscious of the spectacular nature, effect, and quality of the canvas, as opposed to the severe and monotonous compositions used by the Madrid painters of the time. Palomino tells us that Herrera "allowed it to be said that this painting would compete with drums and trumpets." During his stay in Italy, the artist must have seen the great decorations by Pietro da Cortona and the magnificent Venetian works, for their influence is clear in this picture.

Pérez Sánchez points out that this work is conceived as an ascending helicoidal movement, in the manner of a spiral column, and he emphasizes the contrast between the figures in shadow in the foreground and the bodies of the angelic musicians, bathed — almost dissolved — in the iridescent atmosphere. At the feet of the saint appear his father, who had sent him to be executed for his faith, and is now defeated by his death, and an Arian bishop with a chalice, which St. Hermenegild rejects.

FRANCISCO DE HERRERA THE YOUNGER (1622–1685)
The Triumph of St. Hermenegild, 1654
Oil on canvas, 328 × 229 cm

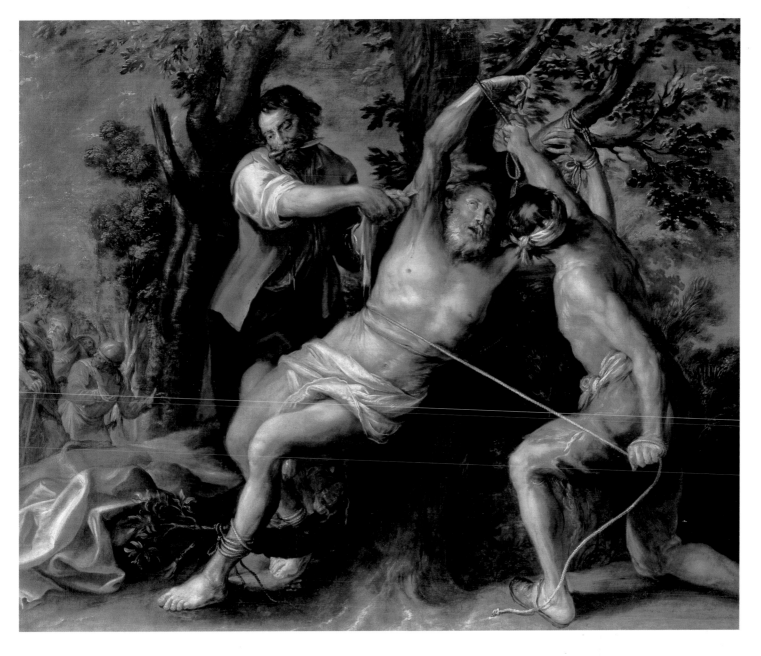

FRANCISCO CAMILO (?–1673)
The Martyrdom of St. Bartholomew
Oil on canvas, 205 × 249 cm

THE MARTYRDOM OF ST. BARTHOLOMEW

Together with its companion, *St. Jerome Flagellated by Angels,* this picture was painted by Francisco Camilo for the convent of the Carmelitas Descalzos of San Hermenegildo in Madrid, where it was valued at 3,500 reales in the 1786 inventory. Ponz mentions them, but believed they were by Pereda. After the Disentailment they passed to the Museo de la Trinidad and from there to the Prado, where both are still preserved.

The scheme of composition seems to have been taken from the painting by Ribera, now in the Stockholm Museum, and more definitely from the engraving made by that artist. The cruelty of the Valencian's martyrdom appears here less harsh, which is consonant with Camilo's sensitivity. As Palomino says, his genius was "more inclined to the gentle and devout." Nevertheless, the result is hard enough, in showing us the moment when two executioners have tied the saint to a tree, and one of them is beginning to flay him. In this, the painter repeats the same attitude as is used for the figure in the Ribera painting.

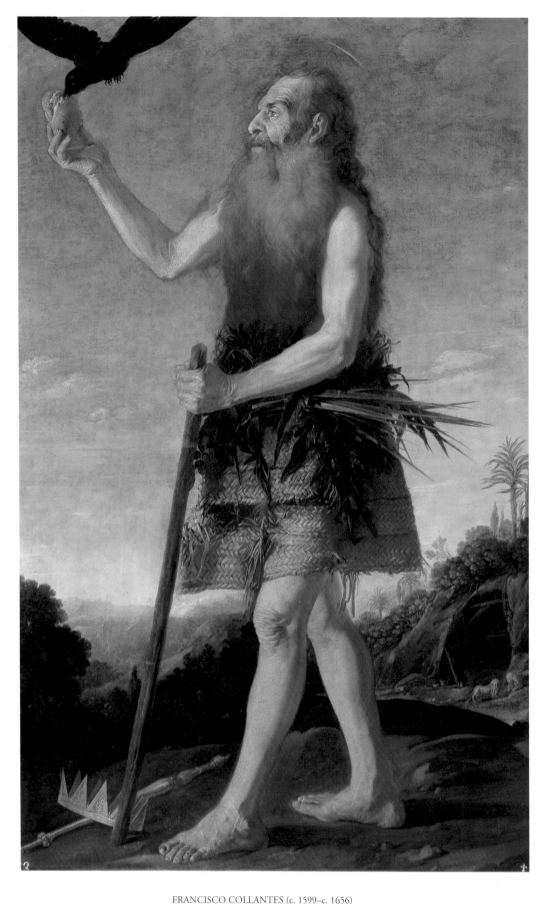

ST. ONUPHRIUS

The attribution of this work to Collantes is due to Madrazo, as this picture was previously classified as a work by Ribera. It comes from the royal collections, being inventoried in La Granja as the property of Isabella Farnese in 1746. For some years, from 1883 to 1956, it remained deposited by the Prado in the University of Henares. In La Granja it was thought to be of St. William of Aquitaine, but the attributes of the raven and the crown of thorns clearly indicate the personality of St. Onuphrius.

This is an unusual work in the panorama of Spanish painting of the epoch; its canon, its conceptual configuration, and its treatment give it a surprising originality. Gaya Nuño pointed out that "it seems to be something by Courbet in its conceptual harshness." Above all, and in relation to the splendid landscape background, Pérez Sánchez notes a definite association with Aniello Falcone, a Neapolitan artist trained by Ribera, who, "in large figures uses, with the same tense harshness, a sparse range of colors employed with exquisite refinement and an impasto applied in fresh and free brushwork, but precisely modeled."

FRANCISCO COLLANTES (c. 1599–c. 1656)
St. Onuphrius
Oil on canvas, 168 × 108 cm

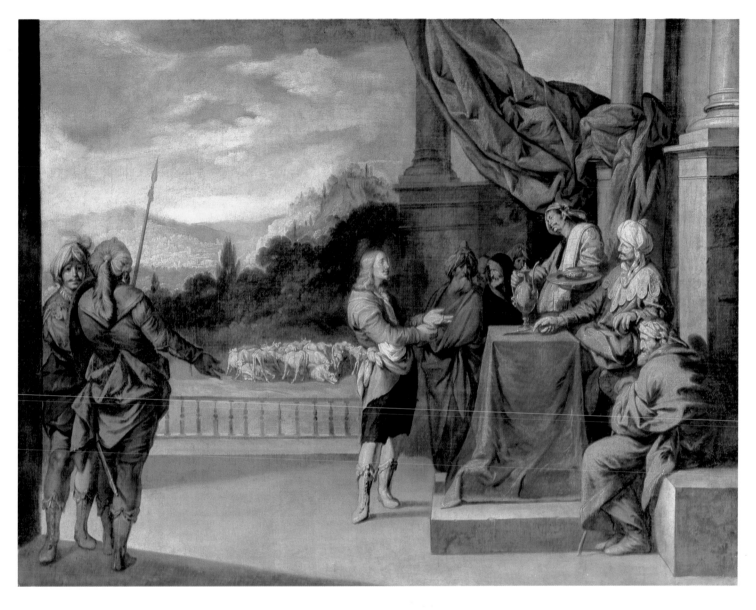

ANTONIO DEL CASTILLO (1616–1668)
Joseph Interpreting Pharaoh's Dreams
Oil on canvas, 109 × 145 cm

JOSEPH INTERPRETING PHARAOH'S DREAMS

This forms part of a series of six canvases, all preserved in the Prado Museum, relating to the story of Joseph. It was acquired for the Museo de la Trinidad from Pedro Victoria Ahumada for 9,675 pesetas, by royal order of April 8, 1863. Up to 1913, these paintings were attributed to Pedro de Moya.

This one was inspired by Genesis 16:14 ff. We see the fat cattle coming up out of the Nile and the lean cattle of the prophecy, relating to the years of plenty and the years of famine that will succeed them.

The precise canon of the figures, the correctness in the architectural background, the clever way of arranging the figures and the vivacity of the brushwork, all contrast with brilliant color tones that, as Palomino said, display "a certain grace and good taste" in comparison with the Andalusian painters of this time, especially those from Seville.

CHRIST AS MAN OF SORROWS

Coming from one of the suppressed convents in 1835–1836, this was catalogued for the first time in the stock of the Museo de la Trinidad. Some art historians identified it with a Christ by Pereda that, in 1810, was chosen to form part of the Musée Napoléon in Paris. This advocation of Christ gained great popularity during the reign of Philip IV.

The work brings together several of the common elements in international Baroque. Thus Mayer notes a certain influence from Ribera, while Camón Aznar sees echoes of Titian and Dürer, as well as "a definite influence from El Greco." There are two more known versions of this painting by Pereda, both closely linked with this canvas, one of them signed.

Pérez Sánchez notes in the image a Nordic and Flemish stamp of strong realism, "with an almost Gothic effect of piety."

ST. JEROME

According to the relevant inventories, this painting was in the Royal Palace of Aranjuez in 1818.

Following the traditional iconography, the hermit appears with a bare torso, grasping a rough wooden cross. On a table are an inkwell, a skull, and two books. In one of these, which is open, Pereda renders tribute to Dürer, reproducing the *Last Judgment* from the series of engravings known as *The Small Passion,* by the German artist, whose monogram the Spanish painter includes. In the upper left is the trumpet proclaiming the hermit's sanctity.

Pereda was exceptionally gifted in capturing reality with exactitude, and we see here the representation of the skull carried out with an almost superhuman eye and with a spirit of meticulous precision. Below these marvels of drawing, which give body to the whole composition, Pereda, as was normal in this period of the decade of 1640, took pleasure in seeking out a chromaticism of fine accents and unexpected shades that captivate the viewer through their substance and fine quality of impasto.

THE RELIEF OF GENOA

Painted for the Hall of Kingdoms in the Buen Retiro Palace, this picture is one of those commissioned by the count-duke of Olivares. María Luisa Caturla relates that the artist was paid the sum of 74,114 reales on July 28, 1734. During the War of Independence the painting was taken to Paris by General Sebastini. Subsequently it went to London where it was auctioned in Lady Ashburton's sale in 1911, being acquired by a dealer, C. Brunner of Paris. The following year it was given to the Prado Museum by the Hungarian collector Marzel de Nemes.

The scene is of an episode that took place in 1625. After Genoa — a Spanish ally — was taken by the duke of Savoy's troops with the support of Cardinal Richelieu, Don Alvaro de Bazán, second Marquis of Santa Cruz, and his squadron achieved the liberation of the old republic of Genoa.

Against a background of the sea with the Spanish fleet and the skyline of the city, Bazán, wearing Baroque armor, appears with the doge of Genoa, who is followed by his senators and is thanking the admiral for his decisive support in the victory.

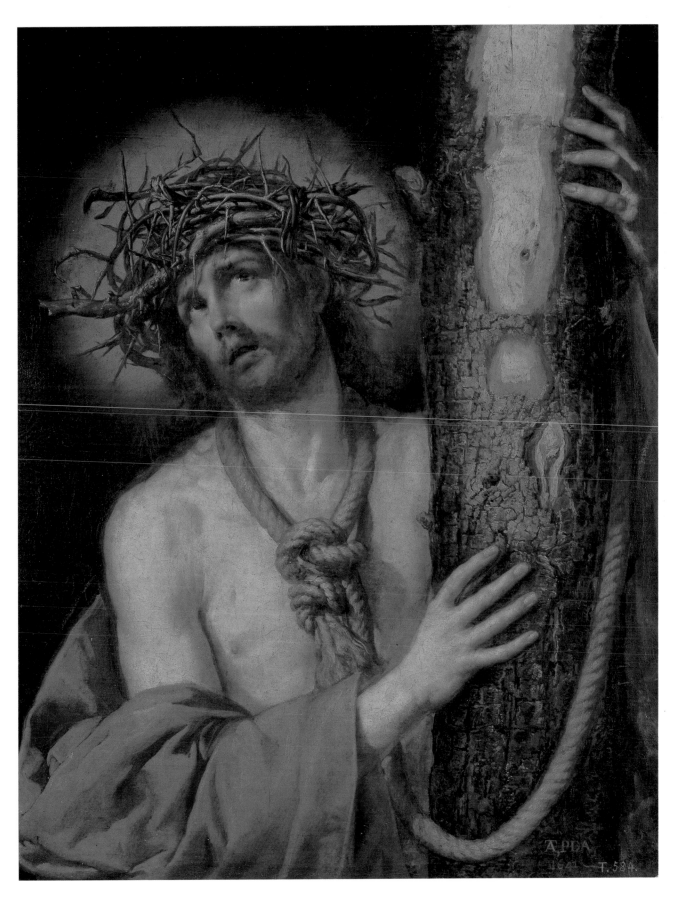

ANTONIO DE PEREDA (1611–1678)
Christ as Man of Sorrows, 1641
Oil on canvas, 97 × 78 cm

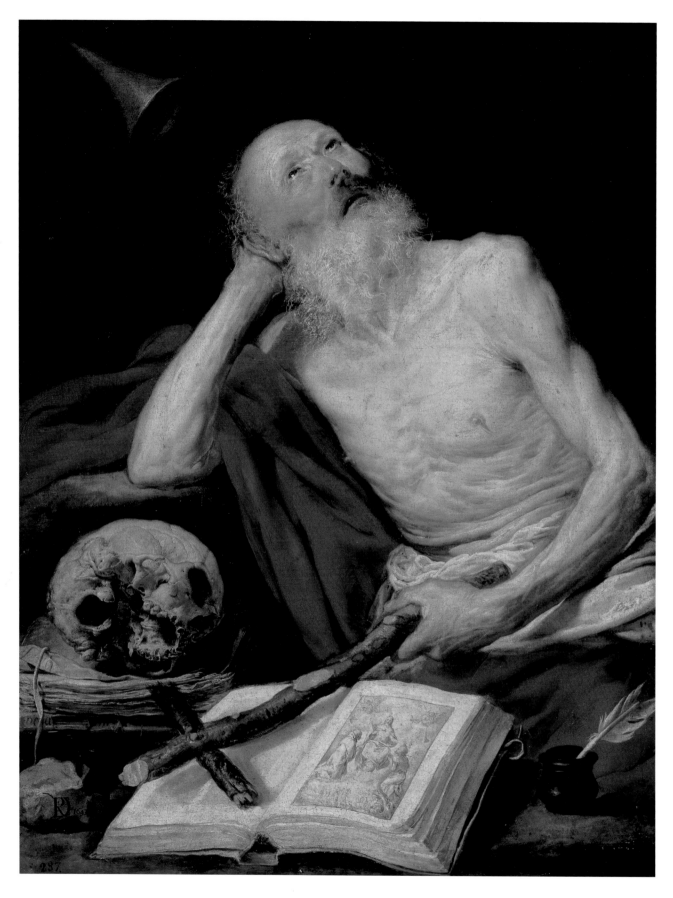

ANTONIO DE PEREDA
St. Jerome, 1643
Oil on canvas, 105 × 84 cm

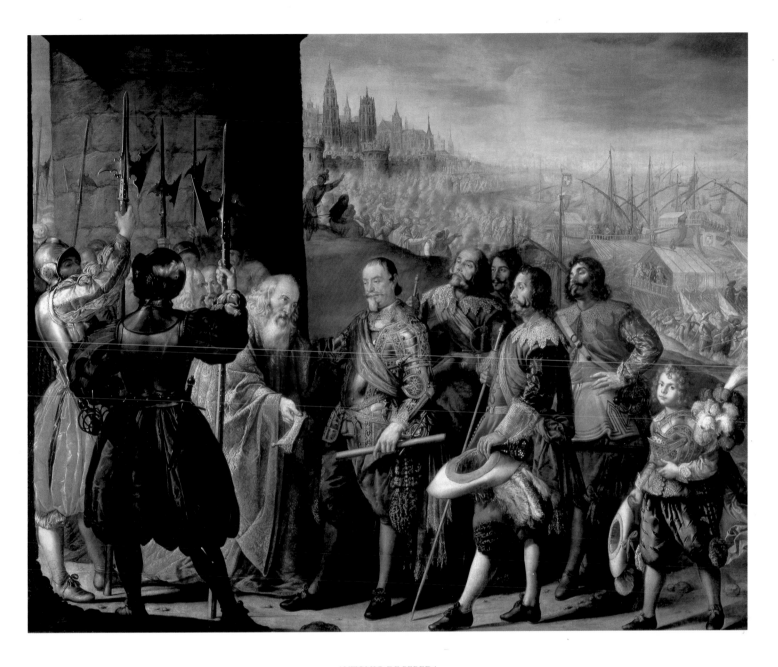

ANTONIO DE PEREDA
The Relief of Genoa, 1634
Oil on canvas, 290 × 370 cm

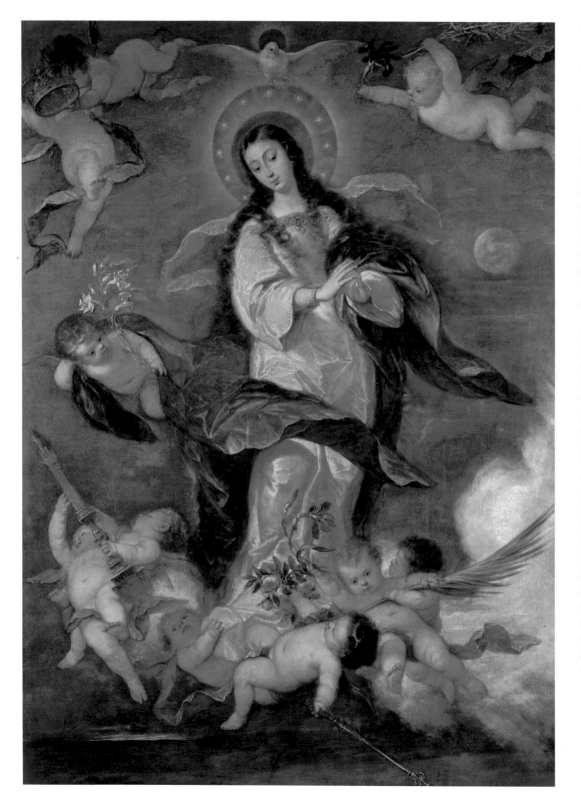

OUR LADY OF THE IMMACULATE CONCEPTION

This came to the Prado Museum in 1931 after being acquired from Lucio González-Tablas, with funds from the count of Cartagena's bequest. Following the representational pattern of the Madrid school for this dedication, to which Antolínez gave a special air, Mary wears a blue mantle, a tunic of cloth-of-silver, and a crown of stars. Above is the Holy Spirit. At her feet, four angels carry her attributes: the palm, irises, roses, the scepter, and a mirror. Others hold the crown, a spray of lilies, and another of olive and irises.

Tragically, the artist died when his mature period was just beginning. Nevertheless, his existing work, as we can see from this canvas, shows him to have been one of the finest colorists of the Madrid circle in the second half of the seventeenth century. Antolínez obtained a great success with this representation of the Virgin, producing several other examples and, as Diego Angulo has pointed out, "It has been said that the tunics of his Immaculate Conceptions are of silver taffeta, and it is true that, with its reflections, the tousled mantle, as blue as the heavens, produces an effect of great richness." Considering the development of this model, we can say that the Prado's is the most effective of these pictures in the essential characteristics of this compositional scheme.

JOSÉ ANTOLÍNEZ (1635–1675)
Our Lady of the Immaculate Conception, 1665
Oil on canvas, 216 × 159 cm

THE TRANSPORT OF MARY MAGDALEN

This picture was acquired by Ferdinand VII by royal order of June 15, 1829, for the Prado Museum, for a price of 2,500 pesetas.

For this key work in his oeuvre, which belongs to the mature period of his career, José Antolínez took the subject from the *Golden Legend,* which tells that Mary Magdalen "was transported to heaven and heard concerts of celestial music." There are reminders of Titian in the iconographic pattern. Antolínez repeated the theme on several occasions, and examples are found in the National Museum of Romania, the Seville Museum, and the Fundación Santamarca.

As Pérez Sánchez points out, "the strong diagonal in which the composition is made produces a sensation of vertiginous movement to which the many varied and unstable attitudes of the cherubim contribute, and the luminous streaks underline the upward impetus of the whole." The Venetian influence is felt also in the background, while the set of books in the foreground is painted with great naturalism.

JOSÉ ANTOLÍNEZ
The Transport of Mary Magdalen, 1670–1675
Oil on canvas, 205 × 163 cm

JUAN DE VALDÉS LEAL (1622–1690)
Jesus Disputing with the Elders, 1686
Oil on canvas, 200 × 215 cm

JESUS DISPUTING WITH THE ELDERS

This picture came to the Prado Museum after being acquired by the state from Luis de Echevarría for 3,000 pesetas, according to a royal order of June 8, 1880.

The composition is divided into two parts; on the right Jesus is talking to the Elders, who surround him, while on the left appear St. Joseph and the Virgin silently watching the scene.

We understand from this painting the firm and, at the same time, delicate precision of the artist's technique, which is expressed with tactility and refined gradations of light, scattering the colors in independent pigments and charging the creaminess of the brushwork with eloquent intimations. A singular spatial sense pervades the composition, and introduces an atmosphere based on tenuous connotations of ambience.

JUAN ANTONIO DE FRÍAS Y ESCALANTE (1630–1670)
Andromeda and the Monster
Oil on canvas, 78 × 64 cm

ANDROMEDA AND THE MONSTER

Coming from the royal collections, this painting was traditionally attributed to Luca Giordano until Ferrari-Scavizzi excluded it from his catalogue of the Neapolitan's work. It was Professor Buendía who classified it accurately.

Andreina Griseri considers it to be an homage to Titian, one that is "highly strung and sketched like a Schiavone."

It recalls the well-known mythological story told by Ovid (*Metamorphosis* IV): "Andromeda, to expiate a crime of her mother, was to perish, unjustly sentenced by Jupiter Ammon. Perseus, seeing the young princess tied to a rock and exposed to the voracity of the marine monster, fell in love with her beauty and the goodness that shone from her eyes." A print by Agostino Carracci is quoted as a source of inspiration (Diana de Grazia Bohlin, *Prints and Related Drawings by the Carracci Family*, Washington, 1979, p. 294, no. 179). Escalante, submitting to the laws that censored nudity in the Spain of his time, arranged a garment on the nude figure that appears in the engraving.

Venetian elements enliven the chromaticism of this composition.

JUAN ANTONIO DE FRÍAS Y ESCALANTE
The Dead Christ, 1663
Oil on canvas, 84 × 162 cm

The Dead Christ

This work, acquired by the Prado in 1910, seems to have come from the convent of the Clérigos Menores de Madrid, and is the picture highly praised by Palomino, who says, "What was outstanding in itself was the effigy of our Lord Christ, dead, which was in the second chapel on the right, entered by the foot of the church of the Espíritu Santo, which truly seems to be by Titian, and today they have withdrawn it inside, through having changed the designation of the said chapel." It is also mentioned by Felipe de Castro, who points out that there was "in the convent a picture of the dead Christ, by the hand of Antonio Escalante, which seems to be by Titian." In fact, the Venetian imprint is manifest both in the model and in the execution, emphasizing the modeling and the coloring of the anatomy of Christ, and the plasticity obtained in the sheet that covers him. The skull and paper in the right foreground have great realism, and it is to be noted that the work corresponds to the mature period of the artist's career, when he was producing his finest works.

137

BARTOLOMÉ ESTEBAN MURILLO (1618–1682)
The Holy Family with a Little Bird, c. 1650
Oil on canvas, 144 × 188 cm

BARTOLOMÉ ESTEBAN MURILLO
The Good Shepherd, c. 1660
Oil on canvas, 123 × 101 cm

THE HOLY FAMILY WITH A LITTLE BIRD

Acquired by the queen, Isabella Farnese, a great admirer of the Sevillian painter, this picture figures in the 1746 inventory of the palace of La Granja de San Ildefonso. During the War of Independence it was taken to Paris by Joseph I, who kept it in his palace in Orléans; it was returned to Spain on November 22, 1818.

Once again, Murillo displays his naturalistic spirit, offering us a domestic scene in which St. Joseph is seated while the Child plays with a little bird, which he shows to his dog. On the left Mary, seated next to a sewing basket, is winding a skein of thread. Finally, on the right, balancing the composition, is the carpenter's workbench of the head of the family.

Here Murillo shows his preference for interior settings. He obtains a unity of ambience from a basis of lateral illumination, emphasizing the contentment of the humble condition, a quality that achieves its maximum expressiveness in his paintings of street children, which he began to produce around this time.

THE GOOD SHEPHERD

This representation of the Good Shepherd comes from the Gospel of St. John (10:11, 14), in which Christ is compared to the Good Shepherd who cares for his sheep. Madrazo had already noted that the sheep upon which His hand rests would be the lost sheep to which reference is made in St. Matthew's Gospel (18:12): "If a man has a hundred sheep and one of them has gone astray, does he not leave those ninety-nine others on the mountainside and go to look for the one that has strayed?"

Murillo specialized in capturing children's faces, and offers us one of his best creations in this canvas, more brilliant and meticulously prepared, as is proved by two previous drawings identified by Angulo. As a source, Murillo used an engraving with a cupid by Stefano della Bella, which illustrated an edition of the *Metamorphoses* of Ovid, as Ceán Bermúdez observed. The painting was originally smaller, but it was enlarged before 1744 to form a pair with *The Young St. John the Baptist* in the Prado. The canvas was acquired by Isabella Farnese in Seville, and it figures in the inventories of La Granja from 1746 and 1774; it later passed to Aranjuez. In 1819 it came to the Prado Museum.

THE DREAM OF THE PATRICIAN

This work is part of a set of four pictures that Murillo undertook for the Seville church of Santa María la Blanca. It is one of the most felicitous achievements in his oeuvre. The church was built after the papal bull granted in favor of the Immaculate Conception of Mary by Pope Alexander VII in 1661; this event stimulated a popular fervor among the citizens of Seville in relation to this mystery. The subjects for Murillo's quartet must have been prepared by Justino de Neve, Canon of the Cathedral, and patron of the works were produced there. The four paintings remained in the place for which they were painted until the French invasion of 1808, when they were taken to France by the nephew of Marshal Soult. Subsequently two of these works returned to Spain, going to the Royal San Fernando Academy where they remained until being transferred to the Prado in 1901.

This painting tells the story of the patrician Juan, who has a revelation in his dreams in which the Virgin tells him to build a temple on the mountain, where there will be a miraculous snowstorm. This temple would later be the Roman basilica of Santa María la Mayor. A preparatory drawing for this composition, with Juan's wife sleeping, is in the Hamburg Kunsthalle.

THE PATRICIAN JUAN AND HIS WIFE REVEAL HIS DREAM TO POPE LIBERIUS

Along with *The Dream of the Patrician,* this is one of the four semicircular paintings that decorated the walls of the nave in the church of Santa María la Blanca in Seville, of which two are preserved in the Prado Museum.

The principal scene shows Pope Liberius on his throne; before him the noble couple kneels, telling him of Juan's dream. On the left is the procession to Mount Esquilino after the miraculous snowstorm. It was on this spot, according to the revelation the Virgin had made to him, that Juan was to build a temple.

The warmest style, the most misty brushwork, and the most exact clarities characterize this splendid composition. As Camón Aznar has said, after these canvases, the impressionist future of Spanish painting was opened up. However, not even Murillo himself drew the final conclusions from his findings, which match the greatest creations of Goya. In a certain sense, this discovery of the modeling of forms by light masses is parallel to that used by Rembrandt.

BARTOLOMÉ ESTEBAN MURILLO
The Dream of the Patrician, c. 1662–1665
Oil on canvas, 252 × 522 cm

BARTOLOMÉ ESTEBAN MURILLO
The Patrician Juan and His Wife Reveal His Dream to Pope Liberius, c. 1662–1665
Oil on canvas, 232 × 522 cm

THE VISION OF ST. FRANCIS AT PORZIUNCOLA

Acquired by Charles IV, this painting was in the Royal Palace in Madrid in 1814.

Following an Italian compositional scheme, which is normal in this iconography, St. Francis kneels before Christ with the Cross and the Virgin. The composition is completed by angels scattering the roses into which brambles have been transformed.

Over a strongly drawn structure of solid shapes, Murillo deploys a technique in which the softness of his brushwork becomes a model of smooth accents, forms, and volumes, giving the figure of St. Francis a strongly human air. At the same time, a feeling of infinite humility flows from his glance in a face charged with an especially profound passion. Seldom has an artist been able to inspire a religious feeling so clearly and convincingly.

OUR LADY OF THE IMMACULATE CONCEPTION

This picture was painted for the church of the Hospital de Venerables Sacerdotes in Seville, commissioned by Justino de Neve. It remained in its original home until the War of Independence, when it was taken to Paris in 1813 by Marshal Soult. On his death it was sold by public auction and was acquired in May 1852 by the Louvre for 615,000 francs.

As part of a series of exchanges of works of art between the Spanish and French governments, it came to the Prado on June 27, 1941.

It must be remembered that Murillo has frequently been referred to as the painter of the theme of the Immaculate Conception. But if it is true that in his several versions he has offered a re-created synopsis of what this particular iconography meant in terms of Sevillian Baroque, he seldom achieved an expressiveness of such illumination, of such consummate plasticity, as in this particular work.

CHILDREN WITH A SHELL

Children with a Shell figures in the 1746 inventory of the Palace of La Granja in the collection of Isabella Farnese, and passed in 1794 to the Aranjuez. Mayer believes that the source of composition was an engraving by Reni (Bartsch, no. 13), after Carracci.

The Child Jesus offers water in a shell to the young St. John, who kneels and leans on a cross that bears the banner ECCE AGNUS DEI. On the left is a lamb. The composition is completed by a burst of glory with angels.

The unique ability of Murillo to capture the figures of children makes him one of the most important painters in the history of art in this respect, both in popular subjects and in these holy figures, which come to the viewer as drawn from daily life, enchantingly natural. It is produced by means of a manner of execution that starts from substantial surfaces with a rich impasto, but at the same time an impression of an almost fluttering lightness results from the skill of the brushwork. A technique of vaporous spirits and pre-Impressionist criteria gives these works an unexpected modernity.

BARTOLOMÉ ESTEBAN MURILLO
The Vision of St. Francis at Porziuncola, c. 1667
Oil on canvas, 206 × 146 cm

BARTOLOMÉ ESTEBAN MURILLO
Our Lady of the Immaculate Conception, c. 1678
Oil on canvas, 274 × 190 cm

BARTOLOMÉ ESTEBAN MURILLO
Children with a Shell
Oil on canvas, 104 × 124 cm

JUAN CARREÑO DE MIRANDA (1614–1685)
St. Sebastian, 1656
Oil on canvas, 171 × 113 cm

St. Sebastian

After the Disentailment this picture passed to the Museo de la Trinidad from the chapel of Don Sebastián de Agramón in the convent of the Monjas Bernardas, known as the "Vallecas." It came to the Prado Museum when the Museo de la Trinidad was closed.

In the compositional scheme, as well as in the representational pattern, there is a close relationship between this work and Orrente's painting of the same theme in Valencia Cathedral. For Marzolf, this similarity arises in both from Orrente and Carreño having been inspired by Sodoma's *St. Sebastian* — which has little justification. It is more likely that the common source of inspiration is to be found in the *Samson* by Guido Reni, done around 1610. Various early copies of this canvas are known, and as Cruzada Villaamil points out, "this makes us think that then, as now, it was much appreciated by the knowledgeable."

The influence of Titian is clear, both in the design and the manner of organizing the subject and in the contours of the figure.

Peter Ivanovich Potemkin

The person portrayed, Peter Ivanovich Potemkin, was Stolnik and Namestnik of Boronsk and prelate of Ullech. He was the ambassador of the Grand Duke of Muscovy, Fedor II, and in this capacity he visited Spain twice, in 1668 and later in 1681–1682. The source of inspiration for this portrait, one of the most successful by Carreño — one described by Camón Aznar as vital and strong, of vigorous distinction in the face — is thought to be the portrait of the artist Martin Ryckaert by van Dyck, which is also in the Prado. The mark of Titian is notable in the execution, as is a certain influence of Francisco Rizi.

Standing, full length, with a walking stick in his right hand, Peter Ivanovich wears a red mantle and tunic trimmed with embroidery, girdled with a broad belt from which a dagger hangs. His head is covered by a high bonnet with leather trimming.

The portrait comes from the royal collections; in the 1686 inventories it was described as being in the workshop of the painters to the household in the Old Alcázar, passing in 1700 to the Zarzuela.

Portrait of Charles II

This painting comes from the royal collections. It figures in the 1794 inventory in the Buen Retiro Palace, where it was sent after the old Alcázar was destroyed by fire in 1734, passing to the Prado in 1819.

The monarch, born in 1661, son of Philip IV and Mariana of Austria, appears in the Hall of Mirrors of the Alcázar in Madrid, beside a console table supported by bronze lions, preserved today in the Royal Palace in Madrid. He is standing, dressed in black with white ruff, cuffs, and hose, wearing the insignia of the Golden Fleece, and holding a paper in his right hand and, in his left, a hat. His hair is parted in the middle, denoting that, at the time of this painting, he was already fifteen years old. This contrasts with the version in the Oviedo Museum dated 1671 and is similar to those of the Stirling-Maxwell collection in Glasgow, the example deposited by the Prado in the Córdoba Museum, and the duke of Sessa's version.

As Pérez Sánchez has pointed out, the weak and sickly aspect of the subject was made clear by Carreño, who succeeded in portraying the biological degeneration of the dynasty brought about by successive consanguineous marriages. There is an evident influence of Velázquez in the compositional style.

JUAN CARREÑO DE MIRANDA
Peter Ivanovich Potemkin, c. 1681–1682
Oil on canvas, 204 × 120 cm

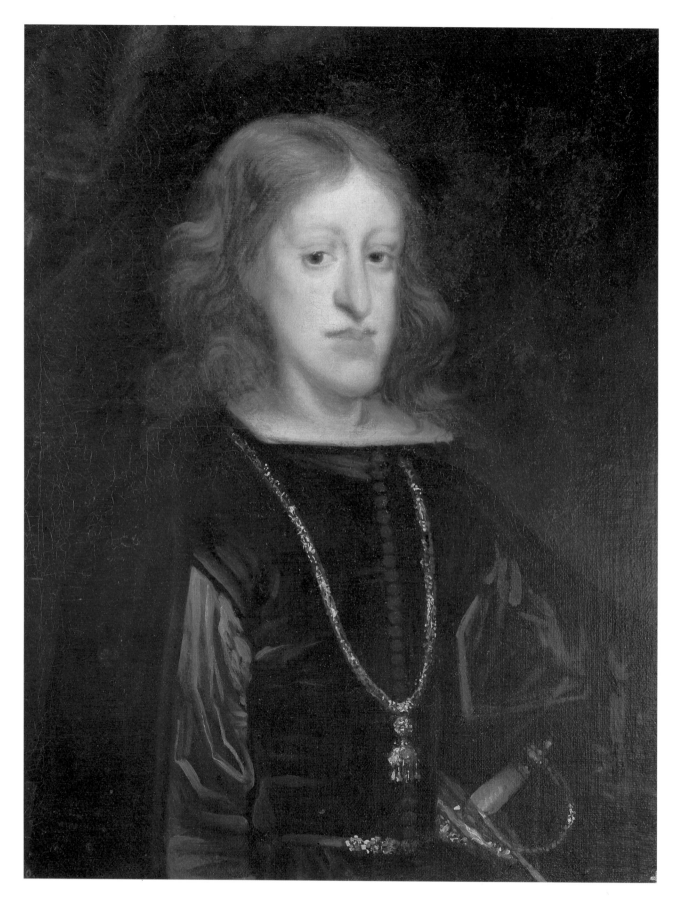

JUAN CARREÑO DE MIRANDA
Portrait of Charles II, c. 1676
Oil on canvas, 201 × 141 cm

CLAUDIO COELLO (1642–1693)
The Triumph of St. Augustine, 1664
Oil on canvas, 270 × 203 cm

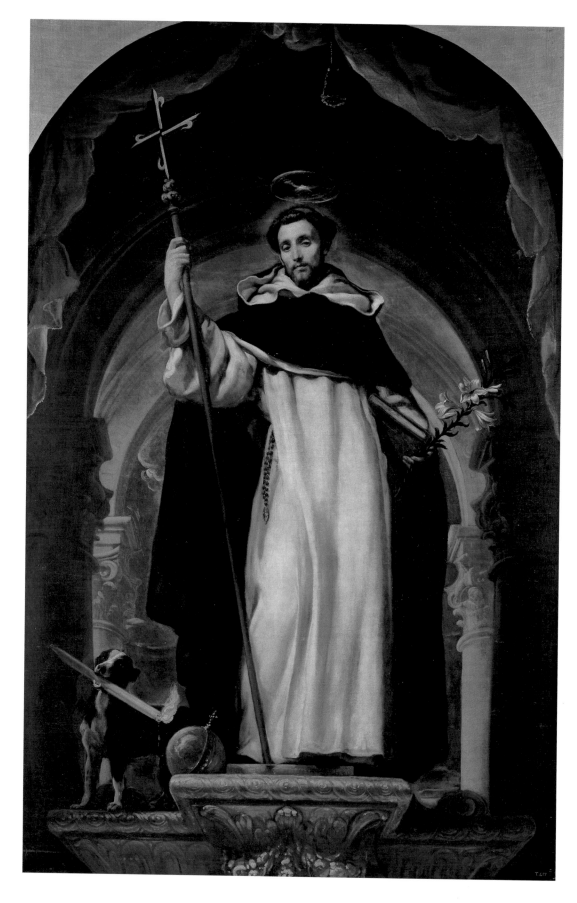

CLAUDIO COELLO
St. Dominic de Guzmán, c. 1684–1685
Oil on canvas, 240 × 160 cm

ROSA
CORDIS MI(?)
TV MIHI
SPONSA
ESTO

CLAUDIO COELLO
St. Rose of Lima, c. 1684–1685
Oil on canvas, 240 × 160 cm

THE TRIUMPH OF ST. AUGUSTINE

The Triumph of St. Augustine was painted for the convent of the Agustinos Recoletos of Alcalá de Henares, where it stayed until Mendizábal's sequestration measures in 1836. It passed subsequently to the Museo Nacional de la Trinidad and in 1872 to the Prado Museum.

St. Augustine, Bishop of Hippo, was a frequent subject for Spanish Baroque painters, including Francisco Rizi, Pereda, and Murillo, among others. Occasionally they portrayed him in the manner of Italian artists, who usually represented him with the Child Jesus carrying the shell of the vision with which the profound mystery of the Holy Trinity and the difficulties of understanding it were demonstrated, it being easier for a man "to empty all the water from the sea with a shell."

Dressed in pontifical robes, the saint rises amidst clouds and angels — below him, to the right, are a dragon and the statue of a pagan divinity — all against a hazy background of landscape and architecture. Thus, St. Augustine symbolizes the triumph of Christianity over paganism.

ST. DOMINIC DE GUZMÁN

This canvas is a pendant to the Coello St. Rose of Lima, also in this museum. According to Palomino, both works were painted for the Madrid Church of the Rosary. In the eighteenth century, these works had already left that church, as Agulló has them in the 1728 inventory of the collection of José Francisco Sarmiento, Count of Salvatierra, valuing them at 3,000 reales. Subsequently they emerged in the inventory of the Museo Nacional de la Trinidad, passing to the Prado, where, in the 1865 catalogue, they were already attributed to Claudio Coello.

Painted in a sculptural manner, the saint stands on a pedestal in front of an architectural background, his right hand resting on the beam of a cross, while in his left he holds his traditional attributes — a book and lilies. At his feet are the globe of the world and a dog with a lighted torch in its mouth. The Dominican theme was frequently painted by Coello; this representation in particular we find in The Vision of the Virgin and Child to St. Dominic de Guzmán (Museum of the San Fernando Academy of Fine Arts) and in another version preserved in the Szépmüvészeti Muzeum in Budapest, where the model repeats the facial features of this painting.

ST. ROSE OF LIMA

As with its companion work, St. Dominic de Guzmán, this was painted for the convent of the Rosary in Madrid, according to Palomino, passing to the collection of José Francisco Sarmiento, Count of Salvatierra, and later to the Museo Nacional de la Trinidad. In the middle of the last century it came to the Prado Museum.

The saint is placed before an architectural background, as though the painter were dealing with a sculpture.

The Dominican saint, born in Lima in 1586 of Spanish parents, is shown here carrying roses, while an angel crowns her with the same flowers. At her feet three angels carry roses and a book in which can be read: ROSA CORDIS MEI TV MIHI SPONSA ESTO ANCILLA TVA SVM DOMINE. This saint was canonized in 1671, just a few years before this canvas was painted, and it is interesting to record that she was the first saint to be born in the Americas. A drawing that could be a preparatory sketch for the figure of the angel crowning St. Rose is in the Uffizi. According to Palomino this work was commissioned by Luis Faurés, a member of the personal guard – bowman of the bodyguard – of the queen, Mariana of Austria. In fact we are dealing with one of the few examples of "sacre conversazioni," very much in the line of Italian painting but done by a Spanish artist. As sources of inspiration, two works have been identified: The Adoration of the Virgin and Child by the Saints by Rubens, in the Prado, and the Mystic Marriage of St Catherine by Mateo Cerezo.

THE ADORATION OF THE HOLY FAMILY BY ST. LOUIS, KING OF FRANCE, AND OTHER SAINTS

With St. Louis, King of France, are SS. Elizabeth and John the Baptist, another unidentified saint, and two angels. The holy king holds a sword, which Sullivan has interpreted as an allusion to the spear that pierced the side of Christ, which, according to tradition, was preserved in Sainte Chapelle in Paris, a church built by the French king to house the crown of thorns and the spear. However, it also could symbolize his position as a crusader. On the ground by his feet are the crown and scepter, symbolic of his earthly position as a monarch.

Originally in the collection of the marquis of the Ensenada, this canvas passed to the royal collections in the second half of the eighteenth century, reported in the 1772 inventory as being in the apartments of the Prince Don Javier in the New Alcázar. J. A. López made an engraving of this painting in the nineteenth century.

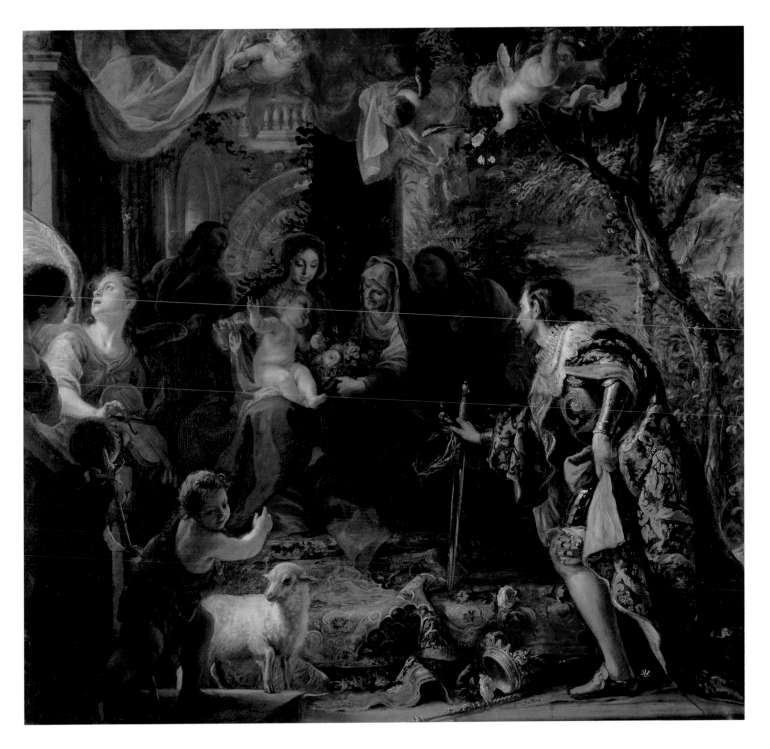

CLAUDIO COELLO
The Adoration of the Holy Family by St. Louis, King of France, and Other Saints, c. 1665–1668
Oil on canvas, 229 × 249 cm

ST. AUGUSTINE DRIVING OFF A
PLAGUE OF LOCUSTS

This sketch was painted for the temple of San Felipe el Real in Madrid, from where it passed to the Museo de la Trinidad, and came to the Prado Museum in 1871.

Until a relatively recent date, 1952, it was catalogued as the work of Sebastián Muñoz, in spite of the fact that Ponz and Ceán had classified it correctly.

As Meléndez died without carrying out the definitive version of this work, Andrés de la Calleja took over the task. The sketch shows the invocations of the village people, with their bishop at the head, to rid itself of a plague of locusts. St. Augustine appears, with miter and crosier, in the upper part, among the clouds.

Faithful to his training in the high Baroque, attested to by the composition, the iconographic patterns, and the material execution, Meléndez developed his approach from the influence of French and Italian artists following the Rococo current. However, the mark of the plastic tradition of the previous century always prevailed — in his religious works more than his portraiture — and, together with García de Miranda, he was its last representative.

MIGUEL JACINTO MELÉNDEZ
(1716–1780)
*St. Augustine Driving off a
Plague of Locusts*
Oil on canvas, 85 × 147 cm

JOSÉ DEL CASTILLO (1737–1793)
The Seller of Fans, 1786
Oil on canvas, 95 × 149 cm

THE SELLER OF FANS

José del Castillo was one of those
great artists who was able to capture
the popular tone introduced into the
cartoons for the Royal Tapestry
Manufactory of Santa Bárbara under
Charles III. He contributed to the
"plebianism" — as Ortega y Gasset
called it — that filled the tapestry
scenes of the time.

It is a carefree, festive, Mad-
rilenian world, in which girls in
typical dress join archetypal, colorful
characters to give life to scenes full of
a singular enchantment. Curiously,
these were destined to decorate the
apartments of the royal family in the
various court palaces.

The Seller of Fans was painted as
a model for a tapestry woven to hang
over the door in the prince's
bedroom in the Pardo Palace.
Castillo was able to infuse a delicious
roguish charm into the face and the
posture of the young vendor, who
gallantly offers his merchandise to the
lady beside him as she reclines at ease
in the San Isidro meadows during the
famous Romería.

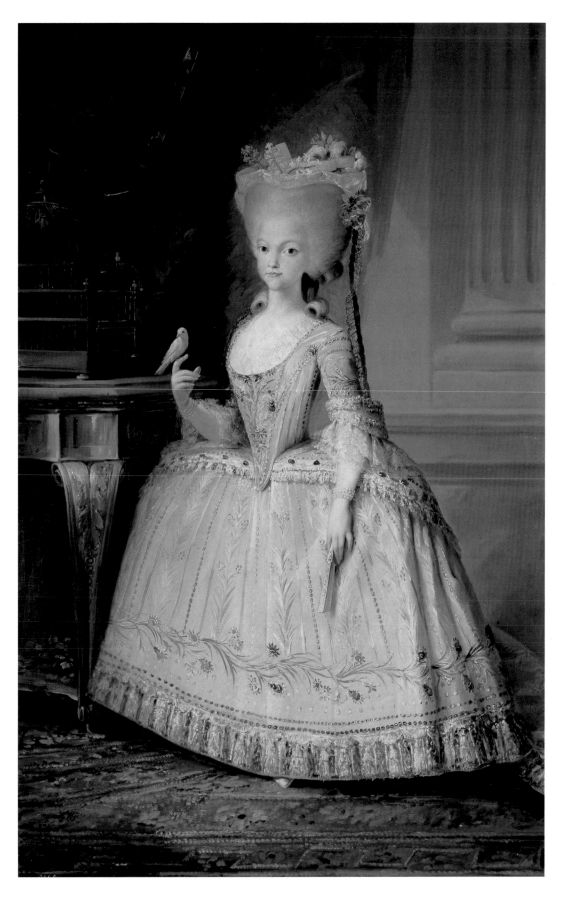

MARIANO SALVADOR MAELLA (1739–1819)
Carlota Joquina, Infanta of Spain and Queen of Portugal
Oil on canvas, 177 × 116 cm

CARLOTA JOQUINA, INFANTA OF
SPAIN AND QUEEN OF PORTUGAL

ALLEGORY OF SUMMER

This portrait came from the royal collections and is described in the 1814 inventory of the Royal Palace in Madrid.

The subject was the daughter of Charles IV. She was born on April 15, 1775, and married the hereditary prince of Portugal, who would reign as Juan VI, in 1785. She died on January 7, 1830.

It is one of the most delicious of the Spanish court portraits from the last part of the eighteenth century. Starting from an academic compositional scheme, in part the legacy of Mengs, Maella added a certain Rococo savor to the attitude and the atmosphere that pervades the composition. The princess wears a rose-colored dress and carries a canary. A replica with slight variations — for example, the sitter is dressed in blue, and in place of the bird she holds a bunch of flowers — is preserved in the Moncloa Palace.

The generous use of design and precise brushwork give this portrait an enchanting aspect.

Allegory of Summer belongs to a series of four canvases representing the seasons, which Maella painted in the most pure, orthodox Baroque style from the iconographic point of view; he faithfully followed Ripa's guidelines and academic criteria in its formal configuration. The sketches for these four allegories, painted with a very smooth technique, were arranged in a contemporary frame to make a small folding screen, which is in the collection of the count of Villagonzalo in Madrid (oil on canvas, 33 × 17 cm each).

This painting offers us the figure of Ceres decked out as a countrywoman, grasping a torch in her right hand and carrying a sheaf under her left arm. On the right, a man ties a sheaf of wheat, while two reapers are seen in the background. In its aesthetic approach, this composition evidences a clear association with the works carried out by the court painters during this period for use as patterns in the Royal Tapestry Manufactory of Santa Bárbara in Madrid.

MARIANO SALVADOR MAELLA
Carlota Joquina, Infanta of Spain and Queen of Portugal
(Detail)

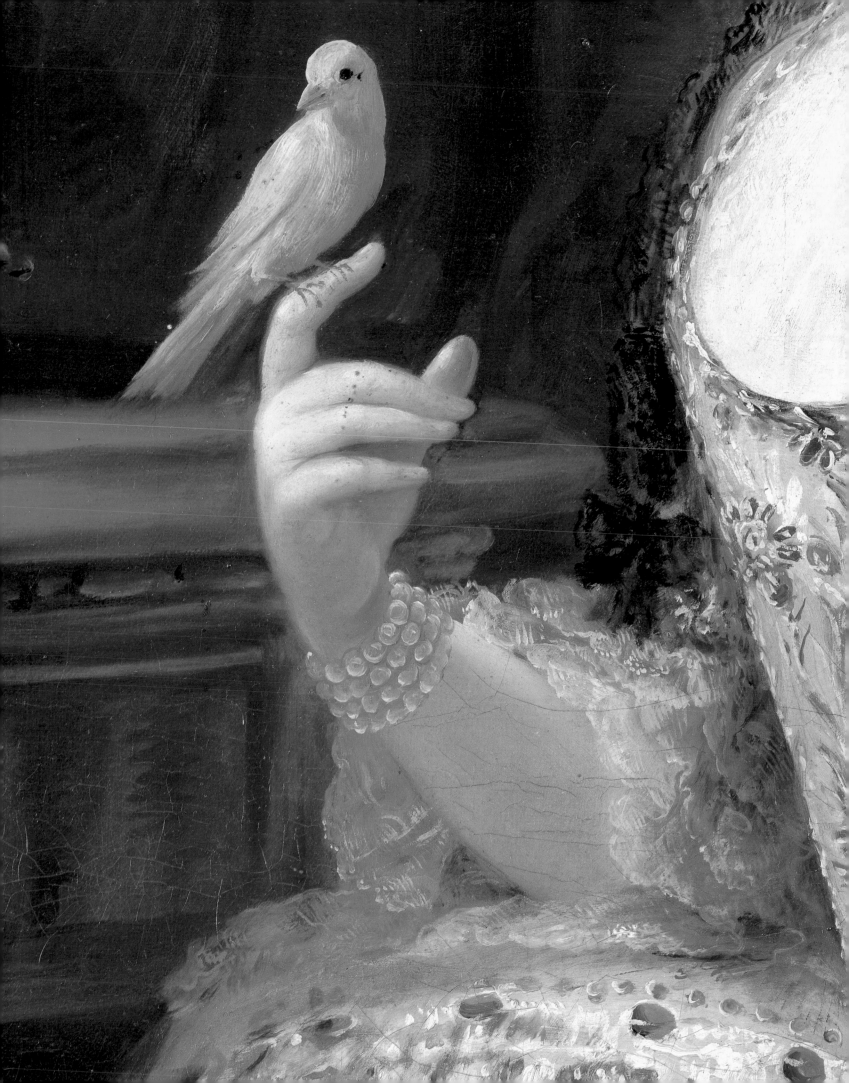

MARIANO SALVADOR MAELLA
Allegory of Summer
Oil on canvas, 144 × 77 cm

FRANCISCO BAYEU (1734–1795)
Feliciana Bayeu, 1787
Oil on canvas, 38 × 30 cm

FRANCISCO BAYEU
Olympus — The Fall of the Giants, c. 1764
Oil on canvas, 68 × 123 cm

RAMÓN BAYEU (1746–1783)
Fans and Bread Twists, 1778
Oil on canvas, 147 × 187 cm

FELICIANA BAYEU

Feliciana, daughter of Francisco Bayeu and Sebastiana Merclín, was born in Madrid in 1774, in the Calle del Reloj, where her parents and her uncle Ramón Bayeu lived. This canvas was a gift to the Prado Museum in 1912, from its former owner, Cristóbal Ferriz, who believed it to be by Goya. Allende Salazar and Sánchez Cantón recognized it as the work of Bayeu. Even afterward, and in view of its superior quality, Enrique Lafuente Ferrari continued to insist on the possibility of its being by Goya. However, beside its displaying the characteristics of Bayeu's work, we have graphological proof from the inscription that figures in the painting, making the attribution to this artist today unquestionable, as opposed to its attribution to Goya.

The girl is dressed in a short cape, and her head is gracefully adorned with satin bows, magnificently handled by the painter. The hair is skillfully drawn. Everything in this work is outstandingly smooth, with creamy brushwork and a delicate palette of fine shades.

OLYMPUS — THE FALL OF THE GIANTS

This is a sketch for the fresco that decorates the old antechamber to the apartments of the princes of Asturias, today converted into a dining hall, in the Royal Palace of Madrid.

Following Ovid, Bayeu, under the direction of Mengs, molded a synthesis from this mythological fable, first treated by Homer, later by Apollodorus, and finally by Virgil. The scene catches the moment in which the giants, after declaring war on the gods, united with Typhon to give battle against the divine legion commanded by Hercules on Minerva's orders. Jupiter appears on a throne of clouds in the center, holding in his right hand the lightning ray of vengeance, which he is about to hurl at the giants. Beside him is his wife, Juno, with her peacock, shown at the moment of directing the attack of the nymphs of the air, who scatter water from their fingernails, and a flaming meteor. Around Jupiter's throne appear Hercules, Minerva, Mars, Saturn, Pluto, Neptune, and Aeolus, among other, lesser known, mythological figures, with the attributes corresponding to their realms. Hercules hurls an enormous spear; Minerva is next to him with corpses, among which the giants' leader, Typhon, stands out; he has been mortally wounded by Jupiter's lightning ray. Mars and Bellona watch those who flee in the midst of the blood and clamor of the battle. Other deities complete the complex composition.

The work was engraved by Manuel Salvador Carmona, and there are many drawings and another sketch preserved in the Real Sociedad Económica Aragonesa de Amigos del País, in Zaragoza.

FANS AND BREAD TWISTS

This is a cartoon by Ramón Bayeu for a tapestry to be woven in the Royal Tapestry Manufactory of Santa Bárbara. It was destined to decorate the "room where the king eats" in the Pardo Palace. The work was valued at 3,000 reales. Following the description given by Bayeu himself, the painting represents "a man selling buns with a basket of these on his arm; in one hand he holds a bread twist; he is standing upon a bank; farther off a boy is selling fans; at his side an orange vendor is seated, approached by a servant in the company of a lady to whom she offers the oranges; the remainder of the painting is sky with clouds."

We see here how Ramón Bayeu, together with José del Castillo, came to be the ideal interpreters of Madrid life in their productions for Santa Bárbara. They were the best pictorial artists of what was developed in literature by the dramatist Ramón de la Cruz.

We are reminded through the artist's eyes of the peacefulness and tradition of eighteenth-century Madrid, of the townsmen and women, full of joviality. Only his brother-in-law, Francisco de Goya, was able to surpass him in this spirit. A proof of this is that, in the last century, insofar as the cartoons are concerned, many of their works were confused one with another.

A RURAL GIFT

Ramón Bayeu was commissioned to produce this cartoon for the Royal Tapestry Manufactory of Santa Bárbara. The tapestry woven from it is now preserved in the Patrimonio Nacional, but the precise position for which it was destined is not known. This museum also preserves a sketch (cat. no. 2599).

The scene represents a dandy offering fruit to two seated damsels. In the background we see a man muffled in a cape. The figure of the dandy, a follower of the French fashion, who put excessive emphasis on personal neatness and careful appearance, became popular in Madrid under Charles III. He was more frequently seen in the comings and goings at court during the following reign, becoming a typical feature of that period and, in general, the "Frenchified" atmosphere. His special nature was a target for irony and jokes on the part of satirical writers and journalists of the illustrated press, who preferred the traditional Spaniard to this new personage of Madrid society.

In spite of the technical difficulties facing the artist in the execution of this type of work, Ramón Bayeu shows a masterly command in the drawing and coloring and in the tight and unusual compositional scheme.

RAMON BAYEU
A Rural Gift, c. 1785
Oil on canvas, 183 × 146 cm

This spectacular composition captures the horse festival that took place at the grounds of the Aranjuez palace in spring 1773. We can identify the participants from preserved documentary records: Prince Don Carlos (later Charles IV), Prince Don Gabriel, Prince Don Luis Antonio (son of Philip V), and the duke of Medina-Sidonia. In the second box, in front of the palace façade, Charles III and Princess María Luisa of Parma attend the festival. Also depicted are several courtiers and a colorful group of members of the general public.

The Royal Couples is undoubtedly one of the most successful creations among the paintings of courtly scenes by this artist. We have here the clearest intimation of the late Rococo, showing the skillful drawing and understanding of the aesthetic tendencies that the artist had learned from the diamond cutter Agustín Duflos, as well as certain reminders of La Traverse.

LUIS PARET Y ALCÁZAR (1746–1799)
The Royal Couples
Oil on canvas, 232 × 365 cm

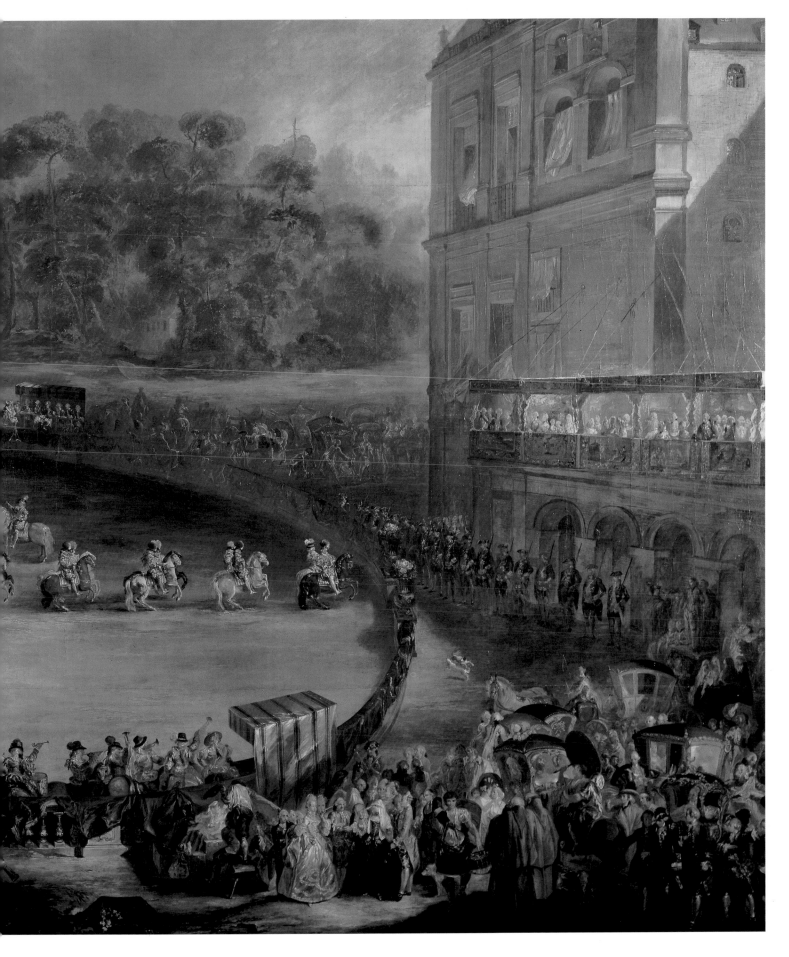

LUIS PARET Y ALCÁZAR
Charles III Dining in the Presence of His Court, c. 1770
Oil on canvas, 50 × 64 cm

CHARLES III DINING IN THE PRESENCE OF HIS COURT

Paret y Alcázar was one of the most representative artists of the second half of the eighteenth century, above all in this series of courtly scenes, which alternate with his well-known "views" and religious paintings. On the one hand he showed hints of the Rococo, learned while training with artists from France, and on the other, a classicist vocation that becomes more clear in the later stages of his career and in his work as illustrator and designer of cartoons.

Here, with a preciseness of detail, filled with references to bourgeois solemnity and refined scenographic displays, he portrays a scene in the daily life of the king, who liked to eat surrounded by members of his family and court. Gaya Nuño sees in the king the mark of years, and for this reason suggests a date later than that given for the painting, placing it at around 1788, but the technique used and the spatial concern lead us to classify it as having been painted in the first years of the 1770s.

It comes from the Gotchina collection in St. Petersburg; the canvas was acquired by the Prado Museum in 1933.

LUIS PARET Y ALCÁZAR
A Masked Ball, c. 1772
Oil on canvas, 40 × 51 cm

A MASKED BALL

The painting features a masked ball that took place in the Teatro del Principe of Madrid, a theater that, together with those of La Cruz and Los Caños del Peral, was the most important for popular presentations in the court. A preparatory sketch is preserved in the British Museum in London. There is also an engraving by Juan Antonio Salvador Carmona, *The Masked Ball,* which corresponds to this painting. The canvas was acquired by the Board of Trustees of the Prado Museum in November 1944, with funds from the count of Cartagena's bequest.

It can be seen here that the formulae used by Paret with respect to popular scenes have little to do with the traditionalism of the artists who worked for Santa Bárbara, as the French sensibility in this painter's style not only affected his plastic forms but also penetrated into his illustration of the thoughts of the time, making him the most individual artist in this respect. Thus this picture is replete with insinuation and suggestion, using the decorative as protagonist instead of for the exposition of an idea, but in an unusual manner.

171

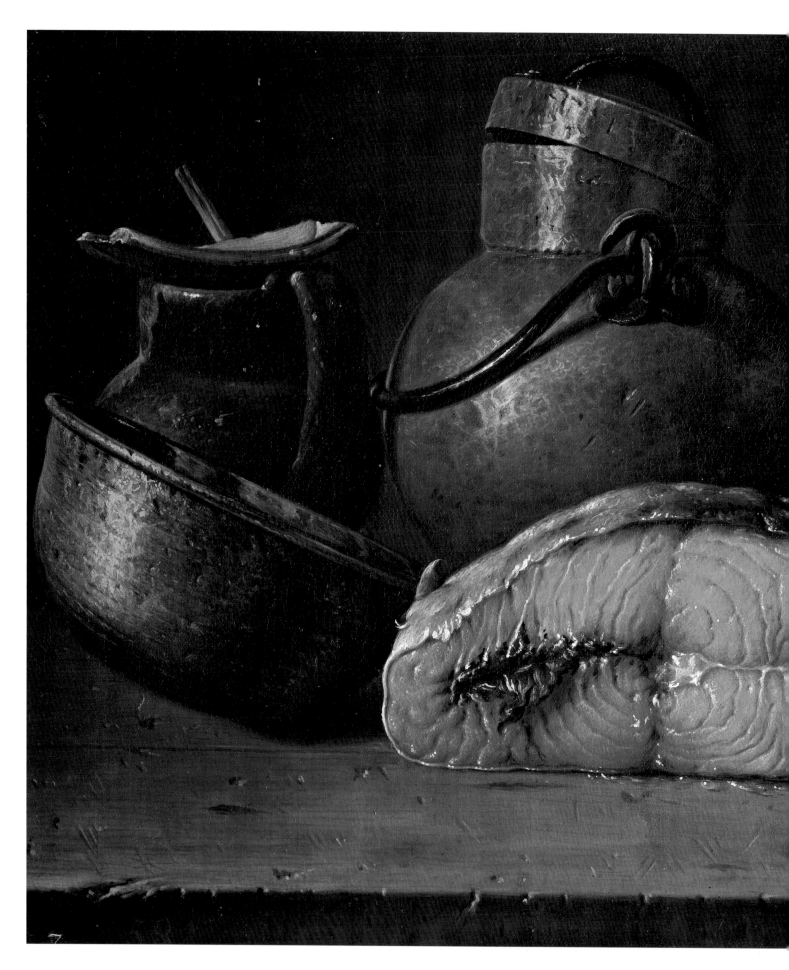

In the painting, the signature reads: L.Mᵗ D.ˡˢ P. AÑO 1772

LUIS MENÉNDEZ (1717–1780)
Still Life with Salmon, a Lemon, and Three Vessels, 1772
Oil on canvas, 42 × 62 cm

LUIS MENÉNDEZ
Still Life with a Box of Sweets, Bread Twists, and Other Objects, 1770
Oil on canvas, 49 × 37 cm

STILL LIFE WITH SALMON, A LEMON, AND THREE VESSELS

As in all his still lifes, Menéndez here maintains the humility and refined intimacy of Sánchez Cotán and Zurbarán, both in the spirit and the simplicity of the elements represented. Even when there is a certain chromatic decorativeness, which is in accordance with the art of the times, it is just this refined austerity impregnating his canvases that makes certain that these works do not lose the primary asceticism, inherent to the cherished purposes of daily life, that inspires them. The manner of lighting the compositions helps to achieve this clearly.

From his rare gift of observation, Menéndez makes the objects stand out against shaded backgrounds of an ambiguous and deliberate opacity, carefully reproducing the visual and physical texture of each element in the composition, giving the food and domestic objects their individual qualities in an affectionate manner, broken only by the intersecting shapes in which the light fades out at the last.

STILL LIFE WITH A BOX OF SWEETS, BREAD TWISTS, AND OTHER OBJECTS

This comes from the royal palace of Aranjuez where it formed part of the collection of Prince Carlos (later Charles IV). The signature sets out in abbreviations the full name and surnames of the painter: "Egidio Luis Menéndez Rivera Durazzo y Santo Padre."

In this composition from the artist's mature period, we have a series of objects of exquisite taste; the fruit bowl, the salver and silver fork, as well as the drinks cooler, denoting a predilection for domestic comfort. The box of sweets in the foreground on the salver has a direct connection with the compositional element which was so often used by the great Spanish still life painters of the seventeenth century, particularly van der Hamen. The execution is meticulous, full of technical nuances, giving the objects a feeling of reality, comparable to that of the great Flemish cultivators of this genre. A carefully thought out, balanced chromaticism actively contributes to the effect sought by the artist.

STILL LIFE WITH CUCUMBERS AND TOMATOES

This canvas is part of a series of still lifes painted by Luis Menéndez for the Aranjuez Palace. It is from this palace that this one passed to the Prado Museum in 1819; today, the majority of these still lifes are preserved in the Prado.

Menéndez was the prime artist of the genre of still life in the eighteenth century, producing various examples in which, using a series of constants from the previous century, he was able to bring this type of work up to date, starting from a smooth treatment and a chromaticism of rich tonalities. Thus, the simplicity and humble nature of the objects represented — in this case a basin, an olive oil bottle, a vinegar flask, a saltcellar, plates, cucumbers, and tomatoes — are sufficient for him to express a sublimation of domesticity, giving value even to the most intimate of small things. The result is a work of great realism and polished execution.

On exactly the date with which this canvas is signed, Menéndez wrote that he was thinking of making a series of works "with all kinds of comestibles that the Spanish climate produces in the four elements, having only finished those belonging to the fruits of the earth."

LUIS MENÉNDEZ
Still Life with Cucumbers and Tomatoes, 1772
Oil on canvas, 41 × 62 cm

PORTRAIT OF TOMÁS DE IRIARTE

This portrait comes from a private collection and was acquired by the Spanish state for the Prado Museum in 1931.

The Aragonese painter Joaquín Inza was an accurate portraitist and in this painting offers us his most successful creation. It follows the pattern set for this genre in Spain by Anton Raphael Mengs, which was maintained by most of the Spanish painters working at the courts of Charles III and Charles IV, as opposed to the Baroque concept of the portrait that had been maintained in Spain until then. Thus this painting responds to an academic interpretation of a firm classical vocation.

The subject, Tomás de Iriarte (1750–1791), was one of the most brilliant writers of the age, attaining great popularity in his time through his *Fábulas Literarias,* published in 1782, which followed the criteria of the Neoclassical French fable writers.

Precise drawing, with an execution that was perhaps a little hard, as was the normal practice of the artist, does not prevent Inza from displaying the personality with great agility, with particular emphasis on capturing the face, which is perfectly modeled.

THE ASCENT OF A MONTGOLFIER BALLOON

Carnicero was an excellent portrait artist, but he also created some works in a narrative and panoramic genre, after the manner of Claude-Joseph Vernet (1714–1789), a manner practiced in Spain by several artists, Luis Paret outstanding among them.

It was once thought that the composition represented the ascent in a balloon by an Italian, Vicenzo Lunardi, which took place in Madrid on January 12, 1792. However, we can today say quite definitely that what Carnicero is setting out in this exquisite graphic document is the ascent of the Frenchman, Bouclé, from the garden of Aranjuez on June 5, 1784 — the first balloon ascent to take place in Spain. It ended most unhappily when Bouclé lost control of the balloon and suffered a spectacular accident in which several people were injured.

This delightful scene records minutely the festival atmosphere of a public in its Sunday best as well as members of the court nobility who stroll by peacefully, following with astonishment the exploits of the French gentleman. Rococo touches are evident, not only in the layout of the numerous little figures that people the scene, but also in the treatment of light flooding the whole with a delightful clarity.

THE MARCHIONESS OF SANTA CRUZ

The person represented is Doña Joaquina Téllez-Girón, daughter of the duke of Osuna, who was born in Madrid on September 21, 1784. She married Don José Gabriel de Silva y Bazán, Marquis of Santa Cruz, and she died on November 17, 1851.

This seems to be a companion work to a portrait of her sister, the marchioness of Camarasa, with a "tric-trac" board. The marchioness of Santa Cruz was painted by Goya twice: the first time, on the occasion of a family portrait, with her parents and brothers (cat. no. 739), and subsequently in 1805, reclining on a couch and holding a lyre, a work also in the Prado. The portrait reproduced here came to the Museum in 1934, having been acquired by the state from the Gutiérrez ladies.

Esteve, collaborator and copyist of Goya, was, after Goya himself, the most fruitful portrait artist within the panorama of Spanish painting during the last decades of the eighteenth century and the first of the nineteenth.

His work always reflects the Goya of the 1780s, a pattern Esteve developed in giving his portraits a special lightness of brush and evanescent atmosphere, which are so characteristic of him and can be seen to good effect in this picture.

JOAQUÍN INZA (c. 1750–c. 1820)
Portrait of Tomás de Iriarte, 1790
Oil on canvas, 82 × 59 cm

ANTONIO CARNICERO (1748–1814)
The Ascent of a Montgolfier Balloon, c. 1790–1795
Oil on canvas, 170 × 284 cm

AGUSTÍN ESTEVE (1753–1820)
The Marchioness of Santa Cruz, 1798
Oil on canvas, 190 × 116 cm

The Holy Family

The *Holy Family* belongs to the stage in Goya's oeuvre in which the influence of Mengs, which was recognized by art historians studying this painter's work in the nineteenth century. This picture was acquired by the state in 1877 for 2,000 pesetas from the heirs of Manuel Chaves.

With the figure of the Virgin as the center of the composition, the descriptive simplicity of the draperies is outstanding — a rose shade in the tunic and a meticulous blue in the mantle. A subtle smile illumines the delicate face with appropriate touches of carmine and there are impressionist lights in the hair. The delightful figures of the two children, above all the little St. John in his graceful pose, are most significant.

As Sánchez Cantón points out, Goya is here attempting a religious picture by the use of intimacy; Velázquez had done exactly the same in the devotional works of his first years. Goya still lacked realistic definition and was influenced by the example of Mengs's ingenuity in the rest.

The San Isidro Meadows

The origin of this work is traced to a letter Goya wrote to his friend Zapater on May 31, 1788, in which he said that he was going to do some cartoons as patterns for tapestries destined for the royal children's rooms in the Pardo Palace, adding that "the subjects are difficult and require much work, such as that of the San Isidro meadows on the saint's day, with all the bustle that the court is accustomed to have." In fact, we are dealing with a sketch for a cartoon that was never completed. It was acquired from Goya by the duke of Osuna in 1799 with eight other sketches. It remained in the Alameda Palace in Osuna until 1896, when it was acquired by the Prado Museum.

The scene shows the festival that took place — and still takes place — on May 15 every year, the festival of the patron saint of Madrid. It shows Madrilenians relaxing on the right bank of the Manzanares River, where they feast in the meadows between dancing and diversions. The detailed handling and accuracy of execution (which Goya made such a specialty in this masterly piece, both in the description of the background landscapes and in the tiny figures, and with chromatic shadings of great effect), make this composition a key work in that field of Goya's oeuvre relating to the creation of cartoons for tapestries.

FRANCISCO DE GOYA Y LUCIENTES (1746–1828)
The Holy Family, c. 1775–1780
Oil on canvas, 200 × 148 cm

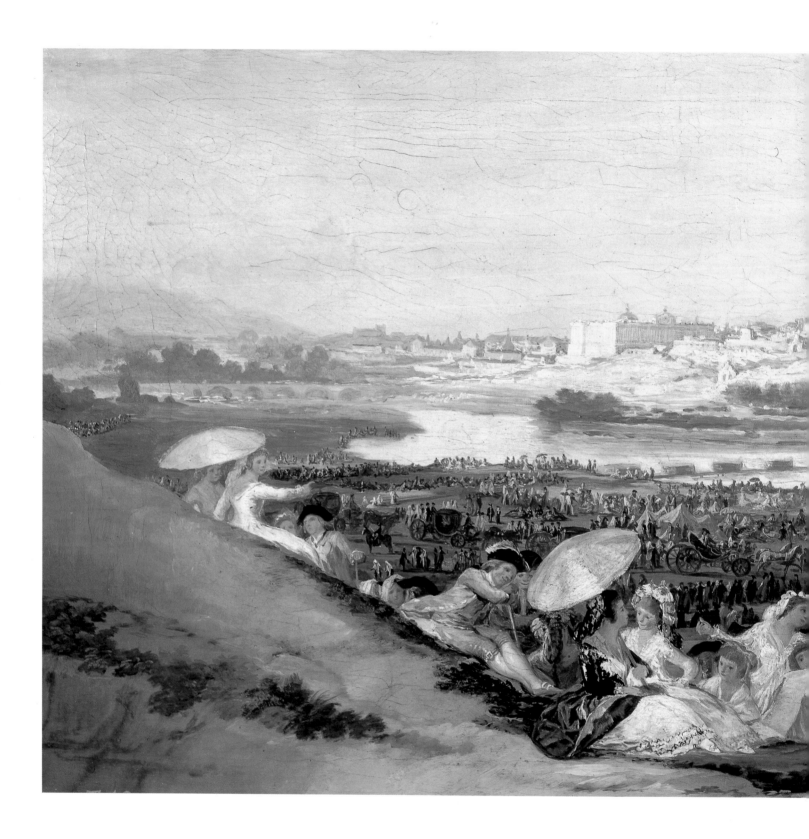

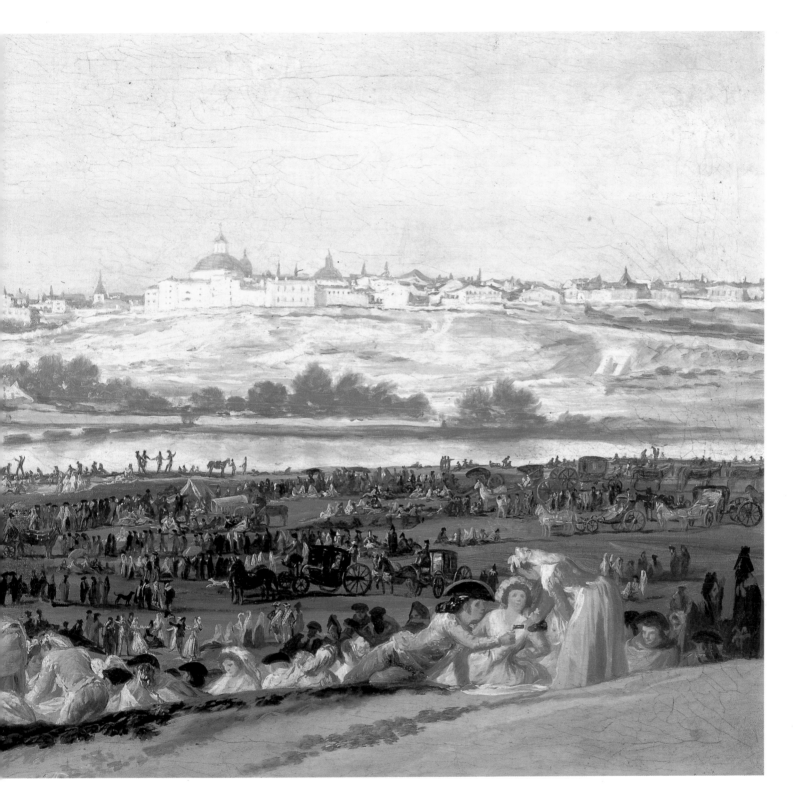

FRANCISCO DE GOYA Y LUCIENTES
The San Isidro Meadows, 1788
Oil on canvas, 44 × 94 cm
(Detail on the following page)

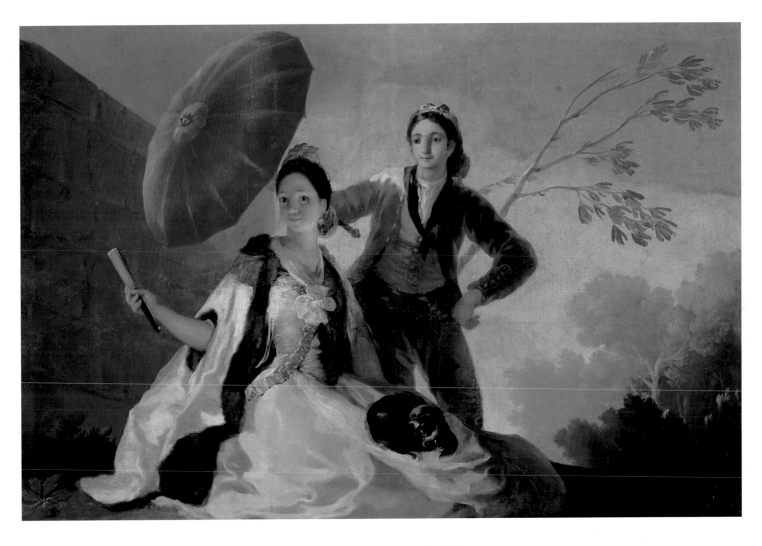

FRANCISCO DE GOYA Y LUCIENTES
The Parasol, 1777
Oil on canvas, 104 × 152 cm

The Parasol

This is a cartoon for a tapestry to hang over the door of the dining room in the Pardo Palace, woven in the Royal Tapestry Manufactory of Santa Bárbara. Goya delivered the work on August 12, 1777, but the tapestry has not survived.

A girl is seated with a little dog on her lap. Behind her is a man who shades her from the sun with his green parasol. The development of Goya's plastic language through his works for the Royal Tapestry Manufactory of Santa Bárbara already seems mature, following several deliveries in the series of tapestries to which *The Parasol* belongs. Here, the influence of Bayeu is less intense. We do find, however, certain reminders of French painting, with some influence from Houasse, and with the naturalistic references accentuated. Besides that, there is a fine meticulousness in the details of the clothing, and the stamp of a rich range, bursting with light, of a delightfully embellished chromaticism may be surprising. As Gudiol saw, the two worlds that always conflicted in Goya — those of the court and of the people — alternate in this picture

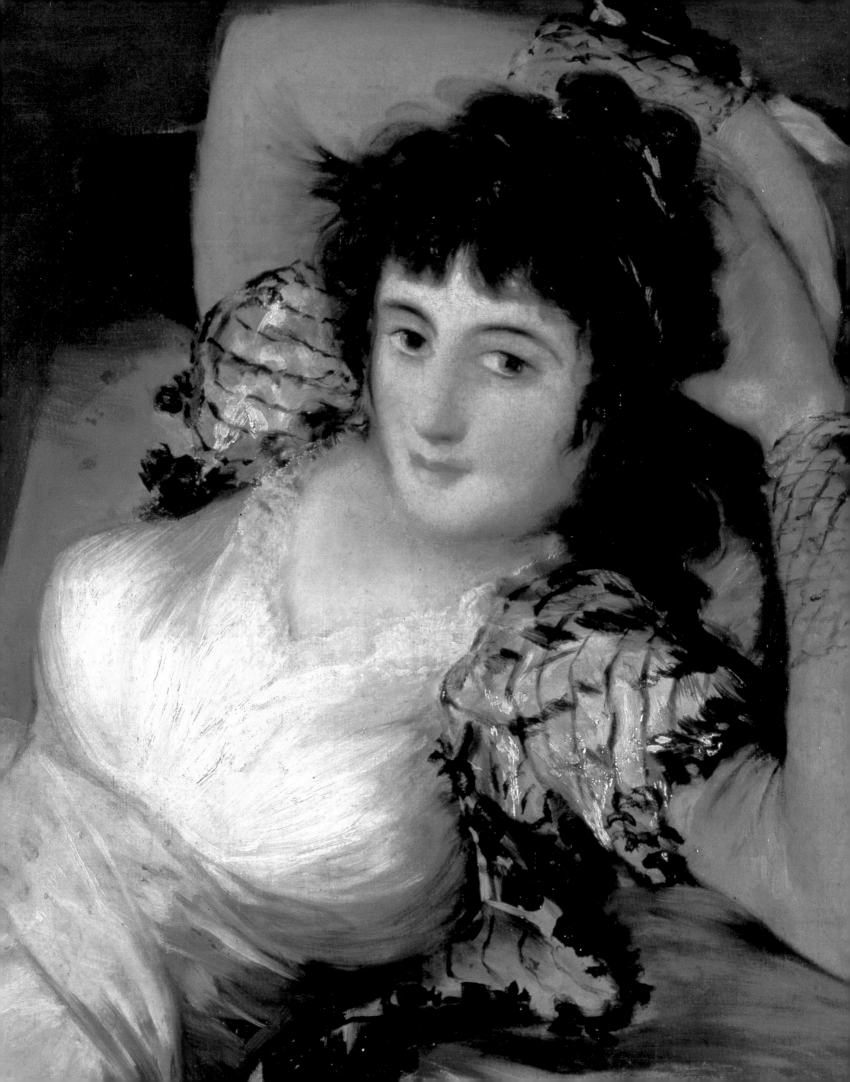

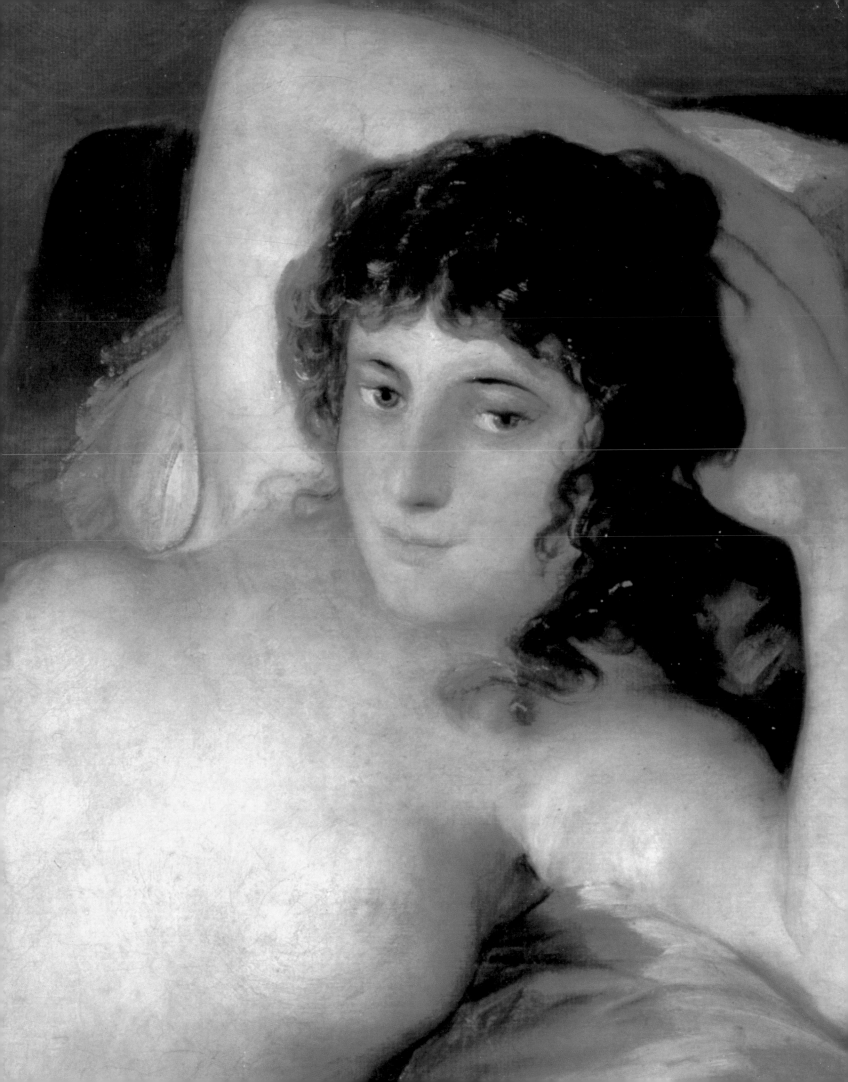

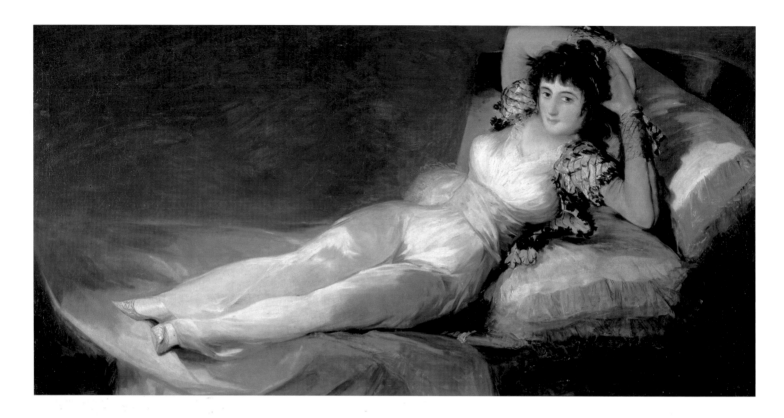

FRANCISCO DE GOYA Y LUCIENTES
The Maja Clothed, c. 1796–1798
Oil on canvas, 95 × 190 cm
(Detail on page 188)

THE MAJA CLOTHED

The old polemic about the identity of the person who modeled for Goya for his famous majas has been a center of attention for all the art critics who have concerned themselves with these works. The theory that it was María Teresa Cayetana, Duchess of Alba, was spread seemingly by Goya himself when he was called before the Inquisition, as has been pointed out by Ezquerra del Bayo. On the other hand, we have the testimony of the artist's grandson, Mariano Goya, who in 1868 confessed to the painter Luis de Madrazo that the model was a woman protected by Father Bari, a friend of Goya's. Other people think the paintings were commissioned by

the duchess who, from childhood, had lived with and known the two most famous paintings of nudes, *The Rokeby Venus* by Velázquez, and Correggio's *The School of Love.* Lastly, Formaggio has tried to show that the models for the two paintings were different.

The painting of the clothed maja seems to have been the first of the two, and it offers a more realistic impression than the nude, showing the liveliness of a portrait, while the second is more unreal. In this one the technique is smoother, with a greater brush length and a tonal quality of vibrant chromaticism in the treatment of the fabrics.

The two majas were to remain in

the duchess's boudoir until her death, then being confiscated by Godoy with other pictures, among them the Velázquez Venus. In the 1808 Godoy inventories they appear as "gypsy nude and gypsy clothed." Subsequently these paintings were deposited in the Casa Almacén de Cristales, being transferred in 1815 to the San Fernando Academy, where they were kept away from public view. They came to the Prado Museum at this time.

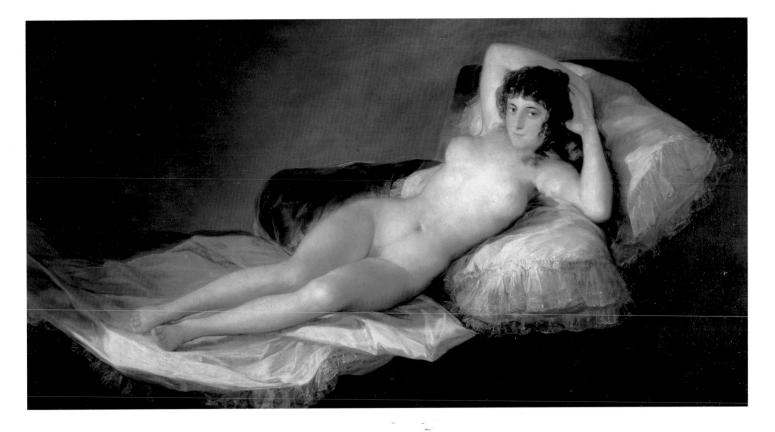

FRANCISCO DE GOYA Y LUCIENTES
The Maja Nude, c. 1796–1798
Oil on canvas, 97 × 190 cm
(Detail on page 189)

THE MAJA NUDE

For comments on the identity of the subject and the history of the painting, please refer to the entry on the previous page.

The problem posed by the depiction of the nude by Spanish artists was followed very closely by the Inquisition for many years, and its use was harshly punished, thus depriving Spanish painting of numerous mythological subjects, especially during the Baroque period. This work, though at a date as advanced as 1815, was to cause Goya serious problems with the Fiscal Inquisitor of the Holy Office.

A classic air animates the drawing and modeling of the body, which gives the impression that the head was in fact placed afterwards. As Camón Aznar recognized, this uncovering of the female body, offering it to view without any pretext of allegory, is the first conscious use of naturalism with an aesthetic based not in abstract beauty but in the fullness of reality. From the results, Juan de la Encina thought that Goya could have made this portrait without the duchess posing at all; that he could have painted it from his own knowledge of her anatomy and her face, since in addition to their intimate relationship, he made several paintings and sketches of her. For Sutton, Goya's woman becomes the "femme fatale" of Romanticism; he thinks that the clothed maja is more seductive than the nude, adding in reference to the clothing, that disguising the duchess as a maja has a Mozartian touch. However, and as has been made clear, this portrait lacks something of the tenderness and fluency of living flesh, with its softness and nuances, that can be observed in other important nudes, such as those of Velázquez and Titian.

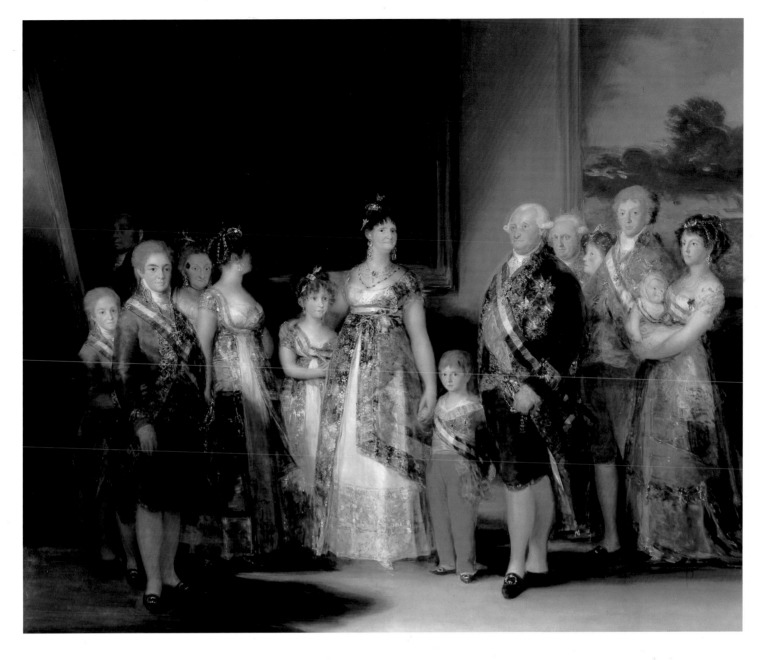

FRANCISCO DE GOYA Y LUCIENTES
The Family of Charles IV, 1800
Oil on canvas, 280 × 336 cm

THE FAMILY OF CHARLES IV

After being named First Painter to the Chamber, the culmination of his court appointments, Goya set out to make a collective portrait of the family of Charles IV, "the painting of all of us together," as Queen María Luisa called it in a letter to the minister Godoy.

For months beforehand, Goya prepared this work minutely, starting with a series of sketches made in Aranjuez, some ten of them are preserved in the Prado Museum; still others are lost, so that we only know them from copies — picking out the faces of the different persons who were to appear in the definitive version.

As opposed to antecedent works, such as *The Family of Philip V* by Van Loo, or even *Las Meninas,* Goya created a completely different picture without any architectural or environmental support: what we see is a canvas of abstract space. As Camón Aznar noted, the subjects are placed in an arrangement at once so uniform and so casual that they seem to have been posed for a photograph. There they are, stiff, exposed to posterity without any kind of scenographic excuse. In contrast to portraits of the French court, the subjects hold no more substance than simply their presence. In spite of the solidity of the forms, the display of reflections, the clean brush strokes, and the golden atmosphere that envelops them, the purity of the Spanish tradition is buried, and something spectral and phantasmagorical flows from the subjects.

The Colossus

This impressive vision constitutes one of the truest discoveries of Goya in showing the terrible visions that beat down upon his spirit during the War of Independence. A painting charged with symbols, it has also been called *The Panic,* in an allusion to the utterly terrified flight of the people before the apparition of the gigantic being, identified possibly with Napoleon, with an allegory of war, or with a pictorial transcription of the poem by Juan Bautista Arriaza, "Profecía del Pirineo."

There is in this apparition, however, much of the apocalypse, an hallucinatory and mysterious grandeur that startles us. Art historians concerned with Goya's art have pointed out that with respect to the innovative nature of this picture, it is to be noted that here, for the first time, allegory ceases to be commemorative; up to this point, allegorical symbols were all of works, histories, or concepts: with this painting modern events and contemporary fears begin to be allegorized.

Relating to this work, an engraving of the same title has been found, done in smoke or mezzotint, which has made Denys Sutton think that the figure of the Colossus is the antecedent of Rodin's *Penseur.*

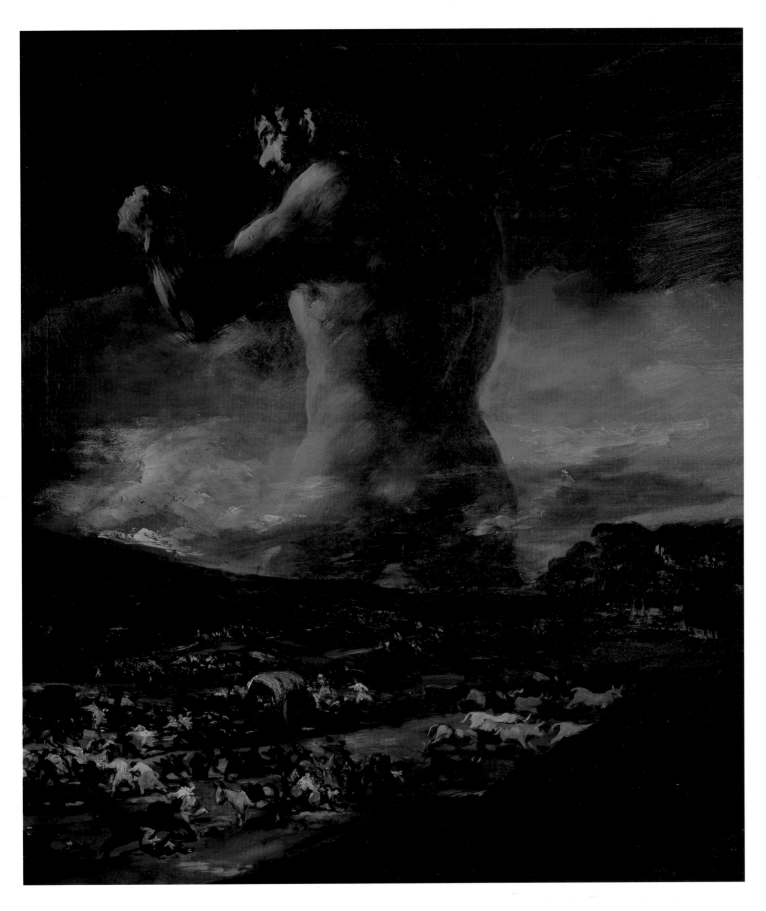

FRANCISCO DE GOYA Y LUCIENTES
The Colossus, c. 1810
Oil on canvas, 116 × 105 cm

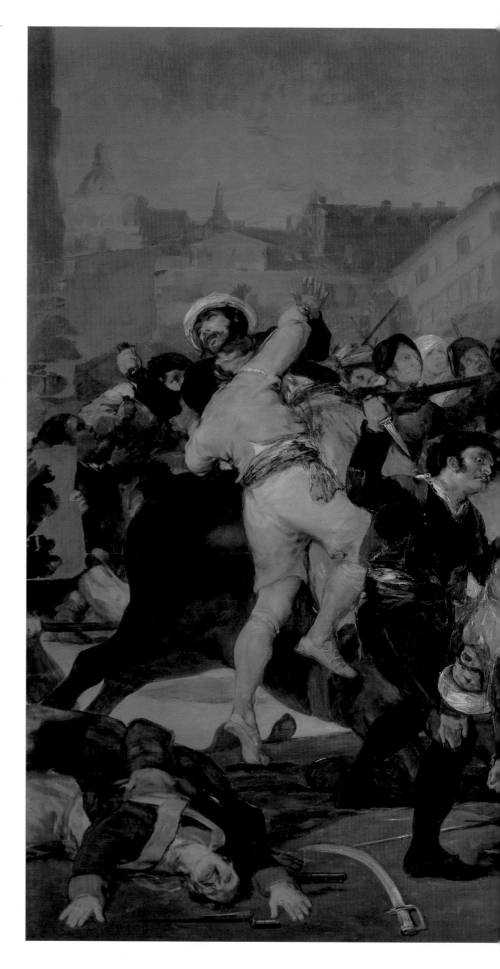

FRANCISCO DE GOYA Y LUCIENTES
May 2, 1808, in Madrid: The Charge of the Mamelukes, 1814
Oil on canvas, 266 × 345 cm

MAY 2, 1808, IN MADRID:
THE CHARGE OF THE MAMELUKES

In this work Goya presents, as no other artist could, his rejection of oppression and, at the same time, the rage of the deceived public, shown in its most robust and real aspect of patriotism. The origin of this painting and its companion – *The Executions of May 3,* also housed in the Prado — is noted in the letter he sent to the regency on February 24, 1814, expressing "his ardent desire to perpetuate through his brush the most notable and heroic actions or scenes of our glorious insurrection against the tyrant of Europe." On March 9, he received the positive response that "in consideration of the great importance of such a laudable endeavor and the well-known capacity of the said master so to undertake it, he shall be paid an amount for canvases, preparations, and colors."

In fact, and with these two paintings, Goya's art advanced considerably in its trajectory, opening courses not only for what was to become its own future development, but for subsequent generations, and from a prism of modernity that even today continues to take note of his discoveries. Thus, as is well known to the modern critic, the daring chromaticisms are so graded that the green neck of a horse has not been bettered in boldness by the horses of Franz March. The dynamism deployed in the scene, the firm and fiery brushwork, the break with any compositional convention, all make this a true revelation of what painting would become in the twentieth century.

FRANCISCO DE GOYA Y LUCIENTES
May 2, 1808, in Madrid: The Charge of the Mamelukes, 1814
(Detail)

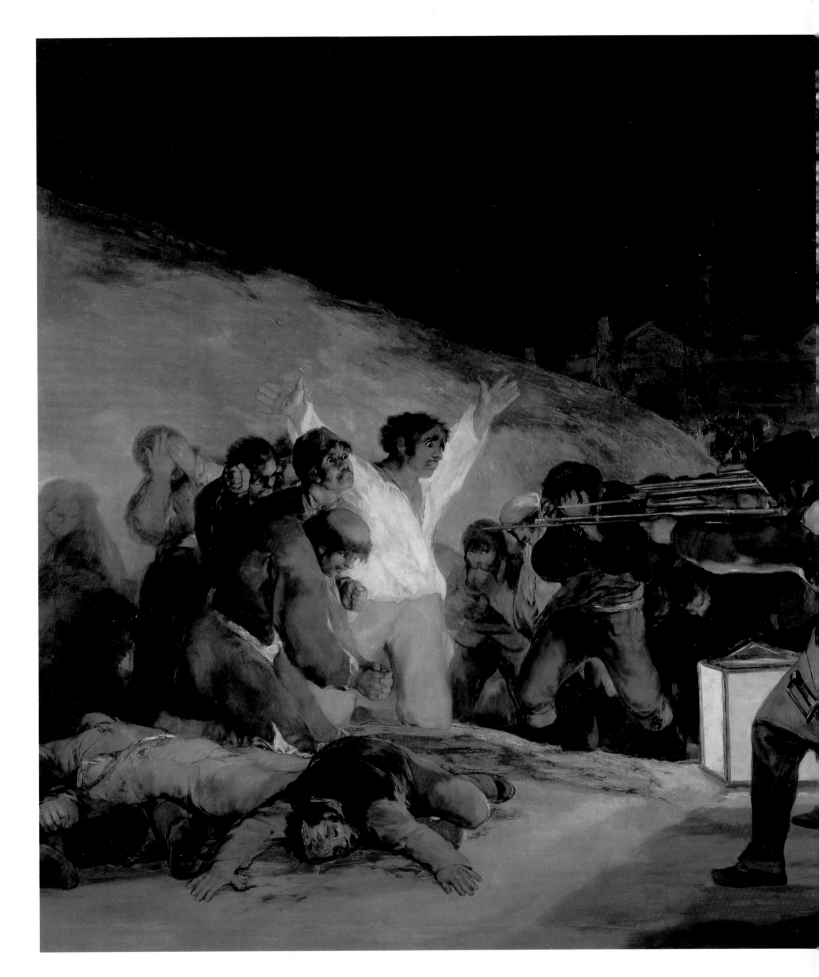

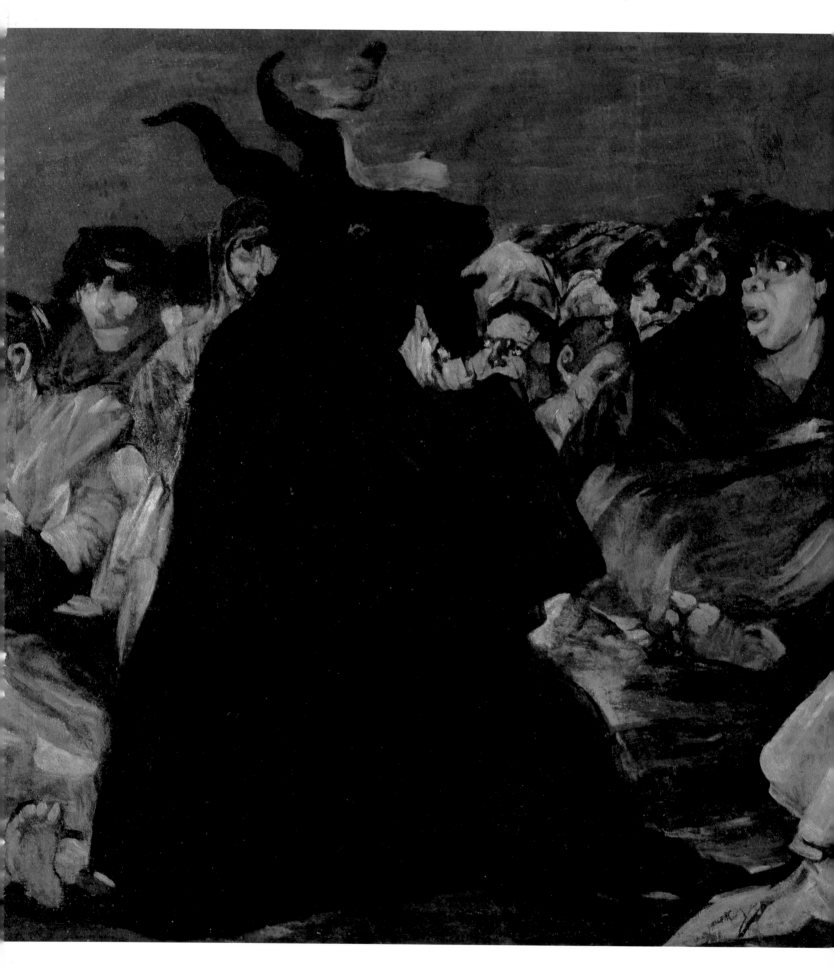

WITCHES' SABBATH, OR THE GREAT GOAT

This composition belongs to the series known as the *Black Paintings,* which Goya painted on the walls of his house, the Quinta del Sordo. This image was painted on one of the walls of the ground floor.

Speaking of the revolutionary execution of these works, the artist's son, Xavier, tells us, "these paintings, which he did at home, were always of his own choice; he painted them with freedom, following his genius, and for his personal use. He did them with a palette knife instead of a brush, thus achieving an admirable effect from an appropriate distance." The series is of a fantastic and monstrous character, especially this composition, which is concerned with the deformities of nature itself.

The word *aquelarre,* a Basque word, means "the field of the Goat," a nocturnal assembly at Christmas, Easter, and the Feast of Corpus Christi, that brings together thirteen witches who celebrate their meetings with black masses. These meetings are presided over by a chief or master representing the Devil, who appears in the form of a black, male goat.

This Goya scene is truly a frieze from Hell; the fantastic characters have mysterious faces — bestial, with bulging eyes, stupid grimaces, and half-witted or terrified expressions. As recognized by Malraux, these witches form a part of those unquiet and cosmic monsters with which Goya expresses that demoniacal world that has always threatened womankind. A delirium of ferocious pessimism imbues the whole composition.

FRANCISCO DE GOYA Y LUCIENTES
Witches' Sabbath, or *The Great Goat,* c. 1820–1822
Oil on canvas, 140 × 438 cm

THE EXECUTIONS OF MAY 3, 1808

After the Madrilenians' uprising against the invaders, reprisals took place immediately, and the day after the rebellion witnessed wholesale executions by firing squad of the most prominent patriots in the battle. The massacre took place in several locations, the one that Goya has recorded being on the Príncipe Pío mountain, where at four o'clock in the morning forty-three patriots were shot. The narrative of Trucha is the best testimony of what was captured by Goya: "in the middle of pools of blood we saw a number of corpses, some face down, others face up, this one from where he was kneeling kisses the earth, that one with his hands lifted to heaven cries for vengeance or mercy...." Trucha was Goya's servant and accompanied him on the fateful day. Once there, the painter, with simply the moon for light, made notes of the sacrifice.

Judging from the smooth technique with which this painting is executed, it must have been done with great speed; according to tradition, it was painted not only with brushes, but by using spoons, palette knife, rags, sponges, etc. The whole shows a truly chromatic display in which vibrant reds, yellows, and bluish greens alternate, mingling with the dreadful pool of blood. The startling light from the lantern gives the scene a spectral aspect and at the same time an unearthly realism.

It seems that Goya painted not merely two, but four pictures about these events. In addition to the pair in the Prado there were also — according to the testimony of Cristóbal Ferriz, as recorded by Mayer — *The Rising of the Patriots in Front of the Royal Palace* and *The Defense of the Artillery Park,* today of unknown whereabouts. Beruete classifies the two paintings in the Prado as of "timeless reality."

FRANCISCO DE GOYA Y LUCIENTES
The Executions of May 3, 1808, 1814
Oil on canvas, 266 × 345 cm.

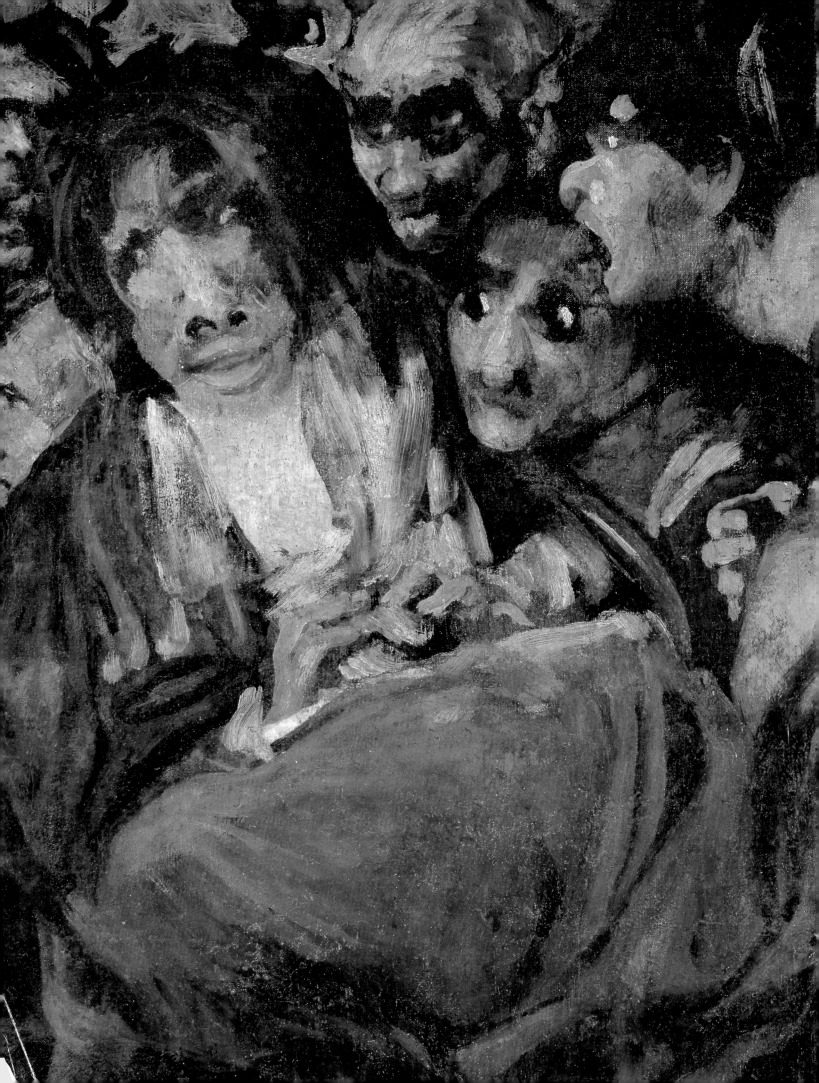

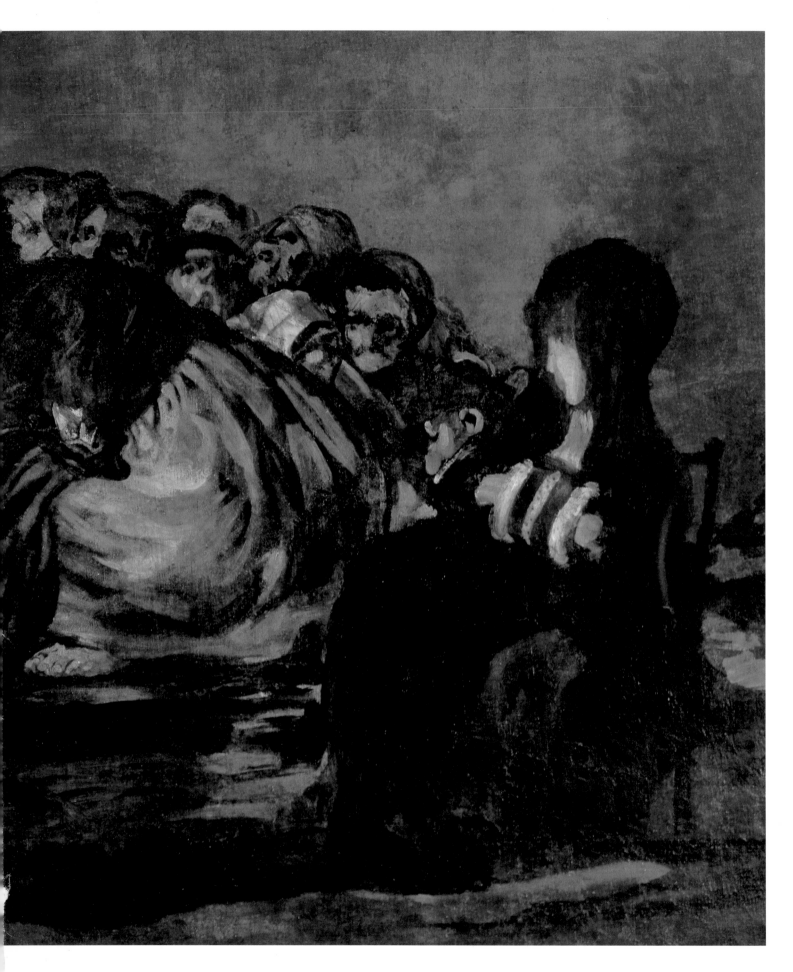

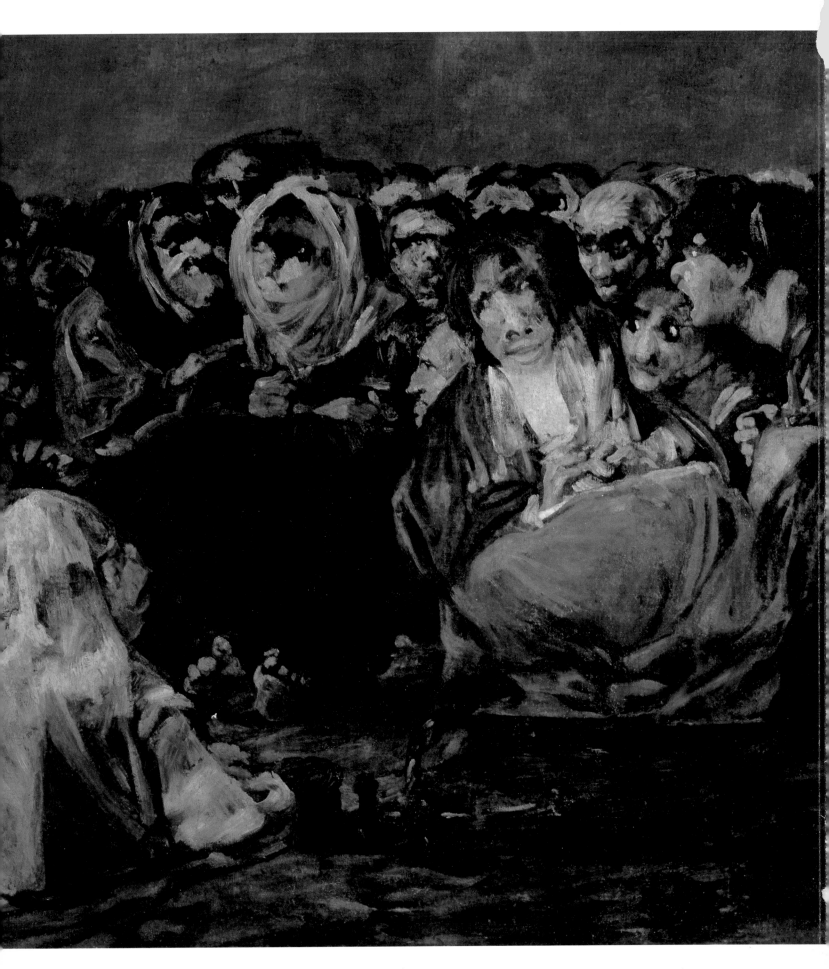

Produced a year before his death, this work is a kind of plastic testament from Goya. In reality, as Camón Aznar says, it was the painter's swan song, his challenge to those other realisms that, in his own time — and forever — constitute one of the poles of art. In this image his creation is truly ethereal and sweetly harmonious, almost musical, without any type of dissimulated naturalism affecting his own genius. Here we have the pre-Impressionist forerunner of Manet, but even finer than the latter in freshness of brushwork. Mayer speaks of vibrant technique, of the small brush strokes, comparing this work in its freshness with the poetry of Goethe, Goya's contemporary.

After Goya's death, as the artist himself had arranged, the painting was sold by Leocadia Weis, who had looked after the painter at the end of his life, to his friend Muguiro, for an ounce of gold. It is both wonderful and surprising that at eighty-one years of age this genius was still capable of making an about-face in his pictorial theories to achieve a coloring that reminds us of his tapestry stage, although now based on renewed criteria, and in a completely innovative way.

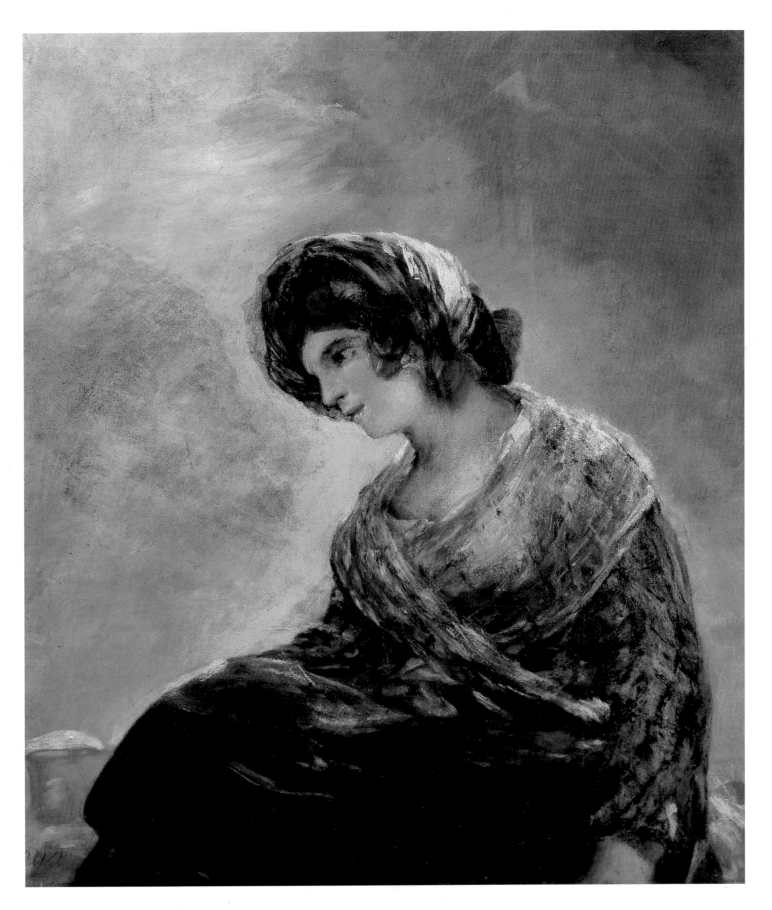

FRANCISCO DE GOYA Y LUCIENTES
The Milkmaid of Bordeaux, 1827
Oil on canvas, 74 × 68 cm

INTRODUCTION TO THE ITALIAN COLLECTION

It is well known that the Prado Museum is outstanding not only for its collections of masterworks by many painters and for the number of paintings that it possesses, but also for its outstanding collections of the works of certain great artists. When one considers the Italian collection, this becomes very evident. Half a dozen painters of outstanding ability are represented by an exceptional number of works.

First is Raphael, who is represented by four works, as many more from his workshop, and some early copies. Of later date are the three great sixteenth-century Venetian artists — Titian, Tintoretto, and Veronese. Titian is particularly well represented by more than thirty paintings, many of fundamental importance, the direct result of commissions from Charles V and Philip II. The catalogue for Tintoretto and Veronese comprises a dozen certain works in addition to others associated with their disciples.

From the seventeenth century we have works by Guido Reni from Bologna, whose fame and influence have been newly recognized and a dozen of whose paintings are here preserved. Since he was Spanish, Ribera is found earlier in the book, but his ample oeuvre kept in the Prado was done in Naples. Still within the seventeenth century is the Neapolitan, Luca Giordano. With his proverbial speed and productivity and his having lived in Spain for ten years, this artist left, in addition to a very large complement of frescoes, an astonishing number of canvases, of which almost fifty remain in the Prado, though some of these were not painted in Spain. Finally, in the eighteenth century, there is Corrado Giaquinto who also worked at the Madrid court for ten years; many of his works, painted both in Spain and in Italy, are in the Prado.

But the Museum's collection of Italian painting includes much more than just important works of these great artists. Other works from the sixteenth to the eighteenth centuries are represented: for example, paintings by seventeenth-century Neapolitan painters Jacopo Bassano and the Carracci family, and G. B. Tiepolo from Venice, who worked and died in Madrid. In all, about a hundred Italian painters are represented in the Prado, and the inventory of their works includes some seven hundred pieces.

This especially brilliant panorama requires some observations. It frequently has been stated that the Prado is weak in Italian works from the fourteenth and fifteenth centuries. However, these pieces were only taken from their places of origin relatively recently, when Spain did not enjoy the necessary prosperity to be able to acquire them, at the same time as needing to satisfy other requirements of cultural training and artistic sensibility. In addition, during the time in which they were carried out, when royalty, the nobility, and the Church could commission them or buy them,

Spanish taste was inclined toward the painting of the Low Countries. In the case of Queen Isabella, for example, it is significant that — apart from the fact that the greater part of her collection of paintings was delivered to the royal chapel of Granada — she possessed only a single Italian painting, a work by Botticelli. Some important artists who traveled to Toledo or Valencia, such as Starnina from Florence at the end of the fourteenth century, and Paolo de San Leocadio and Francesco Pagano in the last decade of the fifteenth century, did not have the links with the monarchy that would have permitted the preservation of their works in the royal collection.

But if nothing arrived at that time from painters then active, some isolated pieces, in general of great quality, came into the ownership of royalty and, later, into that of the Museum. This happened with the splendid panel by Mantegna that belonged to Philip IV and the beautiful altarpiece by Fra Angelico, which had come to Spain previously, although it did not arrive in the Museum until the nineteenth century was well advanced. The two Florentine panels of St. Eligius, dated around 1370, which have recently been attributed to the anonymous Master of the Madonna della Misericordia, are the works of greatest antiquity among the Prado's Italian possessions and were given by Francisco Cambó, as were the three panels from *The Story of Nastagio degli Onesti,* painted by Botticelli and his assistants. These gifts stemmed from this patron's laudable intention of filling the gaps in the Museum's collection from those centuries. The last great work, which for the moment completes this short panorama of important artists and exemplary paintings of the fifteenth century, is by Antonello da Messina, a painting of exceptional worth, not only for its beauty but also for the rarity of his known works and its splendid state of preservation.

For works created after 1500 the situation is very different. Of course, some principal figures, such as Leonardo da Vinci and Michelangelo, are missing; however, beside the fact that their preserved works are few, for obvious reasons they would be difficult to represent in any museum. The same pertains to the master initiators of Tuscan Mannerism: Pontormo (the Prado's painting catalogued under his name is a copy by Andrea del Sarto), Rosso Fiorentino, and Beccafumi. One can regret, too, the lack of representation of the Counter-Reformation Mannerists who worked for Philip II in the Escorial, but as a result of various historical circumstances their works did not come to the Prado from the royal collections. Among these are Cincinnato, Cambiaso (from whom there is some work, but not very definite), Zuccaro, and Tibaldi.

On the other hand, there are numerous splendid works by Raphael, Andrea del Sarto, and Sebastiano del Piombo, which cover the Florentine and Roman panorama in the first quarter of the century. Early Venetian painting is represented by a signed panel by Giovanni Bellini and a canvas attributed to Giorgione, although this may be

from the early period of his disciple Titian, by whom there are paintings encompassing all periods of his ouevre over sixty years. There are also works by Bordone and Catena. Raphaelesque Mannerism in Rome is seen in Penni's important copy of Raphael's *Transfiguration,* and a work by Giulio Romano. On the other hand, magnificent pieces originating in Verona (by India), Parma (Correggio and Parmigianino), Bergamo (Lotto), and Milan (Luini) are to be found in the Museum. Of the Florentine Mannerists, works by Bronzino, along with certain others of more controversial attribution by Salviati and Jacopino del Conte, are representative. From Cremona come interesting paintings by Lucia Anguissola (not to mention the numerous works that were painted in Spain by her sister Sofonisba) and those by the Campi family. Some Mannerist portraits originating in the north can be attributed more or less securely, such as those by Moroni, Dosso Dossi, and Girolamo da Carpi, among others.

In addition to works by Titian, who has already been mentioned, there are many Venetian works by the great masters from the mid-sixteenth century, such as those by Tintoretto, Veronese, and Jacopo Bassano, although those attributed to the latter need a radical reappraisal. Together with these are works by their relatives and disciples and by other artists such as Parrasio and Palma Giovane. Closing the sixteenth-century chapter we have Federico Barocci, who was one of the last but also one of the most important and influential painters of Counter-Reformation Mannerism; he is represented by two paintings of great quality, although one is dated 1604.

The section devoted to seventeenth-century Italian painting is just as rich, although it does not always find an appropriate and significant place in the Museum's rooms. Fortunately there are works from the great initiators of the currents that dominated the century, whose sadly short lives coincide with those of the last Mannerists, such as Barocci or El Greco. Splendid religious and mythological works by Annibale Carracci, his cousin Ludovico, and his brother Agostino are found here.

One of the four certain works by Caravaggio preserved in Spain is in the Prado, as are pieces by some contemporaries who were more or less in tune with his ideas. Giuseppe Cesari, called Cavaliere d'Arpino, remained faithful to Mannerist modes into the new century. On the other hand, Borgianni, from Rome, cultivated a naturalism of splendid modernity quite independently of Caravaggio; the three works by him in the Museum date from his sojourn in Castile. The collection's paintings by Cavarozzi and Antiveduto della Grammatica show less Caravaggism. A painter of mysterious identity, Il Pensionante del Saraceni (so named by Longhi for his relationship with the Venetian painter Carlo Saraceni) is represented in the Prado by one of the six or seven works in the world attributed to him. Also influenced by Caravaggio's realism were Serodine, Manfredi, and Tanzio da Varallo, each of whom is represented by one painting.

A work attributed to Cecco del Caravaggio has recently been identified as being by the Spanish painter Pedro Núñez del Valle. Orazio Gentileschi, a friend of Caravaggio's in Rome, passed through several phases and distanced himself from realism and tenebrism when he traveled as court painter; the Museum has some of his Roman works and one very significant canvas from his time at the Court of St. James in London.

Also represented are the principal classicists who learned from the Carracci family and disseminated this learning with variations on its language. Some splendid fragments are preserved — frescoes transferred to canvas — from the decorations in the Herrera chapel of Santiago de los Españoles in Rome, which were commissioned from Annibale Carracci, although Albani and other of his followers carried them out from his designs. Albani himself has two works typical of his oeuvre exhibited in the Museum. As already noted, a varied and representative group of Guido Reni's work from Rome as well as from Naples and Bologna, is also in the Museum. An important work by Domenichino that was commissioned by his patron Agucchi, as well as others painted subsequently in Rome and Naples, is in the collection. A more advanced moment with Baroque elements is seen in works by Guercino, the different stages of whose career are documented in the Prado. Works from the Parmesan painter Lanfranco's Neapolitan period are also in the Prado.

At this time Florence lost the principal role that it had held for centuries, but it still counted with artists of importance. In the service of the grand duke of Tuscany was the late Mannerist, Cristofano Allori. In contrast, one of Furini's masterworks, a piece of great modernity, is preserved. A seascape by Salvator Rosa is characteristic of his Florentine period. Political and commercial ties with Milan and Genoa explain the presence of works by Procaccini and Daniele Crespi on the one hand, and by Strozzi, Castiglione, and Assereto on the other.

Naples, together with Rome, and to an extent Bologna, formed the artistic hub of greatest activity during the century. That it was the capital of a Spanish viceroyalty meant that relations were very close between Spain and Naples in the artistic ambit. The case of Ribera is a clear example. But many other painters, natives of Naples or those who had come there to live, received commissions from the Madrid court, and their works also arrived in the royal collections by other roads as previously pointed out.

We now come to the painters who carried out series of paintings for the Buen Retiro Palace in the early 1730s. First was Massimo Stanzione, who painted a series on St. John Baptist, to which the Roman artist Artemisia Gentileschi contributed a single work. Lanfranco undertook a series of episodes from imperial Rome with the collaboration of Domenichino, Camassei, and others. Such Neapolitans as Falcone and Codazzi also painted pictures for Buen Retiro or sent their works through other

circumstances, as did Vaccaro. Distinct from these, in style and clientele, is Bernardo Cavallino, a work of whose has recently arrived; others traditionally ascribed to him are doubtfully so attributed. One work signed by Bassante follows his style.

Pietro da Cortona and Carlo Maratta, two of the finest seventeenth-century artists working in Rome, are each represented by several works; although from different generations, their paintings in the Prado are sometimes contemporaneous. Flower paintings by Mario Nuzzi, who had so much influence in Madrid, should be mentioned, as should works by Andrea Belvedere, who was in Madrid from 1694 to 1700.

After the death of Ribera and the plague of 1656, Neapolitan painting had two figures of special importance, first Mattia Preti, who has a single work in the Prado, which may not be from Naples. The other, Luca Giordano, whom we have already mentioned, was in Spain from 1692 to 1702 in the service of Charles II and for a short while in that of Philip V. He produced many pieces during this period, although many others were painted in Naples.

With reservations we can also cite a sketch for the painting of a ceiling, which has been attributed to Colonna and Mitelli, and probably is theirs, but which could also have been by a painter active in Madrid about 1660.

In the eighteenth century, Spanish relationships with Italy and Italian painters were of many and various kinds. Some came to Madrid in the service of royalty and others received commissions in Italy from Charles III when he was king of Naples. Other works came to the Prado through diverse circumstances.

Following the Neapolitan trail, we must mention Solimena. The works by Panini — who also sent others to La Granja Palace — seem to have arrived subsequently. Conca also worked on a series for this palace; the definitive works are in the National Heritage, not the Prado, but a sketch is in the Museum. The importance of Procaccini, who was in Spain almost fifteen years before his death in 1734, is greater in other fields than that of painting, but one work by him, a portrait, is preserved. The work by Bonito, an historic document, was certainly painted for Charles III in Naples. There are relatively abundant works by the two great artists who worked in Madrid in the service of Ferdinand VI — Amigoni and Giaquinto Corrado — as well as by a third master, Giovanni Battista Tiepolo, who worked for Charles III. A series by Giovanni Battista's son, Giandomenico, was completed after his return to Venice. From the painters who specialized in particular genres we have the work of Mariano Nani, who painted still lifes of game during the reign of Charles III and Charles IV, Joli and Battaglioli, who painted *vedute* in Madrid and Naples, and the Roman portrait artist Pompeo Batoni. Portrait artists not represented are numerous but perhaps not especially significant. The lack of Sebastiano Ricci and Piazzetta is

notable and, among specialists in the scenic genre, we miss Longhi and, for urban landscapes, Canaletto, Belloto, and Guardi.

With regard to the arrival in the Museum of Italian paintings, we have already noted that none belonged to the Roman Catholic kings. The oldest from the royal collections are related to the reign of Charles V. Among these are some by Titian, such as the portrait of the king on foot, which must have been painted in Bologna in 1532–1533, and those the painter presented to him in Augsburg in 1548, such as *Venus with the Organ Player and Cupid* and an *Ecce Homo,* and several painted at that time, headed of course by the great equestrian portrait. *The Furies* was commissioned by Mary of Hungary, who also brought to Spain the portraits of the Empress Isabella of Portugal and of the duke-elector of Saxony, which were painted in Augsburg when the duke was a prisoner. In 1551 the emperor commissioned from Titian *La Gloria,* which remained in Yuste until his death. Philip II sent it to the Escorial and from there it came to the Prado in 1837. It would also seem that the *Entry of the Animals into the Ark* attributed to Jacopo Bassano was bought by Titian for Charles V.

Philip II devoted all his energies to the creation and decoration of El Escorial, but he also commissioned works for other purposes, such as the portrait of himself Titian painted in 1551 in Augsburg and the two important mythological paintings (*Danäe* of 1553 and *Venus and Adonis* of the following year), sent a little later. Titian subsequently sent several religious works from Venice, such as *The Entombment* and *The Prayer in the Garden* and, finally, two important allegories: *Religion Supported by Spain* and *The Battle of Lepanto,* which arrived in 1575, a little before the master's death.

Another important group of paintings by various artists and with religious subjects, the definite origin of which is not always known, were sent to the Escorial by the king and came to the Museum a little after its inauguration. Notable among them are the *St. Jerome* by Lotto (1544 or 1546) and another of that subject by Antonio Campi, a *Holy Family* by Luini, which was given to Philip II in Florence, a panel on the same subject attributed to Andrea del Sarto, and *Santa Agueda* by Carlo Caliari, the son of Veronese. There are also two works by Michele Parrasio: the *Reclining Christ Worshipped by St. Pius V,* delivered to the Escorial, and the *Allegory of the Birth of Prince Ferdinand,* sent from Venice in 1575. In addition, between 1568 and 1574, Lucia Anguissola sent her portrait of their grandfather to her sister, Sofonisba, who lived at the Madrid court, and it remained in the royal collections.

Little is known about the arrival of Italian paintings to the royal collections during the reign of Philip III. However, it must be noted that the Emperor Rudolph made a gift to King Philip of the *Venus with the Organ Player and Cupid,* which thus returned to the collections (Charles V having given it to Granvela). On the other hand, Philip

IV was a great enthusiast and collector of paintings. During his reign, many Italian works arrived, as did others, both contemporary and from earlier times.

We now turn to some of the principal acquisitions of groups of works and single pieces through gifts by Spanish or foreign nobility. The decoration of the Buen Retiro Palace provided the reason for commissions of various series in Naples by the viceroy, the count of Monterrey, from 1633 or 1634, and subsequently by his successor, the duke of Medina de las Torres. Included were the series concerning St. John the Baptist by Stanzione and Artemisia Gentileschi; that on imperial Roman history by Lanfranco, Domenichino, Camassei, and Romanelli; one about the soldiers of ancient Rome by Aniello Falcone; and another of Roman buildings by Codazzi and Gargiulo.

A second group came from the collection of King Charles I of England. After his execution, his art collection was sold to pay the debts due his creditors, thus scattering it among different collections. Ambassador Alonzo de Cárdenas bought some works from the new owners for the account of Luis de Haro, who then offered most of these to the king. The purchases were made from 1650 to 1655. Preserved in the Prado from this source are *The Death of the Virgin* by Mantegna, *The Holy Family* (also known as *The Pearl*) by Raphael and *The Madonna of the Rose* from his workshop, *The Madonna of the Stair,* by Andrea del Sarto, *The Exhortation of the Marquis of Vasto* by Titian, *The Washing of the Feet* by Tintoretto, and two works by Palma Giovanni (*The Conversion of St. Paul* and *David with the Head of Goliath*). In addition to these purchases were those Cárdenas made in Flanders from the dowager countess of Arundel, which included *Jesus and the Centurion* by Veronese.

Sent by Philip IV to buy works of art, Velázquez made his second visit to Italy. Among his purchases now kept in the Prado are the Old Testament series and *La Gloria* by Tintoretto, *Venus and Adonis* by Veronese, and possibly *Jesus Disputing with the Elders* by the same artist; certainly he also bought two other Tintoretto works in Venice, *Judith and Holofernes* and *The Battle Between Turks and Christians*.

A fourth group of numerous and important works was acquired in Naples by the viceroy, the count of Peñaranda, from the collection left by Marquis Giovanni Francesco Serra on his death in 1656. Notable among other paintings are the nuptial portrait by Lotto, the portraits of the count and countess of Sansecondo by Parmigianino, *Venus and Adonis* by Annibale Carracci, *Atalanta and Hippomenes* by Reni, and a copy by Andrea del Sarto (*The Madonna and Child*).

But individual pieces also arrived in abundance. The duke of Urbino left Barocci's *Christ Crucified* (1628); the count of Oñate commissioned *The Sacrifice of Abraham* from Domenichino (1627–1628) and donated it a little later; and Orazio Gentileschi sent *Moses Saved from the Waters of the Nile* from London in 1633. Two works by

Sebastiano del Piombo were ceded to the king by Diego Vich in 1645 in settlement of family debts. On the occasion of his second marriage to Mariana of Habsburg in 1649, the grand duke of Tuscany gave Philip IV the beautiful painting by Furini. The Ludovisi family, perhaps at different times, gave the king the two Titian bacchanals and *Susanna and the Elders* by Guercino (along with its pendant, which is in the Escorial). For their part, the Barberini family gave *The Nativity and the Adoration of the Shepherds* by Pietro da Cortona in 1656. Other pieces, such as the pair by Albani and the seascape by Salvator Rosa, may also have been done for the king, and the work by Caravaggio also must have arrived during the reign of Philip IV.

In addition to the commissions made by the viceroys, other works were obtained for the benefit of the king. Some of the most important are Annibale Caracci's *Assumption,* obtained by the count of Monterrey; the duke of Medina de las Torres arranged for *The Madonna of the Fish* by Raphael, in San Domenico Maggiore in Naples, to be given to his sovereign in 1638; another gift to Philip IV was the *Noli me tangere* by Correggio and the work attributed to Giorgione. The viceroy of Ayala obtained Raphael's *Christ Falls on the Road to Calvary* in 1661. Titian's *Self-Portrait* was certainly acquired in the Rubens auction.

Charles II did not show the same enthusiasm for painting as his father and thus during his reign fewer Italian works than in the previous period came to the royal collections. However, this situation was largely compensated for by the work undertaken in Madrid and the Escorial by the Neapolitan Luca Giordano, who lived in Spain from 1694 to 1702. Not all the works housed in the Museum have come from the royal collections, but certainly an important group has.

Certain other works are also notable, such as the *Pietà* by Daniele Crespi, acquired in 1689 in the auction of the marquis del Carpio. The still life artist Giuseppe Recco also must have sent the work preserved in the Museum during the reign of Charles II. The painter died in Alicante in 1694, shortly after his arrival in Spain.

During the long reign of Philip V the most important event in the enrichment of the royal collections with Italian works was the acquisition in 1722 of the collection belonging Carlo Maratta. Through this purchase, works by several Italian artists were acquired. Those of undoubted attribution include *The Madonna and Child with St. John* by Annibale Carracci, the *Triumphal Arch* by Domenichino, Castiglione's *Diogenes,* and portraits of Albani by Sacchi and of Sacchi by Maratta himself. Various works were commissioned from Italy for La Granja, but almost all are still there or in the catalogue of the National Heritage; the Prado has only a sketch by Conca.

Queen Isabella Farnese made her own collection, which we know through the 1746 inventory made at the king's death. Such works as *The Madonna and Child with St. John*

by Correggio and Reni's *St. Sebastian* came from there. Assereto's *Moses and the Water from the Rock* is recorded as having been acquired in Seville. Cavarozzi's *Mystic Marriage of St. Catherine* was painted during the artist's sojourn in Madrid (1617–1619). In addition, a number of important works by Luca Giordano and a group of works by Solimena belonged to the queen. Finally, *The Turkish Embassy in Naples* by Giuseppe Bonito must have been sent from that city by the queen's son, King Charles.

The most important factor during the reign of Ferdinand VI was the stays at court of various Italian painters, principally Amigoni and Giaquinto, who succeeded the former after his death and remained for a short time under Charles III. The landscape artists Joli and Battaglioli were also there. Works by all these painters are in the Museum, coming from the royal collections, though the works by Joli were painted in Naples after his five-year stay in Madrid (1750–1754).

Something similar happened with Charles III. Tiepolo succeeded Giaquinto and worked at court from 1762 until his death in 1770. The Genoese Francesco Sasso came to Spain in 1753 and died in Madrid in 1776. Two scenes from his genre are preserved. Mariano Nani, of Naples, arrived at the beginning of Charles's reign and died in 1804; three still lifes are attributed to him. Various works from the marquis of Ensenada's collection were acquired by the king, including *Rubens Painting an Allegory of Peace* by Luca Giordano and *The Birth of St. John Baptist* by Andrea Sacchi.

During his father's reign, Prince Charles acquired various works (or at least he began to take notice of works of art), as he would continue to do once he became king. The most important are *The Holy Family with a Lamb* and *Portrait of a Cardinal* by Raphael and *The Sacrifice of Abraham* by Andrea del Sarto. We can hardly name any noncontemporary Italian work acquired by Ferdinand VII. In 1827 he bought the *Madonna with Sleeping Child* by Sassoferrato from the Capuchins in Madrid. There is little of importance to note for the reign of Isabella II in respect to Italian painting.

Later, from 1870 on, the stocks of the Museo de la Trinidad were integrated into the Prado. These came from the Disentailment of the assets of the convents and monasteries, which was fundamental to the collection of Spanish painting of the Prado, but less so for its enrichment in Italian works. All the same, one can identify some important pieces: *The Transfiguration* by Penni (copying Raphael); *Christ Crucified* by Borgianni; *The Holy Family and Cardinal Ferdinand de' Medici,* a work by Alessandro Allori from 1583; the fragments of the fresco decorations from the Herrera chapel of Santiago de los Españoles in Rome, designed by Annibale Carracci and carried out by his disciples; works by Giordano; *The Assumption* by Gregorio de Ferrari; and Giandomenico Tiepolo's *Via Crucis* series for St. Philip Neri.

Throughout the twentieth century, gifts and bequests, like acquisitions, have been

important though sparse. The Pablo Bosch bequest in 1915 was very generous and included a work possibly by Cima da Conegliano and others by the Venetian Zanchi, by Solimena, and by Giaquinto. In 1917, through the bequest of José María d'Estoup, Vincenzo Campi's *Crucifixion* came to the Museum. Another legacy was that of Luis Errazu in 1926, which brought *The Vision of St. Paschal Baylon* by Tiepolo, which came from the high altar of San Pascual in Aranjuez. Earlier, in 1924, Tiepolo's *Abraham and the Three Angels* was received through the gift of the Sainz family. In 1929 a presumed self-portrait by Bernini was acquired.

The most important Cambó donation came after the Civil War, in 1941, and it included several Italian works. More recent specialized studies have rejected the authenticity of some of these. But, in any event, the Prado was enriched with the two panels attributed to Taddeo Gaddi, which are now believed to be by the Master of the Madonna della Misericordia, and the three panels of *The Story of Nastagio degli Onesti*, painted by Botticelli with the assistance of his workshop.

In succeeding years few Italian works have come to the collection. Occasionally and sporadically certain pieces were acquired and there has been the occasional donation. The reasons for this could be listed as a low budget, high market prices, and the absence of a tradition of gifts and legacies in Spain.

However, the Prado has been able to display works of interest that have arrived in the last half century. In 1956 a version of *St. Charles Borromeo* by Giordano was purchased. More important was the acquisition in 1959 of *St. Anthony of Pàdua with the Child Jesus,* painted by Tiepolo for San Pascual de Aranjuez, which augmented, though did not complete, the Museum's canvases from this series. The arrival of the panel by Antonello da Messina in 1965 was sensational, given the rarity of his known works and its splendid state of preservation. A magnificent work painted by Tiepolo in his youth, the large canvas of *Queen Zenobia before Emperor Aurelian,* was bought in 1975. The *Diogenes* attributed to Giuseppe Antonio Petrini, an artist from Ticino who was not previously represented in the collection, was acquired in 1992.

As for recent gifts, there have been a number of praiseworthy events. In 1968 *St. Christopher,* a work signed by Borgianni, was given by José Luis Várez-Fisa, thereby increasing the display of works by this important painter who lived in Spain for several years. In 1989, the Friends of the Prado Museum Foundation donated *Stoning of St. Stephen* by Bernardo Cavallino, a work of special refinement and quality. More recently, in 1993, in compliance with the will of his son, who died young, Manuel González sent to the Museum the *Liberation of St. Peter* by Giuseppe Marullo, a work painted in Naples around 1630–1635, which had belonged to the Prince Don Sebastián Gabriel de Borbón.

With its companion work, *King Clotaire I Commissioning St. Eligius,* this belonged to the Toscanelli collection in Pisa in 1883 and was donated to the Museum by Francisco Cambó in 1941.

The two small panels, together with *The Funeral of St. Eligius* (formerly in the Drey collection, Munich), formed part of an altarpiece that was generally attributed to Taddeo Gaddi of Florence (1300–1366), which has been maintained in the Museum catalogues until recently. Other opinions have attributed these works to Agnolo Gaddi and Niccolò di Pietro Gerini. However, they are now believed to be by the Master of the Madonna della Misericordia, an anonymous Florentine artist named for his panels in Florence's Accademia.

In this continuation of the theme on the other panel, the holy bishop of Noyon hammers the throne commissioned by Clotaire, for which the goldsmith has received several gold bars. Two other goldsmiths work on a pyx and a cross and two more at the back handle the hammer and bellows, while we see crowns, chains, and belts hanging from the walls. The panel is interesting as a portrayal of a goldsmith's workshop, operating open to the street, with the bench covered with an attractively designed Anatolian woolen cloth; attending members of the public wear the fashionable garb of the time.

The space is supported architecturally, and the stylized figures, with dark complexions and finely drawn faces with repeated features, reinforce the profundity of the scene.

MASTER OF THE
MADONNA DELLA MISERICORDIA
St. Eligius in the Goldsmiths' Workshop
(Detail)

MASTER OF THE MADONNA DELLA MISERICORDIA (active third quarter of fourteenth century)
St. Eligius in the Goldsmiths' Workshop, c. 1370
Tempera on panel, gilded ground, 35 × 44 cm

MASTER OF THE MADONNA DELLA MISERICORDIA
King Clotaire I Commissioning St. Eligius, c. 1370
Tempera on panel, gilded ground, 35 × 44 cm

ALTARPIECE OF THE ANNUNCIATION

This is one of the three altarpieces the Dominican monk made for the convent of San Domenico in Fiesole, where he lived until his transfer to San Marco in Florence in 1438. The altarpiece was bought in 1611 by the duke of Lerma who hung it in San Gregorio in Valladolid; it then passed to the Royal Discalced in Madrid and came to the Prado in 1861.

In spite of unfortunate restorations after the Civil War that particularly affected the principal scene, the work has great interest as an example of the type of convent altarpiece the painter undertook during his sojourn in Fiesole. Dedicated to the Virgin, it is composed of a principal scene with five others below it, generally, as here, of great novelty and modernity.

This altarpiece was produced shortly after the death of Masaccio in Rome in 1428. Angelico shows here a preoccupation with profundity, the arrangement of figures in space, and for their corporeal nature and volume. There still exists a time and place confusion in the setting of the Expulsion from Paradise (seen to the left of the Annunciation) and a lack of relation between the Virgin and the Angel. Both aspects would be corrected in the same scene in the Cortona altarpiece of 1434.

Among the small border scenes, done with the exquisite miniaturist technique that Angelico must have possessed, we find the surprising scene of the Purification of the Virgin, in which there is a small temple with a central floor — like Ghiberti's on the doors of the Baptistery (before 1437) and Brunelleschi's Rotunda (after 1436), a sign of a common Florentine preoccupation — and some streets with contemporary houses, which are lost in perspective.

FRA GIOVANNI DA FIESOLE, called FRA ANGELICO
Altarpiece of the Annunciation (fragment)

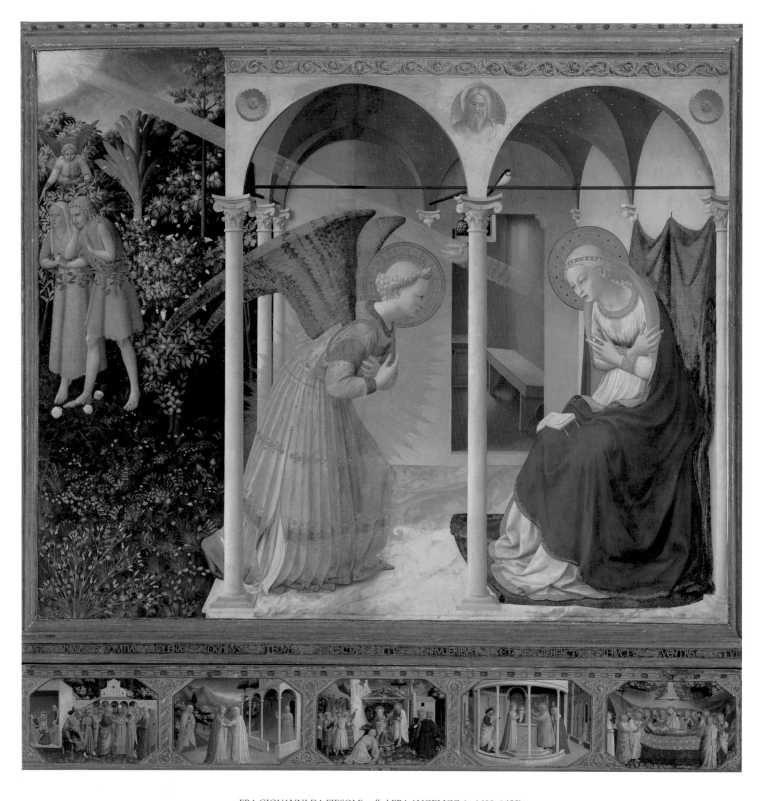

FRA GIOVANNI DA FIESOLE, called FRA ANGELICO (c. 1400–1455)
Altarpiece of the Annunciation, c. 1430
Tempera on panel, 194 × 194 cm

THE DEATH OF THE VIRGIN

The panel belonged to the dukes of Mantua until 1627 and subsequently to Charles I of England. On his death in 1649, it was bought by John Baptist Gaspars and then by Ambassador Cárdenas in 1653 for Luis de Haro, who gave it to Philip IV.

Although originally the work was completed at top by the vaulting of the room and Christ supporting a little figure that symbolizes the soul of the Virgin (a fragment now in the Ferrara Pinacoteca), this is not an obstacle to the Prado's painting being considered a masterwork in its current state.

The dating and location of the painting in the chapel in the ducal palace at Mantua is a matter of dispute. Some believe that it formed a triptych with the *Ascension* and the *Circumcision* in the Uffizi but, as Christiansen wrote, the differences in the figures and the architecture are important. The work can be dated to the arrival of Mantegna in Mantua in April 1460; thus it serves as a bridge between the naturalism of his work in Padua and the classicism of his work in Mantua.

The funereal severity of the architecture and the rigorous development of the perspective are continued in the novel view of Mantua, a precursor of Realist landscape, and in the solemn but active presence of the apostles, which serves as a counterpoint for the color of their clothing.

ANDREA MANTEGNA (1431–1506)
The Death of the Virgin, c. 1460
Tempera on panel, 54 × 42 cm

THE DEAD CHRIST SUPPORTED BY AN ANGEL

Due to the scarcity of works by Antonello and the poor condition of those known, the acquisition of this panel by the Museum in 1965 was surprising since the work was generally unknown. It came from Irún and before that from Galicia; very probably it belonged to the College of Jesuits of Monforte de Lemos.

The iconographic style must originally have come from a German wood engraving, disseminated from Donatello onward in Padua in the middle of the century and appearing with variations in works by painters from Venice. For this reason it is thought that the work was painted in Venice, where Antonello lived until 1476, when he returned to Messina, where he died at the beginning of 1479. It is also possible that he painted it in his own city, not only because it seems to be Messina that is represented in the background, but due to the fullness of its anatomical character and the luminosity and brilliance of the colors. The expressive and chromatic contrast between the dead Christ and the weeping angel is outstanding, as is the carefully studied composition. The result is a devotional image of great impact, clearly painted to fulfill a private commission.

ANTONELLO DA MESSINA
(c. 1430–1479)
The Dead Christ Supported by an Angel,
c. 1476
Oil on panel, 74 × 51 cm

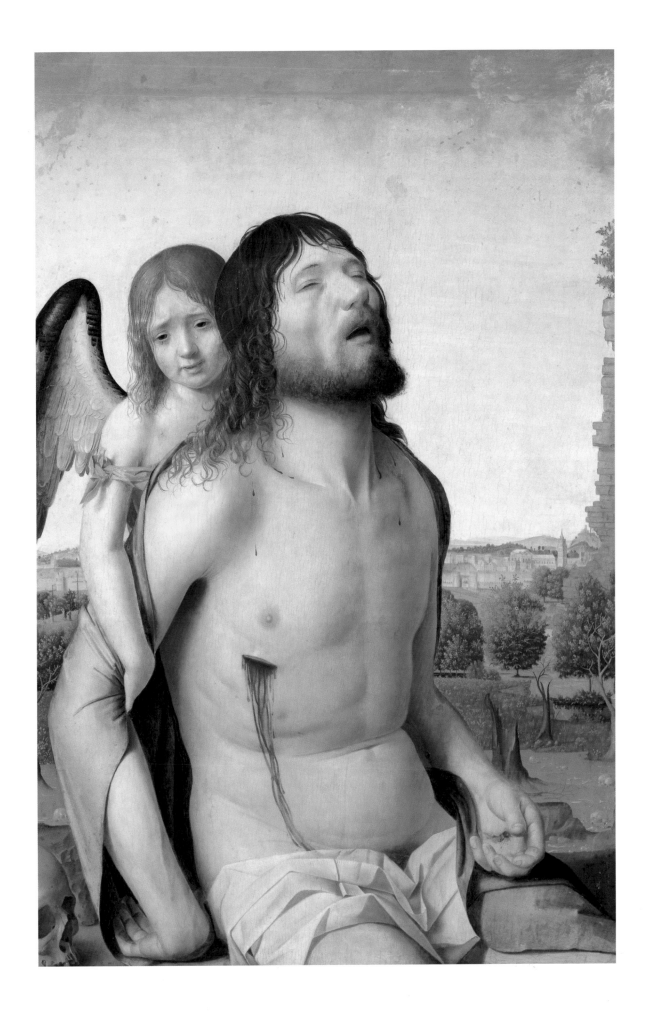

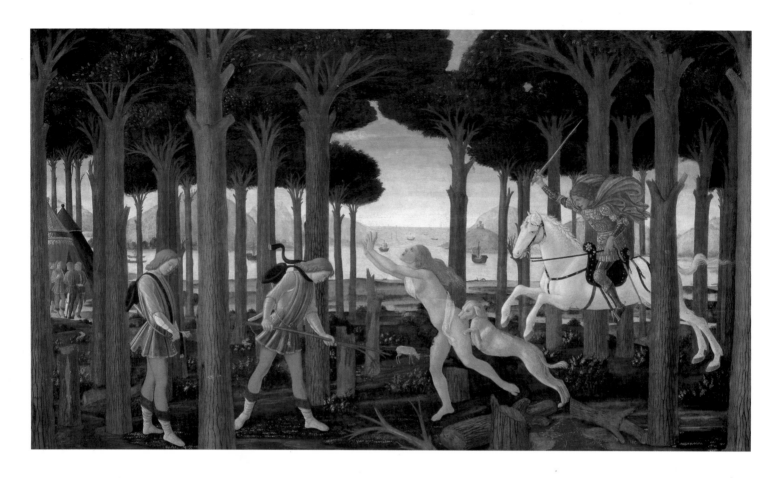

SANDRO BOTTICELLI (1445–1510)
The Story of Nastagio degli Onesti (I), 1483
Oil on panel, 83 × 138 cm
(Detail on page 230)

THE STORY OF NASTAGIO DEGLI ONESTI

With the other two panels in the Museum and a fourth in a private collection abroad, this belonged to the Pucci family of Florence, where Vasari noted them in 1568. They remained there for almost four hundred years, coming to the Prado in 1941 through the Cambó donation.

As the coats of arms of both families appear, it is thought that they formed part of a marriage chest or bed given on the occasion of the wedding of Gianozzo Pucci and Lucrecia Bini in 1483, and that they were commissioned by Antonio Pucci, father of the groom, or by Lorenzo de' Medici, as he arranged the marriage and his arms also appear.

The story of Nastagio comes from Boccaccio's *Decameron* (Day 5, book VIII). A young man is scorned by his lady, but she agrees to marry him when she sees the strange punishment of another disdainful lady who drove her lover to suicide. In the first panel Nastagio is contemplating his misfortune when the condemned lady appears, caught by a hound of her dead, former lover, the ghostly horseman who pursues her. Art historians agree that the conception of the work is Botticelli's, although the participation of Jacopo del Sellaio and Bartolomeo de Giovanni, which increased in successive panels, reduced the quality. In this, the first one, the contrast between the somber foreground and the luminosity of the background is outstanding, with the two figures of Nastagio filled with melancholy. The coloring and quality of the fabrics are extraordinary.

Pages 233–234
The Story of Nastagio degli Onesti (II)
Oil on panel, 82 × 138 cm

Pages 235–236
The Story of Nastagio degli Onesti (III)
Oil on panel, 84 × 142 cm
(Detail on page 231)

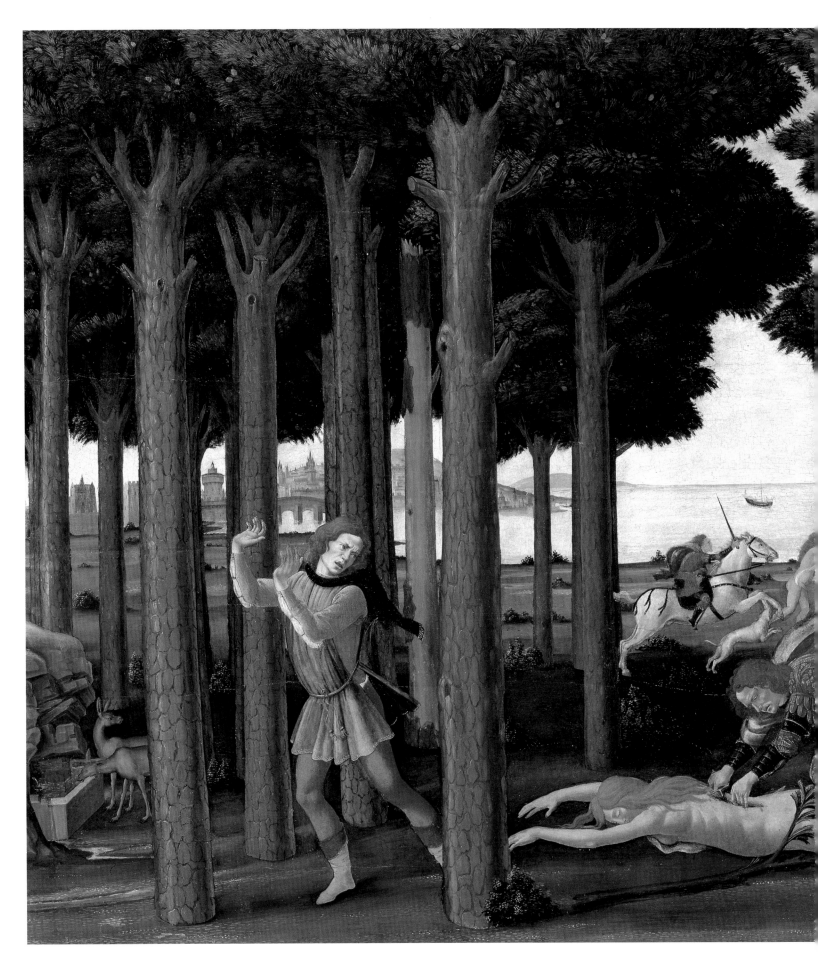

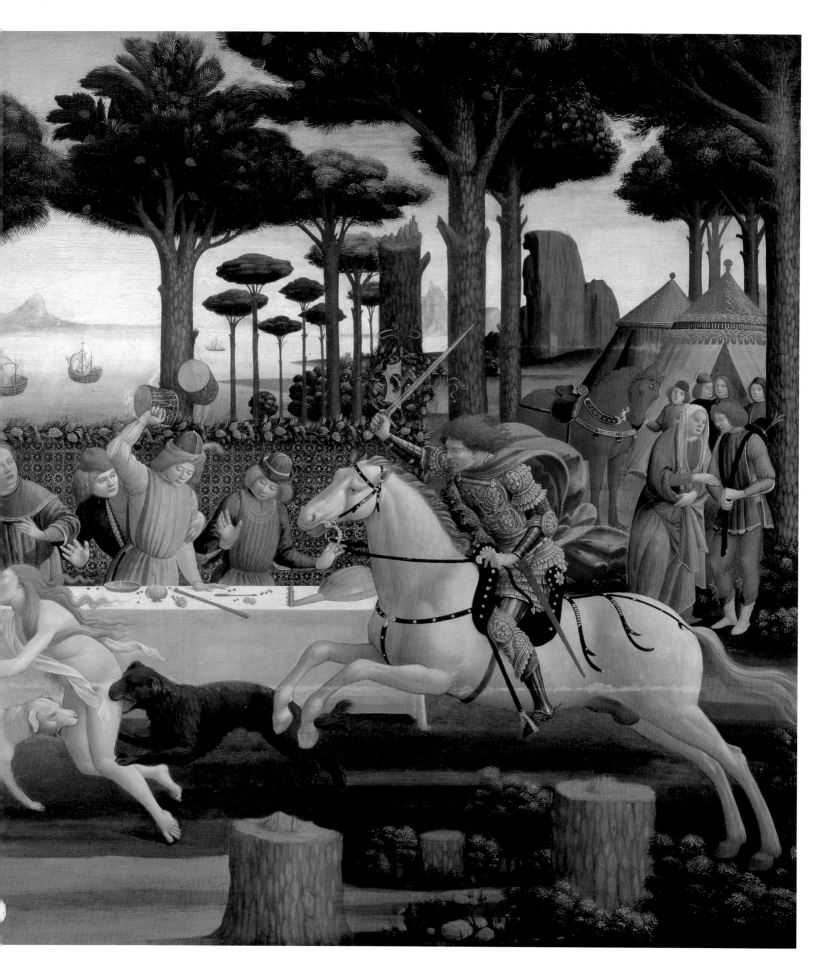

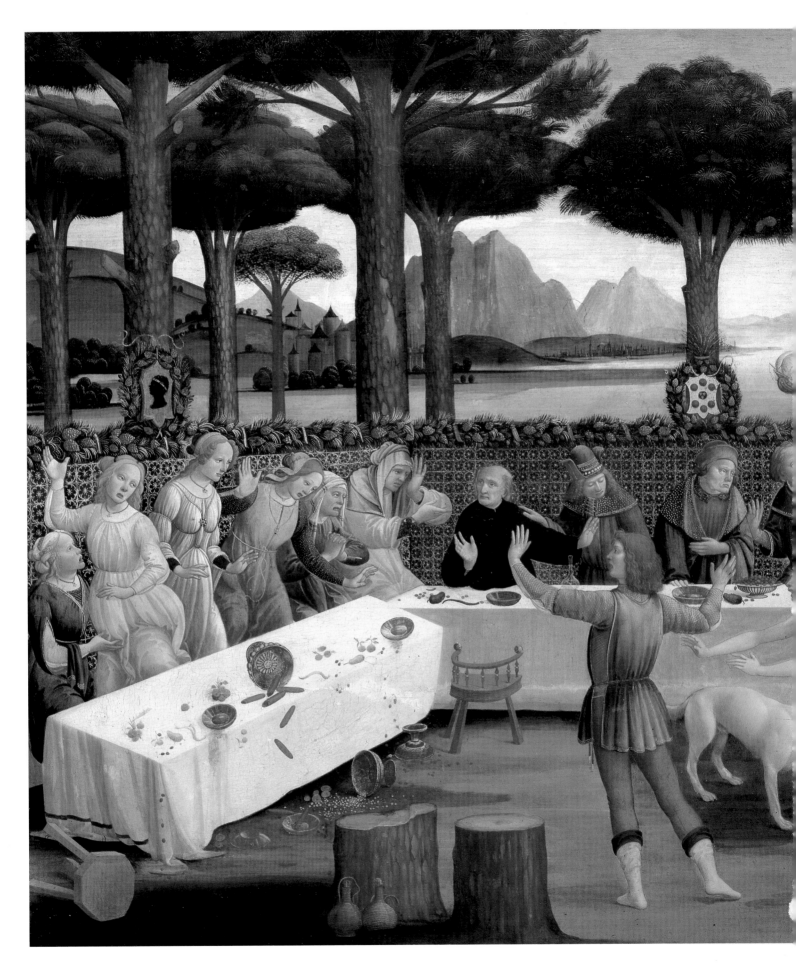

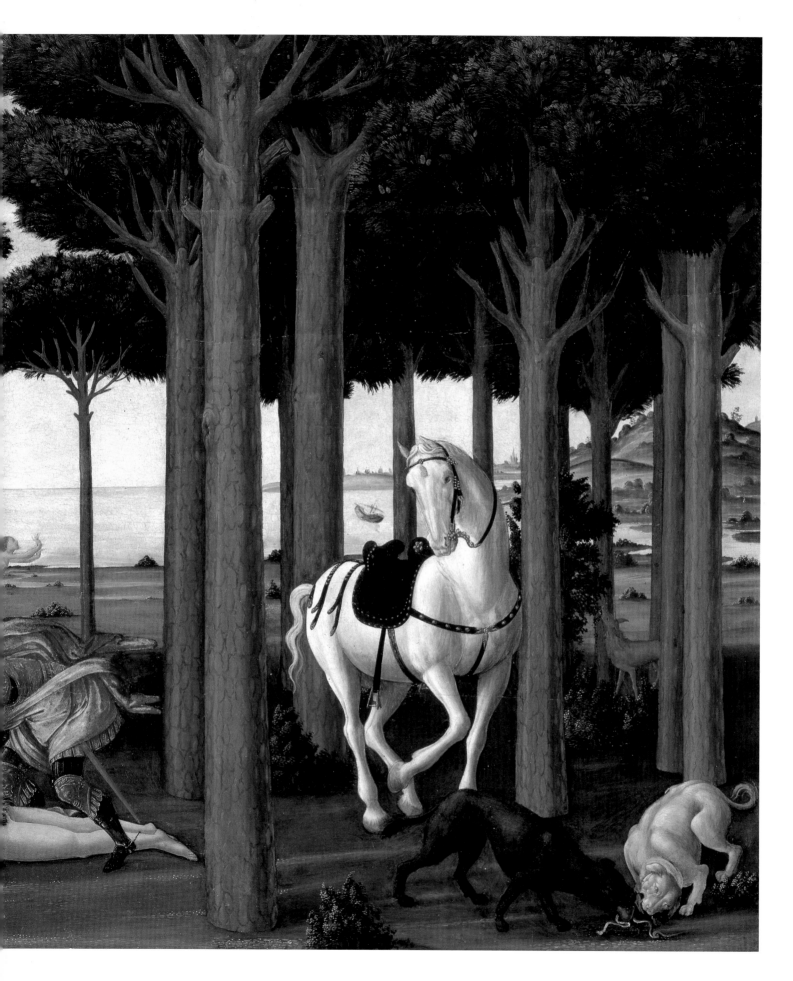

GIOVANNI BELLINI (1430–1516)
Madonna and Child Between SS. Catherine and Ursula, c. 1500
Oil on panel, 77 × 104 cm

MADONNA AND CHILD BETWEEN SS. CATHERINE AND URSULA

This panel is signed in the painter's usual manner and is a version, with variations, of one of greater quality in the Venice Accademia, for which reason it is sometimes thought that this piece was done by Bellini's workshop. In any event, the authentic signature guarantees that the master took part. The Venetian work was bequeathed in 1850 and the one in Madrid entered the collection of Philip V through his purchase of the Maratta collection. The previous location of both paintings is unknown.

There are differences between the figures of the saints in the two versions. In the Venetian example they are identified as Catherine and Mary Magdalen. Although the Madrid figure on the left has a different expression, it must be St. Catherine, while the arrow identifies St. Ursula, who bears no similarity to the Accademia Magdalen. In addition to the iconographic variation, the Virgin embraces the Child in a different way and the wide blank girdle above does not exist in the Venetian version. Some elements of the better example suggest a knowledge of the work of Leonardo, who was in Venice in March 1500. The Prado picture is also from about this time.

The precise and very refined manner of coloring, in which the figures stand out from the shadow in the Venetian example, is muted in this work, with the background a little lighter. The drawing is also more incisive in the Madrid version, whereas the face of the Accademia Magdalene is smoothly blurred.

THE HOLY FAMILY WITH A LAMB

The signature of the painter on the border of the Virgin's neckline, with the date 1507, indicates that this work was painted in Florence. Through its small size and its subject matter, there is no doubt that this was a commission for private devotion, but the client remains unknown. Charles IV acquired it from the Falconieri collection in Rome and had it placed in the boudoir in the Escorial.

From the iconographic point of view it represents the Rest on the Flight into Egypt, as in the background we see the journey of the Holy Family. During his sojourn in Florence (1504–1508), Raphael was often commissioned to paint works on a subject as pleasing and devotional as that of the Holy Family. The composition and the human models (except for the figure of St. Joseph, which comes from Fra Bartolommeo) show an awareness of Leonardo, although with original transformations. The landscape, on the other hand, demonstrates the influence of Perugino.

Raphael's early classicism is demonstrated in the combination of triangles in the composition of each figure and of the work as a whole. This classicism is also evident in the division of areas of color: white for the Child and the lamb, carmine and blue for the Virgin, and grey-blue and orange for St. Joseph. The balance is completed in a logical way in the affectionate relationship between the figures, which close and round off the work.

PORTRAIT OF A CARDINAL

This work was acquired by Charles IV when he was prince of Asturias; its previous whereabouts are unknown. In 1818, in Aranjuez, it was calatogued as a portrait of Cardinal Granvela by Antonio Moro, according to an inscription on the back. In reality the painting is unanimously recognized as a masterwork by Raphael, from the beginning of his period in Rome; on the other hand, what has not been agreed upon is the identification of the sitter. The names of no less than a half-dozen cardinals who were in Rome around 1510 are proposed, as the portrait is usually dated about this year. Perhaps that of Bandinello Sauri, who died in 1518, has the greater number of votes.

A technical study of the work shows very secure drawing with only very slight modifications in the final painting. Raphael used a vermilion red for the cape and lead white with fine brush strokes to show the watering that makes the quality of the satin even more smooth and brilliant. The front arm tempers the imposing force of the reds, while reinforcing the distance and superiority with which the cardinal is presented to us as a paradigm of reserve, intelligence, and diplomacy.

THE MADONNA OF THE FISH

This large canvas was commissioned by Giovanni Battista del Duca for his chapel of Santa Rosalia in San Domenico Maggiore in Naples. At the commencement of his viceroyship in 1638, the duke of Medina de las Torres obtained this painting from the Dominicans and presented it to Philip IV who sent it to the Escorial in 1645, where Velázquez placed it in the Little Hall sometime before 1657. It was taken by the French to Paris in 1813 and returned in 1818, having been transferred to canvas (it was originally on a panel). Preparatory sketches are well known, which explains the absence of reworking in the final canvas.

The presence of Tobias with the Archangel Raphael, and St. Jerome with the Vulgate Bible on the opposite side, has signified an affirmation of the authenticity of the Book of Tobias, which was included by St. Jerome in his Latin translation of the Bible and was accepted by the Catholic church. It was later the subject of controversy and ultimately rejected by the Protestant Reformation.

Although the date of the painting is unknown, its size and Roman classicism date it around 1513, as these are not much seen in the rare subsequent altarpieces. The composition is balanced, solemn, and frontal, the atmosphere severe, the figures simple and powerful, the relations between them closed and in opposition. The color, less dainty and with a deeper tone than in the Florentine works, abounds in nuances in the ranges of the greens and blues and the reds and ochres.

CHRIST FALLS ON THE ROAD TO CALVARY

Philip IV referred to this large painting as the pearl of his collection and it was always valued at the highest price, comparable only to *Las Meninas*. It was done for the convent of the Order of Mount Olive of Santa Maria dello Spasimo de Palermo, from where it acquired the name "El pasmo de Sicilia," by which it was known in Spain in the seventeenth century. Viceroy Fernando de Fonseca, Count of Ayala, sent it to Philip IV in 1661, and the king undertook to pay 4,000 ducados annually to the convent. In 1663 it was placed on the high altar of the chapel of the Alcázar. In Paris it was transferred from panel to canvas before being returned in 1818. Agostino Veneziano made an engraving after the painting in 1517 and Raphael's influence on European painting was very much broadened by this print as well as directly.

It is just possible that Raphael received assistance from important collaborators with this work — always a controversial question. The painter's novel conception and the unquestionable quality of the work justify its fame. The classicism understood as balance and coherence between all the elements, which Raphael had employed in his works to this point, was now split. This composition abounds in geometrical structures, contrasts and repetitions, disproportion between closed and open spaces, large and small figures.

Unmeasured or undefined anatomies under the clothing, snakelike figures, theatrical and uncertain expressions, show the fragmentation of form and feeling. The work anticipates the Mannerist tendencies that would come to the fore some years later as witness to a vision of a world lacking harmony and concern for the human condition.

RAFAELLO SANZIO, called RAPHAEL (1483–1520)
The Holy Family with a Lamb, 1507
Oil on panel, 29 × 21 cm

RAPHAEL
Portrait of a Cardinal, c. 1510
Oil on panel, 76 × 61 cm

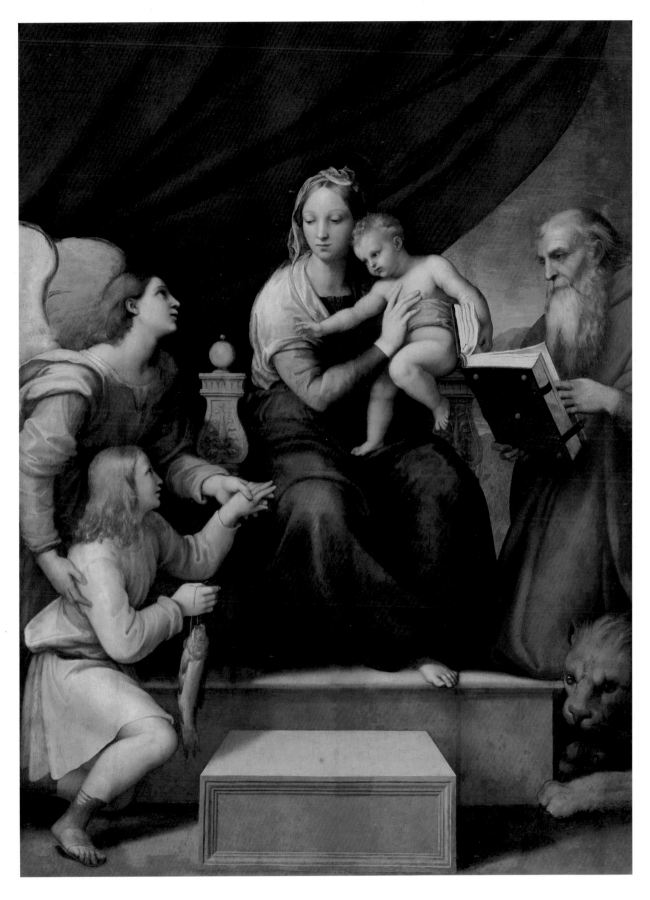

RAPHAEL
The Madonna of the Fish, c. 1513
Oil on canvas, 215 × 158 cm

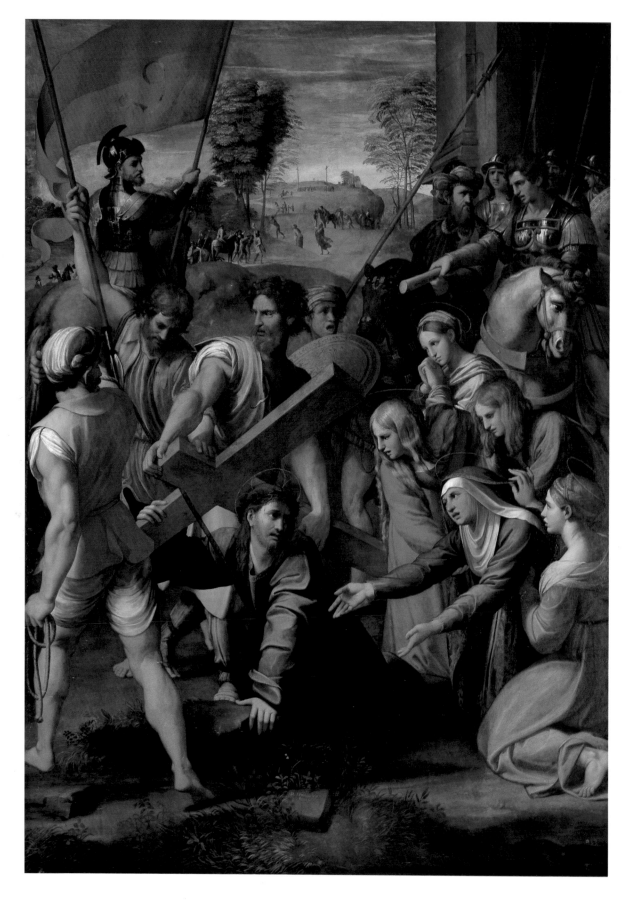

RAPHAEL
Christ Falls on the Road to Calvary, c. 1517
Oil on canvas, 318 × 229 cm

GIORGIO DEL CASTELFRANCO, called GIORGIONE (1476/78–1510)
Madonna and Child with SS. Anthony and Rock, c. 1510
Oil on canvas, 92 × 133 cm

MADONNA AND CHILD WITH SS. ANTHONY AND ROCK

The classification of this painting is typical of the controversy over the attribution of certain works to Giorgione or to the young Titian. After arguments that have now gone on for more than half a century, there are still partisans of both positions with respect to this painting. It is clear that the early works of Titian would be similar to a great degree to that of his master, and from there, lacking any documentation, the question is without solution.

It would seem that this work was acquired by the duke of Medina de las Torres, who delivered it to Philip IV in 1650. In 1656 Velázquez placed it above one of the doors of the sacristy in the Escorial. Attributions have varied throughout the centuries from Giorgione to Titian, but it has also been attributed to Pordenone and Bordone because of their phonetic similarity to the name of the first. The identity of the saints is generally agreed, although

one art historian holds that one is St. Francis the monk.

There are similarities to Giorgione's *Castelfranco Madonna* in the spatial breadth and the conception of large chromatic, contraposed masses as well as less significant details (such as the similar brocade fabric). The principal differences are the greater fluidity of the brushwork and a more determinant development of light and color.

PORTRAIT OF A YOUNG WOMAN

This portrait has traditionally been identified as the artist's wife, Lucrezia di Baccio del Fede, whom Andrea married in 1518, shortly before he traveled to France, where he was in the service of Francis I for fifteen months. But recent art history finds no evidence that this is in fact his wife. It is usually dated a little before the wedding, but the similarity of the model, atmosphere, and color to the fresco of *The Birth of the Virgin* in the Church of the Annunciation in Florence makes the date of 1513–1514 more likely.

This portrait makes irrelevant the romantic and tragic stories about the contemptible personality of Lucrezia, which some critics contrive to find portrayed as malignant in the sitter; this, of course, is no obstacle to the quality and originality of the work. Andrea seldom painted portraits; those he did were only of his family and in his last working years. However, in all of these a calmness and serenity predominate, as seen here, without ever taking on nobility.

It is this — the domestic and bourgeois aspect of the sitter — that separates his work from that of Raphael, or his disciple Pontormo. The highly nuanced, gentle color, the filtered light, the blurred feeling of the image, are all unusual features. The elongation of the oval and the figure presage Mannerism.

Though exactly when this came into the royal collections is not known, it is clearly listed at the death of Charles III.

THE MADONNA OF THE STAIR

Vasari notes this painting, signed with an anagram, as a work done for Lorenzo Jacopi, who it seems was the Florentine banker Lorenzo di Bernardo (1476–after 1549). It must have been painted about 1522, for in the following year Andrea fled from Florence to escape the plague. In 1605 it passed to the duke of Mantua and then to Charles I of England. After that king's death, Ambassador Alonso de Cárdenas bought it in 1651 for Luis de Haro, who sent it to Philip IV. In 1656 Velázquez hung it in the sacristy of the Escorial.

The identification of the characters, with the exception of the Virgin and Child, has been the subject of some discussion. Vasari wrote nothing, and other art historians have considered the figure on the left to be Tobias, St. Matthew, or St. John the Evangelist, but none of these interpretations are really satisfying. The mother and child fleeing in the background must be St. Elizabeth with St. John the Baptist, who escape the Massacre of the Innocents by Herod, according to the early gospel of St. James the Less (22:3), the oldest book of the Apocrypha, which began to acquire prestige in the West, the first Latin translation of which was published in 1552. Thus, the foreground figure on the left must be this apostle. (Note that the painting was commissioned by a man called Jacopi, which would defend the authenticity of the text — and it is this gospel the angel holds.)

Apart from the unusual subject, the work is interesting for its extraordinary quality. A solid triangular structure with strong figures composed with intelligent and varied outlines; intense expressions, with the sad unease of the Virgin, very typical of Andrea; and a diffused landscape in the style of Leonardo are some of its characteristics. But its greatest modernity rests on the chromatic combinations, the profiled trimmings of the garments, and the absence of shadows in some areas of the Virgin's tunic, all of which herald Mannerist tendencies.

THE SACRIFICE OF ABRAHAM

In 1529, or a little before, Andrea painted a large version of this subject for Giovanni Battista della Palla, which must be the painting in Dresden. He repeated the work in 1529 on a smaller scale for Paolo de Terrarossa, but, according to Vasari, without its being in any way inferior to the first. On the death of the painter, it was bought by the marquis of Vasto, who paid Lucrezia for it in 1531; some time later it was acquired by Charles IV. Yet another, unfinished, version in Cleveland could have been the initial idea.

Andrea found inspiration in the *Laocoön* for the figure of Isaac and conceived a complicated pyramidal composition with a strong slant in the arm of Abraham. At the same time he emphasized the contrast in size between father and son, and also between the lamb and the servant. But the most notable aspects are the provocative vitality and the impassioned and pathetic feeling. Some have tried to see signs of the Baroque here, when surely his skill, like other elements, is an example of Mannerism.

ANDREA DEL SARTO (1486–1530)
Portrait of a Young Woman, c. 1513–1514
Oil on panel, 73 × 56 cm

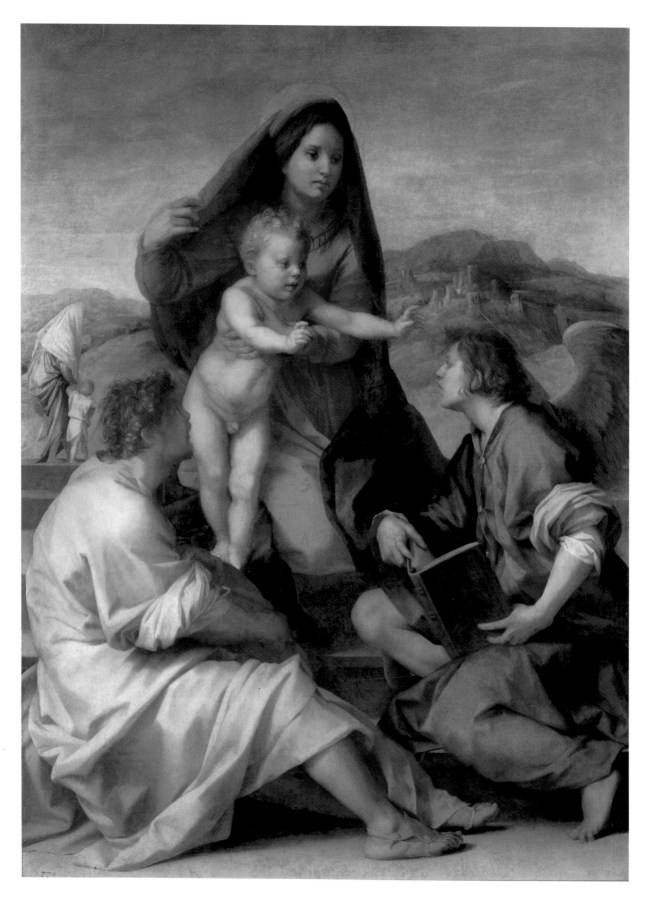

ANDREA DEL SARTO
The Madonna of the Stair, c. 1522
Oil on panel, 177 × 135 cm

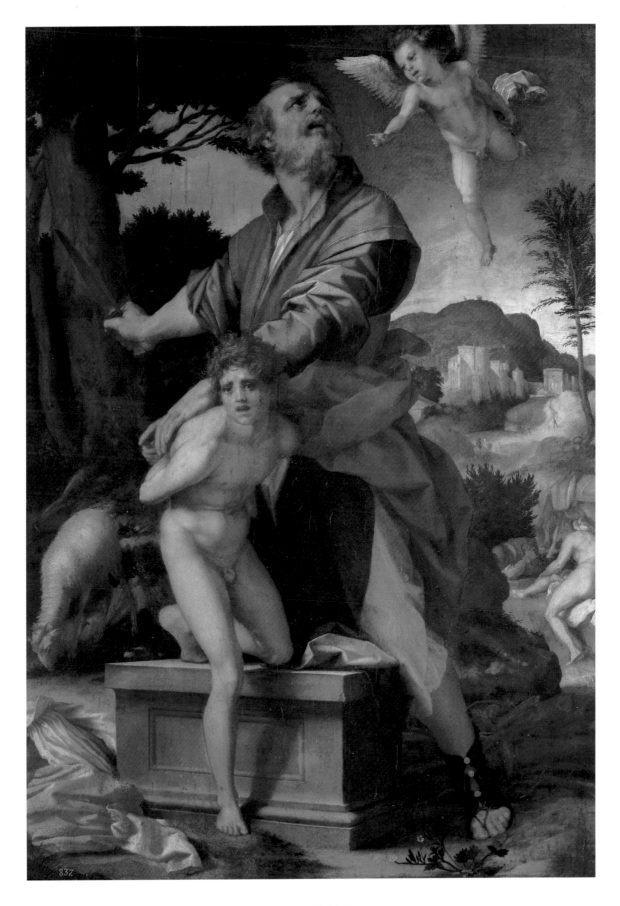

ANDREA DEL SARTO
The Sacrifice of Abraham, c. 1529
Oil on panel, 98 × 69 cm

The Descent of Christ into Limbo

A few years ago F. Benito clarified certain important aspects of the history of this canvas. The work was brought to Valencia by Jerónimo Vich y Volterra, a man of great education and artistic enthusiasm, who was ambassador in Rome from 1507 to 1518, and returned to his native city in 1521. His great-grandson, Diego Vich y Mascó, ceded it to Philip IV who asked for it when he was in Valencia in 1645. It seems to have been in compensation for a debt contracted by his grandfather. Velázquez placed it in the sacristy of the Escorial in 1656.

By means of two copies, Benito confirms an old opinion that the painting in the Prado was the wing of a triptych, the central panel of which was the *Lamentation over the Dead Christ* (Hermitage), dated 1516, which was in the Alcázar in 1666, the other wing being the *Appearance of the Risen Christ to the Apostles,* of which we know no more. Vich's will states that he gave Philip IV "the large altarpiece." The many influences that can be seen in Valencian painting — Masip, from 1529, and Ribalta — show that these were the three works seen in the Vich palace. Before this information came to light, the painting was usually dated about 1532.

The iconographic sense of the triptych is clear: the Death of Christ and his Resurrection through the Descent and the Appearance. For the figure of Christ, who comes to free the just according to the ancient law, Sebastiano used the motif that Michelangelo gave him in the same year, 1516, for the *Flagellation of St. Peter* in Montorio in Rome (which was painted in 1521–1524). The characteristics of the first maturity of the artist are here clearly exposed: monumentality, sculptural texture, marble and bronze colors, and quiet drama tinged with a definite melancholy.

Jesus Carrying the Cross

The will of Diego Vich y Mascó from Valencia, made in 1656, shows that, when he was staying in Valencia in 1645, he ceded to the king two original works by Sebastiano del Piombo, a large altarpiece — of which the *Descent of Christ into Limbo* in the Prado formed a part — and the *Jesus Carrying the Cross* (*Portacroce* in Italian), in order to settle a debt of his grandfather's. Velázquez placed both works in the sacristy of the Escorial by 1656.

This painting must have come to Spain by means of Jerónimo Vich, Ambassador to Rome until 1518, who returned to Valencia in 1521. Although he could have commissioned the work from his own city, it is more logical that he did so directly in Rome, as he had done for the altarpiece dated 1516. Before this information was known, the usual dating was to about 1528–1530, on the basis of the influence of Titian's *Portacroce* in San Rocco and Venetian aspects of the background work that come from the short stay Sebastiano made in his home city while escaping the sack of Rome in 1527. That dating is no longer acceptable.

His Venetian memories could have stemmed from his training before he moved to Rome in 1511 and, again, the painting offers very characteristic traits of Sebastiano. The impressive figures are of natural size, the colors are dark except for the light tunic, the modeling is sculptural and similar to the Christ of the *Descent* and, above all, the disposition — perpendicular to the plane — makes the presence of Christ immediate and sad.

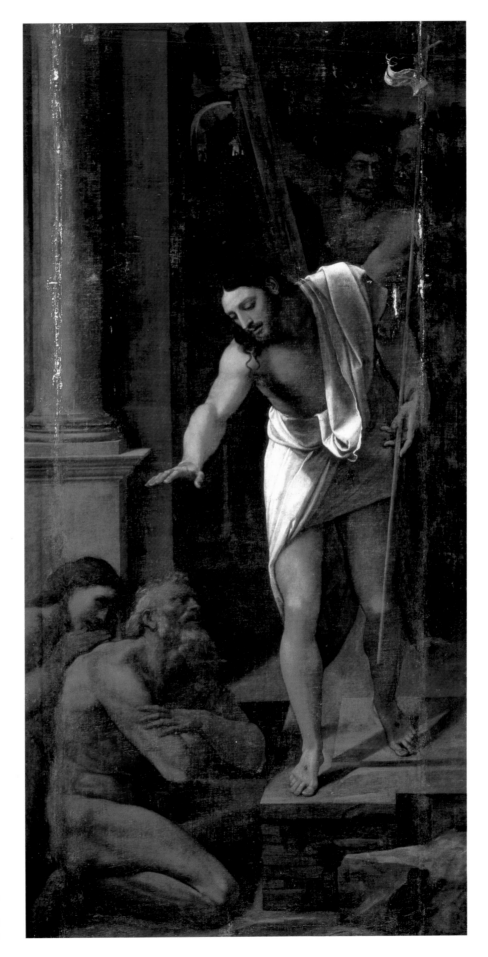

SEBASTIANO DEL PIOMBO
(c. 1485–1547)
The Descent of Christ into Limbo, 1516
Oil on canvas, 226 × 114 cm

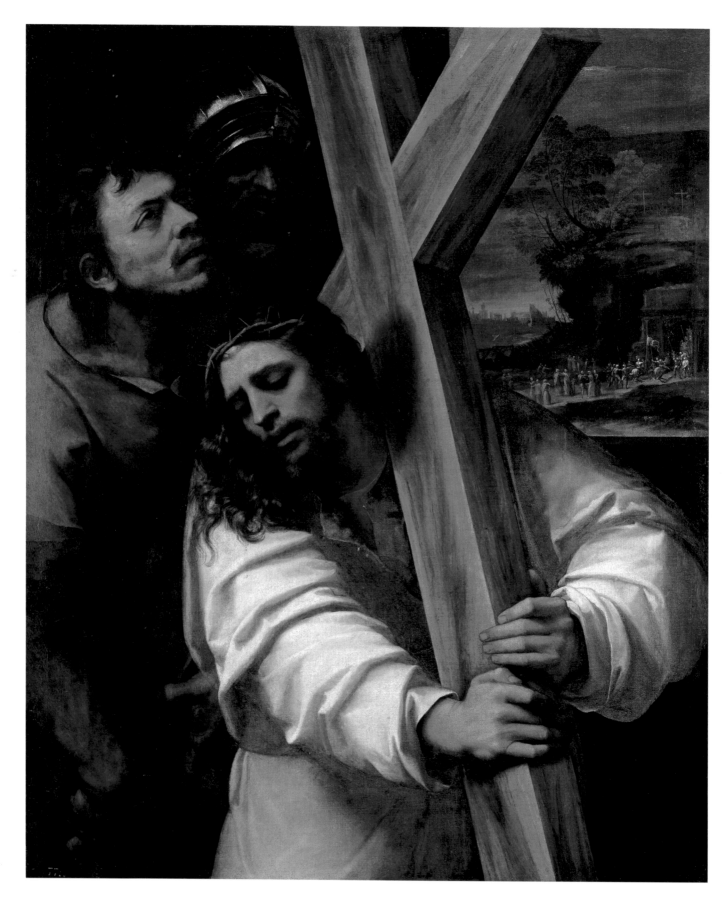

SEBASTIANO DEL PIOMBO
Jesus Carrying the Cross, c. 1516
Oil on canvas, 121 × 100 cm

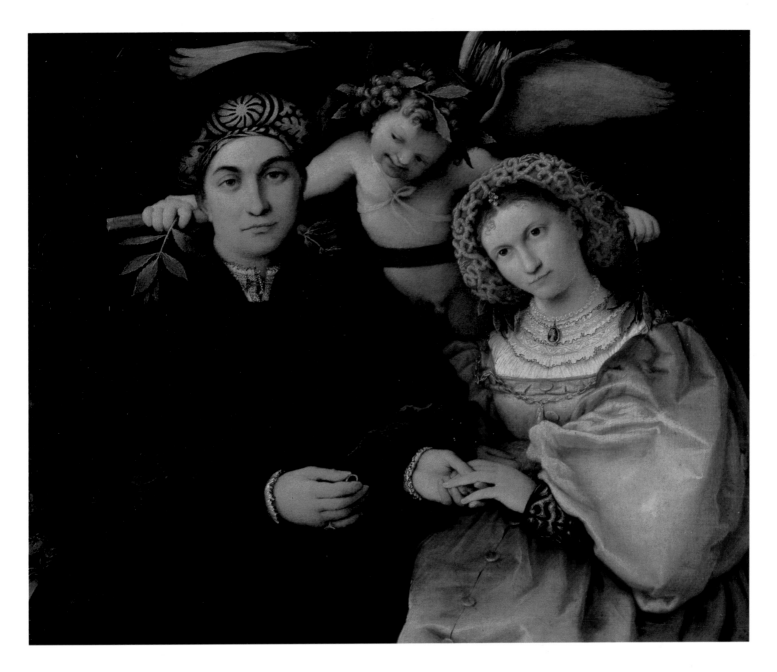

LORENZO LOTTO (1480–1556/57)
Portrait of Messer Marsilio and His Wife, 1523
Oil on canvas, 71 × 84 cm

PORTRAIT OF MESSER MARSILIO AND HIS WIFE

The signed and dated work was described by Morelli when it was in the Cassotti house in Bergamo. Later it formed part of the collection of the Genoese Marquis Giovanni Francesco Serra (1609–1656) and, at his death, was acquired in Naples by Viceroy Gaspar de Bracamonte, Count of Peñaranda, for Philip IV.

Lotto had painted portraits previously and made several during his long sojourn in Bergamo (1513–1525) to commissions from a provincial clientele, whose names are known but not their history. Another wedding portrait from the same period is in St. Petersburg. In both, the emphasis is on conjugal love; here through the flirtation that the painter imposes on the marriage tie and, to a lesser extent, in the joined hands. The painter reacts with precision to the external reality and is able to describe accurately the physical, spiritual, and mental traits as well. In his better portraits, such as this, there is an emotional intensity similar to that in religious compositions of the same period. He offers here a sentimentality that is consistent with the cultural atmosphere of Bergamo, but which would have been unacceptable in a city such as Venice. The commission was highly priced due to the difficulty of reproducing the fabrics, singularly brilliant in the red satin of the wife's costume.

MADONNA AND CHILD WITH ST. JOHN

NOLI ME TANGERE

This painting of unknown origin first appears in the 1746 inventory, made on the death of Isabella Farnese, who had kept it in La Granja Palace. Its size and subject matter confirm that it was a devotional painting from a private commission. The classical characters and the absence of any influence from Rome impose a dating very early in the artist's working life, but one from a time after he had developed the drawing qualities he learned from works by Mantegna.

Correggio uses the triangular composition that had been disseminated by Leonardo and Raphael and here the figure of the Virgin embraces those of the children, establishing a closed relationship of glance and affection. The landscape recalls Leonardo while the colors offer a cold range of blues, violets, and grays, which may have deteriorated through the passage of time. The composition, closed on the left and open toward the landscape on the other side, seems to be a prelude to certain Baroque paintings that have no connection with balanced composition and harmony of sentiments.

As the landscape shows, this canvas, transferred from a panel, is not in a proper state of preservation, perhaps the result of an unfortunate restoration in the last century. Vasari noted it in the Ercolani house in Bologna and praised it highly by means of Girolamo da Carpi, who was fascinated to see it. It seems to have been given to Charles V on his coronation in that city. He, in his turn, must have presented it to a member of the Aldobrandini family, from which it passed in the seventeenth century to the Ludovisi in Rome. The duke of Medina de las Torres, or perhaps the count of Monterrey, then acquired it and delivered it to Philip IV. Velázquez placed it in the sacristy of the Escorial in 1656. Always admired, it was copied freely by Alonso Cano (Budapest Museum). Correggio must have painted it about 1522–1525, when his style was already fully mature.

There are classical traces in the compositional triangles, in the combinations of the figures' attitudes, in the coloring — where red, gold, and blue predominate over the other, natural colors — and also in the closed play of glances. However, what makes the painting unique is the amplitude of feeling, both exquisite and artificial, from Mary Magdalen in her recognition of the risen Christ. It is not so much the natural, almost realist feeling, of the Baroque, as a morbid languor that opens the prevailing classicism toward the line of Mannerism.

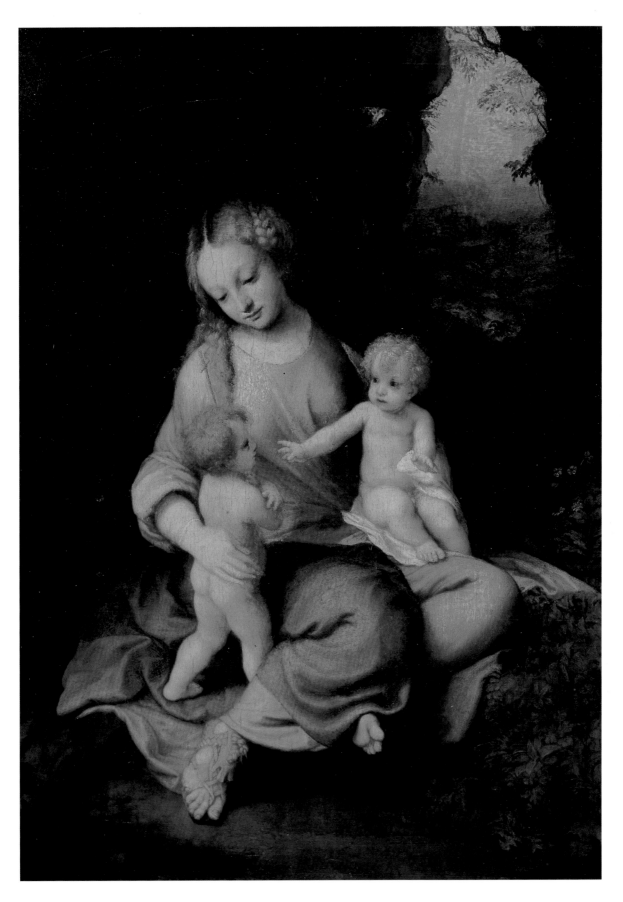

ANTONIO ALLEGRI, called CORREGGIO (c. 1494–1534)
Madonna and Child with St. John, c. 1515
Oil on panel, 48 × 37 cm

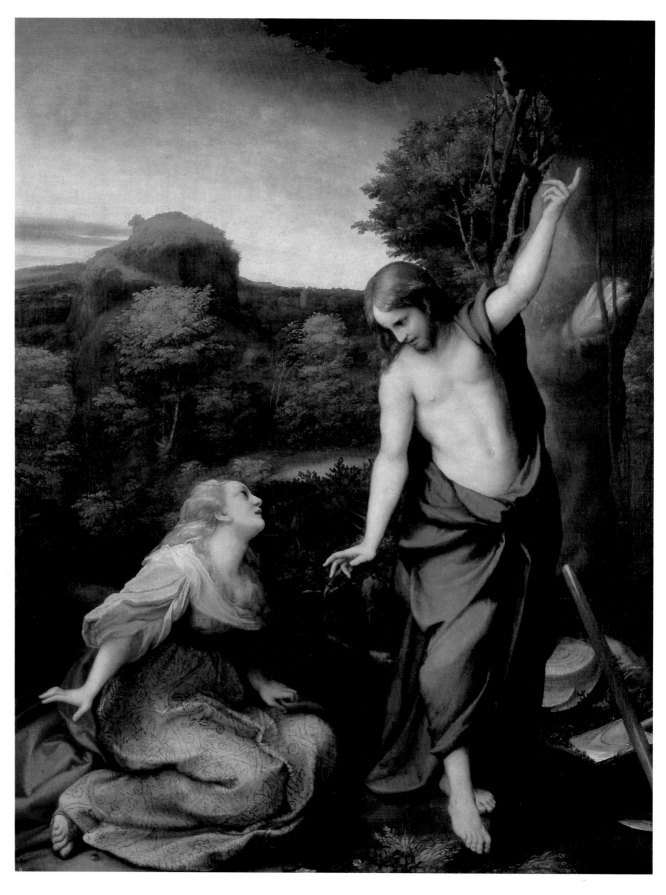

CORREGGIO
Noli me tangere, c. 1522–1525
Oil on canvas, 130 × 103 cm

PORTRAIT OF THE COUNTESS OF SANSECONDO AND THREE CHILDREN

The portraits of Camilla Gonzaga with her children, Troilo, Ippolito, and Federico, and of Pietro Maria Rossi, Count of Sansecondo, were painted by Parmigianino in 1533 or a little later when, after one of his disputes with the deputies of the Stecatta of Parma, he found refuge with Sansecondo. It is true that an art historian of the seventeenth century and some modern art historians consider the portrait of the wife to be the work of Correggio and there are differences of handling and chromatism between the two paintings, but the most common opinion is that they are from the same hand. Their dimensions are the same, and they were together in the possession of Marquis Giovanni Francesco Serra in the seventeenth century. After his death, Viceroy Gaspar de Bracamonte, Count of Peñaranda, acquired the portraits in Naples on behalf of Philip IV.

This portrait is typical of Mannerism, with its incomplete figures lacking communication, enclosed in the space, and shown in their normal dress. They are expressionless and look in opposite directions. The brushwork seems delicate, the colors are cold, the lights are white. The decorations of the clothing and jewelry are meticulously described and the whole painting is pure ornament.

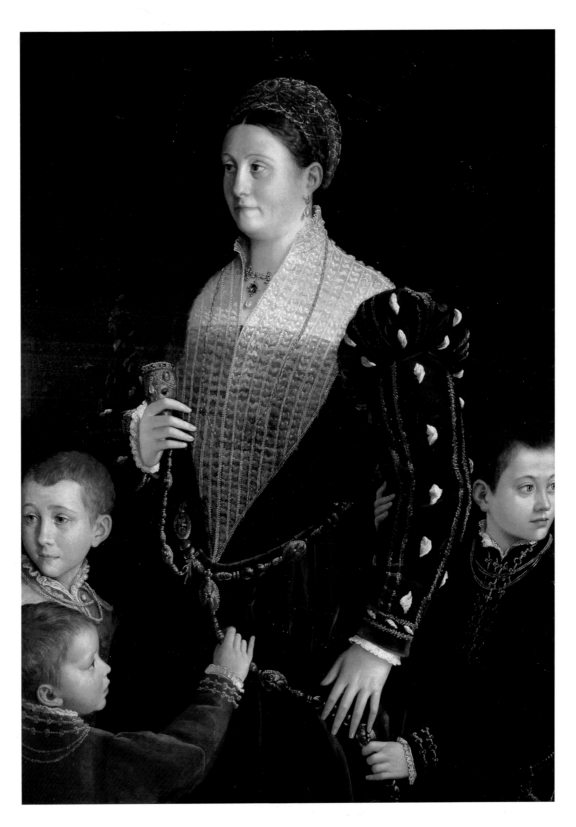

GIROLAMO MAZZOLA, called PARMIGIANINO (1503–1540)
Portrait of the Countess of Sansecondo and Three Children, c. 1533–1535
Oil on panel, 128 × 97 cm

PORTRAIT OF GARCÍA DE' MEDICI

García de' Medici was the seventh son of Cosimo I, Grand Duke of Tuscany, and Eleonora of Toledo. He was born on July 1, 1547, and died in December 1562. There is a remote possibility that the portrait is of an elder brother, Giovanni, who was born in 1546. It has not been clearly established in the royal collections where it came from.

Bronzino was a Florentine portrait artist in the grand duke's court and this portrait was undoubtedly painted as part of his compliance with his duties. The boy is presented half-length, frontally, with an orange blossom in one hand and a cord, from which hangs a little jewel of an embellished horn, in the other. The painter works the human figure, the objects he holds, and his clothing in the same way — handling the abstract through the combination of colors. Blue and dark red in the background and clothing, and clarity in the old gold of the lace edging, the fair hair, and the white face. The image is detached and even seems frozen because the artist was not seeking naturalism or the child's expression, but the play of forms and colors that subject and imprison the image.

AGNOLO BRONZINO (1503–1572)
Portrait of García de' Medici, c. 1549
Oil on panel, 48 × 38 cm

PORTRAIT OF GIOVANNI MATEO GHIBERTI

This was discovered in the stocks of the Museum in 1978 and has been studied by Sergio Marinelli and A. E. Pérez Sánchez. There is a similar example in the Castelvecchio Museum in Verona, bearing a note on the back identifying the sitter and telling of his death in 1543, as well as the attribution to India.

Ghiberti was bishop of Verona and was in Rome at the same time as Clement VII, being a friend and client of Giulio Romano and noted by Vasari as a patron of the arts. India came from Verona, where he occasionally collaborated with Palladio through his specialty in the decorative arts. Since he was born in 1528, this portrait was not only posthumous, but was painted several years after the death of Ghiberti.

India was a portrait artist and created a kind of gallery of illustrious men in which Bishop Ghiberti could be included; St. Charles Borromeo possessed a portrait of the bishop, which a copy preserved in the Ambrosiana in Milan suggests could be this one in the Prado. In any case, the Madrid portrait came from the royal collections, although at what date is unknown.

The inspiration came from a medallion, which explains the incisive profile of the effigy. The composition, with its neutral background, complies with that tradition. The realism of the face and its expression are outstanding.

BERNARDINO INDIA (1528–1590)
Portrait of Giovanni Mateo Ghiberti, mid-sixteenth century
Oil on panel, 21 × 14.5 cm

BACCHANAL

Alfonso d'Este, Duke of Ferrara, commissioned three bacchanals from Titian, who had already worked for him in 1516: *The Cult of Venus* (1518–1519), *Bacchanal* (1520–1521), and *Bacchus and Ariadne* (1522–1523; National Gallery, London).

In 1598 these paintings were brought to Rome by Cardinal Aldobrandini and later passed to the Ludovisi family. It seems that the first two were given by Niccolò Ludovisi to Philip IV, delivered by the count of Monterrey in 1639. Velázquez placed them in the Titian Vaults in the Alcázar in 1652.

The subjects are taken from the *Immagini* by Philostratus. The revival of admired works from antiquity had no precedent in Venice and so the choice of subject depended on the taste and culture of the duke. This painting shows the inhabitants of the island of Andros, dominated by Bacchus. Music appears — the score by Adriaan Willaert, who came to Ferrara about 1520, can be read: CHI BOYT ET NE REBOYT IL NE SCET QUE BOYRE SOIT — as does Love, both of whom are involved with drink, according to a classical theme.

There are references to ancient sculpture — the splendid female nude recalls Ariadne sleeping — and to Michelangelo (the central male figure comes from his *Battle of Cascina*), as well as to other personal elements. The signature of the artist appears on the neck of the woman with the flute, in whose ear are violets, which identifies her as Violante, Titian's lover.

The figures are linked and paired in a continuous rhythm, with contraposed or parallel variations of attitudes or colors, in a Dionysian and Aphrodisian reconstruction of a vanished world.

THE EXHORTATION OF THE MARQUIS DEL VASTO TO HIS TROOPS

Alonso de Avalos, Marquis of Vasto (1502–1546), was sent to Venice by Charles V in December 1539 to greet the new doge, Pietro Lando. It was at this time that this work was commissioned, and it was probably delivered in August 1541. On the death of Charles I of England it was given to the royal embroiderer, Edmund Harrison, in settlement of debts due him, and Ambassador Alonso de Cárdenas bought it from him prior to 1654 for Philip IV, who had it placed in the Alcázar.

It represents an historic fact, that the eloquence of the marquis haranguing his troops — with his son Ferrante as his page — spared the soldiers the disaster of a confrontation with the Turks. Titian has used elements from the Arch of Constantine and from the paintings by Giulio Romano in the Vatican, as well as a medallion of Emperor Gordiano III.

The background, without perspective, causing the figures to stand out, and the repeated insistence on the oblique have been interpreted as influences from the Mannerists Salviati and Vasari, who visited Venice in 1539 and 1541. There are also studied contrasts between high and low, individual and mass. Blues, whites, and reds produce chromatic concord and discord.

EQUESTRIAN PORTRAIT OF CHARLES V

While in Augsburg, from January to October 1548, Titian painted only portraits, among them this extraordinary painting of the emperor on horseback directing the Battle of Mühlberg against the Protestant forces on April 24, 1547. It was begun in April and finished on September 1; while it was drying it suffered (still noticeable) damage to the hindquarters of the horse, which Titian himself and Christoph Amberger repaired. The painting was brought to Spain by María of Hungary. Afterward it passed through the Casa del Tesoro (1600) and the Pardo Palace (1614), and in 1636 was inventoried in the Salón Nuevo of the Alcázar.

According to the *Corpus Iuris Civilis* of Justinian, in order to govern rightly in times of war and in times of peace, imperial majesty should have attributes not only of arms, as this portrait shows, but also of laws — to which the portrait in the Munich Pinakothek alludes. This portrait therefore has an allegorical meaning and is not merely a representation for protocol. The lance refers to the lance that wounded Christ and identifies the emperor *miles christianus* as the savior of the Catholic faith, but at the same time it is an attribute of the Roman emperors (*profectio Augusti*) when they went to war and thus also portrays the defender of the empire.

In this majestic portrayal, Titian shows Charles V's imperturbable resolution. The palette shines with splendor in the fullness of the armor and the landscape is of great nuance in its rich chromatic range.

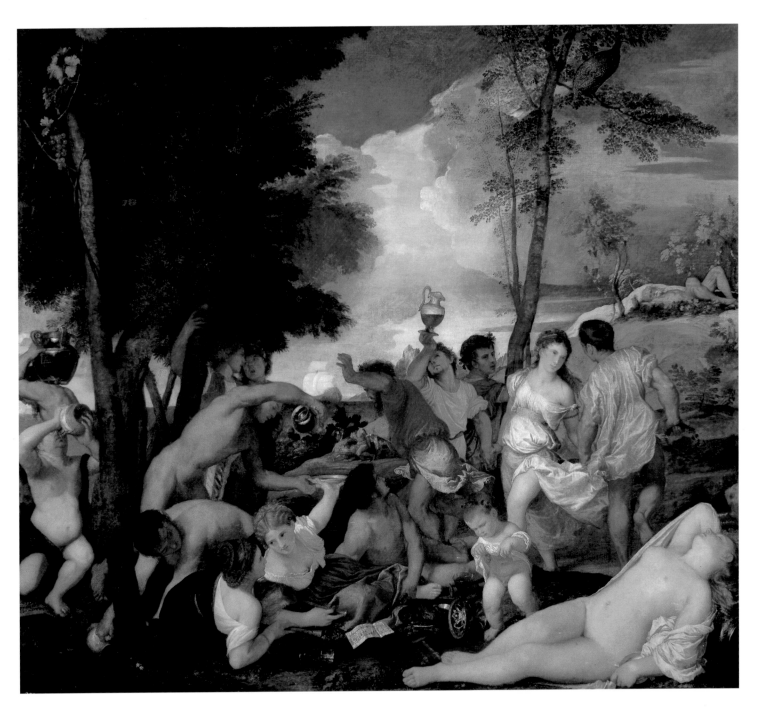

TIZIANO VECELLIO, called TITIAN (1488/90–1576)
Bacchanal, 1520–1521
Oil on canvas, 175 × 193 cm

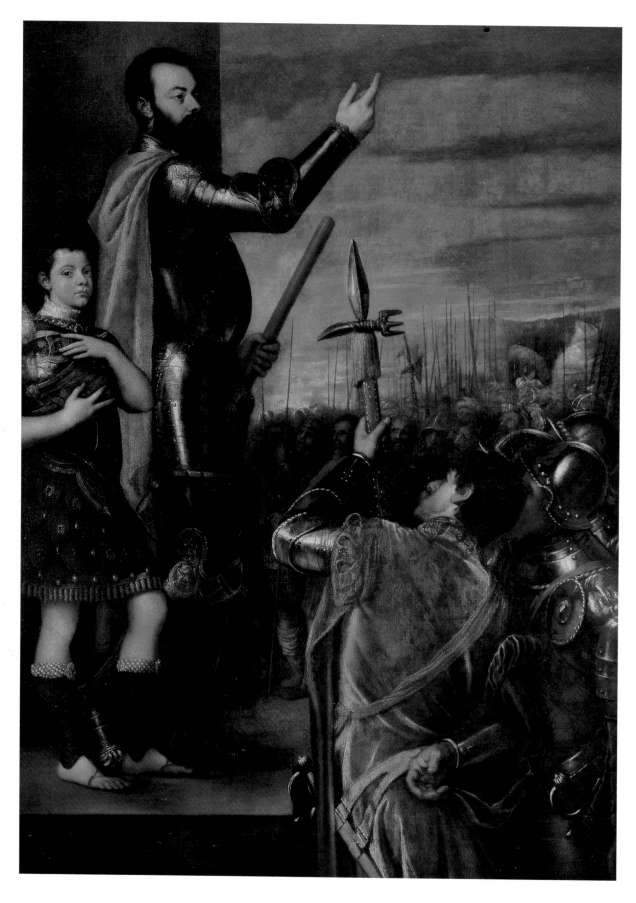

TITIAN
The Exhortation of the Marquis del Vasto to His Troops, 1540–1541
Oil on canvas, 223 × 165 cm

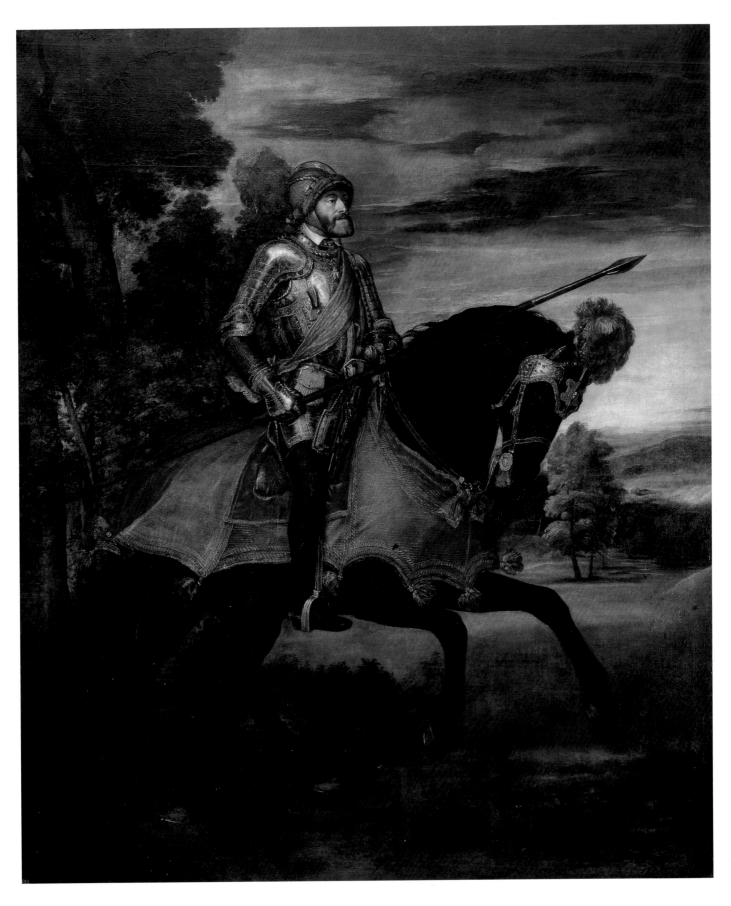

TITIAN
Equestrian Portrait of Charles V, 1548
Oil on canvas, 332 × 279 cm

TITIAN
Venus with the Organ Player and Cupid, 1547
Oil on canvas, 148 × 217 cm

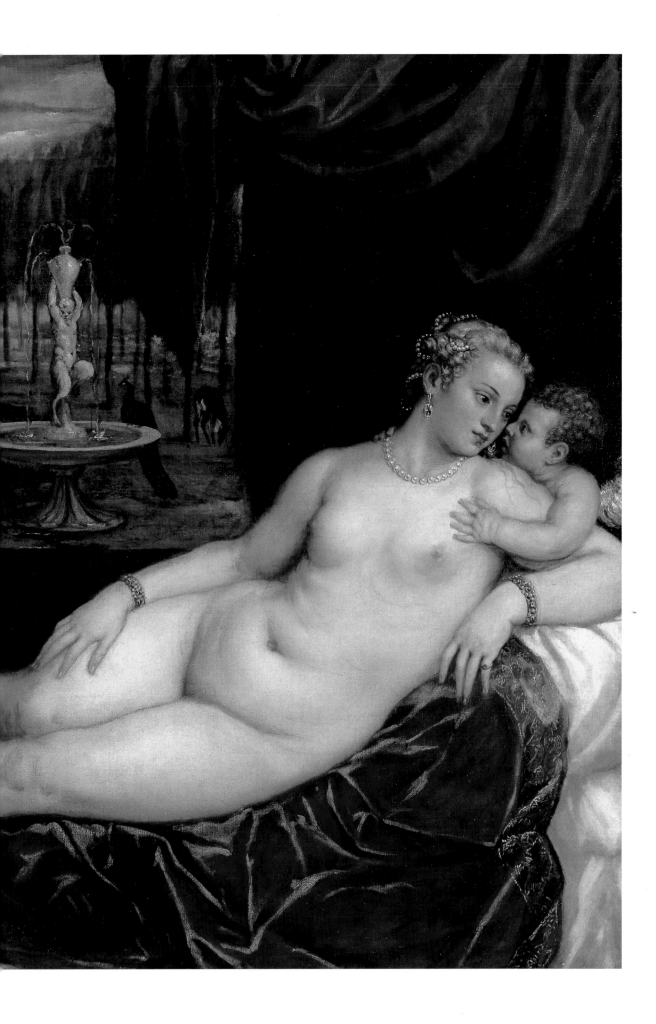

VENUS WITH THE ORGAN PLAYER AND CUPID

This signed work must have been delivered by the painter to the emperor on his arrival at Augsburg in January 1548. Charles V gave it to Cardinal Granvela, whose nephew, Francisco, Count of Cantecroix, sold it to Emperor Rudolph in 1600. He, in turn, offered it to Philip III; in 1636 it appears in the inventory of the Alcázar.

Two matters are brought together in this and other paintings of the subject by Titian: first, the consideration of the senses of vision and hearing as means to perceive beauty; second, Venus as a symbol of earthly love.

Titian first produced the *Venus of Urbino,* a painting of some modesty. Then he painted the other version, in the Uffizi, in which the goddess uncrosses her legs and withdraws her hand from her sex, as she would do in all the subsequent versions.

In Berlin's *Venus and the Organ Player,* the organist does not play music, but looks at Venus. In the Prado's canvas, he turns to gaze at her sex, keeping his hands on the keyboard. Finally, in the version in the Fitzwilliam Museum, Cambridge, the musician plays the instrument while looking at Venus, who has a flute in her hand and a viola da gamba beside her. Thus the traditional primacy of sight in Renaissance culture becomes balanced with the sense of hearing.

However, Titian not only brings an aesthetic discussion to the canvas, but he also shows himself to be an adherent to an iconographical and technical sensuality. The organist's glance, the nudity of Venus close to Cupid, the different elements and figures glimpsed in the garden all refer to sensual and carnal love. The composition brings together horizontals and verticals in the trees, the window and the organ, while it curves in a parallel wave in the figures. Purples and greens, flesh tints and darker hues, show the sumptuous quality of a perfectly prepared and vibrant touch.

TITYUS

In Augsberg in 1548, Maria of Hungary, Governor of the Low Countries, commissioned Titian to paint a series of four works of the condemned. By June 1549 *Tityus* and *Sisyphus* hung in the principal salon of Binche Palace; *Ixion* and *Tantalus* were done later. They arrived in Madrid in 1566, giving the "Hall of the Furies" in the Alcázar its name, but the fire of 1734 destroyed the two latter paintings.

The condemnation of Tityus resulted in vultures eating his entrails, which regenerated continually. According to some commentaries by Ovid, this punishment came about because of the rape of Leto; according to others, it was retribution for his attempt to take possession of the Delphic Oracle. Such torment could be interpreted as punishment either for his sexual depravity or for his arrogance in wanting to contend with a god. In either case, there is present at once the sense of moral allegory, which is confirmed by the rest of the series, and the demand for respect for the sovereign, whose power is of divine origin.

The colossal figure of Tityus has its inspiration in Michelangelo. Fallen and in chains, his legs and arms were contraposed with those of the figure of Tantalus (known from an engraving). The almost monochromatic color range reinforces the drama of the terrible, hellish image. Some admirable scenes in the lower part, while not clearly defined, are of a bold abstract nature.

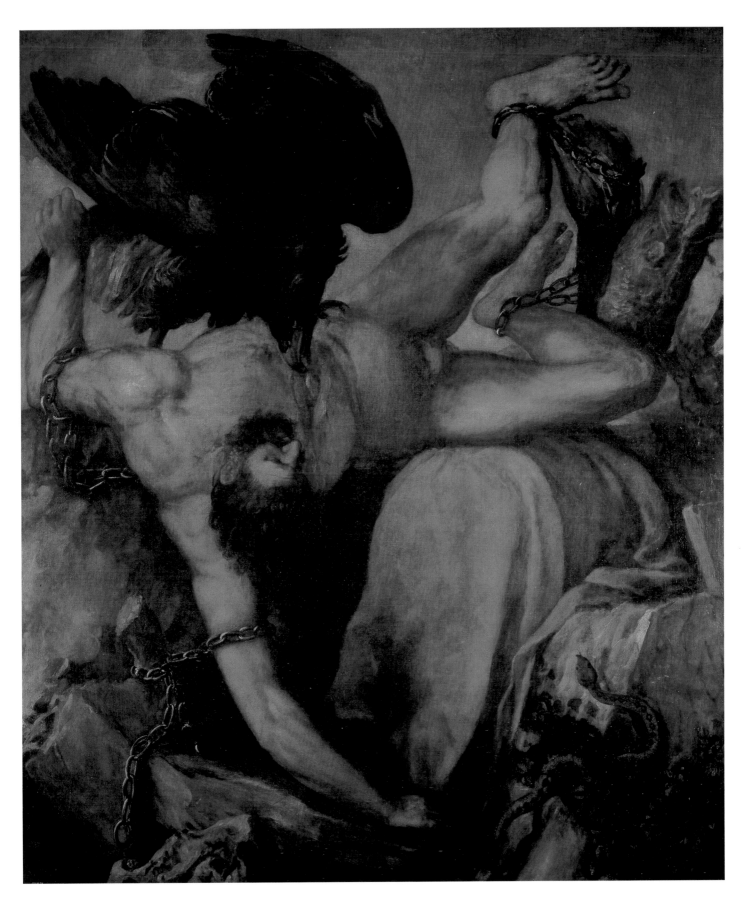

TITIAN
Tityus, 1549
Oil on canvas, 253 × 217 cm

LA GLORIA

Commissioned by the emperor in 1551, the finished painting left Venice in mid-October 1554, and Charles V kept it in Yuste until his death. In 1574 Philip II sent it to the Escorial (replacing it with a copy by Antonio de Segura), and in 1656 Velázquez placed it in the Little Hall.

From early on, the painting has been given different titles, so demonstrating the complexity of its meaning. Charles V, in his will, called it *The Last Judgment;* Cort, who engraved it in 1567, called it *The Triumph of the Trinity.* There is no doubt that Charles V intended it to be a defense of the Trinity, which is represented in the upper part of the painting, while in the lower band is the assassination of St. Peter Martyr, who died confessing his Trinitarian belief. The assembled saints worship the Trinity and from this derives the name given to the painting today, perhaps the least appropriate, because the Last Judgment is imposed over the Communion of Saints. Mary appears as mediator and not as the Queen of Heaven; St. John the Baptist follows her in intercession. Holy ones of the New Testament do not appear, only Ezekiel, the prophet of the Last Judgment, Moses with the tablets of the Law, and Noah raising up the ark, along with the recorders of the Alliance, the Eritrean Sybil, and David, all witnesses of the *Dies irae.* On the right, clad in white shrouds and praying for admittance to the chosen, are Charles V, Isabella, Philip II, and other members of the imperial family.

In some of the figures can be detected compositional influences from the *Landauer Altarpiece* by Dürer, from ancient sculpture (*Galatea* and *Laocoön*), and from Michelangelo. The arrangement of the composition is admirable and is integrated into spectacular light effects. A bird's-eye view of the earthly scene of the martyrdom of St. Peter passes to a low point of vision for the Heavens, with a rich and diaphanous chromaticism in the figures of the prophets. The forms arise through a golden hue; they lose substance and are surrounded by an unreal light, which accentuates the nature of the vision that finally arrives at the Trinity

DANÄE

This is one of the "poesias" offered by the artist to Philip II in a letter of March 23, 1553; it came to Spain the following year. In Venice in 1544, he had begun a version of it for Cardinal Alessandro Farnese (Capodimonte, Naples), which arrived in Rome in 1545, and which Michelangelo praised, except for its lack of drawing. It differs particularly in the drapes that cover Danäe and in including Cupid in place of the old servant.

The painting represents Danäe, who had been confined by her father, the king of Argos, to avert the prophecy warning that his grandchild would lead him to death. The young woman is possessed by Jupiter, who has taken the form of a shower of gold, and she conceives Perseus. The golden rain of coins leads us to suppose that the painter was following the tradition that Danäe was not a virtuous maiden but a courtesan.

In this version, Danäe is less sculptural, and the influence of Michelangelo's *Leda and the Swan* is subdued. On the other hand, her sex is not concealed and her expression and attitude of happy abandon show her as complacent, understanding just what is happening. The contrast between her body and the draperies, and between the zones of light and shade, the tonal vibrations of a chromatic range that tends to blend together, all indicate that the pictorial substance covers density not by plastic definition, but by means of air and light. The fully erotic sensuality assumes the status of an idea, as spiritual and mental experience did in Michelangelo.

VENUS AND ADONIS

Titian promised to send this painting to Philip II in 1553 but it was not received until September 10, 1554, when the king was in London; it arrived with a fold across the middle that is still noticeable. A description of the sensual impression made by such beauty, "which is of the flesh, but at the same time is true beauty," is known from an ardent letter from Ludovico Dolce to Alessandro Contarini. The work was hung in the Alcázar and is listed in the 1646 inventory in the room "to which His Majesty withdraws after eating."

Titian must have painted another version for the Farnese during his Roman stay in 1545–1546, from which the canvases in New York (Metropolitan) and Washington (National Gallery) are derived. The version for Philip II is larger, with ample space above the figures and, among other minor variations, Cupid sleeping instead of holding Venus's dove as though astonished.

The subject is taken from Ovid's *Metamorphoses*: Venus, in love with Adonis, tries to keep him with her when he leaves to go hunting, a hunt in which a wild boar will kill him. As early as 1584, Borghini criticized this interpretation, which appears in this work with only rare precedent: Adonis rejects the love of Venus and, only after leaving her, succumbs to the temptation of the hunt. The sleeping Cupid gives the key to an interpretation that Panofsky showed fitted completely.

In any event, the posture of Venus, whose back faces us, complements that of Danäe. The composed and formal study is but a support for the psychological content that contraposes the desire of Venus with the misogyny of Adonis.

TITIAN
La Gloria, 1551–1554
Oil on canvas, 346 × 240 cm

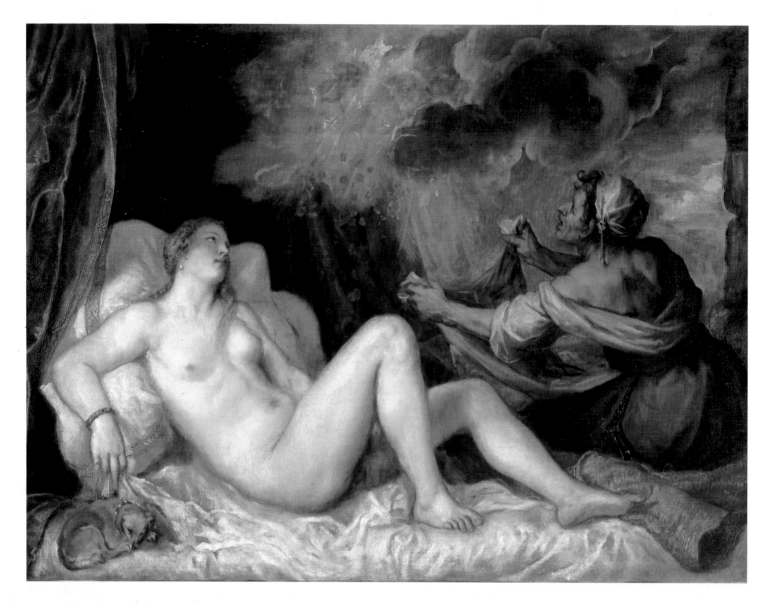

TITIAN
Danäe, 1553–1554
Oil on canvas, 129 × 180 cm

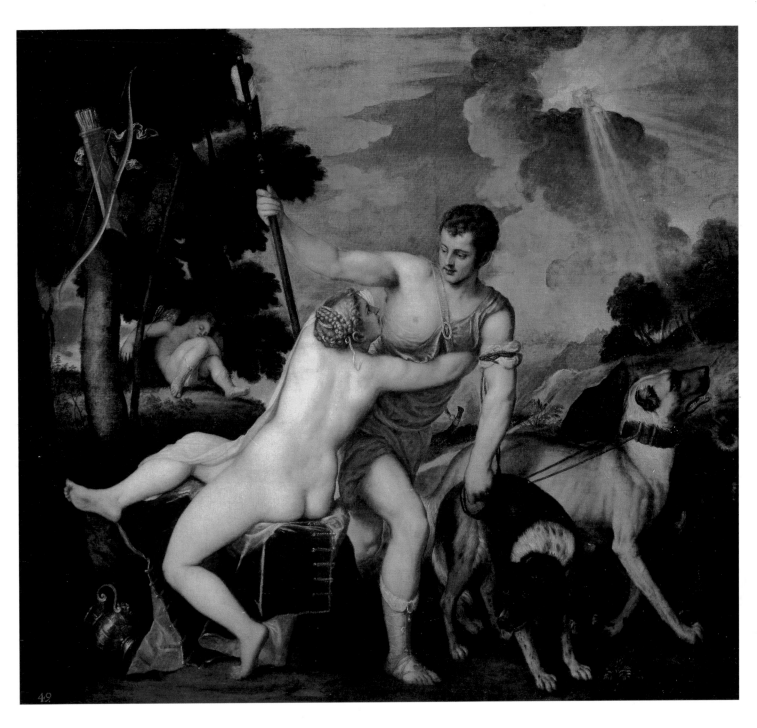

TITIAN
Venus and Adonis, 1553–1554
Oil on canvas, 186 × 207 cm

THE ENTOMBMENT OF CHRIST

Two versions of this subject are preserved in the Prado Museum, both of similar dimensions and signed. The older, on which the painter entitles himself "Knight," was commissioned by Philip II in January 1559, and Titian sent notice of its shipment on September 27 of the same year. It was delivered to the Escorial in 1574. The version presented here — with numerous variations in detail — is believed to be the one that Vasari saw in Titian's workshop in 1566. It was retouched in 1572 when the Venetian republic acquired it to give to Secretary Antonio Pérez, and it passed to the royal collection in 1585. After being hung in the Alcázar and in Aranjuez, Velázquez placed it in the Little Hall of the Escorial in 1656.

The naturalistic and explicitly sensual way in which Titian had expressed himself up to this time, especially in his many mythological works, is here transformed into a spiritual emotion that is at once withdrawn and profound. From this time on, his mythological paintings were very scarce and tragic rather than erotic, but he painted many works on religious themes. Also left behind were the Mannerist ideas of exaltation of form and decoration. The power is now expressive more than physical and of a consistent form; the touch is rapid, the brush perfectly free, the colors blended, the lights glowing, the forms dissolving in space. Here the tragedy portrayed spreads intensely through the formal elements to the pictorial substance itself.

SELF-PORTRAIT

This may be the portrait mentioned by Vasari, which he saw on his visit to Titian in 1566, when he met the elderly artist with his brushes in his hand. It is probable that it was acquired by Philip IV in the auction of Rubens's estate after his death in 1640. It appears in the 1666 inventory in the Mediodía Passage of the Alcázar in Madrid.

As in the self-portrait in Berlin's Gemäldegalerie (c. 1562), Titian here wears the double chain of a Palatine Count and Knight of the Golden Spur. Apart from such decoration, however, the difference between these pictures is very great. In the earlier work he is seen from the front, seated at a table, elegantly dressed, looking with attention at a hypothetical interlocutor, with an energy that is not without a touch of provocative arrogance. In the Madrid portrait, he is placed almost in profile, which lends a serenity of classical origin. The painter looks into the distance, engrossed in the contemplation of his own universe. This is a powerful image of an old man — of a gentleman and an artist.

The color is gathered into a fleeting moment. Black dominates, in the clothing, against which the gold chains gleam, and in the skullcap that covers his head; it contrasts with his face and hand and the light, clear trimming of his shirt, which serves as a border. The economy of brushwork scarcely shades the skin and the beard, revealing extraordinary touches of infinite wisdom and maturity.

RELIGION SUPPORTED BY SPAIN

Titian began an allegory of a young woman before Minerva and other figures for Alfonso d'Este, which was unfinished at the time of the duke of Ferrara's death in 1534. Vasari saw it in the artist's workshop in 1566. Originally, the painting was a political allegory. The young woman represented the "infelice Ferrara," attacked by Venice along the river Po (Neptune appears above the water in his chariot), and begging protection from Minerva, who was accompanied by Peace bearing an olive branch.

Titian transformed the work when he sold it to Maximilian II in 1568; although that work is lost, we know it from the engraving made by Giulio Fontana. With the addition of a cross and a serpent (heresy), Ferrara became Religion, a turban changed Neptune into a Turk, and the imperial eagle on Minerva's standard completed a political–religious allegory of the imperial defender of Christianity repelling the Turkish threat.

The signed painting in the Prado is a second version, which was commissioned by Philip II and sent to him on September 24, 1575. The iconographic modifications Titian made with respect to the imperial example are important: the gorgon on the primitive Minerva's breast is here an angel, a chalice glows on the standard, and she carries a shield with the arms of Philip II, rather than joining hands with her companion who, with her sword, is now Fortitude, not Peace. The Turk is dressed for battle and followed by various ships. Religion, who is unchanged, threatened by heresy and the Turk, seeks the protection of the Spanish monarchy, which is accompanied by the virtue of Fortitude.

ALLEGORY OF THE BATTLE OF LEPANTO

This large canvas was commissioned from Titian by Philip II as a dual commemoration of the victory in the Battle of Lepanto on October 7, 1571, and the birth of Crown Prince Ferdinand on December 5 of that year. The measurements were to be the same as those of the Equestrian Portrait of Charles V, with which it would be paired. According to Jusepe Martínez, a design was sent to Venice together with a portrait of the king by Alonso Sánchez. On May 9, 1573, the work was half completed and on September 24, 1575, it was dispatched to Spain by Ambassador Guzmán de Silva. It was hung in the Alcázar. The work was signed by Titian as a knight of the empire.

Although a naval battle appears in the background it is not treated as a conventional painting on the theme of the Lepanto victory. On the contrary, the birth of Prince Ferdinand (who sadly died in 1578) takes the foreground, but with singular dynastic and religious connotations. The king, standing before a richly covered table in a solemn architectural scene, takes his son in his arms and offers him to a winged victory — or angel, in the view of Jusepe Martínez — who bears the crown and the palm of victory with the legend MAIORA TIBI (Greater Triumphs Await You). As Panofsky showed, we are reminded here of a motif that appears in liturgical miniatures in the text and images relating to the first Sunday of Advent: Ad te Domine levavi animam meam, with the priest lifting a naked child, which represents the soul, toward God.

This subject, certainly devised by Philip II himself, is exceptional, for it bears a biblical metaphor, with the king officiating as priest.

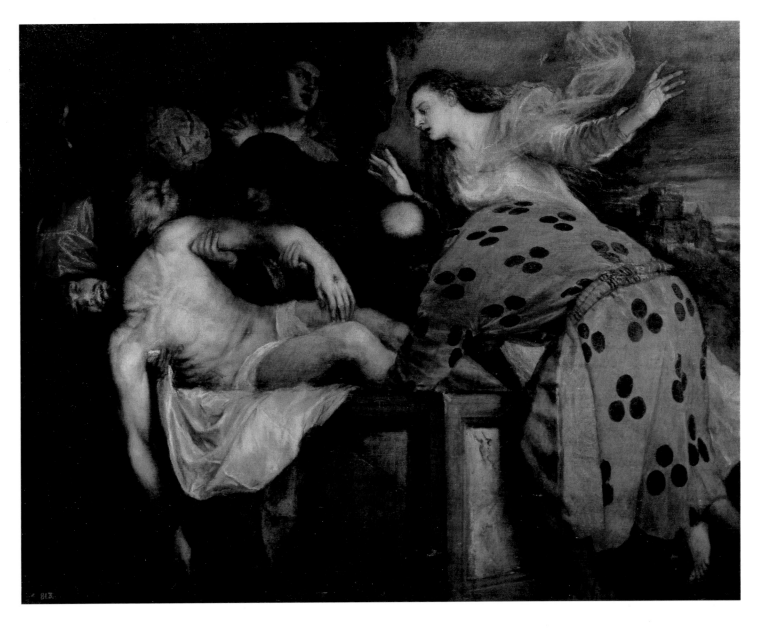

TITIAN
The Entombment of Christ, 1566
Oil on canvas, 130 × 168 cm

TITIAN
Self-Portrait, c. 1566
Oil on canvas, 86 × 65 cm

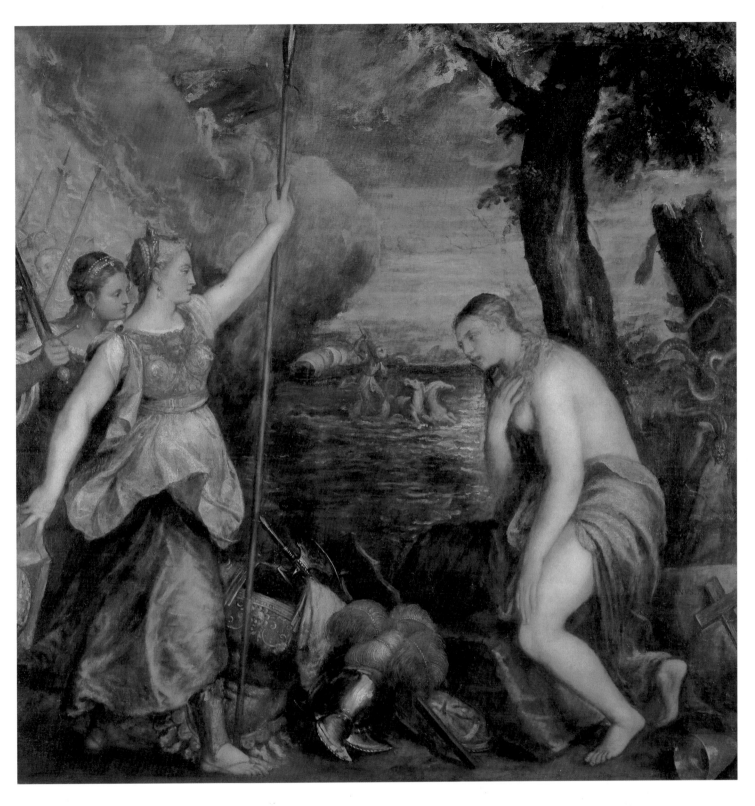

TITIAN
Religion Supported by Spain, c. 1575
Oil on canvas, 168 × 168 cm

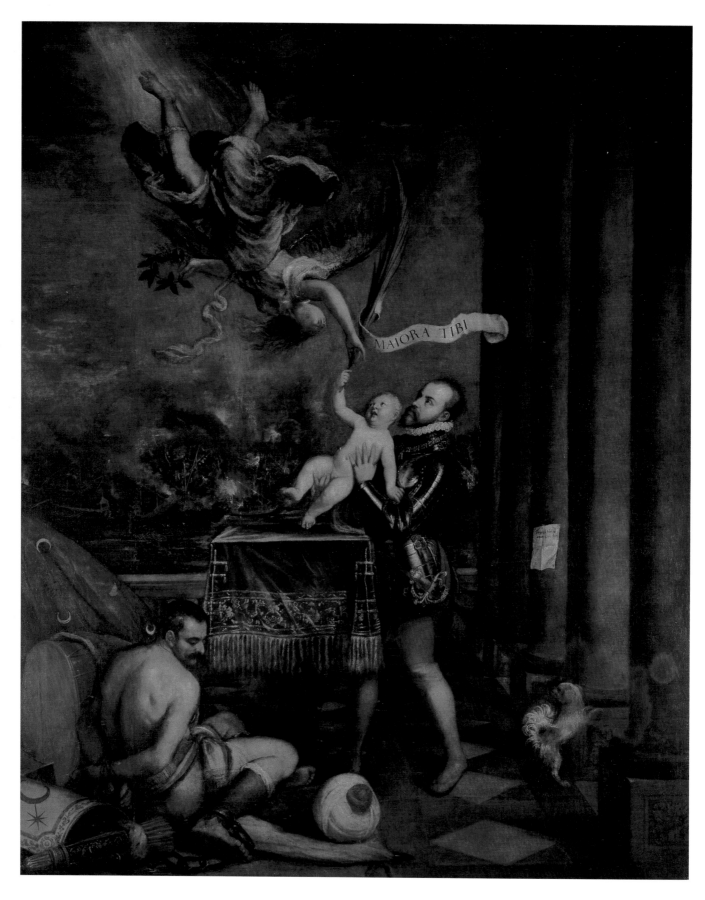

TITIAN
Allegory of the Battle of Lepanto, 1572–1575
Oil on canvas, 335 × 274 cm

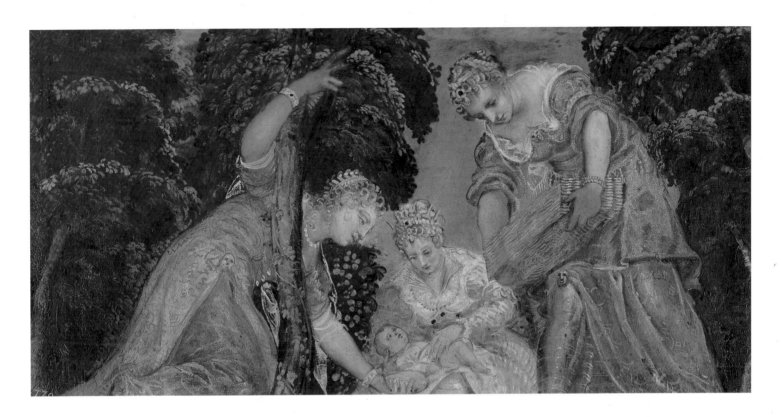

JACOPO ROBUSTI, called TINTORETTO (1518–1594)
Moses Saved from the Waters of the Nile, c. 1555
Oil on canvas, 56 × 119 cm

MOSES SAVED FROM THE WATERS OF THE NILE

In Venice, in 1651, Velázquez acquired a series by Tintoretto comprised of six long canvases depicting episodes from the lives of biblical characters (Joseph, Moses, Solomon, Judith, Esther, and Susanna), and an oval — *The Purification of the Booty of the Midianite Virgins,* which seems more modern. They appear in the 1686 Alcázar inventories and later belonged to Isabella Farnese, although they were kept in the Prado.

Judging from the very low point of view, the paintings must have been hung very high up, under the cornice (or on the ceiling, as in the Alcázar) in some Venetian palace; their profane treatment and nudes do not seem suitable for a religious site.

Certain similarities in color, perspective, and human types reveal the influence of works by Veronese from the period between 1554 and 1556. Thus we normally date these paintings by Tintoretto to this time.

Both Moses and Judith were liberators of their people, although their mission has yet to be completed at the times portrayed. However, the parallels in theme and moral content are less important than the ornamental character. Tintoretto's smooth brushwork and light, pearly trickle unify the atmosphere of architecture and landscape with the figures in both perspective and color. In *Moses Saved from the Waters of the Nile,* the composition is closed by way of its curving figures — for example, the figure behind the tree stretching her arms out in an echo of the trunk. The brilliant color is luminous with vibrant changes.

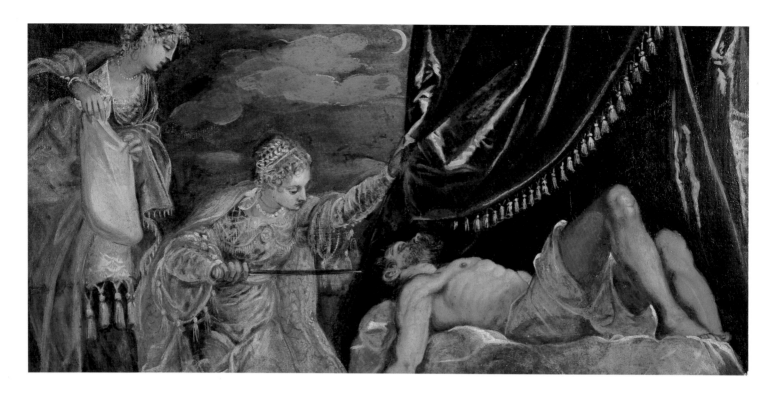

TINTORETTO
Judith and Holofernes, c. 1555
Oil on canvas, 58 × 119 cm

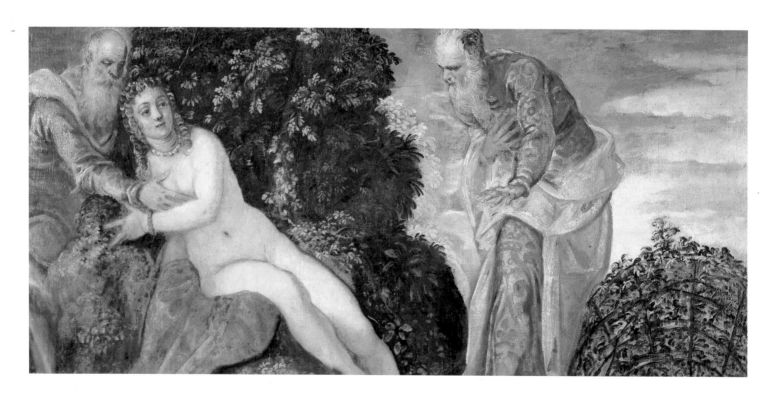

TINTORETTO
Susanna and the Elders, c. 1555
Oil on canvas, 58 × 116 cm

TINTORETTO
Esther before Ahasuerus, c. 1555
Oil on canvas, 59 × 203 cm

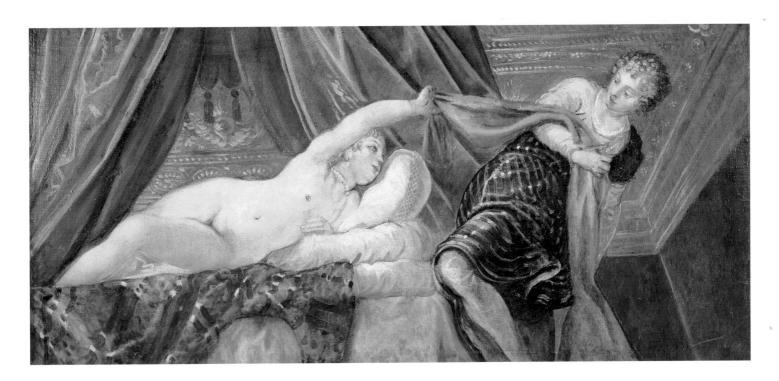

TINTORETTO
Joseph and Potiphar's Wife, c. 1555
Oil on canvas, 54 × 117 cm

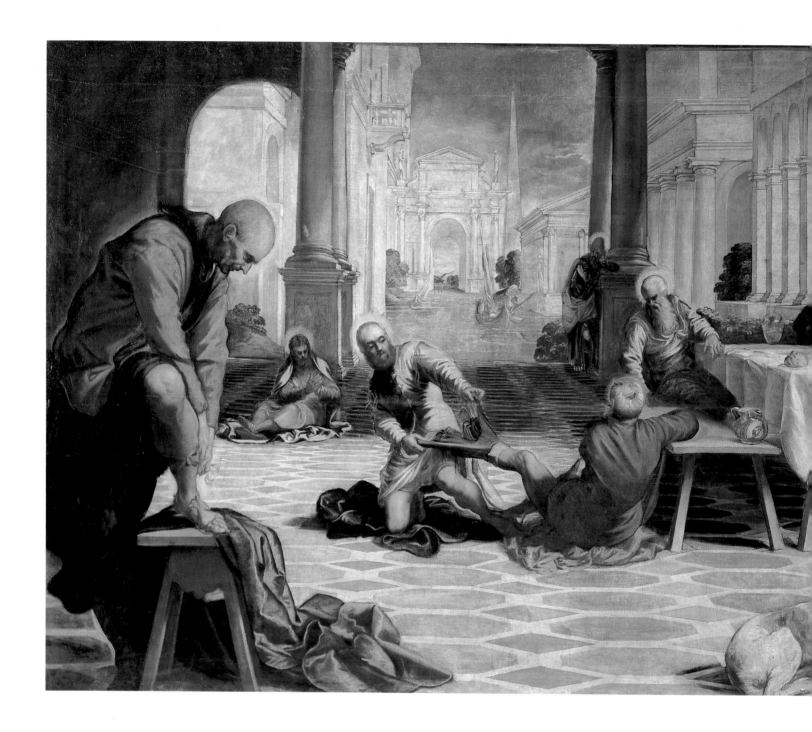

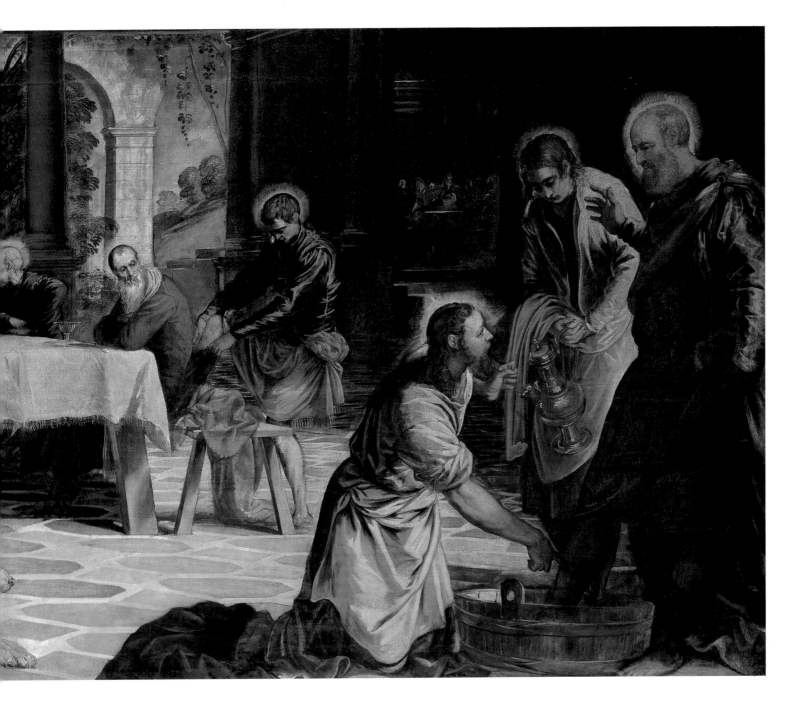

TINTORETTO
The Washing of the Feet, 1547
Oil on canvas, 210 × 533 cm

THE WASHING OF THE FEET

This large picture was painted for San Marcuola in Venice in 1547, according to the date appearing on its pendant, *The Last Supper,* which remains *in situ*. It belonged to Charles I of England, was acquired by Ambassador Alonso de Cárdenas, then sent to Madrid in 1654. Two years later Velázquez placed it in the sacristy of the Escorial. Certainly this painting left its original site at an early date because there is another version, of the same size and with some small variations on the right-hand side, in the chapter room of Newcastle-upon-Tyne Cathedral; after recent cleaning it has been confirmed as being authentic, with a seventeenth-century copy in place in San Marcuola.

The figures in the foreground display the painter's knowledge of Michelangelo's work, perhaps the result of a visit to Florence, but the treatment of the space and color, even with Venetian inspiration, is of an unusual Mannerism. The very large figures at either end of the painting, the spatial acceleration toward the background, an asymmetric perspective in the buildings, patterns running in zigzags between the figures, which are linked together in depth with different rhythms, are among the original characteristics. The cold tonalities — whites, marbles, blues, and oranges — are handled with artistry and not with the sensuality of other Venetian artists. The day-to-day naturalism of the apostles' attitudes does not prevent them from fulfilling their ornamental role.

Father Santos, who heard comments by Velázquez in the Escorial, described the work in 1657 as having "a most excellent fancy in invention and execution" and pointed out that there is "air, atmosphere between the figures." (It is interesting to note that *Las Meninas* was painted in 1656).

THE ISRAELITES DRINKING THE MIRACULOUS WATER

Previously deposited in Murcia Museum as a work from the family workshop, this picture has recently been exhibited in the Prado and is now considered to come from the hand of Jacopo Bassano, an attribution that found international confirmation during this painter's fourth-centenary exhibition. It came from the royal collections, where it had been correctly attributed to the great artist.

Its chronological place among the works of Jacopo swings between 1563–1564 (Vittoria Romani) and 1567–1568 (Alessandro Ballarin). On the one hand, one finds associations with the later period in the fabric of biblical pastoral subjects, as well as with the division of the background between an open area of landscape culminating in blue mountains and another closed by a dark rock and by the balanced grouping of figures and animals in the foreground. However, some figures, such as the kneeling woman in the foreground or the boy on the extreme right have parallels in earlier works. An absence of the formal refinement in the drawing of the figures that is seen in other works of that time is in contrast to the harmonies and chromatic accents, which reach an outstanding quality in the illumination of carmines and greens, and become the foundation of a balanced design subtly studied in the placing and attitude of the people and animals.

JACOPO BASSANO
The Israelites Drinking the Miraculous Water, 1563-1568
(Detail)

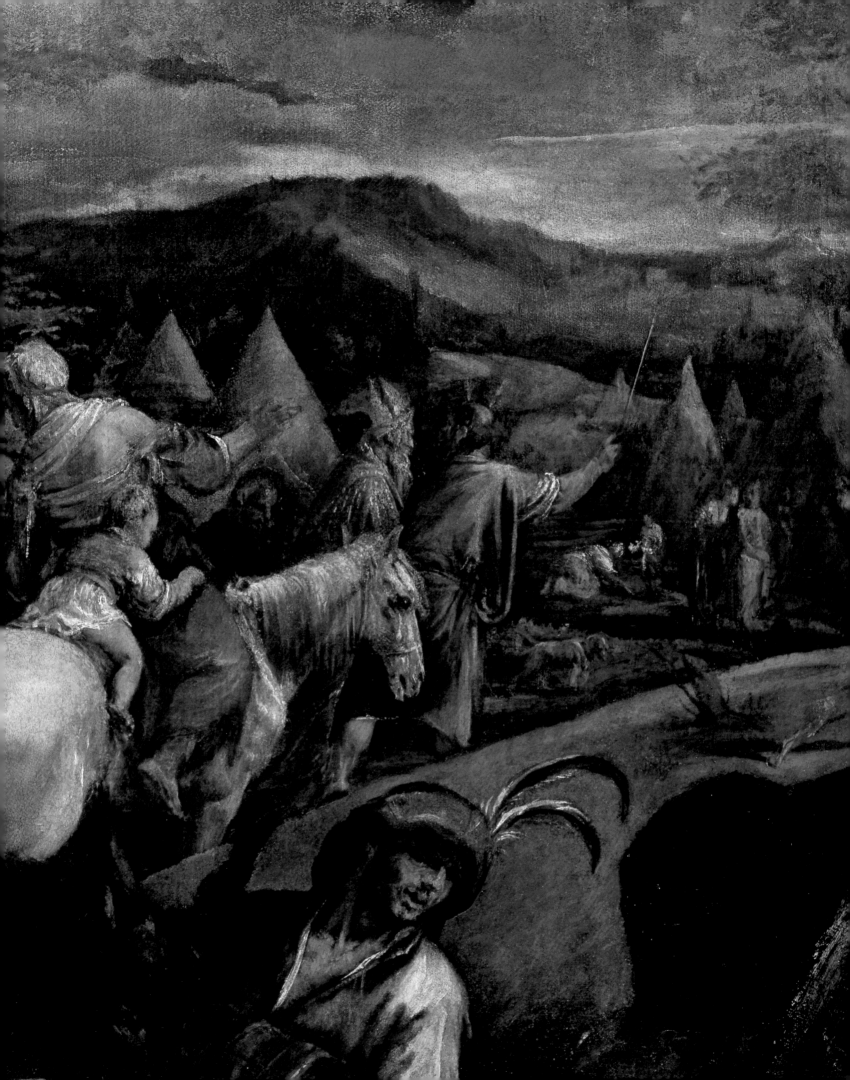

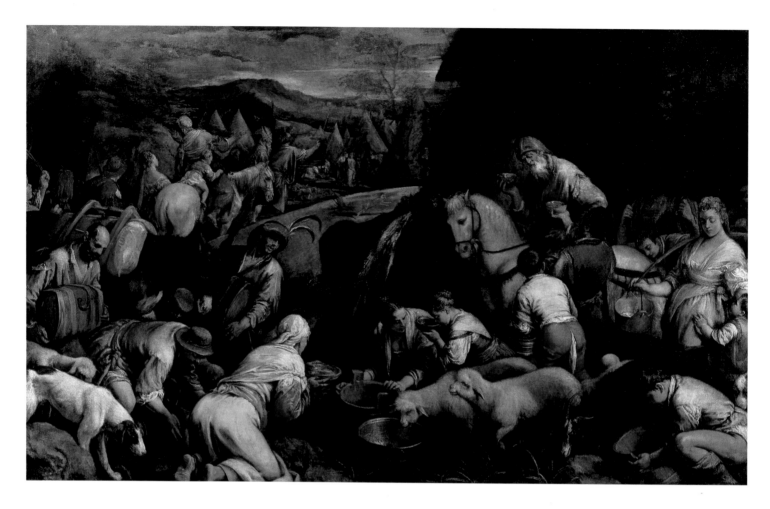

JACOPO BASSANO (c. 1510–1592)
The Israelites Drinking the Miraculous Water, 1563–1568
Oil on canvas, 146 × 230 cm

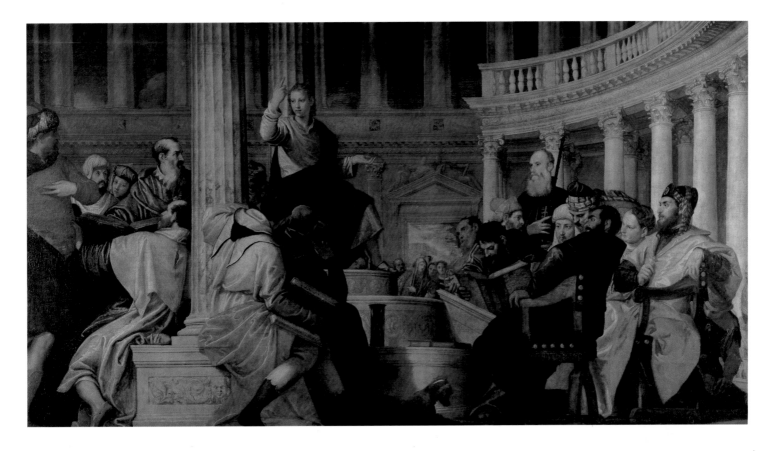

PAOLO CALIARI, called VERONESE (1528–1588)
Jesus Disputing with the Elders, c. 1558
Oil on canvas, 236 × 430 cm

JESUS DISPUTING WITH THE ELDERS

Since no other painting by Veronese on this subject is known, this could be the one mentioned in 1648 by Ridolfi as being in the Contarini house in Padua. In 1659 it was placed in the Hall of Mirrors in the Alcázar by Velázquez; one might suspect that this is one of the works he acquired in Italy for Philip IV. The date of 1548, seen on the edge of the book held by the central figure with its back to us, must be the result of a restoration, as the style indicates a date a decade later. The figure on the right, in the habit of the Holy Sepulcher, could be the person who commissioned the work, but he has not been identified.

Jesus Disputing with the Elders relates to the earliest point of Paolo's maturity, a little before his paintings for San Sebastiano in Venice and the decoration of the Villa Barbaro in Maser (1560–1561). Elements of development and formal relationships predominate: the arrangement of the Palladian-style architecture, the composition with a sense of reflection between the two groups, complementary tones — greens and carmines, yellows and violets — with symmetries, contrasts, and repetitions

JESUS AND THE CENTURION

Although there are different versions of this subject, this is the only one that can be considered completely authentic. It cannot be the work noted in 1648 by Ridolfi as being in the Contarini house in Padua, as it belonged to the earl of Arundel who died in 1646. Alonso de Cárdenas bought it from the earl's widow in Flanders for Philip IV. Velázquez placed it in the Priory Chapter Room of the Escorial in 1656. The head seen peering out from behind a column may be that of the person who commissioned the painting.

Its association with Veronese's canvases painted in 1571–1572 for the Cuccina Palace (now in Dresden) is clear; for this reason it is usually dated to this period. A strong dramatic accent, appropriate to the moment, is assisted by the chiaroscuro and by the greenish tinges in the sky, but formal values continue to predominate. The artist has paid close attention to the architectural setting; seeking the confrontation of the groups, the foreground has been opened, although without symmetry, with figures seen through to the background, where other, very tiny figures are glimpsed. Christ and the centurion, contraposed in parallel, are accompanied, respectively, by the disciples and soldiers. Other formal observations of gesture, expression, attitude, and color are easily observed.

YOUTH BETWEEN VIRTUE AND VICE

The story of Hercules as a youth having to choose between the paths of virtue and vice seems to have been created by Prodicus and disseminated by Xenophon and St. Basil. Due to the moral nature of this tale, it found notable literary and pictorial resonance in the sixteenth century, and paintings of this allegory were even given to children when they reached adolescence, as could be the case with this work. Veronese painted another, larger version in a vertical format, with a very different composition, and with a somewhat older Hercules, for Emperor Rudolf (Frick Collection, New York).

The Madrid example was not listed in the royal collections until 1686 and could have been the one Ridolfi saw in the Sanuto house in Venice. It used to be considered a youthful work, but Italian specialists such as Pignatti and Pallucchini have recently dated it at about 1580–1582. In spite of this, coincidences with the Cuccina paintings and *Jesus and the Centurion* — and discrepancies with other later works — cause us not to discount the possibility that it could have been painted around 1572.

The symbolic elements are set out with clarity: the sumptuously dressed woman representing Vice is seated before an opulent building and exudes a full, rosy beauty. The woman signifying Virtue, who is followed by the boy, is barefoot, abundantly clothed, and walks seemingly with difficulty, leaning forward, demonstrating how arduous is the way and the decision.

VENUS AND ADONIS

In his *Riposo,* written in 1582 and published in 1584, Borghini refers to this work and *Cephalus and Procris,* its pendant, as beautiful, recently painted pictures. Velázquez bought them in Venice for Philip IV at the beginning of 1651, and in the following year he placed them in the Mediodía Gallery of the Alcázar. Joseph Bonaparte seized the second painting and it was subsequently auctioned in 1912, being bought by the Strasbourg Museum, where it is today. The Prado picture had been enlarged at the top by a half meter, perhaps in the eighteenth century. This addition was removed in 1988 in such a way that the dimensions now coincide with those of the Strasbourg painting.

On other occasions Veronese dealt with the subject of the loves of Venus and Adonis and of Venus and Mars, enduing them with a strong erotic sense. However, in this pair of late works, he seems to have been pursuing other objectives. The lovers are not presented in a passage of carnal sensuality, but in the tragic end of Procris and in the deep exhaustion of Adonis. While the first work is painted in the subdued colors appropriate to the death it portrays, the second has light and sunny coloring. Both scenes take place in landscapes with trees. The two men are hunters, but the roles are changed according to the respective myths: Venus watches over Adonis's dream; Cephalus can scarcely attend to the dying Procris.

The composition of *Venus and Adonis* plays felicitously with verticals and horizontals, relating or contraposing heads — including those of Cupid and the hounds — bodies, and extremities. The spectacular color, in blues, greens, carmines, and oranges, is employed with many nuances, both in figures and landscape. The sun, penetrating through the leaves of the trees, transfigures this color, especially where it illuminates Venus.

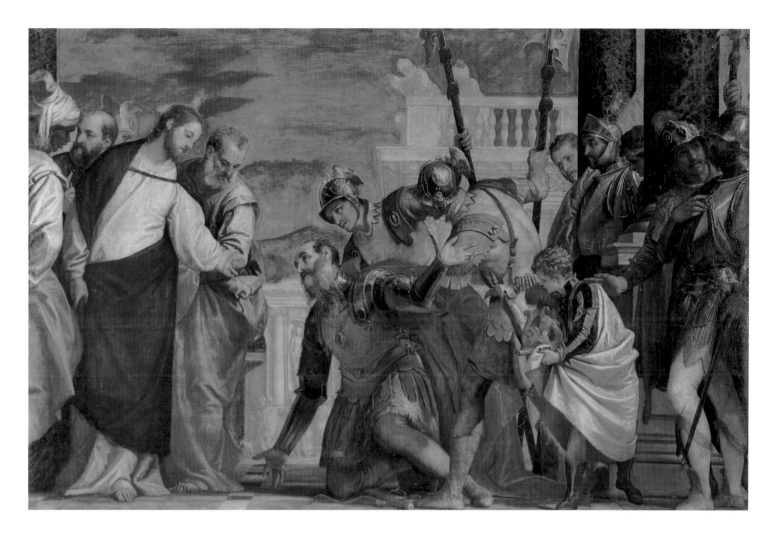

VERONESE
Jesus and the Centurion, c. 1570–1572
Oil on canvas, 192 × 298 cm

VERONESE
Youth Between Virtue and Vice, c. 1572–1575
Oil on canvas, 102 × 153 cm

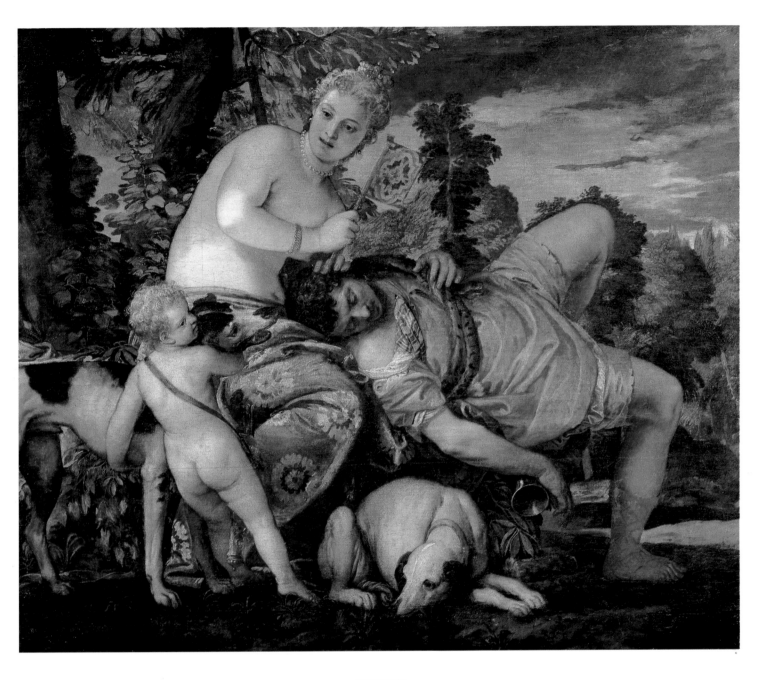

VERONESE
Venus and Adonis, c. 1582
Oil on canvas, 162 × 190 cm

VERONESE
Moses Saved from the Waters of the Nile, c. 1580
Oil on canvas, 50 × 43 cm

MOSES SAVED FROM THE WATERS OF THE NILE

Ridolfi wrote of a picture on this theme in the house of the marquis della Torre in Verona, but the Madrid painting was listed in the Alcázar in 1666, which makes it very unlikely that it is the same one. Another very similar, perhaps also authentic, version, in the National Gallery in Washington, displays slight variations in the costume of Pharaoh's daughter, in the clouds, and in the trees. On the other hand, examples in Dresden and Lyons have a different composition, are much larger and later, and were done with greater assistance from Paolo's workshop. The dating of the Madrid canvas has varied within a range of twenty years, but must be fixed at about 1580. Two preparatory drawings are known (Morgan Library, New York, and Fitzwilliam Museum, Cambridge).

This little masterwork shows a care for detail; its complex composition is supported by the two trees and reinforced by the women who continue the trees' trajectory. An oblique direction is marked by the infant in the center, which serves to emphasize the splendid figure of the princess. The servant with the little basket and the dwarf at the other side are chromatically complementary, as are the two women in the distance in their twisted postures and concerned attitudes. Neither the spectacular and opulent chromaticism of the composition nor its color nullify the dramatic sense of the story.

THE SACRIFICE OF ABRAHAM

Velázquez placed this work in the sacristy of the Escorial in 1656, but its origin is unknown, although it is suspected that it came from the collection of Charles I of England. On the other hand, there is no doubt that this canvas is from Veronese's very late period and was painted about 1585 or perhaps even later. The maturity evidenced by the complicated composition, the luminous use of color, and the culminating dramatic effect make this clear.

The composition is established by a splendid interlacing among Isaac, Abraham, and the angel, who together form a diagonal centered on the body of the patriarch, the other two figures in clear opposition above and below, leaving spaces of repose between the arms and head.

The fiery color of Isaac's hair is a surprise when seen in relation to Abraham's cloak and the manner the artist used for the coloration in the shadows of the figures of father and son. The angel is garbed in a much more brilliant hue, which combines with the intense blues of the background.

As is typical of his last works, Veronese here expresses a dramatic sentiment, seeking the culminating point of the story. More restrained than Tintoretto, he is distinguished also by his use of serpentine structures and brilliant color.

VERONESE
The Sacrifice of Abraham, c. 1585
Oil on canvas, 129 × 95 cm

881.

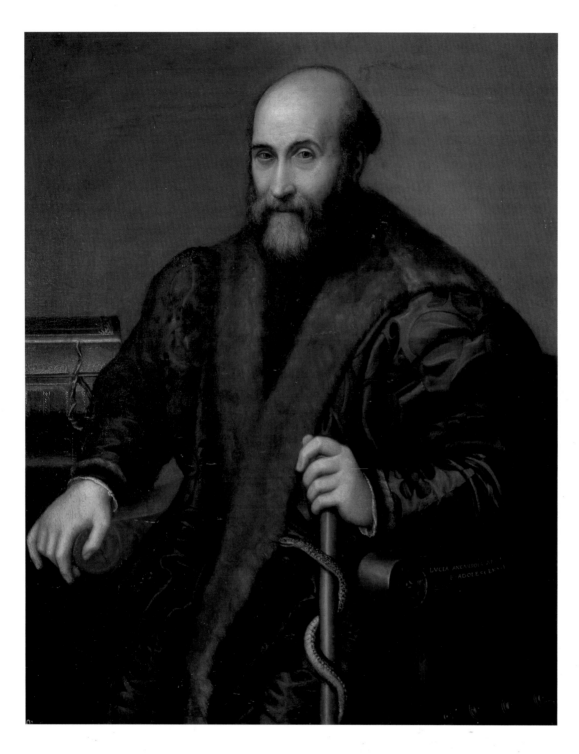

LUCIA ANGUISSOLA (1542/43–1565)
Portrait of Pietro Maria Ponzone, c. 1560
Oil on canvas, 96 × 76 cm

PORTRAIT OF PIETRO MARIA PONZONE

An extraordinary case in the history of painting is that of the Cremonese Anguissola sisters — Sofonisba, Elena, Lucia, Europa, and Ana Maria — all of whom were portrait artists of great precocity. The eldest, Sofonisba (1538–1625), was outstanding. She came to Spain in 1559 as a lady of the court of Queen Elizabeth of Valois and worked in Madrid until 1574.

Lucia, in contrast to her elder sister, lived only a little more than twenty years, but she did have the opportunity to paint some portraits and, as was usual among her sisters, they were of members of the family or were self-portraits. One of these, dated 1557, is in the Sforzesco Castle in Milan.

The Prado's portrait was sent to Sofonisba in Madrid by her father, Amilcar, after 1568 and is signed on the arm of the chair, following the sisters' normal practice, as daughter of Amilcar and "adolescent." Vasari, in the 1568 edition of his *Vite,* refers to the painting he saw in Cremona as a portrait of Pietro Maria, an excellent doctor. In fact, the doctor Pietro Maria (or Pietro Martire) Ponzone was Lucia's maternal grandfather, which explains the reason for the portrait and for its dispatch to Madrid. We do not know why it remained in the royal collections, where it was registered in 1686 in the Alcázar.

The walking stick with the coiled serpent identifies the profession of the sitter, who is dressed in a gown with a sable collar that is indicative of his rank. He is shown more than half-length, seated, with a book in his right hand, following a compositional model Sofonisba also used, although with variations.

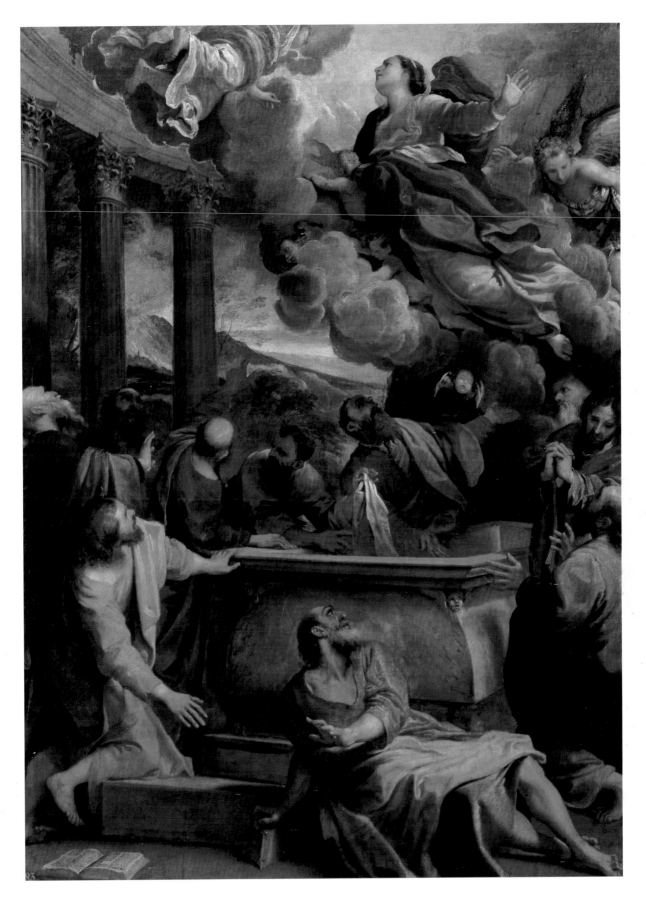

ANNIBALE CARRACCI (1560–1609)
The Assumption of the Virgin, c. 1590
Oil on canvas, 130 × 97 cm

THE ASSUMPTION OF THE VIRGIN

A clear relationship exists between this work and the large altar painting Annibale made in 1587 for the Brotherhood of San Rocco in Reggio Emilia, now in Dresden. However, this reduced work and variations must have been done for a private commission, which was probably painted a year or so afterward. The Prado's painting was brought from Italy by the count of Monterrey for Philip IV, and Velázquez placed it in the sacristy of the Escorial in 1656.

The especially rich chromatic range, matched by the play of light, and the columns that appear on the left bear witness to the artist's continuing interest in Veronese. Annibale received commissions for this subject on various occasions, both in Bologna, where he painted this work, and in Rome, during the second phase of his life. As this theme deals with the relationship between earth and heaven, it suited his aesthetic vision very well.

This example exemplifies Annibale's maturity in its compositional disposition, with the multiple relationships developed among the figures of the apostles, and through the varied uses of foreshortening. It is especially notable for the dynamism conferred on the work by the figure of the Virgin who, in spite of her corporeal nature, appears to ascend vertiginously. The physical agitation of the apostles is consistent with their expressions of surprise, reverence, and even fear. From this point of view, this canvas comes closer to the Baroque sentiment than the majority of Annibale's works.

VENUS AND ADONIS

The source of the commission for this work is unknown, but it was in the collection of Marquis Giovanni Francesco Serra, from Genoa, who was in the service of Spain. After his death it was acquired in Naples in 1664 by the count of Peñaranda, who gave it to Philip IV. A replica is in the Vienna Kunsthistorisches Museum. Both examples must have been commissioned by prominent aficionados.

Judging from its conceptual and formal nature, this canvas was certainly painted in Rome a little before the artist went to Verona in 1594. Compositionally, Venus and Cupid form a triangle while an orthogonal form is comprised by the arm and body of Adonis; in contraposition, the background alternately opens and closes. The closed composition encompasses the affectionate relationship between the protagonists, while Cupid presents the lovers to the viewer. The classic coloring is outstanding, with the red of Venus's cloak juxtaposed to the white of the doves, symbol of the goddess, and the blue and yellow of Adonis's garments. To this are linked the greens of the vegetation and, in contrast, the blacks and browns of the hounds.

The human figures, especially that of Venus, arise from an intense search for a full, natural beauty, like that found in the great masters Titian and Correggio. The grandness and opulence of the forms does not correspond, however, to the sensuality of many works by those earlier painters, but instead to the Virgilian concept so fashionable around 1600 — perhaps more in Rome than in Bologna — that love conquers all (*omnia vincit amor*), a philosophy of love that binds the spiritual and the carnal in intimate and indissoluble union.

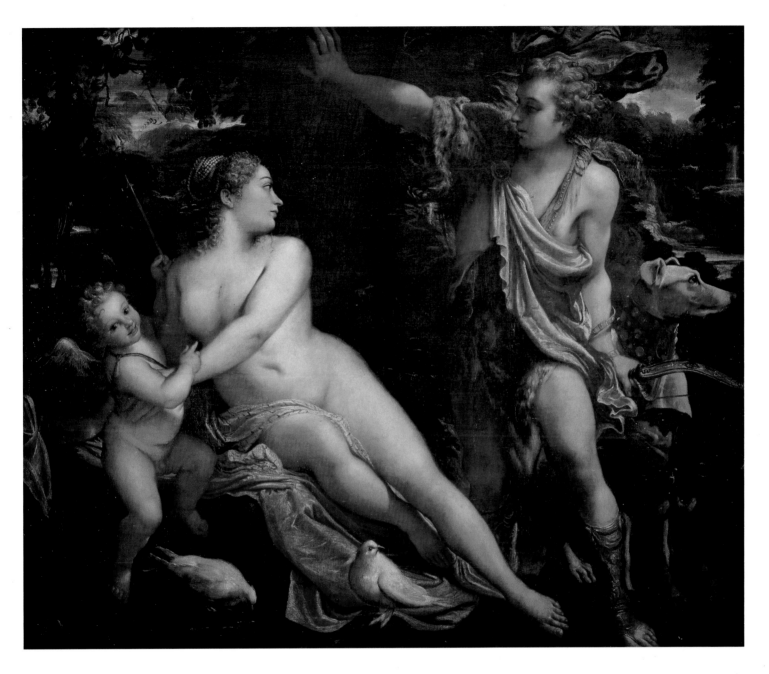

ANNIBALE CARRACCI
Venus and Adonis, c. 1592–1594
Oil on canvas, 212 × 268 cm

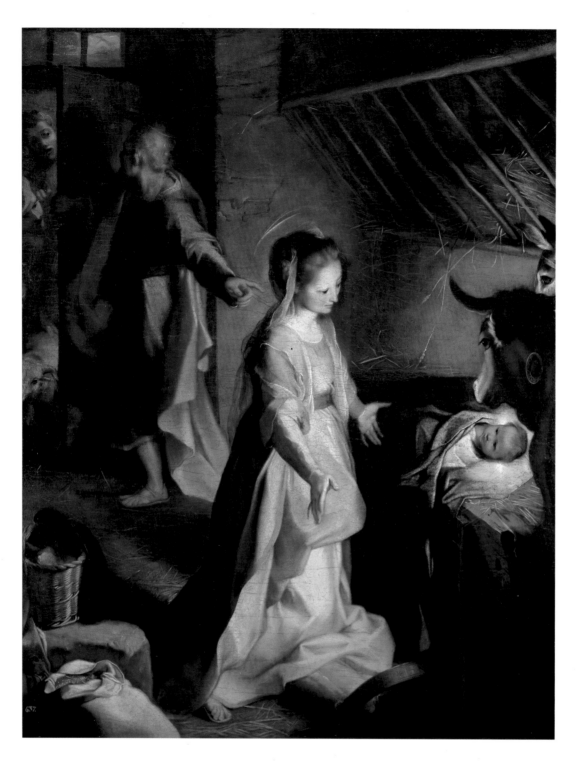

FEDERICO BAROCCI (c. 1535–1612)
The Nativity, 1597
Oil on canvas, 134 × 105 cm

THE NATIVITY

This canvas is very characteristic of the late techniques of the artist. It may be the painting he made on this theme in 1597 for his patron, Francesco Maria II della Rovere, Duke of Urbino, with whom he shared an evident affection and similar thinking. It seems that in 1605 it was sent to Margaret of Austria but it is not identified in the royal collections until 1779 when it was in the Prince's Casita in the Escorial. It must be remembered that in 1653 the count of Benavente also owned a *Nativity* by Barocci.

In the last twenty years of his life in Urbino, where he retired after 1570, Barocci persisted in working with modes he had used earlier, but now he did so with a surprising modernity. At times these works approached an almost Baroque standing; at others they exaggerated the artificiality, gentleness, and sentimentalism that were appropriate to his admiration for Correggio.

The structure of this painting is marked by a long oblique angle that relates St. Joseph, who is seen at the back inviting the shepherds to enter, with the Virgin adoring the Child. The contrasts of light and shade and the familial intimacy of the scene are characteristics that would be used to advantage in Baroque art of the following century, but the formal refinement, the almost excessive gentleness, the elongation of the figures, and the artificial chromaticism truly are traits of Mannerism.

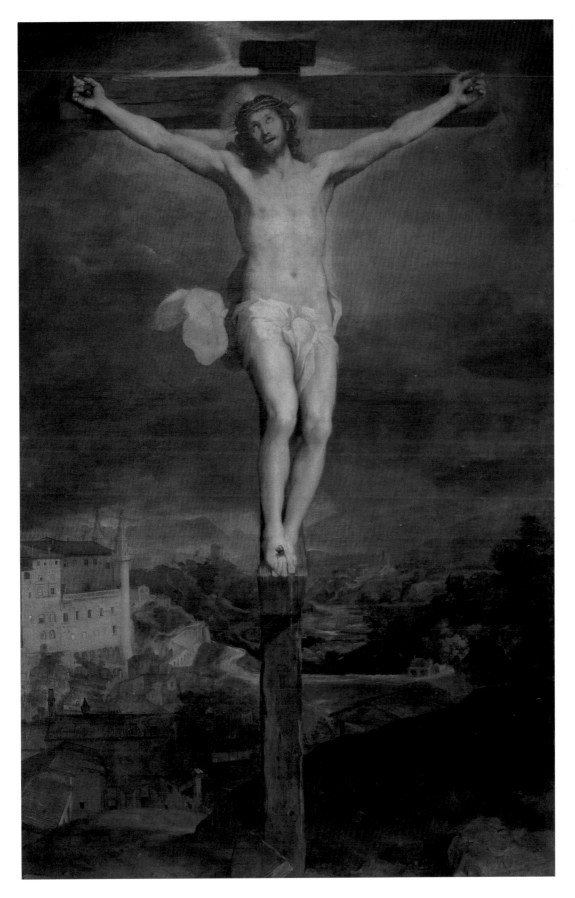

FEDERICO BAROCCI
Christ Crucified, 1604
Oil on canvas, 374 × 246 cm

CHRIST CRUCIFIED

This large altar painting was one of the last commissions Barocci received from his patron, the duke of Urbino. It was done in 1604 for 300 escudos de oro. In 1628 the duke left it to Philip IV who placed it in the chapel of the Madrid Alcázar.

This is not treated as an evangelical episode in a Passion, but as a devotional painting, in which Christ is shown crucified but alone and still living. The duke must have required that the city of Urbino be represented as background, with the ducal palace prominent on the left. The Counter-Reformist Mannerism of Barocci did not lend itself to this type of landscape representation and even less so to such topographical fidelity.

The chromaticism is replete with dark and tenebrous tones although the gray nuances create more of a fantastic image than a nocturnal realism. The painter, who in those final years had made his profession a religious activity, responds here with an understanding to the demands of the obsessive, almost neurotic, meditation of his patron.

The bland modeling of the Christ, which is as far from the naturalism of Borgianni as it is from the spiritual intellectualism of El Greco of that time, confirms the Mannerist imbalance, distanced from Baroque piety.

DAVID WITH THE HEAD OF GOLIATH

The attribution of this work (of unknown origin) to the great Milanese painter has been accepted with more and more enthusiasm recently. It was thought that the painting was brought by the Roman aristocrat Giovanni Battista Crescenzi, whose family was related to Caravaggio, when he came to Spain in 1617. But it was not documented in the royal collection until the death of Charles III.

The small size of this canvas characterizes it as a private commission. The dark, neutral background, effects of illumination such as the smooth fluttering of lights and shadows across the face of the hero, and the geometric — nearly cubic — composition, as well as the economy in color, which remains in a range of blacks, grays, ochres, and whites, all place the painting in the artist's mature phase, around 1600, when he received his first public commissions.

Caravaggio causes the two figures to emerge from the darkness of the background by means of a powerful foreshortening of Goliath's head and torso. While the David is one of the many boys whom the artist painted, taking his models from the urchins of the Roman streets, here he acts with a concentration full of responsibility and awareness of the immense importance of his actions. The meditation on death is fundamental to the oeuvre of the artist. As in his other works, it is here effected in silence and solitude, without gesticulation or exaggerated display of emotion, but with a magisterial realism that is seen in the human types, the objects, and lights, without definition of the scenario, so that the dimension of the drama is made more abstract and universal.

MICHELANGELO MERISI, called CARAVAGGIO (1571–1610)
David with the Head of Goliath, c. 1601–1602
Oil on canvas, 110 × 91 cm

SELF-PORTRAIT

Listed in the royal collections since the 1794 inventory, after the death of Charles III, this was then classified as a work by Mazo. Later it was considered to be from the hand of Esteban March, as either a portrait of Mazo or a self-portrait of March. All these hypotheses have now been set aside. Longhi, followed by Pérez Sánchez, suggested the attribution to Borgianni due to the similarity of the features with another self-portrait (Accademia di San Luca, Rome), which was painted a little before his death. Although it also has been suggested that it could be a self-portrait by Tristan, we prefer the traditional identification.

Judging from the age at which the painter here portrays himself, this work must have been painted in Spain during Borgianni's residence there from 1598 to 1605. No record of his living in Rome prior to 1606 exists, despite the fact that it has been written that he was there in 1604.

Realism is dominant in the painting, which shows the tenebrous illumination characteristic of the work of Borgianni, who introduced into Toledo and Madrid a surprising naturalism independent of that of Caravaggio, the work of whom he could only have known through privately commissioned paintings made under the patronage of Cardinal Francesco del Monte.

The energy of the image is impressive, as is the self-confidence shown by the artist, who seems proud of his art. It must not be forgotten that in 1603 he was one of the founders of the Madrid Academy of Painting, an up-to-date project that put forth the concept of painting as an art and not simply a craft.

ORAZIO BORGIANNI (1578–1616)
Self-Portrait, c. 1605
Oil on canvas, 95 × 71 cm

THE POULTRY KEEPER

The conventional name by which this anonymous painter is known — Il Pensionante del Saraceni — was invented by Longhi to designate an artist associated with the Venetian Carlo Saraceni, in whose Roman workshop he may have been trained. He was active during the second decade of the seventeenth century, the last years Saraceni spent in Rome. Given Carlo's Francophilia and the various characteristics this artist's work has in common with that of French artists in his circle, we cannot discount the possibility he may have been a French artist working in Rome. However, his style does not coincide exactly with that of any of those who can be identified.

Among the half-dozen paintings that figure in the oeuvre of Il Pensionante (which has not increased in number in recent years), the majority, like this one, are of secular, even domestic, subjects. This one represents a poultry vendor — not a rare subject in the first quarter of the seventeenth century in Rome, nor in Toledo, due to its realistic nature — with a customer who, perhaps cheating, holds one of the birds behind the vendor's back.

Though the subject is not unique, this artist is notable for his poetic interpretation of prosaic matters: on the one hand, through chromatic nuances that show themselves in a detailed examination, on the other by the golden light that bathes the scene. Such formal references would be of little consequence, however, if they were not accompanied by the loving treatment of the old poultry-keeper, who is shown as honest and endowed with goodwill.

The work was listed in the royal collections on the death of Charles III with no reference to its previous location.

IL PENSIONANTE DEL SARACENI (active 1610–1620)
The Poultry Keeper, 1610–1620
Oil on canvas, 95 × 71 cm

DOMENICO ZAMPIERI, called DOMENICHINO (1581–1641)
Triumphal Arch, c. 1608–1610
Oil on canvas, 70 × 60 cm

TRIUMPHAL ARCH

This unusual piece came into the possession of Philip V through the purchase of the Maratta collection. From the inscription on the upper part of the arch and the scenes and emblems that decorate it, it has been deduced that this was a votive offering made by Monsignor Giovanni Battista Agucchi to his patron saint, John the Baptist.

The Bolognese Agucchi (1570–1632), one of the most brilliant and influential intellectuals of his time, wrote the important *Trattato della Pittura* (Treatise on Painting). After being in the service of Cardinal Aldobrandini, he withdrew from Roman public life from 1607 to 1615, and this fact, among other matters, is referred to in the images on the arch, in which are set out definite parallels between Agucchi's retreat and that of St. John the Baptist to the desert. The monsignor later returned to Aldobrandini and was secretary to Pope Gregory XV, on whose death, in 1623, he was designated papal nuncio in Venice.

The remarkable cultivation of Agucchi, who even wrote a book on business, is demonstrated in this painting of the arch, a complete interpretation of which has yet to be developed. The choice of this type of votive offering in place of the traditional image of the saint is significant. But the artist was the equal of his friend and did not conform by painting a typical representation, but set the arch, on which weeds have grown over time, in a bucolic landscape invested with an intellectual melancholia. Here the shepherd and his flock live together with the cultured monk who explains its secret and rich meanings to an elegantly attired gentleman.

THE SACRIFICE OF ABRAHAM

Domenichino was summoned to Rome in 1621 by Gregory XV Ludovisi; after the death of the pope he remained there until 1631, when he moved to Naples, where he passed the last decade of his life. The creative force of the artist diminished during this Roman period although he continued to receive important commissions.

This painting was commissioned in 1627 or 1628 by the count of Oñate, Spanish ambassador to Rome. It was brought immediately to the Alcázar where, in 1636, it was listed in the New Salon, although some years later it was relegated elsewhere.

This canvas is a radical example of classical characteristics, one that influenced Velázquez before he went to Italy for the first time. Without doubt, it corresponded to a widespread fashion during the years in which it was painted. The study of the drawing and attitude made for each figure is clear, but independent. In this way a disproportionate relationship arises between Isaac and the figures of Abraham and the very fitting disposition of the angel above the patriarch. The angel is declamatory and displays a forced manner in his gesticulation. Passages of smooth brushwork, such as in Abraham's beard, are startling in contrast to the precise drawing of the rest, especially the drapery. The color is localized; its carmines, oranges, and whites emphasize the compositional fragmentation.

DOMENICHINO
The Sacrifice of Abraham, 1627–1628
Oil on canvas, 147 × 140

St. Sebastian

The early history of this painting is unknown. On the death of Philip V in 1746 it was in the inventory as the property of Isabella Farnese. At times it has been thought that the version in the Louvre — also of unknown origin — was the original, but both must be by the artist's hand, and Reni may have made yet one other example. This one probably was painted in Rome about 1610 or a little after. It is also possible that one of the two canvases was commissioned by Maffeo Barberini, in light of the historical and devotional interest that illustrious family held in St. Sebastian in those years, which is demonstrated in the work commissioned from Ludovico Carracci in 1612. In the years that followed, Guido worked for the Barberini family on several occasions.

The desire to emulate ancient beauty fixed in Guido an admiration for sculpture and, above all, for the male nude, as is shown here. However, this athletic body, an ideal model of beauty, must enclose a Christian soul, so the mythological god becomes a Christian martyr. In spite of the somewhat theatrical face and posture, this figure should not be understood from a sentimental point of view, but from his intellectual, almost philosophical, nature — one that is more classical than Baroque.

There is no naturalism in the color, with its rich range of grays crossed daringly by the white cloth. The melancholic twilight landscape reinforces the sense of a cerebral image, not a realistic one.

Atalanta and Hippomenes

Two similar versions of this large canvas are known and another, which was owned by the marquis of Leganés in the seventeenth century, is documented. The Madrid example was part of the marquis of Serra's collection and, with other splendid pieces, was acquired in 1664 for Philip IV by the count of Peñaranda, viceroy in Naples, passing at that time to the Alcázar. Although we lack information as to this canvas's origin, it is chronologically impossible for Serra to have been the direct client of Reni. Since he married in Naples in 1633 and lived there for some years, it is thought that this picture, together with the other version (Galleria Capodimonte, Naples), must have been painted by Guido when he was in Rome.

Guido spent 1612 and 1622 in Naples, but taking into account the similarity of the background of this canvas to that of *Samson* (1611), and the technique of causing the light bodies to stand out from the darkness, which he repeated in those years, the earlier date is the preferred.

This myth tells of Atalanta's challenging her suitors to a race, after which, if they lost, they would be put to death. Hippomenes devised the stratagem of dropping three golden apples, which Atalanta could not resist retrieving, thus enabling her suitor to win. A canvas on such a subject must have been painted for a client of high culture.

This complex composition contraposes and harmonizes the figures, their movements, and their draperies; it is aided by the cold and distinct colors of the bodies and clothes. Reni's ongoing search for human beauty is inspired yet again by ancient models, but they are endowed with sufficient naturalism to make these legendary figures believable.

The Death of Cleopatra

During the last decade of his life, when he once again lived in his native Bologna, Guido often painted half-length figures of Cleopatra, Lucretia, and the Magdalen, depicting the suicides of the first two and the penitence of the saint. Apart from the stories about careless and rapidly executed works being done to satisfy gambling debts, we have to surmise that there was a kind of competition among the clients who commissioned these images. We know of a Cleopatra, (now in the Pitti Palace, Florence) sent by Marquis Costi of Bologna to Leopold of Tuscany in 1640. But we know nothing of the other examples; that in the Prado was not documented until 1814.

It is possible that much of the success of these canvases was due to the contrast between the feminine figures — young, beautiful, with budding breasts — and their representation in the moment of death or mortification. The truncated vital opulence could have provided a morbid delight for certain clients, although these works lack sensuality.

The known examples present variations, which militates against a series production. The face in this canvas corresponds to Guido's always sought-after ideal of beauty, and for this reason it is more precise in the finish. The greenish grays of the shift are, on the other hand, of very smooth brush strokes. A red cloth and a blue curtain with gold trim complete the chromatic spectrum.

In the play of ambiguity, which was dear to Guido, the open, heavenward look converts this pagan suicide into a Christian martydom, a reversal of what he had done in painting *St. Sebastian*.

GUIDO RENI (1575–1642)
St. Sebastian, c. 1610
Oil on canvas, 170 × 133 cm

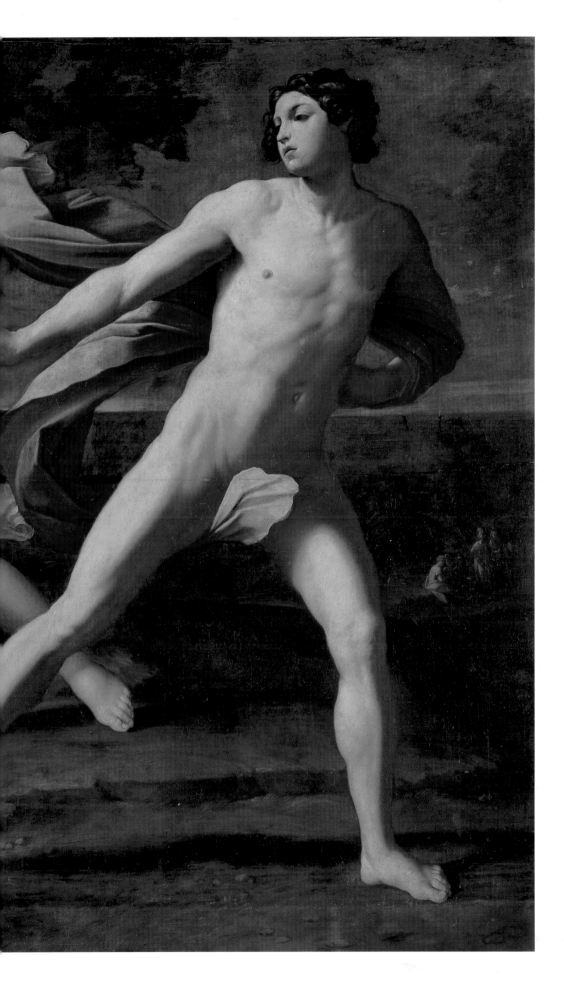

GUIDO RENI
Atalanta and Hippomenes, c. 1612
Oil on canvas, 206 × 297 cm

307

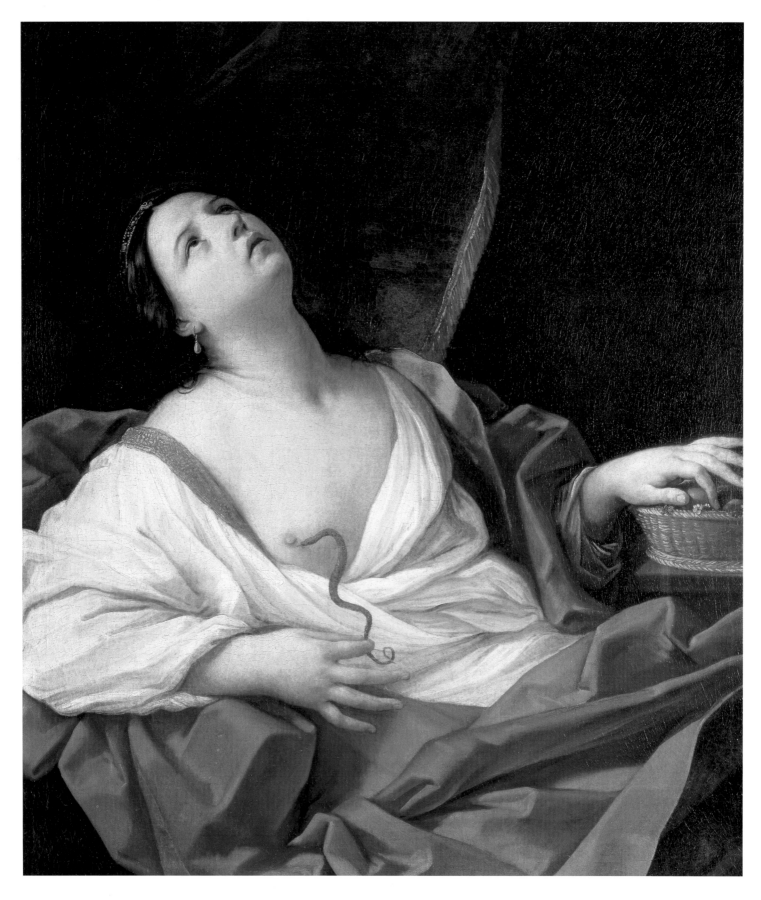

GUIDO RENI
The Death of Cleopatra, c. 1635
Oil on canvas, 110 × 94 cm

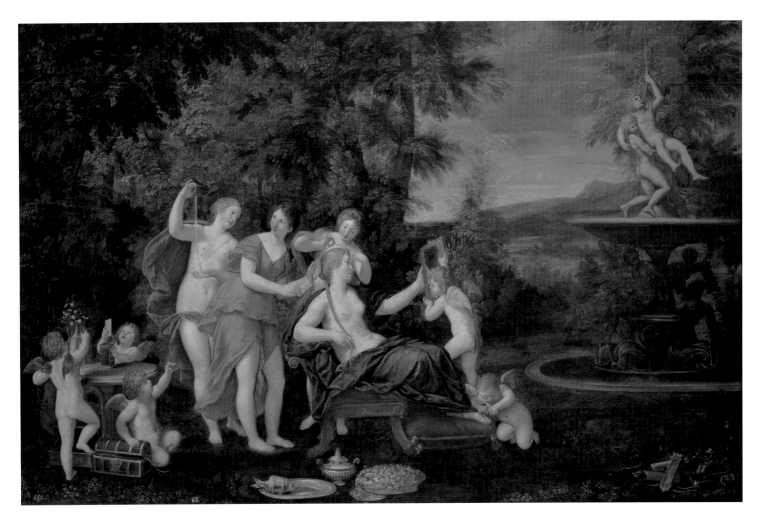

FRANCESCO ALBANI (1578–1660)
The Toilette of Venus, c. 1625
Oil on canvas, 114 × 171 cm

THE TOILETTE OF VENUS

Beginning in 1617 with a Roman commission from Cardinal Scipione Borghese for four circular paintings of mythological scenes of Venus and Diana with landscape backgrounds, Albani went on to produce this style of painting for private commissions from upper-class clients. From that year on, hardly any religious works from the hand of this painter are known. He returned to his home city of Bologna that same year.

This work and its pendant, *The Judgment of Paris,* were not recorded in the royal collections until 1700, when they were in the Buen Retiro. However, it is very probable that they

came to Madrid during the reign of Philip IV and that, directly or indirectly, he was another of Albani's noble clients. Although it is difficult to date the works, which were painted without much variation for many years, the strong inspiration from Annibale Carracci makes us prefer an early date of around 1625.

In fact, this picture follows closely the composition and objects found in a picture on the same subject that Annibale painted for the Tanari palace in Bologna about 1594 (now in Washington). But even though Albani kept the Bacchic image in the fountain, which is

associated with the love of Venus, he suppressed the little figures of Mars and Vulcan, reminders that the goddess was performing her toilette, attended by the three Graces, after an adulterous union. Stylistic differences are also found in the fragile conception of the nudes and the whiteness of the flesh. A nostalgia for the pastoral and the desire for a world separate from the realm of human reality motivated this type of commission of mythological scenes in a landscape.

SUSANNA AND THE ELDERS

In 1617 Guercino received a commission in Bologna, from Cardinal Alessandro Ludovisi, the future Pope Gregory XV, for three paintings: *Lot and His Daughters* (Escorial), *The Prodigal Son* (Galleria Sabauda, Turin; ruined), and this one in the Prado. In 1664, the two in Spain were left by Prince Niccolò Ludovisi, nephew of the pope, to Philip IV, who sent them to the Escorial, from which *Susanna and the Elders* came to the Prado in 1814.

This painting is considered the most advanced of the three and one of the artist's early masterworks; it motivated a eulogy from Ludovico Carracci, who described it in 1617 as a "*mostro di natura*" (exhibition of nature), referring perhaps to the great talent it displays, but also to its direct confrontation with nature, by which the painter distanced himself

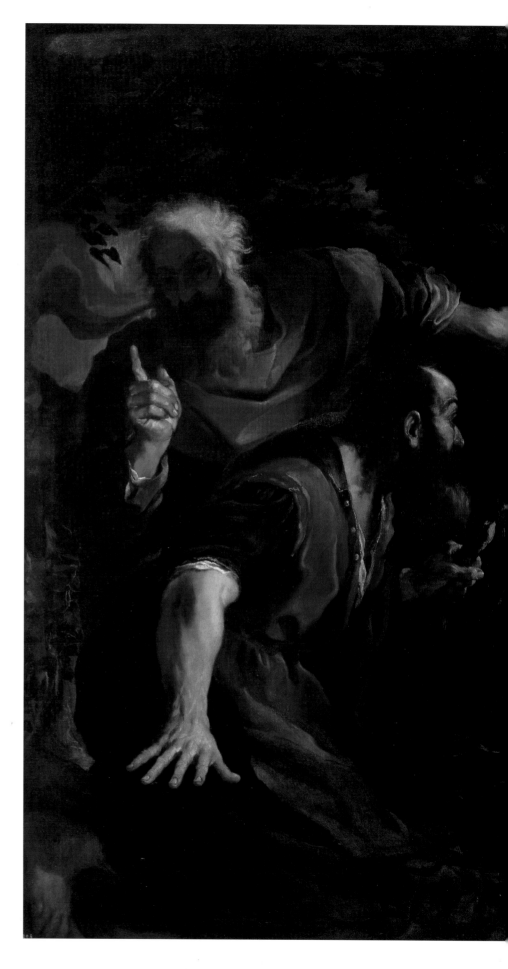

decisively from the influence of the Bolognese master. This naturalism is expressed in the beautiful nude figure of Susanna, the model for whom, according to Malvasia (who probably spoke with Guercino about this work), was a girl confined in the archbishop's prison.

Such naturalism, which does not stem from the influence of Caravaggio, is also expressed in the play of light and shade — the head of the standing old man, the body and face of Susanna — and in the rendering of the woodland and landscape. The painter skillfully contrasts the beautiful but fragile body, luminous in its nudity and unaffected in Susanna's attitude as she washes herself, with the foreshortened gesticulations, the wrinkled folds, abundant beards, and baldness of the Elders.

GIOVANNI FRANCESCO BARBIERI, called GUERCINO (1591–1666)
Susanna and the Elders, 1617
Oil on canvas, 175 × 207 cm

FRANCESCO FURINI (1603–1646)
Lot and His Daughters, c. 1634
Oil on canvas, 123 × 120 cm

LOT AND HIS DAUGHTERS

According to Baldinucci, this work was painted on commission from Grand Duke Ferdinand II of Tuscany, who gave it to Emperor Ferdinand; in fact, the gift was made to Philip IV in 1649 on the occasion of his marriage to Mariana de Austria. The duke of Nájera, steward to the queen, observed the sensuality of the painting and referred to its "delight." The work was placed in the Buen Retiro and, from 1792 to 1827, was in the reserved room of the Royal San Fernando Fine Arts Academy, where various copies were made. Although its authorship was soon forgotten, it is now recognized as a masterwork by this artist from Florence.

The stylistic affinities with the *Madonna of the Rosary* (San Esteban, Empoli), documented about 1634, give us a similar date for the Prado work. The figure of Lot coincides with the saints of the altarpiece and the outline of the daughter on the right recalls the form of the altar's St. Dominic. In 1645 Furini was working in Rome on another version of the same subject for Duke Salviati (Villa Salviati, Florence) but with notable variations. A preparatory sketch for the Madrid painting is in the Uffizi.

The blue background is characteristic of this artist's work and serves here to heighten the sensuality of the white skin of Lot's two daughters. Their placing — in profile, their backs to us, hiding or veiling the significant parts of their nude bodies — is a magnificent invention. The sensual and disquieting beauty of the scene is complemented by the refined rendering of the bottle and drinking cup with which his daughters are inviting Lot to drink in order to obtain their objective.

MASSIMO STANZIONE (c. 1585–c. 1658)
The Triumph of Bacchus, c. 1632–1634
Oil on canvas, 237 × 358 cm

THE TRIUMPH OF BACCHUS

After 1630, when he finally returned from Rome, Stanzione was to become the greatest Neapolitan painter to contend with Ribera. The competition between the two was provoked on occasion by clients themselves, who would commission works from both at the same time. This must have been the case with this large painting, which, together with another by Ribera of the same size and theme, was inventoried in the Alcázar on the death of Philip IV. We know of only three fragments of the Valencian artist's *Appearance of Bacchus,* as it was burned in the fire of 1734, but the one by the Neapolitan has been preserved intact.

These paintings seem to date from the beginning of the 1630s, perhaps between 1632 and 1634, and could have been a commission by the viceroy, the count of Monterrey, in competition with Ribera.

Stanzione does not yet show a radical classicism, since during his training he was influenced as much by Battistello, a follower of Caravaggio, as he was by Reni. The composition, with an unusual movement from right to left, was very carefully studied, in an effort to maintain the constant rhythms and equivalents that were appropriate to the classicism of Carracci. The colors are also those of classicism, but the succession of the reds and the darkening of the yellows have rendered them more dense. The academic nude studies are somewhat modified by the light and shadow, which are the principal anticlassical elements. The sky and clouds are also nearly as realistic as those in the work of Ribera.

Both the canvases from Naples were placed — perhaps due to their association with wine — in the "room where His Majesty dines," where they were surrounded by still lifes.

MOSES SAVED FROM THE WATERS OF THE NILE

Gentileschi sent this large painting to Philip IV in 1633, after it had been refused by the king of England, Charles I. It is not true, as has been thought, that this was done through Giovanni Battista Crescenzi, Marquis de la Torre, who was an occasional dealer in pictures. Although the date of its acquisition leads us to think that it was destined for the Buen Retiro, in 1636 it was inventoried in the Alcázar.

After a brilliant career as court painter — in Turin (duke of Savoy), Genoa (Doria), and Paris (Marie de Medicis) — Gentileschi finally came to London in 1626 at the request of Charles I. In the years up to his death, the Pisan painter (who is referred to as Florentine in the inscription on the bracelet of one of the ladies in this painting) cultivated in particular the painting of Old Testament subjects, and some evangelical passages of the infancy of Christ, that would not upset the Anglican Protestants. At times he

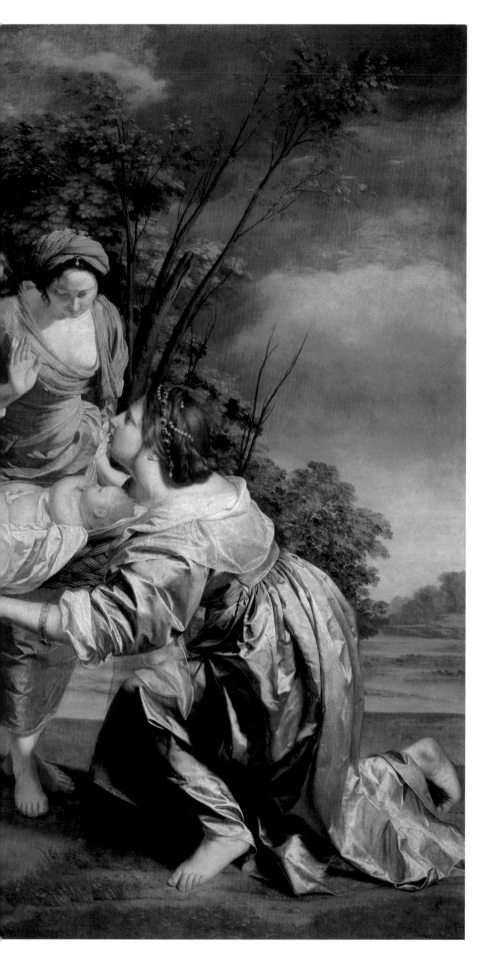

repeated versions of these to meet the demands of a clientele that flattered the king by emulating his taste. However, no replica of this painting is known.

The Caravaggism of Orazio's Roman years was disseminated during the course of his travels from court to court. Here the most important aspect is the palatine ambience of elegant ladies dressed in brilliant satins, which Gentileschi introduced into English painting before the arrival of van Dyck. The ordered arrangement of the group and the classicism of the colors are accompanied by an idealistic landscape in a Venetian key. All these somewhat conventional aspects are consistent with the social and religious demands of his clientele. His precise technique is also outstanding, as is his abiding influence on English painting.

ORAZIO GENTILESCHI (1563–1639)
Moses Saved from the Waters of the Nile,
c. 1633
Oil on canvas, 242 × 281 cm

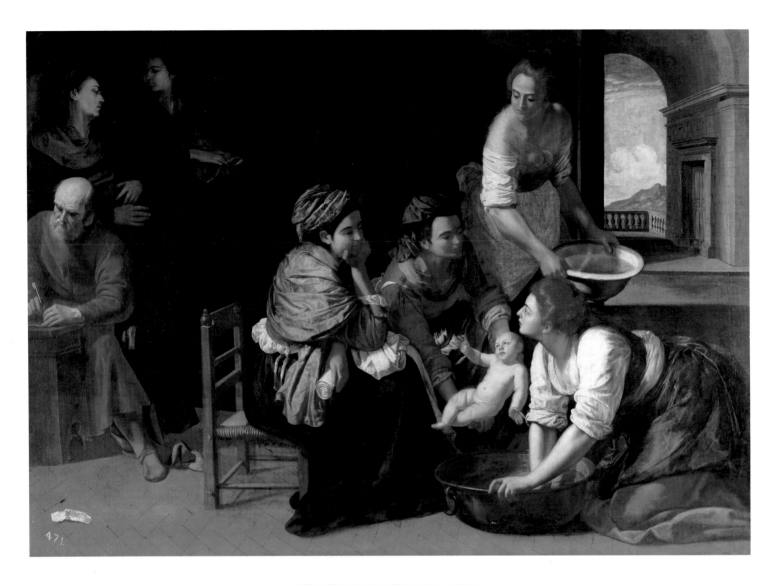

ARTEMISIA GENTILESCHI (1593–1652/53)
The Birth of St. John the Baptist, 1635
Oil on canvas, 184 × 258 cm

THE BIRTH OF ST. JOHN THE BAPTIST

Beginning in 1634, important commissions were granted for the decoration of the Buen Retiro Palace, not only in Madrid but also in Rome and Naples. The count of Monterrey, viceroy of Naples, commissioned from Massimo Stanzione a series on the life of St. John the Baptist in 1634 or 1635. To it belong the four canvases by the Neapolitan artist that

are now in the Prado depicting the sign to Zacharias, the Baptist's farewell to his parents, his teaching, and his execution. Artemisia arrived in Naples in 1630 and it is not known how she came to participate, but this signed work is undoubtedly part of the series, and it corresponds in size with those by Stanzione (two of which are somewhat wider).

In almost no ways did Artemisia's view coincide with that of the gentleman Massimo, however. In opposition to the latter's classicism, she offered an intimate, quotidian view that made Longhi praise the painting as the best executed study of an interior in the whole of seventeenth-century painting in Italy. The background architecture in the

manner of Codazzi, who came to Naples in 1634, and the female faces typical of Artemisia's oeuvre are the most conventional elements. But the objects — the chair, washbasin, bandage, clothes — and the attitudes are represented with an atmosphere of realism, the verisimilitude of which is reinforced through the graduation of light and shade.

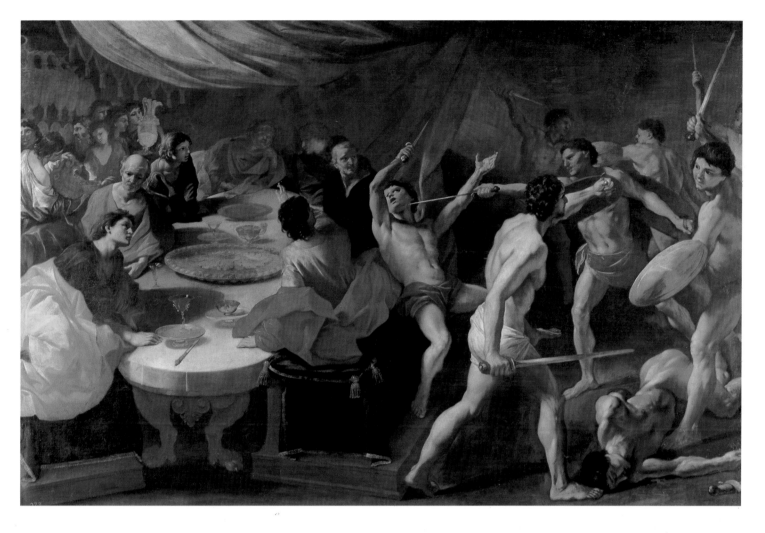

GIOVANNI LANFRANCO (1582–1647)
Banquet with a Gladiatorial Contest, 1637–1638
Oil on canvas, 233 × 355 cm

BANQUET WITH A GLADIATORIAL CONTEST

Among those paintings the count of Monterrey commissioned around 1634 in Naples for the decoration of Madrid's Buen Retiro Palace was a series dedicated to the events of ancient Rome. Although no documentation is known, the paintings were requested from Lanfranco, who came to Naples in 1634 and who had known the viceroy when he was ambassador in Rome. Five large canvases by his hand are preserved in the Prado, another is in the palace of Aranjuez, and a seventh has been lost; all were of different widths but matched in height. Paintings by other artists, such as Domenichino, may also have been part of this series.

A letter of December 1637 from Lanfranco refers to his being commissioned again by the viceroy to make some paintings for Philip IV. It is thought that the *Banquet* and the *Address,* which have the same dimensions, were among these, as they both show the assimilation of Neapolitan tenebrist elements, even though their characteristics are somewhat different.

In this work, the artist has contraposed the tranquil scene of the banquet, its table perpendicular to the plane of the painting to suggest great depth, with the violent and dynamic gladiatorial demonstration. The abridged manner of working and the rapid brushwork do not prevent an old-fashioned and meticulous description of the objects on the table, in the fashion of the seventeenth century.

SALVATORE ROSA (1615–1673)
The Gulf of Salerno, 1640–1645
Oil on canvas, 170 × 260 cm

THE GULF OF SALERNO

Although this is not identified in the royal inventories until the death of Charles III, it is very probable that it came to the court during the reign of Philip IV, whose name can be made out in a blurred inscription on a stone in the ruins at the right. The painting is signed with Rosa's usual interlinked initials, and must be dated during the time the artist was in Florence (1640–1649) in the service of the grand duke of Tuscany. This period came between his departure from Naples and the time he finally established himself in Rome.

The characteristics coincide with those of other documented Florentine landscapes. The monumental amplitude of space is in counterpoint to the little figures occupied in normal daily activities: bathing, strolling, working. The Baroque flavor of the great storm clouds, which are rich in shading, accentuates the Romantic aspect associated with this painter since the last century.

As with other landscapes Rosa painted in Florence, the scenery is that of his homeland: in this example the Gulf of Salerno, south of Naples.

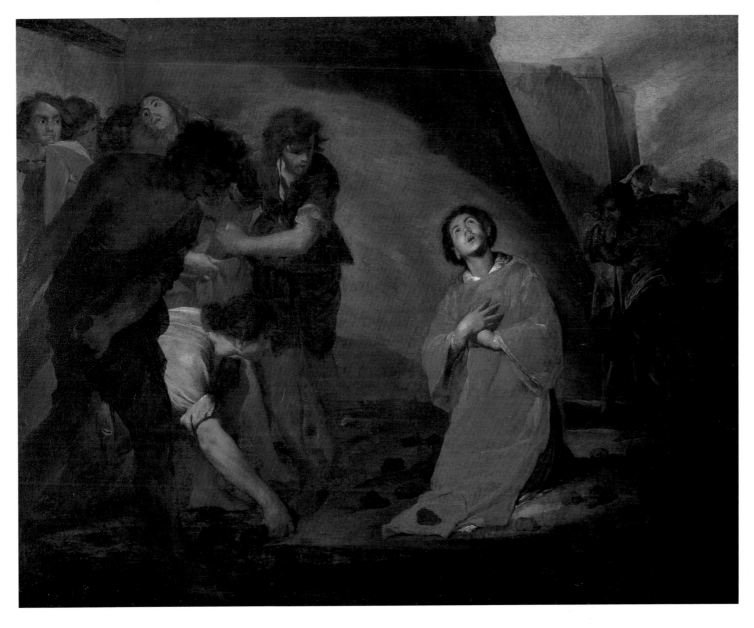

BERNARDO CAVALLINO (1616–1656)
Stoning of St. Stephen, c. 1650
Oil on canvas, 71 × 93 cm

STONING OF ST. STEPHEN

As with the majority of this almost unknown Neapolitan painter's work, this canvas lacks documentation of its origin. It was bought in the London market about a half-century ago and was given to the Prado by the Friends of the Museum in 1989.

Although we know little about this artist (his work is not documented and only one of his paintings is dated), his particular technique has recently allowed us to form a catalogue of certain works. Like this one, they are notable for their small size. Their subjects generally derive from profane literature, unlike this present painting. We may conclude, then, that Cavallino's clientele was noted more for its cultural enthusiasm than for its financial capacity. In a form consistent with these tastes, the painter unfolds an exquisite and delicate language of great refinement.

In his hands, this scene of martyrdom lacks the tragic sense native to those with Caravaggist tendencies. The isolated figure of the saint does not give rise to a distressed desolation but instead seems to have been chosen simply in order to emphasize the marvelous red of his dalmatic against the background wall and the elegantly arched curve from the point of the cloak to his head. In the same way, the violence of the executioners is transformed by the delicacy of grays and chestnuts with which they are painted.

749.

PIETRO DA CORTONA (1596–1669)
The Nativity and the Adoration of the Shepherds, before 1656
Oil on venturine, 51 × 40 cm

THE NATIVITY AND THE ADORATION OF THE SHEPHERDS

Certain letters of Niccolò Ricci, Francesco Barberini's agent in Madrid, inform us that this painting on stone was given by the Barberini family to Philip IV in 1656, and that the king took delight in the work. As a little work of devotion it was placed in the oratory on the ground floor of the Madrid Alcázar.

In the 1686 inventory it was erroneously attributed to Guido Reni, but this was rectified in 1700 when it was registered with the name of Pietro da Cortona.

On finishing the frescoes of the Pamphili Palace in 1654, Pietro went to work for the Barberini family, which had been his most important Roman patron. Shortly afterward he must have painted this small picture, which coincides in its formal aspects with other works of those years. The human models, the purposefulness of the compositional verticals, the balanced and resolved order, the planes organized in depth on the diagonal, and the minor occupation of the space by the figures are defined features of his maturity, which this work demonstrates.

PORTRAIT OF ANDREA SACCHI

While still a boy of eleven, Maratta entered the Roman workshop of Andrea Sacchi, where he painted this portrait, certainly as both an exercise and a tribute. The artist kept the work until Philip V bought his collection in 1722, at which time it came to the royal collections. A 1662 engraving by G. Vellet confirms Maratta's authorship, and the canvas had already appeared in the inventory of the artist's paintings.

The age at which Sacchi (1599–1661) is represented and the fashion of his dress and hairstyle date the work to the last decade of his life, but at a time when the young Maratta had begun to show his own personality. It is clear that the younger painter did not conform to the classic style of his master and by this time had assimilated Baroque elements from such other artists as Lanfranco and Cortona.

This portrait demonstrates an expressive and psychological vigor, an austerity of composition, and a chromatic severity, all characteristics that are clarified and softened in other portraits of this period, by this artist, of cardinals or Roman nobility. This canvas causes us to note Maratta's relationship to Bernini and to Velázquez (Wildenstein portrait).

CARLO MARATTA (1625–1713)
Portrait of Andrea Sacchi, c. 1650–1655
Oil on canvas, 67 × 50 cm

CHRIST IN GLORY WITH SAINTS

When this work was purchased in 1969, it was without indication of its provenance. Its dual perspective from both below and above suggest that it could have formed part of a ceiling decoration but, if this is the case, the original location has not been discovered. The painting has been dated during Preti's stay in Modena, where he painted the frescoes of San Biagio (1653–1656), and also to his return to Naples after the plague, when he painted the canvases in San Pietro in Maiella (1657–1659). In any event, these are the years of the Calabrian painter's maturity, and the high level of quality he achieved is manifest in this splendid work.

The chorus of saints displayed in the lower part bears a heavy grandeur and convincing humanity, but each member is still seen as a perfect being. Notable are SS. Francis, Jerome, and Mary Magdalen, but one can also identify several hermits — SS. Paul, Anthony, Onuphrius, and Mary of Egypt — while bishops and other saints are set out in the distance. Mortification and penitence stand out in a Counter-Reformational context, which is complemented by the appearance of the young and luminous Christ between angels painted with a celestial chromaticism.

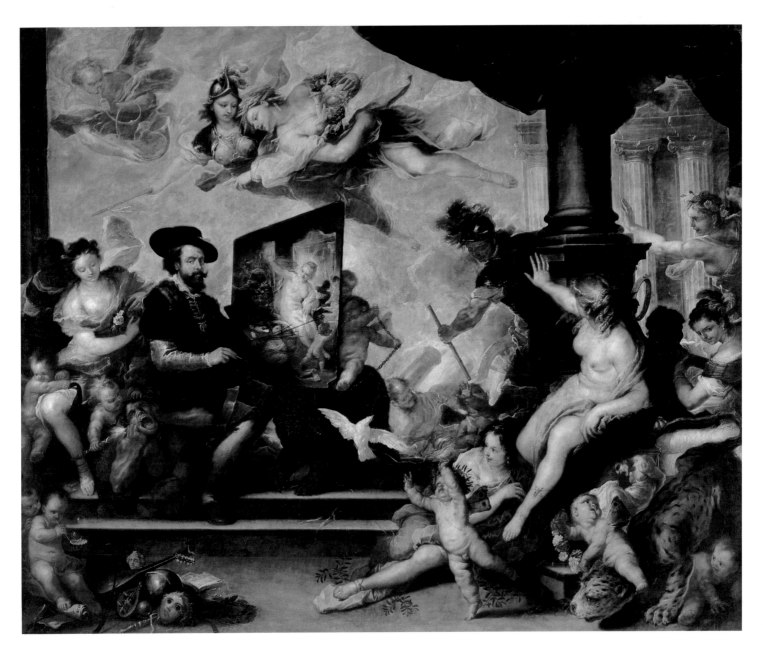

LUCA GIORDANO (1632–1705)
Rubens Painting an Allegory of Peace, c. 1660
Oil on canvas, 337 × 414 cm

MATTIA PRETI (1613–1699)
Christ in Glory with Saints, c. 1656
Oil on canvas, 220 × 253 cm

RUBENS PAINTING AN ALLEGORY OF PEACE

This enormous canvas belonged to the collection of the marquis of Ensenada, and it was acquired by Charles III, but it is not known for whom Giordano painted it.

It is an homage to Rubens, the Flemish painter who died in 1640, who is depicted with the physiognomy taken from one of his self-portraits (now in Windsor Castle), at his work as a painter, but also with the appearance of a gentleman (he wears the scallop shell of Santiago), a diplomat — he is seated upon Discord as he paints Peace — and a stoic, while a complex *vanitas* appears in the foreground.

The allegory, so much to the Neapolitan taste of the time, includes the figure of Juno (who perhaps represents fertility) behind the painter, those of Minerva and Ceres flying together above, and naturally that of Peace, who rejects Mars and the warlike symbols while she is being painted by Rubens. Various other figures tie together the complex composition.

Giordano had the greatest interest in Rubens during the years around 1660, so it is to this period one must date the painting. Despite its formal and conceptual Baroque nature, in 1768 the Neoclassicist Mengs said that there was not "another that is its equal" in Spain.

EQUESTRIAN PORTRAIT OF CHARLES II

This, with its companion portrait of Queen Mariana of Neuburg, is a preparatory sketch for the great portrait that was in the Hall of Mirrors of the Alcázar until it perished in the fire of 1734. The two sketches are inventoried in the Workshop of the Painters to the Royal Chamber on August 10, 1694, as from the hand of Jordán. The Neapolitan painter, who arrived in Spain in 1692, worked on the frescoes of the Escorial and returned to Madrid in July 1694, at which time he would have painted these sketches, several copies of which are known.

The equestrian portraits of Philip IV and Elizabeth of Bourbon by Velázquez, painted sixty years earlier, served as models for Giordano, but he transformed them, in the Baroque sense, by turning the figure of the king toward the front and lifting the horse higher. In addition he added allegorical elements: a woman holding a chalice flies above, followed by an angel with a cross; under the horse two men in turbans lie prostrate, and a page follows the king bearing his helmet. The sovereignty of the monarch is expressed in defense of Religion, as he conquers the infidels.

THE MESSINA HIEROGLYPH

This allegory celebrates the restoration of Messina to Spain by Louis XIV in 1678. Messina, a female nude crowned with a castle, surrounded by peaceful spirits, implores the protection of the Spanish monarchy, which is being crowned and sits enthroned over the cardinal Virtues, who are attended by symbolic attributes and animals. Time is in the foreground center; further back the monstrous figure of Wrath twists before a warrior wearing a cockerel-decked helmet. This representation of France is being compelled to board ship by another symbolic figure.

The work was signed and dated 1678, but on its arrival in Madrid an allusive sonnet was painted over the signature and date. In the mid-eighteenth century, De Dominici described a painting of the same subject by Giordano that had been exhibited in the via Toledo in Naples; as the description does not coincide with that of the work in Madrid we must assume it to have been another version sent for the royal collection and noted by Palomino.

This unusual work from the high Baroque, with its formal elements and complex allegory, was surely inspired by such erudite writers as Canón Celano, Antonio Ciappa, and Carlo della Torre who, according to De Dominici, advised Giordano to paint the first version.

SOLOMON'S DREAM

In June 1694 Giordano began the frescoes in the little vaults of the choir of the basilica of the Escorial. For the passage from the monastery to the choir he chose four stories about David as author of the psalms and, on the opposite side, toward the college, others casting Solomon as a symbol of wisdom. The eight subjects were repeated, with variations, on canvas. Except for the *Judgment of Solomon* and this one, which are in the Prado, these are preserved in the Royal Palace in Madrid. The canvases probably were painted on the artist's arrival at Madrid, but we cannot be certain that they were not done in the Escorial, as he wanted to continue his work on the vaults, having only finished the staircase in April 1693.

A biblical passage (I Kings 3:5–14) tells of the appearance in Solomon's dreams of Jehovah, who offers him whatever he desires. The king asks for "a heart that understands and can judge all people, to discern between good and evil." The wisdom conferred upon him is represented symbolically, and surprisingly, by Minerva, who holds a lamb upon the book of the seven seals in one hand, while the Holy Spirit gleams upon her shield. The goddess does not appear in the Escorial fresco, which, due to the difference in the area covered, had a similar but less concentrated composition.

The eight canvases served as models for a series of tapestries from the Royal Tapestry Manufactory of Santa Bárbara, which are now kept in the National Heritage.

LUCA GIORDANO
Equestrian Portrait of Charles II, 1694
Oil on canvas, 81 × 61 cm

LUCA GIORDANO
Equestrian Portrait of Mariana of Neuburg, 1694
Oil on canvas, 81 × 61 cm

239

LUCA GIORDANO
The Messina Hieroglyph, 1678
Oil on canvas, 272 × 443 cm

LUCA GIORDANO
Solomon's Dream, c. 1694
Oil on canvas, 245 × 361 cm

PORTRAIT OF CARDINAL CARLOS
DE BORJA

After his arrival in Spain in August 1720, the Roman artist Procaccini was occupied in particular with directing the architectural works and decoration of La Granja Palace and acting as artistic adviser to the king and queen. He was a painter to the Royal Chamber and several of his paintings, almost all with a devotional theme, are in the royal collections.

Carlos de Borja Centellas Ponce de León (1664–1733), son of the ninth duke of Gandía, was chaplain major to Philip V and became a cardinal in 1720. His portrait is thought to have been painted at the end of 1721, when he returned from Rome. Via family channels it arrived at the Osuna house and was sold in 1896; it was bequeathed to the Prado by the count of Cimera in 1944.

The full-length portrait was a major undertaking. Since Procaccini was a recent arrival at the court and his sitter was a person of such consequence, the painter had to exercise great care. The influence of his master, Maratta, is clear, but Procaccini's own talent is displayed in the psychological acuity, the able composition with its counterpoint of background figures, and the pure contrast of color and light.

ANDREA PROCACCINI (1671–1734)
Portrait of Cardinal Carlos de Borja, c. 1721
Oil on canvas, 248 × 176 cm

CHRIST SERVED BY ANGELS

As is the case with the majority of works by this original and solitary artist from Genoa, this painting is not documented. It comes from a personal collection in Strasbourg and was acquired in 1967.

In spite of difficulties in dating many of the painter's works, the persistence of certain compositional modes and configurations places this painting at the end of Magnasco's sojourn in Milan. In 1735 he finally returned to his native city.

A fantastic vegetation of tall and exuberant trees fills the background and dominates the composition as a whole. The small-sized figures appear schematic, nervous; they zigzag, and are transfigured by light and shade. The brushwork is radiant and rapid, as though improvised. The often mysterious, phantasmagorical aspect of such disturbing works by Magnasco is muted here due to the evangelical story. The painter used the same atmosphere and technique, whether for scenes of brutality, the macabre and horrible, or for those concerning religious subjects of scripture and the lives of the saints.

ALESSANDRO MAGNASCO (1667–1749)
Christ Served by Angels, c. 1730
Oil on canvas, 193 × 142 cm

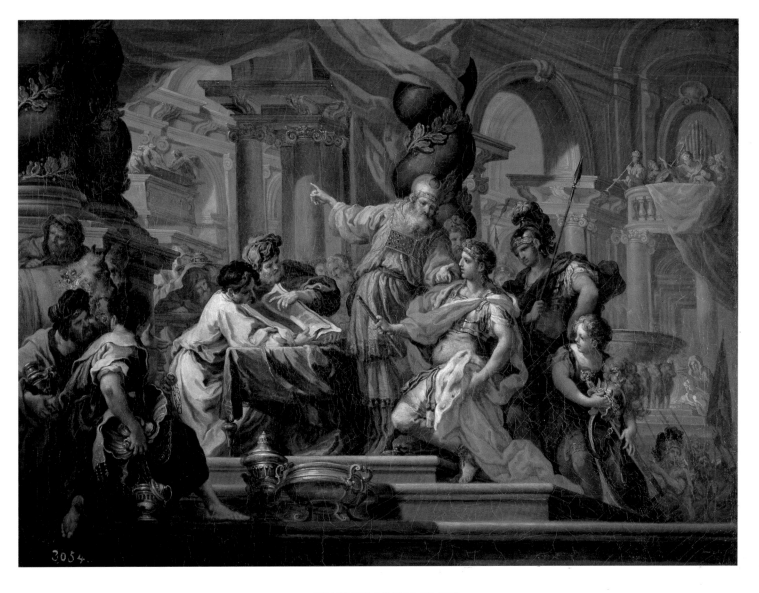

SEBASTIANO CONCA (1680–1764)
Alexander the Great in the Temple at Jerusalem, 1735–1736
Oil on canvas, 52 × 70 cm

ALEXANDER THE GREAT IN THE TEMPLE AT JERUSALEM

Upon the king's initiative, in 1735 Filippo Juvara designed the decoration for the gallery and salon in the San Ildefonso Palace. It comprised large canvases concerning the history of Alexander the Great, whose virtues would thus be reflected by those of Philip V. The artists who accepted the commission were Solimena (Naples), Lemoyne (Paris) — who was replaced on his death by Carle Van Loo — Trevisani, Conca, and Costanzi (Rome), Pittoni (Venice), Imperiali (Genoa), and Creti (Bologna). The paintings did not arrive for placement as had been established, but they are preserved in the collections of the National Heritage.

Conca was sent his commission on September 8, 1735. The painting was to represent the virtue of Religion when Alexander went to Jerusalem with the intention of sacking the city and punishing its people; upon seeing the High Priest robed, however, he became afraid and offered sacrifices in the temple. On September 22, Conca accepted the commission. He then made the preparatory drawing, which is in the Albertina (Vienna); on April 1, 1736, the sketch in the Prado was received.

At the end of 1737 the definitive painting, valued at 600 ducats, was finished. It is now exhibited in the palace at Riofrío.

The qualities sought by Juvara are clearly evident in Conca's invention: monumental perspective, compositional dynamism, majesty, and an effective expression of sentiment.

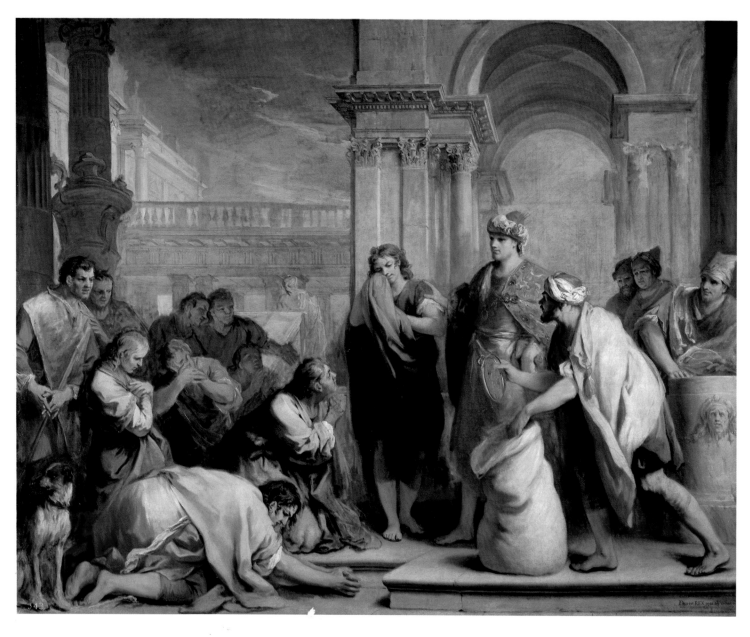

JACOPO AMIGONI (1682–1752)
The Finding of Joseph's Cup in Benjamin's Bag, c. 1748
Oil on canvas, 281 × 355 cm

THE FINDING OF JOSEPH'S CUP IN BENJAMIN'S BAG

With *Joseph in Pharaoh's Palace,* this is part of one of the last commissions received by this Neapolitan artist before his death in 1752. Amigoni arrived in Madrid in 1747 and the following year Ferdinand VI entrusted him with the decoration of the Conversation Room in the palace in Aranjuez. He began to paint the ceiling vault with an allegory of the Virtues requisite to the monarchy. Later he was occupied with a series of large canvases telling the story of Joseph as virtuous governor, which were to cover the palace walls. The series was left unfinished, as can be seen in some parts of this work. After the artist's death, two other paintings, with the same measurements, intended to complete the series, were commissioned from Corrado Giaquinto.

Amigoni's Venetian training is apparent in the architectural scenery with its classical sense of Veronese. The dramatic mood, less frequent in Amigoni, is brought to play here through amplitude of attitudes and lights, which is in accord with the story (Genesis 44). The range and chromatic harmonies are in concord with his smooth and delicate language.

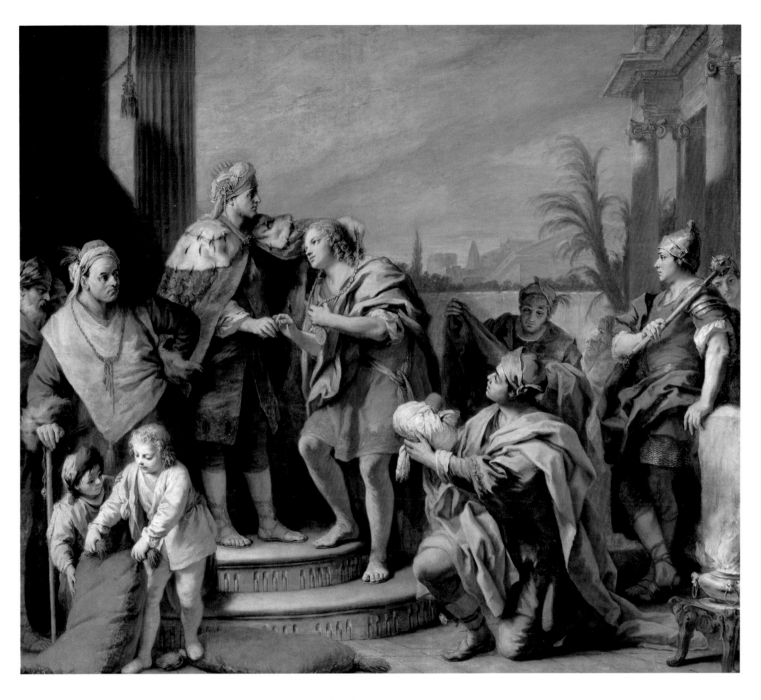

JACOPO AMIGONI
Joseph in Pharaoh's Palace
Oil on canvas, 325 × 283 cm

SAINTS IN GLORY

JUSTICE AND PEACE

Giaquinto, a successful fresco painter in Italy, was granted commissions in Madrid for the decoration of various ceilings and vaults of the Royal Palace. On June 10, 1754, he received the order to paint the cupola of the chapel, for which he made various part sketches, of which three are known, belonging to the Prado Museum. The fresco was finished on September 3, 1755.

In the cupola Glory is shown with the Eternal Father and an extraordinary number of saints and righteous men under the old law, many of whom are identifiable by their attributes. This sketch is known as that of St. Lawrence, who appears on the extreme left robed in a dalmatic, the gridiron in his hand; behind him is St. Stephen. Toward the right are figures from the Old Testament — Abraham and Isaac, Moses, Noah, David, and Judith.

What could have been a conventional composition of monotonous repetition was resolved with a fluid grouping above clouds that mark an undulating, curvilinear rhythm continued in the outlines of the bodies and the ovals of the heads. The luminous chromatic play is made outstanding by the delicate brushwork, which caresses the forms. This sketch is resplendent with all the beauty inherent to the Rococo.

After the death of Amigoni, Giaquinto was summoned to the Madrid court where he was in the service of Ferdinand VI, then Charles III, from 1753 to 1762. He subsequently settled in Naples, where he died in 1766 .

The artist left a profound mark on Spanish painting with his highly refined Rococo style, which is superbly displayed in this work despite its great size. He painted two versions of the same size, but with variations. One was for the assembly hall of the Royal San Fernando Fine Arts Academy; the other, painted for the king, was placed in one of the salons of the Royal Palace, although in 1772 it was found in the rooms of Prince Don Antonio. Both are in the Prado today and, although Ceán wrote that the one in the palace is a copy of that in the academy, the contrary is believed currently.

The inspiration for this subject comes from Psalm 85:10 — "Righteousness and peace have kissed each other." The divine attributes prevail in the world of men. Thus the female figure symbolizing Justice embraces that representing Peace, who offers her cheek. Justice wears a crown and has an ostrich at her side, while cherubs prepare the instruments of war. Peace, with an olive branch, has children around her with sheaves of corn; nearby a lion crouches beside a lamb. The temple of Jerusalem is in the background. All these allegories allude to different Psalms and texts of Isaiah.

The allegory seems suited to celebrations of the arrival of the new sovereign, Charles III, in accordance with Psalm 72, dedicated to Solomon, which sets out that the ideal king is one who brings both justice and peace. This also explains the painting of the other version for the academy. The date of this painting therefore must be 1759 or 1760.

Giaquinto used models of exquisite beauty, and smooth and luminous colors, among which are pinks, greens, golds, lilacs, and others of similar refinement.

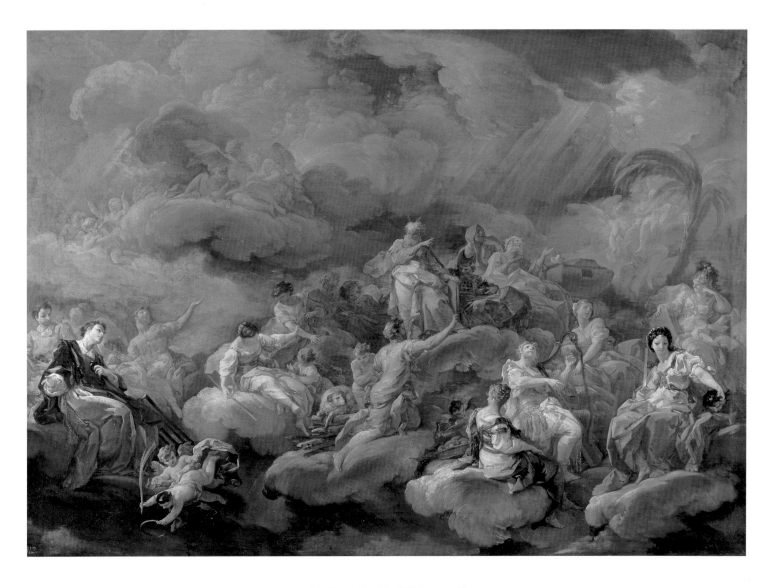

CORRADO GIAQUINTO (1700–1766)
Saints in Glory, 1755
Oil on canvas, 97 × 137 cm

CORRADO GIAQUINTO
Justice and Peace, c. 1759–1760
Oil on canvas, 216 × 325 cm

FERDINAND VI AND BÁRBARA DE BRAGANZA IN THE GARDENS OF ARANJUEZ ON ST. FERDINAND'S DAY

A<small>s</small> is shown with the name of the painter and the date in the inscription, this work represents the royal residence of Aranjuez on the saint's day of Ferdinand VI. While its pendant shows the arrival of the guests at the palace, this one depicts the king and queen walking with them near the lateral façade of the building and the garden bridge to the island.

The vicissitudes of these works are unknown. The pair was commissioned by Carlo Farinelli, but were not discovered until 1929, and were acquired by the Prado half a century later.

When Antonio Joli from Modena left the Madrid court in 1754, he must have recommended that he be replaced by his fellow countryman Battaglioli, who had worked since his arrival under the direction of Farinelli as painter at the Royal Coliseum of Buen Retiro and Aranjuez. But, like his compatriot, he also painted vistas until he was dismissed on the arrival of the new king, Charles III.

The artist preferred architectural and garden scenes with broad perspectives, as is seen in this work, but he did not scorn the introduction of little figures that animate the picture and give it documentary value, in a realistic manner that is more informal than one of protocol.

FRANCESCO BATTAGLIOLI (c. 1725–c. 1790)
Ferdinand VI and Bárbara de Braganza in the Gardens of Aranjuez on St. Ferdinand's Day, 1756
Oil on canvas, 68 × 112 cm

Vista dela Illuminassiua conque
en el Dullsima Real Sitio de
Aranjuez se celebra el dia de
S.n Fernando gloriosisimo nom-
re del Rey nuestro Señor Altesa
ra D. Carlos Broschi Farinelli
pintada da francesco banaglia

1756

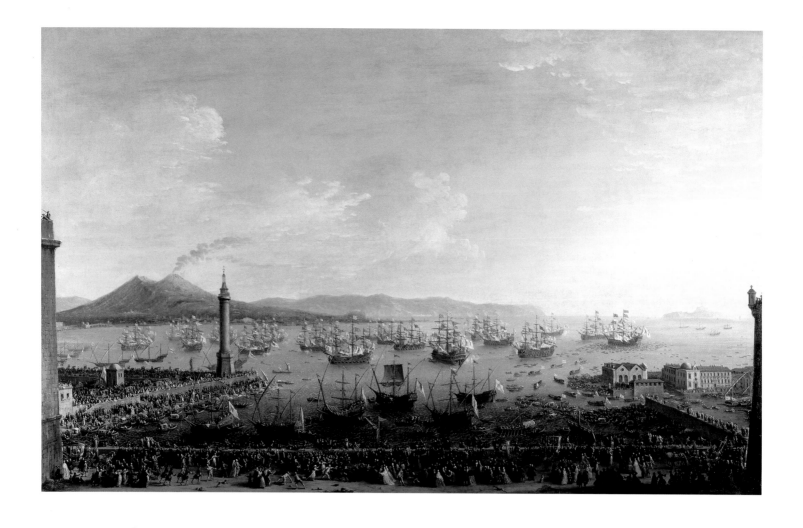

ANTONIO JOLI (1700–1777)
The Embarkation of Charles III in the Port of Naples, 1759
Oil on canvas, 128 × 205 cm

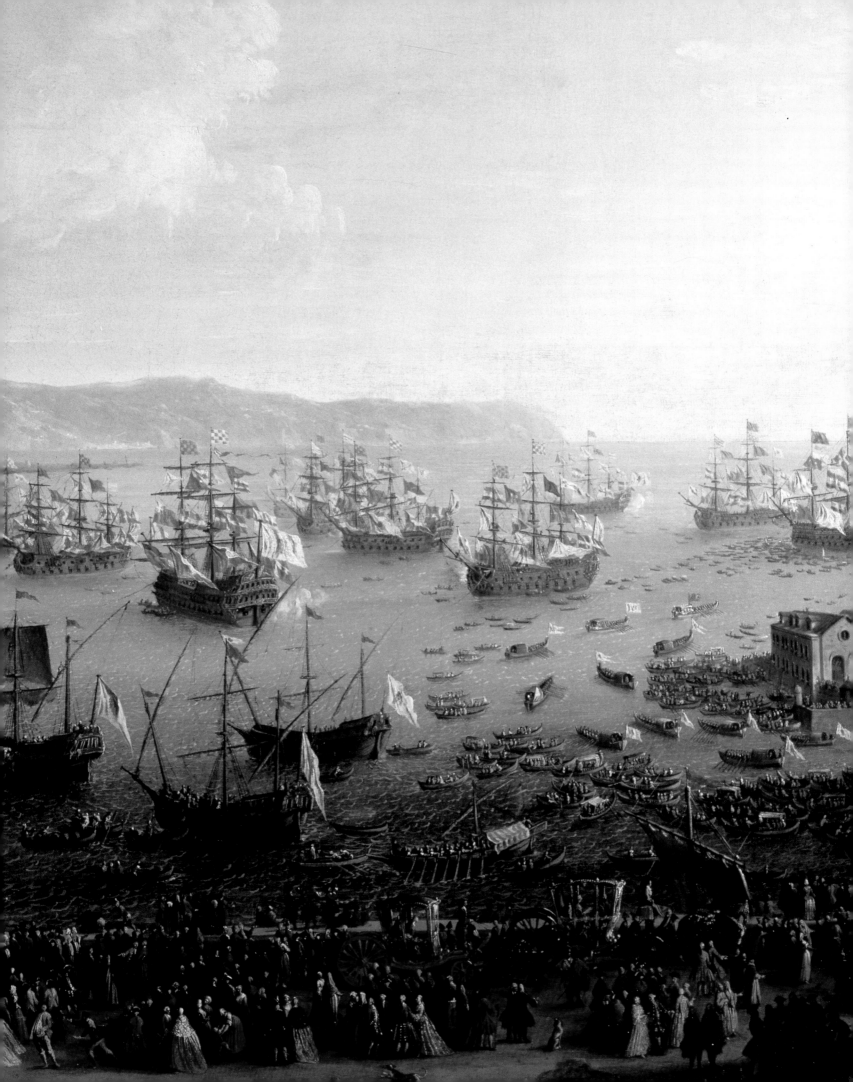

The Embarkation of Charles III in the Port of Naples

An inscription on the wall on the left tells us of the event, the artist, and the date of this work. Ferdinand VI died on August 10, 1759, and the news arrived in Naples on August 22. The ships that formed the fleet that would transport the new king, Charles III, to Spain arrived from September 4 through 30. On October 6 the embarkation of the royal family began and they sailed the following day.

After working in several European cities, including Madrid (1750–1754), the Modenese artist Joli arrived in Naples in time to witness the end of Charles's reign there; Joli remained in Naples until his death. We do not know the circumstances of the commission for this painting and its pendant, which concerns the same subject but from another vantage point. They came from the Museo de la Trinidad, which brought together works that were affected by the Disentailment, but Urrea thinks that this pair would have been in the royal collection, as there is a record of later dispatches of works by Joli, which were admired by Charles III.

The view, taken from the Castelnuovo, is notable for its topographical precision and for the detail with which the Neapolitan people are represented, from the marquis Tanucci, president of the regency council, in his carriage, to people of the most diverse classes.

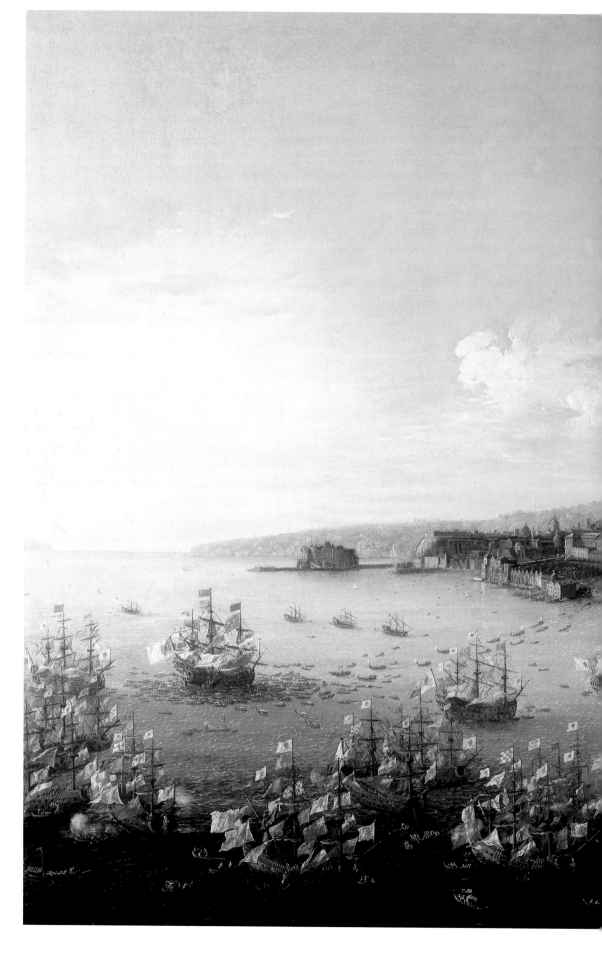

ANTONIO JOLI (1700–1777)
*The Embarkation of Charles III
in the Port of Naples,* 1759
Oil on canvas, 128 × 205 cm

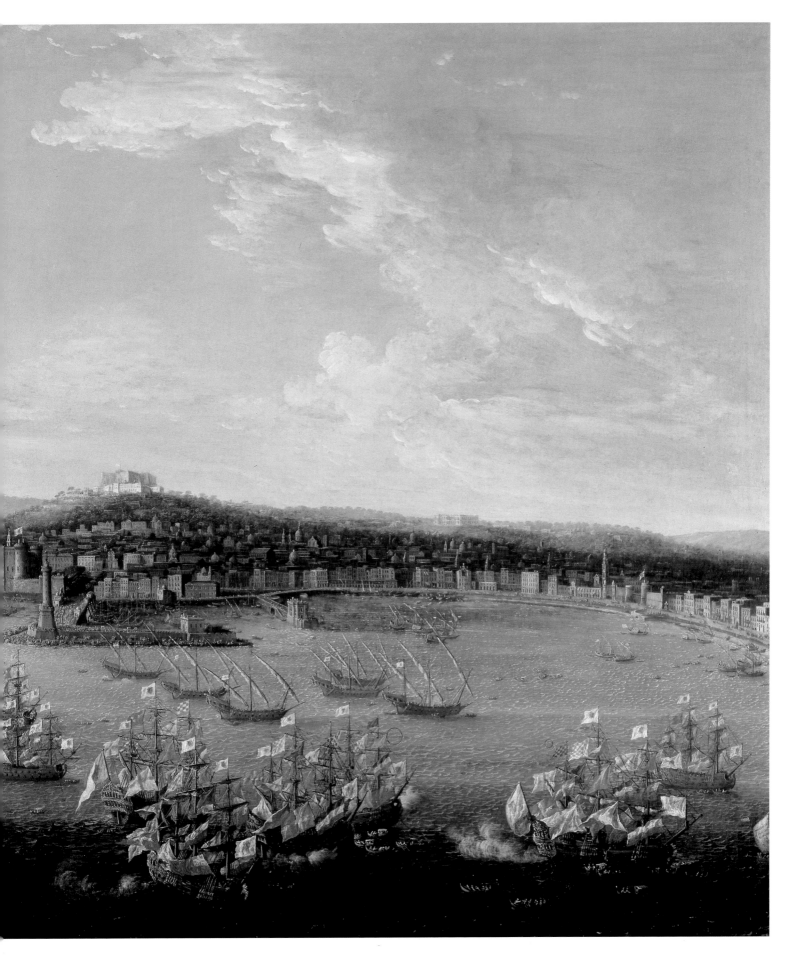

QUEEN ZENOBIA BEFORE EMPEROR AURELIAN

Bought in France some hundred years ago, this painting was acquired for the Museum in Madrid in 1975, but it then bore the title *The Continence of Scipio*. George Knox considered it to have been a pendant to *Syphax before Scipio* (Baltimore Museum), both of which were painted for Ca' Corner in Venice in the 1720s. Knox later showed that this work deals with an episode concerning the queen of Palmyra, which formed part of the decoration of the Zenobio Palace in Venice, home of a family that chose this story because of the coincidence of its name with that of the Syrian queen.

According to the early sources, this canvas was one of the first done by Tiepolo, in about 1717, when he was scarcely twenty years old. His very youth and inexperience is revealed perhaps by his insistence on verticals and the dominance of reds, whites, and blues, and the recumbent prisoners to the right recall figures by Sebastiano Ricci, but the work has ample personal features as well. The luminous refinement of the shaded areas presages the painter's subsequent development, as do the human models, especially the elegant, stylized women.

THE IMMACULATE CONCEPTION

In 1767 Tiepolo completed the paintings for the frescoes of the Royal Palace, for which he had been summoned to Madrid in 1762. Charles III then commissioned the Venetian artist to produce the altar paintings for the church in the convent of the Discalced Franciscans of San Pascual in Aranjuez. These were finished on August 29, 1769. The paintings were *The Adoration of the Holy Sacrament by St. Paschal* (high altar), *The Immaculate Conception,* and *The Stigmatization of St. Francis* (collaterals to the gospel and the epistle), *St. Anthony with the Child Jesus* (in the Prado, as are those above), with *St. Peter of Alcántara* (Royal Palace), *St. Joseph with the Child* (Detroit Institute of Arts), and *St. Charles Borromeo before the Crucifix* (Cincinnati Museum) on the remaining altars.

The Franciscan friar Joaquín de Eleta, confessor to the king and a fervent admirer of Mengs and the Neoclassical aesthetic, some years later achieved the withdrawal of these canvases and their replacement with others by Bayeu and Maella, artists of the Bohemian school. This caused the dispersal and deterioration of Tieopolo's suite, although *The Immaculate Conception,* which is signed, has been in the Museum since 1828. The sketch, by Bayeu, is in Lord Kinnaird's collection in London.

In this work of serene and grave beauty, the elongated model for the Virgin is possessed of an unusual and haughty maturity. The painting is golden colored, its contrast of light and its composition are supported by a rich play of obliques. It is the finest painting of the series and Tiepolo's most successful version of the subject.

CHRIST FALLS ON THE ROAD TO CALVARY

Giandomenico, who worked with his father from an early age, accompanied him to Madrid in 1762 and returned to Venice in 1770 after the death of Giovanni Battista. However, in 1772, as is shown next to the signature on *The Entombment of Christ,* he painted a series of eight canvases of Christ's Passion for the oratory of St. Philip Neri in Madrid, which was perhaps commissioned before he left the court. Before the paintings were shipped, they were exhibited in 1772 in St. Mark's Square in Venice. The subjects represented and preserved in the Prado are: *The Prayer in the Garden, The Flagellation, Christ Crowned with Thorns, The Fall on the Road to Calvary, Soldiers Dividing the Spoils, The Crucifixion, The Descent into Limbo,* and *The Entombment*. Three sketches are in the Lázaro Galdiano Museum in Madrid (*The Flagellation, The Fall on the Road to Calvary,* and *The Crucifixion*).

Giandomenico's first known independent work was that of the fourteen Stations of the Cross (1747) for the oratory of the Crucifix of San Paolo in Venice; they are of a very different nature and composition, however, as they were directly influenced by his father.

Within the Rococo aesthetic, which is noticable in the chromatic refinement and the smooth and delicate workmanship, the artist shows an appropriately expressive vigor in his treatment of the subject. This is offered in an intimate composition that is at once immediate and engaging for the viewer.

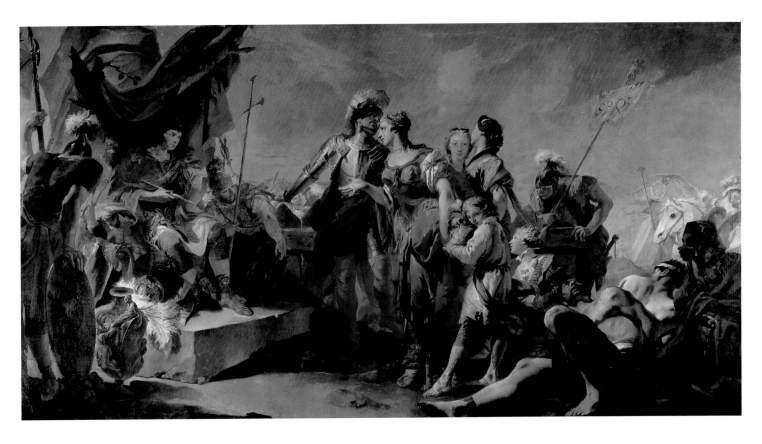

GIOVANNI BATTISTA TIEPOLO (1696–1770)
Queen Zenobia before Emperor Aurelian, c. 1717
Oil on canvas, 250 × 500 cm

GIOVANNI BATTISTA TIEPOLO
The Immaculate Conception, 1767–1769
Oil on canvas, 279 × 152 cm

GIANDOMENICO TIEPOLO (1727–1804)
Christ Falls on the Road to Calvary, 1772
Oil on canvas, 124 × 144 cm

PORTRAIT OF CHARLES CECIL ROBERTS

As is typical of this artist's works, the signature and the date — in Rome — appear on the pedestal. It is not known how this canvas came to be in the rooms of Prince Charles in the Royal Palace in Madrid in 1814.

Thanks to information sent to the Museum by a descendent of the sitter we know the identity of the person represented, that he was born in 1754 and lived in Rome with his cousin, the earl of Leicester, from 1772 to 1778. Before leaving the city when he was only twenty-four years old, he felt called upon to commission a work that would record his Grand Tour in the fashion of British gentlemen of the eighteenth century.

Batoni, an experienced society-portrait painter, used both topical and hackneyed elements to suggest an ambience: a fragment of a cornice from a ruin, a pedestal with a bas relief from antiquity, views of the Castel Sant'Angelo and of St. Peter's opposite one another, and a plan of Rome, which Roberts holds in one hand. The full-length figure attests to the high price paid for the commission. The subject — centered and striking an elegant pose, his legs crossed, hat in hand, which rests atop a walking stick, and leaning on his elbow — displays a somewhat languid attitude. It is well known that Batoni gave great importance to the apparel of his clients and this young man's refined attire is in keeping with his pose and expression.

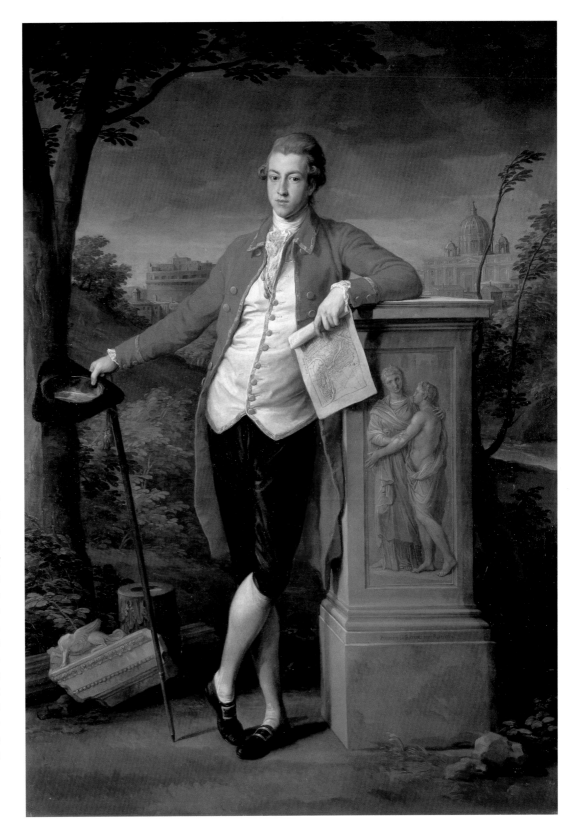

POMPEO BATONI (1708–1787)
Portrait of Charles Cecil Roberts, 1778
Oil on canvas, 221 × 157 cm

THE FLEMISH AND DUTCH SCHOOLS

Until the sixteenth century, the Low Countries formed a single territorial unit governed by the kings of the House of Austria, Charles V and Philip II, who linked their fortunes to those of Spain. However, these two regions gradually drifted apart on the basis of religious differences; the Protestant Reformation became entrenched in the United Provinces of the north, paving the way for Holland's accession to lasting nationhood, which was consolidated in the Peace of Westphalia (1648). The area to the south remained faithful to its own, somewhat critical, brand of Roman Catholicism and it was ruled by a government appointed by the king of Spain. They were especially prosperous under Archduke Albert and Archduchess Isabella (1598–1633) and Cardinal Infante Ferdinand of Austria (1633–1647). Diplomatic relations with Spain, which were very smooth for Flanders and, throughout the seventeenth century, virtually nonexistent for Holland, account largely for the nature of the Flemish and Dutch collections in the Prado Museum. They are based mainly on paintings acquired by the Spanish monarchs in the sixteenth and seventeenth centuries, those acquired through the nineteenth-century Disentailment, and purchases and donations made since the Museum's founding in 1819.

Initially striking about these collections is the unequal representation of the two schools. The prolific Flemish collection, which comprises nearly seven hundred paintings, includes major works by some of the school's leading exponents, particularly from the seventeenth century, such as Rubens, van Dyck, and Teniers. As recalled by Palomino, in reference to Rubens, it was built up day by day both through purchases and direct commissions from delegates of the king of Spain. In contrast, the vicissitudes of war, diplomatic difficulties, the lack of trade relations, and differing cultural and aesthetic sensibilities raised little or no interest in the Dutch school among Spanish monarchs, aristocrats, and the bourgeoisie of the seventeenth century. The examples of Dutch works that did make their way into Spain during that century were conspicuously "un-Dutch," as attested by the production of Catholic painters from the Utrecht school, or of painters of Dutch origin active in Rome with their distinctly Italianate style.

It was not until the eighteenth century, when the Baroque became more decorative, refined, and precious, that the Bourbon kings, Philip V, Isabella Farnese, and, in particular, Charles IV, took it upon themselves to redress the imbalance and to augment the Dutch collection by acquiring representative works: small cabinet paintings, domestic subjects and pastoral scenes, genre and decorative works. About a

hundred paintings currently make up the Prado's Dutch collection, and most of them were acquired by the Crown in the eighteenth century.

Ever since the time of the Catholic kings, the presence in the court of figures such as Juan de Flandes or Michiel Sittow bears out the monarchs' penchant for Flemish painting and their need for artists to paint portraits of their children as part of their policy of striking dynastic and matrimonial alliances that would set Castile on the stage of European politics.

Flourishing trade relations between the Low Countries and Castile led Isabella the Catholic to acquire a large number of Flemish paintings and decorative objects for her collection, the remains of which are housed in the Royal Chapel in Granada. Despite Isabella's predilection and the fact that Charles V had been educated in the court of Burgundy, most fifteenth-century Flemish works in the Prado were originally acquired or inherited by Philip II, who kept them in El Escorial. This is true of the works by Dieric Bouts and Rogier van der Weyden, as well as the *Betrothal of the Virgin* by the Master of Flémalle and Gerard David's *Madonna and Child*.

Some members of the nobility emulated their kings and the palace taste by acquiring for religious institutions such significant works as Vrancke van der Stockt's *Redemption Triptych,* which Doña Leonor Marcareñas placed in the Convent de los Angeles in Madrid, after which it was brought to the Prado during the Disentailment. Together with a few other important works — Memling's *Adoration of the Magi* triptych, acquired by Charles V, or the two panels by the Master of Flémalle bought by Charles IV — the original Flemish collection was subsequently augmented with sizable donations by Pablo Bosch in 1915 and Fernández Durán in 1930.

Charles V (1519–1556) and Philip II (1556–1598) professed a love of art that led to the Spanish collections, paying special attention to Italian Renaissance works, particularly paintings by Titian, who was to become a cornerstone of the best in Spanish Baroque. Flemish painting continued to enjoy a privileged position, however, and in the sixteenth century a cordial entente was established between the Flemish and Venetian schools in Philip II's decorative commissions. Exponents of the former produced mainly portraits, devotional works, and altarpieces, while the latter, particularly Titian, were called upon to execute some of the most extraordinary portraits of the sixteenth century and, above all, religious and mythological themes charged with sensuousness and color.

In the court of Charles V, sixteenth-century Flemish painting was represented by a highly active portraitist, Anthonis Mor, who accompanied Prince Philip to London when the latter married Mary I of England, whose portrait Mor painted. This artist's work was to have a profound influence on the style of Spanish court portraiture up to

the time of Velázquez. Having been born in Utrecht, he was living proof of the unity and stylistic continuity with the Low Countries at the time. But it was Philip II, with his universal leanings, who showed the greatest interest in procuring works by the sixteenth-century Flemish masters for himself and El Escorial. With his broad-based, eclectic taste and clear sense of decorum, he acquired paintings through acquisitions, commissions, gifts, and legacies, such as that of his aunt, Mary of Hungary; taken together, his acquisitions largely form the backbone of the collection of sixteenth-century Flemish paintings in the Prado. Alongside works by painters with strictly Flemish training, such as Bosch's *Garden of Earthly Delights, The Hay Wain,* and *The Seven Deadly Sins,* or Patinir's landscapes, we find paintings by such Italianate Romanists as Bernard van Orley, Jan Gossaert, Michiel Cocxie, Jan Sanders van Hemessen, Anthonis Mor, Justus Tiel, and Marinus van Reymerswaele. Some of these names reappear on the acquisitions made by Isabella Farnese in the first half of the eighteenth century, alongside new names and masterpieces, such as Pieter Bruegel the Elder's *Triumph of Death,* the landscapes of Lucas van Valckenborch, Hemessen's *Virgin and Child* and Cocxie's *Death of Abel.* Her grandson, Charles IV, subsequently added to the royal collections with works by Marinus van Reymerswaele.

Additions dating from the nineteenth and twentieth centuries include Ambrosius Benson's altarpiece, *The Life of Mary,* which made its way to the Prado during the Disentailment, having originally been commissioned by Lucas de Castro for the monastery of Santa Cruz de Segovia. Noteworthy among the donations and purchases from the twentieth century are works such as *Jesus in the Sepulcher* by Marcellus Coffermans, *Head of a Crossbowman* by Bosch, Reymerswaele's *The Moneychanger and his Wife,,* and above all, *Ecce Homo* by Quentin Massys, donated by Mariano Lanuza. The most distinguished of the works acquired through purchase are those by Pieter Coecke van Aelst, particularly *The Temptation of St. Anthony, Two Villagers at Market* by Pieter Aertsen, and Joachim Bueckelaer's *Jesus at the Home of Martha and Mary.*

The atmosphere of the early Flemish works, with their direct religiosity, their pathos, and their bright color continues virtually unbroken through the Prado collection, except for the absence of works by Hugo van der Goes and, most especially, Jan van Eyck. Philip II's admiration for Jan's *Ghent Altarpiece* was a well-known fact, but he managed to acquire only a copy of it. (Van Eyck's *Arnolfini Marriage Portrait* was in Spain until it was taken by the British.)

The early Flemish works, the first to configure a wholly national style, were succeeded by those of the Italianate Romanists such as van Orley, Gossaert, Cocxie, and, later on, Mor, along with other painters from the late sixteenth century.

But this artistic wealth pales when one is confronted with the collections from the

seventeenth century. Changes in politics and sensibilities are likewise strikingly conspicuous in the paintings, making the abundance and importance of Flemish works show up in stark contrast to the dearth of Dutch works. Religious, political, mythological, and genre subjects thronged to Spain on the strength of commissions by the Crown, the aristocracy, merchants, and religious orders, attesting to the prosperity of the southern Low Countries governed by the archdukes in Brussels, and to the thriving trade with Antwerp. Philip II entrusted government of the Low Countries to his daughter, Isabella Clara, wife of Archduke Albert of Austria. From 1598 to 1633, the year of her death, Isabella's political skill led to a resurgence of art amidst a climate of spiritual exaltation characteristic of the Counter-Reformation. The trend found its supreme exponent in Rubens, a protégé of the archdukes from 1600, the year in which he went to Italy with a recommendation from Isabella. The following year he painted the panels in Sta. Croce in Gerusalemme, then under the patronage of Albert of Austria. Although production for the court of Brussels was not particularly abundant, that seat of government was used to channel commissions for Philip III and Philip IV of Spain and their aristocracy.

The "minor Austrias" may well have damaged the political status of their forebears in their government of the Low Countries, but in the field of art the patronage of Philip IV was very likely unsurpassed; it was he who cultivated the taste for Flemish painting and guided the trend. Rubens actually made his first visit to the court of Valladolid under Philip III in 1603, when he painted the *Equestrian Portrait of the Duke of Lerma,* an exemplary work of art. He was likewise commissioned to paint the *Apostles* on panel. The example set by such patronage was followed, among others, by Rodrigo de Calderón, who commissioned the *Adoration of the Magi,* a work that Rubens painted in 1608–1609, which was donated by the city of Antwerp in 1612. It was subsequently purchased at auction by Philip IV and increased by Rubens in 1628. Similarly, the marquis of Leganés, Diego Mexía, whom Rubens held to be the leading art connoisseur in the world, built up a magnificent collection of Flemish works, some of which, like *The Immaculate Conception* by Rubens, *The Devotion of Rudolf I,* the *Vision of St. Hubert,* and four still lifes by Adrienssen, now are in the Prado.

Then a widow, Archduchess Isabella commissioned Rubens to execute a series of twenty compositions on the Triumph of the Eucharist, which he painted between 1622 and 1628, for the tapestries in the Descalzas Reales in Madrid. After changing fortunes, the cartoons for some of them ended up belonging to the Prado. Philip IV's cardinal brother, who ruled the Low Countries from 1633 to 1647, acted primarily as the king's agent. He acquired decorative and devotional subjects by Daniel Seghers, and the series on the senses by Rubens and Jan Brueghel, which was given to the duke

of Medina de las Torres. In turn, the latter presented it to Philip IV. He was likewise instrumental in commissioning the mythological, hunting, and landscape series for the Torre de la Parada (1636–1640) and the Buen Retiro (1639), and his role in purchasing works from Rubens's widow contributed some of the best and most striking works by the young van Dyck and a more mature Rubens to the royal collection. They included the *Equestrian Portrait of the Cardinal,* which Rubens painted to commemorate the Battle of Nördlingen.

Philip IV was a large-scale collector of Flemish art. He extended the collections inherited from his grandparents to a degree unheard of at the time, for which purpose he was fortunate enough to have at his service two of the foremost contemporary geniuses — Velázquez and Rubens. In 1628 the latter visited the court in Madrid and there executed the *Equestrian Portrait of Philip II,* a counterpart to Titian's *Equestrian Portrait of Charles V,* and brought with him eight canvases earmarked for the New Salon in the Alcázar.

From that time on, the Antwerp master and all his followers were to be engaged with decorative commissions for the Spanish monarch. For the last twelve years of the artist's life, Rubens's well-organized workshop was to churn out paintings for Philip IV constantly. At the painter's death in 1640, the cardinal infante suggested purchasing the collection from his brother, which explains the provenance of *St. George and the Dragon, Marie de Médicis, The Three Graces, A Peasant Dance,* and *Diana and her Nymphs Surprised by Satyrs,* and of van Dyck's *Christ Crowned with Thorns* and *The Prayer in the Garden.* The erotic charge of the nude paintings of Hélène Fourment must have persuaded against acquiring other, less heroic and more carnal, works.

Philip IV was the true crafter of the Prado Museum's Flemish collection, to the extent that, according to Carducci, he became the envy of other nations. In addition to the royal Alcázar, where eighteen works on the themes of Hercules and hunting by Rubens and Frans Snyders were housed in 1639, his wealth was distributed among three other venues. In 1638, 118 Flemish paintings arrived in Madrid. For the Torre de la Parada, Philip IV commissioned Rubens to paint the series based on Ovid's *Metamorphoses,* focusing on love scenes, landscapes, and hunting and animal subjects — a body of work that was inventoried in 1700, on the death of Charles II. The Parada series, the most important project Rubens would direct during the last five years of his life (1636–1640), included works by Jean Cossiers, Cornelis de Vos, Erasmus Quellinus, Jacob Jordaens, Jacob P. Gowy, Rubens himself, Snayers — who painted the king's hunting prowess — Theodoor van Thulden, Paul de Vos, and Snyders, with their canvases depicting packs of hounds in pursuit of deer, as well as Aesop's fables.

The Pardo and Zarzuela palaces also feature significant Flemish works, although the collections are not as complete as those in the Parada. Earmarked for El Escorial, by way of a religious art collection, were the *Immaculate Conception* and *Holy Family,* both by Rubens, and the *Christ Crowned with Thorns, St. Rosalía, St. Jerome,* and the *Mystic Marriage of St. Catherine* by van Dyck.

The seventeenth century closed with Charles II's modest contribution and he is best known for his staunch opposition to Mariana of Austria's attempt to give away Rubens's *Adoration of the Magi,* as he considered it to be a royal heirloom.

The presence of Dutch painting in the seventeenth-century royal collections was highly inferior to the Flemish in all respects. Possibly the only work of note was Cornelis van Haarlem's *Apollo before the Tribunal of the Gods,* in Philip IV's collection, and the works by Hendrick van Steenwyck purchased by the king from Luis de Haro. As for commissions for the Buen Retiro, around 1638 Jan Bosch and Herman van Swanevelt, who were resident in Rome at the time, executed a number of landscapes that were alien to Dutch aesthetics, but which reveal borrowings from the contemporary classical Italian idealism of Claude Lorraine.

The eighteenth century brought the Bourbon dynasty to Spain in the person of Philip V, which gradually led to a process of change in the arts handed down by the monarchy, materializing in the construction of a New Palace, renovation of the royal residences and the addition of new floors, as shown in the palace of La Granja, and the foundation of the Royal San Fernando Fine Arts Academy.

Although the Peace of Utrecht wrested the Low Countries from Spain, the Flemish school, having already borne its fruits, had by then entered a period of crisis. Artistic taste in Europe was dictated by Rome or Paris. Alongside Baroque classicism with its international projection, a more congenial, decorative trend gradually developed into the Rococo. The Spanish Bourbons responded to the changes with great enthusiasm and mixed success although, on the whole, Philip V's private collections, those of his second wife, Isabella Farnese, and of his grandson, Charles IV, were based on small-sized works with pleasant coloring — genre scenes, landscapes, animals, marine pictures, in short, cabinet works in tune with Rococo taste. The royal collections were thus enriched with works by lesser Flemish and Dutch masters, although they unfortunately were unable to make up for the losses sustained that century, particularly as a result of the fire that gutted the Alcázar in 1734.

The 1745 inventory conducted after the death of Philip V treated the king's collection as separate from that of the queen and returned a total of over twelve hundred paintings. It also brought to light the care lavished by Isabella Farnese on her steady flow of acquisitions of Italian (the Maratta collection), Flemish, and Dutch

works from Italy and Holland. Alongside works of unquestionable distinction by Rubens, such as the aforementioned *Apostles,* commissioned by the marquis of Leganés, and van Dyck's *Self-Portrait with Sir Endymion Porter* and *Maria Ruthven,* we find nearly seventy works — ascribed with varying degrees of accuracy to David Teniers the Younger — the subject matter of which relates to the Dutch world of Adriaen van Ostade. Teniers was very much in vogue in eighteenth-century Spain and had entire series of tapestries woven from his models. Further works in the collection include fifteen by Johannes Fyt, thirteen by Jan Brueghel, and others by Jacques d'Artois, Adriaen Bloemaert, Joos de Momper, Pieter Neefs, Hendrick de Clerck, and Adriaen van Utrecht. Taken as a whole, these painters worked in genre styles that favored inn interiors, satyrs with animals, landscapes, interiors, and still lifes.

The king's collection also added some new names, such as Willem van Herp, Jan Miel, and Pieter van Lint. Some of these works must have been among the ninety-two Flemish and Dutch paintings purchased in 1735 through the mediation of G. B. Pittoni in Italy. Some fifty works by Osias Beert, J. C. Droochsloot, Gysbrechts, L. Heese, H. van Lin, J. van Oosten, C. van Poelenburgh, J. P. Schaeff, and P. Wouwermans were added to the royal collections.

Ferdinand VI devoted his efforts to building and decorating the Royal Palace while, at an auction held in 1769 by the marquis of Ensenada, Charles III was fortunate enough to acquire Rembrandt's *Artemisia,* dated 1634 — the undisputed masterpiece of the Dutch collection in the Prado.

As a result of the fire in the Alcázar and the palace's subsequent evacuation, the remodeling of the Buen Retiro, and the building of the New Palace, the royal collections were thrown into disarray, with paintings changing venues on several occasions before ending up in the New Palace. That accounts for the collection being based in La Granja during the reign of Philip V and Isabella Farnese, particularly after the queen was widowed. One hundred years ago, the exhibits formed a showcase that reflected bourgeois society in the absence of a monarchy, but ruled by a morally strict and exemplary order. Devoid of religious works, in accordance with Calvinist trends, the prevailing style of art was one of exquisiteness, elegance, and lack of ostentation, with the accent on genre, the key to success in the eighteenth century when religious ideologies were on the decline.

Charles IV was a worthy successor to his grandmother, Isabella Farnese, in terms of his taste in art and collecting. From his father, Charles III, he inherited forty-two paintings, including works by A. van der Meule and David Teniers, and sixty-eight paintings on copper by Jan van Kessel the Elder, which were stored in the Prince's Lodge at El Escorial. Another series acquired in Naples also included works by Joos

van Graesbeeck (who painted *The Marriage Contract*), in addition to other attributions that are difficult to support nowadays.

Charles IV's collection at one time boasted up to twenty-four Dutch paintings. They included some of the finest current holdings in the Prado, such as Gabriel Metsu's *Dead Cock,* Pieter van Steenwijck's *Vanitas,* four works by Adriaen van Ostade, Leonaert Bramer's *Abraham and the Three Angels* and *Hecuba's Sorrow,* Joachim Wtewael's *Adoration of the Shepherds,* and works by Jacob van Ruisdael, Bartolomeus Breenberg, and Godfried Schalken. At the start of the nineteenth century, Valdivieso listed as many as seventy-five Dutch paintings in the royal collections, twenty-four of which Ferdinand VII gave to the duke of Wellington.

The sluggish exchange of artworks between Spain and Holland in the seventeenth century was largely offset in subsequent centuries by acquisitions made either for purely aesthetic reasons or to rectify the shortfall in Museum collections. A number of Dutch works in the Prado were originally donations, like one by Paulus Potter, which was ceded by the widowed marchioness of Cabriñana, or the three still lifes by Willem Claesz Heda and one by Pieter Claesz from the Fernández Durán estate. Other items in the collection were provided by state purchases, such as Michiel Jansz van Miereveld's portraits of a lady and a gentleman.

Apart from Rembrandt's *Artemisia,* what is striking about the Dutch collection in the Prado is the absence of works by the grand masters — Frans Hals, Meindert Hobbema, Jan Steen, and Jan Vermeer. However, the spiritual and aesthetic leanings of seventeenth-century Holland, whose pictorial school had gained international renown, are accurately reflected in the artworks that did make their way to the Prado.

In the nineteenth century, works by several artists who until then had been poorly represented in the royal collections were acquired by the Prado. Noteworthy in this respect were the series by Gaspar de Crayer, a protégé of the marquis of Leganés and official portraitist to the duke of Olivares and the cardinal infante. The latter was instrumental in providing the series on the founding fathers of the religious orders after the Disentailment, the works having previously decorated the cloister of the convent of San Francisco de Burgos ever since the seventeenth century.

Compared to contributions by the monarchs, twentieth-century donations are virtually insignificant. An exception, though donated in the late nineteenth century, was the gift from the duchess of Pastrana, who in 1889 donated Rubens's preparatory works on panel for the Torre de la Parada series and the Achilles series. In contrast, purchases have contributed highly significant works, such as Rubens's *Equestrian Portrait of the Duke of Lerma,* acquired in 1969, a *Pietà* by Jordaens in 1981 and, quite recently, a *Family Portrait* by Adriaen Thomas Key.

MASTER OF FLÉMALLE
Heinrich von Werl and St. John the Baptist
(Detail)

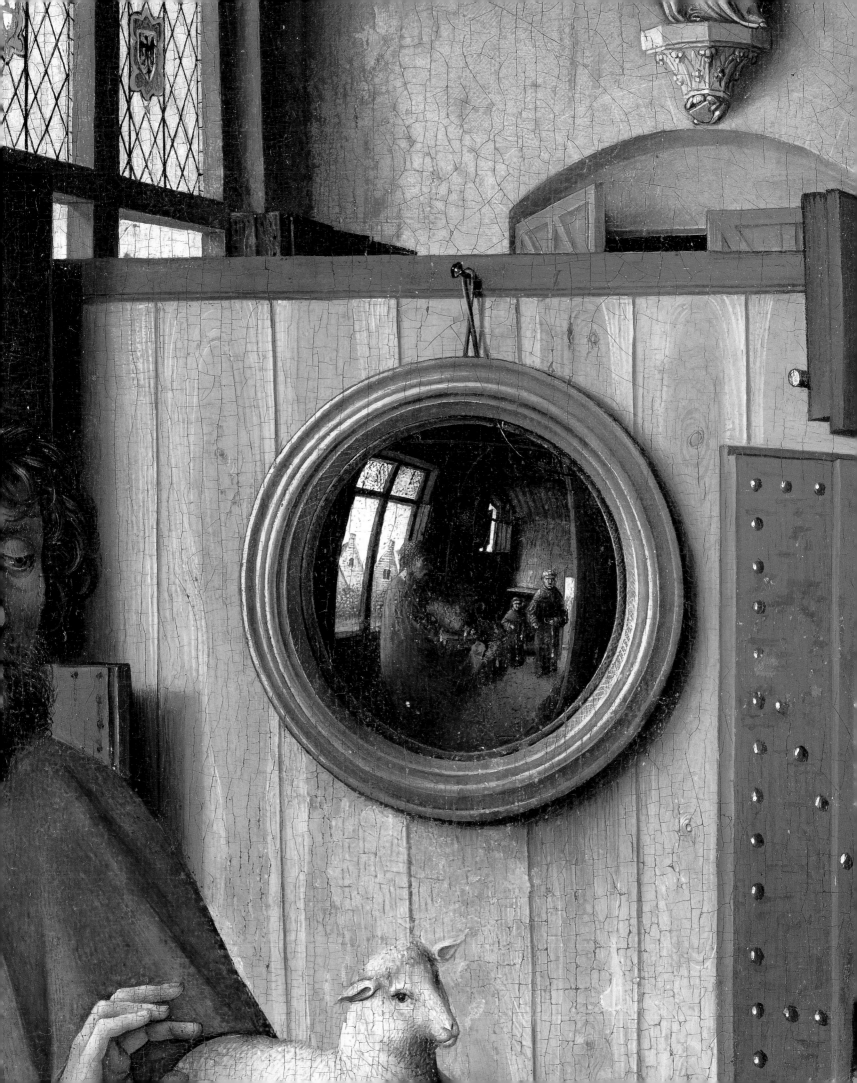

This panel may be regarded as a portrait of Heinrich von Werl, a Franciscan theologian from Cologne, and his devotional saint. The work is dated 1438 in Gothic lettering. Heinrich is shown praying in a narrow but well-lit room that is partitioned with wooden walls. The converging perspective does not accurately match the drawing of the figures, which are not in proportion to each other.

Despite these drawbacks, the Master of Flémalle — a contemporary of Jan van Eyck who is variously associated with Robert Campin (c. 1375–1444) and Rogier van der Weyden — has executed a work that epitomizes the achievements of the fifteenth-century Flemish pictorial style, which was dominated by naturalism, attention to detail and the material, and the individualized quality of objects. The result is an intimate domestic interior that provides a setting for religious devotion. The panel comes from Charles IV's collection and attests to the penchant for early Flemish painting among the Spanish monarchs.

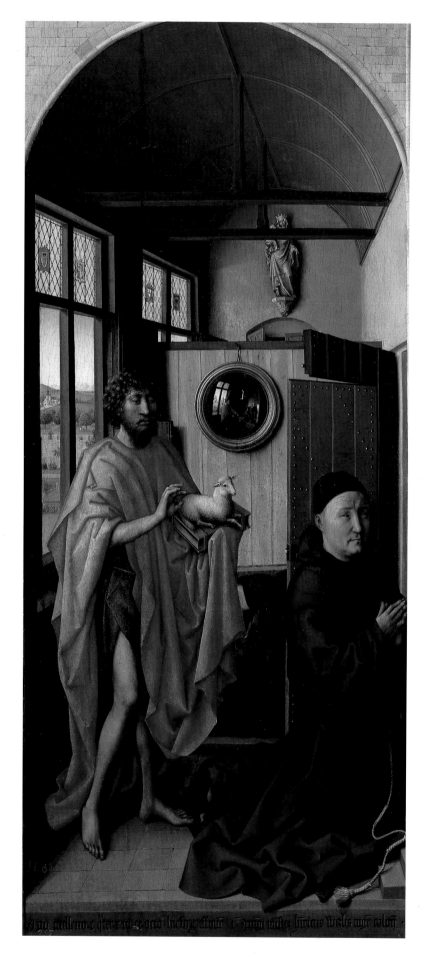

MASTER OF FLÉMALLE
(active c. 1415–1440)
Heinrich von Werl and
St. John the Baptist, 1438
Oil on panel, 101 × 47 cm

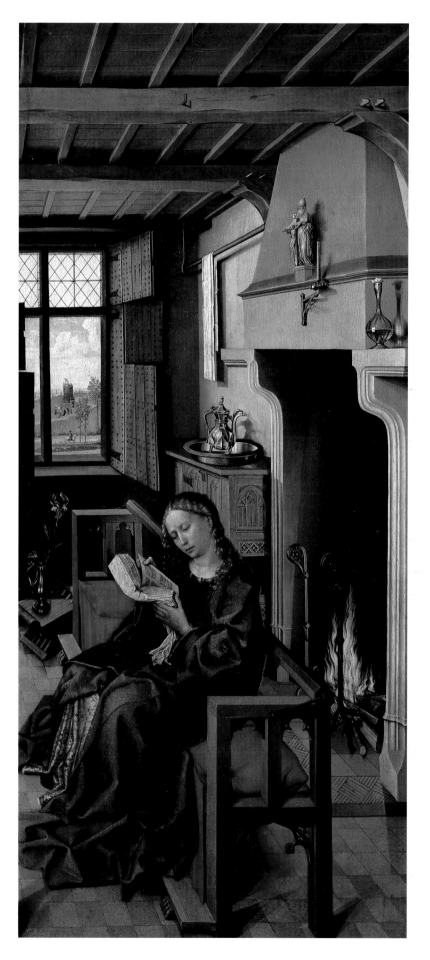

This panel of St. Barbara reading, with her martyrdom foreshadowed by the tower seen in the distance through a window, must have been the right wing of a triptych that included *Heinrich von Werl and St. John the Baptist* as the left wing, plus a missing central panel toward which the spaces and attitudes of the figures in the side panels converge.

Highly characteristic of this artist is the figure of the saint, with her flattened appearance, broad face, and abundant garments with detailed folds. The objects are depicted with extraordinary precision, as evinced in the gilded ewer and the tin jug with irises. The markedly individual treatment of the fire surpasses that of either the spatial perspective or the varying light sources. Despite the construction of space being purely intuitive, this painting and its companion work are prime examples of early Flemish interiors.

MASTER OF FLÉMALLE
St. Barbara, 1438
Oil on panel, 101 × 47 cm

ROGIER VAN DER WEYDEN
(1399/1400–1464)
Pietà
Oil on panel, 47 × 35 cm

This painting is thought to have been executed after 1450. A figurative work akin to *The Descent from the Cross,* it presents a wholly different sense of space in an open landscape that leads back into the distance. The donor and the devout onlooker become a reflection of each other.

The composition hinges around a subtle interplay of parallel axes: the group comprised of St. John, the Virgin, and the dead Christ echoes the direction of the clouds, while the crosspiece on the Cross and the donor bear the same orientation. All lines eventually intersect diagonally. Grouped on the left side of the composition are all the expressive elements in the evangelical narrative, as well as the purely plastic ones. The emphasis drawn by the detailed folds of the garments and their strong but dull coloring have the effect of dramatizing the rigidity of Christ's dead body.

Van der Weyden produced several works based on this composition, which is noteworthy for its devotional and pious qualities and attests to the success of early Flemish painting.

The *Descent from the Cross*, executed c. 1435, is one of the greatest masterpieces of fifteenth-century Flemish art. Mary of Hungary, Governess of Flanders and sister to Emperor Charles V, purchased it from the Louvain Guild of Crossbowmen and, to replace the loss, Michiel Cocxie painted a copy of excellent quality that was purchased by Philip II for the Pardo Palace. In time, the original was transferred to the Escorial monastery and from there to the Prado, where it was eventually replaced by the copy from the Pardo.

The spatial configuration of the frame and the volume of the figures are reminiscent of the way carved altarpieces are structured, with their polychromed images placed in shallow-set niches. The figures, with their weighty presence, appear in a single plane and are handled in a dramatically realistic fashion, their emotions starkly depicted. Exquisite attention is paid to detail in the rich garments and headdresses worn by the holy retinue.

ROGIER VAN DER WEYDEN
The Descent from the Cross, c. 1435
Oil on panel, 220 × 262 cm

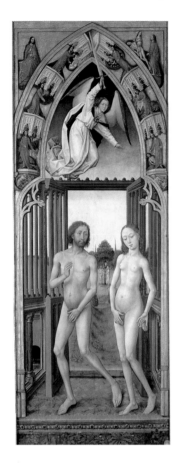

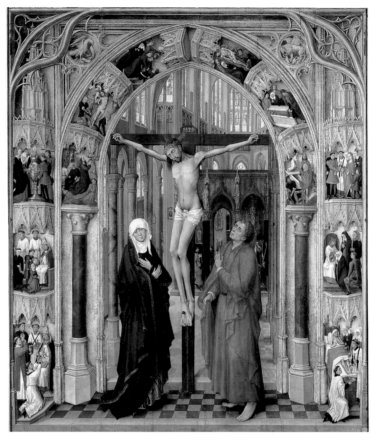

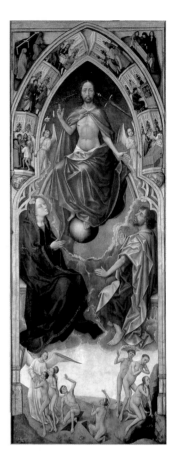

VRANCKE VAN DER STOCKT (c. 1420–1495)
Calvary
Oil on panel, 195 × 172 cm (middle panel)

CALVARY

Van der Stockt was one of Rogier van der Weyden's closest disciples and succeeded him as the leading Brussels painter after the master's death. His style is similar, though he lacks van der Weyden's vigor.

The so-called *Redemption Triptych* is vital to an understanding of van der Stockt's style. Apart from the grisailles in *Caesar's Tribute* (on the reverse side), the main scenes are set under large Gothic porticoes that frame different spatial environments — Paradise, a church, the sky. These are separated by jambs or archivolts that are profusely decorated with polychromed sculptural groups depicting scenes that reinforce the central theme — Christ's Crucifixion as the instrument of redemption that falls between original sin and the Last Judgment, a time span within which human conduct makes its determination between the sacred and the worldly.

Van der Stockt's triptych belonged to Philip II's governess, Leonor Mascareñas, who placed it in his chapel at the Convent de los Angeles in Madrid, from where it was transferred to the Prado in the nineteenth century.

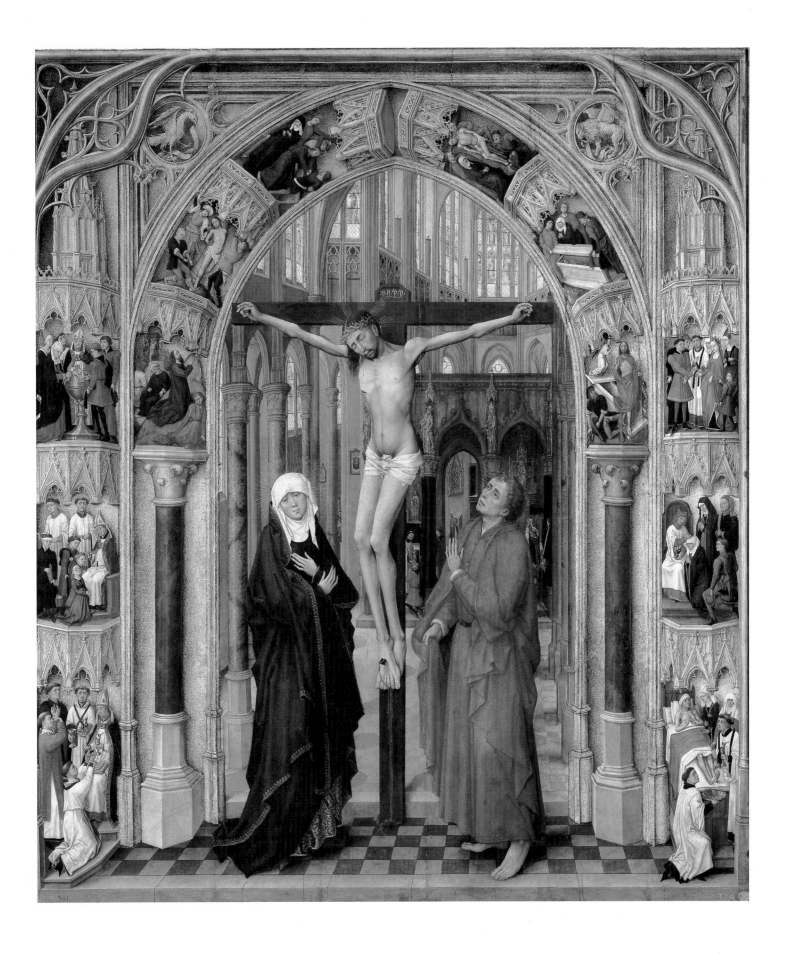

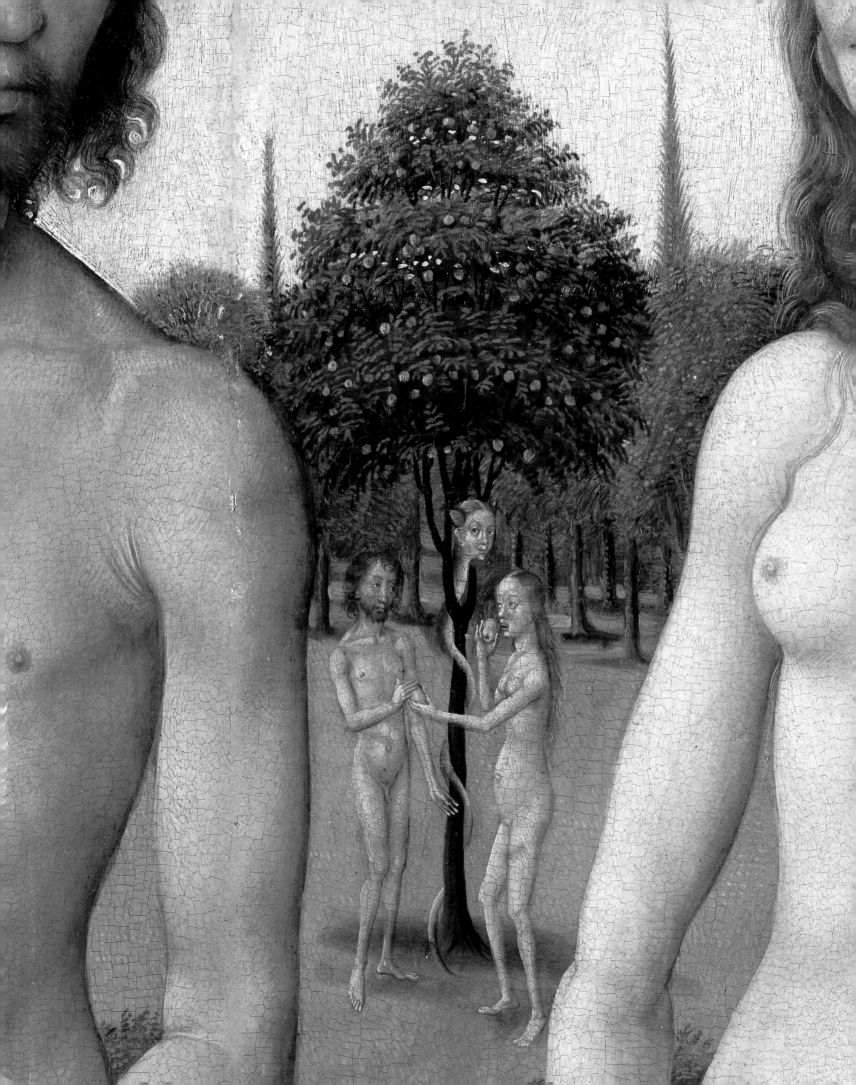

GERARD DAVID (c. 1460–1523)
Rest on the Flight into Egypt
Oil on panel, 60 × 39 cm

DIERIC BOUTS (active 1400/25–1475)
The Annunciation, The Visitation, The Adoration of the Angels, The Adoration of the Magi
Oil on panel, 80 × 56 cm (wings), 80 × 105 cm (middle panel)

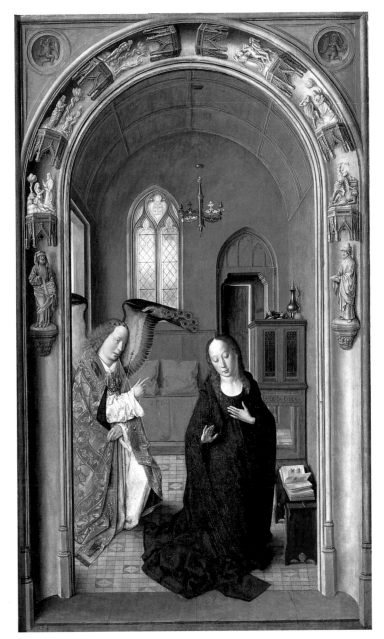

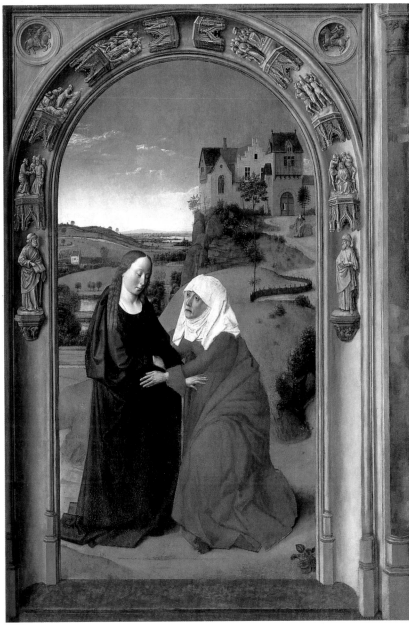

THE ANNUNCIATION, THE VISITATION, THE ADORATION OF THE ANGELS, THE ADORATION OF THE MAGI

This triptych, the central panel of which depicts two scenes separated by a trompe l'oeil column, was attributed to Dieric Bouts by M. Friedländer, who dated it around 1445 on the basis of the short, plastic demeanor of the figures, in contrast to the slimmer figures of his later work. All four scenes are taken from the life of the Virgin, who is the genuine protagonist of the narrative. Despite their lively appearance and their placement within the architectural elements or natural landscape, all the figures display a silent, earnest sense of deep devotion reflecting inner spirituality. Every scene is framed by an architectural grisaille with small, wholly Gothic sculptural groups that complete the story by leading it back to the Old Testament, forming a bridge between the Old Law and the New Law, the nexus between the Virgin and Christ.

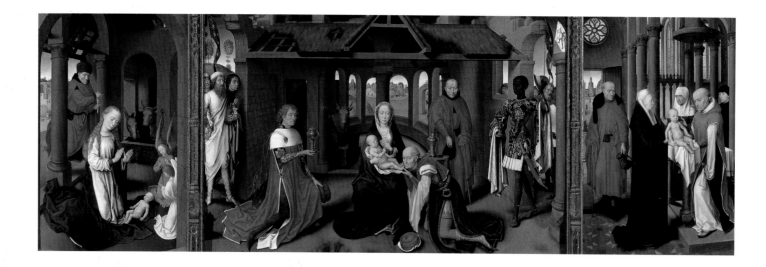

HANS MEMLING (c. 1435–1494)
Triptych: *The Nativity, The Adoration of the Magi, The Presentation in the Temple*
Oil on panel, 95 × 63 cm (wings), 95 × 145 cm (middle panel)

REST ON THE FLIGHT INTO EGYPT

The image of the Virgin breastfeeding the infant Jesus is the iconographic reduction of a holy story expressed in an extremely homely, everyday fashion, backed by small, secondary scenes in the woods. The space is dominated entirely by the monumental structure of the Madonna and Child; the depth is graded, from the plants at the lower edge to the dark, compact thickets of the woods and brilliant counterpoint in the background. David's smooth, velvety brush stroke, the cold, bluish green coloring, and the densely packed masses are hallmarks of the master's style that here help to highlight the beautiful, enameled flesh tones.

This work, dated during the painter's later life, reveals an eminently Flemish artistic background that seemingly makes overtures to the Italian Renaissance environment, with the strong, pyramidal volume of the composition set in a large space leading the eye toward an ever more independent landscape genre.

THE ADORATION OF THE MAGI

This painting is the central panel in the triptych that adorned Charles V's oratory at the royal residence in Aceca, the wings being taken up by a *Nativity* and the *Presentation in the Temple,* which are also in the Prado.

Memling must have worked in Brussels with van der Weyden at some stage, as the latter's influence is noticeable in some of his works, although Memling surpasses him in others. This is true of *The Adoration of the Magi,* which stands out for its horizontal structure, the extensive space in the architectural elements glimpsed in the distance, and the solemn bearing of the Virgin in the center. Each figure is individualized by intense coloring, which creates the impression of their being genuine character portraits, to the extent that two of the magi are usually identified with Charles the Bold and Philip the Good. Memling must have executed this triptych in the 1470s. It is striking for its elegant styling and is associated with another version in the Bruges Hospital dated 1479.

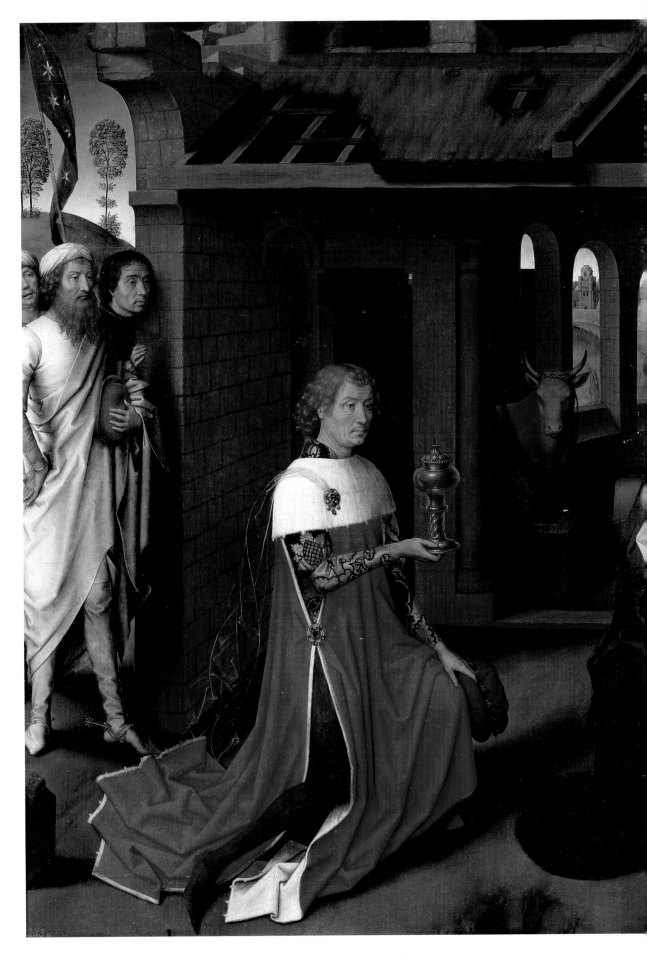

HANS MEMLING
The Adoration of the Magi
Oil on panel, 95 × 145 cm

THE ADORATION OF THE MAGI

Because Bosch followed the gospel story closely, this work is far removed from the customary popular, moralistic iconographies. *The Adoration of the Magi* is one of Bosch's masterpieces and an object of devotion for those whose portraits were painted alongside their patron saints, Peter and Agnes, in the wings. Despite the tripartite physical division, a spatial continuity proceeds from one panel to the next. The broad landscape and the lofty viewpoint, with its aerial perspective, are congenial to the positioning of towns, woods, thickets, rivers, and lakes, and its groups of peasants and soldiers. This is the setting for the humble stable, its rustic character standing out in contrast to the elegant figures. The subdued range of blues and greens in the background heightens the reds, dark blues, and white of the main figures and the austere black of the donors, who are identified as Pieter Bronchorts and Agnes Bosschuyse.

This is one of the master's later works, executed around 1510. Once housed in the Bois-le-Duc cathedral, it was confiscated in 1567 and transferred to El Escorial by Philip II in 1574.

THE HAY WAIN

Like van der Weyden's *Descent from the Cross,* a second version of *The Hay Wain,* executed in the period 1495–1500, is housed in the monastery of El Escorial, an indication of the esteem in which the Spanish monarchs held Flemish painting and works by the Flemish masters.

Only the interior panel on the left, featuring scenes from Creation and original sin, pertain to traditional iconography. Everything revolves around the central panel and the hay wain, a symbol of the fleeting, perishable nature of worldly things. This is the key to interpreting all else — love, greed, envy, and lust are embodied in concrete examples, while a group of demons pull the wagon toward Hell, which is depicted in the right wing. From left to right we find an orderly universe and an allegory of sin taken straight from contemporary literature and sociology, in which the profane always conceals some moral or spiritual symbolism.

This work was originally owned by Philip II who was a great admirer of Bosch and an enthusiastic collector of the painter's work.

THE GARDEN OF EARTHLY DELIGHTS

The most universal and enigmatic of Bosch's works, *The Garden of Earthly Delights* was executed around 1510. Despite the ineffable conceptual complexity of this painting, the Spanish court of the sixteenth and seventeenth centuries — far from considering Bosch to be portraying heretical subjects — clearly understood his purpose in satirizing sin and worldly failings through pungent imagery steeped in popular lore and literature.

Interpretations of this work often border on the fanciful, whereas the content is an integral part of the Creation panels that are visible when the triptych is closed. When open, this scene leads into the Earthly Paradise, where God gives man a companion and where the landscape merges into the central panel, then into the right wing depicting Hell. The relationship between the two wings — Heaven and Hell — is determined in mediaeval theology by sin, the theme of the central panel.

The painting was deposited in El Escorial in 1593 and is documented as having been purchased at an auction held by Ferdinand, the illegitimate son of the duke of Alba and prior of the Order of St. John.

HIERONYMUS BOSCH (c. 1450–1516)
The Adoration of the Magi, c. 1510
Oil on panel, 138 × 33 cm (wings), 138 × 72 cm (middle panel)

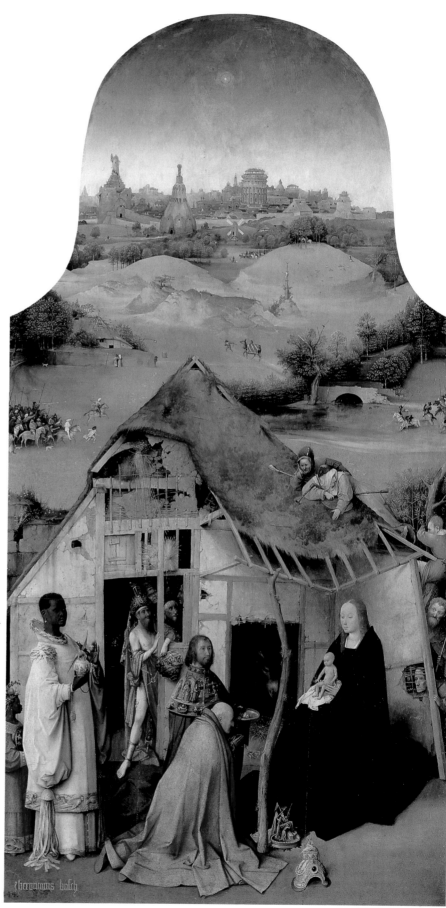

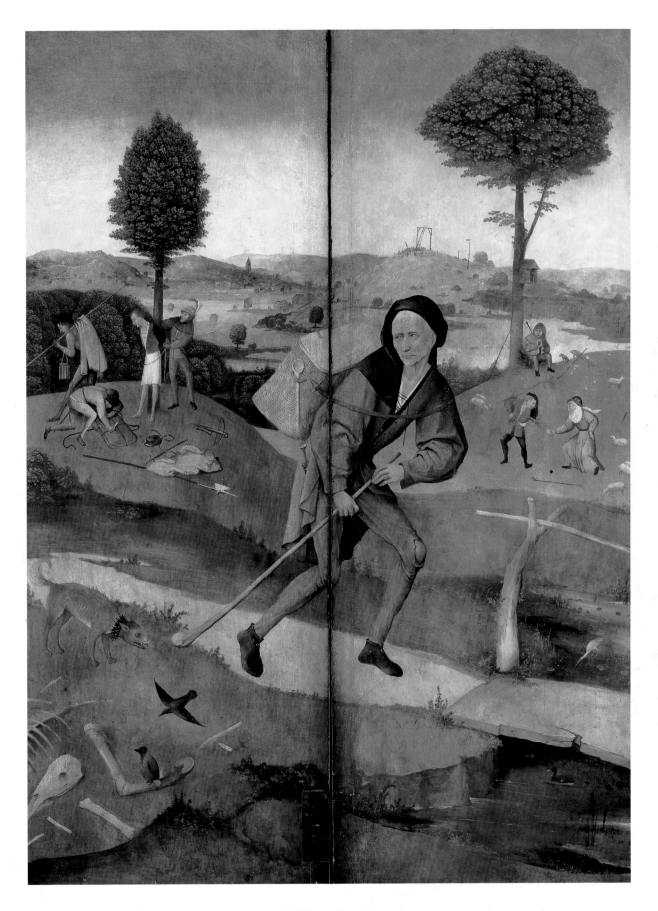

HIERONYMUS BOSCH
The Hay Wain (exterior wings, closed)
Oil on panel, 135 × 100 cm

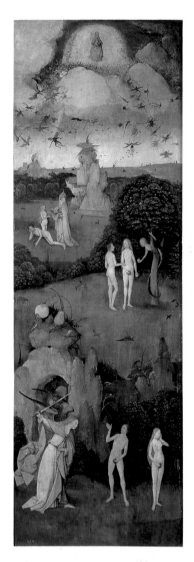
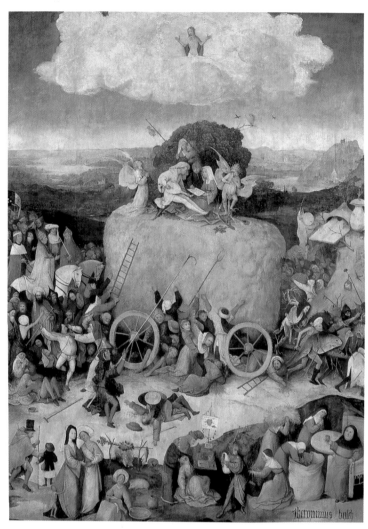
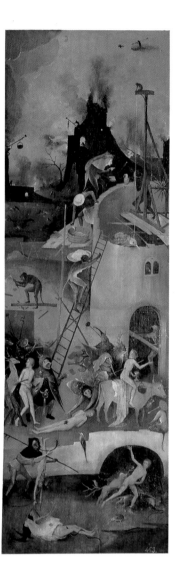

HIERONYMUS BOSCH
The Hay Wain (interior, open)
Oil on panel, 135 × 45 cm (wings), 135 × 100 cm (middle panel)

HIERONYMUS BOSCH
The Garden of Earthly Delights, c. 1510
Oil on panel, 220 × 97 cm (wings), 220 × 195 cm (middle panel)

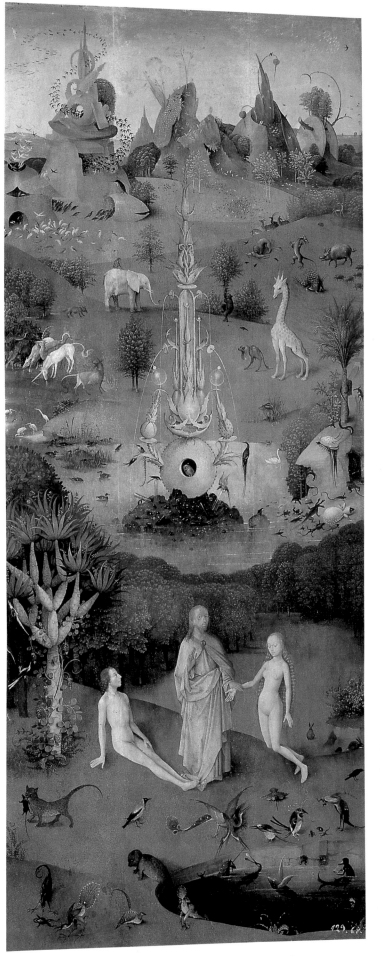
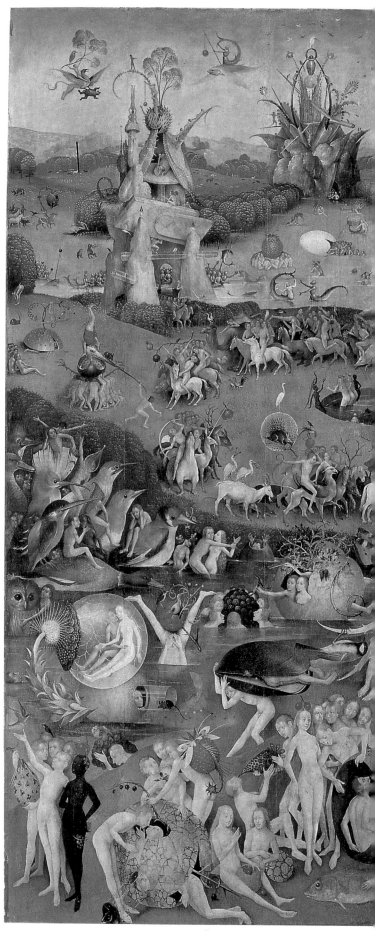

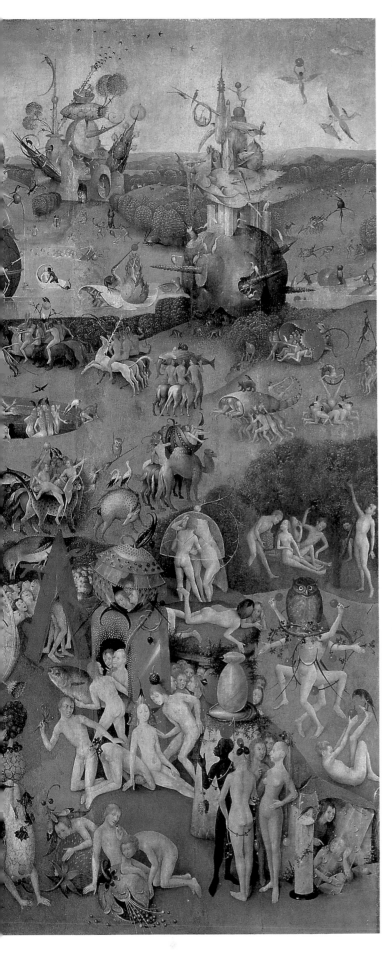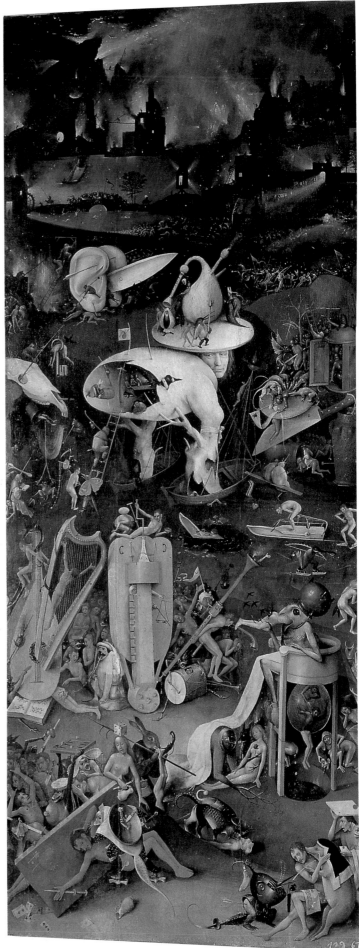

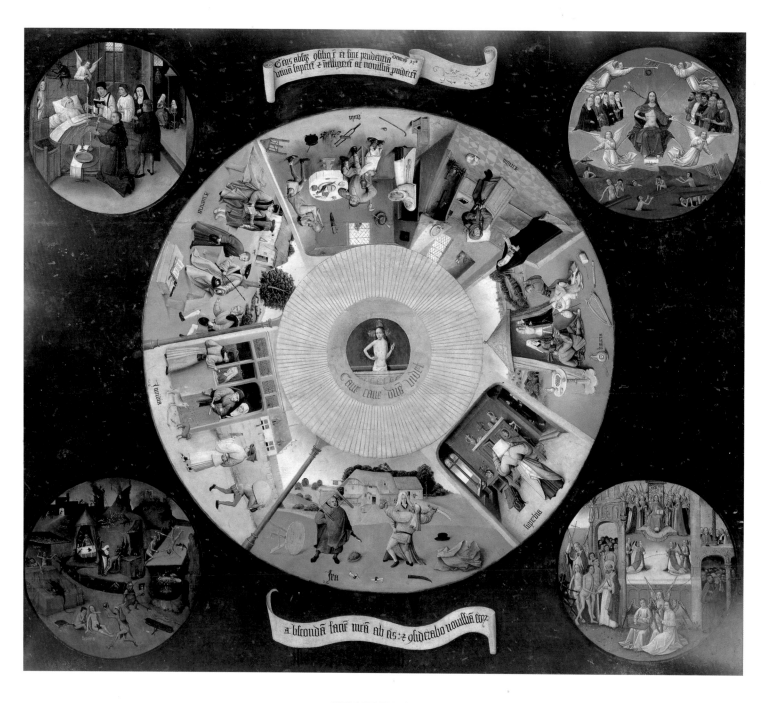

HIERONYMUS BOSCH
The Seven Deadly Sins
Oil on panel, 120 × 150 cm

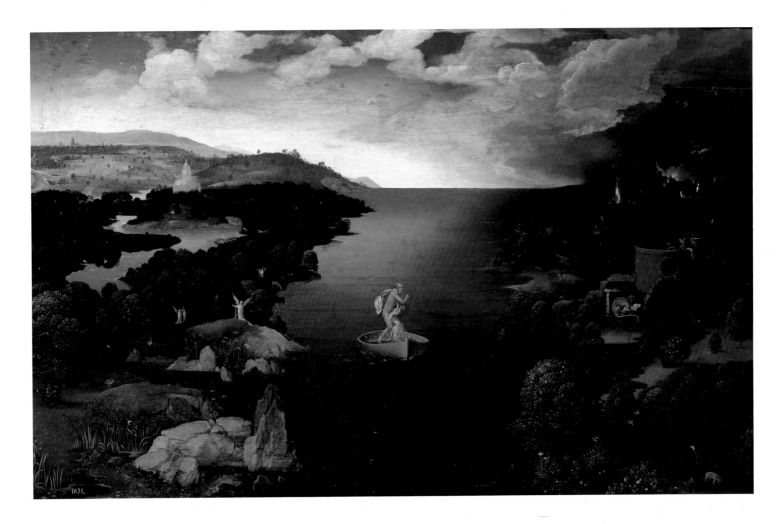

JOACHIM PATINIR (c. 1480–1524)
Crossing the Styx
Oil on panel, 164 × 103 cm

THE SEVEN DEADLY SINS

CROSSING THE STYX

With its unusual arrangement and style, this work reveals a duality in both the distribution of the subjects and the handling. The deadly sins are arranged in a radial pattern and the medallions are shown vertically, while the latter are painted in a more archaic technique. The painting is dated c. 1480, which was a time that marked a change in the artist's style. The subject matter is, however, uniform throughout.

The medallions hold depictions of humankind's end — death, the Last Judgment, Hell, and Glory — while the deadly sins are shown as small genre scenes, resembling miniatures, set radially as a circle of vices. The center is taken up by the figure of the risen Christ, which is set in the retina of a human eye. The inscription CAVE, CAVE DEUS VIDET brings home the idea that nothing can escape God's scrutiny.

The painting was probably a religious commission. It was in Philip II's apartments at El Escorial prior to 1605, but its former provenance is unknown.

The originality of Patinir's work within the context of late-medieval Flemish painting is strikingly revealed in this painting in which mythological concepts — the Elysian Fields, Cerberus, Charon, and the Avernus — are paralleled by their Christian equivalents — Paradise, the angels, Hell.

The subject symbolizes the age-old cliché of the Christian spirit torn between virtue and vice, good and evil, the arduous, ascetic path versus the comfortable, mundane way. The soul in the painting is shown gazing at the easy way, which leads to Hell. Echoing the work's meaning and symbolism, the composition expresses the duality admirably in the vertical division of the river Styx. The high viewpoint overlooks an extensive, all-pervading landscape of cold, bluish green tones accented with flames and gloomy wetlands, marking Patinir as one of the early exponents of a genre in which the subject matter is dwarfed by the pictorial context.

REST ON THE FLIGHT INTO EGYPT

Patinir, an accomplished painter of landscapes and backgrounds, occasionally collaborated with other artists, particularly Quentin Massys. Together they executed the Prado's *Temptation of St. Anthony.* In his own work, landscape becomes the natural setting for depicting small, moral or religious scenes dwarfed by lofty horizons and multiple planes with depths graded by thickets, rocks, half-hidden hollows, towns, country dwellings, and croplands.

Here, the monumental figures and the foreground are singled out by the use of different colors, but they merge readily into the bluish depths of the landscape. The visual prominence of the Virgin and Child should not detract from some minute details that, cloaked in apparent mundanity, are actually important Christian symbols, such as the apple tree near the Virgin, with a vine coiled around its trunk.

JOACHIM PATINIR
Rest on the Flight into Egypt
Oil on panel, 121 × 177 cm

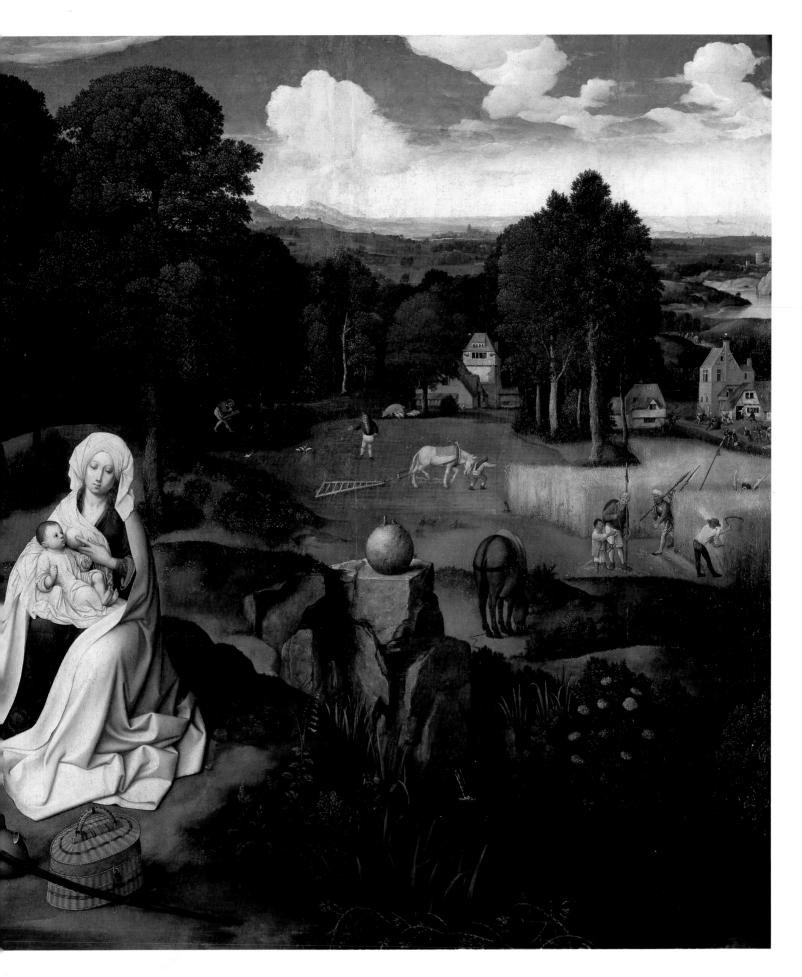

MADONNA AND CHILD

Mabuse's work demonstrates a noticeable approach to Italian Renaissance trends. His compositions are studded with decorative ensembles, ancient buildings, and robust, sculptural figures reminiscent of those of Michelangelo and particularly Raphael, whose work he may have seen on a trip to Rome in 1508–1509. The novelty of his Romanist style made him a celebrity in the court of Margaret of Austria. However, Gossaert's drawing retains a Flemish linear precision and minute characterization of details — pearls, strands of hair resembling gold thread, lacework, and drapery.

The emphatic shading in the nude anatomy of the Child identifies Gossaert with an important group of fourteenth-century Flemish painters who kept abreast of Italian currents. The lively coloring is, nevertheless, more of a Flemish trait than an Italian one. Dated around 1527, this well-preserved painting is one of the artist's finest.

JAN GOSSAERT, called MABUSE (c. 1470/80–1532)
Madonna and Child, c. 1527
Oil on panel, 63 × 50 cm

THE VIRGIN OF LOUVAIN

The back of this panel bears a long inscription attributing the work to Mabuse, which poses a serious confrontation between historical sources and stylistic appraisal. The inscription is dated 1588 — the year in which the painting was given to Philip II by the city of Louvain; it was regarded as Gossaert's work at the time. Today, however, most critics do not attribute the whole work to Mabuse. The complex architecture is thought to be by his hand, but it provides the setting for a Madonna and Child whose forms are gentler than Gossaert's Herculean figures.

The parallels with the work of Bernard van Orley were pointed out by M. Friedländer, who dated the painting around 1520. Apart from the figures, however, other features of the architecture, such as the multicolored marble, the projecting cornices, and the slightly disproportionate forms appear in other works by van Orley, such as the *Triptych of Patience* (Musées Royaux des Beaux-Arts, Brussels), which reveals the artist's endeavor to capture some of the attractive features of the Italian Renaissance through the technical perfection characteristic of Flemish art.

BERNARD VAN ORLEY (c. 1488–1551)
The Virgin of Louvain, c. 1520
Oil on panel, 45 × 39 cm

ADRIAEN ISENBRANDT (active 1510–1551)
The Mass of St. Gregory
Oil on canvas, 72 × 56 cm

THE MASS OF ST. GREGORY

Isenbrandt was steeped in fifteenth-century Gothic tradition, but he gradually adapted his style to meet with that of other masters, who were familiar with the Italian Renaissance. *The Mass of St. Gregory* is a good example.

In this private, devotional subject the painter resorts to the traditional Christian theme of Christ's true presence being made manifest in the consecrated bread and wine of the Mass. (Christ appears to St. Gregory in the flesh, but passes unnoticed among the rest of those present.) In the church we see an "old-style" interior with rectangular pillars, superimposed orders, and balustraded columns, all elements of the Italian Renaissance.

Isenbrandt handled both the figures and background with a painstaking technical accuracy, but he used gentle, soft shadow to mold the figures in a way that marks a departure from his early training, albeit without going as far as the speculative grandeur of the Italian world.

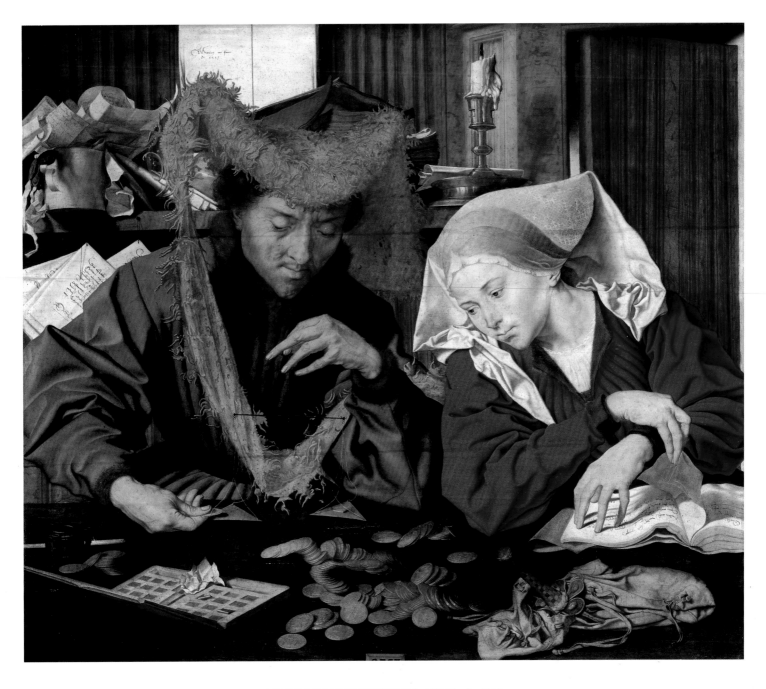

MARINUS VAN REYMERSWAELE (c. 1490/95–after 1567)
The Moneychanger and His Wife, 1539
Oil on canvas, 83 × 97 cm

THE MONEYCHANGER AND HIS WIFE

Following the model of Quentin Massys, Marinus van Reymerswaele developed and popularized a subject that became deeply rooted in grassroots Flemish sensibilities. The composition is expressively simple and economic: two half-length, seated figures are shown weighing money and recording debts on a table laid with a green runner. The setting is overpowered by the monumentality of the figures, while the background reveals shelves teeming with objects — books, candlesticks, paper, boxes, etc. The figures gaze at the scales with such concentration that the rest of the room is all but obliterated. In the sixteenth century, long, crooked fingers were taken to be a sign of greed, so this apparently untoward domestic or genre scene may well be charged with a moral sense. Despite having been executed well into the century, the details are highly Flemish in character, and Italian influences succumb to Northern forms and spirit.

THE DEATH OF ABEL

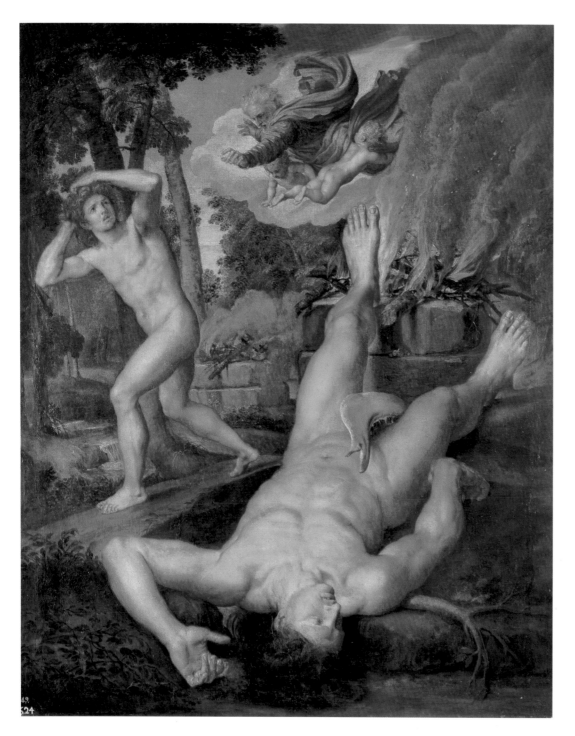

MICHIEL COCXIE (1499–1592)
The Death of Abel
Oil on canvas, 151 × 125 cm

Cocxie was one of the sixteenth-century Dutch artists most intent on adopting the Italian Renaissance style, with which he came into direct contact in 1532 and 1539. The influence of Raphael, and of Michelangelo and his followers, set Cocxie on an equal footing with his Italian peers — indeed, he received decorative commissions in Rome. He was connected to the court of Mary of Hungary, copied van Eyck's *Ghent Altarpiece* for Philip II in 1557–1559, and worked for El Escorial, which accounts for his moving to Spain.

The Death of Abel is a perfect example of the Romanism prevalent in the Low Countries in the sixteenth century; it reveals the influence of the great Italian masters with their grandiose nudes, as evinced in the foreshortening — particularly that of the figure of God — which is reminiscent of Michelangelo. Despite this canvas's dramatic nature, Cocxie achieved a more balanced expressive tone than his contemporary Mannerists, Heemskerck and Lombard, whose works are characterized by a stilted quality and a classical rigor.

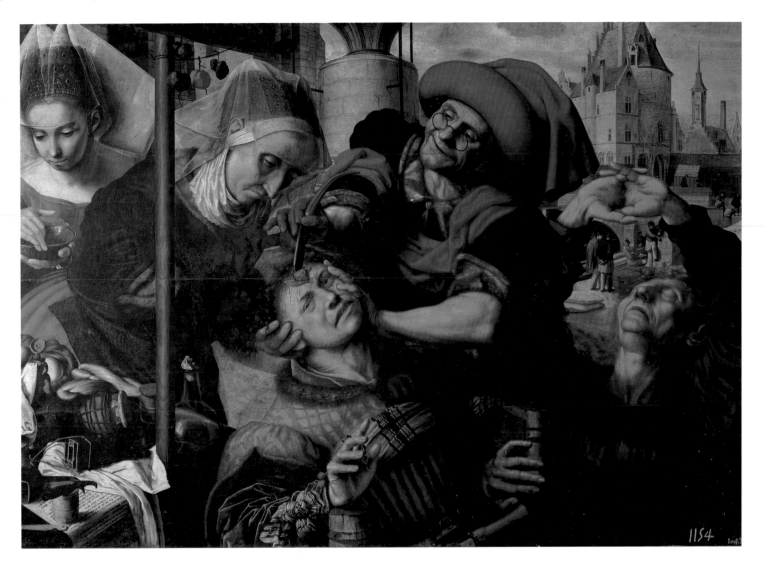

JAN SANDERS VAN HEMESSEN (c. 1500–1556/7)
The Surgeon, c. 1550
Oil on canvas, 100 × 141 cm

THE SURGEON

Hemessen, who started working in Antwerp and subsequently moved to Haarlem, was a forerunner of genre painters both in the northern and southern Low Countries. This work was executed c. 1550. The figures are half-length, a trend that may have originated in fifteenth-century Venetian painting and was to reach its height in Caravaggiesque naturalism.

The depiction of a doctor removing a stone from a patient's head — the stone of Bosch's insanity — is comparatively frequent in Dutch and Flemish art. The theme resorts to popular characters who are portrayed critically and over-realistically, to the point of caricature. The scene is set in the open air, in a sort of marketplace,

and shows a quack surrounded by assistants eager to bear out the success of the operation and so uphold the false reputation of the charlatan who pompously displays his title, implements, and art under the implacable, satirical gaze of the artist.

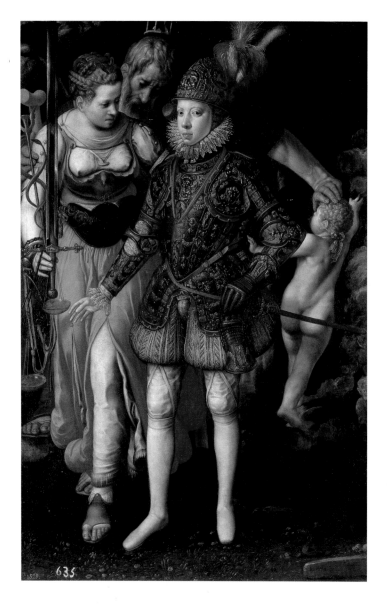

JUSTUS TIEL (active end of sixteenth century)
Allegory of the Education of Philip III
Oil on canvas, 159 × 105 cm

ALLEGORY OF THE EDUCATION OF PHILIP III

Little is known about this painter associated with the court of Philip II, who, in addition to this portrait, executed others of popes Urban VII and Clement VII, which were delivered to El Escorial in 1593. The lack of biographical data is heightened by the fact that this fine portrait of Prince Philip (III) reveals associations with Sánchez Coello's court portraiture and, furthermore, presents a transformed character and allegorical figures that were not customary in the Spanish court.

The prince is depicted wearing blued, gilt parade armor with lace and breeches showing through. Behind him Time, embodied by an old man, is pushing aside a young cupid while a matron bears the caduceus of Mercury, a sword, and scales. The form and handling are Mannerist in style, while the accurate, detailed drawing in the armor reveal the artist's Flemish training.

MARY TUDOR

Mor painted this portrait while he was in London to attend Philip II's wedding to Mary I of England, which resulted in a disturbed, childless marriage. This is the artist's masterpiece of portraiture and it excels for the economy with which the painter has expressed the monarchy's firm, dignified manner, without detracting from the queen's affable, headstrong, and even cruel character. The monumental bearing derives from the Italian models of Raphael, Sebastiano del Piombo, and Titian, although the painter has otherwise taken great trouble over the minutest detail, as may be seen in the pattern on the back of the armchair, the queen's jewelry, the smoothness of the velvet, and the tautness in the petals of the rose, the Tudor symbol.

Mor's style had a profound influence on Spanish portrait painters, who perpetuated it until the last three decades of the seventeenth century. The portrait was commissioned by Charles V, who kept it with him even when he retired to the monastery of Yuste, before it became part of the royal collections.

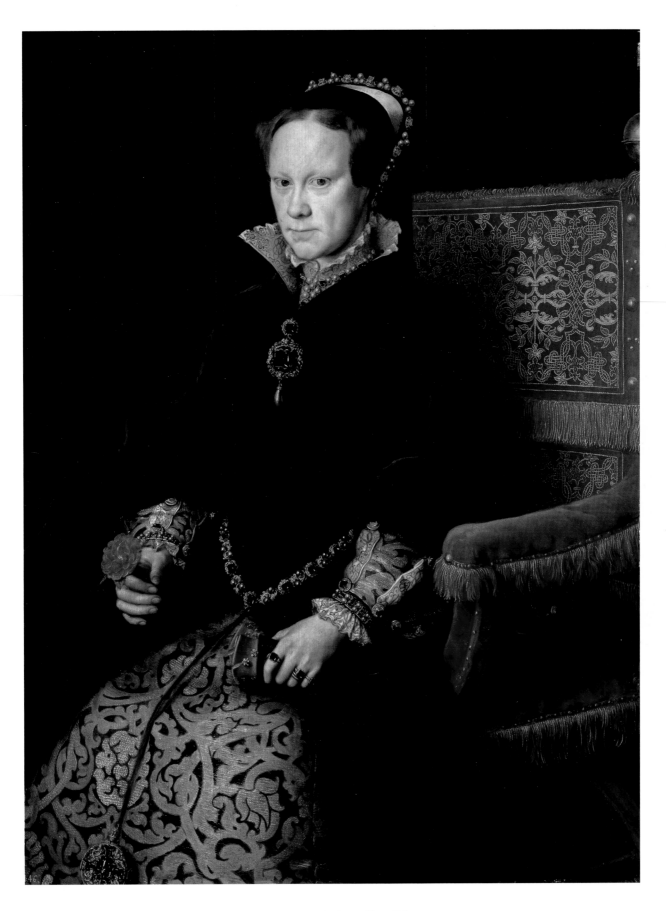

ANTHONIS MOR (c. 1516/19–1576)
Mary Tudor, 1554
Oil on panel, 109 × 84 cm

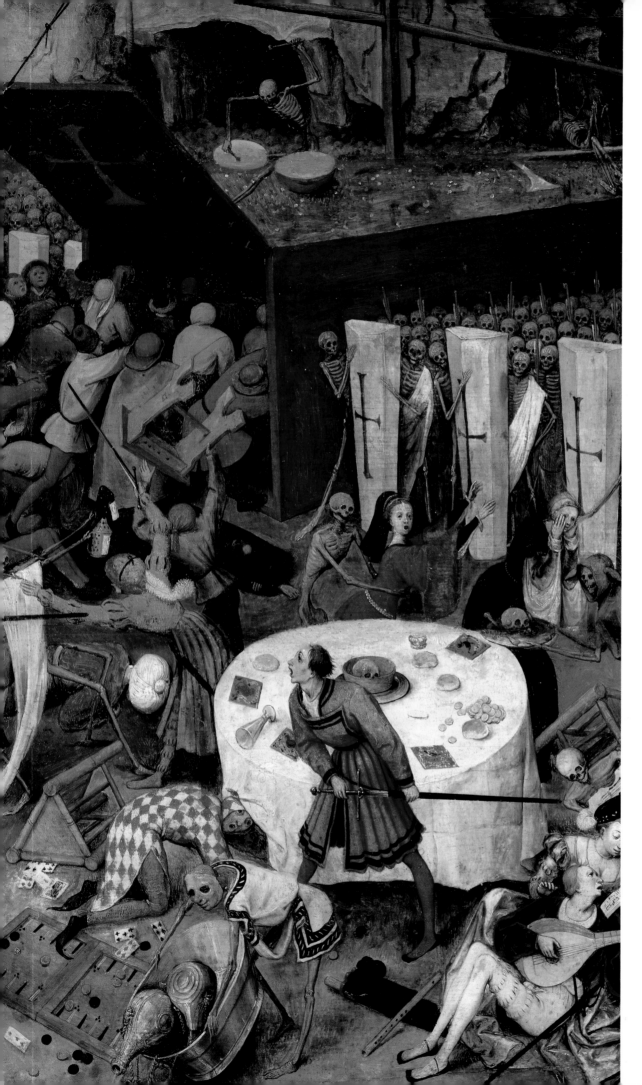

Dated around 1562, its central theme revolving around death, this panel is an extraordinary evocation of Bosch's ethical, apocalyptic, and satirical world. The aerial perspective descends from a lofty viewpoint and provides a setting for groups, scenes, and figures. The panoramic view features the embodiment of medieval ideas of the Triumph of Death, seen in the skeleton galloping on a half-starved steed, and the Dance of Death, which affects every social stratum without discrimination. According to Bruegel, death is the wages of sin, here portrayed in its diversity — greed, gluttony, sloth.

The painter's skill, derived from early Flemish art, is evinced in the densely populated universe of slender, elongated figures rendered by disciplined drawing. The stark symbology in this scene does not, however, detract from others of a genre character, which are charged with erudition, didacticism, and an entertaining but critical moral sense.

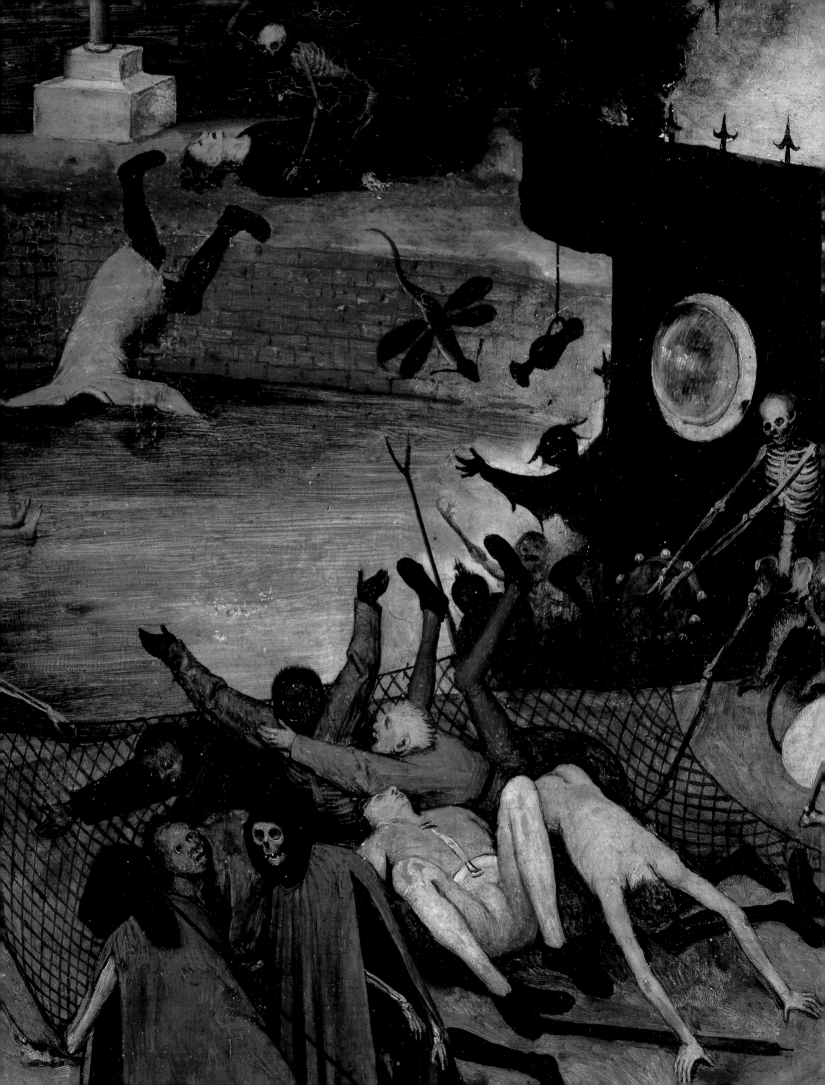

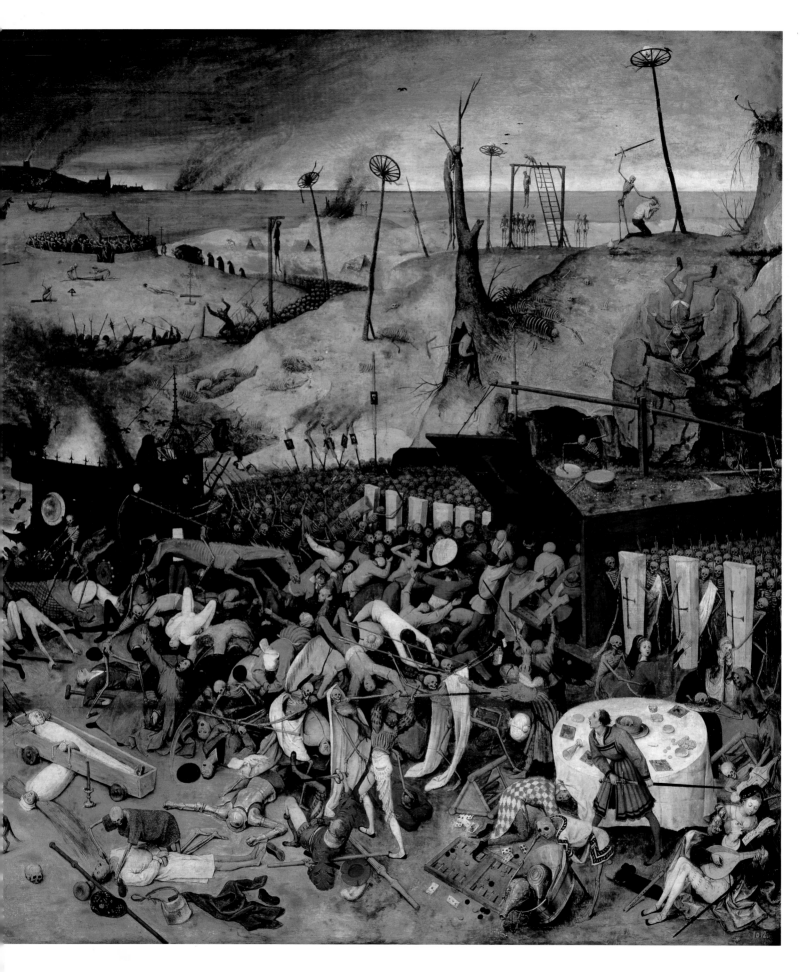

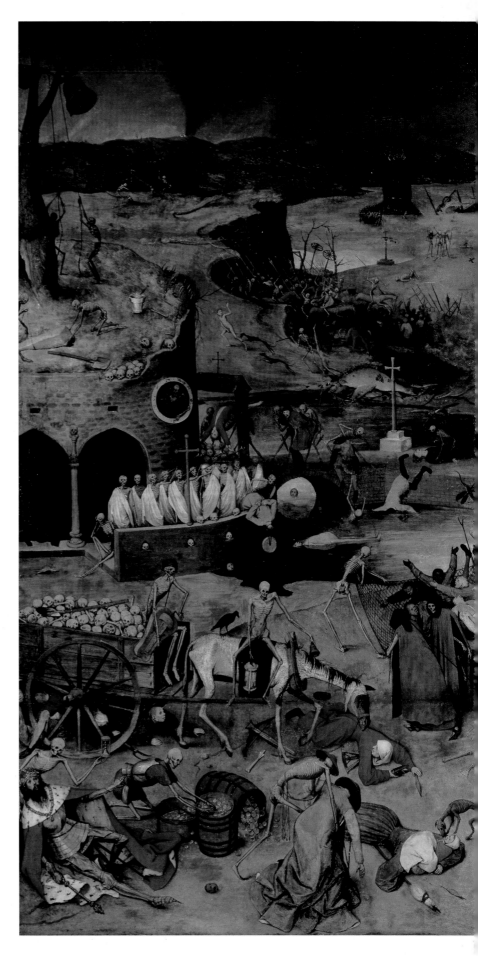

PIETER BRUEGEL THE ELDER
(c. 1525/30–1569)
The Triumph of Death, c. 1562
Oil on panel, 117 × 162 cm

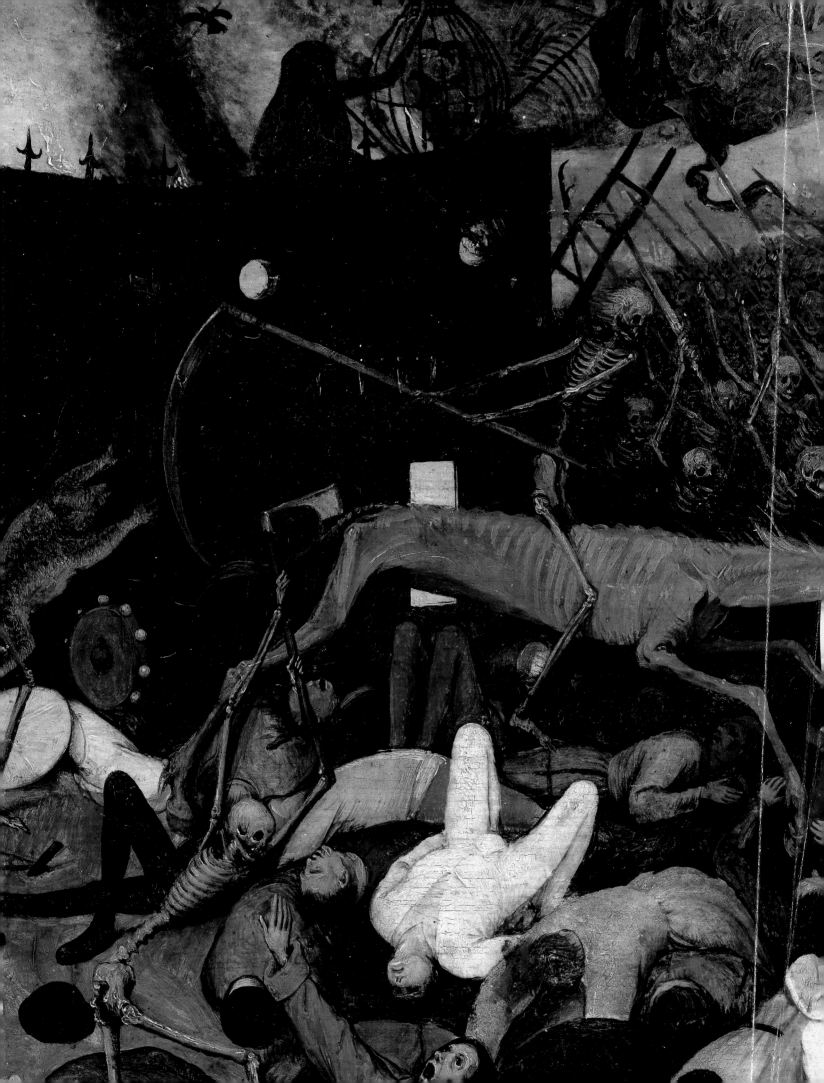

PAUL BRIL (1554–1626)
Landscape with Psyche and Jupiter, 1610
Oil on canvas, 93 × 128 cm

LANDSCAPE WITH PSYCHE AND JUPITER

Paul Bril, one of the leading early Baroque landscape painters, trained in Antwerp and later traveled in Italy before eventually settling in Rome, where his keen observation of nature, so characteristic of the Flemish, was cast within the more grandiose, synthetic, Italian style.

Here, nature is visually prevalent in the clumps of trees and the rock formations that provide an almost theatrical setting, which also includes patterns of spray from a waterfall, a rainbow, and the iridescent profiles of leaves caught in the sunlight at daybreak. The figures are accessory, and probably owe their presence wholly to Rubens, who is assumed to have added them once the painting became part of his belongings, after which it was purchased by Philip IV.

With the help of Jupiter, in the guise of an eagle, Psyche is seen filling a goblet with water from the river Styx. The brilliance of Bril's execution is rivaled by the small but vibrant figure of Psyche, which Rubens rendered monumental with the use of a broad brush stroke.

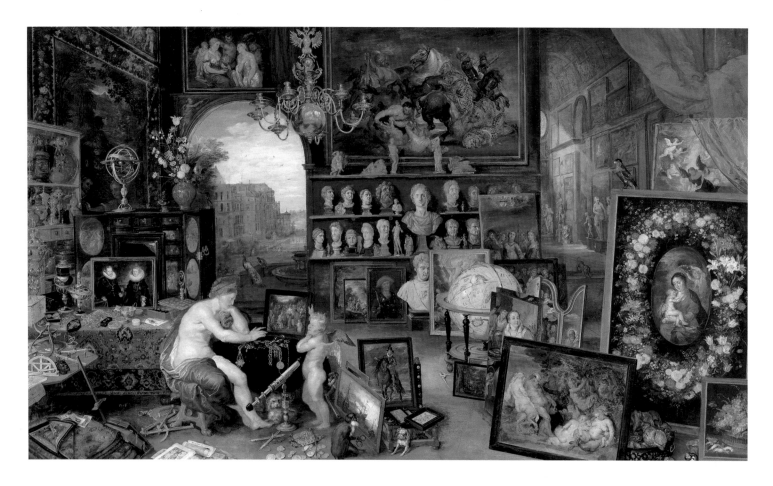

JAN BRUEGHEL THE ELDER (1568–1625) and PETER PAUL RUBENS (1577–1640)
Allegory of Sight, 1617
Oil on canvas, 65 × 109 cm

ALLEGORY OF SIGHT

Allegorical depiction of the senses became very popular in the southern Low Countries during the sixteenth century. This one, painted by Velvet Brueghel c. 1617–1618, is among the most complex, comprising allegorical objects and figures drawn with great accuracy. The series of five panels in the Prado all feature backgrounds in the manner of large, opulent stage settings with extensions shown in perspective.

In *Sight,* for which Rubens painted the figures, Cupid is depicted showing a painting of Christ healing a blindman. The optical instruments — including a telescope, astrolabe, and globe — paintings, statues, flowers, and jewelry are all objects perceived with the sense of sight. Each has been painstakingly characterized with true Flemish skill, sensitive brush strokes, and bright color, so that even the minutest of details is accurately reproduced, as in other paintings or the portraits of the archdukes.

JAN BRUEGHEL THE ELDER and HENDRICK VAN BALEN (1575–1632)
The Four Elements
Oil on panel, 62 × 105 cm

THE FOUR ELEMENTS

A frequent subject in seventeenth-century painting was that of the four elements — air, water, earth, and fire — which, according to a tradition derived from Greek philosophy, were the components of every worldly object.

For this work Brueghel had van Balen paint the figures that personify the elements. They are divided into two groups of two, which stand for abundance and destruction: Earth and Water, together with Ceres, are set in a leafy garden, while Fire and Air are airborne. The quality of Brueghel's landscape of groves, hedges, rivers teeming with a variety of fish and shells, and a profusion of plants, fruit, and beautiful flowers, all characterized by small, highly accurate brush strokes, is matched by the elegance and daintiness of the richly colored allegorical figures, shown as beautiful nudes of a voluptuousness akin to figures by Rubens.

JOOS DE MOMPER THE YOUNGER (1564–1635) and JAN BRUEGHEL THE ELDER
A Flemish Market and Washing-Place, c. 1620–1622
Oil on canvas, 166 × 194 cm

A FLEMISH MARKET AND WASHING-PLACE

After training in Antwerp and subsequently traveling in Italy, Joos de Momper became a specialist in rocky, mountainous landscapes to which he applied the best principles of the Flemish school — a high viewpoint that afforded a large, natural panorama, surfaces graded by color tones and light, and a number of amazing devices for objectively rendering distance, trees, houses, and reflections. By the late sixteenth century he had become one of Antwerp's leading painters, and he absorbed Rubens's bold style.

This highly polished mature work, executed in 1620–1622, includes two juxtaposed scenes provided by Jan Brueghel the Elder, with lively figures engaged in everyday activities. The noisy crowd at the market is cleverly offset by the neatly outspread clothing in the fields, the two areas separated by a large, dry tree-trunk.

DENIS VAN ALSLOOT (1570–1628)
Skating at Carnival, c. 1620
Oil on panel, 57 × 100 cm

SKATING AT CARNIVAL

The scene is set on a frozen river bounding the Antwerp city fortifications. Snowbound, wintry landscapes were often painted by Flemish artists, who successfully conveyed atmospheric cold through blues, whites, and cloudy grays, as well as by including the outlines of leafless trees.

Denis van Alsloot, who executed this work around 1620, was a member of the group known as the "Brussels landscape painters." He worked for Archduke Albert and Archduchess Isabella Clara from the late sixteenth century onward, and several of the archducal commissions are now exhibited in the Prado Museum. In these landscapes by van Alsloot, the archduke and archduchess often feature as passive onlookers in crowd scenes at pageants or civic activities. The many figures in such works are dressed in bourgeois finery, with carriages and animals accurately drawn in bright colors.

SEBASTIAN VRANCX (1573–1647) and JAN BRUEGHEL THE ELDER
Assault on a Convoy
Oil on panel, 46 × 86 cm

ASSAULT ON A CONVOY

Sebastian Vrancx specialized in military scenes, assaults, and skirmishes, a genre highlighting the suffering of both soldiers and civilians and the way it was stoically borne throughout the endless wars that ravaged the Low Countries for almost a century.

This work is unusual in that Vrancx collaborated with another painter on a such a laborious, small-format painting. Velvet Brueghel appears to have painted the landscape, with its topographical modulation and background zigzagging up to the hilltop. His subtle nuances of color, from the dark browns to the bright glow above the blue sky, strike a contrast with Vrancx's linear figures, which retain their freshness amidst the onslaught of cavalry and infantry against the peasants. The sharp brushstroke sets this work among Vrancx's early seventeenth-century oeuvre.

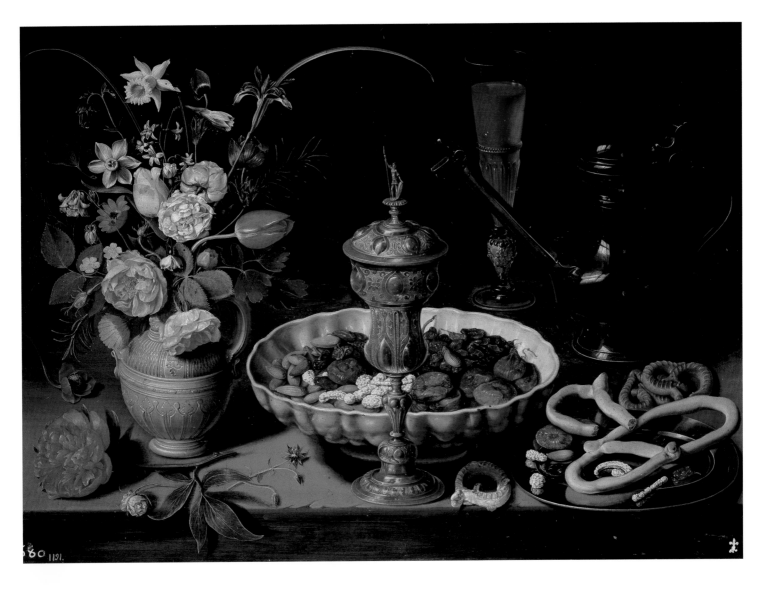

CLARA PEETERS (c. 1590–1649)
Still Life with Vase, Jug, and Platter of Dried Fruit, c. 1619
Oil on panel, 52 × 73 cm

STILL LIFE WITH VASE, JUG, AND PLATTER OF DRIED FRUIT

This is one of four still lifes, most of them dated 1611, that once belonged to Isabella Farnese. Active in Amsterdam and Haarlem, Clara Peeters was one of the few women painters of the Low Countries.

The genre of still life, with its hesitant, multifarious beginnings in the sixteenth century, came into its own in the seventeenth century. The depiction of everyday objects was adopted by painters in northern Europe who paid great attention to material detail and formal characterization. Clara Peeters was famous for her "breakfast pieces," which show tables bedecked with objects against dark, almost monochromatic backgrounds.

Everything is laid bare, pervaded by a sense of luxury and refinement commensurate with Flemish and Dutch bourgeois taste and good living, although there may well be some deeper significance attached to the displays of objects.

EQUESTRIAN PORTRAIT OF THE DUKE OF LERMA

The duke of Lerma, Francisco Gómez de Sandoval, was Philip III's prime minister, who ruled Spain's fortunes until his overthrow in 1618. It was on his initiative that the court moved to Valladolid, where he met Rubens in 1603 during the painter's first visit to Spain as ambassador for the duke of Mantua. That was when Rubens painted this equestrian portrait, in which the horseman's firm control of the wild horse is an allusion to his firm grip of government.

The duke's frontal pose, with the horse set along a sharp diagonal, was Rubens's great contribution to the Baroque equestrian portrait, marking a departure from Renaissance profiles, which he nevertheless adopted on occasion — as in portraits of Philip II — clearly out of homage to Titian. Here, too, the sources of inspiration are the Venetian masters, particularly Tintoretto, whose influence would account for the cold lighting and the blue tones, while the contrasting light and shadow and the stark chiaroscuro coincide in time with the paintings of Caravaggio.

ST. GEORGE AND THE DRAGON

Rubens must have executed this work during his sojourn in Genoa in 1606–1607. In the seventeenth century, this highly popular, apocryphal legend would have meant something only in places where the saint was worshipped, as in Genoa, and it may have been intended as a metaphor of the triumph of virtue over sin, or of Catholicism over Protestantism.

The scene captures the height of the engagement: its neck taut and mane blowing in the wind, the horse is shown rearing up and trampling the formless monster, which, like the other figures, is charged with a fearful, supernatural force. The princess with the lamb, symbolic of meekness, half turns but remains static, resembling a column.

Rubens used his great gift for adapting Renaissance models in this canvas; he has drawn on currents stemming from Leonardo da Vinci, but developed them along Baroque lines through lively drawing, bright coloring, and turbulent, whirling dynamism.

THE DEATH OF SENECA

Of all Rubens's works in the Prado, this one best exemplifies the manner in which the artist set about researching a classical subject. Its constituent parts are taken from the imaginary museum of Western cultural history, as the torso of this nude of an old man is a faithful pictorial replica of the *Fisherman,* a Hellenistic sculpture that Rubens saw in Italy, while the head is a copy of a bust in Antwerp considered to be a portrait of Seneca, a philosopher held in great esteem in humanistic circles in that city. What is most striking, however, is how the artist has put the various pieces together to create an original work, albeit poorer in quality than the version in the Alte Pinakothek in Munich, which is regarded as the original. On the basis of the linear drawing and stark lighting, the painting is considered an early work, c. 1615.

THE ADORATION OF THE MAGI

After traveling in Italy, Rubens settled in Antwerp in 1608. This painting was commissioned that same year by the Antwerp city council and in 1612 it was given to Rodrigo Calderón. Philip IV acquired it at the auction of Calderón's estate after he had been tried and executed.

The canvas appears to have been enlarged by Rubens during his sojourn in Madrid in 1628–1629, the format being increased at the top and on the right side, where he included a self-portrait. The original composition is clearly visible in the figures of the Virgin and the naked slaves bearing gifts. The stylistic differences between the original canvas and the subsequent reworking are quite noticeable. The former reveals bolder outlines and brighter coloring (as in the king's large crimson tunic), and the rich interplay of light sets up stark contrasts and vibrant highlights. Still influenced by his travels in Italy, Rubens was inspired here by Veronese, although the latter's aristocratic style has been transformed in an explosion of power, light, and color charged with Baroque vigor and vitality.

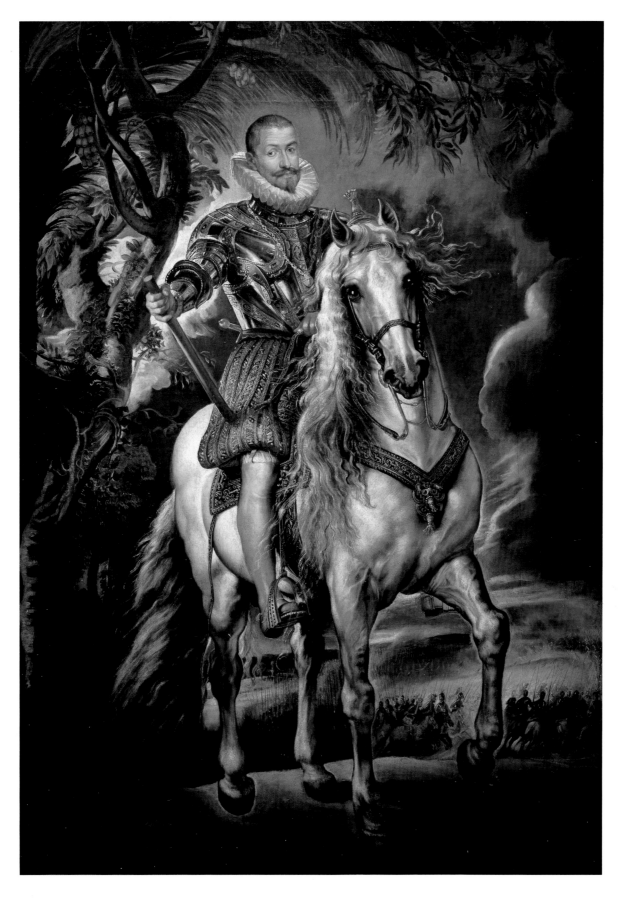

PETER PAUL RUBENS
Equestrian Portrait of the Duke of Lerma, 1603
Oil on canvas, 283 × 200 cm

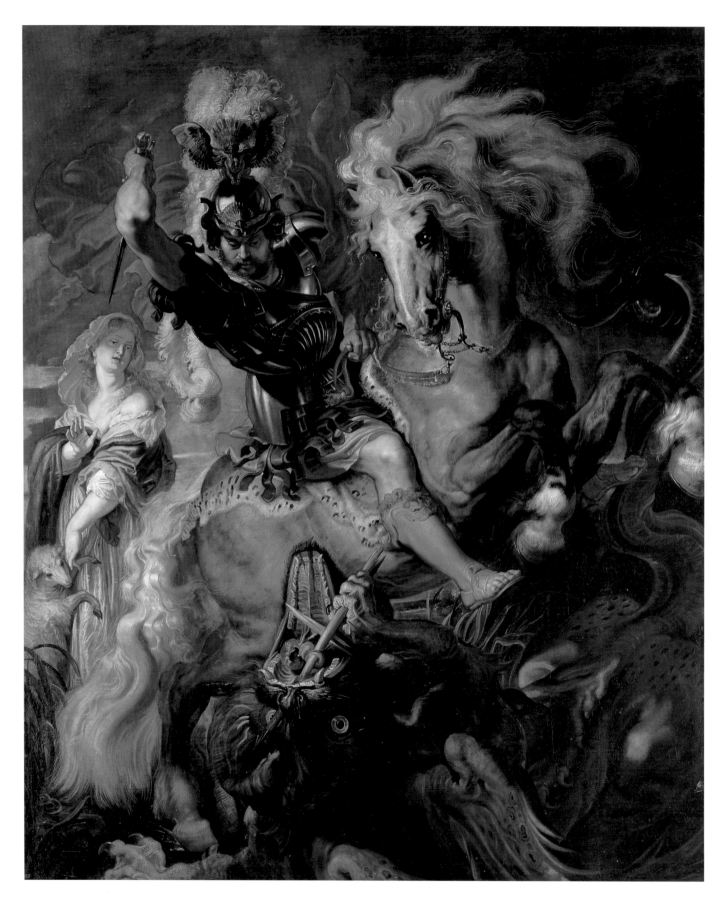

PETER PAUL RUBENS
St. George and the Dragon, 1606–1607
Oil on canvas, 304 × 256 cm

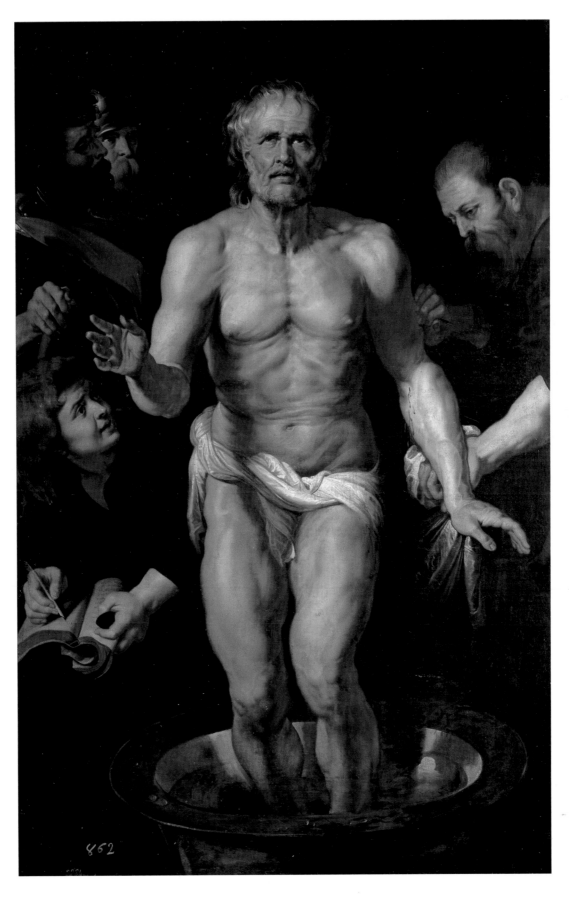

462

PETER PAUL RUBENS
The Death of Seneca, c. 1615
Oil on panel, 184 × 155 cm

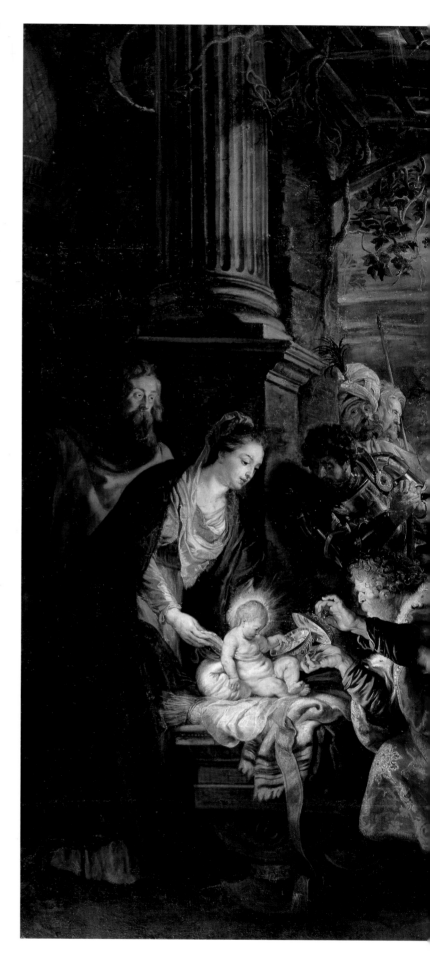

PETER PAUL RUBENS
The Adoration of the Magi, 1608 and 1628–1629
Oil on canvas, 346 × 438 cm

PORTRAIT OF MARIE DE MÉDICIS

This portrait of Marie de Médicis, painted around 1622, belonged to Rubens until his death, when it was acquired by Philip IV. Daughter of the grand duke of Tuscany, wife of Henry IV of France, and regent during the childhood of her son, Louis XIII, Marie de Médicis was a paramount patron of the arts in France. Before the French school eventually found its own identity, she had a great penchant for Flemish painters such as Frans Pourbus the Younger or Rubens, who in 1621 embarked on painting his immense cycle of exaltation and glory to adorn the Luxembourg Palace.

The portrait in the Prado has a schematic, unfinished feel to it, which does not, however, detract from its wholeness. It might have been a preparatory iconographic work for the Luxembourg series. The queen is shown dressed in mourning and is set against a neutral ground. The viewer's eye is drawn toward her face and nacreous hands, which are drenched with light amidst the blackness and void.

THE TRIUMPH OF THE CHURCH

This panel is one of the second group of sketches for the "Triumph of the Eucharist" tapestry series, which comprises twenty hangings that were commissioned by Isabella Clara Eugenia after her husband died; Rubens had completed them by 1628. The painter's characteristically fertile imagination has imbued the work with concepts and symbols joined in an ineffable synthesis of Baroque strength, dynamism, color, and meaning. Most conspicuous are those relating to the triumphant Church, with the most eloquent sermons preached in images. An architectural structure, designed for the site of the tapestries in the church of the Descalzas Reales in Madrid, figures here as frame for an imaginary tapestry held up by angels. The image portrays the triumph of the Church, which bears the Eucharist on a chariot drawn by white steeds; the wheels of the chariot are shown running over Heresy and dragging Ignorance and Blindness in chains. Conceptual imagination and the richness of color and form conspire to produce a brilliantly executed triumphal retinue.

THE GARDEN OF LOVE

Rubens often embarked on painting canvases that were to his own taste, which he then used to adorn his home. In these, he dealt with subjects related to his personal experiences and moods, which is the case for *The Garden of Love*. It was executed around 1630, at the height of his maturity and after he had married his second wife, Hélène Fourment, who was to be his constant source of inspiration and a consummate seller of these "intimate" pictures to the best contemporary collectors, at the forefront of whom was Philip IV.

Set in lush gardens with fountains, the antithesis of Rubens's own townhouse in Antwerp, a group of men and women engage in amorous dalliance accompanied by winged cupids. The real and the imaginary meet in the presence of the mature Rubens and his young wife who are among the couples. This canvas reveals the painter in his prime, with some masterful nuances of color.

A PEASANT DANCE

The setting for this painting, which is practically contemporary with *The Garden of Love,* is a broad rural landscape including trees and a villa with Palladian overtones. Several couples are shown whirling around gleefully to the sound of a pipe. Most are wearing peasant dress, although some women are clothed in bourgeois attire, while a number of men are half naked and have plant wreaths reminiscent of ancient times around their heads.

After concluding his diplomatic missions around Europe and marrying for the second time, Rubens is purported to have turned his attention to the earth — the countryside and rural life — painting scenes like this one, in addition to pure landscapes. The action and color denote a zest for life and pleasure in simple things. The subject may be merely a depiction of playfulness, but it might also have a deeper meaning with literary connotations derived from the artist's eminently humanistic background.

PETER PAUL RUBENS
Portrait of Marie de Médicis, c. 1622
Oil on canvas, 130 × 108 cm

413

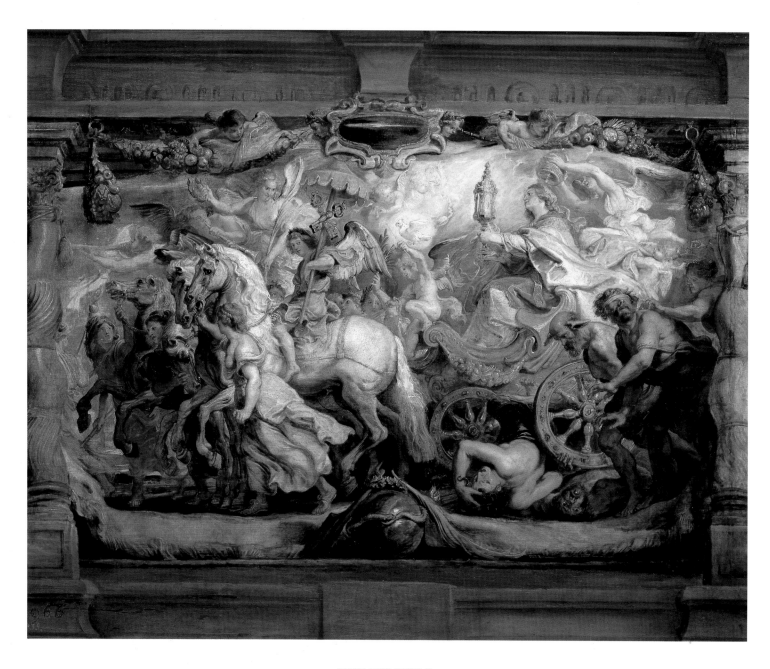

PETER PAUL RUBENS
The Triumph of the Church
Oil on panel, 86 × 106 cm

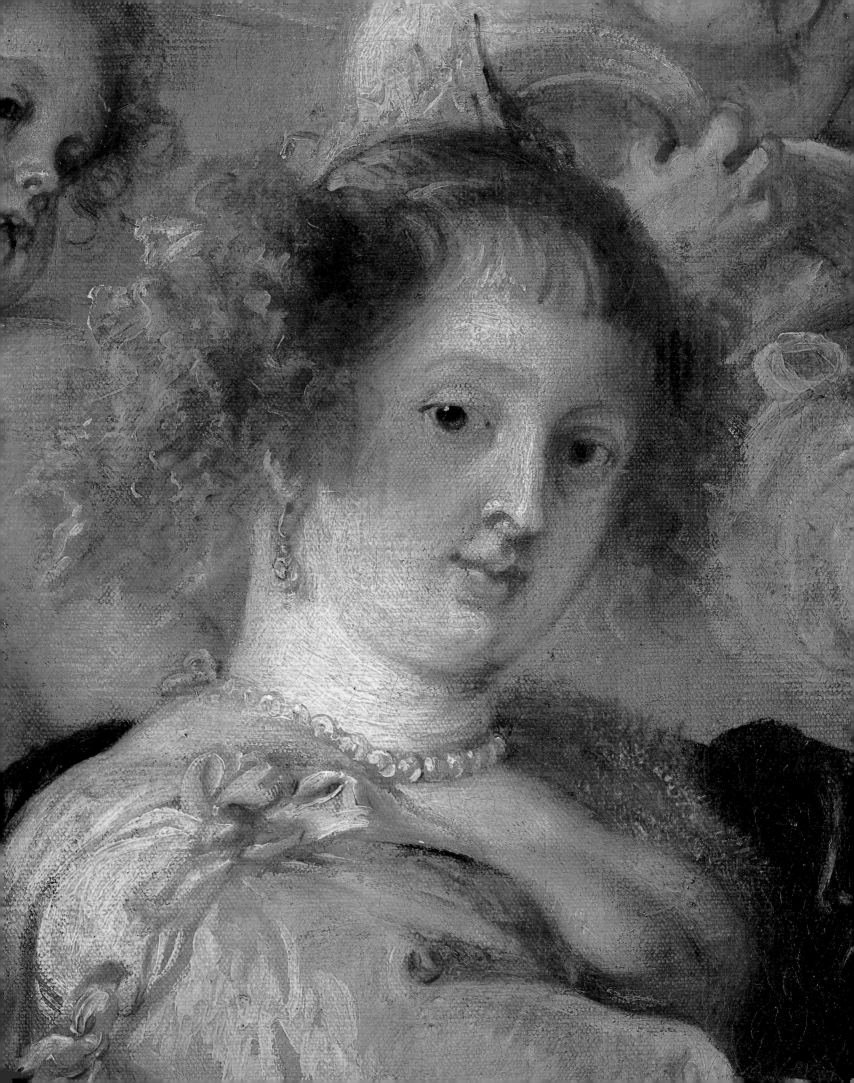

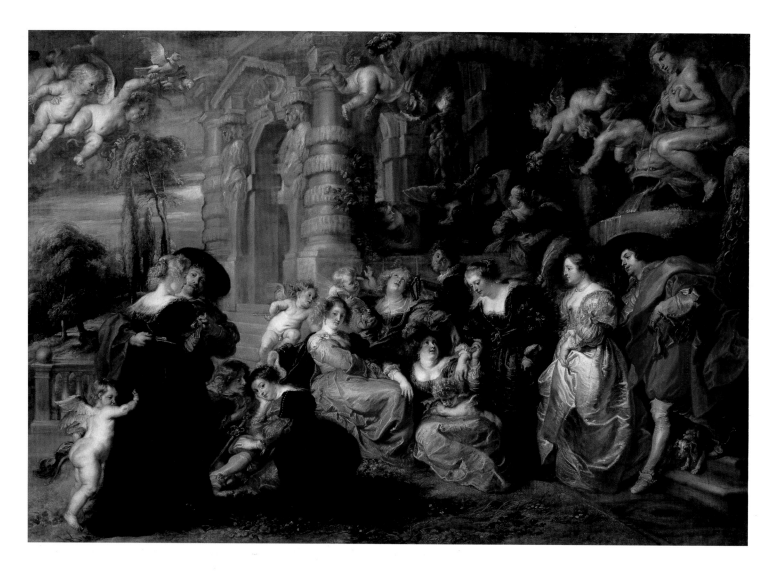

PETER PAUL RUBENS
The Garden of Love, c. 1630
Oil on canvas, 198 × 283 cm

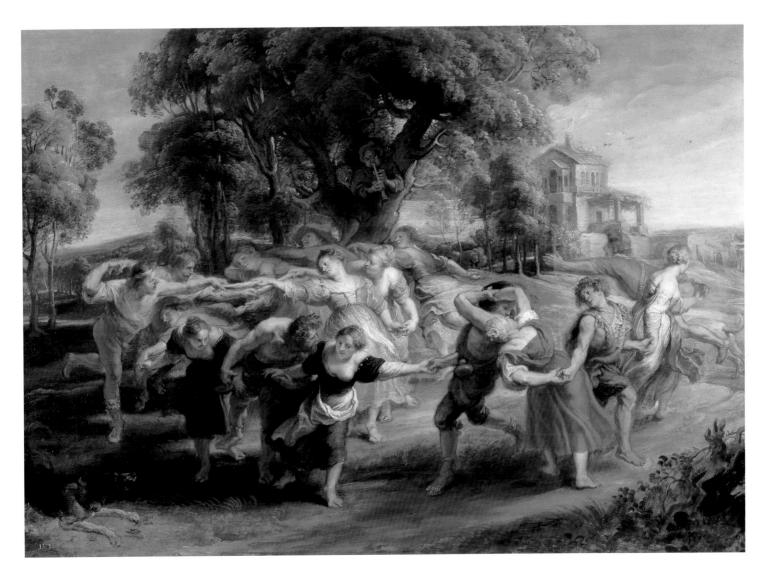

PETER PAUL RUBENS
A Peasant Dance
Oil on panel, 73 × 106 cm

THE THREE GRACES

Rubens was intensely active in his late period as a painter of mythological subjects, at times embarking on extensive literary cycles and at others on illustrating isolated episodes that invariably contained some moral or teaching.

The Three Graces is usually dated 1636–1638 and is very free in style. It displays highly sensuous, curvaceous, monumental nudes flooded with light, setting up gentle shading that envelops their voluptuous flesh. The luminosity is matched by the brightness and transparency of a beautiful landscape framed in the backlighting from the tree and the cool penumbra of the fountain.

Interpreted throughout the Renaissance by Botticelli and Raphael, in the hands of Rubens this classical theme of Zeus and Eurynome's daughters became a Baroque expression of vibrant, naked flesh rendered with delicate glazing.

DIANA AND HER NYMPHS SURPRISED BY SATYRS

This comes from a series of eighteen pictures that Philip IV commissioned Rubens and Frans Snyders to paint in 1638 on the dual theme of the Labors of Hercules and hunting scenes. All the sketches were completed by 1639 and the ensemble might have included contributions by collaborators who specialized in landscape and other complementary elements, although Rubens had the task of coordinating and harmonizing the work as a whole.

As part of the mythological commissions, the circumstances surrounding this work and its pictorial nature would assure it was executed by Rubens himself who, judging from the numerous rectifications, appears to have improvised considerably. The technique, too, is very free, with light but extensive impasting, the artist having drawn directly with brush and oil color and finished with small, vivifying touches of light, shadow, and highlights. Snyders is thought to have painted the wild animals and dogs, and Jan Wildens the landscape. Both assisted Rubens regularly in these late works, which Philip IV intended for decorating the Alcázar, the Buen Retiro, and the Torre de la Parada.

THE JUDGMENT OF PARIS

From 1636 to 1640, Rubens was commissioned by Philip IV to paint a number of mythological subjects, hunting scenes, and animal pictures, among which this canvas was included. It may be deduced from correspondence with the cardinal infante, that it was executed around 1639 and, in addition to the face of the naked Venus reminding him of Rubens's wife, Hélène Fourment, in his opinion the candid sensuality was too audacious.

The picture recounts the literary narrative of the shepherd, Paris, who is called upon to decide whether to give the apple of discord, held by Mercury, to the goddess judged the most beautiful — Minerva, Juno, or Venus. The theme is charged with moral significance: if he chooses Venus (love), he thereby slights Minerva (wisdom), or Juno (wealth), thus unleashing a flood of passion that leads to destruction.

In this late work, the luminous color washes over the naked bodies in long brush strokes with marked sensuousness and delicacy.

THE ABDUCTION OF GANYMEDE

In 1636, Philip IV commissioned Rubens to paint works inspired by Ovid's *Metamorphoses* for the Torre de la Parada. In view of the sheer magnitude of this assignment, the artist was assisted by a number of collaborators.

The Abduction of Ganymede is a companion work to *Saturn Devouring His Young*. The youth, Ganymede, is placed diagonally across the canvas, while Jupiter in the form of an eagle envelops his body with the spiraling motion of his wings and powerful head. Set against the blue sky, the dark plumage heightens the tonal qualities of the nude. The facture of this and other works by the master consists of broad, rough outlines and sweeping brush strokes that enhance the powerfulness of the figures, without the need to characterize secondary details.

This classical, heroic subject interpreted by Rubens also fascinated Rembrandt, although a comparison of their styles reveals the conceptual distance between Flanders and Holland.

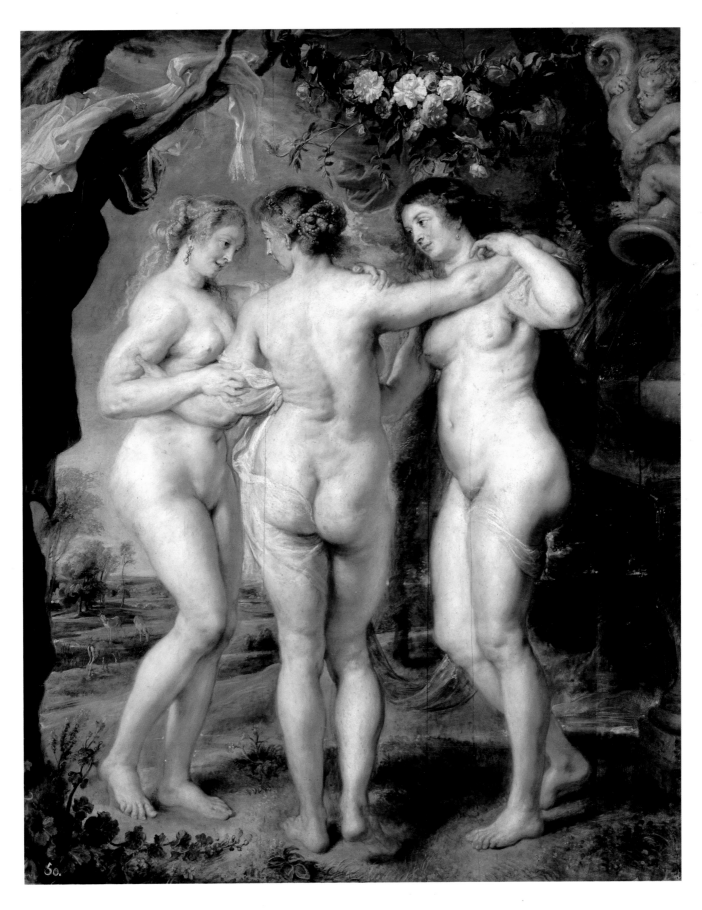

PETER PAUL RUBENS
The Three Graces, c. 1636–1638
Oil on canvas, 221 × 181 cm

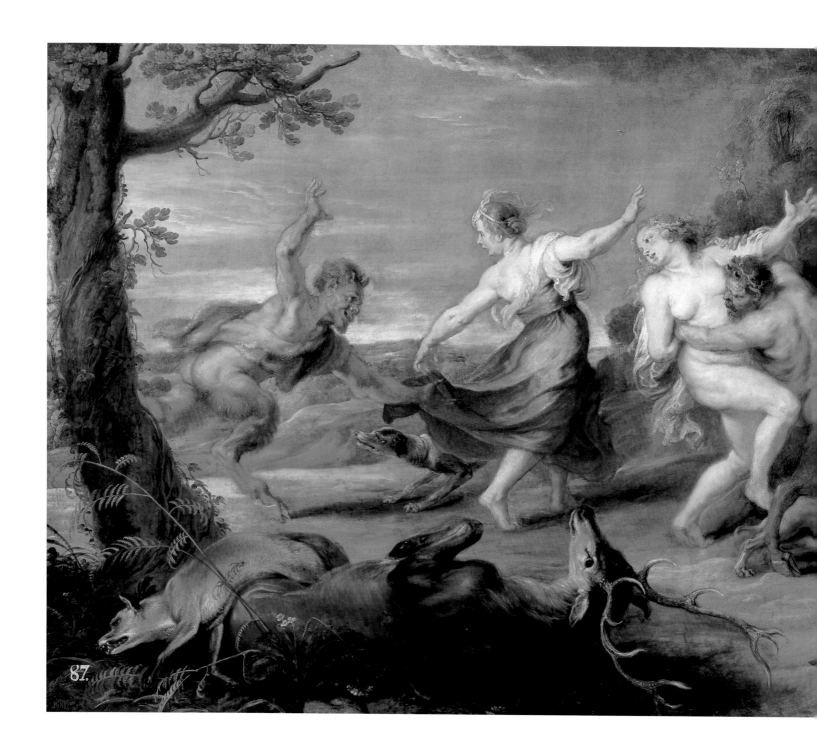

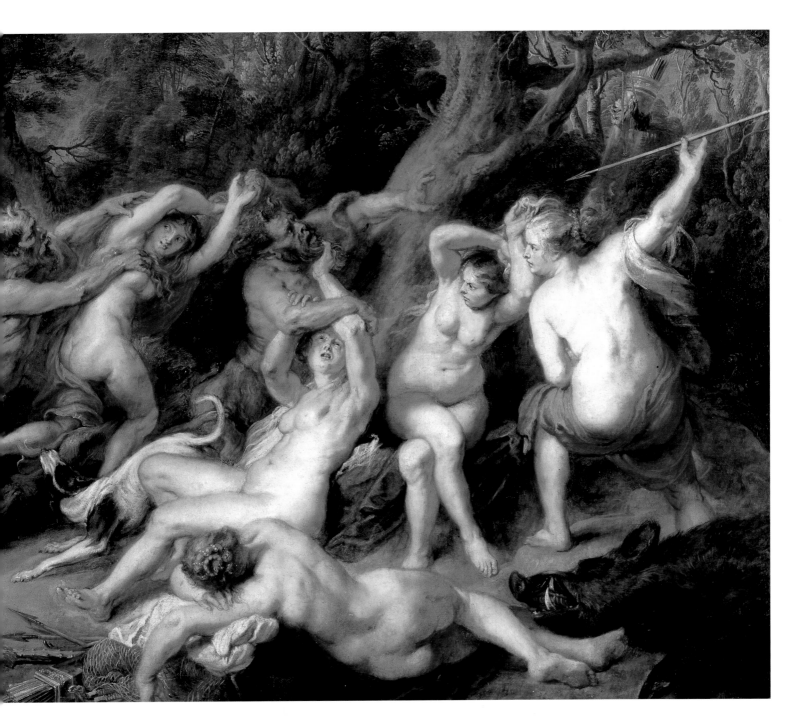

PETER PAUL RUBENS
Diana and Her Nymphs Surprised by Satyrs, c. 1639
Oil on canvas, 128 × 314 cm

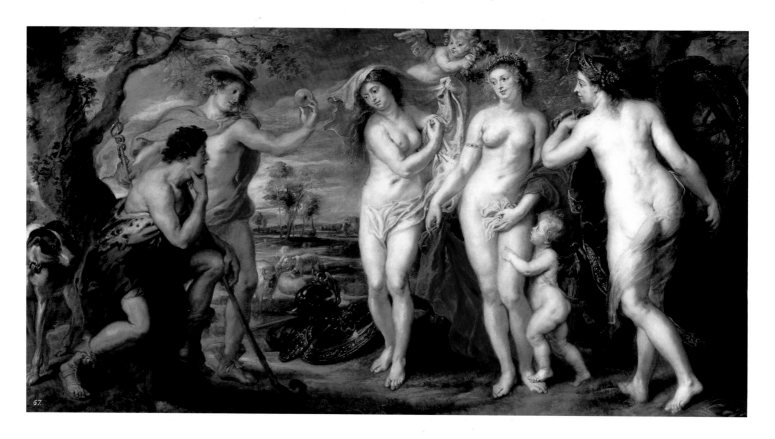

PETER PAUL RUBENS
The Judgment of Paris, c. 1639
Oil on canvas, 199 × 379 cm

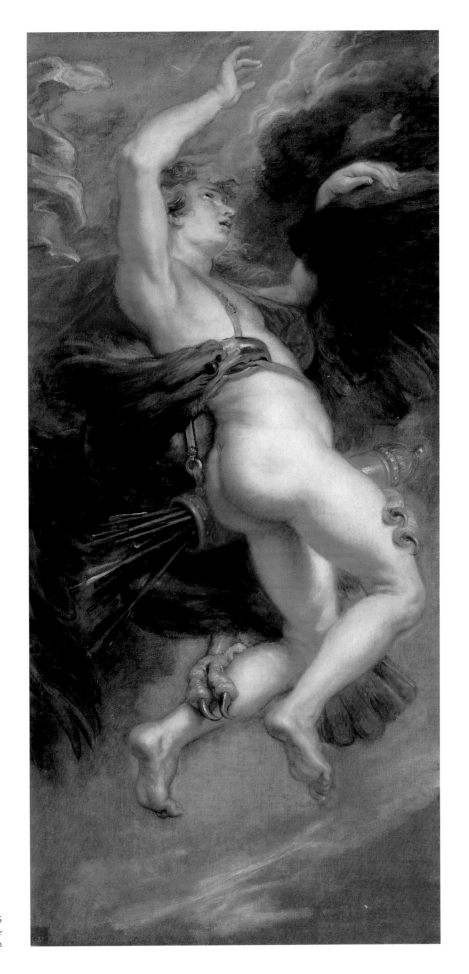

PETER PAUL RUBENS
The Abduction of Ganymede
Oil on canvas, 181 × 87 cm

CHRIST CROWNED WITH THORNS

This painting, executed around 1618 when van Dyck was eighteen years old, reveals the extraordinary skills of an artist who, together with Rubens, became the greatest exponent of quality and sensitivity in seventeenth-century Flemish painting. The composition parallels a work by Titian, revealing the large extent to which the great masters of the Flemish Baroque were interested in Venetian painting, a trend that became interwoven with the overwhelming power of Rubens's work. Compared to the oeuvre of his master, but still within the Baroque current of voluminous body forms, van Dyck's work shows a great deal of balance, serenity, and restrained emotion.

In this painting of Christ's ordeal, Jesus is depicted as long-suffering, surrounded by his tormentors, who are devoid of any overt expression of cruelty or brutality — only the dog appears enraged. The light focuses on the beautiful nude figure of Christ and lends vibrancy to the drapery, armor, color, and flowing outlines of the forms.

THE ARREST OF CHRIST

The intense emotional charge and the serenity of Christ in this masterly early work by van Dyck is comparable only to *Christ Crowned with Thorns*. The disturbed character of the figures thronging behind Judas shows the more turbulent, Rubensesque sensibilities coming through in the pupil. Together with *Christ Crowned with Thorns*, this painting was part of the older master's collection until his death, unquestionably a sign of his appreciation for van Dyck's technical and emotional mastery.

As with other works, van Dyck approached his composition with great care, executing preparatory drawings, sketches, and models and, once he had embarked on the finished work, he painted several versions in different formats and using different techniques. The version in the Prado is regarded as the primary work. Its composition and figure distribution, and the long, fluid brush strokes, heighten the expressive value of the canvas, while stark contrasts are set up by the forested background and torch lighting.

Like the previous work, this painting was acquired by Philip IV when Rubens's estate was auctioned.

THE PAINTER MARTEN RYCKAERT

Van Dyck's pictorial elegance and exquisite sensibilities led him to produce some of the most beautiful portraits of the seventeenth century, whether the sitters were Genoese aristocrats, Flemish burghers, or refined English gentlemen. His technical brilliance shines through in a wealth of portraiture characterized by rich garments, scintillating highlights, and palatial architecture. His illustrious contemporaries had their portraits painted in his famous *Iconography,* which included friends and professional colleagues such as Marten Ryckaert.

The sober setting for this portrait does not detract from the artist's skillful characterization of silks and furs and his searching depiction of human psychology. The frontal composition helps to stress the grandeur of this one-armed painter, who is portrayed with great dignity.

SELF-PORTRAIT WITH SIR ENDYMION PORTER

One of the soberest and most beautiful of van Dyck's portraits is this one in which he appears beside Sir Endymion Porter, purchaser of artworks to Charles I of England.

This self-portrait is imbued with the spirit that characterized van Dyck's production throughout the last decade of his sojourn in England. The atmosphere is charged with poetic allusion and, at once, both the exquisiteness and mundanity of aristocratic refinement. The two half-length figures, wearing contrasting black and silvery-gray suits, are set slightly diagonally against a crepuscular background.

The portrait was painted after 1632, the year in which van Dyck entered the court of London, where he painted primarily portraits and mythological scenes, his presence having a marked influence on the English school. As "the King's Painter," van Dyck successfully portrayed his subject through a light, fluid style based on the technical mastery of one of the great portraitists of the seventeenth century.

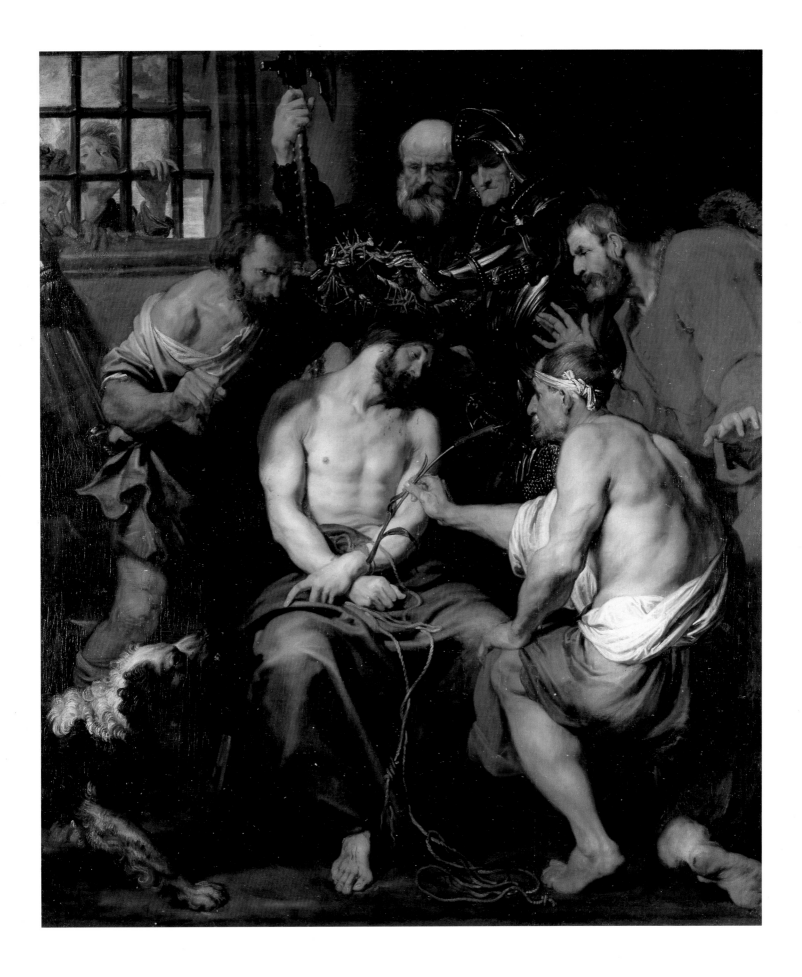

SIR ANTHONY VAN DYCK
The Arrest of Christ
Oil on canvas, 344 × 249 cm

SIR ANTHONY VAN DYCK
The Painter Marten Ryckaert, c. 1629–1631
Oil on panel, 148 × 113 cm

SIR ANTHONY
VAN DYCK
*Self-Portrait with Sir
Endymion Porter*
Oil on canvas, 119 × 144 cm

THE CARDINAL INFANTE, FERDINAND OF AUSTRIA

Despite the comparatively late date of execution, this portrait of Ferdinand of Austria corresponds to the most traditional court portrait as epitomized in works by Pourbus, which were wholly alien to the models created by Rubens and van Dyck.

Ferdinand of Austria was Philip IV's brother and succeeded their aunt as governor of the Low Countries in 1633 after his victory at the Battle of Nördlingen. His triumphal reception in Antwerp was one of the most sumptuous pageants in the Baroque.

As against Rubens's portrait of the victorious cardinal infante on a prancing steed in the heat of battle, Crayer's presents the image of a statesman with conventional expressions of power — the table, drapery, and the figure's sober bearing.

Crayer was noted for his portraits and monumental religious works, which he executed with free, broad brush strokes and pleasant, bright coloring.

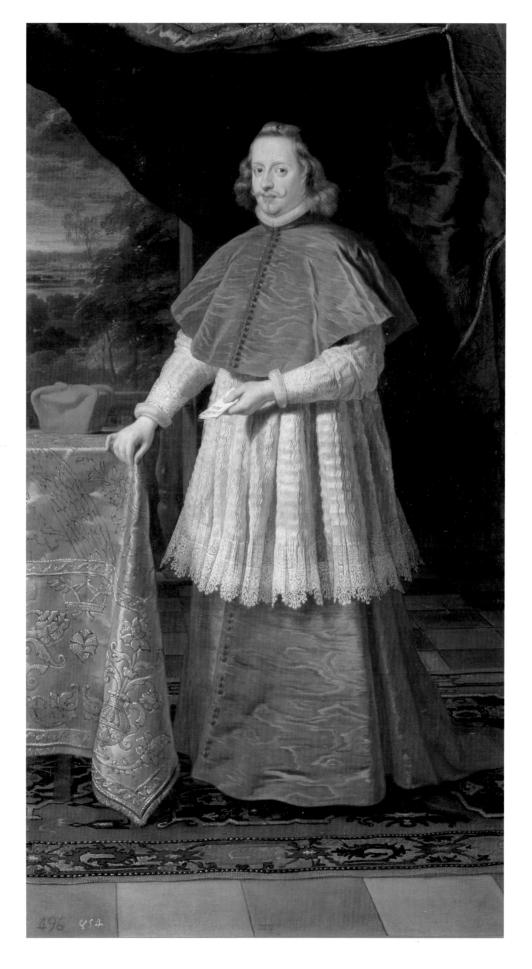

GASPAR DE CRAYER (1584–1669)
The Cardinal Infante,
Ferdinand of Austria, 1639
Oil on canvas, 219 × 125 cm

THE ARTIST AND HIS FAMILY IN A GARDEN

AN OFFERING TO CERES

PIETÀ

This family portrait, painted by Jordaens around 1621, attests to his skills as a portraitist. However, he devoted little time to this genre, as he preferred to create historical and mythological paintings. He admitted that his Protestant faith had facilitated his career in Holland in the mid-seventeenth century when, after the death of Rubens, he had become the leading painter in Antwerp.

To some extent this portrait depicts the well-to-do, bourgeois Flemish ambience of the time — the group features Catalina van Noort and her daughter Elizabeth, a maid wearing an apron and holding a basket of fruit, and the artist holding a lute, with a dog standing behind him — all symbols of harmony and fidelity. The composition exudes balance and security, and the volumes, drawn with a firm brush stroke, are lit by side lighting that falls upon the wife from the front and accentuates the girl's lively expression. The monumentality of the work is heightened by the low viewpoint and plenary composition.

One of the hallmarks of Jordaens's work is his rustic genre characters that, commensurate with his Protestant leanings, imbue his historical paintings. Whether depicting religious or mythological scenes, his figures are markedly peasant, alien to the court rhetoric and literary erudition that informed the oeuvre of Rubens. In Jordaens, events from classical mythology become scenes of peasant life, as demonstrated in this work dated 1620–1625.

The low vantage point reinforces the verticality of the figure of Ceres, a "living statue" on a pedestal surrounded by animals, old country men, rosy peasant women, and children — all ages in the cycle of life paying homage to the goddess of fertility. A certain Caravaggesque air has been noted, more for the affinity in the genre types than for the structure of the painting. The bright coloring and luminosity of the work make it clearly Flemish.

Jordaens did not customarily render evangelical subjects in such monumental terms, as he was more given to an aesthetic of genre types.

This canvas came to the Prado from the church of San Alberto in Seville in 1981 and is thought to have been executed in the period 1650–1660, making it a late work. The artist has, nonetheless, retained his human models, particularly for the female figures; in his maturity, however, his technical handling acquired lighter hues and the contrasts of light softened.

The composition is set in two planes — the foreground comprises a triangular setting, which is enhanced by the rectangular layout of the background structured by the verticals of St. John and the shaft of the cross. The solemn monumentality is heightened by the lively coloring of large masses and the silhouetted figures.

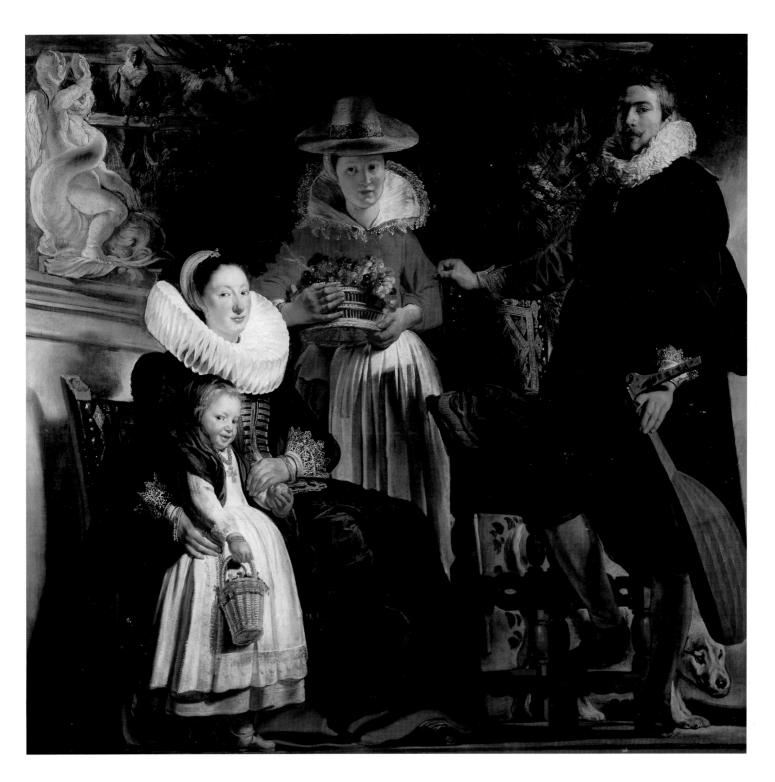

JACOB JORDAENS (1593–1678)
The Artist and His Family in a Garden, c. 1621
Oil on canvas, 181 × 187 cm

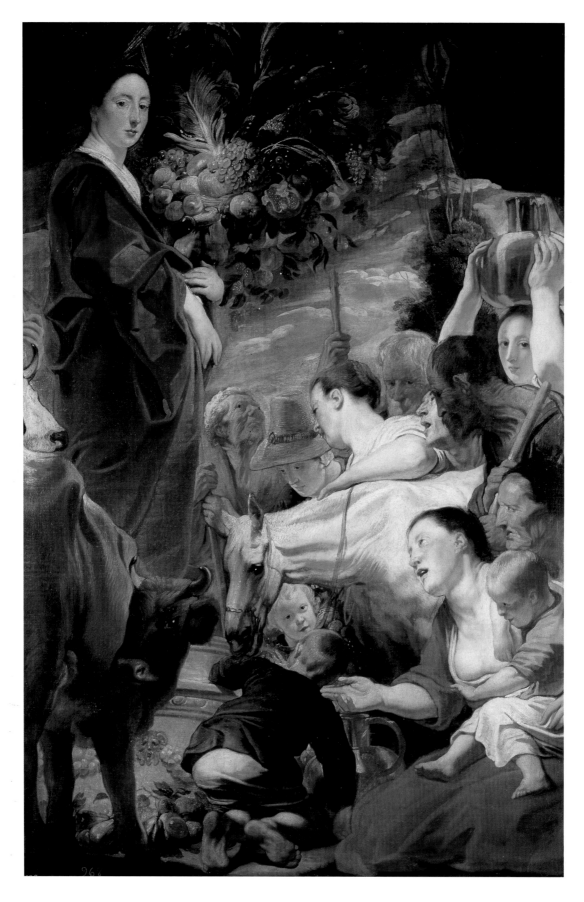

JACOB JORDAENS
An Offering to Ceres
Oil on canvas, 165 × 112 cm

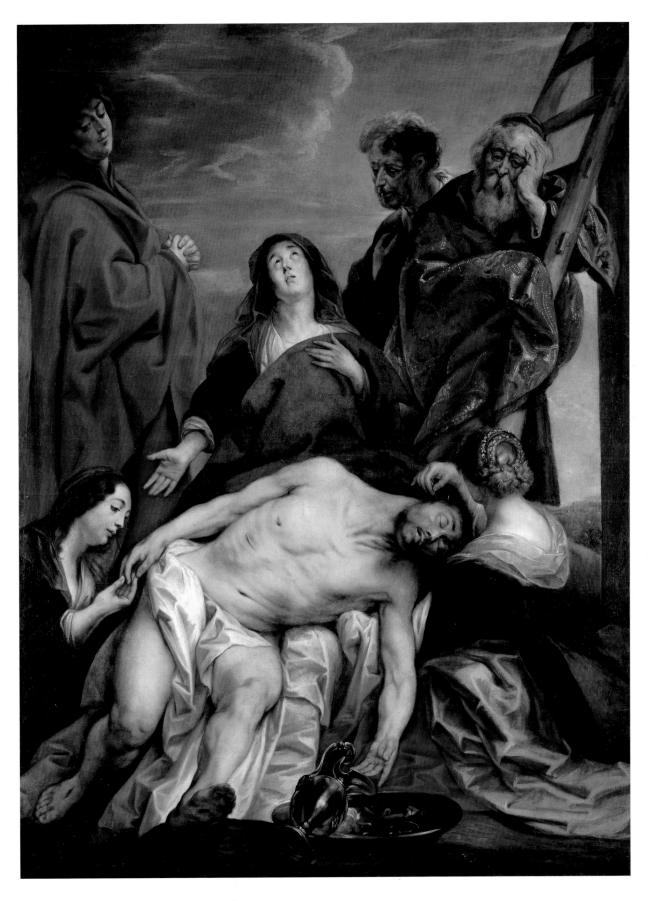

JACOB JORDAENS
Pietà
Oil on canvas, 221 × 169 cm

FRANS SNYDERS (1579–1657) and PETER PAUL RUBENS
Philomenes Recognized by the Old Woman, c. 1610
Oil on canvas, 201 × 311 cm

PHILOMENES RECOGNIZED BY THE OLD WOMAN

The subject, drawn from Plutarch, was the pretext for what has proved to be one of the most exuberant still lifes of the seventeenth century. Executed around 1610 by Rubens and Snyders, it was based on a sketch by the former. The overall design responds to the late-sixteenth-century models of Bueckelaer and Aertsen — large, lavish groups of game, fruit, and vegetables that tend to dwarf the figures central to the subject, resulting in the incidental taking pride of place over the substantial in the composition. Snyders's illusionistic still life takes on a truly Baroque guise through the marked diagonal of the white goose with its outstretched wings and the peacock's tail. Each of the various types of plumage was assigned a distinctive character, a trait echoed in the fruit and vegetables. The monumental figures, with tenebrist lighting, were executed by Rubens.

FRANS SNYDERS
Concert of Birds
Oil on canvas, 98 × 137 cm

CONCERT OF BIRDS

This ensemble of rather arbitrarily grouped birds, each of which is striking for its beautiful plumage or song, was regarded as an example of "animal antics" in the seventeenth century. In keeping with the prevailing trend of various painters specializing in different parts of a picture, the tree silhouetted against the background glow of a landscape — with its low horizon, which accentuates the "aerial" character of the subject — was executed by Jan Wildens. Snyders completed the rest of what is fundamentally a decorative work in which the naturalistic sense in the characterization of parrots, hoopoes, goldfinches, and swallows is not out of place with the playful quality of the owl with its open musical score.

By 1630, when Snyders painted this work, his style had evolved into one that was elegant and decorative, with bright coloring, light facture, and the realistic rendering of animals and surface textures, as seen in the staves of the musical score.

PAUL DE VOS (c. 1592/95–1678)
Cats Fighting in a Pantry
Oil on canvas, 116 × 172 cm

CATS FIGHTING IN A PANTRY

The variety found in seventeenth-century Flemish still lifes is regarded as being due, in part, to the taste of such Spanish clients as the archdukes or the marquis of Leganés, who were prolific collectors of this genre.

Paul de Vos was Frans Snyders's brother-in-law and their styles were similar. They were highly skilled at animal scenes set in pantries or cellars in which the animals are shown in the heat of action, devouring meat or fighting over some morsel.

This painting features fighting cats, shown leaping from a window onto a kitchen table replete with fish, poultry, and vegetables that obviously had been neatly laid out until a short while before. The live animals and their action are clearly distinguished from the lifeless objects, despite the colorful depiction of the latter. The delicate brush strokes enhance the sober, almost monochromatic color scheme.

GARLAND OF FLOWERS, WITH THE
VIRGIN AND CHILD

The flower paintings that
characterized Seghers's work in the
last three decades of the seventeenth
century reveal the technique he
learned in the workshop of Velvet
Brueghel. His floral garlands usually
festoon an oval cartouche containing
some religious image, and the artist
achieved great skill in his accurate
drawing, deep, bright colors, and
exquisite details, such as tiny insects
dotting a garland.

The inset devotional figures,
customarily a Madonna and Child,
were executed by such figure-
painting specialists as Erasmus
Quellinus, Thomas Willeboirts or, as
in this instance, Cornelis Schut the
Elder. The decorative and devotional
tone dominate these painstakingly
executed works, in which the artist
explores the naturalistic depths of the
flowers and figures, while at times
choosing to adorn a stone relief.

DANIEL SEGHERS (1590–1661)
Garland of Flowers, with the Virgin and Child
Oil on canvas, 86 × 62 cm

ALEXANDER ADRIAENSSEN (1587–1661)
Still Life with Fish, Oysters, and a Cat
Oil on panel, 60 × 91 cm

STILL LIFE WITH FISH, OYSTERS, AND A CAT

Adriaenssen remains a rather enigmatic figure: he is known to have embarked on his painting career by 1610, when he joined the guild, but no known works from his hand are dated prior to two decades later.

Although he worked on decorative commissions for the cardinal infante's spectacular entry into Antwerp in 1638 (when he was associated with the Rubens school), his still lifes distinguish him as an artist of extraordinary quietude and repose, as in this work, in which the objects are well distributed on the table, which is dominated by one that is accorded a preeminent position. The composition is uniformly lit by a cold light that heightens the silvery-white and salmon tones of the fish. The rather archaic, painstaking execution on panel reveals the artist's training in the Mannerist tradition and his solid technical prowess.

The four still lifes in the Prado come from the collection of the marquis of Leganés, who gave them to Philip IV.

THEODOOR ROMBOUTS (1597–1637)
The Tooth-puller, c. 1627–1628
Oil on canvas, 119 × 221 cm

THE TOOTH-PULLER

Caravaggio had a marked influence on the Dutch and Flemish artists who visited Rome in the first few decades of the seventeenth century. His innovative style struck a chord with these young bohemians, who brought their great technical skills into play while adapting his models, which they infused with their own peculiar critical, ironical, and moral sense.

Rombouts, for instance, resided in Rome from 1618 to 1625. Without having seen Caravaggio's work firsthand, he successfully re-created superficial aspects of the latter's style, including the horizontal formats, half-length figures, genre characters, accurate drawing, flat impasto, and material characterization of objects within a tenebrist setting, using side lighting to invigorate the powerful body forms that emerge from the dark grounds.

This painting is dated 1627–1628. After the painter's return to Antwerp, he continued to apply the style he learned in Italy, which is in blatant contrast to that of Rubens and his school.

This exceptionally large canvas of a cellar or pantry crammed with fruit, vegetables, dead poultry, shellfish, and game is offset by live parrots and a monkey in the top left-hand corner. The table is swamped by the overwhelming array of fruits of the earth that is displayed in a composition designed in a purely decorative fashion.

For what may well be his major work, van Utrecht opted for a dark ground, with architectural forms only intimated in order to convey the disorder involved in hoarding so many articles. The artist has used a limited palette that is dominated by reds, with a range of nuances in the dark browns, grays, and greens, to achieve an expressive ambience by means of a light touch, subdued lighting, and vivifying highlights. The polished technique and drawing is characteristic of van Utrecht and it sets him slightly apart from the followers of Rubens.

ADRIAEN VAN UTRECHT (1599–1652)
A Pantry, 1642
Oil on canvas, 221 × 307 cm

THE GALLERY OF ARCHDUKE LEOPOLD WILHELM

Gallery paintings designed to reproduce the collections of certain aristocrats down to the finest detail became a genre of their own in seventeenth-century Flemish art. This one shows the gallery of Archduke Leopold Wilhelm, which, at one time, comprised over fourteen hundred works. It would later form the main corpus of artworks at the Vienna Kunsthistorisches Museum.

The archduke, some of his friends, and David Teniers, his court painter, are depicted here, all dwarfed in the forced perspective of a small though representative part of the collection. The wealth of paintings enables us to draw some conclusions regarding the development of seventeenth-century Flemish art: in evidence are works by Giorgione, Titian, Veronese, and Palma Vecchio, among others and, in homage to the great Flemish masters, pictures by Rubens and van Dyck are seen next to the figures.

SMOKERS AND DRINKERS

Of the more than fifty works by Teniers in the Prado, six appear to embody moral teachings exemplified by monkeys dressed up as painters or sculptors, going to school or sitting around a table. This picture is set in a tavern, with the animals shown seated around a table, filling a jug, sleeping, and serving food. It is a critical parody of human actions with monkeys used to symbolize human passion and debauchery of any kind.

Teniers was one of many painters who worked in this genre in the seventeenth century; his paintings are usually small panels with light facture, diluted impasto, and quick drawing, although they are executed with commendable freedom and control. Foremost is the narrow range of dark browns and grays, which is livened up by the colorful highlights on the cap feathers.

This was among the works in Charles IV's collection that completes the series donated by Isabella Farnese.

FÊTE CHAMPÊTRE

Teniers the Younger was a highly regarded genre painter in his time, his oeuvre being perpetuated through engravings and prints used in Spanish tapestry factories in the eighteenth century for hangings commissioned for the royal residences. This painting is typical of the works he produced in Brussels from 1651 onward and its subject links up with the tradition of Pieter Bruegel the Elder.

In contrast to satirical depictions of common folk, however, Teniers presents a more charitable, humane countenance of country life, with a hint of the idyllic in his mixing of characters from the nobility, well-to-do bourgeoisie, and peasants, all dancing, drinking, and smoking together. These scenes are a paean to peaceful coexistence and social harmony rooted in kindness and joyfulness, as expressed here in the party held on the outskirts of Brussels with Ste. Gudule glimpsed in the background.

DAVID TENIERS THE YOUNGER (1610–1690)
The Gallery of Archduke Leopold Wilhelm, c. 1650–1651
Oil on copper, 106 × 129 cm

DAVID TENIERS THE YOUNGER
Smokers and Drinkers
Oil on panel, 21 × 30 cm

DAVID TENIERS THE YOUNGER
Fête Champêtre
Oil on copper, 69 × 86 cm

JOHANNES FYT (1611–1661)
Still Life with Dog, 1649
Oil on canvas, 72 × 121 cm

STILL LIFE WITH DOG

Fyt trained with Frans Snyders as an animalier and still life painter and, after traveling in France and Italy, he developed a more personal style in his maturity. Snyders's influence does show through in his work, but Fyt's pictorial sense and technique gradually became more serene, characterized by a quiet repose in his depiction of live animals and a compact composition in his execution of still lifes. His taut, accurate brush stroke successfully renders the textures of skins, plumage, and drapery, while tree groves reveal the use of brush strokes pointing in all directions. The chromatic uniformity of delicate green and gray tones is broken by the warmer colors used to give greater prominence to the dead game.

Most of the works by Fyt in the Prado were acquired as a result of Isabella Farnese's interest in the minor Flemish and Dutch painters.

JAN VAN KESSEL THE YOUNGER (1654–1708)
Portrait of a Family in a Garden, 1680
Oil on canvas, 127 × 167 cm

PORTRAIT OF A FAMILY IN A GARDEN

Of the numerous painters of Flemish origin who were resident in Madrid in the second half of the seventeenth century, Jan van Kessel the Younger seems to have enjoyed the greatest prestige and fame in court and palace circles. Although active for over thirty years, his only surviving works appear to be this one and a replica dated 1679 housed in the Naradowe Museum in Warsaw. This is one of the most complex and suggestive portraits set in contemporary Madrid. It was this painter who introduced the innovative group portrait, traditionally from northern Europe, to that city.

Palomino points out that the figures depicted were the family van Kessel first stayed with in Madrid. The types seem more Mediterranean than Flemish, and the fact that the painter appears in a self-portrait looking out of a window would suggest he was on close terms with them. While the setting is not imaginary — and the architecture bears this out — the country home, with its garden, fountain, and marble statues, is not mentioned in the records.

MATTHIAS STOMER (c. 1600–c. 1650)
The Doubting Thomas
Oil on canvas, 125 × 99 cm

THE DOUBTING THOMAS

Stomer was one of the Dutch painters who, in the second and third decade of the seventeenth century, adopted the tenebrist style of Caravaggio's Italian followers and cultivated a monumental form of religious painting. Their activity centered around Gerrit van Honthorst and the Catholic city of Utrecht. Stomer may have been a pupil of Honthorst's; in 1630 he was in Rome, and he worked in Naples, where he came under the influence of Ribera. He was active in Sicily until 1650, which is probably how most of his works now in Spain came to that country's collections.

The Doubting Thomas is characteristic of the artist's late period, with tenebrist lighting, firm drawing, and strong volumes; nuance is enhanced by direct light, and the taut, flat surfaces common to the Northern Caravaggisti are in evidence as well. The painting thus acquires a sculptural consistency modeled by gentle lighting that helps to pull the foreground away from the background in powerful relief.

LEONAERT BRAMER (1596–1674)
Abraham and the Three Angels
Oil on panel, 47 × 74 cm

ABRAHAM AND THE THREE ANGELS

Bramer trained in Delft and traveled in France and Italy beginning in 1614 and arriving in Rome in 1618. For some years his style was marked by a penchant for lighting effects on a variety of objects, trees, figures, and architecture. On his return to Holland around 1625, his lighting aroused interest and prefigured similar effects developed by Rembrandt.

The teachings of French painters such as Vignon and Monsú Desiderius, the Flemish Paul Bril and Adam Elsheimer, and the Italian Tetti contributed to Bramer's shaping of a highly personal style that was based on architectural settings with tiny figures. In these, the whole surface is rendered vibrant and scintillating by means of use of a heavy impasto; areas with prominent highlights and light, subtle touches configure a surface that resembles bright lace.

The scene at hand features an idealized reconstruction of Roman ruins, a subject that fascinated Northern painters.

ROMAN CARNIVAL

Miel belonged to a group of painters who were born and trained in the Low Countries and subsequently traveled to Rome, where their aesthetic development came under Italian pictorial influences. They painted mainly genre scenes or pictures of street life. Miel arrived in Rome around 1636 and, although he collaborated with Andrea Sacchi on works for the Barberini family, his own style is more akin to the genre scenes of Pieter van Laer and the Bamboccianti, painting primarily realistic portrayals of picturesque subjects, brigands, and satirical — or simply burlesque — characters.

This canvas is set against a background of classical ruins. At center is a cart drawn by oxen, attended by masked men and women, noteworthy being the colorful trio dressed up as guards. Caravaggesque influence is seen in the stark contrasts between light and shadow, while the only Flemish trait is the strong, realistic depiction of characters. It once belonged to Philip V, and is registered in his inventory in 1745.

JAN MIEL (1599–1663)
Roman Carnival, 1653
Oil on canvas, 68 × 50 cm

HERMAN VAN SWANEVELT (c. 1600–1655)
Landscape with St. Bruno
Oil on canvas, 158 × 232 cm

LANDSCAPE WITH ST. BRUNO

Though van Swanevelt was of Dutch origin, in 1624 he was in Rome, where he lived with Claude Lorrain. He subsequently traveled to Paris and died there in 1641. His early training was in Northern landscape but his painting gradually became more monumental in conceptualization, and by the 1630s he had acquired his most characteristic style through the influence of Claude.

This landscape is part of a series known as the "Hermits," which was commissioned in Rome in 1638–1640 by the marquis of Castel Rodrigo, Philip IV's ambassador to the Holy See, for some chambers in the Buen Retiro Palace. Other artists who collaborated included leading landscape painters such as Claude, Poussin, J. Both, and G. Dughet.

Van Swanevelt's concept of landscape springs from a combination of influences — the horizontal structure, clearly defined by the garden fence, the distance framed by the rocks of a half-hidden valley, and the few, intense tenebrist touches are insignificant in comparison to the gentle twilight, which reveals the influence of Claude.

ARTEMISIA

This outstanding canvas is one of the few Dutch paintings in the Prado. Dated 1634, it is among Rembrandt's early masterpieces.

The great variety in this work — apart from the ostentatious bourgeois sensibilities it reflects and the intimate, pensive nuances — is achieved solely through light. The voluptuous, monumental figure of Artemisia is molded by lighting reminiscent of the Northern tenebrists, although without their stark division between figure and background. Rembrandt uses light to create volume, but his figures are shrouded in a hazy aura in which outlines merge into the background.

Artemisia is shown as she is about to drink the dissolved ashes of her deceased husband, which leads to an interpretation of this painting as a hymn to marital love and fidelity. This is borne out by the fact that the canvas was painted in the year the artist married Saskia van Uylenburch.

The acquisition of this work from the estate of the marquis of La Ensenada in 1769 was one of Charles III's few concessions to art collecting.

REMBRANDT HARMENSZ VAN RIJN (1606–1669)
Artemisia, 1634
Oil on canvas, 142 × 153 cm

STILL LIFE

Together with Willem Claesz Heda, Pieter Claesz was the leading still life painter in the Haarlem school and one of the genre's defining exponents. His classical depictions are based on ordered compositions, accurate portrayal, and gentle lighting.

This still life is a mature work characteristic of Claesz: placed on a table with a runner are a number of glass and metal objects arranged along the diagonal of the composition. They are things typically found in a wealthy Dutch middle-class household and include delicate, blown-glass cups, a gilt fruitbowl, dishes, and a knife, all sharply outlined against a light gray-green background. The highlights on the glassware, silverware, and pewter, their liquid contents, and the freshness of the lemon, are allusions to the comfortable lifestyle of the well-off Dutch middle classes and the strict moral code by which they lived.

This panel was bequeathed to the Prado in 1930 by the Fernández-Durán estate.

PIETER CLAESZ (1598–1660)
Still Life, 1637
Oil on panel, 83 × 66 cm

THE PHILOSOPHER

Highly representative of the atmosphere created by the success of Rembrandt's work, this problematic painting depicts an old man inside a quasi-monastic building. He is shown seated, writing, surrounded by books and papers, as though he has just paused in order to meditate. The presence of the crucifix with the skull and clock point to three elements inherent in the human condition: the passage of time, life's end, and salvation — in short, death. The penetrating gaze directed at the viewer helps to universalize the message.

Although the painting bears a monogram and a date, which led it to be ascribed to Salomon Koninck (1609–1656), it has more recently been attributed to a follower of his, van der Hecken, who was active from 1635 to 1655 in Amsterdam and the Hague, and who adhered to his master's style. It was acquired by the Prado in 1953.

ABRAHAM VAN DER HECKEN (active 1635–1655)
The Philosopher, 1635
Oil on panel, 71 × 54 cm

JAN DAVISZ DE HEEM (1606–1684)
Still Life
Oil on panel, 49 × 64 cm

STILL LIFE

This example of seventeenth-century Dutch still life is entirely Baroque in its external form, its painter having dispensed with symbolism and moral or religious considerations.

De Heem worked in Utrecht and was noted for his decorative forms and structures created by use of dense composition and bright coloring. Curtains have seldom been portrayed with such theatrical opulence as in this panel; the disarray on the table, with the fruit bowl lying on its side, is uncharacteristic of Dutch orderliness.

De Heem also worked in Antwerp, where he picked up influences that differentiate his work from his Dutch contemporaries. His realistic depiction of objects reveals faithfulness to his Northern training, and his formal development was achieved through drawing and an individual style based on color and a plasticity of volumes.

Wouwermans is the best-represented of Dutch painters in the Prado Museum, thanks to Isabella Farnese's purchases for the palace of La Granja. He was highly successful in combining the Dutch and Italian approach to landscape, which he generally used as the backdrop to military scenes, cavalry skirmishes, assaults, soldiers, and hunting parties.

This painting shows soldiers leaving an inn at daybreak. The penumbra of the large, hay-filled stable contrasts with the dawn light, as do the careful preparations for departure with the attitude of the stablehands claiming their gratuity.

Such everyday scenes distinguish Wouwermans as one of the most representative painters of his time. His style later became more epic and serene, with small human or animal figures set in vast landscapes, invariably painted on small panels.

PHILIPS WOUWERMANS (1619–1668)
Scene Outside an Inn
Oil on panel, 37 × 47 cm

PIETER VAN STEENWIJCK (active 1632–1654)
Vanitas
Oil on panel, 34 × 46 cm

VANITAS

Although little is known about this painter, active in Leiden and the Hague in the second third of the seventeenth century, and despite few works of his having come to light, in this *vanitas,* or collection of objects depicting the transience of earthly pleasures, van Steenwijck is perfectly in tune with Protestant sensibilities — restrained pleasure, comfortable living, and measured action within the framework of human conscience.

A number of symbolic objects are placed on a table covered with a dark runner, set against a dark brown, monochrome ground lightened by the diagonal of the illumination, with the ensemble forming a compact volume. The objects form a somewhat pyramidal arrangement, with the skull, symbol of death, starkly prevalent. Surrounding it is a snuffed candle and a suitcase, both alluding to the end of life and a journey in the afterlife. The books, lute, flute, pipe, tobacco, and food are pleasures vanquished by death.

This was one of the masterpieces in Charles IV's collection.

DEAD COCK

Metsu is not usually associated with still life and animal subjects, but the intrinsic quality of this painting makes it one of his most outstanding works. It could not be simpler — the white plumage and red comb of a cock stand out vividly from a dark background, the bird hanging from a string fixed with a nail.

The brilliance of this panel lies in the way the animal is vivified by delicate touches, each of its feathers carefully depicted in naturalistic detail. The head, however, rests in dislocated, inert fashion on the tabletop. The ensemble is uniformly lit by gentle lighting, but the flurry of white emerges powerfully from the background.

This is among Metsu's exceptional works, one that also reveals the aesthetic leanings of the Leiden school and some of its prime exponents, such as Gerard Dou and Frans van Mieris. Metsu produced a number of purely anecdotal genre scenes and in his mature period was influenced by the work and subjects of Vermeer.

GABRIEL METSU (1629–1667)
Dead Cock
Oil on panel, 57 × 40 cm

THE GERMAN SCHOOL

E nrique Lafuente Ferrari, in his extensive work entitled *La pintura nórdica en El Prado* (Northern Painting in the Prado), published in 1977, states that the 1920 Museum catalogue, the last one in which paintings were grouped according to school, ascribes forty paintings to the German school. Consuelo Luca de Tena and Manuela Mena's 1980 guide to the Prado raises the figure to forty-seven. The present work, however, must draw attention to the dearth of German paintings in the Museum, particularly in view of the fact that twenty-four works — accounting for a full half of the German collection — are attributed to a single, eighteenth-century painter, Anton Raphael Mengs. This is regrettable and unusual, in that Spain had close historical and dynastic ties to the Germanic countries, particularly during the Habsburg dynasty.

The fact remains that the Crown's acquisition of artworks to decorate the royal residences was based on prevailing official taste, and the monarchs of the time had a special penchant for Italian and Flemish works. This trend was first evident at the time of the Catholic kings and it lasted into the sixteenth and seventeenth centuries. It was set not only by monarchs and aristocrats, but by artists themselves, and was largely determined by Spain's belonging to the same sphere of Roman Catholic countries as Italy and Flanders, where great, internationally influential, and highly personalized art schools had developed. In the German empire, however, which was feudally articulated by a number of prosperous cities and towns, many of which came under the influence of Protestantism, the initially promising development of art was subsequently checked by religious wars. With the exception of those of Dürer, this prevented artistic achievements from crossing borders.

In the fifteenth century, Flemish aesthetics held sway in several Germanic regions, while the incipient influence of the Italian Renaissance was staunched by internal strife. This allowed for individual genius alone to be developed, a trend paralleled by the situation in Spain. Thus, within the European milieu, German painting was highly personalized, characterized by the marked expressionistic and dramatic senses that are constants in Germanic art. Italy influenced Germany through its humanism and a return to antiquity but, while Germany accepted such currents, it retained its strong character and personality. For example, mythological subjects and the nude are frequently found in Germanic painting, but the figures have become "Germanized" in spirit and form. The works of Cranach exemplify this duality — receptivity paired with resistance. Mischievous dolls, Aphrodite, and the goddesses of Olympus conceal their nakedness under adornments and huge, period headdresses.

Contrasts in the German spirit can be seen in religious subjects. The iconography can be sweet and endearing in subjects such as the Nativity, the Flight into Egypt, or Christ's infancy, but it turns into pathos when the subject becomes Christ's Passion and the Crucifixion. In portraiture, the individualized faces of the sitters reveal their inner psychological state — often an unhealthy one — which is heightened to extremes bordering on expressionism.

In addition, we cannot overlook the influence of Martin Luther on sixteenth-century German art and culture. The triumph of Lutheranism had marked repercussions on Central European painting. Deprived of commissions for large altarpieces, painters had to concentrate on landscape and portraiture, and they devoted considerable activity to the nude as well. Such expressionistic sensibilities, which were likewise prevalent in Spain for much of the fifteenth century, changed with the accession of Charles V and his son Philip II, both of whom commissioned their major portraits from great artists of the Venetian School.

The Prado houses a scant but highly select collection of sixteenth-century German painters, notably Lucas Cranach the Elder, Albrecht Dürer, and Hans Holbein. Works by these artists reached Spain in the seventeenth century in the form of gifts to Philip IV or purchases made by the king himself.

Together with Pieter Bruegel the Elder, Dürer (1471–1528) is the most celebrated master of the Northern Renaissance, clearly an indication of the extent to which his art and thought reflected sixteenth-century concerns. With roots in the late Gothic, he is the German artist who embodied the new era and his art translates local and national traditions into universal themes. He is thus representative of both cultural worlds, and his varied activity led him to become an accomplished painter, draughtsman, sculptor, and engraver.

Initially Dürer trained as a goldsmith under the tutelage of his father, but he subsequently took up painting and traveled widely in Germany, the Low Countries, and Italy, where he became imbued with the spirit of the Quattrocento and, particularly, the light and coloring of Venetian painting. His development and maturity were steeped in firsthand knowledge of the art of those countries. His painting has an underlying sense of purity and clarity and he took great trouble over detail, which prevented him from being prolific. In this respect he resembles the early Flemish masters. Both his paintings and engravings are grounded in drawing skills and, indeed, he is considered one of the great universal geniuses of engraving, an art form in which his work becomes freer and more personalized as it matures. In painting, his subjects were limited to portraits and religious scenes, and he produced a celebrated series of altarpieces.

The Prado also possesses two great works by Hans Baldung Grien (1484–1545), who was influenced by Dürer. These are *Harmony, or The Three Graces* and *The Three Ages and Death,* which, judging from the elongated models, would correspond to his late period, revealing a style akin to Mannerism.

Lucas Cranach the Elder (1472–1553) is the third German master represented in the Prado. On account of his close relationship with Elector Frederick of Saxony, he was linked to the Reformation and became a friend of Luther's, whose portrait he painted. Unlike other German contemporaries, he did not visit Italy and therefore the influence of Renaissance classicism was alien to him and he remained faithful to the baroque classicism that dominated late-medieval art in central Europe.

His collaborator and, subsequently, master of his workshop was Lucas Cranach the Younger (1515–1586), whose art career began in Vienna in the early sixteenth century. He later worked for the court of Frederick the Wise of Saxony. The younger Cranach belongs to the first group of great German artists whose work was noteworthy for beautiful landscapes and intimacy in expression and sentiment, with perfect harmony being achieved between the two elements. Nature and garments, however, are rippled by the wind, a feature more akin to Baroque forms, so that he is associated with the "late-Gothic-Baroque." Although his oeuvre centered on religious subjects and portraits, he also painted nudes, hunting and genre scenes, and tournaments. The winged serpent usually appears on his paintings as his identifying hallmark.

Hans Holbein the Younger (1497/98–1543) is considered the prototype of the new painters whose art went beyond national boundaries. From the very outset, when he trained with Hans Burgkmair in Augsburg, he was a wholly Renaissance painter, who used Italian forms in a quiet and rational manner. He lived and worked abroad for many years — first in Basel, subsequently in Lucerne and northern Italy, and, finally, in London where, as one of Henry VIII's courtiers, he played a major role in the formation of modern English painting. His subjects were highly varied, including religious and historical themes, illustrations, frescoes, and sketches for stained glass and goldsmithery, but he earned international fame first and foremost as a portraitist. His models are portrayed naturally, set against backgrounds with Renaissance architecture, curtains, wall hangings, or landscapes. His portraits rely on accurate, realistic drawing, to which he devoted great care and attention to detail. It appears he used the mirror to trace his models.

Judging from the number of his works housed in the Prado, the great protagonist of German painting in the Museum is Anton Raphael Mengs (1728–1779), who was summoned to Spain by Charles III in 1761. During the ten years he spent there he

directed and executed works and played a leading role in the introduction of Neoclassicism into Spain. His works reveal accurate drawing with a certain coldness or even weightiness in the figures. As director of the Royal Tapestry Manufactory, he devoted his energies to producing abundant purist iconography, a form of Romanticism based on classical drawing. Mengs had a great influence on Spanish painting since, in his capacity as first court painter and supervisor of palace decoration, he engaged the assistance of other painters who followed his directives. Many of them, including Goya, trained in the Royal Tapestry Manufactory.

SELF-PORTRAIT

Acquired by Philip IV on the death of Charles I of England, this work accurately reflects that the artist held himself in high esteem.

Dürer appears in his prime, when he was twenty-six years old, in a noble, elegant posture, dressed in rich garments. The sitter's eyes are fixed on the viewer, and the expression on his face transmits inner peace and a sense of the beauty of the self. The figure is strongly lit by an unreal, shadowless light, causing the head to stand out from the deep half-light of a room that opens in the background and is devoid of any precise detail or adornment on the walls. Long, blond, wavy hair with small curls falls gently onto his half-bared shoulders.

The half-length figure takes up most of the center of the panel. To his left is an illuminated window frame through which we glimpse a beautiful, idyllic landscape resembling Patinir's "total landscapes," in which nature — water, earth, blue skies, and clouds — dwarfs the human presence. The depth of the landscape offsets the figure in the foreground. The half-turned position of the figure, which heightens the fore-shortening of the broad shoulders on the young, athletic body, is countered by the parallel axis of the right arm, which rests on the table and straddles most of the width of the picture. The gloved right hand clasps the left hand, revealing a detailed rendering of seams, fingernails, and folds on the fingers.

The figure's verticality is balanced by various horizontal lines, including the dark ribbons on the sleeve, the gold brocade on the shirt border, and the green-and-white cord holding the cape that is draped over the left shoulder and falls in folds onto the painter's arms without reaching the hands. Under the window is an inscription: 1498. I PAINTED THIS OF MY FACE. I WAS TWENTY-SIX YEARS OLD. ALBRECHT DÜRER. AD.

ADAM — EVE

Both of these panels were a gift from Queen Christina of Sweden to Philip IV and have since formed part of Spain's art heritage. The first life-sized nudes in German painting, these are two of Dürer's best works, executed shortly after his second visit to Venice, as borne out by the legend on the sign hanging on the branch of the tree in the picture of Eve: ALBRECHT DÜRER, GERMAN, PAINTED IT AFTER THE VIRGIN BIRTH, IN THE YEAR OF OUR LORD 1507.

Both figures reveal a great degree of plasticity and reflect the artist's idea of classicism in nude studies, to which end he has contrasted the two illuminated naked bodies against their completely dark backgrounds.

Dürer has a deliberate purpose in his analysis of the nature of Man and Woman, whom he shows from the front, their heads and bodies tilted slightly inward. The figure of Adam is set in contraposto and he holds an apple branch that hides his genitals. Eve is depicted in a more graceful, provocative pose, with her right leg slightly advanced, the left leg just behind, rendering the figure unstable, causing her to lean against a branch and the trunk of the apple tree in which lurks the serpent that offers her the forbidden fruit of Paradise.

The plastic realism of the figures is heightened by the ground, while the darkness of the backgrounds appears to be a reference to sin and the loss of innocence.

PORTRAIT OF A MAN

The sitter for this portrait by Dürer remains unknown, but judging by his elegant bearing and rich garments, including a broad-brimmed hat, he was probably a high-ranking government official, a fact supported by the parchment he holds.

The picture is charged with tension, since the half-length figure lacks space. This forces the viewer to look at the face, which is starkly lit by a powerful source of illumination from the left, toward which the sitter gazes. The strong, firm lips, pressed together in a frown, and the way the subject grips the parchment reveal him to be a stern man of strong character.

This is one of Dürer's best portraits, painted in his late period.

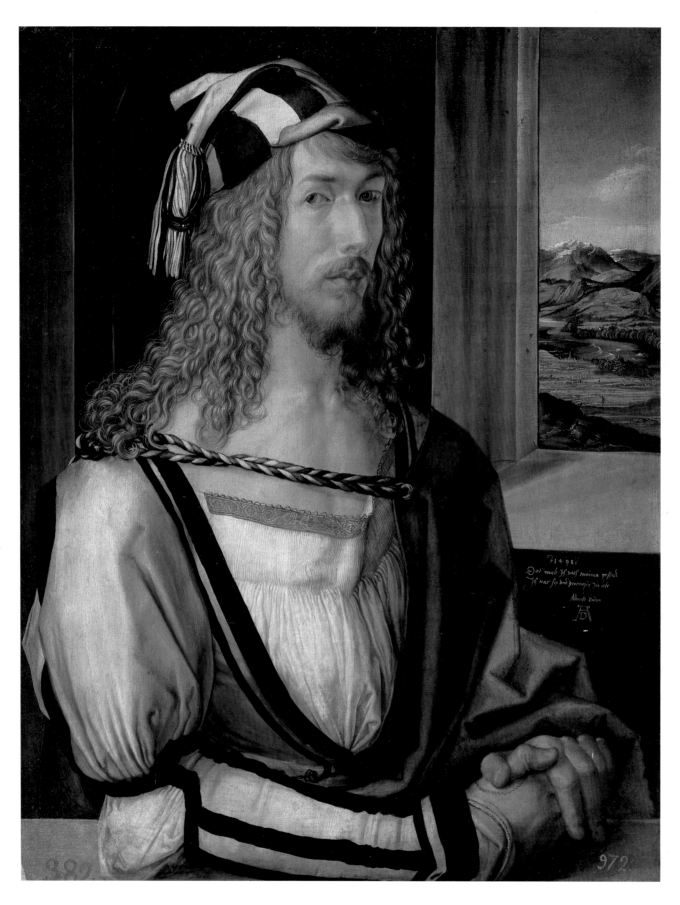

ALBRECHT DÜRER (1471–1528)
Self-Portrait, 1498
Oil on panel, 52 × 41 cm

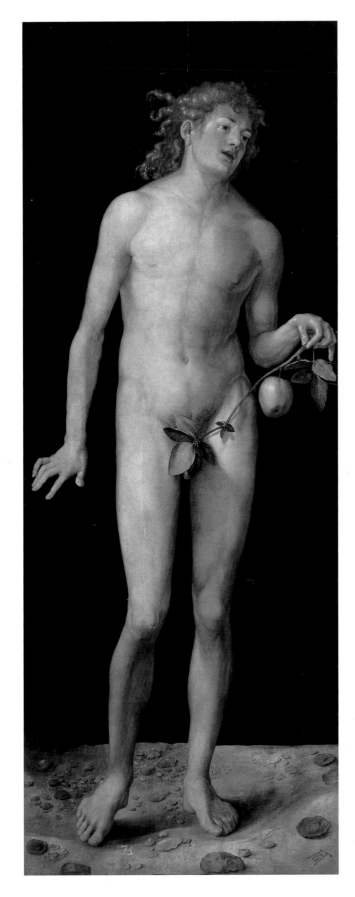

ALBRECHT DÜRER
Adam, 1507
Oil on panel, 209 × 81 cm

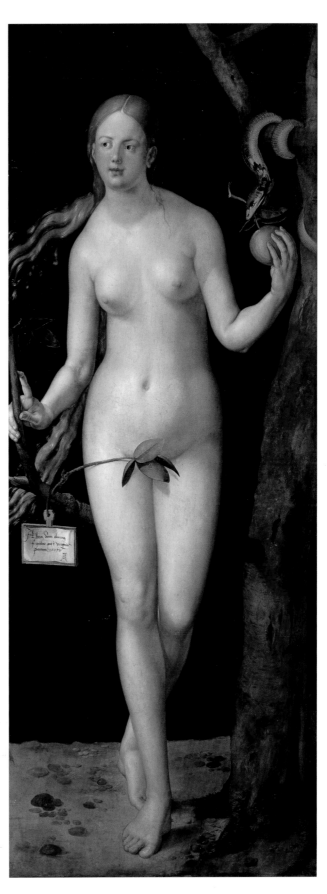

ALBRECHT DÜRER
Eve, 1507
Oil on panel, 209 × 80 cm

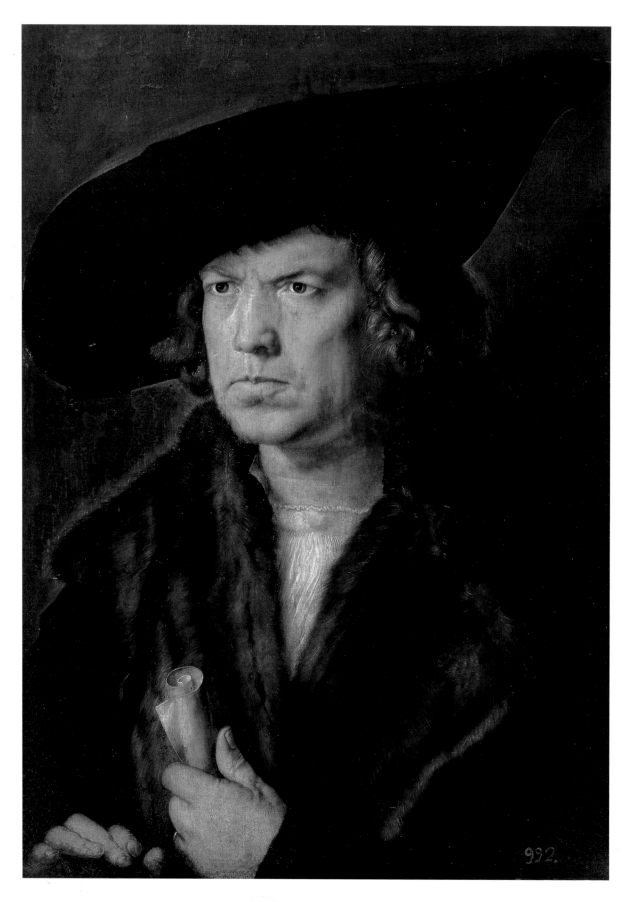

ALBRECHT DÜRER
Portrait of a Man, 1524
Oil on panel, 50 × 36 cm

THE THREE AGES AND DEATH

The prime ingredients in this excellent work of the German school are the sensuous interpretation of nudes characteristic of Germanic art, and the symbolically portrayed moralistic theme of medieval origin. Depicted with stark, crude realism, although possibly with an excess of detail, is the message that death brings about the ruin of nature, humankind, and its works.

At the foot of the ensemble an infant sleeps on the ground; a young woman demurely covering herself stands to the right of an old, wizened hag whom death is trying to carry off. Death holds an hourglass and, instead of a sickle, a broken spear. The background reveals a landscape in ruin, with its dessicated tree and ruined military tower. On high a small effigy of Christ on the Cross is lit by the feeble sunlight that filters through a break in the clouds.

If one takes the key to this work from symbology, it can be found to take inspiration from a sonnet by Petrarch, which suggests that it concerns depiction of love finding its origins in sight. This results in death claiming the lover, who becomes isolated from the beloved sun. The spear stands for the warrior, but is also sexual. As for the owl, which symbolized death for the Egyptians, for the followers of Alciato it was Athena, symbol of wisdom and virginity, and in Ripa it stands for night and darkness.

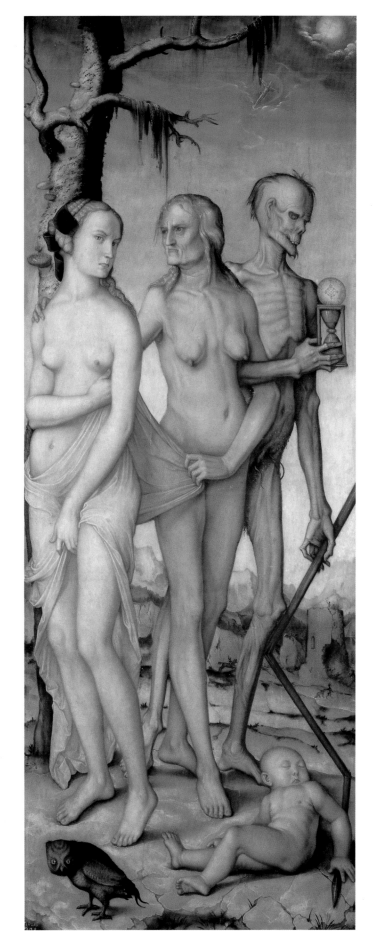

HANS BALDUNG GRIEN (1484/85–1545)
The Three Ages and Death
Oil on panel, 151 × 61 cm

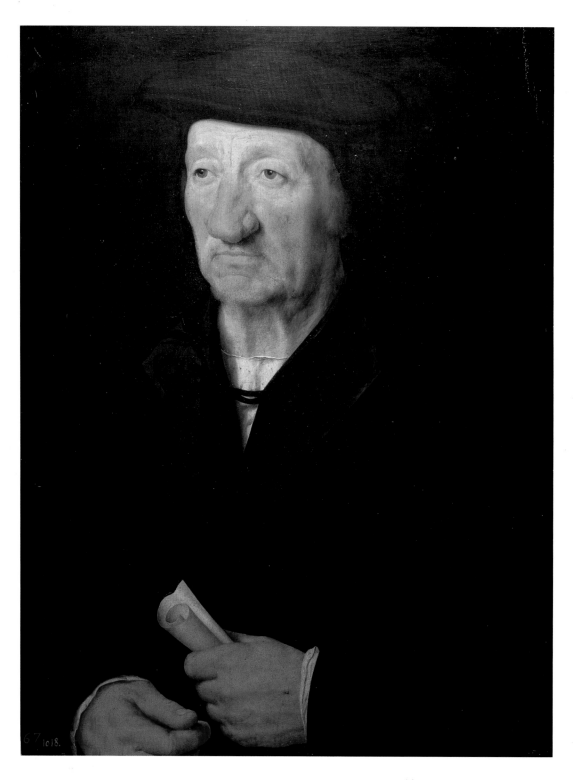

PORTRAIT OF AN OLD MAN

Some critics ascribe this painting to Joos van Cleve, while others feel it should be classed as an anonymous work. Although it features an elderly, rather than a mature, man, it reveals the influence of Dürer's *Portrait of a Man,* described earlier.

Like the latter, this portrait is charged with a tension that arises from a lack of vital space; the sitter also wears an expression of determination. The face looks toward the light source coming from the left, which sets up stark shadows on the face. A strong, resolute character that may be marked by illness is indicated by the powerful nose, while the lips reveal a certain scornful attitude.

This portrait shows the artist's psychological, almost expressionistic intent, one bordering on caricature. The figure holds a scroll indicative of his office in his left hand, and his garments blend into the dark background, from which only the damask folds of the dress coat and the triangle of white shirt emerge to become visible.

HANS HOLBEIN THE YOUNGER (1497/98–1543)
Portrait of an Old Man
Oil on panel, 62 × 47 cm

A Hunt in Honor of Charles V at Torgau Castle

Dated and signed with the little dragon symbol of the family, this panel was acquired by Philip II from the collection of Mary of Hungary. Together with a companion work of the same name, this painting is part of a series that depicts the elector hunting; the other works are now in Vienna, Basel, Copenhagen, Stockholm, and Monzburg Castle.

The two panels feature different scenes of the same hunt held at Torgau Castle by Emperor Charles V, who appears in the lower left-hand corner of the composition, accompanied by two crossbowmen and Elector John Frederick. A group of women on the other side of the composition are likewise engaged in the noble, chivalrous art of hunting.

The background, rendered in the form of a tapestry, shows Hartenfels Castle and park and some hunters leading deer to the hunting ground. A group of beaters are flushing out wild boar in the upper left-hand corner of a wood. Beside the castle is glimpsed the town of Torgau, which was originally thought to be Monzburg.

Everything has been drawn painstakingly, suggesting the work was painted for the purpose of faithfully chronicling the event. Indeed, the panel is imbued with a naïve, rudimentary sense. Although both works were signed by Lucas Cranach the Elder, some historians believe them to be from the hand of Lucas Cranach the Younger.

LUCAS CRANACH THE ELDER (1472–1553)
LUCAS CRANACH THE YOUNGER (1515–1586)
A Hunt in Honor of Charles V at Torgau Castle, 1544
Oil on panel, 114 × 175 cm
(Detail on page 471)

CHARLES IV AS PRINCE

Velázquez must have left a lasting impression on this Central European artist, as his work, particularly his portraits, is highly reminiscent of the Sevillian painter's work. But Mengs himself was responsible for directing aesthetic taste during his years in Spain.

This canvas depicts the weak-willed prince and future king, Charles IV, much slimmer than he would be when he grew older, dressed in hunting gear, wearing a white wig, gray dress coat, and suede waistcoat. He holds a shotgun in his left hand and has a dog beside him. The somber, mountainous background with deer contrasts with the strong lighting on the prince's face.

The Spanish monarchs had a special penchant for hunting, and numerous hunters from Madrid and the surrounding areas assisted them in this activity. Its function was not limited to that of entertainment and leisure, but also involved training for war. This king, however, was not particularly suited for the latter, as he was dominated by his family and, above all, by his haughty wife. The future sovereign is shown wearing the sashes of Saint-Esprit and San Genaro, and the Order of the Golden Fleece.

CHARLES III

In the 1972 Prado catalogue this work is dated 1761. Its companion work is *Portrait of Queen Maria Amalia of Saxony*. Being the official portrait of the king, this canvas was copied on numerous occasions. Despite the period in which it was painted, and the fact that the painter was the foremost exponent of Neoclassical art in Spain and Europe, this canvas resembles the grand Baroque portraits that Velázquez painted of Philip IV and the duke of Olivares in the seventeenth century.

The three-quarter-length figure is shown standing in front of a huge pilaster, thick curtains to his right. He is fitted out with all the attributes of power and of the general of the armed forces: the cross of the Order of Charles III, half-armor of damascened steel, a large crimson sash knotted at the waist, and a baton in his right hand. His left hand is raised and pointing, as if drawing attention to a battle.

THE ADORATION OF THE SHEPHERDS

Painted in Rome in 1770 for the Spanish royal collection, this is one of Mengs's finest religious works. It reveals the influence of the Italian nocturnal Adorations that Correggio initiated, which are characterized by strong contrasts of light and shadow. Nevertheless, this is classed as a Rococo work on account of its enameled coloring and delicate figures of angels flying above the shepherds. With gestures of surprise and amazement, the shepherds stand around the Holy Family, from whom an otherworldly light emanates, suffusing the entire picture. The artist himself appears on the left, behind St. Joseph.

For this rather pretentious work, Mengs has taken great care with all elements of the composition, in addition to the drawing and, above all, the light. A replica on canvas of this painting in the Royal Collection is also considered an original.

ANTON RAPHAEL MENGS (1728–1779)
Charles IV as Prince
Oil on canvas, 152 × 110 cm

ANTON RAPHAEL MENGS
Charles III, 1761
Oil on canvas, 154 × 110 cm

476

ANTON RAPHAEL MENGS
The Adoration of the Shepherds, 1770
Oil on panel, 258 × 191 cm

The English School

The protracted political and military confrontations between Spain and England, which lasted from the time of Philip II to the end of the eighteenth century, provide the reason that so few English works found their way into the royal collections, the source of most of the Prado's exhibits. The small collection of English painting in the Museum dates from the late-eighteenth and early nineteenth centuries and concentrates on works by such celebrated portraitists as Gainsborough, Reynolds, and Lawrence.

The triumph of the Reformation and the schism of the Anglican Church led the English society of the modern age to be interested solely in commissioning portraits, for which it sought out the services of German and Flemish portraitists, notably Anthonis Mor, Rubens, and van Dyck. These masters were to mark the later development of English painting during its golden age in the eighteenth century, in which the two paramount genres were portraiture and landscape. The summit of achievement was attained during the mid-eighteenth century, when English painters rose to the standards of the great contemporary European schools — those of France, Italy, Germany, Holland, and Spain.

William Hogarth (1697–1764) was the first English artist to achieve international standing. He was trained at the Royal Academy, and his art is the result of numerous influences, many of them from the continent. Although he worked in a number of pictorial genres, he was most outstanding as a portrait painter, imbuing his figures with a gracefulness and expressiveness unknown in previous English portraiture.

Hogarth's generation was succeeded by the so-called classical period of English painting (1760–1790), which was led by two of England's best artists, Reynolds and Gainsborough. The Prado has several of their canvases on display.

Sir Joshua Reynolds (1723–1792) is the most outstanding figure in English painting in the second half of the eighteenth century. He painted portraits of contemporary English society, becoming the prototype of the cultured artist. He traveled in Italy, where he founded the English Academy. As an admirer of Renaissance and Baroque painting, particularly that of Murillo, he revealed in his portraits great perfection and beauty, albeit of a rather idealized sort. Churchmen and scholars, soldiers and governors, aristocrats and burghers, seamen and intellectuals — all were captured on canvas by this eminent portraitist, who strove to reproduce the character of his sitters. He drew resources from the great portrait painters who had gone before, was a highly accurate draughtsman, and used a swift, broad brush stroke.

Thomas Gainsborough (1727–1788), a contemporary of Reynolds's, was quite his opposite on both a personal and professional level. He was pre-Romantic in terms of his sentimental nature, his sensibilities, and his bohemian spirit. From a technical stance he is a highly modern painter, his pictures taking on a different appearance when viewed at a distance, as would occur in the works of the Impressionists a century later. He used long brush strokes and highly dilute color, making his surfaces very flat and virtually without impasto. He worked quickly, with light touches, for the purpose of capturing the fleeting, changing appearance of images, in which respect he was ahead of his time. Apart from portraiture, he painted landscapes that are characterized by Flemish influences and bold color. Well acquainted with childhood and adolescence, he painted a number of excellent portraits of children.

The Romantic period in English painting (1790–1830) is another important epoch, one in which prominent portraitists such as Sir Thomas Lawrence (1769–1830) flourished alongside two great painters of Romantic landscape — John Constable (1776–1837) and J. M. W. Turner (1775–1851). The Prado Museum unfortunately possesses only three portraits by Lawrence and nothing by the two geniuses of landscape painting.

The gap is filled to some extent by two beautiful landscapes of the Guadalquivir River flowing through Seville and Alcalá de Guadaira, painted in the 1830s by the Scottish painter David Roberts (1796–1864). This painter of humble origins is regarded as one of the most delicate of British artists. Having originally been inspired by eighteenth-century Dutch landscape painting, he started out in theater decoration and subsequently traveled widely in Europe, Africa, and the Middle East, sketching and painting the landscapes he saw. His work was later reproduced in lithographs, and he published an outstanding series entitled *Picturesque Sketches in Spain*. He also contributed to the *Landscape Annual*. His initially bright and vigorous coloring gradually turned colder and more somber with the passage of time.

PORTRAIT OF A CLERGYMAN

This portrait was purchased from the marquis of San Miguel by the Ministry of Education in 1943.

Reynolds produced basically two types of portrait — grand images influenced by Venetian colorism and Roman classicism, and simple likenesses inspired by the models of van Dyck, Frans Hals, and even Rembrandt. This portrait belongs to the second group, as the artist has focused his attention on the strongly lit face of the sitter. He has used resolute gestures to depict an intelligent man, while the rest of the body fades into the surrounding darkness. Only the right hand, clasping a book, is noticeable. The subject stands stiffly, his head turned slightly to the right, so that the light, coming from the left, sets up smooth shadows on his pale neck and the opposite side of his face.

SIR JOSHUA REYNOLDS (1723–1792)
Portrait of a Clergyman
Oil on canvas, 77 × 64 cm

SIR JOSHUA REYNOLDS
Portrait of James Bourdieu, 1765
Oil on canvas, 121 × 61 cm

Although this canvas reveals a hint of Venetian colorism, particularly in the background drapery, the portrait is more Northern in character, with the subject soberly dressed. Prominence is given to the buttons, the silk stockings, and the collar and cuffs of the light-colored shirt. The model sits calmly on an armchair upholstered in fabric, his body set slightly to the right and his face turned toward the viewer. His arms rest on the arms of the chair and in his right hand he holds a sheet of paper on which he has just written, using the pen placed on the desk in the background, which indicates the subject's occupation.

This magnificent portrait clearly reveals how seventeenth-century English painting was influenced by the Flemish school.

Dr. Isaac Henrique Sequeira

Bertran Newhouse of New York donated this portrait to the Prado in 1953. Sequeira, a Jewish doctor of Portuguese origin, was Gainsborough's physician.

Furthering the style of the Flemish portrait painter van Dyck, Gainsborough portrays this upright, aloof, dispassionate, middle-class member of English society in a natural fashion. The elegantly dressed, seated figure rests from his reading, his book still held in his hands, and reflects on some scientific issue. The technique is broad and free; the highlights and clothing textures are particularly noteworthy. The predominantly cold chromatic range seen in the garments contrasts with the warm color range of the furniture.

THOMAS GAINSBOROUGH (1727–1788)
Dr. Isaac Henrique Sequeira, 1775
Oil on canvas, 127 × 102 cm

At once a model of elegance and simplicity, this work was executed during the artist's time in Ipswich.

This small portrait framed in an oval is reminiscent of some of Reynolds's works. The viewer's attention is focused on the strongly lit face emerging from the dark background. The figure, staring out at the viewer, comes across as resolute and strong-willed, which does not detract from his also being perceived as congenial and personable. However, the tone of severity prevails through the painter's use of simple lines and the sitter's tightly closed garments, which reveal only his face. This, and the compact, even shape of the white wig are, to some extent, offset by the warm, burgundy tones of the jacket and waistcoat.

THOMAS GAINSBOROUGH
Robert Butcher of Walthamstan
Oil on canvas, 75 × 62 cm

DAVID ROBERTS (1796–1864)
Alcalá de Guadaira Castle
Oil on canvas, 40 × 48 cm

ALCALÁ DE GUADAIRA CASTLE

This canvas faithfully reflects how English artists and intellectuals with Romanticist leanings were interested in Spanish art and culture, particularly that of Andalusia, which stood for the distant, Eastern world that inspired European Romanticism. The influence of Venetian Rococo landscape on English Romantic painting is conspicuous; it in turn spawned the birth of Romantic Sevillian painting.

In this work, as in *The Tower of Gold,* another of Robert's canvases in the Prado, the protagonist is the river Guadalquivir; two monuments of Moorish Spain — the Tower of Gold and the Castle of Alcalá de Guadaira — are mirrored in its placid waters. While the riverbanks in Seville are plausible, the castle at Alcalá is perched on rugged heights more characteristic of eastern Andalusia, specifically Granada.

The exotic character of this work was much in vogue in the first half of the nineteenth century.

THE FRENCH SCHOOL

In terms of the number and the quality of works on exhibition, and of the artists represented, the French School ranks third among the non-Spanish schools in the Prado, after the Italian and Flemish. The Museum possesses over three hundred works from this school, providing an important synopsis of French painting from the sixteenth to the nineteenth century. Most of the seventeenth-century works were acquired from the large community of French artists resident in Rome, while those of the eighteenth century were executed by French painters active in Spain, in addition to acquisitions made by the monarchs and, above all, the legacy Philip V inherited from his father, the dauphin. Other, isolated French works also made their way to the Prado by varying means.

Simon Vouet (1590–1649) is the first important French painter exhibited in the Prado and he is regarded as the innovator of a new era in French painting. He trained in Rome, Venice, and other parts of Italy, where he worked for fifteen years and earned considerable fame, being appointed president of the Accademia di San Luca in Rome. In 1627 he returned to Paris where he promoted a harmonious and eclectic Baroque style with Venetian, Roman, and Bolognese influences. He was highly influential in official and academic art circles in the period of Louis XIV and his pupils included Charles LeBrun, Eustache Le Sueur, and Pierre Mignard. He painted primarily religious subjects and his works lack imaginative depth.

He was followed chronologically by Philippe de Champaigne (1602–1674), an artist of Flemish origin who arrived in Paris at an early age and became a protégé of Cardinal Richelieu and King Louis XIII, of whom he painted some fine portraits, this being his speciality. His work reflects the intimacy and simplicity of the Jansenist religious movement, a style that became popular in Spain and was tied in with the existing currents of naturalism that lasted most of the first half of the century. His handling of light, color, and even composition mark him out as a follower of Rubens, although Champaigne produced a more subdued dynamism and employed colder, unmixed color tones.

The Prado recently acquired a work by Georges de La Tour (1593–1652) who, although he was a contemporary of the two above artists, belonged to the small group of French painters influenced by Caravaggio's naturalism and tenebrism. A native of Lorraine, he earned the title of painter to the king, although he was mostly active in Nancy. There, he became associated with the new religious spirit promoted by the Franciscans, which led him to engage in a highly personal form of naturalism

characterized by simplicity, austerity, and a handling of light that linked him to the Dutch followers of the Neapolitan painter. However, the simplicity of his compositions and the monumentality of his figures were his important personal contribution to early seventeenth-century European naturalism.

Treaties and royal marriage ties with France throughout the seventeenth century led to numerous acquisitions of French works, in addition to commissions during the reign of Philip IV for Nicolas Poussin and Claude Lorrain to decorate the new Buen Retiro Palace. Both artists were steeped in the classicist aesthetics that had come to the fore after the founding of the Académie Royale, which was to play an important role in the development of French art.

Nicolas Poussin (1594–1665), Norman by birth, trained with the late Mannerist Quentin Varin and, in Paris, with the portraitist Ferdinand Elle, from whom Poussin inherited a style akin to the second Fontainebleau school. He subsequently traveled in Italy, where he matured both personally and professionally. In 1624 he settled in Rome, and lived there for the rest of his life, except for the period from 1640 to 1642, during which he was court painter to the king. Despite the long years spent in Italy, he was in fact a wholly French artist in the sense that he embodied seventeenth-century French classicist idealism. His style reveals a striving for unity, clarity, and truth, and indeed his works are devoid of accessories or padding. His classicism also shows through in background landscapes, taken from the Roman countryside, which are subordinated to the composition. Drawing is the prime element in his work while his use of color, which he tended to mix with the warm background highlights, changed throughout his life — first it was moderate, later vibrant, and finally light. His subjects generally centered on mythology, ancient history, and religion, although he achieved greatest perfection in his landscapes with figures, along the lines of the Carracci, and his work in this vein is one of his finest contributions to European art.

Claude Lorrain (1600–1682) also settled in Rome, after traveling to various French and Italian towns. He may be considered the creator of French landscape painting, which, in contrast to Poussin's archaeological interpretation, is characterized by a more realistic naturalism, including lakes and riverbeds. He coincided with Poussin, however, in the inclusion of mythological or historical scenes in his landscapes. His works are invariably sunlit and his colorism reveals an evolution from an initial period (1630) dominated by dark brown tones, later superseded by golden ones, which then became primarily cold and silvery in a second period (1647), which then evolved into a third one (1667) in which warm, gentle tones prevail.

The Prado currently houses one of the largest collections of Claude's work, which was acquired by Spanish monarchs from Philip IV onward. The most important and

comprehensive group is the so-called "hermit series," which was purchased from various artists resident in Rome for the purpose of decorating the new Buen Retiro Palace. According to Brown and Elliot, it was the marquis of Castel Rodrigo, the Spanish ambassador to the Holy See at the time, who in 1637 commissioned Claude and other Northern artists to execute one of the most important decorative series of the seventeenth century: two landscape series — one of pastoral scenes and the other with hermits in vast natural settings. Together the two groups comprised over fifty works, of which about half were placed in the long gallery on the north end of the west wing in the Buen Retiro Palace. The series was intended to transmit a pastoral form of Christianity, with hermits set in landscapes resembling the countryside surrounding the palace. At least three of the pictures were painted by Claude: *Landscape with the Penitent Magdalen, Landscape with a Hermit,* and *Landscape with the Temptations of St. Anthony Abbot.* His friend and compatriot, Poussin, executed another two paintings: *Landscape with St. Jerome* and *Landscape with St. Mary of Egypt and the Abbot Zosimus,* of which only a preparatory drawing is known to have survived. Disciples of both masters participated in the work, including Jan Both, Gaspard Dughet, Jean Lemaire, and Jacques d'Arthois.

The marquis of Castel Rodrigo also commissioned Poussin and Claude to paint another four landscapes, grouped into pairs. The former painted the mythological scenes of *Meleager's Hunt* and *The Feast of Priapus,* while the latter executed landscapes with scenes from the lives of saints: *Landscape with the Burial of St. Serapia* and *Landscape with St. Paula Embarking at Ostia.*

These works, acquired by the marquis of Castel Rodrigo in Rome, were joined by purchases by the marquis of Monterrey in Naples. They were sent to Madrid to decorate the new palace, which, all in all, boasted one of the finest collections of French painting, which is now in the Prado Museum.

When the Habsburg monarchs in Spain were replaced by the Bourbons, in the person of Philip V, the paramount influence in culture shifted from Italian and Flemish to French, a change that was echoed in the acquisition of artworks. The young king, raised in the atmosphere of Versailles, did not understand or appreciate traditional Spanish culture and therefore brought a large number of French artists for the building of the palace of La Granja de San Ildefonso, which was to emulate Versailles. However, the king had some trouble finding a suitable court painter in France and had to make do with what was available. For this reason, such French artists as Ranc and Van Loo, specialists in the field of court portraits, replaced their Spanish counterparts as chamber painters. Easel painting was dominated by Houasse and Ranc.

Michel-Ange Houasse (1680–1730) arrived in Madrid in 1715. His oldest surviving work, signed and dated 1719, is the *Bacchanal* in the Prado. Despite original expectations, he painted very few portraits of the Spanish royal family and the most noteworthy of them is one he did of Don Luis, Prince of Asturias. Although Houasse led a rather mysterious, sickly life, he painted a wide range of subjects including fables, religious scenes, and, above all, genre and landscape. His landscapes of the royal residences located near the court are striking for their freshness and spontaneity. In his own words, "I use my personal touch to reflect the countryside of Castile, its harsh light, and even its silence."

Houasse, however, lacked the splendor with which the French monarchs were painted by the likes of Hyacinthe Rigaud (1659–1743), the innovator of official portraiture in France, a style that would be continued into the eighteenth century. In 1721 the king summoned Rigaud to Spain but, when the artist sent his excuses on the grounds of old age, the minister, Dubois, sent instead the great portrait painter Jean Ranc.

Ranc (1674–1735), a pupil of Rigaud's, arrived in Madrid in 1723 and was appointed chamber painter. He was held in great esteem and respect by the sovereigns and painted portraits of all the members of the royal family. In 1729 he was sent to Portugal to paint the family of John V, who had just married into the Spanish Bourbon dynasty. Despite his conceited character, Ranc was well loved by the king and accompanied him on his visits to La Granja and Seville. His name is associated with the famous fire in the Madrid Alcázar, as it started in his chambers, a fact that has led him to be regarded with suspicion.

Despite his academic training and his continuation of the official style of French portraiture, which is characterized by ostentation, he was not unaffected by the influence of Rubens and Velázquez, whose works in the royal collections he was able to analyze. He is accused of paying excessive attention to detail, with objects revealing reiterative definition and repainting, and he was rather aloof and cold in his portrayals of his subjects, who appear amidst heavy curtains, grandiose architecture, or open landscapes. In this respect, he furthered the trend set by his master, Rigaud, although he lacked the latter's genius. He often repeated backgrounds, attitudes, and garments when painting the same persons.

On the death of Ranc, the new king was intent on seeking a French replacement, despite the presence of consummate Italian artists in the Spanish court. He approached the elderly Rigaud, who recommended Louis-Michel Van Loo (1707–1771), who was entrusted with the task of continuing with the type of pompous portrait painted by his predecessor. But Van Loo, who had traveled in Italy

before arriving in Spain, had a broader, more international training and his activity was not limited to portraiture, but extended to tapestry cartoons and mythological subjects. He also taught in the academy, and became its director. A wholly Baroque artist, his personal taste and preference for drawing brought him close to the classicist painters.

Works were also acquired of outstanding Rococo painters such as François Boucher (1703–1770) and Jean-Antoine Watteau to decorate rooms in the new palaces built in Madrid and its environs. Contemporary artists reflected the spirit of the Louis XV period with their decorative embellishment and congenial, feminine aesthetic. Flemish-inspired colorism was back in vogue in the second half of the seventeenth century, as opposed to the predominance of drawing imposed by the academy. This was a time when the French school held sway over the other European schools, owing to the prestige of the French court, which in Spain had gained considerable importance with the introduction of the Bourbon dynasty.

The leading eighteenth-century French painter to be represented in the Prado collections is Jean-Antoine Watteau (1684–1721), who was of Flemish origin but French by birth due to Louis XIV's territorial occupation. His training was Flemish and he was influenced by Rubens, but in 1712 he settled in Paris and was admitted to the Académie Royale. Through his painting he became the narrator of worldly customs of the period, particularly the frivolous, evasive atmosphere of court aristocracy, with scenes set in beautiful landscapes flooded with sunlight. His works are interesting for their delicate conception and broad pictorial sense and his main subjects were courtly gatherings in which French high society sought happiness through permanently festive activities. It was after entering the Académie that his works took on their characteristic vaporous chromatism and warm tones. In his late period his art became more realistic, in contrast to the prevalence of fantasy in his earlier work, and his technical skills came to the fore, as evinced in the distribution of his figures in scenes and a freer, more colorist brush stroke.

One of the last French artists whose works are displayed in the Prado is Jean-Baptiste Greuze (1725–1805). He was part of the classicist movement that arose in reaction to the Rococo, with aristocratic painting being replaced by a moralistic bourgeois painting praised by the encyclopaedists. When in 1755 he entered the Académie, he did so as a painter of genre scenes, despite the fact that he had wished it to be as a history painter. In more mediocre fashion than Jean-Baptiste-Siméon Chardin (1699–1779), he stood for the atmosphere of artistic and ideological renewal then sweeping France with the advent of the Revolution. A protégé of Diderot's, Greuze specialized in a form of genre painting that chronicled simple bourgeois concerns.

Time Conquered by Youth and Beauty

Signed and dated 1627, this canvas was acquired in London in 1954.

Although its dynamism and composition identify this work as Baroque, its precedents are Titian's *Sacred and Profane Love* and *Hercules at the Crossroads* by Annibale Carracci. In this instance, the figure of Time, embodied by the old man Cronus (but also as the deadly Saturn), has fallen helplessly and is held by the hair. He holds an hourglass in one hand and his scythe lies on the ground. Beauty is shown holding a spear and Youth threatens him with a hook. The open, illuminated space is completed by various cupids and trees.

SIMON VOUET (1590–1649)
Time Conquered by Youth and Beauty, 1627
Oil on canvas, 107 × 142 cm

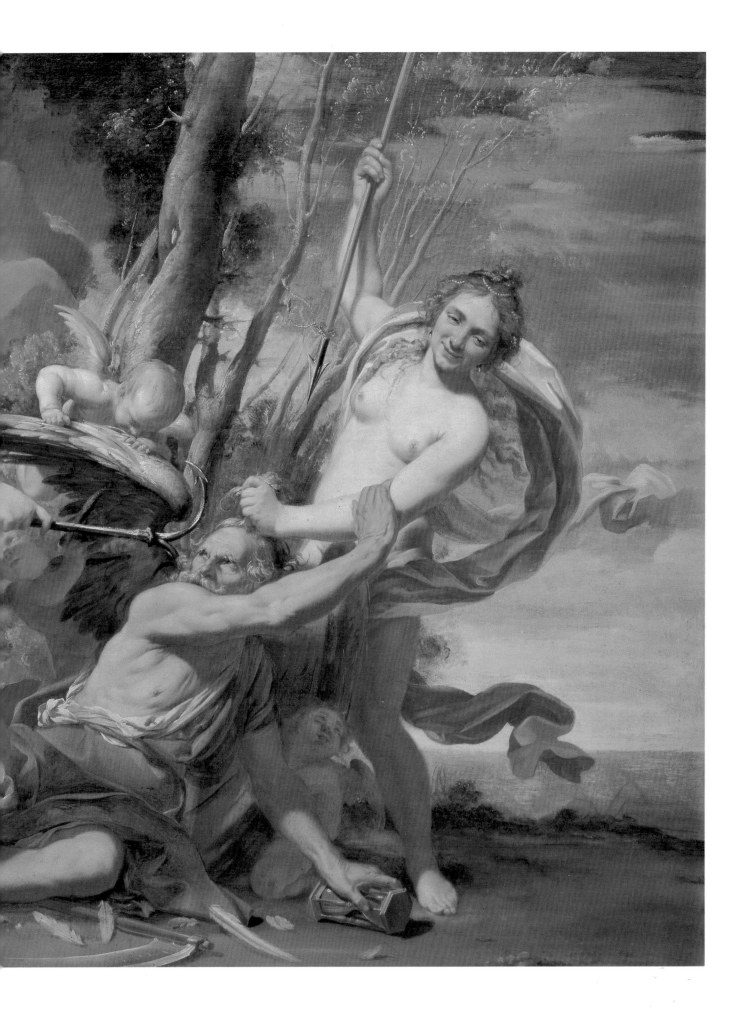

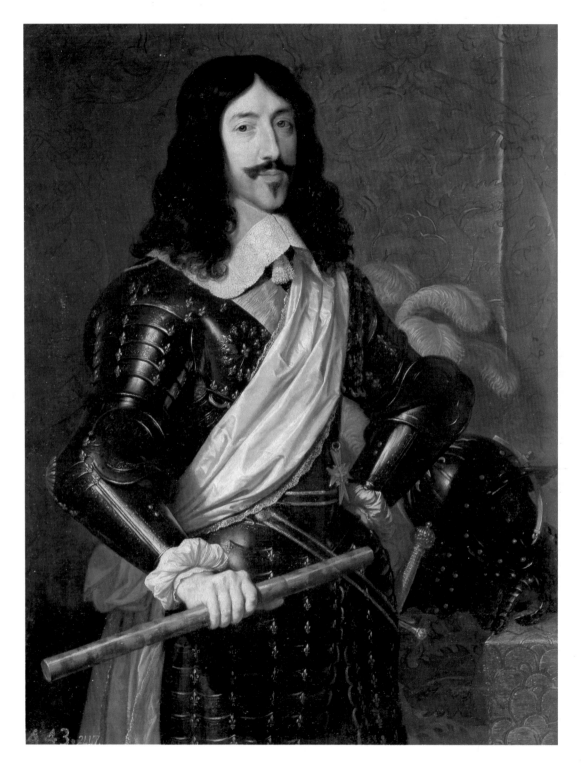

LOUIS XIII OF FRANCE

According to the inventories, this canvas was signed CHAMPAIGNE FECIT 1665. It was sent to Philip IV by his sister, Anne of Austria, Queen of France. A work of outstanding quality, the date of execution was deleted when the canvas was remounted. There has also been some doubt as to its attribution since, Louis XIII having died in 1643, the artist would have had to paint it from an earlier portrait.

It is characterized by the preciousness of the objects and the rendering of the minutest detail in even the accessorial, secondary items. Exemplary of his sober style, it depicts the stern figure of Louis XIII in over half-length format, posed against a dark ground. He wears black damascened armor and a white sash across his chest that is knotted on one side; he holds a general's baton and wears the medal of Saint-Esprit. Behind the king emerge the white feathers of the plume in his helmet, which has been placed on a table.

PHILIPPE DE CHAMPAIGNE (1602–1674)
Louis XIII of France, 1665
Oil on canvas, 108 × 86 cm

BLINDMAN PLAYING THE HURDY-GURDY

This canvas was purchased in London in 1992 with funds from the Manuel Villaescusa bequest.

For this excellent work in the French naturalistic style, the artist has used a simple, schematic technique, with great economy of media, to capture masterfully a highly popular street character, one of the many that thronged the streets of European cities in the seventeenth century and were set to canvas by such leading painters of the time as Velázquez, Ribera, and Caravaggio. La Tour himself painted the same blindman with the same hurdy-gurdy in other works.

This canvas presents a genre scene: an old blindman playing a medieval stringed instrument that was used by troubadours and minstrels. Its four strings are sounded by friction against a toothed wheel, which is driven by a crank. The figure, seated and turning slightly to the right, appears ecstatic; his face, illuminated by a cold, unreal light, is starkly outlined against a dark shadow, which in turn contrasts with the stronger lighting to the left. The background is vague, while the artist has created a successful textural study of the musical instrument and the garments.

As in other works of this style, the figure lacks surrounding space, with the frame impinging on the body, causing it to appear abnormally large, while the lower extreme is truncated.

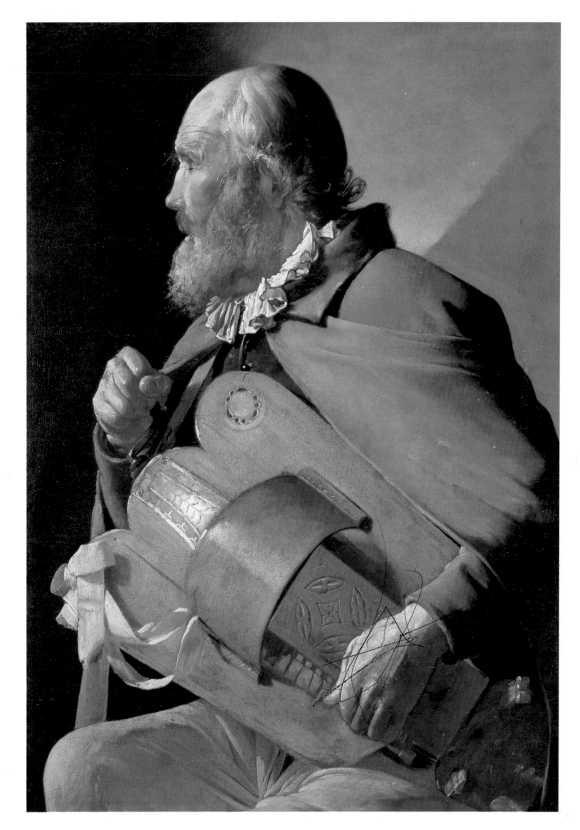

GEORGES DE LA TOUR (1593–1652)
Blindman Playing the Hurdy-Gurdy
Oil on canvas, 84 × 61 cm

LANDSCAPE WITH ST. JEROME

Poussin painted two of the works in the series of hermits in landscapes commissioned by Ambassador Castel Rodrigo for the decoration of the Buen Retiro Palace. His other work was *Landscape with St. Mary of Egypt and the Abbot Zosimus,* of which only the preparatory drawing has survived.

In this painting, Poussin set the old priest and Doctor of the Church in a somber, wooded landscape that lacks any architectural support that might represent Bethlehem, where the saint lived as a hermit for several years, devoting himself to the study of the Bible. As an ascetic dedicated to prayer and penitence, St. Jerome is shown kneeling, half naked, holding a palm, the stone with which he beat his breast, and, in his right hand, a rough-hewn crucifix and a skull.

DAVID VICTORIOUS

Painted in Poussin's early period, this canvas clearly reveals the influence of Venetian lighting and chromatic ranges, particularly those of Titian.

Regarded as an allegorical subject, it portrays the pensive David as a youth, who leans against the giant's sword and sits near his head, shield, and armor. Triumph approaches to crown him with laurel as a putto hands the royal crown to the allegorical figure. On the left, a little angel — or possibly Zephyr — leans against an aeolian harp, the strings of which are being plucked by a child.

This canvas appears to refer to ancient Talmudic writings in which King David's kinnor (a stringed instrument with a sound box similar to those in the harp and zither family) hanging from the monarch's bed emitted a harmonious sound at midnight when brushed lightly by the wind. Aroused by the celestial music, the king rose to study the holy books.

The triumph of the young Jewish hero is interpreted in classical fashion, and includes a winged Victory, while the king, instead of being shown as proud and happy after vanquishing the giant Goliath, is depicted as rather melancholy. The background landscape is one of Poussin's most beautiful and delicate works.

BACCHANAL

This early work, once part of the royal collections at La Granja, was acquired by the Prado through the mediation of Castiglione in 1829. Blunt does not accept the attribution to Poussin, which is, in contrast, accepted by Dorival and Mahón.

The bacchanal, depicted in the form of a classical triumph, recounts Ariadne's abduction by, and marriage to, Bacchus on the island of Naxos. Their liaison is indicated by the two cupids flying over the god. The center of the composition is taken up by a chariot drawn by three lions, which carries Bacchus on his return from fetching the beautiful Ariadne. He is surrounded by the festive, orgiastic retinue of maenads, bacchantes, satyrs, goats, and children; old Silenus heads the parade. The revelers dance in a frenzy under the influence of ethylic vapors to the tune of the musical instruments provided by the goddess Cybele: pipes, drums, cymbals, castanets, and a thyrsus.

The work is clearly Titianesque in inspiration, with attention having been paid to the textural qualities of objects.

PARNASSUS

Also an early work, *Parnassus* reveals Poussin's admiration of Raphael and Titian and the inspiration they took from classical mythology. Titian's Venetianism is also obvious in Poussin's use of light and color.

The composition, inspired by a fresco on the same theme by Raphael in the Stanza della Segnatura in the Vatican, is centered on the seated figure of Apollo, who officiates at the crowning of the Greek writer Homer. Together they pay homage to the friend and poet, Marinus, who is surrounded by Muses and groups of poets and literati. These figures draw near to drink of the poetic wisdom in the crystal-clear waters of the spring of Castalia, the nymph who perished by hurling herself into a spring on Mount Parnassus in order to elude Apollo, who was in pursuit of her. The naked nymph reclines at the center of the group, where two cupids offer water from the fountain to the poets. Verticality is emphasized by the trunks of trees, which appear to mark out a sacred ground, completing the composition in the background.

NICOLAS POUSSIN (1594–1665)
Landscape with St. Jerome
Oil on canvas, 155 × 234 cm

NICOLAS POUSSIN
David Victorious, c. 1630
Oil on canvas, 100 × 130 cm

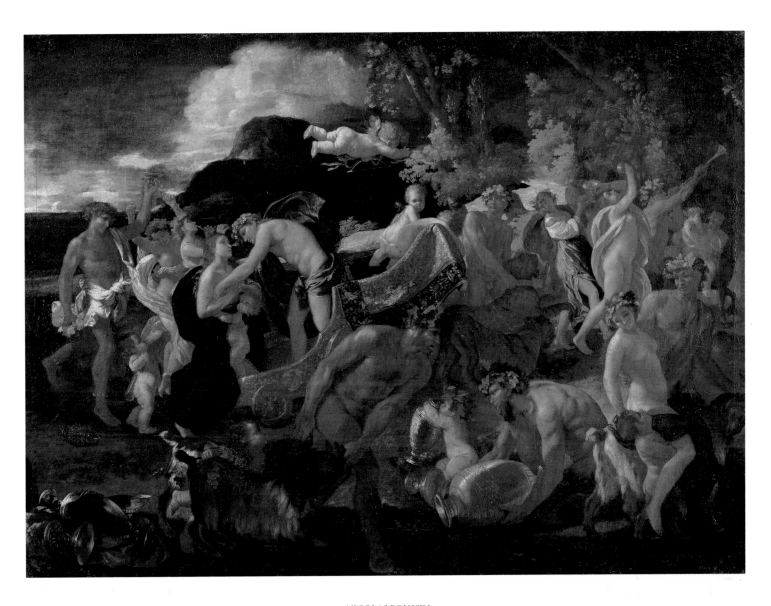

NICOLAS POUSSIN
Bacchanal, c. 1632/36
Oil on canvas, 122 × 169 cm

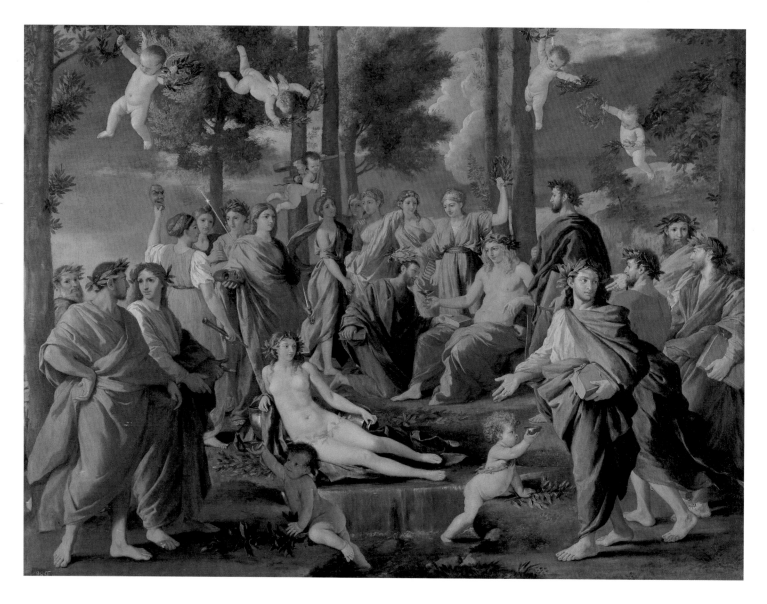

NICOLAS POUSSIN
Parnassus, c. 1626/35
Oil on canvas, 145 × 197 cm

NICOLAS POUSSIN
Meleager's Hunt
Oil on canvas, 160 × 360 cm

MELEAGER'S HUNT

This canvas is a companion work to *The Feast of Priapus,* both of which were assigned to Poussin by the marquis of Castel Rodrigo to decorate the Buen Retiro Palace.

The subject for this work is the hunt by the famous Argonaut, Meleager, and his lover, Atalanta, of the boar sent by Artemis to lay waste the land of Calydon. The goddess prescribed as punishment that the boar should strike men and livestock dead and prevent the fields from being sown. The hero and heroine are seen riding two beautiful white horses to the right of an extraordinary, horizontal-format composition. Meleager is joined by other hunters, some of whom once were Argonauts — Idas, Lynceus, Theseus, Jason, and others. With mounting tension the action in the scene unfolds directionally from right to left, where a pack of hounds and their handlers point to the place where the boar has been sighted.

The painting must have been well received in the palace, given that Philip IV and his family had a special penchant for hunting. The arrangement of the horses and horsemen might have been influenced by the equestrian portraits Velázquez executed about that time.

LANDSCAPE WITH THE FINDING OF MOSES

This work and the three that follow were all listed in the same order in the *Liber veritatis* and were painted by Claude in 1639 and 1640 in vertical format. The measurements and subjects indicate that they formed two pairs. This work, therefore, is the companion to *The Burial of St. Serapia,* with which it shares some compositional elements, although the two contrast in subject — one dealing with life, the other with death.

Having liked the artist's previous works, the palace commissioned these four paintings, which mark a noticeable progress in style. Claude had abandoned his original meticulousness in favor of a more mature style, rendering these works veritable masterpieces.

The subject is taken from the Old Testament and depicts the infant Moses being found by Pharaoh's sister, who is accompanied by maids. It is set in a beautiful landscape against a bright sky. The serene, idealized landscape bears little resemblance to the Nile riverbanks and might have been modeled on the Roman countryside.

CLAUDE GELLÉE, called LE LORRAIN or CLAUDE LORRAIN (c. 1600–1682)
Landscape with the Finding of Moses, 1639–1640
Oil on canvas, 209 × 138 cm

LANDSCAPE WITH THE BURIAL OF ST. SERAPIA

While this canvas is a companion work to the previous title, it differs in its theme — death. It is considered the most beautiful, monumental, and well known work by Claude that the Prado possesses.

The subject concerns the attendance of St. Sabina and others at the funeral for St. Serapia. The scene is set in a beautiful and, as it were, romantic, landscape of classical Roman architectural ruins, affording a hazy glimpse of the silhouette of the Coliseum in the background.

This painting displays Claude's total assimilation of the eclectic, Roman-Bolognese style of the Carracci, which was to spread throughout Europe. Their work epitomized the so-called classical landscape, which featured a natural setting with a narrative and a background of Roman ruins.

CLAUDE LORRAIN
Landscape with the Burial of St. Serapia, 1639–1640
Oil on canvas, 212 × 145 cm

This canvas is a companion to *Tobias and the Archangel Raphael,* both of which are regarded as masterpieces by Claude Lorrain.

The architectural, urban setting appears to be a reconstruction of the ancient port of Ostia. The artist has skillfully placed an architectural complex on either side of the port area, leading the perspective into the background, from which emerges the light source that illuminates the foreground scene of St. Paula and her children embarking for the Holy Land. The perspective is divided into two stretches: the first comprises the converging lines of the clearly defined harbor buildings, while the second stretch starts at the harbor mouth — with buildings veiled in mist — and ends in the open sea, which will lead St. Paula to her destination and provides the source of the unearthly light.

CLAUDE LORRAIN
Landscape with St. Paula Embarking at Ostia
Oil on canvas, 211 × 145 cm

CLAUDE LORRAIN
Landscape with the Temptations of St. Anthony Abbot
Oil on canvas, 159 × 239 cm

LANDSCAPE WITH THE TEMPTATIONS OF ST. ANTHONY ABBOT

This work appears in the *Liber veritatis,* which Claude produced as a defense against imitators and forgers. The canvas is part of his series *Landscapes with Hermits.*

It presents the small figure of St. Anthony Abbot in the foreground beside a pillar, meditating with an excessively theatrical, declamatory gesture that is customary in Claude's work. He is positioned in front of a vast landscape with architectural ruins, groves of trees, and a boat of demons sailing along a river. The canvas is bathed in a gentle, lunar light. Unlike the calm prevailing in his other landscapes, this one depicts an infernal atmosphere. According to Rothlisberger, the figures were painted by another artist, which would account for the departures from Claude's normal style.

CLAUDE LORRAIN
Landscape with a Hermit
Oil on canvas, 158 × 237 cm

LANDSCAPE WITH A HERMIT

This canvas, too, formed part of Claude's series of *Landscapes with Hermits* commissioned for the Buen Retiro Palace decorations.

Here, the hermit, who appears at the right of the canvas, has never been identified. Although he is shown flagellating himself, there are no other iconographic symbols that reveal the saint's possible identity. Professor Juan J. Luna claims it could refer to any penitent saint from the Old Testament or, in the last resort, to St. Peter, the first hermit.

As Rothlisberger has pointed out, the landscape lacks architectural elements but is markedly romantic in character. The foreground half-light surrounds the hermit and contrasts with the misty light emanating from the mountain in the background, which foreshadows the unusual, disturbed landscapes of the nineteenth century. This painting was ahead of its time, which subsequently led to its being copied and imitated repeatedly.

CLAUDE LORRAIN
Landscape with the Penitent Magdalen
Oil on canvas, 162 × 241 cm

LANDSCAPE WITH THE PENITENT MAGDALEN

This is the third in Claude's series of landscapes with hermits. Although the sole figure in the painting is referred to as Mary Magdalen, there is nothing to bear out this association. Rothlisberger suggests that the cross to which she prays might have been a later addition. The work must have been celebrated in its time, since it was successively copied by, among others, Ramón Bayeu, while another copy, once part of the royal collection, is now in the duke of Wellington's collection in London.

The composition in this work lacks architectural elements and is basically structured by two tree masses set on either side of what appears to be a riverbed. Above it lies the only open space in the painting, through which the light filters. The kneeling Magdalen, on the left, is shown praying, her arms outstretched toward the wooden cross, from which emerges a supernatural light that illuminates her face, the rest of her body, and part of the surrounding ground. The two clumps of trees lead the infinite perspective into the background to some faintly visible mountains shrouded in mist.

LOUIS XIV

T his portrait was acquired from Philip V's collection. Although considered a replica of an original executed in 1701 by several artists in the master's workshop, this canvas is one of extraordinary quality.

The impressive court portrait portrays the king who uttered the famous words *"L'état c'est moi"* (I am the State), and chose as his symbols the sun, which rules the planets, and Apollo, patron of the arts. The Prado's work is a replica of the painting that Louis XIV gave to his grandson, which was originally in the Throne Room at Versailles and is now in the Louvre. The sumptuous, spectacular setting — a battle scene, painted by Parrocel, in the background — the pose, and the garments of the king, who wears full armor and holds a baton that rests on his helmet as if it were Hercules' mace, all combine to make this the work that best embodies the spirit of the French monarchy. The king's self-important pose is intended as a challenge to whoever dared usurp his grandson's throne in Spain.

Considerable importance has been attached to the metallic highlights glinting off the armor, helmet, sword hilt, white sash, and gilt-embroidered gloves. The Baroque counterpoint to the bright black of the armor is provided by the wind-blown ripples in the white sash, which is knotted at the waist.

HYACINTHE RIGAUD (1659–1743)
Louis XIV, 1701
Oil on canvas, 238 × 149 cm
(Detail on preceding pages)

MICHEL-ANGE HOUASSE (1680–1730)
Bacchanal, 1719
Oil on canvas, 125 × 180 cm

BACCHANAL

This is the earliest of Houasse's canvases that date to his time in Spain.

The composition harks back to the Renaissance, although it is transformed by Rococo aesthetics. A classical scene of reveling nymphs and fauns, drinking and dancing to the sound of a double aulos, is set in a beautiful garden with broad perspective. The classical appearance, however, does not belie the same peasant types that throng oil on canvas genre scenes characteristic of the artist's oeuvre. On the ground in the front is a naturalistic still life with bunches of grapes, wicker baskets, and vases noteworthy for their textural nuances.

MICHEL-ANGE HOUASSE
View of the Monastery of El Escorial
Oil on canvas, 50 × 82 cm

VIEW OF THE MONASTERY OF EL ESCORIAL

In this artist's work, royal residences provided a recurring theme that gave prominence to beautiful Castilian countrysides and used architectural monuments as the central focus or the background of the composition.

In this canvas, the composition is centered by the prismatic volumes of the monastery, with forms heightened by the contrasting light and shadow that are produced by a low, setting sun. The building is surrounded by an austere countryside with projecting rocks in the foreground. The interpretation of atmosphere and the impressionistic touch resemble the background landscapes Velázquez painted in his portraits of Philip IV. The invariable presence of a human figure in these settings is provided here by the figure of a monk, seen on the left reading on a rocky outcrop. He provides the viewpoint for this personal and unusual view of El Escorial, which is imbued with a feeling of peace that is reinforced by the silvery light.

JEAN RANC (1674–1735)
Equestrian Portrait of Philip V
Oil on canvas, 335 × 270 cm

EQUESTRIAN PORTRAIT OF PHILIP V

Philip V is portrayed here in almost identical fashion to a bust of the monarch also in the Prado. Ranc was in the habit of using the same poses in different portraits. This practice was common at the time and enabled artists to rework models and introduce slight alterations or variations.

This is one of Ranc's most ostentatious works, along the lines of Baroque equestrian portraiture, although it lacks the grandeur and nobility characteristic of Rubens or Velázquez. He depicts the king mounted on an unrealistically rendered horse in courbette that fills almost the entire foreground. The king wears his symbols of military command — sash knotted at the waist, tassles rippled by the wind, and cuirass — and grasps a general's baton in his right hand.

Unlike royal portraits of the Habsburgs, the king is shown here wearing a white wig instead of a hat. He is surmounted by a winged Victory who holds palms and a laurel garland and points to the road of victory above, while several battle scenes are portrayed between the horse's hooves below. The canvas has been given depth by the landscape and the mounted figure on the king's left, which has been markedly foreshortened and set perpendicular to the monarch. Philip V's astrological birth sign, Sagittarius, is depicted at the top of the canvas.

QUEEN ISABELLA FARNESE

Isabella Farnese, also known as Isabella of Parma, was Philip V's second wife and the daughter of the duke of Parma. Painted in 1723, this is a companion work to a portrait of Philip V, which together constitute the first pair of royal portraits to be painted by Ranc, and which he would later repeat with some innovations.

This official portrait successfully portrays the character of a cultivated, intelligent woman whose strong-willed, intriguing nature led her to dictate the course of events for the Spanish Crown as well as to determine the future of her children, whom she placed as kings in various European courts. To this end, she did not hesitate, whenever necessary, to resort to a number of wars.

She is depicted in three-quarter length and wears a crimson velvet dress edged with ermine and a similarly designed mantle. Her noble and serene expression gives way to no stilted or lavish gestures and is offset by her rich garments bedecked with jewels. Unlike the pendant portrait of Philip V, which is set in a landscape, the taut, imposing figure of the young queen is set in a palace against an extraordinarily simple, sober background.

CHARLES III AS A CHILD

Charles III, son of Philip V and Isabella Farnese, was born in 1716 and became the duke of Parma and the king of the two Sicilies. In 1759 he was crowned king of Spain.

This is an exquisite portrait of the Infante Charles, set in his study room. With the delicate gesture of a child, he is shown classifying flowers in an open book on a Baroque console. He holds a sprig of flowers in his right hand. The scene appears to herald the enlightened king's future penchant for culture and science.

The subject wears a sky-blue velvet dress coat adorned with a profusion of details embroidered in gold thread, and red hose. The painting is replete with anecdotal, picturesque, and secondary elements, such as the flowers that have fallen from the vase onto the book, the parrot on the right and the exotic bird in the background, the red cape and feathered cap on the chair, and the pink fabric draped casually on the ground. The introduction of a more informal ambience with a host of random objects, in addition to the infante's interest in plants and rare animals, is commensurate with the child's character.

This work adheres to the style of French portraits of dauphins from the first half of the eighteenth century. The Spanish infante is set in a frame that resembles that of the Louvre's portrait of the dauphin of France at the age of ten, dated 1739.

JEAN RANC
Queen Isabella Farnese, 1723
Oil on canvas, 144 × 115 cm

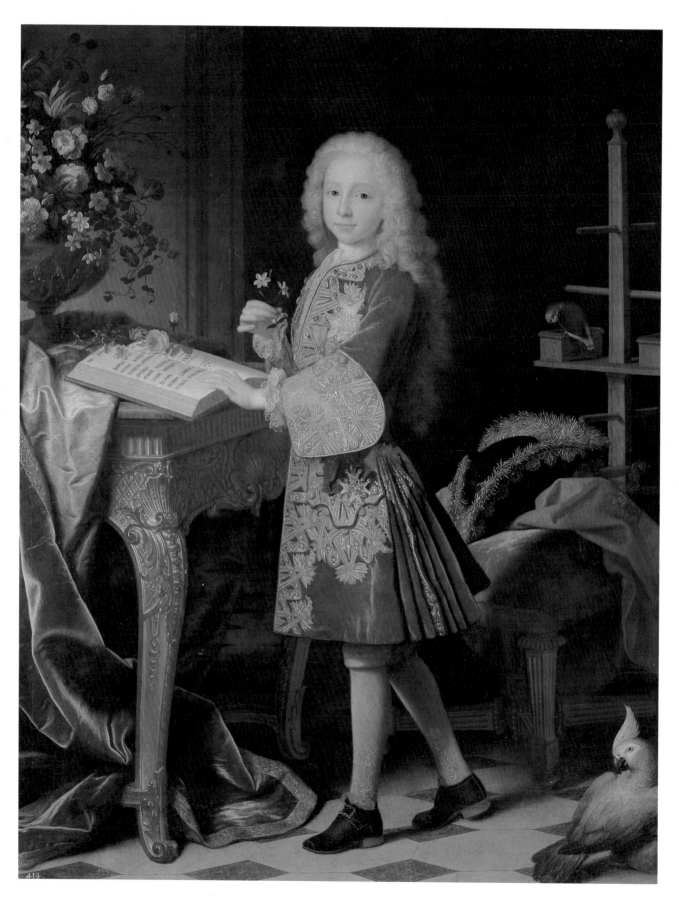

JEAN RANC
Charles III as a Child
Oil on canvas, 142 × 115 cm

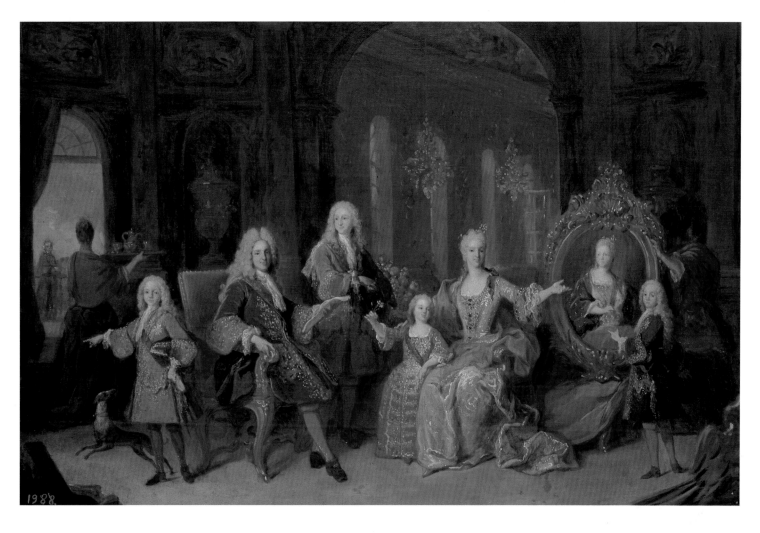

JEAN RANC
King Philip V and His Family, c. 1722
Oil on canvas, 44 × 65 cm

KING PHILIP V AND HIS FAMILY

This may have been a preparatory work for a larger-sized, typical family portrait that is listed in the royal inventories and must have been destroyed in the Alcázar fire in Madrid.

The small family portrait is set in some real or imaginary palace interior, with various pieces of furniture and a number of servants adorning the space in the background. Philip V and Isabella Farnese are shown seated. Next to the king stand the sons from his first marriage, Luis I and Ferdinand VI, while beside the queen are her sons, Philip, the future duke of Parma, and Charles, who was to reign as Charles III. The queen points to a female portrait, the subject of which has been associated with various women, including Mariana Victoria of Bourbon, daughter of Philip V and Isabella Farnese, who, at the time, was engaged to Louis XV and living in Paris.

Although the scene is simpler and more intimate than that in the famous painting by Van Loo, the two have some features in common: the central, predominant figure of Isabella Farnese, her protective attitude toward her children, and her poor relationship with her stepchildren, who appear separately on the opposite side of the canvas.

KING PHILIP V AND HIS FAMILY

Regarded as Van Loo's masterpiece, there are several sketches and copies of this grandiose canvas, including those housed in the Royal San Fernando Fine Arts Academy, the Versailles museum, and the palace of La Granja. It is, however, not among the finest portraits of the royal families, such as those by Velázquez, or Goya's *The Family of Charles IV.*

Unlike the aforementioned works, Van Loo's portrait is characterized by theatrical taste, with Philip V's family depicted in a luxurious salon of sumptuous marble and architectural surroundings that bear no resemblance to any interior in the Spanish royal palaces. At best, the setting may be related to French palaces, although it is most likely a form of stage scenery of the kind used in the Italian operas that the Madrilenian court attended with some frequency. Indeed, the royal family appears to have been cast in some theater piece, and is serenaded by a group of musicians on a balcony in the background, nestled among monumental marble columns and grandiose red-velvet curtains that half conceal the musicians.

In the foreground at the bottom are the members of the king's family, most of them seated, some standing, the children in the front. Rather than the king, it is his young wife, Isabella Farnese, who occupies the center of the painting. Placed slightly in front of the group, her left arm rests on a cushion bearing the crown. Thus, the queen appears as the head of the family and of the kingdom itself. To the right are Philip of Parma and his princess wife, the infantas María Teresa and María Antonia, Queen Amalia of Naples, and the infante Charles, who stands, holding his cloak in one hand. To the left, set slightly apart from the rest of the group, are the prince and princess of Asturias and the princess of Brazil. On the floor in front of the queen, Isabella, daughter of Philip of Parma, and María Isabella, daughter of Charles, are fondling a miniature hunting dog. All of the figures are portrayed realistically and are individualized by gesture and attitude.

LOUIS-MICHEL VAN LOO
King Philip V and His Family, 1743
(Detail)

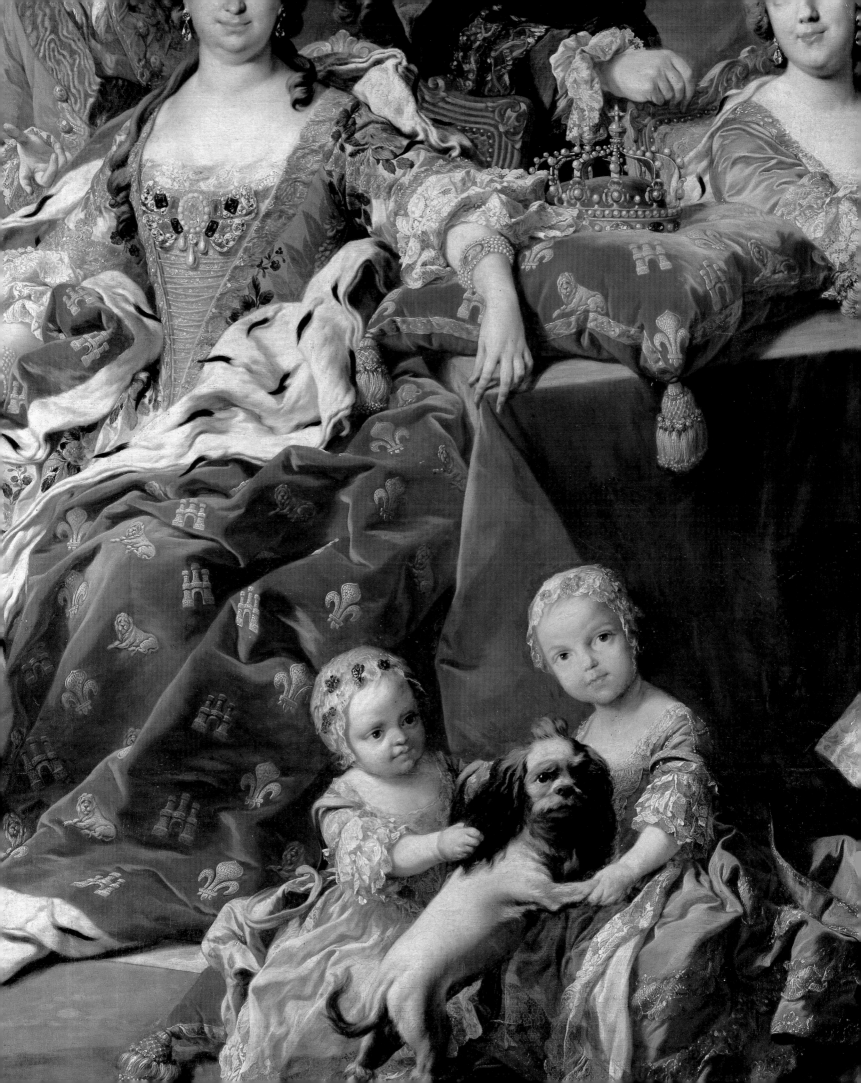

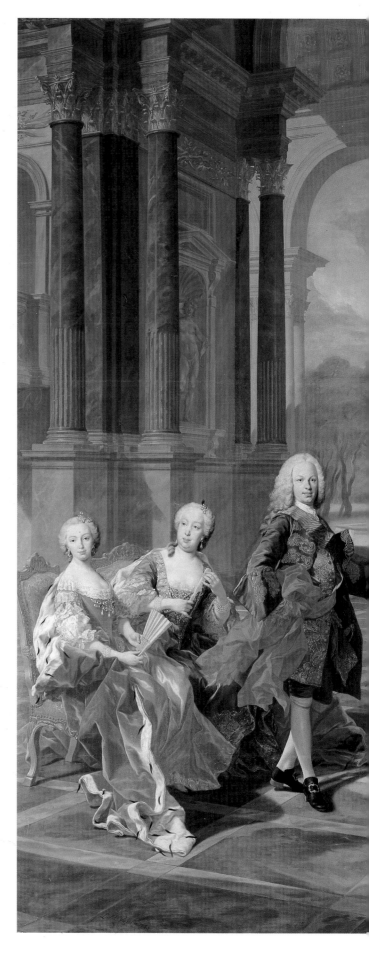

LOUIS-MICHEL VAN LOO (1707–1771)
King Philip V and His Family, 1743
Oil on canvas, 406 × 511 cm

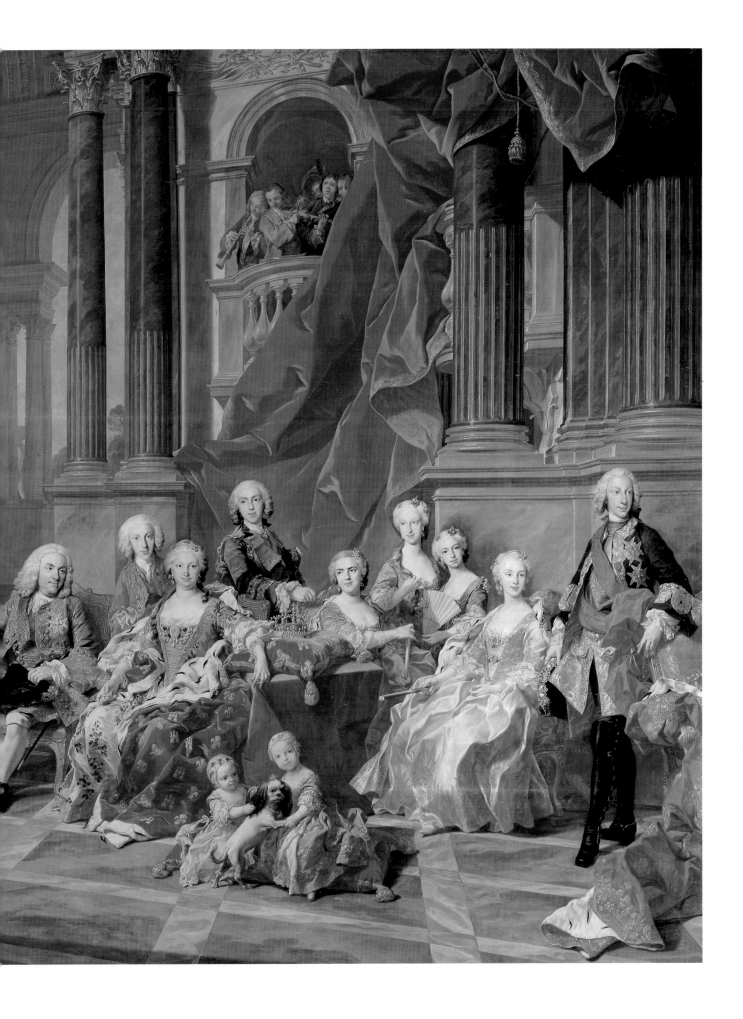

JEAN-ANTOINE WATTEAU (1684–1721)
The Marriage Contract, 1710/16
Oil on canvas, 47 × 55 cm

JEAN-ANTOINE WATTEAU
Courtly Gathering in a Park
Oil on canvas, 48 × 56 cm

THE MARRIAGE CONTRACT

This canvas was originally kept by Isabella Farnese, Philip V's wife, in the palace of La Granja; it was acquired by the Prado between 1819 and 1828. Although authors such as Ferré reject this attribution, it is currently considered to be by Watteau. The date of execution is set between 1710 and 1716.

The signing of a marriage contract is depicted in a scene set slightly left of center in the canvas. Around the central subject, groups of figures dance to music played by various musicians. These genre scenes are enveloped by a landscape of densely packed trees that opens to the left, revealing a bright sky and, lower down, a church tower. The figures are richly dressed for the occasion, typical of the *fêtes galantes* of which the artist was so fond. With the dense, lush, arborial vegetation, the predominance of dark, somber tones is lit only by a few weak light sources. The opening on the left is prominent.

COURTLY GATHERING IN A PARK

Like the previous work, this canvas was once part of Isabella Farnese's collection and was acquired by the Prado between 1819 and 1828. Although it appears to date from the same period, 1710 to 1716, it is technically more modern, suggesting it was executed at a later date. X-ray analysis has revealed the presence of Isabella's coat of arms; in *The Marriage Contract* the legend REGINA ELISABETH DEI GRATIA is found surrounded by the arms of the queen and Spain. Since both paintings have been remounted recently, this is no longer visible.

Although similar to the subject of the previous work, with figures set in a landscape, there are some major differences. First, the figures in this canvas are more scattered about the canvas and take various postures — standing, walking, reclining on the ground, seen from the front or in profile — but all are set within the compositional oval. Most prominent are the two figures in the lower right-hand corner of the picture, who appear to be gazing at Neptune's Fountain. On the opposite side is another fountain, dedicated to the goddess Ceres, which is surrounded by several figures. The people are elegantly dressed and portrayed in sedate, aristocratic poses. The vegetation, too, is more balanced here, and opens up toward the top of the picture for the sky to illuminate the scene, fringed by dark, leafy trees.

The artist has paid little attention to detail; instead he used broad swaths of highly diluted color and left some of the figures roughly sketched.

YOUNG WOMAN SEEN FROM THE BACK

This canvas was donated to the museum in 1935 by the duke of Arcos, José Brunetti y Gayoso de los Cobos. It is representative of the change in subject matter that affected artists who were active during the transition to classical aesthetics, which replaced frivolous, aristocratic subjects with themes associated with the bourgeoisie then aspiring to take power in France. The ethics and moral code of the new political and intellectual elite were likewise reflected in the change of model used for portraits.

This canvas is a representative fragment of this change. The woman, with a lively expression, is depicted in the form of a bust, her left shoulder and part of the back bared, as she half-turns toward the viewer. It emulates the compositional arrangement of a painting engraved by H. Legrand under the title *La pudeur agaçante.*

JEAN-BAPTISTE GREUZE (1725–1805)
Young Woman Seen from the Back
Oil on canvas, 46 × 38 cm

Paintings of the Nineteenth Century

The collection of nineteenth-century paintings that is now displayed in the Casón del Buen Retiro is but a small part of the rich and important holdings of paintings from the nineteenth century that belong to the Prado Museum. Many others are in storage or are deposited with other Spanish institutions.

The origin of the Prado's collection of nineteenth-century paintings is as varied and disparate as it is for the Museum's other collections. A first contribution comes from the royal collections and figures in the different catalogues of the Real Museo de Pintura y Escultura (Royal Museum of Painting and Sculpture) from about the middle of the last century — to be more exact from 1843 till 1858, as a short catalogue section entitled *Escuelas contemporáneas de España.* This listed pictures by painters who were, in some cases, still living at the time, and included those from the end of the eighteenth to the first half of the nineteenth century, including works by Francisco de Goya, Francisco and Ramón Bayeu, Mariano Salvador Maella, Antonio Carnicero, Mariano Sánchez, Luis Menéndez, José Aparicio, José de Madrazo, Vicente López, Rafael Tejeo, and Bartolomé Montalvo, among many others. This section had already disappeared by the time of the *Catálogo Descriptivo e histórico del Museo del Prado de Madrid* — which was compiled by Pedro de Madrazo, published in 1872, and known as the *catálogo extenso* — in which the paintings by José de Aparicio, Vicente López, José de Madrazo, Bartolomé Montalvo, Juan Antonio Ribera, and Rafael Tejeo were listed alphabetically among the works of the Spanish school.

An important nucleus of the collection came from the stocks that were gradually coming together in the national museum of painting and sculpture — the Museo Nacional de la Trinidad — from its formation in 1837 until its termination and merger with the Prado by the decrees of 1870 and 1872. In it were deposited the acquisitions made by the state in the Exposiciónes Nacionales de Bellas Artes (National Fine Arts Exhibitions) created by Queen Isabella II in 1856, with the addition of certain gifts and purchases. In 1865, Gregorio Cruzada Villaamil published his *Catálogo Provisional, Historial y Razonado del Museo Nacional de Pinturas,* where the catalogue of the *Galería de Cuadros Contemporáneos pertenecientes al Museo Nacional* was included in the appendix differently numbered. Here were noted — with their provenance, which makes it very interesting — more than 150 works by 97 painters, the greater part of them having been prize winners in the Exposiciónes Nacionales de Bellas Artes and acquired through royal order.

After the museums were merged, few paintings of the nineteenth century were

included in the new Prado Museum catalogues that were published from this date on, with the exception of those works from the royal collections and those that were already included in the previous editions. However, and in spite of the joining of the two museums, it did not seem that many of these paintings could be accommodated in the Prado Museum — now known as the Villanueva Building — which left many of them in the offices and dependencies of the ministry of public works, where they were before. We do know, for example, that they showed, among other canvases, *The Testament of Isabella the Catholic* by Eduardo Rosales and *The Contemporary Poets* (or *The Poets' Reunion*) by Antonio María Esquivel.

Of particular interest for studies of the current collections of paintings of the Prado Museum is the *Catálogo de las obras del Museo Nacional de Pintura y Escultura: Pintores contemporáneos,* by Emilio Ruiz Cañabate, published in 1889, in which 306 paintings are listed — complementing that of Villaamil of 1865 — showing the new acquisitions and gifts. We can consider this work as the first catalogue of Spanish nineteenth-century painting. In it, and following the scheme of the *Catálogos de las Exposiciones Nacionales de Bellas Artes,* the artists are listed in alphabetical order, with a brief biographical note about each — place of birth and teacher(s) — and a listing of their works giving the titles, dimensions, and in some cases a description, also taken from the national exhibition catalogues. This catalogue is essential to understand the Prado Museum "collection" of nineteenth-century paintings.

In 1894, by royal decree of the regency of María Cristina, dated August 7 of that year, the Museo Nacional de Arte Contemporáneo (National Museum of Contemporary Art) — after 1895, known as the Museo Nacional de Arte Moderno (National Museum of Modern Art) — was founded, its first director being Pedro de Madrazo. It was inaugurated on August 1, 1898, in a part of the upper floor of the Palacio de Museos y Biblioteca Nacional (Palace of the National Museums and Library). This museum arose, according to the founding decree, in order to meet "the need felt by public opinion and called for by commentators," thus making it possible to bring together the nineteenth-century works that were in some of the rooms of the Prado Museum and in the dependencies of the ministry of public works, among other places. In 1899 a *Catálogo Provisional del Museo de Arte Moderno* was published, in which the compiler is not named, and a year later, in its second edition, it lists 693 paintings and drawings, and also includes 88 sculptures.

Even at the time of its creation, space in this museum was scarcely adequate to supply its requirements, and its subsequent directors — the artist Alejandro Ferrant and the sculptor Mariano Benlliure — tried unsuccessfully to rectify the problem. The second Republic also made an attempt to solve the problem of space by

undertaking important efforts to improve the spaces and by freeing up the holdings by indiscriminately placing works in various museums and provincial institutions (city halls, offices of local government, residences of captains general, universities, embassies, etc.), where, for the greater part, these canvases are found to this day.

On this point, Juan Antonio Gaya Nuño writes that, "in this year (1931) Ricardo Gutiérrez Abascal, better known by his pseudonym Juan de la Encina, occupied the position and made a considerable clearance of the larger historical paintings and of sculptures of decadent and presumptuous modernism, taking care that each era admitted to the Museum should be represented by its most prominent names. This valiant work was continued by Eduardo Llosent y Marañón, who was director until October 1951." In recent years special attention has been given to reviewing the holdings of what is called the "*Prado disperso*" (scattered Prado), which is published in the *Boletín del Museo del Prado*.

These works were evacuated to Valencia for the duration of the Civil War along with others from the Prado Museum. After the conflict they were newly installed in the Palacio de Museos y Biblioteca Nacional, with the addition of works by younger artists, which therefore placed them side by side with those of the most important painters of the nineteenth century. However, these new acquisitions by the Museum meant that many nineteenth-century works were laid aside, creating considerable confusion and endangering the collections in terms of preservation.

In 1951 the museum's holdings were divided, though with little success, thereby creating the Museo Nacional de Arte del Siglo XIX (National Museum of Nineteenth-Century Art) and the Museo Nacional de Arte Contemporáneo. These had a short life until their reunification in 1968 as the Museo Español de Arte Contemporáneo (Spanish Museum of Contemporary Art). Its directors were, in order, Julio Cavestany, Marquis of Moret, and Enrique Lafuente Ferrari. In view of the illogicality of this new museum, in 1971 a ministerial order split the nineteenth-century paintings off from the Museo de Arte Contemporáneo and they then came under the control of the Prado Museum. They were installed in what is called the Casón del Buen Retiro, and the new Section of Nineteenth-Century Art was opened on June 24, 1971. Its catalogue was published some years later, in 1985, by the then subdirector of the Museum and curator of the Casón del Buen Retiro, Joaquín de la Puente.

When Picasso's *Guernica* arrived in Madrid it was hung in the central salon of the Casón del Buen Retiro, and the other exhibited works had to be rearranged, causing the large historical paintings hanging there to be removed. The new arrangement was inaugurated on June 25, 1981. After the transfer of *Guernica* to the Museo Nacional Centro de Arte Reina Sofía in 1992, the Casón collections were reinstalled.

THE COLLECTION

As we have already pointed out, the first contribution of nineteenth-century painting to the Prado Museum, although small, came from the royal collections. It was increased little by little through other gifts by Ferdinand VII, María Cristina, and Isabella II, who ceded a series of royal-family portraits by Vicente López, which had been in the royal palace, to the Prado in 1847. The Exposiciónes Nacionales de Bellas Artes — created by royal decree of Isabella II, which was presented in the palace on December 28, 1853, and published in the *Gaceta de Madrid* on January 12, 1854 — were of greater importance for the acquisition of the important stock of nineteenth-century pictures that are exhibited in the Prado Museum today. The royal decree was intended, as is mentioned in the document, "to give a new impulse to the fine arts through public exhibitions and prizes."

These exhibitions were to take place biennially in May, and the works of living artists, both Spanish and foreign, were to be included, provided that the works by non-Spaniards had been produced in Spain. The specially appointed panel of judges — made up in the first place by members of the Royal San Fernando Fine Arts Academy — was to suggest the works that deserved the prizes awarded by the government, which, in the case of painting, were two first-class medals, four second-class, and six third-class; a medal of honor could also be awarded by unanimous vote. In addition, Article 9 is worthy of quoting in regard to this theme: "At the end of the Exhibition, the Academy will make separate lists following the order of merit of the artists, showing which works they consider should be purchased by the Government."

Thus from the first exhibitions that took place in the headquarters of the ministry of public works— located in what had been the Convento de la Trinidad, in calle Atocha, on the corner of the calle de las Relatores (the building in which the Museo Nacional de Pintura y Escultura had been installed) — the works proposed by the panel of jurors, in general the prize-winning works, were acquired by the government by royal order; in some cases, other paintings and sculptures of outstanding quality were also acquired in this way. It is interesting to note that after the Exposición Nacional de Bellas Artes of 1881, in which José Casado del Alisal aspired to the medal of honor with his painting *The Bell of the Monk King* but the medal was awarded instead to the architect Juan de Madrazo y Küntz, Emilio Castelar asked parliament to vote a credit to buy the painting, which was acquired for 35,000 pesetas. Due to the initiative of Segismundo Moret the amount was doubled, making possible the additional acquisition of Eduardo Rosales's painting, *The Death of Lucretia*, which had not been purchased by the government, in spite of its having won the first medal in 1871. A different fate befell another painting by Casado del Alisal, *The Surrender of*

Bailén, with which he won the first medal in the national exhibition of 1864: it was acquired by Queen Isabella II for her collection, and was later given to the Museo Nacional de Arte Moderno by King Alfonso XIII in 1921.

Many other paintings, not necessarily those entered in the national exhibitions, were bought for the Museum, and it is notable that in 1878, a few years after the death of Eduardo Rosales in 1873, two works by the ill-fated artist were bought — his *Female Nude* and, a year later, *Tobias and the Angel.*

Notable purchases in the twentieth century include those of the pendant portraits of Juan Alvárez Mendizábal and his wife, by Antonio María Esquivel (1916); *The Waters of Moguda* by Joaquín Mir (1917); the *Portrait of Carolina Coronado* by Federico de Madrazo (1942); *St. Catherine* by José Gutiérrez de la Vega (1946); and two pictures by Francisco Gimeno Arasa, *The Preserve* and *Blue Water* (1956).

Since the nineteenth-century collection was installed in the Casón del Buen Retiro it has followed a sound policy of acquisition of works that has increased the existing rich holdings, completed the collections with works by missing artists, or added important works that have broadened significantly the existing representation of many artists. Accordingly, in 1974 it acquired *The Drunk* by Leonardo Alenza and in 1982, the portrait of *The Little Countess of Santovenia* by Eduardo Rosales, one of the most beautiful nineteenth-century canvases in this genre, and Casado del Alisal's *Lady with Fan.* Two years later, the study by Francisco Pradilla, *Juana la Loca on the Walls of La Mota Castle,* was bought, and in 1985 the sketch of *The Goddess Juno in the House of Dreams* by Luis López y Piquer, while in 1990 the *Self-Portrait* by Zacarías González Velázquez and Francisco Pradilla's canvas *Queen Juana la Loca Confined in Tordesillas with Her Daughter, Princess Catherine* came to the Museum.

Finally, we must mention that among the recent acquisitions made by the Prado, the paintings acquired between 1992 and 1993 with funds from the bequest of Manuel Villaescusa Ferrero are outstanding: two river landscapes with figures by Manuel Barrón y Carillo; a *Portrait of a Girl* by Rafael Tejeo, and the *Portrait of the Artist Raimundo de Madrazo* by his father, Federico de Madrazo y Küntz.

An important and significant part has been played in the formation of the collection of nineteenth-century painting by the numerous donations received. It is interesting to analyze briefly some of these cases, as their origin is extremely varied.

First come the donations or bequests made by collectors, particularly the important bequest of Ramón de Errazu in 1904, which included many paintings by outstanding artists, such as this donor's portrait painted by Raimundo de Madrazo and, also by this artist, *After the Bath, A Gypsy, María Cristina of Habsburg,* and two portraits of the model Aline Masson. Errazu also bequeathed a considerable number of paintings by

Fortuny, among them *Faust's Fantasy, Idyll, A Moroccan, Nude Old Man in the Sun, Nude on the Beach at Portici, Landscape, Copy of "Menipo" by Velázquez,* and *Flowers.* Of Martín Rico's works he gave *The Bidasoa Estuary, Venice,* and *Alcalá: The Banks of the Guadaira.* In 1930 Xavier Laffite donated *Interior with Moors* by Francisco Lameyer and the *Bust of a Girl* and *Head of a Boy* by Ignacio Pinazo.

What is called the "Vitorica Gift," made by María de los Angeles Sáinz de la Cuesta in 1968 in memory of her husband, Juan Vitorica Casuso, includes outstanding works by Eugenio Lucas such as *Man with Guitar, Still Life, Sermon in the Fields, Sermon to the Masks, Village Bullfight, Women on the Balcony, A Pair of Fashionable Men, Self-Portrait,* and *Condemned by the Inquisition.* The most recent of these important gifts is that of Juan Bautista Robledo in 1981, which included the paintings *Moor* by Manuel Benedito Vives; *The Cardinal* by José Benlliure Gil; three landscapes by Juan Espina y Capo; *A Procession in the Month of May* by José Jiménez Aranda and *Corner of a Patio in Toledo* by Antonio Muñoz Degrain.

A number of people have given nineteenth-century paintings, and it is interesting to note their relationships with the artist or with the picture. In some cases, the artists themselves have given the pictures, such as Alejandro Ferrant, who gave his *Portrait of Francisco Pradilla* (1903), and Fernando de Amarica, who donated his canvas entitled *September Afternoon on the Banks of the Zadorra* (1923). Other artists have given portraits of themselves painted by their painter friends and colleagues, as was the case for the portrait of Sorolla painted by José Jiménez Aranda, donated by the painter from Valencia in 1920 shortly before his death.

Also there have been frequent gifts made by the families of the artists. Vicente Esquivel, son of Antonio María Esquivel, gave his father's *Self-Portrait* to the museum in 1903, and Aureliano de Beruete, son of the artist of the same name, gave several works by his father in 1913, a benefaction to which were added other works of Beruete, owned by his widow, María Teresa Moret, in 1922.

The donation of the legacy of the landscape artist Carlos de Haes, who died in 1898, is significant. His disciples, headed by Jaime Morera, and the heirs of the painter left a part of their inheritance to the Museo Nacional de Arte Moderno that amounted to several hundred paintings.

We must also mention gifts made by portrait subjects, such as *Manuel Flores Calderón as a Boy* by Esquivel, given in 1911, and the bequest in 1927 of *Doña Josefa Manzanedo e Intentas de Mitjans, Marchioness of Manzanedo,* a work by Raimundo de Madrazo. In other cases, a relative of the person portrayed has made the gift, as happened with the *Portrait of Fernanda Pascual de Miranda,* a work by Antonio María Esquivel, given by Paz Miranda Pascual, the daughter of the subject, in 1913.

Finally, we must mention other gifts of works in more recent years, such as the *Portrait of the Duchess of Castro Enriquez* by Federico de Madrazo, given by María Paz García de la Lama y Alvarez in 1964, and the *Portrait of Josette,* a 1916 work by Juan Gris, given by Douglas Cooper in 1979. In 1980 Mariano Garrolón Francesconi gave a *Family Scene* by Francisco Sans y Cabot. The marchioness of Manzaneda bequeathed the painting *View of Paris* by Martín Rico in 1987, and in 1991 María Luisa Ocharán bequeathed to the Casón two important works by Francisco Pradilla: *Baptismal Procession for Prince Don Juan, Son of the Catholic Kings, Through the Streets of Seville,* the last of the historical paintings by the painter of *Juana la Loca* (1910), and another, more sketched, version of *Queen Juana la Loca Confined in Tordesillas with Her Daughter, Princess Catherine,* a work the Prado acquired in 1990.

In this brief summary of the history of the nineteenth-century works now held directly by the Prado Museum, and the vicissitudes suffered by them over the years, no mention has been made of the chronological limits of what has been brought together in the inadequate space of the Casón de Buen Retiro, built by the Habsburgs. In general, the collection that can be visited today — with the limitations mentioned — covers what was produced by Spanish artists of the court and officially throughout the last century. It includes the work of some artists whose work is difficult to classify from a stylistic point of view, whose aesthetic and technical offerings would be more in consonance with the past century than with the present, though they lived several decades of their lives during each of the two centuries.

Thus we have, in what we refer to as the first sixty years of the nineteenth century, an abundant representation of what was meant by Spanish painting on two different economic and social levels. Here we find the productions of the last painters to the chamber of Ferdinand VII and Isabella II. The dethronement of the latter in 1868 ended a long and prosperous era of court artists at the service of, and under the patronage of, royalty, which was almost the only patronage, together with that of the Church and certain other isolated cases, up until a date that could be set at around 1920, when there began to arise a true incipient middle class.

Following the conclusion of the revolutionary period, the short reign of Amadeo of Savoy, and with the Bourbon restoration with Alfonso XII, the title of Painter to the Royal Chamber would be granted only exceptionally and always as an honorary one.

Returning then to the period from 1814 to 1868, the representation of the court artists in this nineteenth-century section of the Prado Museum is based upon the traditional subjects for artists in the royal service: portraits of members of the sovereign's family, decorative works for the palaces — including some examples of preparatory works, such as the sketches by Vicente López and his son Luis López

Piquer for various apartments in the Royal Palace in Madrid — and paintings of a patriotic nature, such as the celebrated, mediocre painting by Aparicio, *Famine in Madrid,* in its day valued more highly by Vicente López than Velázquez's *Las Meninas.*

Artists of an eclectic training still of the eighteenth century, such as Zacarías González Velázquez and Vicente López, open this gallery of Spanish painters in the service of the Crown, whose lives would close toward the end of the century.

In parallel, the brief stage of classicism is also well represented, showing what this style really meant in Spain. It was better understood and practiced in the court than in the regional schools. Toward the 1830s, regional artists began to use a Romantic approach in their handling of popular subjects, as in the Andalusian school, particularly in Seville; their paintings hang next to those of their court contemporaries. The same may be said of those artists of the Madrid school who found in the modern middle class a providential clientele, among whom must be mentioned as vital elements on this level Leonardo Alenza, Eugenio Lucas, and Francisco Lameyer, all examples of Romanticism and excellently represented in the Casón. In addition, painters in José de Madrazo's family, like their father, who was in the court's service, all excellent artists, are the best representatives of what can be classified as the Romantic portrait.

After the revolution and with the creation of a state modern art museum, the different acquisitions by the government continued gradually to complete the panorama with what is called Restoration art, which consisted of a post-Romantic style of disputable modernity but of absolute quality. In this way and in the new museum, together with works by the majority of the artists named, holdings separated from the Prado and coming from the royal collections, and with new gifts made by the sovereigns, the stocks grew, principally from the prize-winning works from the Exposiciónes Nacionales de Bellas Artes, as we pointed out earlier.

In this showcase the evolution of Spanish art in a period of rapid stylistic changes could be followed. The long period of Hispanic Romanticism was finally supplanted by works of so-called Realism, Symbolism, and the first echoes of Impressionism, above all through the landscape painters, and concluding with modernist painters after the style of Rusiñol and works tied to the first manifestations of the so-called historical vanguard, although these were from purely figurative tendencies. Daniel Zuloaga, Valentín de Zubiaurre, and other artists whose chronologies and work — above all the former — would have a significant effect on other artists whose works are now exhibited in the Museo Nacional Centro de Arte Reina Sofía, as in the cases of José Gutierrez Solana and Daniel Vázquez-Diaz, to name just two examples. As we have seen, the collection has been increased over the years by an unceasing flow of new acquisitions and bequests, which culminates in the exhibition of a work that is a key representation of Cubism — the *Portrait of Josette* by Juan Gris.

PORTRAIT OF A YOUNG WOMAN

This portait of an unidentified woman was acquired from Antonio Poz by the board of the Prado Museum on October 13, 1964.

This artist's extended career, combined with his astonishing precocity, led to unexpected changes in the development of his painting, to which the aesthetic milieu of his life also contributed. Thus, throughout his initial training and early work, the influence of his brother-in-law and master, Mariano Salvador Maella, is paramount and may be detected above all in González Velázquez's religious works and decorations for the royal residences. A classical stage followed, which led to a final period characterized by a clearly Romantic spirit, as shown by this work.

It is true that González Velázquez felt a certain predilection for portraits, which he produced with some frequency. The Prado owns his portrait of his father, Antonio González Velázquez, who was also a painter, Zacarías's self-portrait, acquired in 1960, and this painting of a young woman. Her dress and coiffure in the Imperial style enable us to date this canvas to around 1800.

ZACARÍAS GONZÁLEZ VELÁZQUEZ (1763–1834)
Portrait of a Young Woman, c. 1800
Oil on canvas, 45 × 35 cm

JUAN ANTONIO RIBERA Y FERNÁNDEZ (1779–1860)
Cincinnatus Leaving the Plough to Bring Law to Rome
Oil on canvas, 160 × 215 cm

CINCINNATUS LEAVING THE PLOUGH TO BRING LAW TO ROME

Traditionally this canvas has been held to be the culmination of Neoclassical Spanish painting. It was produced in Paris between 1804 and 1807, during the artist's apprenticeship with David, whose pupil he was and upon whose advice he relied for this composition. When the canvas arrived in Madrid, Charles IV was so impressed that he increased the pension the artist had been receiving since 1802 to 12,000 reales.

From this time on, the picture was moved several times from one building to another. Under Ferdinand VII it was in the now-defunct Queen's Casino, which the Madrid city council gave to the king's second wife, Isabella of Portugal. In 1863 it was ceded to the Prado Museum and for many years was exhibited on loan in the Cáceres Museum, returning to the Buen Retiro Palace just a few years ago.

The subject, quite common in European Neoclassical art, is the scene in which Lucius Quintus Cincinnatus, an honorable Roman, is called from his country home in 458 B.C. to take over the reins of power and fight against the Aequi and Volsci, who were threatening Rome. After accomplishing this, he returned to his country life, refusing all honors.

JOSÉ MADRAZO Y AGUDO (1781–1859)
The Death of Viriato, 1818
Oil on canvas, 307 × 460 cm

THE DEATH OF VIRIATO

This key work of Spanish Neo-classical painting has been enshrined within what has come to be called "historical painting." It was painted in Rome in 1818, at which place and time it was exhibited with great success. The work was then sent to Spain together with other paintings, the journey not being without incident, as the ship carrying the pictures was wrecked in the Golfe du Lyon. When the canvas was exhibited in Madrid, critical opinion was divided. It was acquired by Ferdinand VII and ceded to the Prado Museum, and later to the then defunct Museo Nacional de Arte Moderno.

The scene portrays the moment in which Viriato, a Portuguese leader who commanded a guerrilla band against the Romans (147–139 B.C.), having been recognized as the king and a friend of Rome, was assassinated by his associates and fellow countrymen, Audax, Ditalkon, and Minuro, who were hired by the Roman Cepion and surprised him sleeping in his tent. His despairing followers, who clamor for revenge, surround the corpse.

David's influence is decisive in the composition, but Madrazo's pictorial line and plasticity give the picture a quality seldom attained in European painting at this time.

COMMEMORATIVE PAINTING OF CHARLES IV'S VISIT TO VALENCIA UNIVERSITY

THE PAINTER FRANCISCO DE GOYA

THE DUKE OF INFANTADO

This work was painted by Vicente López Portaña in Valencia to commemorate the visit of Charles IV to that city's university in November 1802; it was presented to the sovereign on December 6 of the same year. Until 1935 it had been deposited by the Prado Museum in the Arts Faculty of the University of Madrid.

The compositional scheme meets the academic criteria of special eclecticism in which the traditional Baroque is combined with other elements of classical inspiration. Together with various allegorical figures of the University of Valencia and its faculties, which are protected by Minerva and crowned by Peace and Victory, several members of the royal family are seen: Charles IV and Queen María Luisa of Parma, who is seated; next to them are the prince of Asturias — subsequently Ferdinand VII — the princess of Asturias, María Antonia of Bourbon, the princes Carlos María Isidro and Francisco de Paula, and the king's brother, son of Charles III, Antonio Pascual.

The precise drawing, sumptuous chromaticism, and display of lusters and lights in the draperies, which are executed with dense and rich brush strokes, give the composition spectacular plastic results.

López painted this portrait in Madrid between May and June 1826, the period during which Goya visited the court from his retreat in Bordeaux to ask Ferdinand VII for permission to retire and to continue to obtain his full salary as First Painter, which was granted to him by the monarch with much good will.

Among the large number of portraits done by López, this is one of the freest and most spontaneous, demonstrating great psychological penetration. On this point, and as it is not overworked and given clever effects as are others by the same painter, José de Madrazo, who was present at some of the sittings, tells us that when the picture was at the stage at which we see it now, Goya said to López, "Don't touch it any more. Leave it. If you touch it, I'll run you through."

Goya is portrayed seated, more than half length, looking directly at the viewer, holding his palette and some brushes in his left hand while in his right he holds the brush he is about to use.

This portrait was given to the state by Doña María Dionisia de Vives, Countess of Cuba and Duchess of Pastrana, and accepted by royal order on October 19, 1887.

The subject, of whom Vicente López made several portraits, is shown standing, full length, wearing the uniform of captain general with decorations, against a landscape background. The index finger of his right hand points to an open map on a rock with a book, compass, and spyglass.

Pedro de Alcántara de Toledo (1773–1841), Duke of Infantado, was a valiant soldier and patriot who fought against the French in Catalonia and against the Portuguese in the War of the Oranges in 1800. After staying with Ferdinand VII in Bayonne and collaborating with Joseph I, in 1809 he decided finally to join the cause of independence against the invaders and acted proficiently in this undertaking.

The work, signed and dated 1827, constitutes one of the artist's greatest successes among his portraits. Painted in the moment of his maturity, when he was in full control of his own style in this genre, he was able to create a personal scheme that combines the resources of his academic training with uniquely interpreted Romantic echoes.

VICENTE LÓPEZ PORTAÑA (1772–1850)
Commemorative Painting of Charles IV's Visit to Valencia University
Oil on canvas, 348 × 249 cm

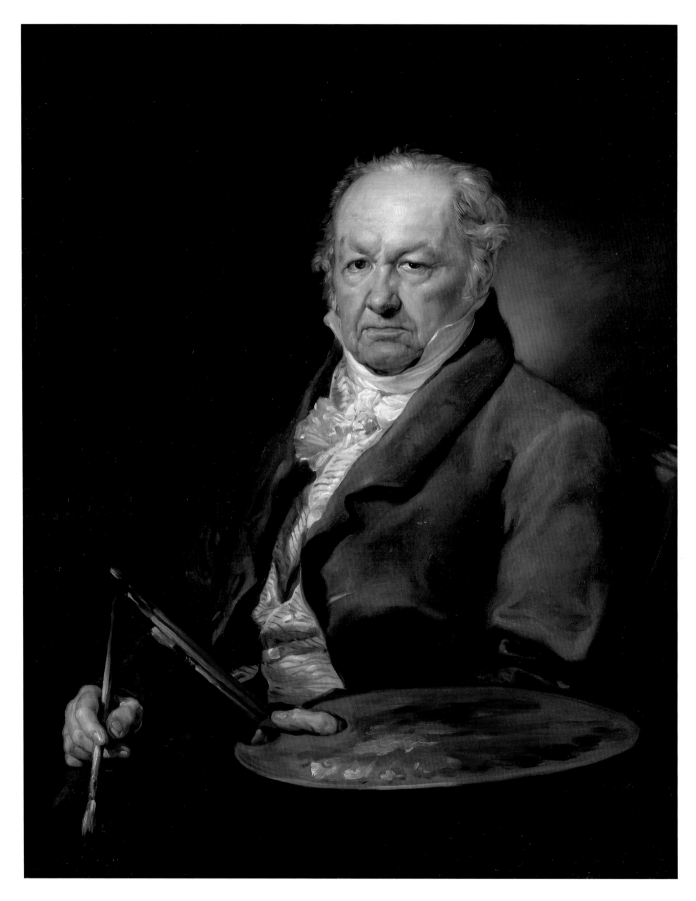

VICENTE LÓPEZ PORTAÑA
The Painter Francisco de Goya, 1826
Oil on canvas, 93 × 75 cm

VICENTE LÓPEZ PORTAÑA
The Duke of Infantado, 1827
Oil on canvas, 230 × 165 cm

LUIS LÓPEZ Y PIQUER (1802–1865)
The Goddess Juno in the House of Dreams
Oil on canvas, 515 × 515 cm

THE GODDESS JUNO IN THE HOUSE OF DREAMS

This is a sketch for a fresco in the Yellow Salon — formerly the Charles III Salon — in the Royal Palace in Madrid. Luis López was the last painter-decorator of the great circle developed in the New Alcázar, which had been started under Ferdinand VI with Corrado Giaquinto. López also painted another fresco in the palace, its symbolic subject being the virtues required by those who undertake public duties.

This work, which was described in 1829 by the painter and academic Francisco José Fabre, shows the goddess Juno — charged with watching over marriages — in a carriage drawn by two swans. At her side is Hymen, winged and carrying the nuptial torch. Completing the group are spirits who carry Juno's attributes: the yoke of matrimony and some lilies, which they are spreading. In the foreground the dreamer sleeps next to a nude boy. A rabbit, symbolizing silence, is shown, as is an owl, which stands for darkness. Bats, symbols of night, appear in the background in allusion to the dream.

The influence of Vicente López, father and teacher of this artist, is clear in the execution and chromaticism of this work. This picture was acquired by ministerial order of June 3, 1985.

THE GALICIAN PUPPET-MASTER

Alenza painted this work, together with three others in the Prado (*A Madrilenian Girl, The Compensation,* or *The Trap,* and *The Beating*), for a commission from Isidoro Llanos, an architect and a friend of the painter's. The last of these works bears an inscription on the back that calls this work *Galician with the Punch-and-Judy Show.*

It belongs to a group of scenes this artist produced concerned with local customs. His sources of inspiration are principally Goya and David Teniers. The scene takes place in a suburb of Madrid, with some humble buildings of a rural nature seen in the background. Before an audience made up of popular types, the Galician is performing wrapped in his cape, with a small boy hidden underneath to move the puppets, which peep out from the cloth while the Galician tells the story.

The tense drawing, luminosity of a great intensity, and an impasto of spontaneous effect are this canvas's most characteristic notes. It came from the Museo Nacional de Arte Moderno, but was not catalogued until 1954.

LEONARDO ALENZA Y NIETO (1807–1845)
The Galician Puppet-Master
Oil on canvas, 325 × 255 cm

THE DRUNK

Clearly inspired by Goya, this work is related to *Capricho* no. 18 (*And They Burned His House*), and the drawing *The Blindman in Love with his Filly*. It was acquired for this section of the Prado by ministerial order of February 12, 1974.

In the interior of a wine cellar several barrels are seen on the right of the composition, with a strong figure of a man wearing unkempt clothing, in front of a big pilaster, staggering due to the effects of too much drinking.

Alenza — the only artist who knew how to capture Goya's plastic spirit without imitating it as did other painters, notably Lucas — was also capable of expressing this stamp, these reminiscences, from very different premises and using the personal language of a considered palette, without concessions to facile chromatic tricks. Looking at this work, one laments yet again the unfortunate circumstances of Alenza's life, which prevented him from creating a more abundant oeuvre, although the quality of the existing works have identified him as an artist of original expressiveness who still fits within the Spanish tradition.

LEONARDO ALENZA Y NIETO
The Drunk
Oil on canvas, 22 × 16.8 cm

PORTRAIT OF A GIRL

The recent acquisition of this portrait of a child by Rafael Tejeo — other portraits by whom are also in the Casón — was made possible by funds from the Villaescusa bequest. Previously it belonged to the Felipe Rodríguez Rojas collection, where it was to be found in 1913.

A painter from Murcia, Rafael Tejeo's oeuvre is immersed in the Neoclassical tradition, although his more advanced works present some characteristics of the Romanticism that reigned during the last stage of his life. An excellent portrait artist and an exquisite draughtsman, he gives us this full-length portrait of a girl wearing a colorful dress of striped satin adorned with lace edging. In her lap are some roses, one of which she holds in her right hand. Her almond-shaped face, with large and expressive eyes, catches the viewer's attention. Her face is similar to that of the girl in the same painter's *Portrait of the Barrio Family,* also in the Casón, so she may be the same subject.

Lastly, the landscape in the background of the composition is of outstanding interest. It shows Tejeo's undeniable gifts as a landscape artist, a facet that is almost unknown.

PORTRAIT OF A GIRL

This was donated by Doña María Ascensión Elvira Villaneuva e Idígoras to the Museo Nacional de Arte Moderno and accepted by royal order in 1915.

Signed and dated 1847, it displays a landscape background that appears to be the garden of a splendid mansion. Here, a girl of perhaps five years of age is shown full length, standing, with a closed fan in her right hand and an orange in her left. Next to her, at the left of the composition, her hat with a great bow is on a rock. Behind her are two dogs. This canvas is a work of impeccable drawing and controlled chromaticism based on smoothly melted timbres.

The artist's apprenticeship in Paris with painters such as Delaroche and Gros becomes apparent in the execution of this work, as does his solid academic training in firm design, with his father, Painter to the Chamber Juan Antonio de Ribera. Perhaps his portraits do not have the weight of those by his fellow student and friend, Federico de Madrazo, but they have their own special enchantment and there is something of the idealization of reality in the limning of the faces, for which he was especially gifted, as is the case for this child, as well as for other works done from child models.

RAFAEL TEJEO DÍAZ (1798–1856)
Portrait of a Girl, 1842
(Detail)

RAFAEL TEJEO DÍAZ (1798–1856)
Portrait of a Girl, 1842
Oil on canvas, 111 × 81.5 cm

CARLOS LUIS DE RIBERA Y FIEVE (1815–1891)
Portrait of a Girl, 1847
Oil on canvas, 116 × 95 cm

The Contemporary Poets

This came from the ministry of public works, then passed to the Prado by royal order on April 17, 1886; it hung in the Museo Nacional de Arte Moderno after 1896.

It constitutes a valuable graphic testimony to Romantic Spanish literature, portraying its most distinguished representatives: poets, playwrights, journalists, scholars, etc. Esquivel repeated the theme in another work, *Ventura de la Vega Reading a Play in the Prince's Theater*.

The personages are: Antonio Ferrer del Río, Juan Eugenio Hartzenbusch, Juan Nicasio Gallego, Antonio Gil y Zárate, Tomás Rodríguez Rubí, Isidoro Gil y Baus, Cayetano Rosell y López, Antonio Flores, Manuel Bretón de los Herreros, Francisco González Elipe, Patricio de la Escosura, Count of Toreno, Antonio Ros de Olano, Joaquín Francisco Pacheco, Mariano Roca de Togores, Juan González de la Pezuela, Duke of Rivas, Gavino Tejado, Francisco Javier de Burgos, José Amador de los Rios, Francisco Martínez de la Rosa, Luis de Valladares y Garriga, Carlos Doncel, José Zorrilla, José Güell y Renté, José Fernández de la Vega, Luis de Olona, Julián Romea, Manuel José Quintana, José de Espronceda, José María Díaz, Ramón de Campoamor, Manuel Cañete, Pedro de Madrazo y Küntz, Aureliano Fernández Guerra, Ramón de Mesonero Romanos, Cándido Nocedal, Gregorio Romero Larrañaga, Duke of Frías, Eusebio Asquerino, Manuel Juan Diana, and the artist himself, who is seen in front of his easel, painting. The scene is the painter's studio, which displays various paintings, sculptures, and easels.

Esquivel achieved a fully Romantic atmosphere in this work, in addition to a unique gallery of portraits excellently done.

Rafaela Flórez de Calderón as a Child

This is a pendant to the portrait of the subject's brother, Manuel, who gave both paintings to the Museo Nacional de Arte Moderno in 1911. It is undoubtedly one of the most beautiful portraits of a girl in Spanish Romantic painting.

She is shown full length, standing, her right forearm resting on a large cage while a parrot perches on her left hand. As Joaquín de la Puente said, "it does not matter that the background is a mere curtain of hollyhocks or plants that look like them, with an archly composed vase on a pedestal. The girl is everything. She dominates as an exemplar of Romantic childhood, with her parrot friend on her hand. Quiet, unmoving and animated at the same time."

Once more, Esquivel displays his great gifts as a portrait artist, a specialty in which he would reach a level difficult to match, that combined the perfect drawing of a Neoclassical tradition with a Romantic, intimate interpretation of his subjects in their most varied and distinct attitudes.

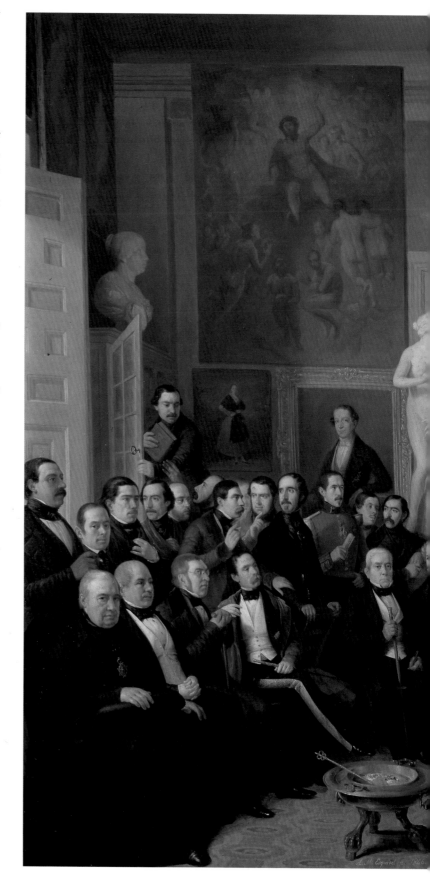

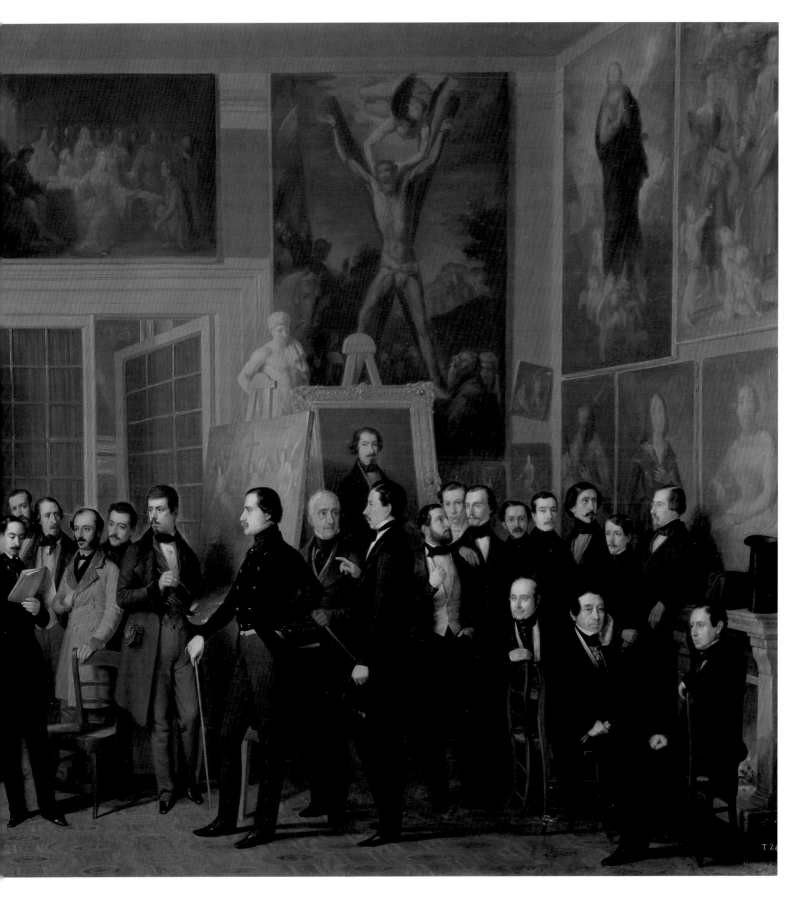

ANTONIO MARÍA ESQUIVEL Y SUÁREZ DE URBINA (1806–1857)
The Contemporary Poets, 1846
Oil on canvas, 144 × 214 cm

ANTONIO MARÍA ESQUIVEL Y SUÁREZ DE URBINA
Rafaela Flórez de Calderón as a Child
Oil on canvas, 138.5 × 105 cm

FRANCISCO LAMEYER (1825–1877)
Interior with Moors
Oil on panel, 38 × 54 cm

INTERIOR WITH MOORS

This painting was bequeathed by Xavier Lafitte in 1930 to the now defunct Museo Nacional de Arte Moderno. It is much in line with the works created by Spanish artists in what is called Orientalism, a genre in which Lameyer acquired special importance due to the frequency and effectiveness with which he practiced this specialty.

We see in this work a group of Moroccans sitting peaceably in a little street of an old native quarter. The quality of the execution demonstrates once more the neglect of Lameyer and the unjust disregard of his work that stems from the lack of serious and specialized studies. His great gifts of illustration are evidenced in this work of such calm technique, smooth and penetrating.

That he was an impeccable copyist and follower of Goya in part of his oeuvre appears in these Oriental scenes, but he possessed his own plastic language and a contemporary aesthetic totally opposed to the world of Goya. The chromatic richness and variety that he developed in these Oriental themes place him, as Camón Aznar has said, on the level of the French Orientalists.

This work was part of the bequest of Arturo Ambland to the Museo Nacional de Arte Moderno, which was accepted by the board on April 24, 1921.

It represents an unidentified scene, in which we see a female figure — without doubt a queen — kneeling before a prelate and surrounded by numerous people in court dress in the fashion of the seventeenth century. Although the scene has not been identified, Enrique Arias thinks that there can be no doubt of its character as an historical painting, and calls it *Ceremony in the Chapel of the New Kings in Toledo Cathedral,* the exact place in which the action takes place within this cathedral. Margarita Nelken calls it a "marvel of impressionism," believing that it is clearly the most advanced application to painting of Chevreuil and Helmoltz's theories on the composition of the solar spectrum.

JENARO PÉREZ VILLAAMIL (1807–1854)
Interior of Toledo Cathedral
Oil on canvas, 160 × 108 cm

JENARO PÉREZ VILLAAMIL
Gaucin Castle
Oil on canvas, 147 × 225 cm

GAUCIN CASTLE

This landscape was acquired from the painter's son by royal order on April 26, 1864, for a price of 1,500 pesetas. It was purchased for the Museo Nacional de la Trinidad, whose director had written a report in which he said, "this picture, if not among the greatest, is one of those in which the manner and the personal nature of all the works of the landscape artist Villaamil are most marked…one of the works that most clearly reveals his style, his manner, his rich imagination, his fervent fantasy, and the free or disorganized manner in which he worked." For Margarita Nelken, it was the most typically Romantic of this artist's works.

The scene shows a group of bandits near their hideout, watching some travelers in the ravine. In the background, facing a great plain, arises a huge crag surmounted by Gaucin Castle. Pérez Villaamil's great gifts as a landscape artist come together here with his Romantic temperament to portray a subject that is as much a legend of the period as that of the Andalusian bandits.

VILLAGE BULLFIGHT

CONDEMNED BY THE INQUISITION

ENCHAINED

In fact, this deals more with an enclosure of bulls than with a bullfight. This canvas and other works by this artist that are hung in the Museum were bequeathed to the now defunct Museo Nacional de Arte Moderno in 1968 by María de los Angeles Sáinz de la Cuesta, Countess of Los Moriles, in memory of her husband, Juan Vitorica Casuso.

In front of a phantasmagorical landscape in which are set various rural buildings, and under a sky of heavy storm clouds, a multitude of little figures scurry along as they herd the fighting bulls. The group with the mounted picador jabbing a bull with his lance is outstanding. From purely Impressionist criteria, the dynamism of the short brush strokes, the chromatic vivacity with which each person is shaped, and the impasto and unexpected resolutions Lucas uses with such elegance, make this work one of the bullfight scenes of greatest expressive force among the wide range of his paintings of this genre. Throughout his life, he dedicated many paintings, watercolors, and sketches to the subject, always paying attention to every detail related to the national festival.

Condemned by the Inquisition was acquired by resolution of the Fine Arts Direction General on February 24, 1984.

Lucas dedicated several compositions to the subject of the Inquisition, which, for him, had an important reference point in the works of Francisco de Goya, for whom Lucas held a great admiration. He studied Goya's technique intensively, to the point that many of his works were attributed to his predecessor for many years, even by the great Goya specialists.

This one, which is part of the catalogue of Lucas's oeuvre, is one of the most spectacular and well-achieved. Through the artist's use of fine drawing, it shows the passing of the condemned men, who are mounted on asses, their torsos bared and scourged, wearing the conical hats of those who have been condemned by the high court, amidst a crowd that surges and shouts at their passing. The muffled figure in the right foreground stands out in his arrogant posture and gaudiness.

The dramatic chromaticism contributes actively to the impression of tragedy that Lucas infuses into this dramatic scene, which he would have seen in his childhood — the Court of the Holy Office was not abolished until 1828, when the painter was nine years old — leaving a tremendous impression on his subconscious.

This work comes from the Board for the Recovery of Works of Art from the Spanish Civil War of 1936–1939. It was inventoried for the first time in 1954 in the Museo Nacional de Arte Moderno.

Inspired by several drawings, paintings, and engravings by Goya — intimately related to the print from the Caprichos called The Prisoner, a proof of which is kept in the National Library — the scene shows a murky dungeon where a woman lies exhausted, undoubtedly from having suffered torture. She is attended by another female figure of sinister aspect.

The light contributes to the sordid atmosphere the artist sought and achieved in this composition. The chromatic range of great richness and the material Lucas was able to use from his pre-Impressionist ideas give the painting a plastic strength of highest quality. This strongly dramatic work, with its clear Romantic accents, is outstanding, placing it among the most interesting by the artist.

EUGENIO LUCAS VELÁZQUEZ (1817–1870)
Village Bullfight, 1862
Oil on canvas, 28.5 × 39.2 cm

EUGENIO LUCAS VELÁZQUEZ
Condemned by the Inquisition
Oil on canvas, 77.5 × 91.5 cm

EUGENIO LUCAS VELÁZQUEZ
Enchained
Oil on tinplate, 33.5 × 40.8 cm

MANUEL BARRÓN Y CARRILLO (1814–1884)
River Landscape with Figures and Cattle, 1850
Oil on canvas, 79.5 × 140.5 cm

RIVER LANDSCAPE WITH FIGURES AND CATTLE

Together with another canvas of the same date by this artist — *River Landscape with Figures* — this work was acquired with funds from the Villaescusa bequest, thus filling an important gap in landscapes of the Spanish Romantic school. Before its acquisition, the works of this important landscape painter from Seville were lacking, though he was undoubtedly the most outstanding artist of his time from the Andalusian school.

An early work, although not one from the artist's youth, this was painted with care and meticulous technique. It is an idealized landscape made up from different influences, in which the broad banks of a river with trees are highlighted. The human element, characteristic of a Romantic countryside, is found in this case in the little figures in the boats on the river, and in the washerwomen. Cows and other animals graze in the foreground, tended by shepherds.

The painting is in its original and unusual gilded frame, which contributes to its brilliance and interest.

FEDERICO DE MADRAZO Y KÜNTZ
(1815–1894)
The General Duke of San Miguel, 1854
Oil on canvas, 210 × 135 cm

FEDERICO DE MADRAZO Y KÜNTZ
Amalia de Llano y Dotres, Countess of Vilches, 1853
Oil on canvas, 126 × 89 cm

THE GENERAL DUKE OF SAN MIGUEL

Coming from the Prado Museum, from which it was moved in 1896 to the now defunct Museo Nacional de Arte Moderno, this portrait is signed and dated 1854. It portrays the famous general full length, standing, wearing a uniform with decorations, a sword at his belt. His left hand rests on a book on the table. To the left, on a chair, are his hat, gloves, and general's baton.

A soldier of great liberal and patriotic spirit, he fought against the French in the War of Independence. After he was minister of state, from 1822 to 1823, it passed subsequently to the opposition and he had to return to arms to fight the French "hundred thousand sons of St. Louis" and the Carlists. Again in 1837 he became minister of war and the navy, obtaining this portfolio for a second time in 1842. He wrote the lyrics of the "Hymn to Riego" and a biography of Philip II.

This portrait of strong and clear characterization shows the subject through Madrazo's psychological perception and strong realism. The work is impeccable in the execution of the drapery and the decorations.

AMALIA DE LLANO Y DOTRES, COUNTESS OF VILCHES

This portrait was left to the Prado Museum by the second count of Vilches, son of the subject. It was put into the national picture gallery in 1944 after a time when it was in the possession of the count of La Cimera.

In this portrait of impeccable execution, Amalia de Llano y Dotres, Countess of Vilches (1821–1874), is seen more than half length, seated on an elegant chair, leaning her right arm on the chair's arm as her fingertips brush her cheek. In her left hand she holds a fan. While the influence of Ingres is very clear, above all in the treatment of the fabrics and the effects of light, the fluency of the brushwork and the magical impasto set Madrazo's art firmly within the great Spanish tradition.

The subject, who became countess of Vilches through her marriage in 1839, had had an exquisite musical and literary education and published several novels, among which the most important was *Berta y La Lidia*. Respected by critics and writers, on her death in 1879 many articles were published in the press praising her work. Notable among them was the poem signed by Antonio Canovas del Castillo and published in *La Ilustración Española y Americana*.

The rich chromaticism of delightful contrasts, starting from the brilliant and shaded blue of the dress, contributes to the fortuitous result of this painting.

THE HORSE YARD OF THE OLD BULLRING IN MADRID, BEFORE A BULLFIGHT

At the first Exposición Nacional de Bellas Artes in 1856 this picture received an honorable mention; it had been shown previously in the Paris Universal Exhibition of 1855. The work was acquired by royal order on April 2, 1867, by the Spanish state.

Juan Sánchez de Neira identified some of the personalities who appear. The toreadors include Francisco Arjona Herrera ("Cuchares"), Francisco Montes ("Paquiro"), and José Redondo Domínguez ("Chiclanero"). The picadors Pepe Muñoz Domínguez, Juan Alvarez Buen ("Chola"), José Trigo, Bruno Azaña, and Mariano Cortés are also present. Also depicted are the banderilleros Angel López, Julián Casas "Salamanquino," Cayetano Sanz, Matías Muñiz Cano, and Mariano Antón, as well as various enthusiastic followers and bull-fighters' agents.

This bullring, demolished in 1875, was near the Puerta de Alcalá and was built from plans drawn by Ventura Rodríguez and Fernando Moradilla to a commission from Ferdinand VI.

In the subgenre of bullfight painting, this image came to be one of the works of greatest interest. It takes place just moments before the bullfight begins, making it an instant archetype for a series of later such pictures.

MANUEL CASTELLANO (1826–1880)
The Horse Yard of the Old Bullring in Madrid, before a Bullfight, 1853
Oil on canvas, 168 × 245 cm

CHRISTOPHER COLUMBUS IN THE
CONVENT OF LA RÁBIDA

EDUARDO CANO DE LA PEÑA (1823–1897)
Christopher Columbus in the Convent of La Rábida, 1856
Oil on canvas, 228 × 260 cm

This canvas gained the first medal in the first Exposición Nacional de Bellas Artes in 1856. It was acquired by the government for the Museo de la Trinidad by royal order of August 7 of that year, and was subsequently deposited in the Palace of the Senate, where it was in 1881.

The theme of the canvas — the first of the famous pictures of Spanish historical painting — is summarized in the text by the painter himself, which was sent for publication in the exhibition catalogue: "Columbus is conferring with Father Fray Juan Pérez de Marchena and some pilots from the port of Palos, telling them of his certainty that the shortest way to the Indies is to the west, which is indicated by his gesture."

The work was painted in Paris where Cano de la Peña was living, and one notes the definite influence of French artists, particularly in the models. The painter's luminous treatment seems to flood the whole room, as he was seeking to produce an appropriate atmosphere from the filtered reflections coming from the leaded lights in the background.

MANUEL CABRAL Y AGUADO BEJARANO (1827–1891)
Corpus Christi Procession in Seville, 1857
Oil on canvas, 152.5 × 243.5 cm

CORPUS CHRISTI PROCESSION IN SEVILLE

This picture received an honorable mention in the Exposición Nacional de Bellas Artes of 1858. It was acquired by the state by royal order of February 1859.

Within the Romantic genre of local Seville customs, the painting displays the façade of the cathedral of that city at the moment when the Arfe monstrance emerges under the typical awnings and before a colorful throng. A military group, mounted and on foot, gives the appropriate salute. The duke of Montpensier, Antoine-Marie Louis Philippe of Orléans (1824–1897), son of the king of France, is seen on a dais with his wife Louisa Fernanda de Bourbón (1832–1897), daughter of Ferdinand VII and sister of Isabella II.

The work was displayed for the first time in the Seville exhibition of 1857 with great success. The achievement of the remarkable luminosity that floods the whole scene is perhaps the most successful aspect of the work. The figures lack precise drawing and movement, which makes the composition seem to be an instant captured from an agreeable perspective. It lacks mobility, but not an enchanting capacity to evoke Romantic echoes.

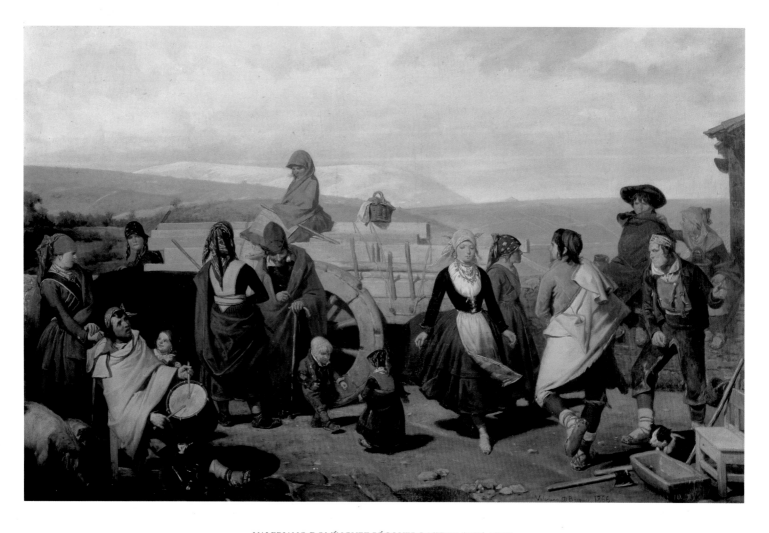

VALERIANO DOMÍNGUEZ BÉCQUER BASTIDA (1834–1870)
The Dance, 1866
Oil on canvas, 65.5 × 110.5 cm

THE DANCE

This work is also known as *The Wagon* and was painted by the artist to comply with his commitment to the state after he obtained a government pension in 1865. The painting was delivered by Bécquer two years later. It was in the now defunct Museo de la Trinidad from which it passed to the Prado on May 4, 1878; subsequently, it was moved to the Museo Nacional de Arte Moderno.

A group of people, dressed in the regional costume of the province of Soria, are dancing animatedly near a wagon. A brilliant luminosity bathes the composition, which is full of grace and dynamism, its figures arranged with a definite scenographic sense.

During his short career, Valeriano Domínguez Bécquer showed himself to be a consummate colorist, which is especially manifest here. The canvas is also observed with a conceptual simplicity that surprises the viewer. As has been pointed out, he is the first artist in the genre of local customs to deal with these scenes from a realist viewpoint and not through the eyes of a seeker of superficial or topical festivals.

This canvas was acquired by the board of the now defunct Museo Nacional de Arte Moderno following a resolution of August 3, 1946.

Gutiérrez de la Vega is undoubtedly one of the painters of greatest interest — if not the most outstanding — in the religious genre of the nineteenth century. He was a dedicated follower of Murillo, whose technical, aesthetic, and iconographical premises he was able to modernize from a fully Romantic perspective, as is shown in this work.

The popular religious tradition that had existed in Seville over the years is summarized in this painting, which shows St. Catherine of Alexandria in a glorification of her life and martyrdom. Catherine, who is considered to be the patron saint of philosophers, defended her faith before Emperor Maxentius and was martyred in the year 307. Beside her are her attributes — the wheel of knives on which she was tortured and the sword by which she finally died, which here is held by an angel together with the palm of her spiritual triumph.

The suppleness of the brush strokes, textures shaded with skillful veiling, precision in the clothing, and the delicate atmospheric tone that pervades the composition combine to give the work a singular enchantment.

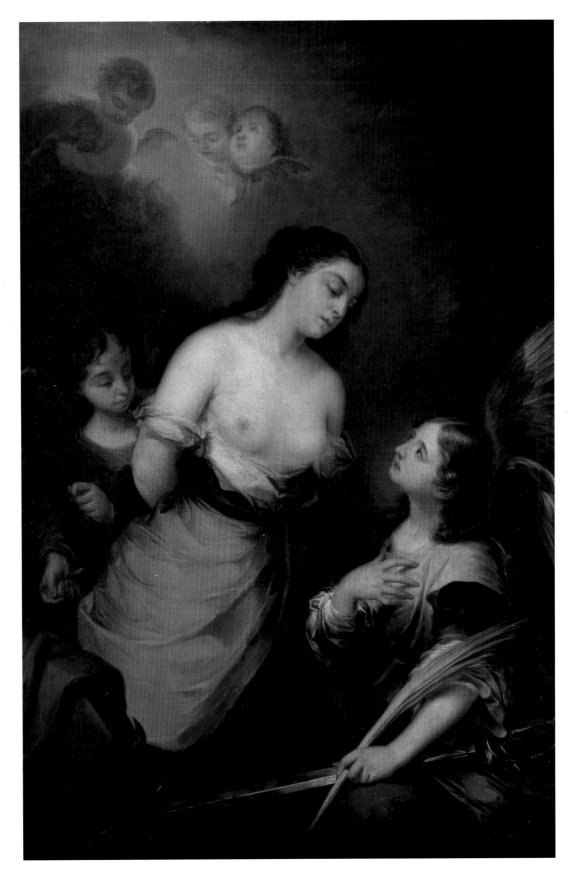

JOSÉ GUTIÉRREZ DE LA VEGA (1791–1865)
St. Catherine of Alexandria
Oil on canvas, 153.3 × 104.3 cm

Considered to be one of the most outstanding works of Spanish historical painting, this was painted by Rosales in Rome between 1863 and 1864, when he was twenty-eight years old. It was shown at the Exposición Nacional de Bellas Artes of 1864, where it gained the first medal. After this success, Rosales showed it in the Paris Universal Exhibition in 1867, where he not only won a gold medal but was awarded the Legion of Honor through the express wish of Napoleon III.

In 1877 an etching of it was made by Bartolomé Maura y Montaner. Many preparatory notes and drawings are known, as is an excellent sketch that is also in the Casón. There has been no unanimity of the critics regarding the identification of the figures except for that of the Catholic queen. Rosales used the *History of the Catholic Kings* by Prescott as his literary source of inspiration.

With this painting Rosales leaves behind artifice and the scenographic conventionalisms of the Spanish historical painters and returns to the great naturalistic tradition of Spanish painting. This, together with his own technical resources, infuses a plastic feeling seldom achieved in Spanish art, except, of course, for those works by the great artists of the Spanish Golden Age.

This work was acquired for the now defunct Museo Nacional de Arte Moderno by royal order of May 31, 1916.

During the last part of the nineteenth century, the theme of the African war was tackled by several Spanish artists, most notably Mariano Fortuny. Rosales presented this painting as an entry to the sketch competition for this historical event set up from April to July 1868 by the duke of Fernán Nuñez, which was won by Vicente Palmaroli.

Rosales's canvas was painted with a smooth and supple technique and a sketchlike character that, in view of the taste of the time, would have been difficult for the panel of judges to understand, which explains their preference for Palmaroli's entry, with its greater precision in drawing and its being better adjusted to the cultural view of the moment.

The battle of Tetuán took place on February 4, 1860, between Moroccan troops commanded by Muley-el Abbas and Muley Ahmed, brothers of the sultan, with forty thousand men, and the Spanish troops under the orders of General O'Donnell, supported by Juan Prim, Antonio Ros de Olano, Mackenna, Galiano, and Ríos.

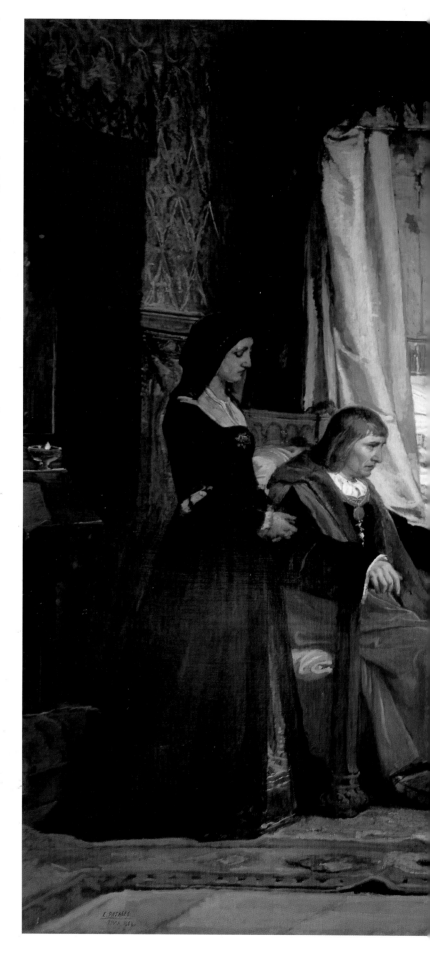

EDUARDO ROSALES GALLINAS (1836–1873)
The Testament of Isabella the Catholic, 1864
Oil on canvas, 290 × 400 cm

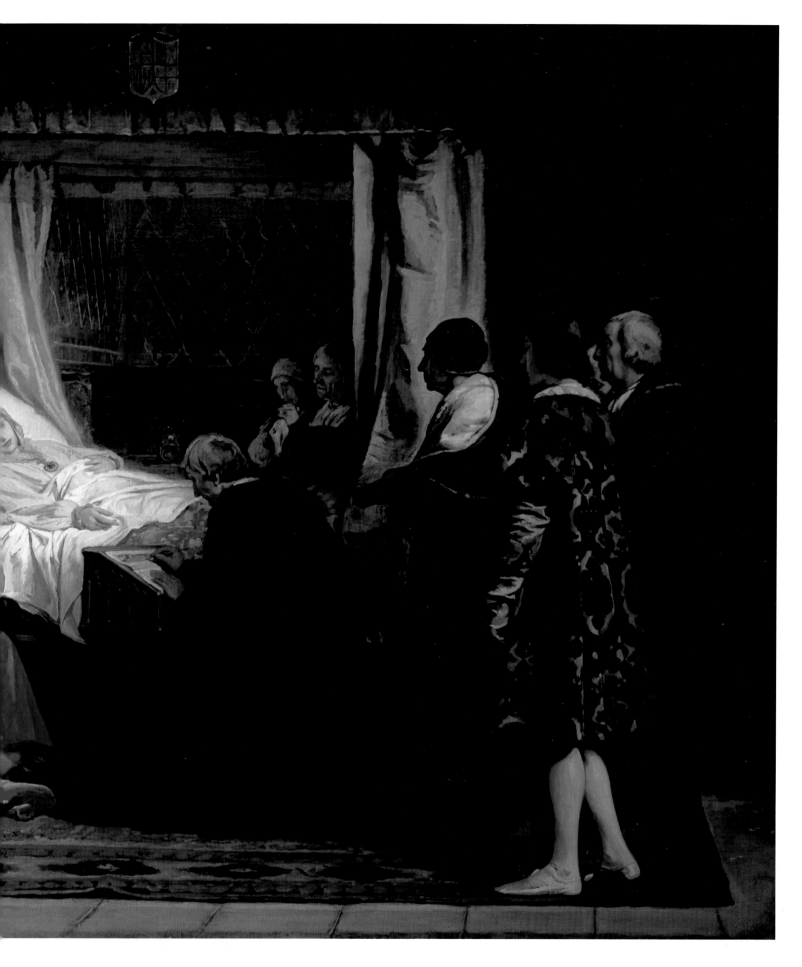

EDUARDO ROSALES GALLINAS
Episode from the Battle of Tetuán, 1868
Oil on canvas, 75.5 × 125 cm

This work was acquired by royal order of June 12, 1878, and is considered to be the most beautiful nude in Spanish painting after the *Rokeby Venus* of Velázquez, which is in the National Gallery in London.

The model, drying herself, appears with her back to the viewer. Rosales, experimenting with the priming, composes this simple scheme to achieve delicate and effective results based on a dematerialization of the volumes, demonstrating an ability to synthesize that we find only in artists such as Manet. Never has so much in art been achieved with so little material; never has a form so rotund as that of this bather been obtained with the plastic simplicity reflected in this canvas.

The model was an Italian woman, Nicolina, who posed for Spanish artists living in Rome, where this masterwork of European painting was created in 1869. It is deliberately unfinished, and what is expressed is correct and sufficient — it does not lack a single brush stroke. The overflowing sentiment Rosales was able to infuse into this magisterial nude is enough.

EDUARDO ROSALES GALLINAS
Female Nude, 1869
Oil on canvas, 185 × 95 cm

THE BATTLE OF WAD-RAS

This painting was acquired by royal order of June 29, 1878, for the now defunct Museo Nacional de Arte Moderno.

The scene is one of the best-known successes of the African war, the Battle of Wad-Ras, which took place on March 23, 1860. Fortuny himself was present, and this painting, executed between 1862 and 1863, is based on the sketches he had made directly during this battle between the Spanish and the Moroccans, which signaled the end of the conflict when Prince Muley-el-Abbas, brother of the sultan of Morocco, was obliged to sign a peace treaty with O'Donnell, who was the vanquishing general acting in the name of Spain.

In this picture, Fortuny achieves a scenic dynamism that has seldom been matched. This is helped by a sketchlike technique, with strong chromatic effects of vibrant contrasts, plays of light, and supple impasto.

The movements of the many figures that are depicted demonstrate by their attitudes the harshness of the battle and the spirit of terrifying combat in which more than fifty thousand Muslims took part.

MARIANO FORTUNY Y MARSAL (1838–1874)
The Battle of Wad-Ras, c. 1862–1863
Oil on canvas, 54 × 185 cm

MARIANO FORTUNY Y MARSAL
The Artist's Children in the Japanese Salon, 1874
Oil on canvas, 44 × 93 cm

THE ARTIST'S CHILDREN IN THE JAPANESE SALON

IDYLL

This work came to the Prado Museum in 1952, through the gift of Mariano Fortuny y Madrazo (1871–1949), son of the artist, who appears in the picture as a child. He was a painter, photographer, designer, and engraver who lived in Venice for the greater part of his life.

A key work in the artist's oeuvre, this canvas fetched a price of 35,000 francs in the sale of a part of his works that took place in Paris in 1875. It was painted in 1874, between Portici and Rome.

The scene is set in one of the rooms of the painter's house, where the young Mariano appears with a bare torso and a mask on his head. His sister, María Luisa, is reclining, dressed in white and holding a fan in her right hand.

The delicacy and smoothness of execution, replete with Oriental echoes, make this painting a tribute to the great interpreters of the Japanese style. The conception of the floral elements, the dematerialization of the volumes, and the subtle suggestion of the forms all give the picture an unusual enchantment, and render it a true aesthetic abstraction.

This work was left to the Prado Museum, along with other important works by Fortuny and other painters, in 1904 by Ramón Errazu.

A nude shepherd boy is seated on a red cloth draped over a ruin, playing a double pipe. This became a popular subject, and the artist himself made an engraving of it.

The technical qualities Fortuny achieved in the watercolor, the emotional intimacy, the aesthetic decadence of the subject treated in such an unusual way, and the contrasts in light that he attained are the fundamental characteristics of this masterwork.

With a delicate refinement that never falls into the syrupy excesses of his contemporary Italian colleagues, he shaped this delightful composition in which exists nothing of grandiloquence or pedantry, in spite of the nature of the subject. We find none of the errors committed by so many painters who undertook such themes during those years. On the contrary, everything appears fresh and graceful, in a timeless re-creation of what one could believe to be a mythological vision.

MARIANO FORTUNY Y MARSAL
Idyll, 1868
Watercolor on paper, 31 × 22 cm

LANDSCAPE

FEMALE NUDE

In the field of nineteenth-century Spanish landscape painting — between the typically Romantic works and the approaches instituted by the novelties of Carlos de Haes — we have in Martí Alsina one of the most interesting artists, who was, in the Catalan panorama, the painter able to get closest to nature through extreme naturalism. Purely self-taught, Martí Alsina was, nevertheless, a great master, and his example was followed by all the Catalan artists who came to the genre of landscape with these renewed ideas. When Ramón Vayreda came to Martí Alsina's class in La Lonja, having attended the classes of earlier artists, he wrote, "From the first lessons I saw a new world extending before me, with broadening horizons." In addition, and as can be appreciated in this work, Alsina was an extraordinarily gifted painter, with a great facility for line and a sense of color that he used to bring near to us every bit of nature that is found in his paintings.

This work comes from the Mangrane collection in Barcelona, where it was in 1941; it appeared in the special exhibition of the artist's work of that same city and year. After remaining on the market for some time, it was acquired by ministerial order on June 11, 1981, from María del Dulce Nombre Casanovas Sánchez for the Prado Museum.

In an interior, a full-length nude female figure is shown seated on a chest covered with a cloth of great chromatic richness, painted with Impressionist effects. Some writers believe that the woman here is a biblical character, perhaps Bathsheba or Susanna, but the somewhat provocative expression on her face and her attitude as she enters a swimming pool make us think that she is more likely to be a courtesan. This is supported by the definite tone of sensuality the artist has infused into the modeling of her body, with its voluptuous hips and delicate, luxurious skin.

RAMÓN MARTÍ ALSINA
Landscape
(Detail)

RAMÓN MARTÍ ALSINA (1826–1894)
Landscape
Oil on canvas, 112 × 205 cm

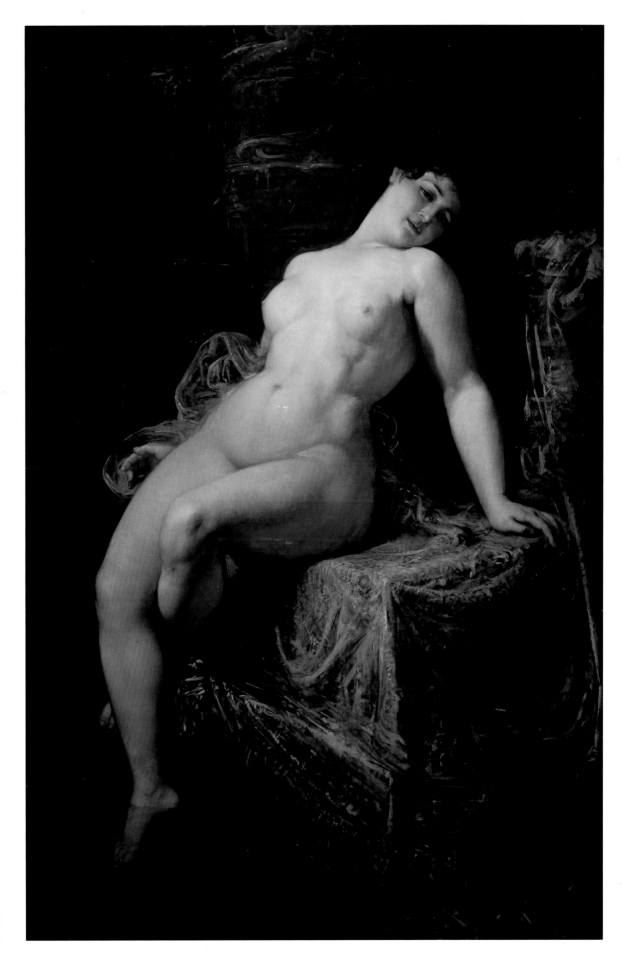

RAMÓN MARTÍ ALSINA
Female Nude
Oil on canvas, 167 × 111 cm

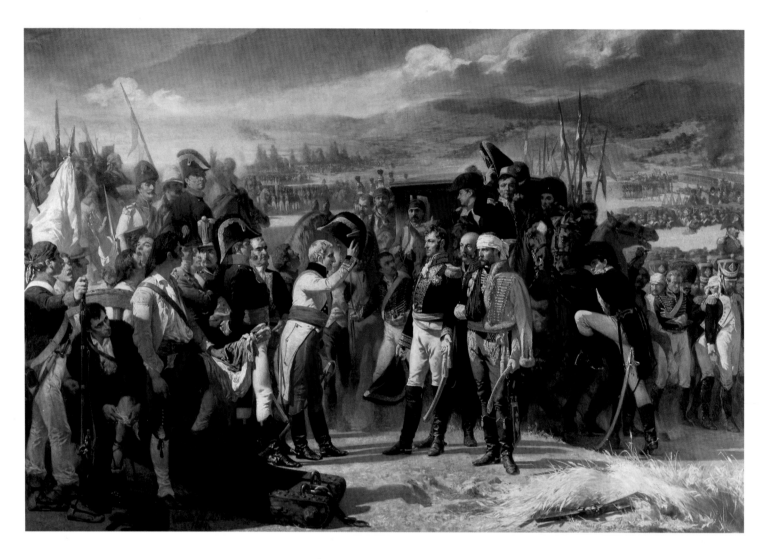

JOSÉ CASADO DEL ALISAL (1832–1886)
The Surrender of Bailén, 1864
Oil on canvas, 338 × 500 cm

THE SURRENDER OF BAILÉN

Casado obtained the first medal in the Exposición Nacional de Bellas Artes of 1864 with this composition, and it was acquired by Isabella II for her collection. In 1921, Alfonso XIII donated it to the Museo Nacional de Arte Moderno.

The picture narrates the moment in which, after the defeat suffered by the Napoleonic troops at the hands of the Spanish during the War of Independence, General Pierre Dupont appeared before General Castaños for the signing of the capitulation, which took place on July 22, 1808. This decisive victory caused Joseph Bonaparte I to leave Madrid, although he returned shortly afterward.

The picture, which was painted by Casado de Alisal in Paris, presents a compositional scheme that draws from the *Surrender of Breda* by Velázquez, maintaining the same chivalrous spirit of the victors in front of the vanquished. Next to General Castaños are shown General Reding, the marquis of Compigni, Marshal Jones, General Peña, Colonel Mourgeon, and the count of Valdecañas; among the French, in addition to Dupont, is General Vedel.

For this work, without doubt one of the key pieces in the section of historical painting, Casado del Alisal carried out extensive research into his subject — both the iconography of the individuals and the appearance of uniforms and their decorations — before actually producing the painting.

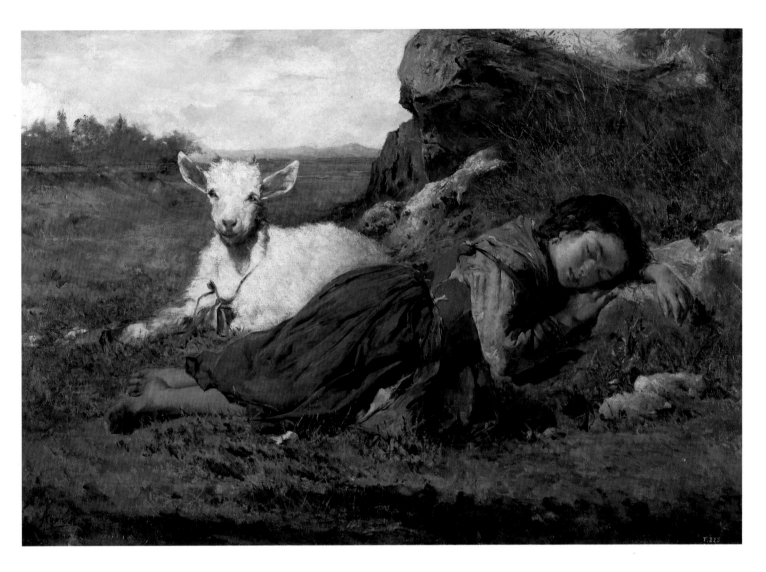

JOAQUÍN AGRASOT Y JUAN (1837–1919)
The Two Friends, 1866
Oil on canvas, 100 × 145 cm

THE TWO FRIENDS

This work by the artist from Alicante gained the second medal in the Exposición Nacional de Bellas Artes of 1867 and was acquired by royal order of May 3, 1867. It was painted in Rome in 1866, as is indicated by the signature. Mariano Fortuny helped with the execution, assisting with the painting, as was the habit among companions living in the Eternal City.

The simplicity of the subject does not preclude the intimacy and delightful impression that is created in the viewer. A shepherd girl sleeps on a rock in an idyllic landscape; beside her sits one of the sheep from her flock.

An intimate friend of Fortuny and of the members of his circle, Agrosot y Juan nevertheless maintained an aesthetic and technical independence from Fortuny, whose influence was decisive for so many young Spanish artists living in Rome. However, a decided refinement, or better, meticulousness, in the line and in the resulting forms, and a predilection for light effects of a definite theatricality, were the consequences of this relationship.

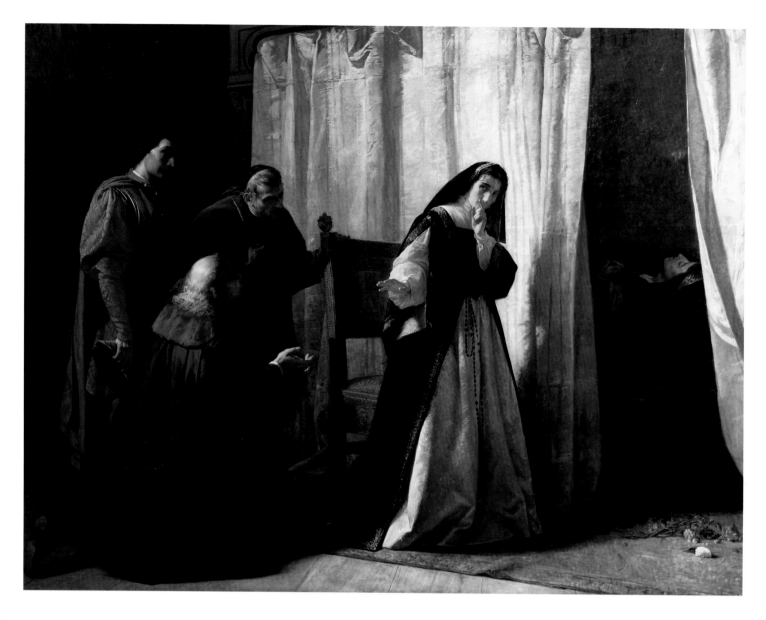

LORENZO VALLÉS (1831–1910)
The Madness of Doña Juana, 1867
Oil on canvas, 238 × 313.5 cm

THE MADNESS OF DOÑA JUANA

This work was acquired by royal order of May 3, 1867. It was shown in the Exposición Nacional de Bellas Artes, which was held on this date, and it was awarded the second medal. Subsequently it was presented in the Vienna Universal Exhibition of 1873 and in Philadelphia in 1876, when it gained new awards.

From the notes that appeared in the catalogue of the Spanish exhibition, we know that the literary source used by the artist for this composition was the *Epistolas* of Pietro Martir de Angleria, in particular the following paragraph: "The queen had the body of her husband, Philip the Handsome, taken from the sepulcher and placed in her bedroom on a rich bed, as she recalled that a certain Carthusian monk had told her of a king who had revived after being kept for fourteen years, and she did not leave his side for a moment, awaiting the happy instant of seeing him return to life. All the efforts of the most respected members of her court were ineffective in dissuading her from her mania; she always answered them that they must keep silent and hope that her lord would soon awake."

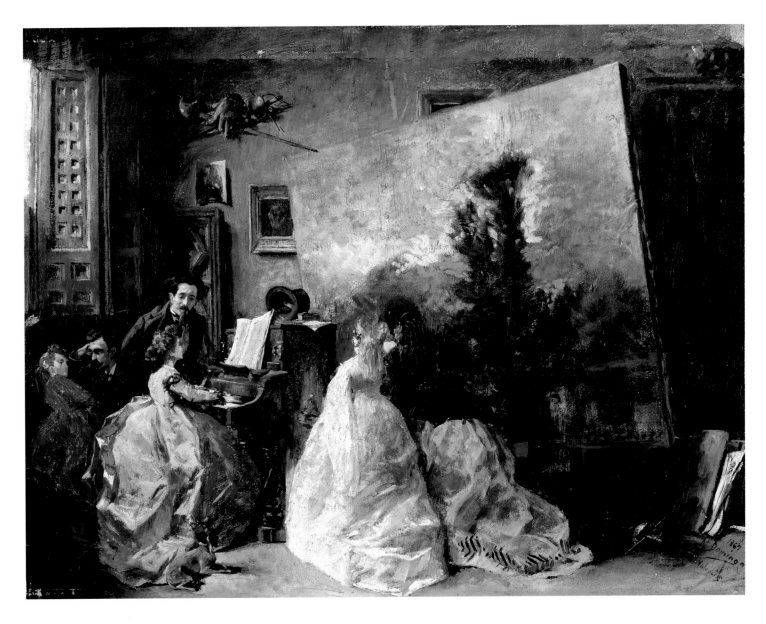

FRANCISCO DOMINGO MARQUÉS (1842–1920)
Interior of Muñoz Degrain's Studio in Valencia, 1867
Oil on canvas, 37 × 50 cm

INTERIOR OF MUÑOZ DEGRAIN'S STUDIO IN VALENCIA

This work was acquired by ministerial order in 1940 for the former Museo Nacional de Arte Moderno.

The picture, signed and dated in Valencia in 1867, shows an everyday view of the studio of Muñoz Degrain, a fellow painter from Valencia, whom we see leaning on a piano at which a young girl is playing a piece of music. The big painting occupying the center of the composition is the *Landscape of El Pardo* by the artist himself, which is preserved in the Casón.

Domingo uses his gifts of execution to their full extent in order to pay tribute to the great painter for whom he feels an admiration that was always reciprocated. But this does not mean that he is confined or solemn; on the contrary, here he displays, in a way that is seldom seen in his works, all his capacity and knowledge of color and line, offering one of the most free and spontaneous canvases, which is, of course, also full of feeling and typical of its time.

SELF-PORTRAIT

This work was signed and dated in 1884 and acquired by the Museo Nacional de Arte Moderno by ministerial order of 1964.

The artist is seen seated, in profile, greater than half length, holding the palette in his left hand and his brush in the right, working on a canvas on a stretcher.

Domingo Marqués painted several self-portraits during his long career and this is one of the best. Although much smaller and only of his head, an earlier version, from 1865, is also kept in the Casón del Buen Retiro.

This one is rich in the way it displays his extraordinary pictorial faculties and his unique facility for the "speckling" of a painting. Domingo Marqués used this plastic treatment first so that he then could shape the picture with sure, exact brush strokes, in a truly prodigious freshness of line and generosity of purpose. The setting is one of great sensitivity and of some novelty.

FRANCISCO DOMINGO MARQUÉS
Self-Portrait, 1884
Oil on canvas, 118.5 × 90 cm

DIÓSCORO DE LA PUEBLA TOLÍN (1831–1901)
The Daughters of El Cid, 1871
Oil on canvas, 232 × 308 cm

THE DAUGHTERS OF EL CID

Shown in the Exposición Nacional de Bellas Artes in 1871, this work was later acquired by the state from the artist on February 12, 1874.

We know from the artist himself that he used the Romance XLIV from the *Tesoro de Romanceros* as a literary source, in particular the following verses: "They cry to the heavens for justice from the counts of Carrión, the two daughters of El Cid, Doña Elvira and Doña Sol. Tied to an oak tree, they cry out for compassion; there is no answer but the echo of their voices."

A certain Nazarene air surrounds these figures, as Joaquín de la Puerta saw; Dióscoro de la Puebla was in Rome at the same time as the principal representatives of this style, and was much influenced in his youth by that artistic current.

The seminude daughters of El Cid are portrayed with their hands tied, desolate in their abandonment in a landscape of luxuriant foliage. The shaded greens of dense tints contrast with the clarity of the clothing and the flesh tones of the bodies of Elvira and Sol.

Although the artist did not receive an award, he was granted the María Victoria cross. The definitive sketch for this painting was preserved in the Vindel collection.

This painting comes from the
Ramón de Errazu collection in Paris.
The benefactor left it to the Prado
Museum and it was accepted by royal
order of December 12, 1904.

The picture was painted in the
artist's mature period, during his stay
in Granada (1871–1872) with
Mariano Fortuny, whose influence is
felt in the refinement of detail
attained in the execution of this
work, and also in the luminous
clarity filling the scene.

The vantage point for this
landscape is from the flat rooftop of a
building annexed to the Alhambra,
where three children play peacefully
under the caresses of an almost
blinding sun. The rendering of the
Moorish palace gives a good
indication of its condition at the
beginning of the century, before the
massive project that restored it to its
original appearance. Among
admirably depicted leafy gardens,
with an almost naturalistic interest,
the silhouette of the Generalife
Palace rises in its Mediterranean
solemnity in the background.

MARTÍN RICO Y ORTEGA (1833–1908)
The Ladies' Tower in the Alhambra, Granada, 1871–1872
Oil on canvas, 62.5 × 39 cm

MAJO

This work was bequeathed to the Museum by Juan Bautista Robledo, and came to the Casón in 1981.

A *majo,* shown full length, standing, a cigarette in his left hand, is dressed in the fashion of the eighteenth century, the period in which the composition is set. Rural buildings in the background are very much in the line of the cartoons for tapestries executed by the painters for the Royal Tapestry Manufactory of Santa Bárbara. Behind the primary figure, a *maja* is seen from the back, while the presence of other figures is suggested in the background. On the left is a kind of wooden construction, on which we can see the end of an inscription, RCIO, and the flag of Spain; we understand that these are the last letters of the word *Tercio* and thus it has to do with a village bullring.

The scene comes within the category of Goya-style painting, which Lizcano produced with relative frequency, recreating scenes of the period in the manner of an eighteenth-century plebianism that, as Ortega had already noted, surprised contemporary Madrilenian society. A singularly attractive chromaticism enlivens this commemorative image of an earlier era, with its gossiping, traditional courtiers.

ÁNGEL LIZCANO MONEDERO
(1846–1929)
Majo, 1876
Oil on canvas, 79.5 × 49.5 cm

Queen Juana la Loca, Confined in Tordesillas with Her Daughter, Princess Catherine

Signed and dated in 1906, this canvas was painted many years after the completion of the great canvas concerning the same queen that won for Pradilla the 1878 medal of honor in the Exposición Nacional de Bellas Artes. This canvas was acquired for the Prado Museum by ministerial order of May 31, 1990.

As indicated by an inscription on the back, the literary source the artist used was "the historical studies by Antonio Rodríguez Villa for the Royal Academy of History." For the architectural disposition of the chimney, the painter used an engraving from *La Ilustración Española y Americana,* which showed the palace belonging to the duke of Frías.

Once again, Pradilla took special care with the reproduction of objects, clothing, and other details of orientation, utilizing an historical, almost cinematographic, sense. Above all, his use of chromaticism and light effects provide the exact atmosphere, the precise ambience, to bring us into the sad, lifelong confinement to which the sovereign was destined, as she watched over the corpse of her husband, which was to remain in the castle until her death.

Juana la Loca

This work was awarded the medal of honor — the first to be awarded — in the Exposición Nacional de Bellas Artes of 1878 and obtained the identical award in the Universal Exhibitions in Paris in 1878 and in Vienna in 1882. The complete title the painter gave it was *Juana la Loca Traveling from the Cartuja de Miraflores to Granada Accompanying the Coffin of Philip the Handsome.*

The success this canvas achieved at the time stimulated its engraving that same year by Arturo Carretero Sánchez and in 1885 by Bartolomé Maura y Montaner. Taking advantage of the success gained by the painting, Emilio Serrano wrote an opera in nine acts entitled *Juana la Loca.* The composition was reproduced for the cinema by Juan de Orduña in 1948 in his film *Locura de amor* (Mad for Love).

Pradilla prepared the work in his Roman studio, meticulously making sketches, notes, and drawings for its execution. Among the preparatory works is the outstanding sketch the artist gave to his friend Jaime Morera, which is in that artist's museum in Lleida.

Queen Juana is shown standing in a chilly dawn looking absently at the bier of her husband. Her clothing is ruffled by the wind; smoke from the dying fire rises behind the tragic figure. Near her, in the arid landscape, are several ladies, priests, and courtiers who have remained faithful to their queen. In the background a monastery is seen in silhouette. The gray storm clouds give a strong sense of plasticity.

Baptismal Procession for Prince Don Juan, Son of the Catholic Kings, Through the Streets of Seville

This work, a bequest of Luisa Ocharán, was accepted by the Spanish state on July 23, 1991, and came to the Prado Museum together with the same artist's *Queen Juana la Loca Confined in Tordesillas with Her Daughter, Princess Catherine,* which we can consider to be the final historical painting done by one of the most renowned artists of this genre.

This canvas was almost unknown until its arrival in the Prado. As in the artist's earlier historical paintings, Pradilla's strict discipline is made clear when we study each of the elements that make up the picture — the apparel of the individuals and the objects and effects displayed in this large work, which is filled with incidental details. His use of light and shade is remarkable; they produce an unusual effect and tend to clarify a composition that would otherwise seem to be too busy and variegated.

Preceding pages:
FRANCISCO PRADILLA ORTIZ (1848–1921)
Queen Juana la Loca, Confined in Tordesillas with Her Daughter, Princess Catherine, 1906
Oil on canvas, 85 × 145.5 cm
(Detail on facing page)

FRANCISCO PRADILLA ORTIZ
Juana la Loca, 1878
Oil on canvas, 340 × 500 cm

FRANCISCO PRADILLA ORTIZ
Baptismal Procession for Prince Don Juan, Son of the Catholic Kings, Through the Streets of Seville, 1910
Oil on canvas, 193 × 403 cm

THE PEAKS OF EUROPE: THE MANCORBO CANAL

This work was acquired by royal order of August 10, 1876; the date and signature appear on the canvas.

A background of high mountains under a pure sky with small clouds gives this work a special solemnity. The light falls upon a craggy hill, at right, which is depicted with precise accuracy, while trees in a backlight, on the left, break the rocky tone of the composition. Though its naturalism and realism give this work the appearance of having been executed directly from nature, in reality it was not, and it is among the works painted in the studio from sketches made earlier.

With Haes, we come to the end of the period of Spanish landscape painting that was characterized by its picturesqueness, following the ideas of Villaamil. From this point on, nature is portrayed in all its awesome reality. Starting from the European ideas Haes brought to Madrid, the era of Romantic ideas in the genre of landscape painting was thus concluded.

CARLOS DE HAES (1826–1898)
The Peaks of Europe: The Mancorbo Canal, 1876
Oil on canvas, 168 × 123 cm

CARLOS DE HAES
Tileworks in the Principe Pio Mountains
Oil on canvas, 39 × 61 cm

TILEWORKS IN THE PRINCIPE PIO MOUNTAINS

This work was part of the legacy that Haes's disciples gave to the Spanish state. It was in the Museo Nacional de Arte Moderno in 1900. Later, through ministerial order of April 22, 1933, it was deposited in the Escuela de Magisterio in Madrid, returning to the Prado on May 6, 1981.

A geological exactitude — a study in depth of every bit of nature that this painting reflects — has as its consequence an approach to the reality of landscape in each part captured on the canvas. This amounts to a precise and exact reproduction of the whole that avoids idealistic interpretation or conventional and gratuitous accessories.

As Gaya Nuño has said, "[Haes] seems more a naturalist than a painter, and, moreover, there is something, even much, to be admired in the total commitment of this blond and handsome Dutchman to his philosophy of traveling all over Spain and recording places until then completely unknown. He was the discoverer of the Spanish countryside, and for that alone we should honor his memory."

JAIME MORERA GALICIA (1854–1927)
Snowy Bank of Lake Trasimeno
Oil on canvas, 42.7 × 61.2 cm

SNOWY BANK OF LAKE TRASIMENO

This picture is also known as *Snowy Beach,* which is a mistaken title. It was acquired by the Spanish state by royal order of June 1, 1882.

The imprint of Carlos de Haes, creator of modern Spanish landscape painting and Morera's master, is evident in this work in which the artist created a landscape scene of undoubted novelty, executed with the freshness of the direct sketch from nature. The artist made numerous preparatory works before painting this definitive version.

A definite coldness certainly pertains to this painting, but Morera was striving more to bring the exact observation of nature — its definitive capture and faithful interpretation — to his works. A palette of measured tones serves as a basis for a work of elaborate nuance and the studied chromaticism he gave each one of his works, which make this painter outstanding as the key artist in the development of this genre in Spain. He became one of the most vital links in the continuation of the road paved by Haes, and he has not been evaluated at his precise worth.

THE MODEL RESTING

This work took the third medal in the Exposición Nacional de Bellas Artes of 1876, in the catalogue of which it is listed with a triple title: *The Rest, The Painter's Studio,* and *What Will She Think?* It was acquired by royal order on May 23, 1876, for the Museo Nacional de Arte Moderno.

Although Casimir Sáinz is considered to be one of the most important landscape artists in the history of nineteenth-century art, we find some works of great quality in other genres in his oeuvre. Unfortunately, the artist's life was ruined when he suffered an acute mental illness that confined him to a psychiatric hospital at the age of thirty-four. He died eleven years later.

This work shows the artist drawing in his studio (we know of several self-portraits) and, at his side, the model resting during the sitting. A refinement in the manner of the master Palmaroli marks the execution of this painting, which is meticulously constructed, with an attention to detail very far from the fluency of brushwork typical of the greater part of his landscape paintings. The filtered light in the room illuminates the picture with a delicate effect, giving it an atmosphere of placid serenity.

CASIMIRO SÁINZ Y SÁINZ (1853–1898)
The Model Resting, 1876
Oil on canvas, 62 × 51.5 cm

VICENTE PALMAROLI GONZÁLEZ (1834–1896)
The Concert, 1880
Oil on canvas, 47.5 × 67.5 cm

The Concert

Also known as *Chamber Music, Intimate Conversation,* and *Charming Meeting,* this work belonged to the Bauer collection, from which the painter's son, Vicente Palmaroli Rebulet, acquired it in 1931. He bequeathed it to the now defunct Museo Nacional de Arte Moderno.

This canvas falls within the category of the "conversation piece" — an evocation of the eighteenth century that was very much to the taste of artists in the last part of the nineteenth century. The composition is centered on a sofa, where a woman wearing a mantilla and holding a fan in her right hand reclines. Two gentlemen stand behind her. All are listening to a musician playing an early form of guitar, who is seen seated on a stool on the left. On the wall, in a rocaille frame, is a reproduction of a Rubens painting, *The Virgin Surrounded by Saints,* the original of which is in the Antwerp museum. The Prado has a smaller version, which came from the Escorial and which Palmaroli used as his model.

Executed with refined design and meticulous drafting, the atmosphere infused into this scene by the artist is of special delight.

JOSÉ MORENO CARBONERO (1860–1942)
Prince Charles of Viana, 1881
Oil on canvas, 310 × 242 cm

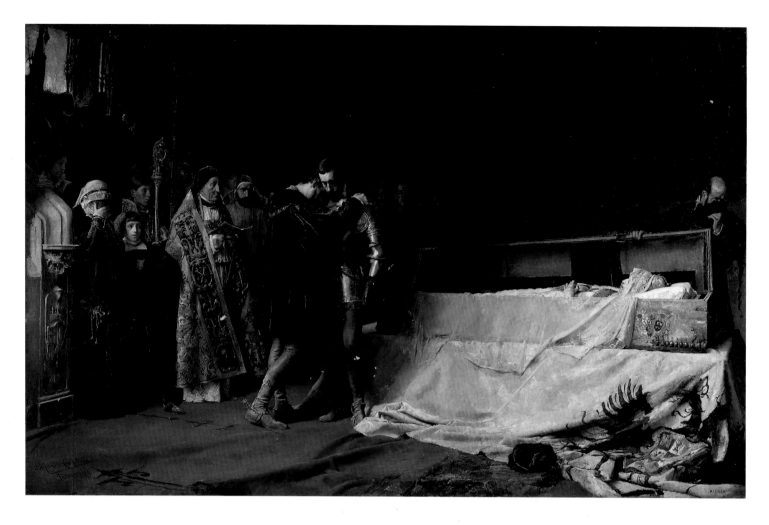

JOSÉ MORENO CARBONERO
The Conversion of the Duke of Gandía, 1884
Oil on canvas, 315 × 500 cm

PRINCE CHARLES OF VIANA

THE CONVERSION OF THE DUKE OF GANDÍA

This is an early work by Moreno Carbonero, who produced it when he was twenty-one years old. It was nevertheless awarded the first medal in the 1881 Exposición Nacional de Bellas Artes. The textual source of inspiration was V. Gebbardt's *Historia General de España,* (vol. IV, chapters 1 and 52).

The subject was the eldest son of Juan II of Aragon and Doña Blanca of Navarre. Although Charles was heir to the throne, he fell into his father's disfavor after the latter's second marriage, to Juana Enríquez, mother of Ferdinand the Catholic. The prince of Viana was imprisoned by his father and, in his seclusion, devoted himself to study. Later he

fled to France and took refuge in the court of his uncle, Alfonso V of Naples, living in a monastery close to Messina. It is this period the present painting represents. With the help of some Catalans he returned to Spain, but was again imprisoned by his father in Lleida in December 1460. He died the following year.

This story was retold during the Romantic period in various literary, pictorial, and musical works, as the nature of the plot was in accord with the taste of the movement.

The precocity and extraordinary pictorial ability of Moreno Carbonero brought him another first medal, this one when he was twenty-four, in the Exposición Nacional de Bellas Artes of 1884. In fact, this medal-winning painting was executed by the artist as the obligatory final exercise for the scholarship he enjoyed in Rome.

As with all the great historical compositions, Moreno Carbonero conscientiously prepared the definitive work, making four preparatory studies, among which the most outstanding is dedicated to his friend, painter Vicente Palmaroli, and is kept in the museum of the Royal San Fernando Fine Arts

Academy. After the painting's success in the Madrid exhibition, it was shown in several international exhibitions and garnered further awards.

The scene depicts the moment when Francisco de Borja, Duke of Gandía, faces with astonishment the putrefied corpse of Empress Isabella, wife of Emperor Charles V, and decides to leave the court and join the Jesuits. The pathos of the sequence is captured by Moreno Carbonero with raw realism, making manifest the drama of the composition in all its aspects.

On a few occasions, as in this work, the subject is of so little importance that it appears to be purely incidental. The work is a clear example of the fruitful efforts of José Jiménez Aranda, without doubt one of the most significant Spanish painters of the second half of the nineteenth century. He was responsible for the creation of a full and broad range of works, among which his superb landscapes are outstanding, as are the many varied and witty "conversation pieces," for which he won several awards.

Of subtle and exact drawing, this particular work was done in Paris, where he lived between 1881 and 1890. It shows us a lively wooded landscape with the trunk of an old, dead tree amidst the springtime budding branches of young trees and blackberry bushes. Each knot and bit of dried bark is meticulously described.

This painting was acquired by the Museo Nacional de Arte Moderno by royal order of 1903.

JOSÉ JIMÉNEZ ARANDA (1837–1903)
The Old Tree Trunk, 1885
Gouache on paper, 48 × 32 cm

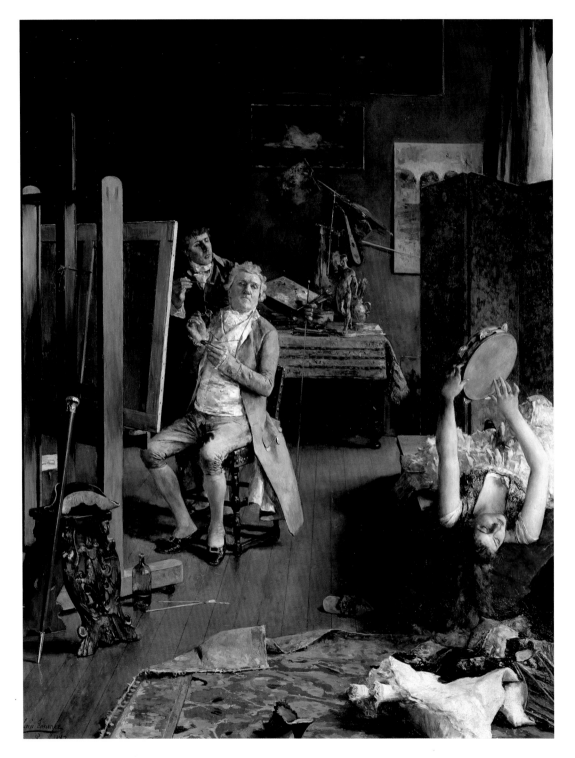

IN THE ARTIST'S STUDIO

This work was acquired by the Spanish State by ministerial order of May 11, 1976. It is typical of the so-called "conversation piece" genre, an evocation of eighteenth-century atmosphere, which Spanish artists frequently produced toward the end of the nineteenth century.

The painter is seen in front of his easel, capturing the image of the model to the right, who reclines on a divan and plays a tambourine. A gentleman is watching the artist at work. Various elements give the work a baroque air.

The regularity and control so characteristic of Jiménez Aranda's technique come out clearly in this work, which, in spite of the affectation and the ingenious arrangement of the subject, has a dignity of execution based on a treatment of sure lines and definitive brush strokes, making us move beyond a first impression of superficiality.

LUIS JIMÉNEZ ARANDA (1845–1928)
In the Artist's Studio, 1882
Oil on panel, 46 × 37 cm

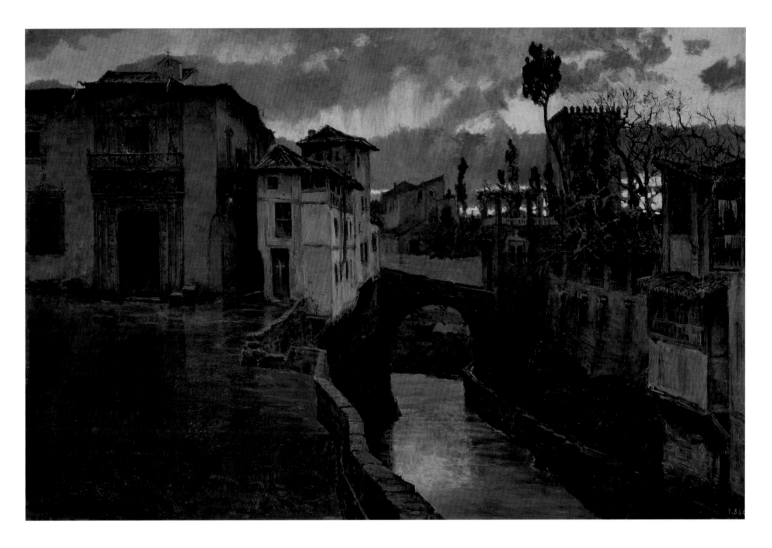

ANTONIO MUÑOZ DEGRAIN (1840–1924)
A Shower in Granada
Oil on canvas, 95 × 145 cm

A Shower in Granada

This was acquired by the state by royal order of Janaury 31, 1882, for the Museo Nacional de Arte Moderno.

Besides his great gift for painting works on historical themes, the singular personality of Muñoz Degrain led him to cultivate a mode of landscape painting that was completely distinct from that of the naturalistic painters of his time. He offers us some moments — as in this example — where the interpretation of the Impressionist formulas then being used by Spanish artists disappears altogether, producing instead pictures in which symbolic and modernist echoes combine through a technique of unassailable modernity.

Here, the romantic and beautiful impression of the Acera del Darro on a rainy day offers a new and original vision, due precisely to that plastic quality that characterizes the works of Muñoz Degrain. His habitual chromaticism was not understood by critics in the first half of the twentieth century, but from today's perspective, it takes on an aspect of timeless colors of considerable validity.

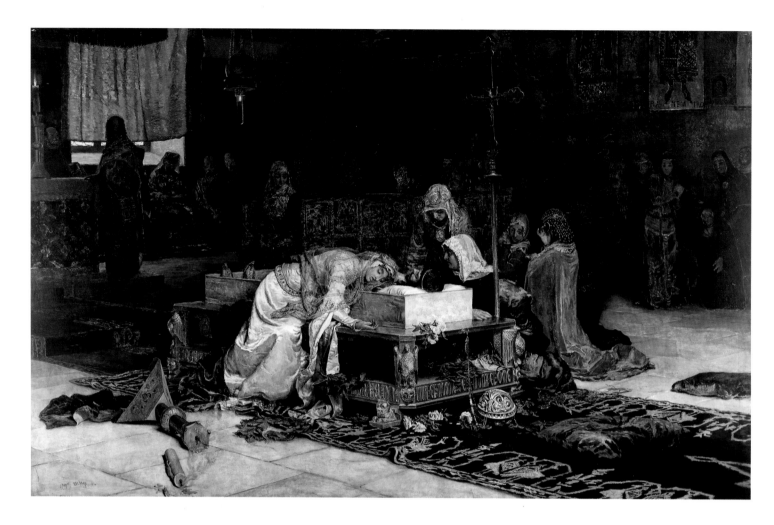

ANTONIO MUÑOZ DEGRAIN
The Lovers of Teruel, 1884
Oil on canvas, 330 × 516 cm

The Lovers of Teruel

With this work the artist obtained the first medal in the Exposición Nacional de Bellas Artes in 1884. The canvas was acquired by the state in accordance with the royal order of June 19, 1884.

Corresponding to what Gaya Nuño regards as the second period of historical painting, the picture tells the truly romantic story of the young lovers, Isabella de Segura and Diego Juan Martínez de Marcilla, whose relationship was opposed by their parents. The tragedy that unfolds and ends with the death of both refers to historical fact, and comes close to Shakespeare's *Romeo and Juliet*.

After the success of the painting in the exhibition — and using a text by Hartzenbusch that was certainly Muñoz Degrain's inspiration for the painting as well — an opera by Tomás Bretón was performed in the Royal Theater in Madrid in 1889.

Echoes of a symbolic modernism emanate from this large canvas. The Valencian artist, working in Rome, meticulously prepared the scenography, both from the archaeological and historical points of view and in terms of plastic considerations. He made numerous sketches and drawings and undertook two unfinished works, one of which is in the Museo de San Pio V in Valencia.

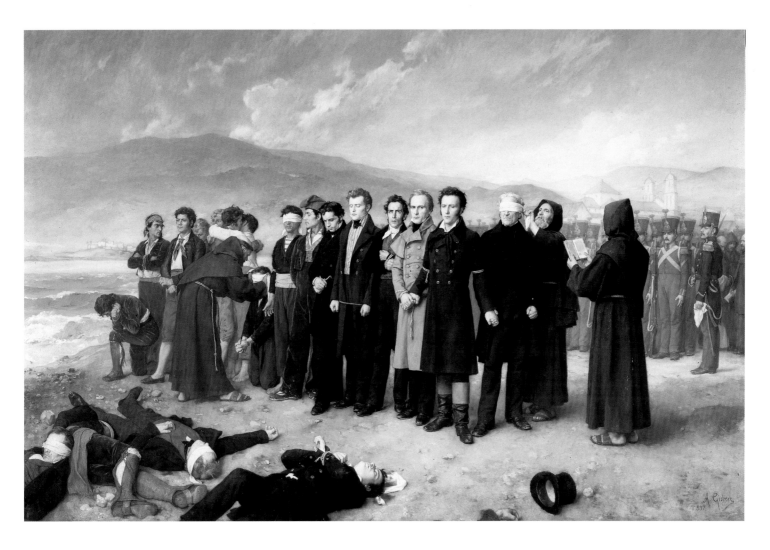

ANTONIO GISBERT PÉREZ (1834–1901)
The Execution of Torrijos and His Companions, 1886–1888
Oil on canvas, 390 × 600 cm

THE EXECUTION OF TORRIJOS AND HIS COMPANIONS

This work was commissioned from the artist by the government, in accordance with a royal order of January 21, 1886. It was finished two years later and came to the Prado Museum on July 28, 1888.

One of the best-known historical paintings, it portrays the shooting of the Liberal José María Torrijos (1791–1831) and his companions on December 11, 1831, by the governor

of Málaga, Vicente González Moreno, after the failure of the uprising against the absolutist policy of Ferdinand VII. Their capture was brought about by the duplicity of the governor, who made them believe that he would collaborate with them against the monarch.

Torrijos was a brave soldier with a patriotic spirit, who participated in the rising against the Napoleonic

troops in Madrid on May 2, 1808. Two years later he was appointed lieutenant-colonel for his military actions in Vich, and was captured and imprisoned in Tortosa, then later moved to France. He escaped and returned to Spain to enlist under the command of Wellington, with whom he fought valiantly. After the accession of Ferdinand VII and the Liberal Three Years of 1820–1823, he

began a strong political career, which caused his banishment, condemnation, and, finally, his execution.

This profoundly poignant picture brings together the ingredients of the genre: atmospheric tone, precise iconography, and scenographic sentiment in the disposition of the composition. The realism of the persecution in the scene is outstanding.

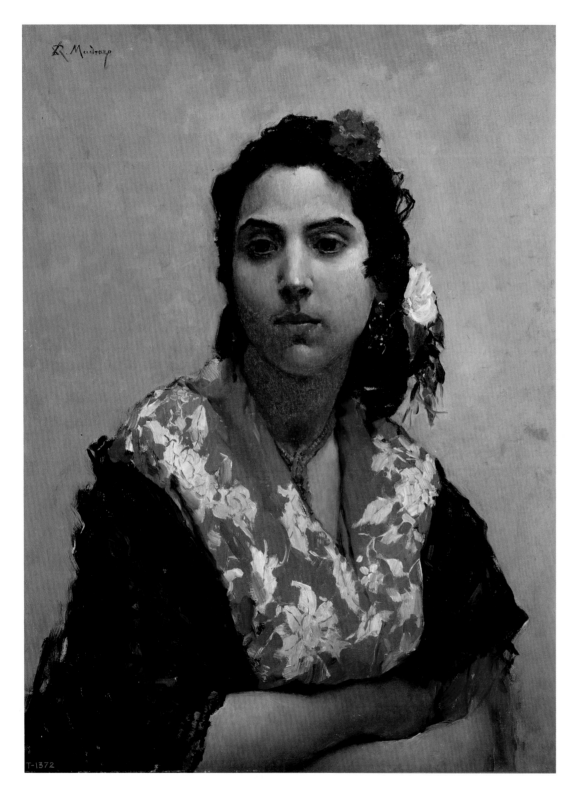

A GYPSY

This was part of the bequest of Ramón de Errazu to the Prado Museum, together with other works by this artist. It depicts a young gypsy girl, almost half length, with her arms crossed. The black of the mantilla she wears on her shoulders contrasts with the red dress with its pattern of white flowers.

Besides the smooth creation of easy brushwork, there is a formal configuration in the scheme of this painting that reminds us of the works of the painter's father, the outstanding Spanish portrait artist Federico de Madrazo. In the works of Raimundo, perhaps, we can see that he suffered from the plastic firmness of his father's works, but the younger painter was able to add a spontaneous suppleness and a chromaticism that reinvented ranges and shades, and thus enriched each and every one of his delicious works with unsuspected, simple chromatic nuances. Above all, when he painted the female model he did not need the accentuated representation or personality of a portrait. Any unknown face could arouse his spirit, his ability to transmit the whole meaning of a face, of a grimace or a smile, with its true value, without the unnecessary pedantry that was so much in vogue in portraiture at the time.

RAIMUNDO DE MADRAZO Y GARRETA (1841–1920)
A Gypsy
Oil on canvas, 65 × 49 cm

THE MODEL ALINE MASSON
WITH A WHITE MANTILLA

Ramón de Errazu bequeathed this canvas to the Prado Museum together with other paintings by Raimundo de Madrazo and other artists in 1904. It displays the sitter half length, smiling, wearing a white mantilla on her head and a red-and-blue bow in her hair. Reclining slightly, she rests her right cheek on her hands.

Aline Masson was the artist's favorite professional model and he painted numerous canvases of her in the most diverse attire and poses. In this case it would seem that he was seeking to capture the true personality of the girl, leaving her free from all artifice, making this an intimate and reposed portrait in which the influence of his Parisian master, Leon Cogniet, is clear.

We must not forget that it is precisely in female portraits that Raimundo de Madrazo offers his greatest creations. Gaya Nuño points out that the portraits of Aline Masson always result from a great agility in the brushwork that "other painters of the time tried in vain to imitate."

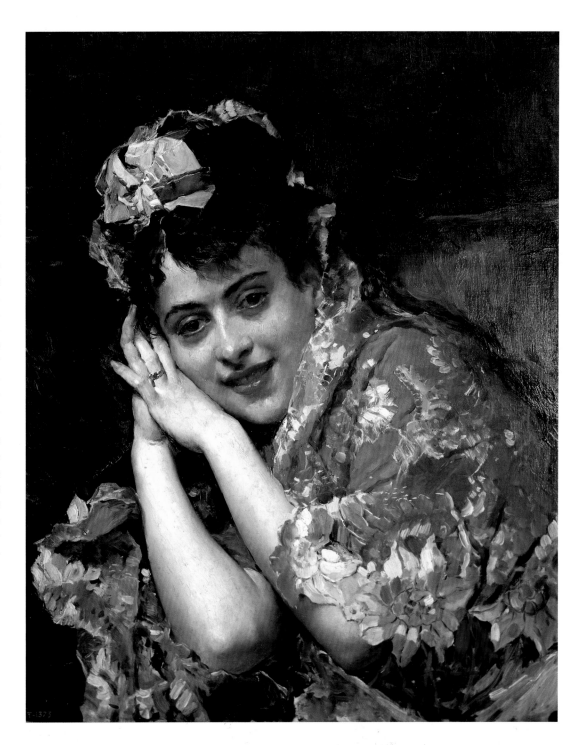

RAIMUNDO DE MADRAZO Y GARRETA
The Model Aline Masson with a White Mantilla
Oil on canvas, 65 × 52 cm

FRANCISCO MASRIERA MANOVENS (1842–1902)
Young Woman Resting, 1894
Oil on canvas, 41 × 55 cm

YOUNG WOMAN RESTING

This canvas was bequeathed by María Barrios Aparicio, Marchioness of Vistabella, Dowager Marchioness of la Ensenada, to the Museo Nacional de Arte Moderno in 1953, where it arrived on May 27, 1960. It was painted in 1894.

A woman is portrayed reclining on a couch, smoking, while she languidly fans herself with a Japanese fan, in an atmosphere of decadent Orientalism that was very fashionable in Europe at that moment.

The precision of the drawing, the hyper-realistic criterion that guides the artist, enables him to achieve effects of high quality in this field. This may be seen in the lace on the model's clothing and the fine modeling of the face and arm where she holds the cigarette. The whole composition is novel and of great originality.

The chromatic air cooperates actively to perpetuate the realistic impression sought by the artist. The ease and skill with which Masriera depicts the garments is displayed with subtle variations, without concession to unnecessary detail or tactile qualities of a silky impression.

JOAQUÍN SOROLLA Y BASTIDA (1863–1923)
And They Still Say Fish Is Dear!, 1895
Oil on canvas, 153 × 204 cm

AND THEY STILL SAY FISH IS DEAR!

This work was awarded the first medal in the Exposición Nacional de Bellas Artes of 1895. It was acquired by the state for the Museo Nacional de Arte Moderno, for 4,000 pesetas, by royal order of August 12, 1895. It was also known as *The Injured Fisherman.*

This painting belongs in the genre that took on subjects of a social nature at the end of the nineteenth century. Several such works won awards in the national exhibition of 1892. Here, in a simple boat, two elderly fisherman attend to another much younger fisherman — almost a boy — who has suffered an accident.

The size of the painting, much smaller than the historical paintings or the stormy, hard landscapes of previous national exhibitions, is appropriate to the more intimate nature of the composition. The tones are dark, with the lighting effects perfectly marked by the lantern, which, although we cannot see it, illuminates the back of one old fisherman and the torso of the injured youth. The atmosphere is appropriate and real, and the image includes many elements connected to the occupation of fishing as well as other accessories, such as a large barrel, which occupies the center of the composition, and the fish, which are portrayed in the left part of the canvas.

MARÍA GUERRERO

Acquired by resolution of the board of the now defunct Museo Nacional de Arte Moderno on February 17, 1933, this portrait of the famous Spanish actress María Guerrero (1868–1928), was painted and dedicated by Sorolla in 1906, at a moment when the career of the subject — who was called "the grande dame of the stage" — was at its zenith.

It represents the actress performing one of her great roles — the protagonist in *La dama boba,* by Lope de Vega — and wearing a farthingale. The canvas was clearly inspired by that of the *Infanta Margarita* by Velázquez. Here was an opportunity for the artist to render tribute to the great painter from Seville with a dematerialized technique of winged plasticity in the depiction of the attire, with rounded and subtle brush strokes.

In the background we see her husband, Fernando Díaz de Mendoza, Count of Balazote and Grandee of Spain, the aristocrat who became an actor in order to marry María Guerrero. The actress, depicted more than half length, appears to be in the act of taking her curtain call, smiling elegantly to her public.

CHILDREN ON THE BEACH

This work was donated on February 18, 1919, to the now defunct Museo Nacional de Arte Moderno.

The Valencian painter Sorolla is the prototype of what have been called "painters of light" — the Spanish equivalent of the French Impressionists. In the full catalogue of the sizeable oeuvre of this important artist, beach scenes, particularly those with children bathing, provided the subject matter for some of his most successful creations, as is the case with this particular canvas.

Here, a white eastern light, and the water shimmering in the sun's burning rays, spread over the fine skins of these children, who are scarcely interrupted by the drops of water that run over their limbs and backs. This song of intimate delight has a sense of instant and vibrant happiness seldom achieved in Spanish painting. The extraordinary technical gifts of Sorolla are displayed to the utmost in these paintings filled with light and disconcerting chromatic contrasts.

JOAQUÍN SOROLLA Y BASTIDA (1863–1923)
María Guerrero, 1906
Oil on canvas, 131 × 120.5 cm

JOAQUÍN SOROLLA Y
BASTIDA
Children on the Beach, 1910
Oil on canvas, 118 × 185 cm

This painting was bequeathed to the Prado Museum by Juan Bautista Robledo, and came to the Casón in 1981. Dated 1895 and dedicated to his "friend Iñigo," the work can be classified within the Oriental genre so much cultivated by the European artists in the final decades of the last century, and which would find its ideal interpreter in Spain — Fortuny.

Executed with a hyper-realistic precision, the figure of the Muslim is shown in front of a wall with plasterwork and tiles meticulously depicted. He looks up in an attitude of prayer, lifting his hands.

Benedito, an artist of enviable skill, enjoyed a long and active life, and was the last great representative of the typically nineteenth-century genre subjects — such as historical painting or Orientalism — who had a clear Romantic lineage, as we see in the vision of this work. Although the approach was past its time, this painter was able to infuse such conviction into his canvases, painted with such integrity, that we never have the impression of its having been a reactionary production. He used his vibrant and spontaneous brush to add to the successful innovations of an Impressionism that he knew how to interpret in a very personal way.

MANUEL BENEDITO VIVES (1875–1963)
Moor, 1895
Oil on canvas, 92 × 56 cm

LEARNING BY HEART

This work was acquired by the now defunct Museo Nacional de Arte Moderno by royal order of June 8, 1898, the time at which Pinazo was awarded the first medal in the Exposición Nacional de Bellas Artes for this work.

In reality it is an atypical portrait, in which his son is portrayed seated with a book in his hands, memorizing the lesson at the moment he looks fixedly at the viewer. A predominance of gray and dark tones, executed with a rapid brush and little material, characterize the painting.

As González Martí tells us, Pinazo referred to this portrait in the following way: "I painted it at home; the model and the light are familiar to me. I worked peacefully and allowed my brushes to work spontaneously and freely; I wanted to make a work displaying knowledge and reality." The artist has achieved this in this canvas.

In the Casa Pinazo in Godella is kept a preparatory study for this portrait, which is a key work in its genre within the panorama of Spanish painting of the latter part of the nineteenth century.

IGNACIO PINAZO CAMARLENCH (1849–1916)
Learning by Heart, 1898
Oil on canvas, 107 × 107 cm

The Vile Garrote

Painted by Ramón Casas in 1894, this canvas was acquired by royal order of July 12, 1895. For years it was in the Museo Nacional de Arte Contemporáneo and was hung in the central salon of the Casón del Buen Retiro in the reorganization of 1992, after the relocation of the *Guernica*.

This canvas, which was exhibited on completion in the Sala Parés of Barcelona, caused considerable excitement, not only due to the bleakness of its subject, but through its graphic pictorial quality. Casas shows clearly his ability to paint open-air themes with an atmosphere in which the gray and cold tones predominate. In 1894, the art critic Casellas noted a pictorial reflection of human civilization, of the state of social consciousness, at that time. He points out that this painting, in its time, must have emphasized the heartlessness of society. There is no incidental dramatization; it is notable for the lack of black and the wise use of shades that afford the naturalism so characteristic of Casas's oeuvre.

RAMÓN CASAS CARBÓ (1866–1932)
The Vile Garrote, 1894
Oil on canvas, 123 × 162 cm

JOSÉ MARÍA LÓPEZ MEZQUITA (1883–1954)
Chain Gang, 1901
Oil on canvas, 235.5 × 352 cm

CHAIN GANG

When he was only eighteen years old, the painter was awarded the first medal in the Exposición Nacional de Bellas Artes of 1901 for this work. It was acquired by the state for the Museo Nacional de Arte Moderno by royal order in July of the same year.

During the last decades of the past century and the first years of this one, alongside the traditional so-called historical paintings, landscapes, and canvases depicting other conventional subjects, works began to appear that displayed a definite social preoccupation. This work is without doubt one of the best known and most meaningful on this theme.

As its title indicates, the scene represents a rainy street at dusk, with the passage of a group of prisoners tied together, escorted by two members of the civil guard. Among the prisoners we see a peasant, a gentleman, a boy, and a man with his arm in a sling. The drama of the sequence is accentuated by the realism embodied by each one of the individuals. This may be seen particularly well in the depiction of the woman with a child in her arms who follows the pathetic cortege and, over all, through the effect of wretched and weak glimmers of light.

JOAQUÍN MIR TRINXET (1873–1940)
The Waters of Moguda, 1917
Oil on canvas, 129 × 148 cm

THE WATERS OF MOGUDA

This work won the first medal in the Exposición Nacional de Bellas Artes of 1917. It was acquired by the now defunct Museo Nacional de Arte Moderno by the Spanish state in accordance with royal order of June 11, 1917.

Mir's capacity to capture the transparencies of the air and the incidence of light on each fragment of landscape, expressed from his unique perception, is demonstrated ably in this painting. He accentuates this by bringing into play his ability as a colorist of the first order, one who knows how to combine the most disparate contrasts existing in nature by utilizing his highly skilled manner to transmit to the viewer the atmosphere and the light of the Mediterranean.

As Bernardino de Pantorba points out, "Mir surpassed all the landscape artists of his country in the abundance of his palette and variety of his tones. No one has surpassed him in the energy of production. He possesses an eye that can trap the nuances of the light in an astonishing manner." The test of this is that this painting earned the artist one of his many prizes in the national exhibitions.

THE HERMITAGE GARDEN

This work, with which Mir took the second medal in the Exposición Nacional de Bellas Artes of 1899 was acquired by the state by royal order of July 8 of that year.

As Melida points out, in this work Mir "has employed a vigorous note, a richness of color, and the contrast between the golden stone of the old building and the green of the luxuriant plants." For this reason Mir's approach has come to be called "Mediterranean Impressionism" and is shown here in its finest form. All the elements that characterize his style appear admirably blended.

The field of cabbages in the foreground — one of the landscape subjects he employed most frequently — the orange tree, and the vine arbors that constitute foreground and middle ground, are set in a fertile, damp garden. These contrast with Mir's golden light of such special nuance, which he causes to fall upon the chalk white of the garden walls of the humble hermitage of San Medín.

JOAQUÍN MIR TRINXET
The Hermitage Garden, 1899
Oil on canvas, 115 × 151 cm

AURELIANO DE BERUETE Y MORET (1845–1912)
The Outskirts of Madrid, 1906
Oil on canvas, 57.5 × 81 cm

THE OUTSKIRTS OF MADRID

We know from a signed note on the stretcher that this painting dates to 1906. Also known as the *District of Fine Views,* it was given to the Museo Nacional de Arte Moderno in 1913 by the artist's son, Aureliano de Beruete.

The light, and the bright chromatics of the foreground, make one briefly forget the poverty of the humble buildings in this outlying area of the city. In this work Beruete shows us once more that he is a master of light and color and possesses a true style. The aesthetic echoes and techniques he learned from Carlos de Haes and studied in the works of the Barbizon artists have been left behind.

As Gaya Nuño points out, these out-of-the-way suburbs of the Madrid of the time, these poverty-ridden banks of the Manzanares, the shacks and the miserable trees on the periphery of the capital, do not seem to contain great pictorial substance. And they would not if Beruete, who was so given to these modest scenes, had not been able to compose them in their powerful completeness, which is dominated by the infinite grace and redemption of the light. In this way, and from his innermost thoughts, Beruete came to Impressionist ideas of very special consequences.

AURELIANO DE BERUETE Y MORET
The San Isidro Meadows, 1909
Oil on canvas, 62.5 × 103 cm

THE SAN ISIDRO MEADOWS

This work was given, in 1922, to the now defunct Museo Nacional de Arte Moderno by the artist's widow, together with another painting, *The Manzanares River.* According to a note on the stretcher, it was painted in 1909.

This view, when seen in the context of those already painted by two illustrious antecedents, José del Castillo and Francisco de Goya, now shows the effects of the passage of time. Here it has a more populated appearance than it had in the eighteenth-century pictures, which were painted when it was simply countryside. Now, architectural silhouettes of the Royal Palace and the cupolas of San Francisco El Grande and San Andrés may be seen in the background, while humble rural buildings and tiny figures are in the foreground and middle ground.

Everything is executed with a spirited brush and the supple chromaticism that was natural to the temperament of this "painter of light," as he has come to be called.

Together with other artists of his generation, Beruete became one of the singular interpreters of Spanish Impressionism.

FRANCISCO GIMENO ARASA (1858–1927)
Blue Water
Oil on canvas, 60 × 98.5 cm

BLUE WATER

This work was acquired by royal order of October 19, 1956, for the Museo Nacional de Arte Moderno, together with the picture called *The Preserve*.

It is a splendid example of the great ability Gimeno Arasa displayed for landscape throughout his productive life. The title, *Blue Water,* fully reflects what is displayed in the canvas. Gimeno took his perspective from above, showing an extremely rocky coast, with spectacular inlets of the sea, emphasizing the beauty of the blue rock seen to the left. A rich Mediterranean vegetation serves as a pretext for the artist to display his Impressionist capacity and vision, as do the two country buildings.

It must be remembered that Gimeno was the first Catalan artist to come close to the French painting movement, the ideas of which he combined with the teachings of Carlos de Haes, as may be noted in his precision. Considering the time in which he lived, in contrast to the sad and worn-out conformist art that was then generally practiced in Spain, this is a landscape that is profuse in its plastic dexterity and absolutely modern in its atmospheric solutions.

GARDEN IN ARANJUEZ

THE OLD FAUN

This canvas earned the artist the first medal in the Exposición Nacional de Bellas Artes and it was acquired by the state by royal order of February 7, 1908.

Beyond a narrow promenade flanked by flowerbeds are shown the romantic fronds of Aranjuez, which Rusiñol re-created with an atmospheric tone that combines Symbolist and Modernist elements. A rich variety of greens, in imaginative ranges, forms the basis for a palette from which the artist built impastos and nuances of the most varied chromatic kind. He offers a deliciously subjective plastic interpretation of idealized nature.

Above all, we must remember the artist's literary experience, which is also in evidence here. His versatility helped to convert him into the true patriarch of Modernism. He influenced a great number of figures from this movement in Spain in general, and in Catalonia in particular, not only through his pictorial work but also by means of his writings and conversations.

Nature modified, as he used to call his landscapes, is what he offers us here: the snapshot of reality in the re-creation of a refined spirit.

With this work, Rusiñol won the first medal in the Exposición Nacional de Bellas Artes of 1912. It was acquired for the now defunct Museo Nacional de Arte Moderno by royal order of January 31, 1914.

In fact, the sculpture that gives the title to this painting and is shown dwarfed among a great French-style garden panorama before a natural setting of tall trees, served as a pretext for the artist to develop his splendid capacity to capture this type of greenery. It was, after all, amidst the capricious corners in the vicinity of the palace of Aranjuez that he found the happiest inspirations for his paintings. As a result, it is not only the contained expression of the garden plantings and Modernist elegance that are most interesting in these paintings, nor even his way of capturing the light, but the atmospheric sense — its purpose — that distinguish his work from that of the rest of the painters who produced these instant landscapes.

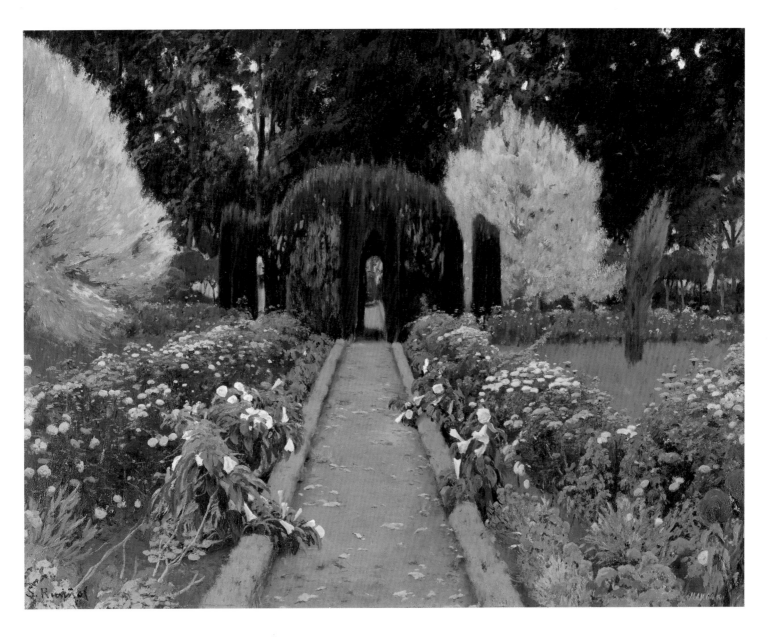

SANTIAGO RUSIÑOL PRATS (1861–1931)
Garden in Aranjuez, 1908
Oil on canvas, 140.5 × 134.5 cm
(Detail on following pages)

SANTIAGO RUSIÑOL PRATS
The Old Faun, 1912
Oil on canvas, 117 × 146 cm

AGUSTÍN RIANCHO Y GÓMEZ DE PORRAS
Tree, 1929
(Detail)

TREE

In 1954 this work was catalogued in the holdings of the Museo Nacional de Arte Moderno by Joaquín de la Puente, who identified it through information sent to him by a niece of the artist.

Agustín Riancho came from Santander and was a disciple of Carlos de Haes in the Royal San Fernando Fine Arts Academy. He lived in Antwerp and Brussels and was an outstanding landscape artist.

This particular work, executed in the last year of his life, exemplifies his form of landscape painting, which is characterized by a very smooth and spirited brush at the same time as it incorporates a richness and use of dense material. In this case the color is sober, with black used to mark a greater strength in the vibrant brushwork, which the artist employed together with a spatula, to depict this simple landscape of his native Cantabria, during his final retirement to his village.

AGUSTÍN RIANCHO Y GÓMEZ DE PORRAS (1841–1929)
Tree, 1929
Oil on canvas, 96 × 66 cm

THE CHICKEN COOP

This canvas was acquired by resolution of the board of the now defunct Museo Nacional de Arte Moderno on April 23, 1932.

It is the best-known work of this artist from Asturias who was a disciple of Carlos de Haes, and who completed his training by making frequent sojourns abroad, mostly in Belgium and France.

In this canvas, we have an exposition and summary that constitute his artistic credo. He makes clear his sincere adhesion to Impressionism with a simple Pointillism and a capacity to capture light through the most elemental approaches. In this way he achieves a work of distinct ingenuity and originality that differs from anything being done by contemporary Spanish painters, who always started from a free transcendentalism. There is in this canvas an exquisite Franciscan execution that led Ortega y Gasset to refer to him as the Fra Angelico of the cabbage and thicket.

DARÍO DE REGOYOS VALDÉS (1857–1913)
The Chicken Coop
Oil on canvas, 65 × 55 cm

VALENTÍN ZUBIAURRE (1879–1963)
Versolaris, 1913
Oil on canvas, 165 × 237 cm

VERSOLARIS

A racial atmosphere hangs over these stout, firmly modeled figures, which are characteristic of Zubiaurre. They are characters of a legendary primitive nature, as though extracted from a Gothic mural in a country church. This also occurs in the folkloric backgrounds of his canvases, which are relegated to being simply incidental against the force and solemnity that he infuses into each composition, always overcoming "the manner of telling" by what he really "tells." As is the case for but a few painters, the actual theme ceases to be of interest beside the popular monumentalism Zubiaurre is capable of expressing, both in his marine scenes and in those that deal purely with local customs.

Camón Aznar points out that in these paintings, "the things are outlined independently, detached from each other and from the atmosphere, as though apart from the background, which is like velvet for jewelry. All is cold and detailed. And always there is a feeling for atmosphere, one of the enchantments of his paintings."

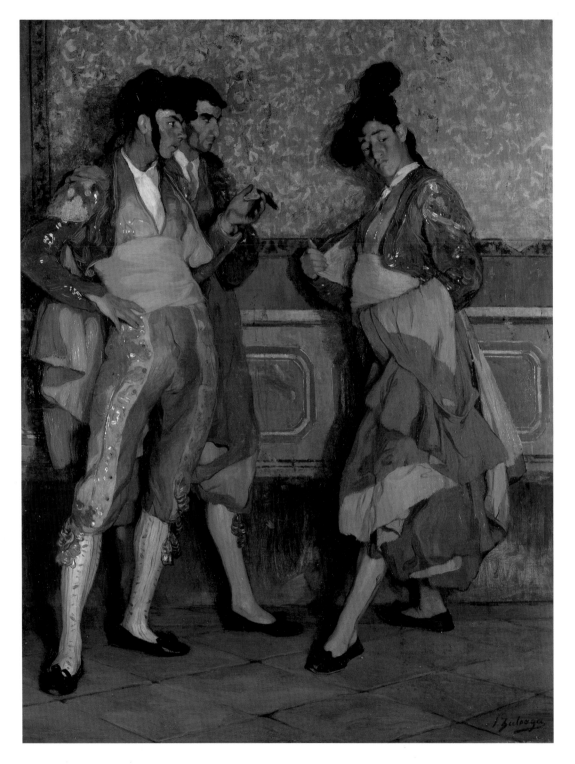

YOUNG VILLAGE BULLFIGHTERS

As is usual in Zuloaga's bullfight pictures — and is parallel to Solana's treatment of the subject — it is not the triumphant brilliance of a famous matador, the bright colors of the festival, or the most folkloric and attractive aspects that this painter customarily portrays. On the contrary, what interests him is the less attractive and unknown aspects, the intimate moments of isolation, the awful little country bullrings, the squalor, even the scenes of poverty of the aging, unsuccessful bullfighter.

In this case he shows us a modest room in a cheap village restaurant where three novice bullfighters, already dressed, prepare to go out to the arena, improvised with carts and barricades, where the bullfight will take place. The hope and fear evident on their young faces contrasts with the depressing flowered wallpaper and the dado that cover the walls.

The dry chromaticism that characterizes this painter's work accentuates with dramatic echoes what this first step to glory means to these young bullfighters.

IGNACIO ZULOAGA (1870–1945)
Young Village Bullfighters, 1906
Oil on canvas, 196 × 180 cm
(Detail on preceding pages)

Since this work was given to the Prado Museum by Douglas Cooper on October 11, 1979, it remains in the Casón, rather than being placed with the works of other artists of the historical vanguard, which were brought together in the Museo Nacional Centro de Arte Reina Sofía.

Signed in October 1916, it is known that this canvas was executed by the artist in Beaulieu. Josette — Juan Gris's companion from 1912 until his death — is depicted within a cubist technique, as is usual for the artist's work.

She is inserted into a geometrical play of impeccable planning. The painting responds to Gris's plastic perception, to his ability to transpose from the material plane into the mental. Also apparent is his rigorous approach in chilling some tonalities and illuminating others. He thus obtains the developed lyricism that acquires a special meaning through the motive of the theme itself. All remains deafened, serene, full of grave harmonies; the simple aligned forms produce in the viewer profound intellectual suggestions.

JUAN GRIS (1887–1927)
Portrait of Josette, 1916
Oil on canvas, 116.5 × 73 cm

BIBLIOGRAPHY

GENERAL

ALCOLEA BLANCH, S., *El Museo del Prado,* Barcelona, 1991.

BEROQUI, P., *El Museo del Prado: Notas para su historia,* Madrid, 1923.

BUENDÍA, J. R., *El Prado básico,* Madrid, 1994 (1st ed. 1979).

COLORADO, A., *El Museo del Prado y la Guerra Civil: Figueras-Ginebra, 1939,* Madrid, 1991.

CHUECA, F., *El Museo del Prado,* Granada, 1972 (1st ed., Madrid, 1952).

—— *La vida y la obra del arquitecto Juan de Villanueva,* Madrid, 1949.

CRUZADA VILLAAMIL, *Catálogo del Museo Nacional de pinturas,* Madrid: Museo de la Trinidad, 1865.

MADRAZO, M. DE, *Historia del Museo del Prado, 1818–1869,* Madrid, 1945.

MADRAZO, P., *Viaje artístico de tres siglos por las Colecciones de los Reyes de España,* Barcelona, 1884.

PÉREZ SÁNCHEZ, *Pasado, presente y futuro del Museo del Prado,* Madrid, 1977.

ROMEU DE ARMAS, A., *Orígenes y fundación del Museo del Prado,* Madrid, 1980.

SÁNCHEZ CANTÓN, F. J., *El Museo del Prado,* Santander, 1961.

VV.AA., *Un mecenas póstumo: El legado Villaescusa: Adquisiciones 1992–1993,* Madrid, 1993 (1st ed. 1933).

—— *Museo del Prado: Catálogo de las pinturas, Madrid 1985.* The first three catalogues were edited by Luis Eusebi, curator of the museum (1819, 1821, and 1824); a slipcased edition was published for the Prado Museum, 1994).

THE SPANISH SCHOOL

ANGULO, D., *Pintura del Renacimiento. Ars Hispaniae,* vol. XIII, Madrid, 1955.

—— *Pintura del siglo XVII,* in *Ars Hispaniae,* vol. XV, Madrid, 1971.

ANGULO D. and A. E. PÉREZ SÁNCHEZ, *Escuela madrileña del primer tercio del siglo XVII,* Madrid, 1969.

—— *Escuela toledana de la primera mitad del siglo XVII,* Madrid, 1972.

—— *Escuela madrileña del segundo tercio del siglo XVII,* Madrid, 1983.

BROWN, J., *Jusepe de Ribera: Prints and Drawings,* Princeton, 1973.

—— *Velázquez. Pintor y cortesano,* Madrid, 1986.

BUENDÍA, J. R. and I. GUTIÉRREZ PASTOR, *Vida y obra de Mateo Cerezo (1637–1665),* Burgos, 1986.

CAMÓN AZNAR, J., *Velázquez* (2 vols.), Madrid, 1964.

—— *El Greco,* 2nd ed. (2 vols.), Madrid, 1970.

—— *La pintura española en el siglo XVI,* in *Summa Artis,* vol. XIV, Madrid, 1970.

—— *La pintura española del siglo XVII,* in *Summa Artis,* vol. XXV, Madrid, 1977.

—— *Pintura medieval española,* in *Summa Artis,* vol. XXII, Madrid, 1978.

—— *Goya* (4 vols)., Zaragoza, 1980–1984.

GALLEGO, J., and J. GUDIOL, *Zurbarán,* 1600–1682, Barcelona, 1976.

GASSIER, P., and J. WILSON, *La vie et l'oeuvre de Francisco de Goya,* Paris, 1970.

HARRIS, E., *Velázquez,* London, 1984.

JUSTI, C., *Velázquez y su siglo,* Madrid, 1953.

LUNA FERNÁNDEZ, J., *Luis Meléndez, bodegonista español del siglo XVIII.* Exhibition catalogue. Madrid, 1982.

MARTÍNEZ RIPOLL, A., *Francisco de Herrera el Viejo,* Seville, 1978.

MAZÓN DE LA TORRE, M. A., *Jusepe Leonardo y su tiempo,* Zaragoza, 1978.

MORALES Y MARÍN, J. L., *Los Bayeu,* Zaragoza, 1979.

—— *La pintura española en el siglo XVIII,* in *Summa Artis,* vol. XVII. Madrid, 1984.

—— *Arte Barroco y Rococó,* in *Historia General del Arte,* vol. 7, Barcelona: Planeta, 1986.

—— *Mariano Salvador Maella,* Madrid, 1991.

—— *La pintura en España durante el periodo de la Ilustración, 1750–1808,* Madrid, 1994.

PÉREZ SÁNCHEZ, A. E., *Juan Carreño de Miranda (1614–1685),* Avila, 1985.

—— *Carreño, Rizi, Herrera y la pintura madrileña de su tiempo.* Exhibition catalogue. Madrid, 1986.

—— *La Nature Morte espagnole du XVe siècle A Goya,* Freiburg, 1987.

—— *Pintura barroca en España, 1600–1750,* Madrid, 1992.

SAMBRICIO, V., *Tapices de Goya,* Madrid, 1984.

SÁNCHEZ CANTÓN, F. J., *Vida y obra de Goya,* Madrid, 1951.

—— *Escultura y pintura del siglo XVIII,* in *Ars Hispaniae,* vol. XVIII, Madrid, 1965.

SPINOZA, N., *La obra completa de Ribera,* Barcelona, 1979.

SULLIVAN, E. J., *Baroque Painting in Madrid: The Contribution of Claudio Coello, with a Catalogue Raisonné of His Work,* New York: Columbia, 1986.

TUFTS, E., *Luis Meléndez, Eighteenth-Century Master of the Spanish Still-Life,* New York: Columbia, 1975.

VALDIVIESO, E.: *Valdés Leal,* Seville, 1989.

VALDIVIESO, E., and J. M. SERRERA, *Escuela sevillana del primer tercio del siglo XVII.* Madrid, 1985.

WETHEY, H., *Alonso Cano, pintor, escultor y arquitecto,* Madrid, 1983.

THE ITALIAN SCHOOL

BENITO DOMENECH, F., *Sobre la influencia de Sebastiano del Piombo en España: A propósito de dos cuadros suyos en el Museo del Prado,* "B.M.P." 25–27 (1988), 5–28.

BOTTINEAU, Y., *El arte cortesano en la España de Felipe V (1700–1746),* Madrid: Fundación Universitaria Española, 1986.

FERRARI, O., and G. SCAVIZZI, *Luca Giordano,* Milan: Electa, 1992.

KUSCHE, M., *Sofonisba Anguissola en España,* "A.E.A." 248 (1989), 391–420.

NATALI, A. y CECCHI, A., *Andrea del Sarto,* Florence: Cantini, 1989.

PANOFSKY, E., *Problems in Titian, Mostly Iconographic,* London: Phaidon, 1969.

PÉREZ SÁNCHEZ, A. E., *Pintura italiana del siglo XVII en España,* Madrid, 1965.

—— *El retrato de Giovanni Mateo Ghiberti por Bernardino India,* "B.M.P." 13 (1984), 64–66.

—— *Pintura napolitana de Caravaggio a Giordano,* Madrid: Museo del Prado, 1985.

—— *El martirio de San Esteban.* Bernardo Cavallino, Madrid: Fundación Amigos del Museo del Prado, 1989.

PIGNATTI, T., and F. PEDROCCO, *Veronés.* Catalogue raisonné. Madrid: Akal Ediciones, 1992.

SPEAR, R. E., *Domenichino.* New Haven and London: Yale University Press, 1982.

URREA, J., *La pintura italiana del siglo XVIII en España,* Valladolid: Universidad de Valladolid, 1977.

VANNUGLI, A., *La colección del marqués Giovan Francesco Serra.* "B.M.P." 25–27 (1988), 33–43.

CATALOGUES

Andrea Mantegna (J. MARTINEAU, ed.), London and New York: Olivetti-Electa, 1992.

Artemisia (compiled by R. CONTINI and G. PAPI), Verona: Leonardo-De Luca Editori, 1991.

Colección Cambó, Madrid: Ministerio de Cultura, 1990.

El arte europeo en la Corte de España durante el siglo XVIII, Madrid: Ministerio de Cultura, 1980.

Giovanni Francesco Barbieri, il Guercino, Bologna: Nuova Alfa Editoriale, 1991.

Il Seicento fiorentino, Florence: Cantini, 1987.

Itinerario italiano de un monarca español. Carlos III en Italia, Madrid: Museo del Prado, 1989.

Jacopo Bassano c. 1510–1592 (compiled by B. L. BROWN and P. MARINI), Bologna: Nuova Alfa Editoriale, 1992.

Michelangelo Merisi da Caravaggio (compiled by M. GREGORI), Milan: Electa, 1991.

Museo del Prado: Catálogo de las pinturas, Madrid, 1985.

Museo del Prado: Inventario general de pintura. I. La colección real. II. El Museo de la Trinidad, Madrid: Espasa Calpe, 1990.

Nell'età di Correggio e dei Carracci, Bologna: Nuova Alfa Editoriale, 1986.

Pintura italiana del siglo XVII, Madrid: Museo del Prado, 1970.

Rafael en España, Madrid: Ministerio de Cultura, 1985.

The Genius of Venice, 1500-1600, London: Weidenfeld and Nicolson, 1983.

Tiziano, Venecia: Marsilio Editori, 1990.

THE FLEMISH AND DUTCH SCHOOLS

ADLER, W., *Landscapes (Corpus Rubenianum Ludwig Burchard XVIII–1),* London, 1982.

ALPERS, S., *The Decoration of the Torre de la Parada (Corpus Rubenianum Ludwig Burchard IX),* Brussels, 1971.

BALIS, A., *Rubens's Hunting Scenes (Corpus Rubenianum Ludwig Burchard XVIII–2),* London, 1986.

BALIS, A., M. DÍAZ PADRÓN, C. VAN DE VELDE, and H. VLIEGHEM, *La pintura flamenca en el Prado,* Antwerp, 1989.

BERMEJO, E., *La pintura de los primitivos flamencos en España, I,* Madrid, 1980.

—— *La pintura de los primitivos flamencos en España, II,* Madrid, 1982.

BLANKERT, A., *Dutch 17th-century Italianate Landscape Painters,* Soest, 1978.

BREDIUS, A., *The Paintings of Rembrandt* (3rd ed.), London and New York, 1969.

—— *Brueghel: Une dynastie des peintres,* Brussels: Palais des Beaux-Arts, 1980.

CLERICI, F., *Allegorie dei Sensi di Jan Brueghel,* Milan, 1946.

—— *Splendeurs d'Espagne et des villes belges, 1500–1700,* Brussels: Palais des Beaux-Arts, 1985.

DAVIES, M., *Rogier van der Weyden,* London, 1972.

D'HULST, R. A., *Jacob Jordaens,* Antwerp, 1982.

DÍAZ PADRÓN, M., *Museo del Prado: Catálogo de pinturas. I Escuela Flamenca. Siglo XVII,* Madrid, 1975.

DUPARC, F. J., "Philips Wouwerman, 1619–1668," in *Oud Holland* 107 (1993), pp. 257–286.

EEMANS, M., *Jan Brueghel de Velours,* Brussels, 1964.

FAGGIN, G. T., *L'opera completa di Memling,* Milan, 1969.

FALKENBURG, R. L., *Joachim Patinier: Het landschap als beeld van de levenspelgrimage,* Nijmegen, 1985.

FRIEDLÄNDER, M. J., *Jan Gossart and Bernard van Orley (Early Netherlandish Painting, VIII),* Leiden and New York, 1972.

GRIMM, C., *Stilleben: Die niederländischen und deutschen Meister,* Stuttgart and Zurich, 1988.

HUEMER, F., *Portraits (Corpus Rubenianum Ludwig Burchard XIX–1),* Brussels, London, and New York, 1977.

HUYS JANSEN, P., *Schilders in Utrecht, 1600–1700,* Utrecht, 1990.

JAFFE, M., *Rubens: Catálogo Completo,* Milan, 1989.

KRUYFHOOFT, C., AND S. BUYS, *P. P. Rubens et la peinture animalière,* Antwerp, 1977.

LARSEN E., *L'opera completa di Van Dyck,* Milan, 1980.

—— *The paintings of Anthony van Dyck,* Freren, 1988.

NICOLSON, B., *Caravaggisme in Europe,* Turin, 1990.

POORTER, N. DE, *The Eucharist Series (Corpus Rubenianum Ludwig Burchard II),* Brussels, 1978.

ROBINSON, F. W., *Gabriel Metsu (1629–1667),* New York, 1974.

SCHNEIDER, A. VON, *Caravaggio und die Niederländer,* Marburg, 1933.

SEGAL, S., *Jan Davidsz de Heem en zizjn kring,* The Hague, 1991.

TOLNAY, CH. DE, *Hiëronimus Bosch,* Basel, 1937 (2nd ed., 1965).

VALDIVIESO, E., *Pintura holandesa del siglo XVII en España,* Valladolid, 1973.

—— "Un nuevo retrato de la familia de Jan van Keesel el joven," in *Boletín del seminario de estudios de Arte y Arqueología XLI,* 1983.

VERGARA, W. A., "The Count of Fuensaldaña and David Teniers: Their Purchases in London after the Civil War," in *Burlington Magazine,* CXXXI, 1989, pp. 127–132.

VLIEGHE, H., *Saints (Corpus Rubenianum Ludwig Burchard VIII–1),* Brussels, London, and New York, 1971.

—— *Saints (Corpus Rubenianum Ludwig Burchard VIII– 2),* Brussels, London, and New York, 1973.

WHITE, C., *Peter Paul Rubens: Man & Artist,* New Haven and London, 1987.

WILENSKI, R. H., *Flemish Painters, 1430–1830,* New York, 1960.

THE GERMAN SCHOOL

BENESCH, O., *The Art of the Renaissance in Northern Europe,* London: Phaidon, 1965.

—— *La pintura alemana de Durero a Holbein,* Geneva: Skira-Carroggio, 1966.

GLÜCK, *Arte del Renacimiento fuera de Italia,* Barcelona: Labor, 1935.

GROHN, H. W., *La obra pictórica completa de Holbein el Joven,* Barcelona: Noguer, 1972.

LAFUENTE FERRARI, E., *El Prado. La pintura nórdica,* Madrid: Aguilar, 1977.

PANOFSKY, Erwin, *Vida y arte de Alberto Durero,* Madrid: Alianza Editorial, 1982.

ROSENBERG, J., S. SILVE, and E. H. TER KUILE, *Dutch Art and Architecture 1600–1800,* Harmondsworth: Penguin, 1972.

URREA FERNÁNDEZ, J., *El Arte Europeo en la Corte de España durante el siglo XVIII.* Catalogue of the exhibition at the Museo del Prado, Feb. 1 to Apr. 27, 1980. Madrid: Ministerio de Cultura, 1980.

WARZÉE, P., *L'Humanisme en Flandre et en Allemagne. 1500–1570.* vol. XVI de la *Grande Histoire de la Peinture,* París: Skira, 1979.

WEISBACH, W., *Arte Barroco en Italia, Francia, Alemania y España,* Barcelona: Labor, 1934.

THE ENGLISH SCHOOL

BAKER, C. H. C. and W. G. CONSTABLE, *English Painting of the Sixteenth and Seventeenth Centuries,* Florence and París, 1930.

GATT, G., *Gainsborough,* Barcelona: Toray, 1969.

GONZÁLEZ-ARNAO, M., *Los cuadros ingleses del Prado. Historia 16,* no. 88, 1983.

HIPPLE, W. J., *The Beautiful, the Sublime and the Picturesque in Eighteenth-Century British Aesthetic Theory,* Carbondale, Ill., 1957.

IRWIN, D. and F., *Scottish Painters at Home and Abroad, 1700–1900,* London, 1975.

LAFUENTE FERRARI, E., *El Prado: La pintura nórdica,* Madrid: Aguilar, 1977.

LUNA, J. J., *Pintura británica (1500–1820),* in *Summa Artis,* vol. XXXIII, Madrid: Espasa Calpe, 1989.

MAYOUX, J., *La pintura inglesa: De Hogarth a los prerrafaelistas,* Geneva, Barcelona, 1972.

MORALES Y MARÍN, J. L., *Barroco y Rococó: Historia Universal del Arte,* vol. VII, Madrid: Planeta, 1987.

MOUREY, C., *La peinture anglaise au XVIIIe siècle,* Paris, 1932.

PENNY, N., and P. ROSENBERG, *Reynolds.* Exhibition organized by the Royal Academy of Arts, London, and La Réunion des Musées Nationaux, Paris; October 7 to December 16, 1985. Paris: Ministére de la Culture, 1985.

SÁNCHEZ CANTÓN, F. J., "Retratos ingleses en el Museo del Prado," in *Goya,* no. 24, 1958.

WATERHOUSE, E., *Painting in Britain, 1500 to 1790,* Harmondsworth: Penguin, 1954.

THE FRENCH SCHOOL

BLUNT, A., *Arte y arquitectura en Francia 1500/1700,* Madrid: Cátedra, 1977.

—— *The Paintings of Nicolas Poussin: A Critical Catalogue,* London, 1966.

BOTTINEAU, I., *El arte cortesano en la España de Felipe V (1700–1746),* Madrid: Fundación Universitaria Española, 1986.

BROWN, J., and J. H. ELLIOT, *Un palacio para el rey: El Buen Retiro y la corte de Felipe IV,* Madrid: Alianza Editorial, 1981.

CRELLY, W. R., *The Painting of Simon Vouet,* New Haven: Yale University Press, 1962.

DIMIER, L., *Histoire de la peinture francaise,* vols. II and III: *Du retour du Vouet à la mort de LeBrun, 1627 à 1690,* Paris and Brussels: G. van Oest, 1925–1927.

FRANCASTEL, P., *Historia de la pintura francesa,* Madrid: Alianza Forma, 1989.

GÁLLEGO, J., and F. MÉGRET, *Le XVIIIe siècle en France et en Italie.* vol. XI of *La Grande Histoire de la Peinture,* Paris: Skira, 1979.

GARRIDO, M. C., "Capitulaciones de boda y baile campestre y Fiesta en un parque de Jean-Antoine Watteau," *Boletín del Museo del Prado,* vol. X, January–December, 1989, pp. 55–65.

GAUTIER, M., *Watteau,* Barcelona: Teide, 1966.

ISARLO, G., *La peinture en France au XVIIe siècle,* Paris: La Bibliothèque des Arts, 1960.

LUNA, J. J., *Claudio de Lorena y el ideal clásico de paisaje en el siglo XVII. Catálogo,* Madrid: Ministerio de Cultura, 1984.

—— "Un centenario olvidado, Jean Ranc," in *Goya,* no. 127, Madrid, pp. 22–24.

—— "Louis-Michel Van Loo en España," in *Goya,* no. 144, Madrid, 1978, pp. 330–337.

MIRIMONDE, A. P. DE, "Poussin et la musique," in *Gazette des Beaux Arts* LXXIX, March 1972, pp. 146–147.

PARISET, F. G., *Georges de La Tour,* Paris, 1948.

REAU, L., *Histoire de la peinture française au XVIIIe siècle,* Paris, 1928–30.

ROTHSLISBERGER, M., *Claude Lorrain: The Paintings,* New Haven, 1961.

TEYSSÉDRE, B., *El arte del siglo de Luis XIV,* (2 vols.), Barcelona: Labor, 1973.

THUILLIER, J., *La obra pictórica completa de Poussin,* Barcelona and Madrid: Noguer, 1975.

URREA, J., *Pintura* en *El Barroco y el Rococó.* Vol. IV of *La Historia del Arte Hispánico.* Madrid: Alhambra, 1980.

WEISBACH, W., *Arte Barroco en Italia, Francia, Alemania y España,* Barcelona: Labor, 1934.

PAINTINGS OF
THE NINETEENTH CENTURY

AGUILERA CERNI, V., *Pinazo,* Valencia, 1982.

ARIAS ANGLES, E., "Manuel Barrón y Carrillo, pintor sevillano," in *Archivo Español de Arte,* Madrid, 1983, pp. 313–340.

—— "Influencia de John Flaxman y Gavin Hamilton en José de Madrazo y una nueva lectura de 'La muerte de Viriato,'" in *Archivo Español de Arte,* Madrid, 1985, no. 232, pp. 351–362.

—— *El paisajista romántico Jenaro Pérez Villaamil,* Madrid, 1986.

—— "La pintura, la escultura y el grabado," in *Historia de España,* by Ramón Menéndez Pidal, vol. XXXV (2), Madrid: Editorial Espasa-Calpe, 1989, pp. 267–512.

—— "Pintura Española del siglo XIX," in *Cuadernos de Arte Español,* Historia 16, Madrid, 1992.

ARIAS ANGLES, E., and W. RINCÓN GARCÍA, *Exposiciones Nacionales del Siglo XIX. Premios de Pintura.* Exhibition catalogue. Madrid: Centro Cultural del Conde Duque, 1988.

ARIAS DE COSSÍO, A. M., *José Gutierrez de la Vega, pintor romántico sevillano,* Madrid, 1978.

ARNÁIZ, J. M., *Eugenio Lucas,* Madrid, 1981.

BERUETE Y MORET, A., *Historia de la Pintura Española del siglo XIX,* Madrid, 1926.

BOIX, F., "Francisco Lameyer, pintor, dibujante y grabador," in *Raza Española,* Madrid, 1919.

CALVO SERRALLER, F., *Rosales: Los Genios de la Pintura,* Madrid: Editorial Sarpe, 1988.

CASADO ALCALDE, E., *Pintores de la Academia de Roma: La primera promoción,* Madrid: Lunwerg Editores, Ministerio de Asuntos Exteriores, 1990.

CID PRIEGO, C., *Aportaciones para una monografía del pintor Carlos de Haes,* Lérida, 1956.

ESPI VALDÉS, A., *Vida y obra del pintor Gisbert,* Valencia, 1971.

GAYA NUÑO, J. A., *Historia y Guía de los Museos de España* (2nd ed.), Madrid: Editorial Espasa-Calpe, S.A., 1962.

GONZÁLEZ, C., and M. MARTÍ, *Pintores españoles en Roma (1850–1900),* Barcelona: Editorial Tusquets, 1987.

—— *Pintores españoles en París (1850–1900),* Barcelona: Editorial Tusquets, 1989.

GONZÁLEZ LÓPEZ, C., *Federico de Madrazo y Kuntz,* Barcelona, 1981.

—— *Los Madrazo: una familia de artistas.* Exhibition catalogue. Madrid: Museo Municipal, 1985.

—— *Mariano Fortuny y Marsal,* Barcelona, 1989.

GONZÁLEZ MARTÍ, M., *Pinazo. Su vida y su obra (de 1849 a 1916),* Valencia, 1920.

GUERRERO LOVILLO, J., *Antonio María Esquivel,* Madrid, 1957.

—— *Valeriano Bécquer (romántico y andariego),* Sevilla, 1974.

GUTIÉRREZ BURÓN, J., *Exposiciones Nacionales de Pintura en España en el siglo XIX,* Madrid, 1987.

JUNOY, J. M., *Ramón Martí Alsina,* Barcelona, 1941.

MARINEL-LO, M., "Francisco Masriera, el pintor de la riqueza," in *Bulleti dels Museus D'Art de Barcelona,* no. 18, Barcelona, 1932, pp. 321–325.

MÉNDEZ CASAL, A., "Rafael Tejeo: Su vida, oficial, El pintor de retratos," in *Boletín de la Junta del Patronato del Museo Provincial de Bellas Artes de Murcia,* no. 4, Murcia, 1925.

MIGUEL EGEA, P. DE, "Juan Antonio de Ribera, pintor neoclásico," in *Academia: Boletín de la Real Academia de Bellas Artes de San Fernando,* no. 56, Madrid, 1983, pp. 187–212.

—— *Carlos Luis de Ribera: pintor romántico madrileño,* Madrid, 1983.

MORALES Y MARÍN, J. L., *Vicente López,* Zaragoza, 1980.

—— *Vicente López (1772–1850),* Exhibition catalogue. Madrid: Museo Municipal, 1989.

OSSORIO Y BERNARD, M., *Galería Biográfica de artistas españoles del siglo XIX,* Madrid, 1883–1884.

PALENCIA TUBAU, C., *Leonardo Alenza,* Madrid.

PANTORBA, B. DE, "Evocación de Martín Rico (en el centenario de su nacimiento)," in *Revista Española de Arte,* II, no. 8, Madrid, 1933, pp. 456–465.

—— *El arte de Jiménez Aranda,* Madrid, 1943.

—— *Los Madrazo,* Barcelona, 1947.

—— *El pintor Jiménez Aranda,* Madrid, 1972.

—— *Historia y crítica de las Exposiciones Nacionales de Bellas Artes celebradas en España* (2nd ed.), Madrid, 1980.

PARDO CANALIS, E., "El fusilamiento de Torrijos y sus compañeros. Ante el cuadro de Gisbert," in *Arte Español* XVIII, Madrid, 1950–1951, p. 89.

—— "Ante la Rendición de Bailén," in *Goya,* no. 98, Madrid, 1970, p. 121.

PENA LÓPEZ, M. C., *El paisaje español del siglo XIX: del Naturalismo al Impresionismo,* Madrid, 1982.

—— *Pintura de paisaje e ideología. La generación del 98,* Madrid, 1983.

PÉREZ CALERO, G., *José Jiménez Aranda,* Seville, 1982.

—— *El pintor Eduardo Cano de la Peña (1823–1897),* Seville, 1979.

PÉREZ MORANDEIRA, R., *Vicente Palmaroli,* Madrid, 1971.

PORTELA SANDOVAL, F., *Casado del Alisal (1831–1886),* Palencia, 1986.

PUENTE, J. DE LA, *Museo del Prado–Casón del Buen Retiro: Pintura del Siglo XIX,* Madrid: Ministerio de Cultura, 1985.

REYERO, C., *Imagen Histórica de España,* Madrid, 1987.

RINCÓN GARCÍA, W., *Francisco Pradilla,* Madrid: Editorial Antiquaria, 1987.

RODRÍGUEZ GARCÍA, S., *Antonio Muñoz Degrain, pintor valenciano y español,* Valencia, 1966.

—— *El pintor Francisco Domingo Marqués: Resumen de su vida y significación de su obra,* Valencia, 1950.

SALAS, X. DE, "El testamento de Isabel la Católica, pintura de Eduardo Rosales," in *Arte Español* XIX, Madrid, 1953, pp. 108–133.

SAN NICOLÁS SANTA MARÍA, J., *Darío de Regoyos,* Barcelona, 1990.

SANTOS TORROELLA, R., *Valeriano Bécquer,* Barcelona, 1948.

SEQUEROS, A., *El pintor oriolano Joaquín Agrasot,* Alicante, 1972.

VV.AA., *La pintura de historia del siglo XIX en España.* Exhibition catalogue of the former Museo Español de Arte Contemporáneo, Madrid, 1992.

INDEX OF NAMES

INDEX OF WORKS OF ART REPRODUCED IN COLOR

PHOTOGRAPHY CREDITS